Self Help Graphics & Art

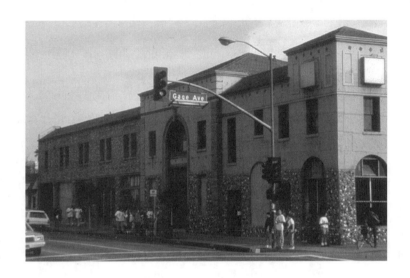

THE CHICANO ARCHIVES

This series brings together resources related to major Chicano special collections. The goal is to facilitate access to these collections and thereby stimulate new critical and historical research based on archival sources. Each book includes original scholarship, one or more finding aids, reproductions of key documents and images, and a selected bibliography. The series draws primarily on collections in the UCLA Chicano Studies Research Center Library and Archive. Because preserving Chicano history requires efforts and coordination across multiple institutions, the series includes projects undertaken in collaboration with other Chicano archives.

Series Editors

Chon A. Noriega

Yolanda Retter Vargas

Wendy Belcher

www.chicano.ucla.edu

Self Help Graphics & Art
Art in the Heart of East Los Angeles

Kristen Guzmán
Edited by Colin Gunckel

UCLA Chicano Studies Research Center
Los Angeles
2005

Library of Congress Cataloging-in-Publication Data

Guzmán, Kristen, 1969-
 Self Help Graphics & Art : art in the heart of East Los Angeles / Kristen Guzmán ; edited by Colin Gunckel.
 p. cm. -- (The Chicano archives ; v. 1)
 Includes bibliographical references and index.
 ISBN-13: 978-0-89551-100-3 (alk. paper)
 ISSN: 1557-5934
 1. Self-Help Graphics and Art, Inc.--Catalogs. 2. Graphic arts--California--East Los Angeles--Catalogs. 3. Mexican American prints--California-
-East Los Angeles--Catalogs. 4. Political posters, American--California--East Los Angeles--Catalogs. 5. Prints--California--Santa Barbara--
Catalogs. 6. University of California, Santa Barbara. Library. California Ethnic and Multicultural Archives--Catalogs. I. Title: Self Help Graphics
and Art. II. Gunckel, Colin, 1975- III. Self-Help Graphics and Art, Inc. IV. University of California, Los Angeles. Chicano Studies Research Center. V.
University of California, Santa Barbara. Library. California Ethnic and Multicultural Archives VI. Title. VII. Series.
 NC999.4.S45A4 2005
 760'.092'3680794--dc22
 2005023237

Photograph of Self Help Graphics & Art building (2005) reprinted courtesy of Harry Gamboa Jr.

A good faith effort was made to secure written permission from all copyright owners of the images reproduced in this volume. Where those efforts
have not been successful, copyright owners are invited to contact the press so that their copyright can be acknowledged.

UCLA Chicano Studies Research Center
193 Haines Hall
Los Angeles, California 90095-1544 USA
press@chicano.ucla.edu
www.chicano.ucla.edu/press

Center Director: Chon A. Noriega
Publications Coordinator: Wendy Belcher
Business Manager: Lisa Liang
Assistant Editor: Erica Bochanty
Production: William Morosi
Copyeditor: Catherine A. Sunshine

To find out more about CSRC Library and Special Collections, contact:
Yolanda Retter Vargas, Librarian
310-206-6052 (phone)
310-206-1784 (fax)
yretter@chicano.ucla.edu
UCLA Chicano Studies Research Center Library
144 Haines Hall
Los Angeles, CA 90095-1544
www.chicano.ucla.edu/library/

Contents

Acknowledgments

This book is the outgrowth of an ongoing community partnership between the UCLA Chicano Studies Research Center and Self Help Graphics & Art, Inc. We are grateful to the artists and staff of Self Help Graphics and especially to Tomás Benitez, its executive director from 1997 to 2005, for their invaluable collaboration.

The California Ethnic and Multicultural Archives (CEMA) at the University of California, Santa Barbara, which houses the Self Help Graphics & Art archives, provided vital contributions to this project. Special thanks to CEMA director Salvador Güereña for his enthusiastic support.

The Center for Community Partnerships at UCLA under the leadership of Vice Chancellor Franklin Gilliam provided generous support for the community partnership with Self Help Graphics and for this publication. The University of California Institute for Mexico and the United States (UC MEXUS) also provided support for partnership activities. Our thanks to all.

Collaborators' Notes

Founded in 1970, Self Help Graphics & Art in East Los Angeles remains a national model for both community-based art making and art-based community making. The UCLA Chicano Studies Research Center, founded the same year, continues its own mission of fostering research that makes a difference. We are proud to have an active and ongoing community partnership with Self Help Graphics, and this relationship serves as a cornerstone of our arts projects that put research and archival preservation at the service of both scholars and the community at large. Just as important, we are pleased to collaborate with the California Ethnic and Multicultural Archives at the University of California, Santa Barbara, which serves as the official archive for Self Help Graphics. These partnerships make a crucial contribution to our shared goal of preserving Chicano history. It is our hope that this book, written and edited by young scholars, will encourage others to enter the Chicano archives and expand the scholarly record.

Chon A. Noriega, Director
UCLA Chicano Studies Research Center
University of California, Los Angeles

For many years the artists and the work of Self Help Graphics & Art have enriched and broadened our understanding of Chicano art and of the special role it has played within the broader orbit of American art. The materials produced by Self Help Graphics form an important part of our cultural memory that should be kept alive through the synergy of archivists and cultural historians. The California Ethnic and Multicultural Archives (CEMA) has, since 1986, been the official repository for preserving that memory as it is recorded in the archives of Self Help Graphics & Art. CEMA is dedicated to preserving and making accessible primary sources including silk screen prints, slides, photographs, organizational records, and ephemera that illuminate the history of this organization and its artists. It is hoped that the historical essay and finding aid in this book will lay the groundwork for further analysis, interpretation, and discourse.

Salvador Güereña, Director
California Ethnic and Multicultural Archives
Special Collections Department, University Libraries
University of California, Santa Barbara

When Self Help Graphics & Art was founded and artists were busy creating their work in close rank, the spirit of that time was to disseminate art as broadly as possible and increase the access to the message and vision captured in its imagery. The print multiple answered this need most efficiently and most effectively. Indeed, the work's value resided in its ability to touch more and more people. Thus, the archive of fine art silkscreen prints is more an accidental legacy than a purposeful endeavor. The end result is no less valuable, giving us the most inclusive documentation of Chicano printmaking. Whether through an image of bold, idealistic neo-nationalism or a more personal narrative, the artists convey a voice from the heart; heretofore rarely heard, but a voice, loud and clear just the same. This collection of over 500 prints puts to rest any doubt that Chicano artists have been part of the fabric of modern U.S. culture during the last part of the twentieth century.

Tomás Benitez
Executive Director, 1997–2005
Self Help Graphics & Art, Inc.

Author's Preface

This book is the product of several years of sitting down over coffee with artists and cultural workers, poring over papers and slides, and spending time in Self Help Graphics & Art. I first visited Self Help and its gallery, Galería Otra Vez, in my teens and early twenties to see exhibits, bands from East L.A., fashion shows, and the annual Christmas art sale, and, of course, to see the *altares* for the Day of the Dead. I never imagined that one day I would have a hand in documenting Self Help's history.

I first realized that I could turn my fascination with Self Help Graphics into a scholarly investigation in the course of a graduate seminar at UCLA on the history of Los Angeles, led by John Laslett. He helped guide my research by giving me a solid background in the historiography of the city. I began my research on Self Help in 1998, one year after the death of its co-founder and first director, Sister Karen Boccalero, and I regret that I was never able to meet her. Luckily, Tomás Benitez, who became the executive director, graciously gave me his time and insights and allowed me free access to the space. Tomás worked tirelessly to uphold Sister Karen's vision and to guide Self Help into new avenues.

Chon Noriega, director of the UCLA Chicano Studies Research Center (CSRC), offered me the opportunity to turn this project into a book with support from the UCLA Center for Community Partnerships. (The prospect of having your first book published before you graduate is a rare treat for any doctoral candidate.) Colin Gunckel was a patient editor who tolerated my failings when deadlines would come and go. He worked hard to keep me focused—no easy feat. Sal Güereña, director of the California Ethnic and Multicultural Archives (CEMA) at University of California, Santa Barbara, helped me over a period of several years to comb through the Self Help Graphics archives and even allowed me to peruse materials not yet cataloged. Yolanda Retter Vargas, the librarian at CSRC, helped me to access the newly arrived Self Help Graphics archives.

Shifra M. Goldman generously opened her home and her private archives to me, where I found a rich trove of newspaper clippings, flyers, and personal notes. A fellowship through the Smithsonian Institution's Center for Latino Initiatives during the summer of 2004 allowed me to engage with other scholars and cultural workers from the United States and Latin America as we tried to tease out the complex histories and directions of Latino and Chicano art. Throughout all of this, my adviser and mentor, Juan Gómez-Quiñones, commented on drafts, asked difficult but essential questions, and repeatedly reminded me to *dale gas!* He deserves recognition beyond what I have the space to say here.

Finally, I would like to thank the many colleagues, friends, and family members who supported me intellectually, emotionally, and financially. They include my parents, Isaac and Ana; *mis hermanos* Isaac, Ben, Sabra, Barbara, Kelly, and Michael; *mis tios y primos*; my grandfathers Guillermo Mimiaga and Isaac Guzmán, who have passed on but continue to watch over me; and my grandmothers Carolina Mimiaga and Imelda Guzmán, both amazing teachers and mentors of life who are always happy to talk with their granddaughter. Old friends and new stood by me even when I forgot to return phone calls and had to miss dinners and movies. I am humbled when I think of what a loving community of friends and compañeros I have. My academic career would not be as rich were it not connected to the real world and to the political work of these workers, activists, artists, and students. Finally, I do not think I would have come to this place without my partner in crime, Angelo Logan. His love for history surpasses even my own. When we first met, we ended up talking for hours about our City of Angels. That was nearly a decade ago; here's to many more decades exploring the city we call home—together. *Te amo, mi vida.*

Kristen Guzmán

Editor's Preface

Constructing a historical overview of an institution as enduring and yet mutable as Self Help Graphics & Art presents a formidable challenge, but an important one. While organizing and documenting Self Help's archival holdings through the UCLA Chicano Studies Research Center (CSRC), I came to appreciate both the pivotal role that Self Help has played as a Chicano arts center over the last three decades and the neglect it has suffered in many art histories. This short book is intended to help remedy that oversight by stimulating dialogue and inspiring further research.

Kristen Guzmán's essay traces the origin and foundations of Self Help Graphics and shows how the organization has grown and adapted in response to changing circumstances. Self Help provides a useful vantage point from which to reconsider intertwined narratives about the evolution of Chicano art and culture, the history of Los Angeles and East L.A. in particular, the intersection of art and activism, and the momentous shift in arts funding over the last few decades.

Following Guzmán's essay, Chon Noriega discusses the groundbreaking archival efforts undertaken by the UCLA Chicano Studies Research Center and the California Ethnic and Multicultural Archives at UC Santa Barbara in collaboration with Self Help Graphics & Art. As the CEMA finding aid indicates, a wealth of resources are available to support diverse research efforts—on Self Help's internal development and cultural expression as well as its social role and relationship with grassroots organizations, government agencies, and other institutions. This publication does not claim to offer a definitive history of Self Help, but we hope it will serve as a critical resource and foundation for histories yet to be written.

I am grateful to CSRC director Chon Noriega for giving me the opportunity to contribute to the center's efforts at Self Help Graphics, and for his assistance in editing this publication. I also thank Self Help Graphics director Tomás Benitez and CEMA director Sal Güereña for facilitating this project and for their insightful comments on the manuscript. Tere Romo, Rita González, and Jennifer Sternad Flores at CSRC offered helpful guidance and suggestions as the manuscript evolved. CSRC manuscript processor Michael Stone and librarian Yolanda Retter Vargas provided valuable support and advice. At Self Help Graphics, Roxana Arana, Marissa Rangel, and Veronica Soto offered generous assistance to the archival project and continue to contribute, through their art and discussion, to an ongoing dialogue about the institution's past and future. Finally, I owe a large debt to both Ana Guajardo at CSRC and Getty summer intern Dana Heatherton for their contributions to the organization and documentation of Self Help's archival holdings.

Colin Gunckel

Illustrations

Art in the Heart of East Los Angeles

Kristen Guzmán

Early in 1970, inside a dusty garage in Boyle Heights, a radical Catholic nun and lauded printmaker named Karen Boccalero got together with a group of artists including Carlos Bueno, Antonio Ibáñez, and Frank Hernández, and dreamed of starting an artistic revolution. These artists and friends, then in their thirties, sought to create an art center that would nurture young artists while supporting the Chicano cultural identity and pride then emerging in East L.A. Working initially out of the garage at Soto Street and Brooklyn Avenue (now Avenida Cesar Chavez), they planted a seed that would grow into one of the most important Chicano art centers in the United States and one of the premiere printmaking workshops in Los Angeles—Self Help Graphics & Art, Inc.

The following year, even before finding a permanent site for the new center, the group hosted its first exhibition at El Mercado, a sprawling indoor shopping plaza on First Street in East Los Angeles. Inside El Mercado, among piñatas and delicately stacked pyramids of *dulce de leche*, with mariachi bands belting out the chorus of "Volver," Sister Karen, Carlos, and Antonio hung their prints and batiks. From these beginnings, Self Help officially opened in 1972 in a third-floor space on Brooklyn Avenue. In 1979 it relocated to Gage Avenue and Cesar Chavez, across the street from Super Taco and Little China Express and a block from Brooklyn Hardware and Taquería La Que Sí Llena. Here, in the heart of East L.A., artists, activists, and art audiences mingle with the neighbors who live in modest stuccoed bungalows, their gardens bursting with red roses and bright pink geraniums, almost every window covered with wrought-iron security bars.

My first experience with Self Help Graphics came in the early 1970s, when I was in elementary school. My grandparents, Isaac and Imelda Guzmán, owned a small business called East Side Wholesale and Notions at Brooklyn Avenue and Record Avenue, a block away from Self Help. It was a crowded, chaotic store with boxes piled high above my head. It stocked toilet paper, pens, Vicks cough drops and more that were wholesaled to local mom-and-pop liquor stores and corner markets owned by Jews, Mexicans, and Japanese. My father took my siblings and me to visit the Self Help gallery and the colorful mosaic statue of la Virgen de Guadalupe that protected the parking lot, standing twelve feet tall on a bed of tile and real rose petals.

In 1991, after I graduated from college and moved back to L.A., I started to go to shows at Self Help and was struck by the continuing vibrancy of this art center. Hundreds of people

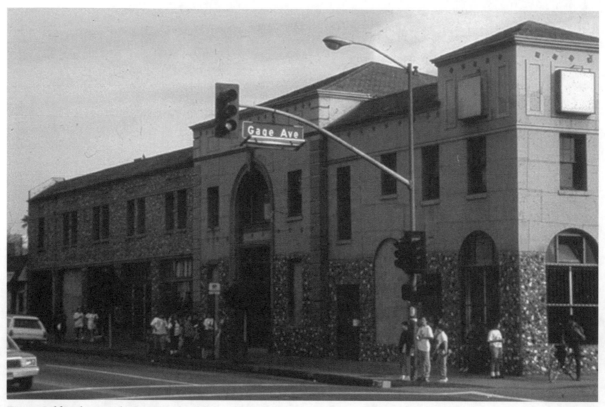

Fig. 1. Self Help Graphics & Art building at Cesar Chavez and Gage Avenues, in the heart of East Los Angeles. Circa 1980s. From the CEMA Self Help Graphics Archives.

came to attend punk music shows *en español*, see graffiti artists throw up their pieces inside the gallery (with protective face masks, of course), and support fundraisers for different social causes. Musicians and artists came, of course, but also punks and skateboarders. Chicanas and Chicanos, African Americans, Anglos, Pilipinos, and assorted other ethnicities all gathered under Self Help's roof. The audiences included a mix of teens, youth, adults, and even a few parents with their toddlers. I was surprised that an institution born in a garage had survived so many years and seemed to be in touch with the cultural changes of the times. I wondered how it had lasted so long, especially when other galleries founded by Chicanas/os in the 1960s and 1970s had survived only a few years. What

made Self Help special, and how did it adapt and endure? What continues to make Self Help a place we should know about?

"Making Visible Our Own Reality": Self Help Graphics and the Chicano Movement

To understand the setting in which Self Help Graphics got its start in the early 1970s, one must begin with the world of East Los Angeles in the 1960s. Prevailing narratives of American history generally see the sixties as an era of radical politics led by a generation of mainly middle-class youth who opposed the Vietnam War, supported greater freedom of individual expression, and sought racial and gender

equality. East L.A. was not unaffected by these social currents, but it also had a unique brand of working-class politics intertwined with an emerging sense of Chicano ethnic identity and youth militancy. Mexican Americans had constrained access to political and economic power and faced a two-tier job market that largely restricted them to low-paying jobs. The bottom-up politics of East L.A. therefore operated outside of traditional political institutions such as the Democratic Party and allied labor unions. It also went beyond the mainly middle-class and assimilationist agenda of established ethnic organizations such as the League of United Latin American Citizens (LULAC).[1]

Rejecting complacency, the young Chicanos who took up the banner of the *movimiento* adopted a radical politics based on direct action and willingly walked into contentious battles. These included the struggle to create the multiracial United Farm Workers under the leadership of César Chávez and Dolores Huerta. La Alianza Federal de las Mercedes, led by Reies López Tijerina, organized a campaign for land reclamation in New Mexico, and the Crusades for Justice and La Raza Unida Party called for political self-determination. Against this backdrop, Chicano art became an integral part of a political movement founded on ideas of cultural affirmation and pride in indigenous roots.[2] As poet and artist José Montoya declared, "Chicano art was born out of struggle ... the struggle goes on!"[3] The impetus to create art centers like Self Help Graphics arose in the context of this linkage between cultural identity and political empowerment.

A few years earlier, young artists had played a role in the high school walkouts known as the East L.A. Blowouts, which had sharpened the emerging mood of militancy. In Boyle Heights, City Terrace, Lincoln Heights, El Serreno, and East L.A., and in the Maravilla and Estrada Courts public housing projects, residents and their children wanted access to the same educational and economic opportunities afforded to the city's Anglo population. Instead, Roosevelt, Lincoln, and Garfield high schools ran vocational education programs geared toward steering young Chicanos and Chicanas into working-class jobs as mechanics, janitors, and clerks. The inferior educational conditions in Eastside public schools were reflected in a 50 percent dropout rate among Chicana/o students.[4] In 1968, thousands of Chicana/o students walked out of these schools, effectively shutting them down; in doing so they shocked the school board and empowered a generation of youth with a new understanding of their own identity, history, and power. For some of the artists who would later work at Self Help Graphics in other creative ventures—Harry Gamboa Jr., Patssi Valdez, and Moctesuma Esparza, to name just a few—their participation in the East L.A. Blowouts gave them the experience of being part of the Chicano civil rights movement and a political consciousness that would shape their later contributions to a Chicano arts movement.

Self Help Graphics thus emerged at a specific historical moment and within a particular urban landscape. It adopted a model developed by earlier Chicano collectives such as Teatro Campesino, which came out of the farm workers' movement. Self Help can to some extent be understood as a continuation and expansion of these alternative autonomous cultural spaces. Together with other groups and individuals, it helped to shape the Chicano art movement, promoting art as a vital expression of the goals and struggles of people of Mexican descent across the country. Chicanos facing political and economic disempowerment could use the visual and performing arts as one way to express their

frustration, criticisms, aspirations, and identity and to organize for political and social change. For many years, muralism remained the favored vehicle for such expression and the signature art form of East L.A. Professional and self-taught painters created numerous murals on the walls of small markets, liquor stores, elementary schools, and public housing projects such as the Estrada Courts.[5]

The emergence of cultural spaces like Self Help was also a response to Chicano disempowerment within the larger art world. Historically, the works of Chicanos and other minority groups had faced exclusion from major public arts institutions and private galleries. Such an exclusionary attitude on the part of public entities was especially troubling because they were, in theory, charged with the duty of representing the populations in and around their communities.[6] In response to this lack of access and lack of authority to create and articulate their own representations, artists of color and women artists began their own art centers, studios, and galleries during the 1960s and 1970s. Artists and cultural workers, many of them also involved with social justice and civil rights organizing, pulled together what resources they could and created sites of artistic production. This began a movement of creating autonomous cultural spaces throughout the United States, not only in Los Angeles but also in Chicago, New York, Philadelphia, and elsewhere. In Los Angeles, in addition to Self Help Graphics, new sites and groups included the Women's Building located west of downtown and a muralist collective called East Los Streetscapers in East L.A.[7]

Self Help fought against artistic exclusion by promoting exhibitions by Chicano artists on a regular basis and marketing the fine art prints created in its ateliers. Roberto Gutiérrez expressed the frustrations he and many other Chicana/o artists felt: "It was a catch-22. You had to have name recognition to get into a gallery, and vice versa. The beauty of Self Help was that they gave Latino artists visibility."[8] By pooling their resources, Chicana/o artists at Self Help could build their technical artistic skills and receive invitations to show their work at Galería Otra Vez, Self Help's nonprofit, in-house gallery, where they might occasionally earn a small sum for selling some of their pieces. This made it possible for Chicana/o artists to have creative control over the production and exhibition of their work. Eva Sperling Cockcroft, a renowned muralist and art educator, explained the desire to establish autonomous avenues for community expression:

> The shift away from integrationism and reformism toward empowerment and radicalism touched a vibrant chord in many people … People everywhere sought to establish their sense of selfhood, their cultural identity, their own image, their own heritage. People wanted to control their own media, their own schools, their own lives.[9]

Accordingly, artists sought to play a greater role in how they communicated and revealed their cultural identity to audiences.[10] Those working through Self Help challenged the curatorial process of most galleries and museums, which "juried" works in order to determine who made it onto gallery walls. Instead, at Self Help the artists themselves took on much of the responsibility for creating exhibitions, promoting openings, and selling their art. Self Help was, and continues to be, an example of self-determination and community building for Chicanas and Chicanos.

Self Help Graphics was not the only entity promoting Chicano artists in East Los Angeles and greater L.A. By 1974, the city was home to five other art *centros* and galleries, six art *grupos*, and seven *teatros*.[11] Méchicano Art

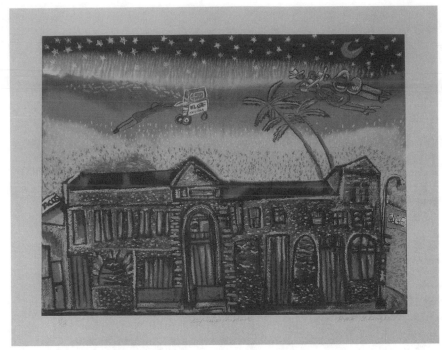

Fig. 2. *Self Help Graphics*, 2004 serigraph by Roberto Gutiérrez. Reprinted by permission of the artist. From the CEMA Self Help Graphics Archives. Photograph by Carole E. Petersen.

for several reasons. First, it was not a center for muralists; instead, the main art form was printmaking. Self Help Graphics can therefore also be situated within a tradition and movement of silk screening that exploded in L.A. during the 1960s, resulting in the founding of the Tamarind Lithography Workshop (1960), Gemini Graphic Editions Limited (1966), and Cirrus Editions (1970). The second distinctive feature of Self Help was that its principal founder was a woman—a nun, no less. Third, it had some support from government agencies but was not, initially, related to any public institution or agency such as the city's Department of Cultural Affairs. Finally, Self Help distinguished itself by its longevity. It survived the difficulties of funding even through the 1980s, when the arts were especially targeted for elimination amid tumultuous debates in the National Endowment of the Arts over what constituted "appropriate" and "decent" art.

From the Ground Up: The Early Years

Self Help Graphics became a space where artists and the art they produced strengthened national and ethnic identities of Chicanas/os in Los Angeles. The founding members of Self Help Graphics saw themselves developing a space, both literally and figuratively, that would become a point of identity and pride for the Chicana/o community. Over the years, dozens of Chicano and non-Chicano artists participated in the programming, exhibitions, or ateliers of Self Help. Their names

Center and Goez Gallery were two significant sites for producing and exhibiting Chicano posters and art.[12] Méchicano, founded in part by artists Victor Franco, Ray Atilano, Frank Martínez, and Leonardo Castellanos, opened in 1969 near a row of upscale art galleries at La Cienega Boulevard and Melrose Avenue in West Hollywood and later moved to Whittier Boulevard in East Los Angeles. The artists at Méchicano offered silk screening classes, painted over fifty murals at Ramona Gardens and Estrada Courts housing projects, and hosted cultural events with art, music, and theater.[13] Goez Gallery, headed by Joe González, opened its doors in 1969 on First Street in East L.A. and housed a private gallery, classrooms, and space for muralists. Although the artists at Goez did some work funded by community grants, over time they concentrated on being a for-profit space.

While emerging as part of this trend, Self Help stood apart from most of these art centers

make up a "who's who" of Chicano art: Carlos Almaraz and Frank Romero (both painters and muralists, and co-founders of Los Four); Michael Amescua (sculptor); Barbara Carrasco (printmaker, painter, and muralist); Yreina Cervántez (printmaker and painter); Richard Durado (printmaker, painter, and co-founder of Aztlán Multiples); Diane Gamboa (fashion designer and performance artist); Patssi Valdez and Gronk (both painters and part of the art group Asco, along with Harry Gamboa Jr. and Willie Herrón); Leo Limón (painter and muralist); Malaquías Montoya (printmaker, painter, and muralist); and Linda Vallejo (painter and sculptor). The newer generation of artists who have more recently become part of Self Help's roster include cartoonist and printmaker Lalo Alcaraz, musician and artist Lysa Flores, printmaker and publisher Artemio Rodríguez (who started La Mano Press), and graphic designer and entrepreneur Favianna Rodríguez—to name only a few.

This eclectic and multi-talented group of artists saw themselves not only as artists but also as community resources, teachers, and cultural "instigators." They creatively remade traditional events, such as the Day of the Dead, that reflected the cultural *mestizaje* or blending of Los Angeles. This broad cultural purpose is reflected in Self Help's mission statement:

> To foster and encourage the empowerment of local Chicano/Latino artists; to present Chicano/Latino art to all audiences through its programs and services; to promote the cultural heritage and contribution of Chicano art and artists to the contemporary American experience.[14]

From the inception of Self Help Graphics in 1970, Sister Karen Boccalero, who was both a co-founder and the first director, articulated two distinct objectives for the space. First, Self Help would provide training and studio space for local artists in East L.A. who worked with printmaking. Second, it would offer the surrounding community, including families and children, cultural experiences that would instill a sense of cultural pride. By training artists in printmaking and sending them to local elementary schools to teach children about art, Self Help hoped to become a political force, the nexus for an "artistic revolution" that would seek social change through art.[15] The group of artists that came together at Self Help during the early 1970s believed that East L.A., an area besieged by poverty and crime, had the potential for cultural and economic transformation. As Sister Karen envisioned this change, she wrote, "One of the greatest impacts that the Chicano community is making in the greater Los Angeles area is [in] art. It is through art and artists that we, the Chicano community, are now giving a viable image of who we are, our culture, our ideas, our dreams."[16] She struggled tirelessly to fulfill the dreams of *her* community—the community with which she identified and to which she remained committed all her life, even though she was not Chicana by birth, nor born in East L.A.

Carmen (Karen) Boccalero was born May 13, 1933 in Globe, Arizona to a family of Italian descent. She grew up with her Italian mother and Jewish stepfather in Boyle Heights, an ethnically diverse section of Los Angeles in the 1940s and 1950s, and lived in East Los Angeles until her death on June 24, 1997. Karen received formal training as an artist, studying first at the Immaculate Heart College in Los Angeles with Sister Corita Kent, an instructor at the college. Sister Corita, whose peace posters gained acclaim in the 1960s, had a profound effect on the artistic education and emerging sociopolitical consciousness of Karen Boccalero. From Sister Corita, Karen learned to pull prints, a technique she developed further at Temple University's Taylor Art

School. Equally important, Sister Corita "revolutionized the prevailing concepts of artistic experience and its pedagogy by insisting on the idea that creativity should be allowed to flow and flourish."[17]

The aesthetics of Sister Corita and Karen Boccalero were part of an intellectual and ideological evolution connected to their religious community. Both women increasingly emphasized critical thinking within their religious and academic lives. Immaculate Heart College empowered a generation of women by investigating and evaluating the tenets of the Church, and these women, in turn, formulated critiques of the Church's patriarchal hierarchy. Ana Mimiaga, a student at the college in the mid-1960s, reflected on her experience there: "At Immaculate Heart, you were expected to be smart. I don't mean book smart, but you were expected to be a thinking person. Women who attended [the college] were definitely empowered."[18] Karen Boccalero was no exception.

Sister Corita eventually left the Immaculate Heart Sisters as a result of clashes with the Church hierarchy. Her protest art, silk screens with messages of nonviolence and love, together with the growing independence of the Immaculate Heart community drew the ire of the conservative archbishop, Cardinal James McIntyre.[19] But Sister Corita had a lasting influence on Karen's artistic and community work and, indirectly, on the future artistic development of Self Help Graphics. Michael Duncan, curator of Sister Corita's 2000 exhibition *The Big G Stands for Goodness: Sister Corita Kent's 1960s Pop*, connected the aesthetics of her early work with silk screens produced a decade later at Self Help. "Corita's graphics help establish a tradition of L.A. art that is grounded in textual play and Pop specificity. Sister Karen Boccalero … worked with social messages in the spirit of Corita,

who was her teacher and mentor. SHG prints … have often incorporated highly personal texts into their compositions."[20]

Karen Boccalero went on to join the Order of the Sisters of St. Francis (OSF). She integrated the philosophy of Sister Corita with the "Franciscan point of view, which consists of an everyday effort to practice and nurture the value that every person has to offer."[21] Sister Karen's role, as an ordained person, was to develop the potential of each person she met in her community. In her own words, Karen connected that mission with her philosophy of Chicano art: "Individuals have a significant contribution to make for themselves and society. Chicano art and artists are a gift to society, mirroring a powerful and desired cultural richness."[22] Thus, feminist religious thinking from outside the Chicano community intersected with and gave support to Chicano nationalist ideas and the Chicano movement.

Sister Karen traveled to Rome in the late 1960s to hone her printmaking skills by working with master printers there. While in Rome, she participated in atelier settings, producing works that won her the La Sulla award in 1969. The collaborative method of such ateliers was familiar to many artists of Mexican descent. The *taller*, or atelier, was a long-standing tradition in Mexico, exemplified by the Taller de Gráfica Popular (People's Graphic Workshop). Leopoldo Méndez, considered one of the best twentieth-century Mexican graphic artists, co-founded the Taller in 1937. Along with other artists such as Jean Charlot and Pablo O'Higgins, he revived and built upon the artistic legacy of Mexican printmaker and illustrator José Guadalupe Posada.[23] The Chicano movement recognized the importance of establishing its own ateliers, as well as its own publishing houses and newspapers, to disseminate cultural messages important to the Chicano community

and develop an artistic and political aesthetic relevant to its experiences.

Early Chicano art centers and galleries such as Self Help Graphics were also influenced by larger regional, national, and international movements linking culture and politics, and specifically by trends in political poster art, graphic design, and silk screen.[24] While drawing on artistic trends in Mexico and other countries, Chicano artists also paralleled the cultural movements of other groups in the United States, such as African Americans and women, whose work was historically marginalized.[25] Through collaborative projects in murals and silk screen, artists and cultural workers could nurture a sense of cultural identity and establish a distance from the dominant culture.

This complex relationship between politics, cultural/ethnic identity, and social change in Los Angeles was central to the evolution of Self Help Graphics. In particular, it was critical to its ability to raise funds. Initially, the most vital funding source came through Sister Karen's connection to the Catholic Church and her community of nuns. This was true even though the gender and sexual identities of the principal founders of Self Help—a woman and two gay men who were partners—in themselves represented an implicit challenge to the patriarchy and heterosexism of the Church.

Sister Karen, muralist Carlos Bueno, and photographer Antonio Ibáñez created an organization that actively reenvisioned the Chicano community. All three believed strongly in the importance of doing artwork that would serve the larger community. Bueno, born in Cuernavaca, Mexico in 1941, spent most of the 1970s in Los Angeles. In addition to co-founding Self Help, he painted murals in Los Angeles and elsewhere in the Southwest. Some of his artwork depicted street life, featuring hustlers,

prostitutes, and transvestites. In his later years he and Ibáñez, who was also born in Mexico and died in the late 1990s, collaborated on some of the pieces. Bueno eventually returned to Mexico, where he taught art to inmates at El Cereso Jail in Mazatlán, and died in 2001.[26]

In 1970, two years prior to Self Help's official opening, Sister Karen was already working to secure materials and space for artists. In a letter to the proprietor of El Mercado, Sister Karen requested art materials and publicity to "enable [the founders of Self Help] to continue promoting more artists in this area as well as provide training and supplies for them."[27] With this mission in mind, the three friends set off to find a site larger than a cluttered garage for their vision. It was an invigorating moment. Tomás Benitez, who joined the staff of Self Help in the late 1970s, described this period as a "post-hippie, naïve period of political turmoil" for Karen and the other sisters in the St. Francis order. "[They] thought they could do anything because the idea that they couldn't was just not part of their articulation."[28] By soliciting donations, in-kind support, and exhibition space from local merchants, Karen and her co-founders stressed the importance of the relationship between the artists and community residents.

The most important asset in securing a long-term home for Self Help was Karen's connection to her religious community. Although Self Help received initial funding from several sources, the Order of the Sisters of St. Francis played a fundamental part in getting the project off the ground. Indeed, Sister Karen, in her first requests for funds to support the new art space (then referred to as "Art, Inc."), used the address 1168 Eastman Avenue, the address of the Franciscan convent. Karen and the other artists also tried to raise money by selling their own work, but this did not carry them

far. For example, Sister Karen sold a series of four works (including a serigraph and batik) to Los Angeles City College for a paltry $10.[29] In the fall of 1972, however, deliverance came from the Sisters of St. Francis in the form of $10,000 to pay rent on a 9,000-square-foot space. Self Help moved into the heart of Boyle Heights and rented a third-floor suite in a building at 2111 Brooklyn.

The inaugural program of Self Help was a batik and silk screening class for local artists, culminating in an exhibition of their work.[30] Entrants paid a fee for the class and had to bring their own materials. For many cash-strapped artists, this may have seemed a small price to pay for the prospect of eventually selling their work. Self Help said it would provide "training and promotion to artists in this area who otherwise would be unable to continue their work."[31] A small group of these artists who became involved with Self Help Graphics in this early period focused on working with the surrounding community. Building on a staff made up of the co-founders, Sister Karen hired Michael Amescua and Linda Vallejo as teachers for a program funded by the California Arts Commission called Artists in the School and Communities. Sister Karen envisioned the drawings, serigraphs, oils, and batiks that students would produce as "professional works with a distinct Mexican character."[32]

During the first two years of its existence, Self Help used an eclectic mix of donations, gifts, and in-kind services to maintain the space. Sister Karen, a tireless fundraiser, asked art supply companies for discounts, Beverly Hills art enthusiasts for donations, and a local museum for Huichol art to exhibit in elementary school classes. In a letter to the director of St. Mary's Academy in Redwood City, Sister Karen opened by lamenting the school's closure due to lack of funds, but quickly changed her tone when she turned to the purpose of her letter—the donation of equipment and materials that the school might be throwing out.[33] Artists in residence at Self Help also joined the collective effort to keep the center afloat. Carlos Bueno sent a handwritten letter in Spanish, which the other members of Self Help also signed, to an official in the Mexican government's Office of External Relations, urging him to call Washington, DC on behalf of Self Help. Bueno stressed the need for such a gallery in a predominantly Mexican American community, and suggested that a grant from the Mexican government could help fund this project.[34]

In this frantic approach to fundraising, the staff realized they would need a more comprehensive strategy if they were going to fulfill their vision of creating a permanent home for the art center. In 1974, with a little more shrewdness, Sister Karen began to investigate the possibility of obtaining financial resources from larger and more prominent national foundations, such as the National Endowment for the Arts. This did not prove an easy task—Self Help had superb artists, but not enough experience running the business side of an organization to meet funders' requirements. In order to bolster Self Help's chances for funding, Sister Karen attended grant-writing workshops sponsored by the city of Los Angeles and hired professional staff to aid the organization's administrative operations.[35] A bilingual office manager, for example, was requested from SER-Jobs for Progress.[36]

While it explored avenues for funding, Self Help was also developing its mission and solidifying its goals to train artists and implement community outreach programs. Self Help took a collaborative approach to decision making, and the process was not without disagreements. Often, Sister Karen, Carlos Bueno, and

the others would come up with ideas over lunch or coffee. Leo Limón, an artist at Self Help in the early days, recalls, "We'd sit around at lunch and just brainstorm ways we could give things back into the community."[37]

In 1978, Sister Karen enlisted the support of the sisters from her Franciscan community to write letters to Church administrators, asking for assistance so that Self Help could rent space in a building at Cesar Chavez and Gage. Sister Pius Fahlstrom, OSF, wrote that "the work [Sister Karen] has been doing is of great value for the Mexican-American people of the area, and ... any support you can give her would only be to the benefit of the Church in Los Angeles."[38] From this and other correspondence involving Sister Karen and members of her community, as well as the Franciscan Priests of St. Barbara in Oakland, it is evident that the Church was vital to Self Help's existence in this period.

Self Help moved into its new quarters in 1979. The building had been used previously by the Catholic Youth Organization and rented to various private and public enterprises, such as a dance hall and a legal defense group. It was much larger than the third-floor studio that Self Help had occupied. Self Help paid one dollar a year to lease the building, renewable every ten years.

As an expansion of its outreach to neighborhood residents during this period, Self Help converted a step van into a moving cultural center on wheels, called the Barrio Mobile Art Studio (BMAS). The artists of BMAS designed programs for adults and youth "to develop the individual's aesthetic appreciation, to provide

Fig. 3. Barrio Mobile Art Studio poster. The screenprint on this promotional poster is typical of the children's artwork produced and exhibited through BMAS. Circa mid- to late-1970s. From the UCLA CSRC collection. Photograph by Carole E. Petersen.

an alternative mode of self-expression, and to increase the individual's appreciation of Chicano culture."[39] Originally funded by Los Angeles County general revenue sharing monies and by the Sisters of St. Francis, the BMAS contracted with public and parochial schools in East Los Angeles to teach photography, batik, sculpture, and filmmaking. During nonschool days, the walk-in van offered art activities to residents of Boyle Heights, City Terrace, and

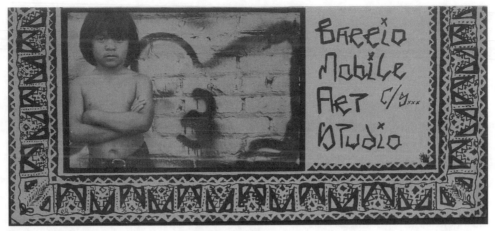

Fig. 4. Barrio Mobile Art Studio brochure announcing studio activities and listing participating staff, including Linda Vallejo and Michael Amescua. Circa mid- to late-1970s. From the UCLA CSRC collection. Photograph by Carole E. Petersen.

Lincoln Heights. One such activity was a "gang news sheet," created by youth who were members of gangs, complete with cartoons, articles, and commentary on youth activities.

Artists hired by Self Help for the van project specialized in painting, photography, puppetry, and silk screening. In its first eight months of operation, the BMAS reached 7,500 children, teenagers, and senior citizens.[40] Artists wrote lesson plans for each activity in a way that not only emphasized artistic techniques but also demonstrated the activity's relevance to Chicano culture. Sister Karen believed that the mobile studio did much to foster Chicano cultural pride. "I could, but second handedly, feel the pride the Mexican-American felt in relaying and receiving information of their great culture."[41] The BMAS also drew inspiration from the concept of *rasquachismo*, or making the most out of the little you have. At a time when Self Help had very little money and space due to the dearth of institutional support, the van took services to people in schools and neighborhoods who needed and wanted to create art. Almost twenty years later, major art museums were calling Self Help to talk about

setting up similar mobile art projects. Other nonprofit art organizations in Los Angeles have recently implemented such programs as well; for example, Side Street Projects takes woodworking programs to youth.

The annual Día de los Muertos or Day of the Dead celebration was another important project of Self Help. For this festival honoring loved ones who have died, Mexicanos and Chicanos have taken a traditional indigenous rite from Mexico and reinvented it north of the border. El Día de los Muertos, as practiced in Mexico, is a syncretic ritual that melds indigenous beliefs about life and death with Spanish Catholicism's observance of All Saints Day and All Souls Day on November 1 and 2. In contrast to the Western attitude of somber detachment regarding death, Meso-American indigenous cultures emphasize the duality of life and death and a symbolic communion between the living and the dead. Over time, the blending of ancient indigenous and Catholic ceremonies produced a festival in which families prepare feasts for the dead, create elaborate personal altars, and make offerings in the form of food and drinks placed in the home or in the cemetery.[42]

Beginning in 1972, Self Help brought together residents of East L.A. to celebrate el Día de los Muertos each year through cultural ritual, performance, visual arts, and educational workshops. The day would begin with a procession that typically started at Evergreen Cemetery in Boyle Heights, continued down First Street, and ended at Self Help Graphics. There were art exhibits with ornate, layered altars created by artists and local youth to honor the dead.[43] Chicano artists reenvisioned el Día de los Muertos to include images of Mexican artists such as José Guadalupe Posada, Diego Rivera, and Frida Kahlo. The celebration also featured teatro performances and music. In 1978, El Teatro Campesino, the renowned farm workers' theater group headed by Luís Valdez, performed *El Fin del Mundo* at Roosevelt High School as part of Self Help's Day of the Dead program.[44]

Self Help's annual tradition became central to how Chicanos in the United States celebrated this holiday, so much so that The Mexican Museum in San Francisco dedicated a substantial portion of its 2000 exhibit *Chicanos en Mictlán: Día de los Muertos in California* to Self Help and its founder Sister Karen.[45] The yearly festival was also central to Self Help's vision of promoting Chicano culture. Although el Día de los Muertos took on a different meaning when transported from Mexico to East Los Angeles, the artists of Self Help emphasized its traditional roots. Brochures advertising the festival affirmed:

> We believe that the Mexican tradition of Día de los Muertos offers a special opportunity for young people who learn about the important

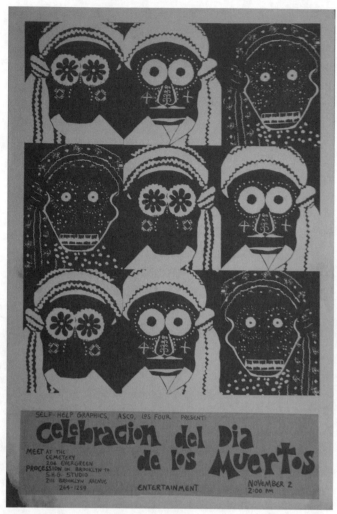

Fig. 5. Poster announcing Día de los Muertos parade and celebration, sponsored by Los Four and Asco. Circa mid-1970s. From the UCLA CSRC collection. Photograph by Carole E. Petersen.

role that heritage and tradition play in defining who we are. Día de los Muertos is the Mexican tradition that reminds us that death is a part of life, of remembering the dead as being with us, of taunting death with some humor … [This tradition] is an integral part of Chicano culture.[46]

So important was the celebration that Self Help worked hard to secure funds for its continuation. In 1978, Self Help projected that at least $14,000 would be needed to run that

year's program, beginning with workshops in August and culminating in the procession and party in November.[47] Although the cost and effort seemed monumental at the time, the program was seen as fundamental to Self Help's mission. With funds granted by the National Endowment for the Humanities, Self Help reached as many as 20,000 young people and 6,000 adults over five and a half years.

The yearly event was a collaborative effort headed by Sister Karen and the artists of Self Help, but was not limited to them. Self Help was a fluid and dynamic group. Although the staff was more or less permanent, various people floated in and out, working with the art center on different occasions. Harry Gamboa Jr., Gronk, Willie Herrón, and Patssi Valdez, who were members of Asco, and Carlos Almaraz and Frank Romero, members of Los Four, participated in Day of the Dead programming in different years.[48] For the celebration on November 2, 1974, Asco interjected its unique brand of street performance and cultural commentary. Gamboa described their action:

> The members of Asco have all experienced close encounters with the death of culture, death of fashion, death of dreams, and death of innocence. The mass was interrupted by the unexpected arrival of a massive, special delivery envelope containing an absurdist message. Enclosed with postage due were Valdez as the Universe, dressed in a gold sequined formal gown, rainbow tissue paper halo, and an 8-foot span of clouds; Herrón as a Triplane, constructed of corrugated cardboard with wings that followed the winds of change and a pilot who was an extension of this flying weapon; Gamboa as the Archangel Blackcloud, wearing veiled threats and a bolt of intrusive lightning; Gronk as the Documenteur carrying the official, oversized cardboard Asco-brand camera; Sandoval as the Asco Tank, with an operable gun turret, transported on a pair of formidable knee-high, leather platform boots. The mass

dissolved as Death laughed hysterically. Two *momias* (painter Roberto Gil de Montes and performer Fernando Torres) waved good-bye as the contents of the envelope were torn and scattered across the cemetery like so many discarded lives.[49]

To a certain extent, Asco's philosophy and aesthetic fit in with Self Help's mission to highlight aspects of the Mexican cultural heritage from a Los Angeles perspective. Asco's performances made the Day of the Dead celebration come alive, so to speak. For art and film scholar Chon Noriega, Self Help's celebration synthesized multiple traditions and trajectories: "Inspired by a Charles and Ray Eames film on the Mexican festival, the event combined cultural nationalism and spiritual syncretism, while also serving as a staging ground for the Chicano avant-garde. In the process, it also made various unacknowledged gestures towards mainstream culture: U.S. secular rituals (Halloween), modernism (the Eames influence), and performance art."[50] From the beginning, however, Asco also challenged the boundaries of Self Help's interpretation of Day of the Dead. Gronk explained it this way:

> We [Asco] initially were asked to come in to do a piece. We went to a meeting at Self Help Graphics, and they were talking about Mexico's Day of the Dead and how they did this kind of skull heads, and they'd showed a movie about the Day of the Dead, and we sat through it. I mean, we were like nice people. So we sat through it but we sort of rolled our eyes like, "Are we gonna repeat that?" Just like, "That's fine for somewhere else, but that's *not for us.* Day of the Dead can mean a lot of different of things, and it doesn't necessarily mean paper cutouts, skull heads. We can invent it, what it means to us.[51]

Asco's dedication to performance shaped Self Help's programs in other ways. It pushed Self Help to go beyond the boundaries of its silk screen program, both in terms of creative

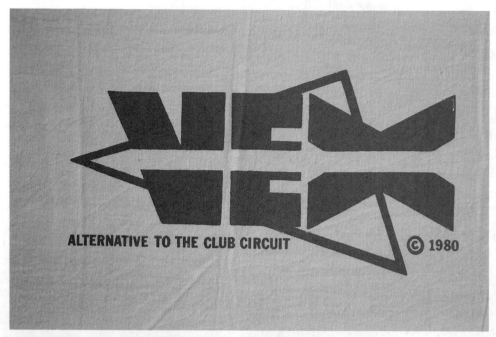

Fig. 6. Screen-printed patch designed by Willie Herrón in 1980, promoting short-lived punk venue The Vex. Reprinted by permission of the artist. From the UCLA CSRC collection. Photograph by Carole E. Petersen.

experimentation and in terms of adherence to "traditional" Chicano iconic culture. Asco's influence was particularly evident in The Vex, a weekly punk music club that operated briefly out of Self Help's main hall.

Harking back to the building's history as a dancehall, The Vex tapped into a new wave of Chicano musical production. Willie Herrón, a member of Asco and of the punk band Los Illegals, along with other groups from East L.A. (including the Brat, Thee Undertakers, the Warriors, the Stains, the Odd Squad, and the Violent Children), had proposed to open a regular venue for Eastside punkeros.[52] Although Chicano bands had the chance to play on the Westside with the Plimsouls and the Go-Go's, the crowds were usually white. "All of this changed on March 22, 1980," explains journalist Josh Kun, "when Herrón and Sister Karen opened the Vex's all-ages doors for the first time. On a night hosted by au courant Chicano artists Gronk and Jerry Dreva and featuring

sets by Los Illegals, the Brat, Plugz, and the Fender Buddies, East L.A. put in its bid as West Coast punk's first multicultural utopia."[53]

The collaboration around The Vex marked a departure from "traditional" folk forms and brought a mix of urban youth trends to Self Help as the artists and their friends continued to expand the definition of Chicano culture. A number of artists associated with Self Help during this period, including Richard Duardo, also made silk screens that contributed to the visual aesthetic of the vibrant L.A. punk scene.

In the early 1980s, after almost a decade of providing workshops for children through the Barrio Mobile Art Studio, organizing the Day of the Dead processional, and supporting artists in residence, many of the artists at Self Help felt that the experience had given them a supportive environment in which to explore their personal visions. In particular, the experience of working with Sister Karen had a positive influence on many young artists.

Wayne Alaniz Healy, co-founder of East Los Streetscapers, began working at Self Help in 1976, initially through the Día de los Muertos program. He credits Self Help with enabling him to obtain resources for printmaking that would have otherwise been unavailable to him. "Sister Karen and the people at Self Help did not influence the artists as far as what to do, but attracted a whole crowd that represented the spectrum of Chicano artists. They didn't say, 'Do Chicano art.' Rather, they said, 'Here's the stuff. Now go do it.'" For Healy, who also directs large public projects such as murals, Self Help provides a space and a sanctuary to do his individual work. He calls it "the greatest place on earth."[54]

Leo Limón, a printmaker and painter who worked at Self Help Graphics for over two decades, was invited by Sister Karen to become an artist in residence. Limón recalls, "She gave me a one-month trial run and I was still there ten years later. I asked her what I should do and she said 'Do graphics.'" Limón became part of the team that started the silk screen atelier and later developed the Self Help logo now stamped on all prints made there. He remembers that Sister Karen acted as a constant force that urged him to work hard. In terms of discipline, "she was relentless. You better finish what you start. She also taught me to be positive, to see the kids as fresh and new, not as bad grades and poor scholars. She taught me to help them to see that art should be an everyday part of their lives." Artists at the space recognized that Sister Karen's own education had an effect on the way she directed the programs at Self Help. After her death, her influence remained strong. Limón says, "She taught us to make the 'art experience' count. I keep a picture of her near and feel the endless strength of her teachers like Sister Corita and herself flow through me and on into the kids I work with and I know that they'll keep on passing it on, too.'"[55]

Patssi Valdez, a painter and printmaker, spent two years in residence at Self Help in the early 1980s. Jeff Rangel, in an interview for the Smithsonian Institution's American Archives of Art, asked Valdez what Self Help Graphics meant to her. Valdez responded enthusiastically, "I have to say more than the space, it's Sister Karen. I want to [say], 'Thank you Sister Karen!' … I call her a 'sister' because we became very close friends. I became her mentor and she became mine."[56]

The Atelier Program: New Directions

It was Sister Karen's commitment to nurturing artists like Healy, Limón, and Valdez that led her and Self Help Graphics to turn to a more complicated and costly form of serigraphy in the atelier program. The atelier, or workshop, grew out of the desire of artists to create works through limited edition serigraphy. It also enhanced the possibility for individual experimentation. Serigraphy, a form of printmaking using screens and stencils, would permit artists, guided by master printers, to make or "pull" prints in a supportive atmosphere. Over time, Self Help's goal was to continue the silk screen program and expand it by also including intaglio and lithography, prints made by etching or drawing on plates to pull the print.[57]

The first Experimental Screenprint Atelier emerged from the Mexican American Master Printers Program in late 1982 and was the forerunner of the atelier that continues today. In part to mark the ten-year anniversary of the Day of the Dead celebration at Self Help, and prior to opening the first "official" atelier to a group of artists, Sister Karen invited Gronk to work with master printer Stephen Grace to pull a few prints. This was the first of the

Special Projects. Gronk, who already had a relationship with Self Help through Asco and the Day of the Dead celebrations, created three prints: *Untitled No. One, Untitled No. Two,* and *Untitled No. Three.* They exhibited a bold, iconic style that is representative of much of Gronk's work. In this series, a pink cross was the focal point of each print, the first with light green, the second with blue-black, and the third with photo stencil details in the background. There were several reasons why Gronk's work was significant at this time for Self Help's atelier. According to Reina Prado, curator and museology scholar:

> Gronk was gaining notoriety in the early 1980s from both the Anglo and emerging middle-class Latino community, [so] his involvement in the Special Project became instrumental in attracting new collectors to Chicano artists and the medium of serigraphy. ... Having Gronk experiment in the medium of serigraphy, his artistic caliber and experience set the tone for future participants in the internationally recognized biannual Ateliers.[58]

This first Special Project and the subsequent Experimental Atelier represented a new direction for Self Help, strengthening the connection of their work in East L.A. to the mainstream art world and art market. This not only provided income for the organization, but also gave Chicano artists a greater possibility of receiving the recognition they deserved, taking advantage of the art world's expanding interest in a broader range of artists. This was especially crucial at this point in the 1980s when monies for arts programming were being drastically cut at both the state and federal levels.

The first exhibition opening for Atelier I and II was held in April 1983. The announcement

SELF-HELP GRAPHICS

is pleased to announce
publication of a Series
of prints

by

GRONK

a hand-printed, limited edition of 25 signed and numbered prints
will be available December 15th, 1982.

Each serigraphy will be accompanied by
a certificate of authenticity.

The Series will be pre-sold, by subscription;
the price to subscribers will be twenty-five
dollars per print.

Complete Series price upon request.

Sr. Karen Boccalero
Self-Help Graphics
Los Angeles, CA
Phone (213) 264-1259

Fig. 7. Flyer announcing the 1982 sale of Gronk's serigraphs, which provided a financial and promotional boost to the atelier program. From the UCLA CSRC collection. Photograph by Carole E. Petersen.

brochure described it as a collection of "serious, finished works" created by the artists through a process that gave "all of the participants the maximum degree of freedom possible in individually and collectively exploring and manipulating the screenprint medium."[59] In addition, Self Help made a pitch to keep the program going through the sale of the prints:

> The degree to which the Atelier program has succeeded in providing a unique and valuable opportunity for the artists it has served can perhaps best be determined by speaking with them. The degree to which it has succeeded in presenting significant, technically

accomplished images, an examination of the work itself will show. But the degree to which the program can continue and expand—and, optimistically, Ateliers III and IV are already underway—will ultimately be determined by the community itself.[60]

These first ateliers did have great success, and Karen's commitment to this project in some ways cemented the artistic reputation of Self Help. Today, the atelier remains Self Help's most visible program.

Through the atelier, Sister Karen wanted to open up wood block prints, linocuts, and serigraphs to a wide spectrum of artists—from the trained fine arts graduates to the self-trained printers. She felt that "art" should not be limited in people's minds to the work of a few famous artists. "Art in the United States is very elitist: We encourage the myth that only very educated people can understand it and they establish what is acceptable," she said. "If it isn't European, people dismiss it as not valid art."[61]

Self Help also consistently emphasized the relationship between the artist and the master printer. In the decades preceding the founding of Self Help, abstract artists in the United States generally considered the graphic arts, such as lithography, to be of inferior aesthetic quality and therefore not "good" art. "The graphic medium was considered the lowest possible way of expressing yourself," said graphic artist and printmaker Will Barnet. To be respected, art "had to be direct, it had to be on canvas, and it had to be immediate."[62] Lithography was not the work of a sole artist, but a collaboration between artist and master printer, and the result depended not just on aesthetic style and content but on knowledge of chemical mixtures, machinery, and technical measurements. Moreover, the graphic arts were often used by the Chicano movement for political purposes. One way for art historians and art reviewers to discount such work was to say that it was simply "political" or "agitprop," with value only as propaganda, not as art.

The political nature of the work created at Self Help Graphics is a complex question, particularly considering the political and social context from which the center emerged in the early 1970s. Art historian Shifra M. Goldman has argued that Sister Karen's spiritual vocation created a religious sensibility at Self Help, leading to a "cultural practice infused with religious undertones."[63] Her analysis was based on a comparative survey of several Chicano art centers in California, many of which demonstrated an overt militancy. The artwork that came out of centers like Galería de la Raza in San Francisco and the Royal Chicano Air Force in Sacramento reflected these politics in very concrete ways. In a seminal article, "A Public Voice: Fifteen Years of Chicano Posters," Goldman contended that Self Help "skirted the more 'troublesome' and controversial politics of the Chicano movement and Chicano art addressed to these issues."[64] However, although Self Help did not require its artists to include political content in their work, this did not mean that Self Help was primarily a religious or apolitical art space.

Many artists and long-time staff members of Self Help affirm that the organization's work was indeed political and sought to expand the boundaries of what it means to engage in Chicano politics. Self Help reflected political and social convictions that paralleled ideas from the Chicano movement, while also providing a space for artists of all ethnicities who embraced Chicano culture and politics. Additionally, the distinction and tension between "political art" and "fine art" is not necessarily useful, and some artists and scholars believe that a focus on this distinction creates a false dichotomy. Chon Noriega offers a compelling argument about the mission of Self Help's co-founder in the introduction to

an interview with Self Help's second director, Tomás Benitez: "Rather than subordinate art to politics, form to content, Sister Karen understood art itself as a social practice that could build and sustain community—through the active making, buying, and experiencing of art within the community."[65]

During the late 1960s and 1970s, many Chicanos were expressing political demands to alleviate the poverty and discrimination they faced in their neighborhoods and communities. An essential component of this emerging political consciousness was cultural pride, the assertion that Chicanos had a unique heritage of which they should be proud. Consequently, by simply saying "I am proud to be Chicano," one was undertaking a political act. As Benitez explained: "There was never a compelling notion that you had to come in here and be political. The very thought of creating a place in which people could come and do what they wanted reflected some of the themes which were deeply political like the relationship between Chicanas and Chicanos in terms of sexism and machismo. Border issues. Issues of cultural remembrance and cultural fortification."[66] Benitez's assessment of the political nature of Self Help resonates with the feminist notion of the "personal as political."

Yet to be political was never an articulated objective for Self Help. Moreover, the political activism and militancy of the artists who worked there changed over time. For example, Roberto Gutiérrez first became involved with Self Help in the 1960s, when he attended Roosevelt High School and East Los Angeles College. At the college, he met Gronk and members of Los Four, picketed the Safeway Market with César Chávez, and marched on Whittier Boulevard. But he eventually pulled back from the confrontational politics of the East L.A. barrio:

At that time, there was a lot of confusion and rumors. With other Chicano artists, I did posters for the movement, but I felt like I was being used. With the turmoil, politics, and commotion, I backed out ... The politics were not pleasant and I felt like my personality was being assaulted.[67]

Although he "resisted going back to Self Help Graphics," Gutiérrez says, he did so in the early 1990s, and has continued to work there producing monoprints.

One of the paradoxes of the Chicano art movement is that as it was creating its personal visions and political statement of Chicano cultural independence, it was at the same time becoming increasingly dependent on dominant institutions for support. How that affected the production of art and the direction of the galleries is a question that needs continuing exploration.

The atelier facilitated diverse and sometimes divergent aesthetic styles, making it difficult to identify any single style as characteristic of Self Help. This stands in contrast to what some art critics and scholars have written about Chicano art—that certain tendencies appear consistently in the work. Many art historians, curators, and artists within the movement have debated the definition of Chicano art, and some have challenged the term itself for offering a narrow notion of identity. This argument stems from several perspectives: not wanting to box oneself in (as an individual or an artist trying to make a living); being opposed to the political implications of the term Chicano; and opposing the gender bias historically present in the Chicano art movement (a bias that some would argue persists today).

Within the growing number of conversations about Chicano art, scholars acknowledge the complexities and diversity of the artists and mediums, although the narrative at times divides the work of California Chicano artists into two separate, and sometimes unfriendly,

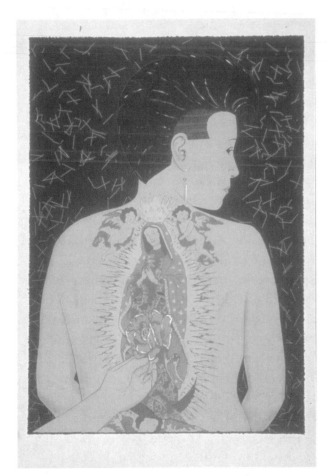

Fig. 8. *La Ofrenda*, 1988 serigraph by Ester Hernández, in which the artist simultaneously reimagines and pays tribute to the Virgin of Guadalupe. Reprinted by permission of the artist. From the CEMA Self Help Graphics Archives.

factions. For example, in studies of the L.A.-based art groups Los Four and Asco, some scholars have created a polemical framework within which they argue that one side is political propaganda steeped in nationalist iconography, while the other is avant-garde, experimental, and performative. In considering these two poles, Reina Prado writes in her work on formation of a Chicano art canon, "The art of Los Four is representative of the realist figurative style prevalent in Chicano art, while Asco's use of photography, performance art, and video speaks of cutting edge abstract artists of the period."[68] Prado contends that Self

Help is the "synthesis of both." In some ways, the frequency of Self Help's twice-a-year ateliers encouraged a diverse group of artists to participate (they were not exclusively Chicano or Latino) and allowed some artists to participate more than once, giving them space to experiment with a broad range of styles.

The Experimental Screenprint Ateliers at Self Help allowed artists to engage with these debates and others. Ester Hernández's *La Ofrenda* (The Offering), produced at one of Self Help's ateliers in 1988, portrays the image of la Virgen de Guadalupe tattooed on the back of a woman. According to Tere Romo, art historian and curator at the Mexican Museum in San Francisco, the Virgin's image invokes meanings "at the political, social, and gender-identity levels."[69] Hernández lovingly handles the grace and serenity of the Virgin, but as a woman's hand enters the picture to offer a rose to *la virgencita*, the hand at the same time offers a rose to the woman on whose back the Virgin's image appears. The work suggests that the Virgin is both a symbol of religious devotion and a channel that allows the viewer to witness intimacy between women. Thus, Hernández honors the Virgin in her work—the artist participated in the Guadalupana Society devoted to the Virgin of Guadalupe—but, Romo notes, also subverts the traditional narrative of the Virgin as the chaste, celibate saint. This is just one example of how members of Chicano communities challenged teachings of the Church that required strict adherence to gender roles and proscribed dissent or criticism of the Church's authority.

In 1990 the artists and Sister Karen decided to give up the Barrio Mobile Art Studio and dedicate more time to the atelier and to professional printmaking. Michael Amescua, who has worked with Self Help since 1975 and currently occupies studio space there,

characterized this decision as a realistic one. "The primary goal of Self Help Graphics is to be an artists' space. It's a space for artists to live and breathe art, prints, [and] etchings. It was hard work to run the van. It was difficult to get artists to leave their studios. Today [in 1998] you would have to pay them fifty dollars an hour [to teach those classes]."[70]

In order to obtain artists of the quality it wanted, Self Help needed to concentrate on building expertise through the workshops. At the same time, the organization attempted to remain true to the artist "rank and file" who worked there. Tomás Benitez explained that Self Help "was an organic environment where people basically came and did things to use the place as a forging ground. So it has survived changes, substantial directions where you gave up the Barrio Mobile Art Studio which costs $90,000, almost the entire annual budget, to work on a whole other thing." Although Self Help continues to develop youth programs, which Benitez admits are a "cash cow," it cannot meet the burgeoning demand for such programs. For example, in the summer of 1998, over 600 people signed up for fifty available slots in the *S.O.Y. Artista* summer youth program.[71]

In 1999, Self Help Graphics began its series of "maestras" workshops for women artists. Maestras Atelier XXXIII was the first all-female silk screen workshop in the sixteen-year history of the Experimental Screenprint Atelier. Curated by Yreina D. Cervántez, who had a twenty-year relationship with Self Help, the maestras atelier brought together female artists from communities of color and created a body of work "striking in its integrity and its socially meaningful explorations."[72] Many of the pieces addressed the life, art, and intellectual contributions of Sor Juana Ines de la Cruz, the seventeenth-century nun who wrote poetry and treatises attacking the patriarchy of the Catholic Church. Like Sor

Juana, whose studies of science and philosophy challenged not only the Church but also prevailing social mores, the women taking part in the Maestras atelier pursued "the revolutionary and visionary conviction that 'there must be another way to be,'" as the Mexican philosopher, writer, and diplomat Rosario Castellanos asserted in her writings.[73]

The first maestras workshop was important for many reasons. The artists—Laura Alvarez, Barbara Carrasco, Yreina Cervántez, Diane Gamboa, Pat Gómez, Margaret Guzmán, Yolanda López, Delilah Montoya, Noni Olabisi, Rose Portillo, and Favianna Rodríguez—represented a wide variety of talents, aesthetic directions, professional experience, and cultural backgrounds. Carrasco, Cervántez, Gamboa, and Lopez had already participated in several different ateliers and exhibitions at Self Help. Portillo, an actor, writer, and visual artist, had worked with Plaza de la Raza in Lincoln Heights. These artists realized the potential of intergenerational and cross-cultural dialogue through their works. The single male artist who worked with the group, master printer José Alpuche, "felt honored" to be part of a "great milestone for Self Help Graphics.[74] The production of this series also created a space where women could learn from each other. "Fundamental to the success of this Atelier," wrote Yreina Cervántez, "were the monthly meetings where mentoring, the sharing of ideas and techniques, and the discussion of content proved invaluable to the process and conceptualization of the serigraphs."[75]

In *Double Agent Sirvienta: Blow Up the Hard Drive*, artist Laura Alvarez takes on stereotypes about Latinas in Los Angeles. A Latina nanny on the job holds a towheaded child on her lap. Young, immigrant, female, a member of the working poor, Alvarez's subject could be mistaken for many of the nannies seen in

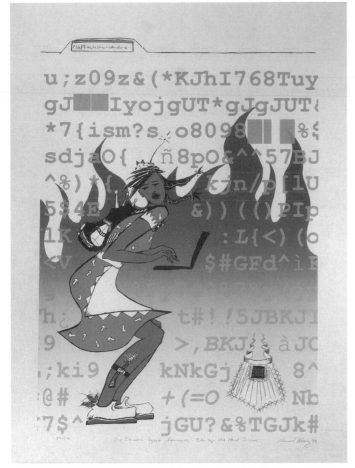

Fig. 9. Domestic service as high-tech espionage: Laura Alvarez's 1998 serigraph *Double Agent Sirvienta: Blow Up the Hard Drive*. Reprinted by permission of the artist. From the CEMA Self Help Graphics Archives. Photograph by Carole E. Petersen.

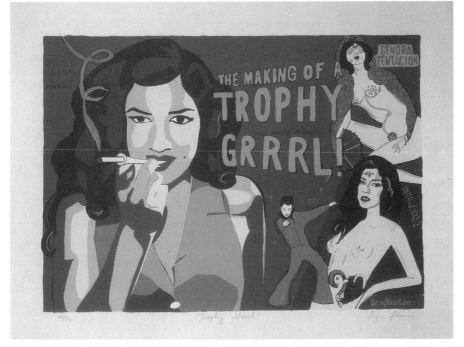

Fig. 10. *Trophy Grrrl!* Artist Lysa Flores evokes the aesthetic of Mexican film posters to reference her career as a musician and actor in this 2002 serigraph. Reprinted by permission of the artist. From the CEMA Self Help Graphics Archives. Photograph by Carole E. Petersen.

Beverly Hill parks in the afternoons or indeed for a majority of the domestic laborers in Los Angeles.[76] A closer look, however, reveals that the nanny has a small antenna protruding from her ponytail. Is her employer keeping tabs on her? No, it is instead the Latina nanny observing the behavior of the employer and her ilk. As a double agent servant, working for the "man," she is actually on a mission to collect information about the "enemy." Alvarez has developed this silk screen piece as part of a larger series of silk screen prints, paintings, and video installations dedicated to the Double Agent Sirvienta.

The issues and aesthetics captured by Alvarez's work speak to the changing dimensions of Self Help's space and interests. From its origins in the tumultuous Chicano movement of the early 1970s, with its focus on community social and political issues, Self Help has seen its work gradually transformed by economic, political, and cultural changes in the barrio and in the larger society. In the 1980s, the ateliers increasingly emphasized individual expression and experimentation. This work referenced cultural and political icons that were expressly Chicano or Latino but also delved into other areas and questions of aesthetics. Artists at Self Help, including Laura Alvarez, Lalo Alcaraz, and Lysa Flores, have recently revisited some of the cultural icons of the Chicano movement, such as Alcaraz's *Che* with a Nike swoosh. But these artists have also raised issues of Latino immigration, and the ever-growing class of Latina domestic servants, and have sought to set new standards of

feminist thought and practice in art. Through these changes Self Help has continued to be a site where artists can push boundaries of their own—related to their technical skills, their artistic vision, and their racial/ethnic/cultural background.

For audiences, Self Help has been a place where Los Angeles residents—from a block away or from the Westside across town—can come and engage with the works. As the centerpiece of Self Help Graphics, the atelier has consistently reflected the collaborative ethic of the space. Continuing the tradition of sharing, Self Help has created a stock of prints that members of the local community can borrow. These prints hang in neighborhood cafés and *mercados* and are enjoyed by a wide audience. In many ways, Self Help has achieved what larger national museums have not—they have raised awareness about Chicano art by making visible what was for so long invisible. Benitez describes Self Help as "a portal and a window: it's a way people leave and arrive from the community." Self Help seeks "to expand the identity of the American experience to include Chicanos and to connect with people who are all different, and respect the mutualities of who we all are."[77]

The Nineties and Beyond: Expanding the Vision around the Block, around the World

During the 1990s, Self Help Graphics reached beyond the gallery walls of the center and the confines of the barrio to bring Chicano art to a wider audience. The objective was to introduce Chicano/Mexicano art and culture, in the words of Sister Karen, "into the mainstream of the American Experience."[78] This period was a turning point for Self Help Graphics, when they decided that "cultural tourism" was an

important strategy that could help to ensure their survival. A first step was to promote the center in city-sponsored travel literature as an integral part of the East L.A. cultural experience. Sister Karen and Tomás Benitez went on to initiate several projects that brought wide national and international exposure to artists from East Los Angeles. Two of these programs stand out as particularly important: the *Chicano Expressions* exhibition in 1993 and the archive project that began in 1986.

Chicano Expressions was an exhibit of serigraphy by twenty different artists. Some had worked with Self Help for years, while others were visiting artists from other parts of the United States and from Puerto Rico and Mexico. The exhibit was sponsored by the Arts America Program of the United States Information Agency (USIA). *Chicano Expressions* traveled to various countries, including the "new" South Africa, Colombia, Honduras, Germany, France, and Spain. Sister Karen was also able to facilitate travel for some of the artists and Self Help staff, so that the tour became a way to create new linkages and exchanges between artists and audiences.

The show's sponsorship by USIA, a government agency that came out of the Cold War and was folded into the Department of State in 1999, raises interesting questions both about the relationship of art to the state and about the relationship of Chicano culture to the American mainstream. As part of its mission to enhance the image of the United States around the world, USIA was supposed to "provide exposure to American values and culture."[79] This raises the intriguing notion that the government was using Chicano art to convey "American" values and culture. This theme, that Chicanos are part of what it means to be American, is of necessity a complicated one, especially given the history of repatriation

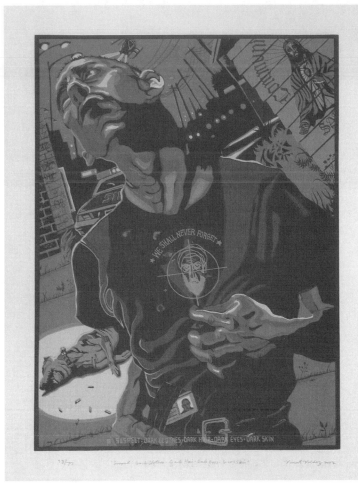

Fig. 11. *Suspect: Dark Clothes, Dark Hair, Dark Eyes, Dark Skin*: Part of an exchange between San Antonio and Los Angeles artists, Vincent Valdez's 2003 serigraph offers a scathing critique of racism and state authority after 9/11. Reprinted by permission of the artist. From the CEMA Self Help Graphics Archives. Photograph by Carole E. Petersen.

programs that forcibly deported U.S. citizens of Mexican descent in the 1930s and 1950s. It acquires new significance in light of recent anti-immigration policies, a trend exacerbated by the events of September 11, 2001. Historically, Chicanos have been outsiders, strangers in their own land. Government sponsorship of Self Help's tour abroad is one indication that, whether for political expediency or for other reasons, the official conception of American culture is gradually becoming more inclusive.

The *Chicano Expressions* show toured South Africa in 1994, accompanied by Benitez. His experience in Pretoria illustrates the power of art as a vehicle for cultural exchange. Speaking of the South Africans, Benitez recalls: "This is a population that understands the struggle for identity. And they said, 'This is some of the most exciting art from you Yanks ever.'"[80] As this statement somewhat paradoxically suggests, South Africans saw Benitez and the other Chicano artists in the exhibition not only as Mexican Americans, struggling to assert a specific cultural identity, but also as simply "Americans." Benitez interpreted this as a sign that the continuing creative work in the field of Chicano art is helping to recreate the understanding of America and American art, both at home and abroad.

Throughout the decade, Self Help made steady progress in expanding its reach and impact, and these outreach efforts had positive effects on its funding and programming. Through the successful *Chicano Expressions* show, work by artists from East L.A. was brought to audiences at the Mexican Fine Arts Center Museum in Chicago, the Museum of Art and History in Anchorage, and the Museum of South Texas. By 1997 the University of California, the University of Texas, the Smithsonian Institution, and the Los Angeles County Museum of Art all owned works produced at Self Help. This not only fostered an appreciation of Chicano art but also furthered Sister Karen's efforts, continued by Benitez, to make Chicano art an important boon to the growing world of cultural tourism. Consequently, the *Seattle Times*, the *San Antonio Express-News*, and even *The Guardian* of London frequently had more to say about this East L.A. art space than did the mainstream media in Los Angeles.[81] Art viewers as well as emerging and established Chicano collectors visited Self Help regularly to

support the space. An alternative paper in Los Angeles wrote, "We like to buy things here, not just because of their beauty, but because we're investing in an ongoing dream."[82]

The importance of preserving the history of this groundbreaking, internationally recognized institution motivated the initiation of an archiving project in 1986. The Self Help Graphics Archives is an ongoing collaboration between Self Help Graphics and the California Ethnic and Multicultural Archives (CEMA) at the University of California, Santa Barbara, under the leadership of Sal Güereña. It focuses on collecting, categorizing, and documenting a wide array of photographs, flyers, postcard invitations, and institutional documents, as well as hundreds of serigraphs and prints. These materials are made available for research and community outreach. Under CEMA's auspices, the Caridad (1990–92) project cataloged and duplicated Self Help's immense collection of slides, and the Caridad II project (2003) provided digital images of photo and print collections, guaranteeing the accessibility of these images to scholars, students, and Self Help staff. CEMA holds the most extensive collection of the institution's materials and has since expanded its preservation efforts to include other Chicano cultural centers in California.

When Sister Karen Boccalero died in 1997, Self Help lost not only an inimitable, indefatigable leader, but also a substantial portion of its institutional memory. Tomás Benitez, who took over as director, had been on staff at the center for a decade and had become an important part of its administrative leadership, writing grant proposals and coordinating programs. With Sister Karen's passing, he was thrust into a role that, in truth, was impossible to fill. Who could command the same respect as the cofounder of an organization? Who could fulfill the vision that Sister Karen had been nurturing for decades? Aside from these questions, Benitez faced the practical task of keeping Self Help Graphics afloat as a vibrant, relevant, and financially viable institution.

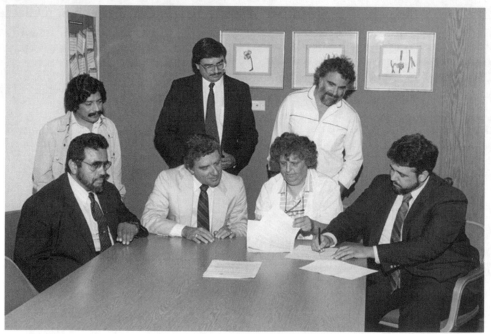

Fig. 12. Sister Karen Boccalero with the Self-Help Graphics & Art Board of Directors signing the archives agreement with the University of California, Santa Barbara in 1986. From left to right: in the front, artist Jesus Perez, UCSB University Librarian Joseph A. Boissé, Sister Karen, and Board President John A. Kotick; in the back: UCSB Art History Professor Ramon Favela, CEMA Director Salvador Güereña, and artist Sam Costa. Photograph by Doug Farrell. From the CEMA administrative files.

One way to do that was to amalgamate all of the amazing work that had been created over twenty-five years and document it for all to see. Demonstrating that the organization had a remarkable and successful history would also improve the chances of receiving funding and other support. But how could they document the accomplishments when prints and photos were stored in musty boxes, stacked in precarious towers under leaky roofs? Self Help Graphics had now been around for a quarter century and in that time had amassed an overwhelming amount of artwork and papers, but had never had the staff, time, or space to organize all the pieces. In addition to continuing Self Help's relationship with CEMA, Benitez collaborated with other partners to archive and preserve these on-site materials. Staff and intern positions were created (with assistance from the J. Paul Getty Foundation) to undertake the organization and preservation of the institution's impressive collection, holdings that now span more than thirty years of Chicano art history.

As Self Help moves into its fourth decade, its staff and artists have been reevaluating existing objectives and setting new goals on several levels. First, Self Help has actively pursued and cultivated new sources of funding and new institutional partnerships, especially with foundations. The California Community Foundation has been particularly supportive: a $20,000 grant in 1999 supported the salary of the assistant director, a $30,000 grant in 2000 allowed the hiring of an archivist, and a $300,000 grant in 2001 supported the development and implementation of a capital campaign and the hiring of new staff members.[83] Most recently, Self Help has begun to work in partnership with research centers at local universities, notably UCLA's Chicano Studies Research Center (CSRC), in order to collect, document, and preserve the body of work that its artists have created over the past three decades. And, initiating a historically significant collaboration, the Los Angeles County Museum of Art has finally acknowledged the importance of Self Help Graphics and plans to acquire a representative collection of its atelier production.[84]

At the same time, Self Help has also been getting more attention from and turning more frequently to corporate donors and large mainstream art institutions. The substantial growth of the organization's staff and programs has necessitated some compromises, and Tomás Benitez acknowledges that the center's financial growth is largely due to increasing interest in Chicano art among corporate donors (such as the Nissan and Toyota companies, which have showcased Self Help prints in their corporate headquarters during Hispanic Heritage Month). These affiliations demonstrate the growing recognition of Self Help's achievements but also raise perplexing questions. Can the organization stay true to its mission while tapping new sources of support? Will funders drive the programming and the aesthetics?

The second area in which there is ongoing reassessment is the conception of Self Help's role in the art world. With the recent addition of an artistic director position, Self Help clearly aspires to contribute its perspective to the larger national and international discourses on art and aesthetics. Gustavo Leclerc, hired to fill this post in 2004, argues that Self Help needs to place itself "more in an international position" by creating a "more theoretical framework" and shifting to a more "aesthetic-based approach" to printmaking and exhibitions.[85] This in turn reflects new ways of thinking among some Chicana/o artists who are consciously moving away from their past. Some writers and art observers have made a great deal of these developments and have proposed a paradigm that sets the "new" genera-

tion in opposition to the "old," or "Chicana/o artists" against "transnational/international artists."[86] Such frameworks not only create oversimplified, artificial divisions, but also disregard a more important factor—that Chicano art has never been a monolithic or static category. From the emergence of a "Chicano art movement" in the late 1960s and early 1970s, there were already strains of artwork that did not fit into the iconography of the farm worker movement, low riders, or the Day of the Dead. Even in the heyday of the movimiento, Asco and other groups were already creating a critique of nationalism from within the barrio. It is important to recognize that Chicana/o artists have provided audiences and the art world with a rich, extensive, and heterogeneous body of work. Self Help is an important participant in this ongoing dialogue, and changes in the organization continue to both shape and reflect larger changes in the study and theory of Chicano art and the nature of the art market today.

While engaging these debates, Self Help Graphics continues to play an exemplary role in the cultural and artistic life of Los Angeles, showing how art institutions can creatively approach a city of remarkable diversity. As Chicana/o art evolves and transforms itself, it also embraces a diverse group of artists as allies and collaborators—Latina/o immigrants, blacks, Asians, queers—and freely incorporates an expanding array of subject matter and aesthetic styles. Cultural formations that reflect transnational aesthetics, popular/street culture, disjuncture, dissonance, and synthesis demand that we reassess our notions of the Chicano art movement. Self Help Graphics is a ready witness to this complexity and remains a vital point of convergence for multiple communities and artists with a wide range of artistic practice. In its fourth decade, Self Help continues to produce significant artwork by both emerging and established artists while providing a model for cultural intervention and community building in Los Angeles.

Notes

1. Although it served as an advocate for some Mexican immigrants and their children and organized Spanish language classes, cultural parades, and voter education, LULAC also aligned itself with middle-class economic concerns and politics. As a result, the organization's positions often stressed assimilation and complacency rather than direct protest against inequality. Not all Mexican Americans were quick to support *la causa*; some were wary of rocking the boat for fear of losing the economic and social gains they had made.

2. Some members of the movimiento held the view that Aztlán was the mythical birthplace of the Aztecs (or Mexicas). This area, which spans the Southwestern United States, was originally part of Mexico. For a broad survey of Chicana/o history, see Rudolfo Acuña's seminal work *Occupied America: A History of Chicanos*, 5th ed. (New York: Pearson Longman, 2004). On the Chicano youth movement, see Carlos Muñoz, *Youth, Identity, Power: The Chicano Movement* (New York: Verso, 1989).

3. José Montoya, "La Cultura Chicana: Voices in Dialogue," prologue to *Chicano Art: Resistance and Affirmation, 1965–1985*, ed. Richard Griswold del Castillo, Teresa McKenna, and Yvonne Yarbro-Bejarano (Los Angeles: University of California, Wight Art Gallery, 1991), 19. Montoya was also a professor and co-founder of the Royal Chicano Air Force, an artists' collective based in Sacramento.

4. Antonio Ríos-Bustamante and Pedro G. Castillo, *An Illustrated History of Mexican Los Angeles, 1781–1985* (Los Angeles: UCLA Chicano Studies Research Center, 1986), 180–81.

5. Numerous publications document the impact of Chicano muralism. For a broad survey, see Eva Sperling Cockcroft and Holly Barnet-Sánchez, eds., *Signs from the Heart: California Chicano Murals* (Venice, CA: Social and Public Art Resource Center, 1990), and Robin J. Dunitz, *Street Gallery: Guide to Over 1000 Los Angeles Murals*, 2nd ed. (Los Angeles: RJD Enterprises, 1998). Other helpful resources are in Shifra M. Goldman's collection of essays,

Dimensions of the Americas: Art and Social Change in Latin America and the United States (Chicago: University of Chicago Press, 1994).

6. "Public arts institutions—those agencies that by definition should be fulfilling their public purpose, artistic, legal and moral, to a significant portion of the total community by recognizing and housing Chicano art—have not been traditionally receptive to it," argued the Comité Chicanarte when creating the Exposición Chicanarte in 1980 in Los Angeles. This historically significant exhibition represents only one example of the persistence and hard work it has taken to expose Angelenos to Chicano art.

7. Cockcroft and Barnet-Sánchez, *Signs from the Heart.*

8. Roberto Gutiérrez, interview by author, Los Angeles, April 25, 1998.

9. Eva Cockcroft, John Weber, and James Cockcroft, *Toward a People's Art: The Contemporary Mural Movement* (New York: Dutton, 1977), 17, 24.

10. For more on museum and exhibition practices in relation to Mexicano/Chicano art and culture, see Karen Mary Davalos, *Exhibiting Mestizaje: Mexican (American) Museums in the Diaspora* (Albuquerque: University of New Mexico Press, 2001); Alicia Gaspar de Alba, *Chicano Art Inside/Outside the Master's House: Cultural Politics and the CARA Exhibition* (Austin: University of Texas Press, 1998); and Chon A. Noriega, "On Museum Row: Aesthetics and the Politics of Exhibition," *Daedalus: Journal of the American Academy of Arts and Sciences* 128, no. 3 (Summer 1999): 57–81.

11. "Appendix: Catalog of Grupos, Centros and Teatros," in Griswold del Castillo, McKenna, and Yarbro-Bejarano, *Chicano Art*, 223–32. In its listing for the Los Angeles area, the appendix includes five art galleries and centers (Galería Ocaso, Goez Gallery, Méchicano Art Center, Plaza de la Raza, and Social and Public Art Resource Center, the last two of which continue to operate); six artists' groups (Asco, Chicano Art Student Organization, El Concilio de Arte Popular, Council of Latino Photographers/USA, Los Four, and East Los Streetscapers, which continues to create public murals); and seven theater groups (Teatro Aztlán, Teatro de los Barrios, Teatro Cariño, Teatro Chicano, Teatro Machete, Teatro Mescla, and Teatro El Movimiento Primavera). Similar centers opened in Northern California, such as Galería de la Raza in San Francisco.

12. Goldman, *Dimensions of the Americas*, 169. Although the Méchicano and Goez galleries are no longer operating, other Los Angeles art centers that focus on murals are still producing large public works. East Los Streetscapers, headed by Wayne Alaniz Healy, and SPARC, co-founded by artist Judy Baca, are two examples.

13. "Anglo Audience to Get Look at Chicano Culture," *Los Angeles Times*, August 29, 1971. For more information on the Méchicano Art Center and the network of community art centers in the early 1970s, see an interview with Victor Franco (co-founder of Méchicano Art Center) conducted by Barry Schwartz in July 1972, Collection of the Smithsonian Institution Archives of American Art.

14. Self Help Graphics & Art, "About Us: History and Mission," http://www.selfhelpgraphics.com.

15. Sister Karen Boccalero, letter to the Campaign for Human Development, Washington, DC, August 6, 1974, box 4, folder 6, Self Help Graphics & Art Archives, California Ethnic and Multicultural Archives, University of California at Santa Barbara (hereafter cited as CEMA SHGA Archives).

16. Ibid.

17. Margarita Nieto, *Across the Street: Self Help Graphics and Chicano Art in Los Angeles*, ed. Colburn Bolton (Laguna Beach, CA: Laguna Beach Art Museum, 1995), 28.

18. Ana Teresa Mimiaga, interview by author, Los Angeles, June 7, 1998. Mimiaga is the author's mother.

19. Cardinal McIntyre opposed many of the convent reforms implemented by the more radical sisters within the ecumenical communities of Los Angeles. Eventually, this led the Mother General at that time, Anita M. Caspary, to have her religious congregation dissolve its canonical ties with the Vatican and form an independent, ecumenical community that would provide authority and dignity for women within the Church and promote justice in the wider society. For more on the historic struggle of the Sisters of the Immaculate Heart of Mary, see Anita M. Caspary, IHM, *Witness to Integrity: The Crisis of the Immaculate Heart Community of California* (Collegeville, MN: Liturgical Press, 2003).

20. Michael Duncan, "The Big G Stands for Goodness: Sister Corita Kent's 1960s Pop," Arcadia University Gallery, http://gargoyle.arcadia.edu/gallery/archives/corita.htm.

21. Nieto, *Across the Street*, 29.

22. Sister Karen Boccalero, quoted in a press release issued by Self Help Graphics on June 26, 1997, following her death (Archives of Shifra M. Goldman).

23. Michael T. Ricker, "El Taller de Gráfica Popular," Graphic Witness: Visual Arts & Social Commentary, April 2002, http://www.graphicwitness.org/group/tgpricker.htm. For a collection of Posada's prints, see Julian Rothenstein, *J. G. Posada: Messenger of Mortality* (London: Redstone Press, 1989).

24. For a discussion of other art centers see Alan W. Barnett, *Community Murals: The People's Art* (Philadelphia: Art Alliance Press, 1984), 18–19.

25. In the late 1960s and early 1970s, various grassroots art centers catering to these groups opened their doors. The City Arts Workshop in New York City, headed by Susan Shapiro-Kiok, and the Chicago Mural Group, headed by John Weber, both worked with Asian, Latino, and Black communities. See Cockcroft, Weber, and Cockcroft, *Toward a People's Art*, 148, 171. Also see Eva Cockcroft, "More Alternative Spaces: The L.A. Woman's Building," *Art in America*, May/June 1974, 85.

26. Associated Press, "Muralist Carlos Bueno Dies at Age 60," September 5, 2001.

27. Sister Karen Boccalero, letter to Mr. Salem (owner of El Mercado), June 30, 1970, box 4, folder 3, CEMA SHGA Archives.

28. Tomás Benitez, interview by author, Los Angeles, 1998.

29. Sister Karen Boccalero, letter to Mr. Raoul DeSota, Los Angeles City College, November 13, 1972, box 4, folder 5, CEMA SHGA Archives. Serigraphs are produced through a silk screening process in which the printmaker uses various stencils printed over one another to make a complete print. Batik refers to the process of cracking solidified wax and covering it with an ink or dye that penetrates the cracks, thus leaving a unique imprint on the paper or cloth below. For more on the process of printmaking, the primary medium of Self Help Graphics, see Jules Heller, *Printmaking Today: A Studio Handbook*, 2nd ed. (New York: Holt, Rinehart, and Winston, 1972).

30. Self Help Graphics & Art announcement, November 28, 1972, box 4, folder 3, CEMA SHGA Archives.

31. Sister Karen Boccalero, letter to Mr. Salem, June 13, 1972, box 4, folder 5, CEMA SHGA Archives.

32. Ibid.

33. Sister Karen Boccalero, letter to Sister Catherine, OSF, director of St. Mary's Academy, July 27, 1973, box 4, folder 5, CEMA SHGA Archives.

34. Carlos Bueno, letter to Emilio O. Rabasa, secretario de relaciones exteriores, Mexico City, August 21, 1974, box 4, folder 5, CEMA SHGA Archives.

35. Sister Karen Boccalero, letter to Mr. Norton Kiritz, Grantsmanship Center, Los Angeles, September 19, 1974, box 4, folder 5, CEMA SHGA Archives.

36. Sister Karen Boccalero, letter to Ricardo Zazueta, SER-Jobs for Progress, Inc., November 13, 1974, box 4, folder 3, CEMA SHGA Archives.

37. Leo Limón, "A Tribute to the Ones Who Light Our Creative Spark, Fan Our Flames and Encourage Us to Pass It On," *Arroyo Arts Collective Newsletter*, September 1997, http://www.arroyo-artscollective.org/news/sep97/tribute.html.

38. Sister Pius Fahlstrom, OSF, letter to Msgr. John P. Languille, director, Catholic Welfare Bureau, Los Angeles, December 13, 1978, box 4, folder 10, CEMA SHGA Archives.

39. Barrio Mobile Art Studio brochure, 1976, box 28, folder 5, CEMA SHGA Archives.

40. Sister Karen Boccalero, letter to Baxter Ward, chairman of the Los Angeles Board of Supervisors, September 15, 1976, box 20, folder 7, CEMA SHGA Archives.

41. Ibid.

42. See Sybil Venegas, "The Day of the Dead in Aztlán: Chicano Variations on the Theme of Life, Death, and Self Preservation" (PhD diss., University of California, Los Angeles, 1993). Venegas defines el Día de los Muertos as practiced in the United States as a "politically motivated celebration of Chicano spirituality and cultural heritage."

43. Mary McMasters, "Celebrating the Spirit," *Los Angeles Times Home Magazine*, October 22, 1978, 52–56.

44. Self Help Graphics & Art, Día de los Muertos silk screen poster announcement, November 5, 1978, Archives of Shifra M. Goldman.

45. Tere Romo, *Chicanos en Mictlán: Día de los Muertos in California* (San Francisco: The Mexican Museum, 2000).

46. Self Help Graphics & Art, funding application for the Día de los Muertos Youth Project to the National Endowment for the Humanities, 1978, box 34, folder 1, CEMA SHGA Archives.

47. Ibid.

48. Venegas, "Day of the Dead in Aztlán," 34.

49. Harry Gamboa Jr., "In the City of Angels, Chameleons, and Phantoms: Asco, a Case Study of Chicano Art in Urban Tones (Or, Asco Was a Four-Member Word)," in *Urban Exile: Collected Writings of Harry Gamboa Jr.*, ed. Chon A. Noriega (Minneapolis: University of Minnesota Press, 1998), 80.

50. Chon Noriega, introduction to "Self Help Graphics: Tomás Benitez Talks to Harry Gamboa Jr.," in *Sons and Daughters of Los: Culture and Community in Los Angeles*, ed. David E. James (Philadelphia: Temple University Press, 2003), 195.

51. Gronk, interview by Jeffery Rangel, January 20 and 23, 1997, Collection of the Smithsonian Institution Archives of American Art, http://archivesofamericanart.si.edu/oralhist/gronk97.htm.

52. Flyer and concept proposal for the Vex Alternative Space for Musicians, 1980, box 11, folder 6, SHGA CEMA Archives.

53. Josh Kun, "Vex Populi: At an Unprepossessing Eastside Punk Rock Landmark, Utopia Was in the Air. Until the Day It Wasn't," *Los Angeles Magazine*, March 2003.

54. Wayne Alaniz Healy, interview by author, Los Angeles, April 12, 1998.

55. All quotations in this paragraph are from Limón, "Tribute."

56. Patssi Valdez, interview by Jeffery Rangel, May 26, 1999, Collection of the Smithsonian Institution Archives of American Art, http://artarchives.si.edu/oralhist/valdez99.htm.

57. See essays by Sister Karen Boccalero and Stephen Grace, master printer, in "L.A. Prints: Self Help Graphics Atelier Program, 1983–1986," box 21, Papers of Tomás Ybarra-Frausto, Collection of the Smithsonian Institution Archives of American Art. See also Heller, *Printmaking Today*, for information on techniques of intaglio and lithography.

58. Reina Alejandra Prado Saldivar, "Self-Help Graphics: A Case Study of a Working Space for Arts and Community," *Aztlán: A Journal of Chicano Studies* 25, no. 1 (Spring 2000): 173.

59. Brochure announcement of the first Experimental Screenprint Atelier Exhibition, March 1983, box 21, Papers of Tomás Ybarra-Frausto, Collection of the Smithsonian Institution Archives of American Art.

60. Ibid.

61. Sister Karen Boccalero quoted in Pat O'Brien, "Gift of Art, Opportunity," *Riverside (CA) Press-Enterprise*, November 13, 1996, A13. In order to further the recognition of Chicano art and combat elitist visions of art, Self Help has donated its prints to various museums and archives over the past decade. For example, in 1996 Sister Karen helped finalize the donation of over forty prints to the Riverside Art Museum in Riverside, CA. The museum highlighted this body of work in an exhibition titled *Aztlán and Beyond: Works from Self Help Graphics*.

62. Will Barnet quoted in Clinton Adams, "An Informed Energy: Lithography and Tamarind," *Grapheion*, Spring 1997, 21.

63. Goldman, *Dimensions of the Americas*, 170.

64. Ibid.

65. Noriega, introduction to "Self Help Graphics," 196.

66. Benitez, interview.

67. Gutiérrez, interview.

68. Reina Alejandra Prado Saldivar, "Formation of a Chicano Art Canon: Narrations and Exhibitions on Los Four, Asco and Self Help Graphics and Art, Inc." (PhD diss., University of Arizona, Tucson, 1997).

69. Tere Romo, "Points of Convergence: The Iconography of the Chicano Poster," in *Just Another Poster? Chicano Graphic Arts in California*, ed. Chon A. Noriega (Santa Barbara: University of California, University Art Museum, 2001), 110.

70. Michael Amescua, interview by author, Los Angeles, June 2, 1998.

71. Benitez, interview.

72. Scholar Laura E. Pérez quoted in the brochure "Self Help Graphics and Art: Maestras Atelier XXXIII," 1999, CEMA SHGA Archives.

73. Castellanos is quoted by Pérez in the Maestras Atelier brochure.

74. José Alpuche quoted in the Maestras Atelier brochure. The brochure was released after the completion of the atelier.

75. Yreina D. Cervántez quoted in the Maestras Atelier brochure.

76. Pierrette Hondagneu-Sotelo states that over 80 percent of domestic workers in Los Angeles (live-in and live-out nannies, housekeepers, housecleaners) are Latina. Additionally, although most of these women are also mothers themselves, their children often live in their countries of origin—a phenomenon Hondagneu-Sotelo calls "transnational motherhood." See "Maid in L.A." in *Doméstica: Immigrant Workers Cleaning and Caring in the Shadows of Affluence* (Berkeley: University of California Press, 2001).

77. Tomás Benitez quoted in Sonya Geis, "Tomás Benitez, Executive Director of Self Help Graphics & Art" (keynote speaker biography for Memoria, Voz, y Patrimonio: The First Conference on Latino/Hispanic Film, Print and Sound Archives, Los Angeles, August 15–17, 2003, http://www.gseis.ucla.edu/LAConf/Keynote_Bios.html).

78 . Self Help Graphics & Art grant application to the Southwestern Bell Foundation for a National Chicano Printmaking Exhibition Project, July 26, 1999, CEMA SHGA Archives.

79. U.S. Department of State, "2004 Report of the United States Advisory Commission on Public Diplomacy," http://www.state.gov/r/adcompd/rls/36275.htm.

80. Benitez, interview.

81. See, for example, Cynthia Rose, "A Slice of East L.A.: Self Help Graphics Bolsters Art from the Barrio," *Seattle Times*, September 1, 1998, E1.

82. "Best Latino Art: Self Help Graphics," *New Times* (Los Angeles), March 7, 2002.

83. Jack Shakely, "The Source of the Nile," California Fund, http://www.calfund.org/arts/organizations_5.php.

84. Daniel Hernández, "A Changing Imprint: Self Help Graphics Is Forging Links beyond Its Eastside Roots and Planning a More Innovative Future," *Los Angeles Times*, August 1, 2004, E41.

85 . Ibid.

86. In particular, Josh Kun, who writes for print media, has framed this debate as one of "competing tendencies that continue to divide contemporary Chicano art." See "The New Chicano Movement," *Los Angeles Times*, January 9, 2005, I12.

The CSRC Partnership with Self Help Graphics: A Model for University-Community Collaboration

Chon A. Noriega

Since 2002 the UCLA Chicano Studies Research Center (CSRC) and Self Help Graphics & Art, Inc. have had an ongoing community partnership. In many respects, this formal collaboration has provided a model that informs many of the CSRC's current programs and initiatives. But the relationship and, indeed, the similarities between the two organizations extend much farther back. Both CSRC and Self Help were founded in 1970 in the context of the Chicano civil rights movement, and their subsequent histories speak to the ways in which that movement sought to institutionalize social change within the community and the university. Today CSRC is addressing the crucial role of the public university with respect to community-based arts. These are trying times for both the arts and public education, but through strategic partnerships each side can help the other better achieve its mission.

In July 2002, when I became CSRC director, my first challenge was to find a way to structure the center so that it could grow in a coherent and coordinated way despite severe cuts in state funding. In the first year I set about expanding the center's research capacity and its roster of affiliated faculty members and professional staff, placing emphasis on four areas: health, demographics, education, and the arts. The connective tissue across these research areas

would be preservation and publication—that is, the work of our center's library and press, drawing upon the expertise of our librarian, Dr. Yolanda Retter Vargas, and publications coordinator, Wendy Belcher. In developing the center's research capacity, I also concentrated on empowering the staff researchers and graduate students involved in our projects, so that the idea of our "capacity" rested not generically with the center (or its director) but with these individuals and the positions they occupied. Whenever possible, authorship of center publications would go to the research assistant or other person who did the work, a departure from the typical practice of assigning authorship to the director who conceives the project, hires researchers, and pays the salaries.

I drew on the center's legacy since the 1960s in order to articulate and foreground a preexisting intellectual framework: "Research that makes a difference." This speaks to the imperative that emerged out of the Chicano civil rights movement, that is, that scholarship and the university must contribute to the knowledge base, resources, and development of the Chicano community. Ironically, that imperative echoed the founding mission of the very universities then excluding or ignoring Chicanos and Chicanas. In the United States, land grant universities such as the University

of California were founded on the basis of precisely such a dual mission: to look inward in the pursuit of knowledge, and outward in an effort to apply that knowledge in the service of society. In effect, the Chicano movement merely restated the same practical question that ushered in the public university. How can these institutions serve the entire population and its various communities?

I took this challenge as central to the CSRC's activities. How, exactly, does one create research that makes a difference? First of all, it is important to understand that the same research project can serve one function within the university and quite another in the community. We need to become aware of these differences early in the process, so that the research can and will serve both functions effectively. In that way, scholars can establish and nurture informed, substantive, and continuing partnerships between the university and community-based groups.

Involving the Community in Strategic Planning

One of the first things I did as director was to organize and host a series of community forums around the CSRC's key program areas. The forums proved to be an invaluable tool. The idea was to let community leaders know about our ongoing efforts and plans and to get their input about the state of the field and their sense of what UCLA and the center could do—or had not been doing!—to support their efforts. These dialogues provided a reality check on the relationship between the university and the community. They also established goodwill, provided invaluable feedback on existing projects, and presented the center with solid new ideas about how to proceed. For the arts forum, we brought together about a dozen community leaders, including curators, arts administrators, collectors, critics, and artists. After meeting for over two hours, we continued the discussion over dinner at the UCLA Faculty Center, gaining a detailed sense of the issues facing the Latino arts community in Los Angeles. With the forum as a starting point, we continued to involve the participants in subsequent arts activities, strengthened our relationship by developing collaborations and partnerships, and used the event to identify and engage other individuals and organizations.

So what did we learn through this process? First, we learned that we needed to know even more about the Latino arts community and the potential interface with scholarship. Toward that end, the center conducted surveys on arts resources whose findings were released in two reports: *Archiving the Latino Arts Before It Is Too Late*, and *An Undocumented History: A Survey of Index Citations for Latino and Latina Artists*.[1] Written by Rita González, then CSRC arts project coordinator and now a curator at the Los Angeles County Museum of Art (LACMA), both reports underscore the need to take immediate action in order to recover and safeguard the history of Chicano and Latino participation in the arts. This history is fragile, ephemeral, and—in terms of the archive— largely neglected. Preserving and documenting this history is vital, not just for the academy, but for the Chicano and Latino arts community itself. One of the worries we kept hearing, during the forum and in our surveys, was that community-based arts organizations were losing their "institutional memory" as documents disappeared and cultural workers retired or died. These documents and memories can tell us about artistic production, exhibition practices, critical reception, and funding patterns for cultural organizations, as well as about the interconnections of Latino arts to national and

international spheres. Such materials also allow scholars to assess the role of artists in identity- and rights-based social movements. However, this is only possible if these materials are preserved and made accessible.

While preservation quickly emerged as an area where the needs of scholars and the community converged, we had to acknowledge the considerable skepticism that existed toward the university. Latino arts organizations and ethnic museums, faced with severe budget shortages, often cannot afford the costs of documenting their own histories. But, as one respondent to our survey on Latino arts preservation observed, "Many organizations would like to institute a formal archive or designate a recipient of archival materials, however, they refrain from doing so due to financial constraints and negative experiences in collaborative ventures." Indeed, the skepticism about collaborative ventures with universities is based on experience: universities have a well-earned reputation for dropping into communities to extract what they need—for research, for their libraries— but then doing little to benefit the community and its institutions in a way that is immediate and transparent. The moving van that shows up and takes the artifacts of a community's heritage back to the university archive may indeed serve the commonweal and preserve the historical record, but it can also weaken the community in that very same moment by removing those artifacts from its day-to-day life. Thus, we realized the need to pose a new kind of question about our projects: How can doing what we do as academics *also* strengthen community-based organizations? One answer would be to develop long-term collaborations that not only serve our needs as a research university, but also bring real, tangible benefits to our community-based partners. There is no template or cookie-cutter approach that will

work in all instances. From the start, each side must be precise and particular about its needs and expectations for the collaboration.

Perhaps the most important lesson we learned from this process had to do with the need to make room for other contexts than the one that informs the academy, especially with respect to collections development. After all, as art collector Armando Durón stated at our first Latino art summit, no one can tell what the "historical cut" will be one hundred years from now—that is, what or who will be seen as important or, conversely, forgotten. Along these lines, in our surveys and meetings everyone stressed the need to incorporate the community's own contexts for our archival holdings and research. The artists and their communities sustain a vibrant and vital context within which the arts make sense, and it is incumbent upon the university to take that into account as part of the collection process. After all, that context is itself an essential, if ephemeral, part of the history that the archive is attempting to preserve. Oral history provides one way to "capture" that context, and it should be done whenever possible. But it is even more important to take a partnership approach in establishing an archival holding in the first place.

Such an approach begins by ensuring community access to the collections and the research. Why? Because for many in the Latino arts community, access means that they have been taken into account as part of the university's activities. In other words, access is fundamental to context. The practical implications for the university are clear: If community members do not feel that they will be allowed access to the documents and artifacts that used to reside in the community, there will be little incentive to place these objects in an archive. But the concern about access actually goes beyond access to the objects per se. Instead, it's

about what those objects represent—a mission, a history, a philosophy, a way of being—and the hope that the university can give greater voice to these ideas buried within documents, artifacts, ephemera, and lived experience. This hope actually dovetails with the research mission of the university itself, provided the university accepts the community as part of the audience for its publications and academic presentations.

The Partnership with Self Help Graphics

One of our first efforts in the arts was to establish a community partnership with Self Help Graphics & Art, Inc., through a new "UCLA in LA" initiative established by the university's Office of the Chancellor. Started in 2002 with a one-year grant, this partnership continues with other support. It provides a model for our other partnership efforts, especially with respect to how we attempt to define products or outcomes that serve both the university and the community.

Self Help Graphics is a visual arts center in East Los Angeles that emerged amid the cultural and political ferment of the Chicano movement. Thirty-five years later, it has managed to sustain a relationship with the Los Angeles community while at the same time establishing a national profile among arts organizations. But like all small arts centers with modest means, it has had to struggle for survival. With the bulk of resources going toward maintaining its organizational infrastructure and consistent programming, monies and staff for documentation and preservation have been scarce if not altogether nonexistent. Consequently, the on-site Self Help Graphics print collection—approximately 450 singular editions, constituting a significant history of

multiethnic artistic production in East Los Angeles—was at risk of deterioration, damage, and even destruction. In fact, during summer 2001, a short-circuit in the air-conditioning system caused a fire on the roof that might have destroyed the building. Fortunately, the fire was contained promptly and losses were minimal. But the event provided a harsh reminder of the fragility of the historic building and its contents.

To its credit, Self Help Graphics had years earlier archived a set of prints as well as its institutional papers at the California Ethnic and Multicultural Archives (CEMA) at the University of California, Santa Barbara. Indeed, under director Salvador Güereña, CEMA had taken the lead in the preservation of Chicano graphic arts across the entire state of California. So preservation of those prints and papers was not the issue; rather, the need was to strengthen Self Help's infrastructure and on-site holdings through preservation and publication efforts. Our partnership therefore focused on overhauling their on-site storage facility by (a) providing necessary flat file cabinets and archival supplies to upgrade on-site storage, (b) improving the on-site cataloguing system, and (c) carrying out a methodical sorting and inventory of all prints and objects. For us, the project allowed our center library to train graduate students and thereby improve our ability to work with special collections. We also used the project to establish an internship program with the university's Department of Information Studies so that we can continue to provide on-site support to Self Help Graphics, as well as training opportunities for UCLA graduate students. In exchange, our center library received a selected suite of prints from Self Help Graphics that provide an immediate research resource for students and faculty at UCLA and in the Los Angeles area.

The community partnership with Self Help Graphics provided a first step toward continuing collaborations and externally funded projects that have had a significant impact within Los Angeles. In February 2004, the CSRC and Self Help Graphics jointly convened a Latino Arts Summit that brought together fifteen L.A.-based Latino arts organizations as well as The Mexican Museum (San Francisco), the Mexican Fine Arts Center and Museum (Chicago), and the National Association of Latino Arts and Culture (San Antonio). The summit sought to address the urgent need for preservation and access efforts within community-based arts groups serving the Latino population. The University of California Institute for Mexico and the United States (UC MEXUS) provided a mini-grant for this first meeting. When it became apparent that these groups had never met before and that continuing contact would be valuable, the CSRC agreed to continue providing a forum for these groups to address issues of common concern, including preservation and documentation related to their diverse histories, missions, and programs. The first follow-up meeting was held in June 2004. As a result of these and other efforts, the CSRC received support from the Getty Grant Program to undertake a survey of Latino art historical materials in the Los Angeles area. The survey includes questions posed by the Latino arts organizations themselves and will lay the foundation for the center's collection development in this area. The CSRC has also negotiated a five-year agreement with LACMA in order to develop Latino-themed exhibitions, public programs, and permanent collection holdings. The agreement includes efforts to develop ongoing working relations between the museum and Latino community-based arts organizations.

The final component of our community partnership with Self Help Graphics is the publication of this resource guide. The book is intended to serve as a reference tool for libraries, as a classroom text featuring original scholarship, and as a marketing and development tool for Self Help Graphics. Equally important, the process of researching and writing it has involved PhD students already working on these collections, and in this way is helping to lead a new generation of young scholars to the university-based archival collections (primarily at CEMA, but also at UCLA). Finally, working on the book has deepened our collaboration with CEMA through the creation of shared resources. In this way, the publication serves not just the needs of university-based archives and academic programs, but also the community that contributed the archival holdings.

The CSRC plans to publish resource guides for each of its major special collections as well as to continue collaborations with other archives. Another guide in this series, on filmmaker Efraín Gutiérrez, will be published in collaboration with Stanford University's Mexican American Collection, which holds the filmmaker's paper archives. (UCLA has restored and archives his films.)

Research that Makes a Difference

In addition to archival preservation, there is a need to facilitate and support research efforts that expand the art historical record and thereby provide the documentation that community-based arts groups need in order to survive and remain relevant. This research must be rigorous, critical, and expansive, connecting the Latino arts to the community, the nation, the art world, and beyond. It must question and challenge, not just offer praise, otherwise it will fail to meet both academic standards and community needs.

We see this research as crucial on two fronts: the institutional and the individual. We have

therefore focused on the community-based arts institutions that have supported, exhibited, and otherwise circulated the Latino arts. But we have also grounded this history in the experiences of individual artists, curators, collectors, and arts administrators. This approach is substantially different from one that starts with cultural formations or with cultural precepts, aesthetics, and practices that can predetermine what gets taken into account. We cast the net widely, so that the historical record can include the inevitable contradictions, exceptions, and complications that challenge any categorical system or interpretive paradigm. There is, for example, both historiographic irony and insight in the fact that the founders of at least two U.S. Latino museums were artists whose work—because it was abstract or associated with non-Latino avant-garde movements—fell outside the category of "Latino art" that these museums helped define. I'm thinking here of Raphael Montañez Ortiz, co-founder of El Museo del Barrio in New York, and Peter Rodríguez, founder of the Mexican Museum in San Francisco. Likewise, the Self Help Graphics archives give evidence of a complex set of historical origins, influences, and practices. Kristen Guzmán's essay provides an excellent treatment of these complexities while also arguing that much remains to be done by scholars using the extensive archival record.

The CSRC's various projects are concerned not only with archive building and scholarship but with developing long-term relationships with the Latino community that result in a strengthened arts infrastructure. Research projects related to the arts must serve not only the scholars who will use primary research materials but also the larger public, including the artists themselves. That dual mission, which coincides in large part with the founding mission of public universities, will only be fulfilled if we structure our activities in such a way as to facilitate both community partnerships and research that makes a difference.

* * *

As we go to press, Self Help Graphics is facing its most serious challenge since its founding, having been abruptly closed by its board of directors in early June due to lack of funds and liability insurance. Since then, the board has worked to re-open Self Help Graphics, while artists, peer organizations, and community members have organized in order to voice their concerns and lend their support. With several foundation grants, the board is now undertaking a restructuring process with an outside consultant and making plans to re-open sometime in Fall 2005. Many in Los Angeles and around the country look to this crisis as posing an open question about the continued viability and relevance of the community-based arts organizations formed in the 1960s and 1970s. We hope that this book and our ongoing partnership help answer that question.

Notes

For a longer version of this essay that considers all the arts projects at the UCLA Chicano Studies Research Center, see "Preservation Matters," *Aztlán: A Journal of Chicano Studies* 30, no. 1 (Spring 2005): 1–20. Available at www.chicano.ucla.edu.

1. Rita González, "Archiving the Latino Arts Before It Is Too Late," Latino Policy & Issues Brief 6, April 2003; and González, "An Undocumented History: A Survey of Index Citations for Latino and Latina Artists," *CSRC Research Report* 2, August 2003.

Guide to the Self Help Graphics Archives
1960–2003 [mostly 1972–1992]

Salvador Güereña

Archive:	California Ethnic and Multicultural Archives (CEMA), Department of Special Collections, Donald C. Davidson Library, at the University of California, Santa Barbara
Collection Number:	CEMA 3
Size of Collection:	27 linear feet of organizational records and 466 silk screen prints.
Acquisition Information:	Donated by Self Help Graphics & Art, Inc., 1986–2004
Access restrictions:	None
Use Restriction:	Copyright has not been assigned to the UCSB Department of Special Collections. All requests for permission to publish or quote from manuscripts must be submitted in writing to the Head of Special Collections. Permission for publication is given on behalf of the Department of Special Collections as the owner of the physical items and is not intended to include or imply permission of the copyright holder, which also must be obtained.

Processing Information:	
Project Archivist	Salvador Güereña.
Principal processors	Rosemary León, Alicia E. Rodríquez, Naomi Ramieri-Hall, Alexander Hauschild, Victor Alexander Muñoz, Maria Velasco, and Benjamin Wood. Curatorial support Zuoyue Wang.
Processed	July 1993–2005.
Process support	University of California Office of the President and University of California Institute for Mexico and the United States (UC MEXUS).
Location:	Del Norte Wing

Contact:
Salvador Güereña
University Libraries - CEMA
University of California
Santa Barbara, CA 93106
http://cemaweb.library.ucsb.edu/cema_index.html
805-893-8563 (phone)
805-893-5749 (fax)
guerena@library.ucsb.edu

Organizational History

Self Help Graphics & Art, Inc. is a non-profit organization and serves as an important cultural arts center that has encouraged and promoted Chicano art in the Los Angeles community and beyond.

The seeds of what would become Self Help Graphics & Art, Inc. were planted in 1970 during the height of the Chicano Civil Rights movement when two young Mexican artists, Carlos Bueno and Antonio Ibañez, and several Chicano artists including Frank Hernandez, met Franciscan nun and Temple University-trained Master Artist, Sister Karen Boccalero. Reflective of the contemporary social and political climate, Bueno and Ibañez were frustrated by the inaccessibility and lack of facilities available to young Chicanos wishing to develop their talents as artists. The cost of private art schools was prohibitive to most Chicanos. While it is generally conceded that art is an intensely personal expression that holds no creative boundaries, some in the art world did not yet accept the concept of a unique Chicano art that would serve as an expression of cultural values. In this context, they set out to develop a plan that would remedy this situation; a plan that would not only serve the needs of aspiring Chicano artists, but that would also serve the greater East Los Angeles community.

Long hours of careful planning and canvassing the community for support ultimately paid off. With a grant from the Order of the Sisters of St. Francis, the trio (who by this time were joined by others interested in serving their cause) was able to acquire 2,000 square feet of space that had once served as a gymnasium in the heart of East Los Angeles. Its subsequent conversion into an art studio and gallery enabled the group to open the doors of Self Help Graphics in 1972. The organization was so well-received by the surrounding community and by aspiring artists that operations soon outgrew the 2,000-square foot facility. Continuing the search for funding through public as well as private resources, a grant from the Campaign for Human Development in 1973 enabled Self Help Graphics to acquire an additional 7,000 square feet adjacent to the existing studio and gallery space.

Once Self Help Graphics was firmly established as an art center, the core members of the group began to think beyond the walls of the studio and imagine how, in addition to developing their own talents and furthering Chicano art, they could reach out in a way that would benefit the greater East Los Angeles community. Placed in its larger historical context, Self Help Graphics' efforts may be seen as a microcosm of the macrocosmic Chicano Power movement of the late 1960s and early 1970s. One of the goals of this movement was to foster an appreciation for Chicano roots. Chicano activists placed an emphasis on their mesoamerican past rather than on their European Spanish heritage. Many contemporary activists argued that rather than honoring and preserving this heritage, the dominant Anglo sociocultural norms were eroding the indigenous culture. Like these activists, Self Help Graphics feared that within such an atmosphere, young Chicanos would not only soon forget their cultural values, but also would develop a negative sense of their heritage and of themselves in light of the Anglo sociocultural practices and values being taught in the public school system and disseminated by the popular media.

Self Help Graphics spent long hours developing and planning ways through which, in addition to exposing barrio children to a variety of artistic media, they could utilize art forms to instill within these children a positive sense of self, community, and culture. Many of the children that Self Help Graphics wished to help were either immigrants themselves, or the sons and daughters of immigrants not far removed from their Mexican past. Since participation in art does not require a sophisticated command of spoken or written language, art was perceived as an excellent vehicle by which to achieve this end.

While Self Help Graphics held workshops on its premises to educate neighborhood children (as well as adults) about art and culture, the sheer physical geography of East Los Angeles isolated much of the target group from their services. In an effort to remedy this shortcoming, they set out to devise a plan that would bring the art studio to the surrounding community.

In August 1975, following an exhaustive fundraising campaign, Self Help Graphics instituted the Barrio Mobile Art Studio. The organization acquired and customized a van for this purpose. This specially equipped van introduced children to filmmaking,

silkscreen, photography, sculpture, batik, painting, and puppetry. Through contract with the Los Angeles Unified School District, Self Help Graphics was able to bring its program to various East Los Angeles elementary schools and thus provide a level of multicultural education in the arts to children who currently had none in their curriculum. The Barrio Mobile Art Studio program was enormously successful and well-received by students, teachers, school administrators, and civic leaders. It remained in operation until Self Help Graphics phased out the program in 1985. Arguably, the Barrio Mobile Art Studio served as a prototype for the types of multicultural curriculum programs that the Los Angeles Unified School District would later adopt.

Self Help Graphics has played an active role in community affairs. Included among these activities are the sponsoring of numerous workshops and art exhibitions. Ever since 1974, the organization staged the now nationally recognized East Los Angeles Día de los Muertos Celebration. This holiday, which is traditionally celebrated on November 1 and has its origins in Mexico, was originally conceived of as a one-time celebration to be staged by Self Help Graphics. The following year the community demand for this event was so great that the organization decided to continue sponsoring the annual event. With support from the National Endowment for the Arts and the National Endowment for the Humanities, the East Los Angeles Día de los Muertos celebration grew into an event that attracted national attention. The elaborate celebration continued to survive and thrive not only because of grant money received from numerous public agencies and private foundations, but through the widespread community support that served as the backbone for producing the celebration. This three day celebration accomplished some of Self Help Graphics' goals by educating East Los Angeles residents of their heritage, introducing them to the creative processes involved in art, and ultimately, helping to build a stronger community. By 1985, the Día de los Muertos celebration had become so popular among the residents of East Los Angeles that the program could be sustained without the primary support of Self Help Graphics. With assurance that others would take up the responsibility for planning and organizing the event, the organization decided to take a secondary

role in staging the celebration. Such a role allowed Self Help Graphics to devote more time and energy to the primary reason behind its founding: furthering Chicano art and providing a training ground for aspiring Chicano artists.

Self Help Graphics has developed a national reputation for the exceptional quality of the screenprints produced by artists at the facility, while its private gallery, the Galería Otra Vez, also receives much praise and is well-recognized as an important arena for exhibiting artists' works. With its continued emphasis on advancing Chicano art, Self Help Graphics remains one of the most important centers in the country for training Chicano artists.

Scope Note

The Self Help Graphics & Art, Inc. Collection consists of eight series distributed among fifty-seven archival boxes that occupy twenty-seven linear feet of space. These boxes hold information pertaining to the everyday operation of Self Help Graphics. In addition, the collection contains one hundred twenty-nine silk screens that were produced at the East Los Angeles facility. There are eight portfolio containers for the silk screen prints. The organizational records cover the years from 1960 to 1992, while the silk screen collection holds works that were produced between 1983 and 2003. The collection is arranged in the eight series as follows:

Series Descriptions

Series I: Internal Administrative Records, 1960–1992. Series I consists of seven subseries and is housed in nineteen archival boxes.

Subseries I: Correspondence, 1960–1992, consists of both incoming and outgoing correspondence. Much of the incoming correspondence (arranged alphabetically by sender) are letters of support from various public and private institutions. These letters call attention to the valuable social and cultural benefits provided to the East Los Angeles area as a result of the community activities sponsored by Self Help Graphics. Outgoing correspondence (arranged chronologically) largely consists of copies of letters and reports that were

mailed to current and potential financial supporters in an effort to keep them apprised of the services Self Help Graphics provided to the community, as well as to inform them of the successes of its outreach programs. Public relations materials of this kind were used to acquire future support and to help ensure continued support from those already financially assisting Self Help Graphics. The multitude of outgoing correspondence found in Subseries I reflects the tireless efforts of a grassroots organization struggling to secure funding for continued operation.

Subseries II: Educational Programs, 1972–1992, consists of documents that may be used to trace Self Help Graphics' efforts to expose the low-income and otherwise culturally isolated East Los Angeles community to various types of art media and techniques for producing art. In addition to developing an appreciation for the arts, the participants in these Self Help Graphics-sponsored educational programs were encouraged to use art as means of cultural expression. Another goal of Self Help Graphics' programs was to instill within each participant a sense of pride in his or her Chicano culture. In addition to housing documents that describe the educational programs implemented by Self Help Graphics at local public and private schools, this subseries consists of information pertaining to the many programs sponsored at locations throughout the East Los Angeles community, as well as those held at the Self Help Graphics Avenida Cesar Chavez facilities. Of particular interest are the contracts between the Los Angeles Unified School District and Self Help Graphics that outlined the policies and guidelines for services rendered by Self Help Graphics to the District. Also of interest are documents that detail the program agenda and goals of the activities that Self Help Graphics developed for the many East Los Angeles schools it visited.

Subseries III: Exhibitions, 1980–1990, consists of loan agreements, print purchase receipts, and documents relating to exhibitions sponsored by Self Help Graphics. The organization has sponsored exhibitions and loaned prints to galleries both nationally and internationally. While the exhibition documentation represents a small number of the exhibitions actually staged, the materials preserved in this subseries are indeed rich.

Subseries IV: General, 1973–1991, consists of a wide variety of material that is related directly and indirectly to activities of Self Help Graphics during the years noted. Contracts for artworks commissioned by Self Help Graphics, minutes of meetings of various Chicano artist organizations, and information that highlights various Chicano issues on the state and local level are among the most significant holdings in this subseries. They reflect the social and political climate under which Self Help Graphics operated during various phases of its existence. (Minutes of Self Help Graphics staff meetings are found in Subseries VI, Personnel, 1972–1990).

Subseries V: Grant Proposals, Reports, and Applications, 1972–1989, is the largest subseries in Series I. The California Arts Council, the Campaign for Human Development, the City of Los Angeles, and the National Endowment for the Arts figure prominently among the many institutions that provided funding to Self Help Graphics. Documentation of various gifts and grants awarded by these agencies are a large part of this subseries. This subseries includes copies of applications for funds submitted to various public and private foundations, detailed proposals of the programs for which Self Help Graphics requested funding, and actual contracts between Self Help Graphics and various supporters. These contracts reveal the amount of the grant and detail the provisions of the award. Included in this subseries are multitudes of letters of inquiry from Sister Karen Boccalero to various organizations requesting information on the types and conditions of grants offered by these groups. Also included are a number of replies from agencies that rejected Self Help Graphics' requests for support.

Subseries VI: Newspapers, Magazines, and Miscellaneous Articles, 1971–1984, primarily consists of clippings that highlight the accomplishments of and services provided by Self Help Graphics. Most of the articles in this subseries deal in general with Self Help Graphics' activities and programs. Articles that deal primarily with the Barrio Mobile Art Studio and the Día de los

Muertos will be found in their appropriate series. The clippings in this subseries were originally found in Spanish as well as English language publications. There are also materials that do not deal directly with the activities of Self Help Graphics, but were housed in their organizational files and are retained in this collection at the request of Sister Karen Boccalero. Self Help Graphics subscribed to numerous periodicals that focused on Chicano art and culture. These periodicals, which Self Help Graphics kept among their organizational files for reference, were not produced by Self Help Graphics, and because they are among the titles that are already held by the Davidson Library, they have been removed from the archives.

Subseries VII: Personnel, 1972–1990, the final subseries in Series I, holds applications, resumes, and other personnel-related documents pertaining to artists and other staff employed by Self Help Graphics. These records, however, provide only an impressionistic view of Self Help Graphics' personnel history and should not be interpreted as a complete collection of the personnel files of all those who were a part of Self Help Graphics during the 1972–1990 period. Such detailed records of a potentially sensitive nature have not yet been made available by Self Help Graphics. Included in this subseries is an incomplete collection of Self Help Graphics staff meeting minutes that illuminate the decision making process of, and issues dealt with, at Self Help Graphics.

Series II: Barrio Mobile Art Studio, 1972–1986, (BMAS) is divided into seven subseries and is distributed among twelve archival boxes.

Subseries I: Correspondence, 1974–1986, consists of copies of letters written by teachers and other school officials in the Los Angeles Unified School District to state and local officials. The letters inform these officials of the Barrio Mobile Art Studio's valuable service to the district's school children. School employees urged these officials to support Self Help Graphics' request for grants from city, county, and state agencies. Four of the seven folders in this subseries contain "thank you" notes written by school children expressing gratitude to BMAS staff artists for visiting their schools and for introducing them to various artistic media.

Subseries II: General, 1975–1980, consists of a variety of documents relating to the daily operation of the Barrio Mobile Art Studio program. This subseries provides a wealth of information on the many schools visited by the mobile studio. Of particular interest are copies of the worksheets that were distributed to the school children during BMAS visits, as well as the detailed lesson plans developed by the staff artists. These items testify to the careful planning that went into each mobile studio visit. Also included in this subseries are evaluations of the program by teachers whose classrooms were visited by the BMAS. These short-answer evaluations shed light on what the school teachers perceived to be the strengths and weaknesses of the BMAS educational program.

Subseries III: Grant Proposals, Reports, and Applications, 1974–1979, consists of eleven file folders of documents relating to Self Help Graphics' efforts to secure funds for the continuation of the BMAS program. This subseries contains applications to the California Arts Council as well as to local fund-granting agencies. Because most agencies required that Self Help Graphics submit with the grant application information about the BMAS program's operation, the goals and objectives of the program, and a projected budget, richly detailed program descriptions as well as information about BMAS operations costs may be gleaned from the documents.

Subseries IV: Newspaper and Magazine Articles, 1976–1978, is the smallest of the seven subseries in Series II. This subseries consists of a selection of articles from English as well as Spanish language publications. While the majority of these articles survey the history and accomplishments of the BMAS, there are a few that highlight other Self Help Graphics endeavors, such as the Galería Otra Vez, and focus on Self Help Graphics personalities, such as Carlos Bueno and Antonio Ibañez.

Subseries V: Personnel, 1972–1988, is comprised of six file folders and contains copies of various personnel-related documents, such as employment applications and program evaluation

forms. Like the personnel subseries in the series I, there are no files in this subseries that give detailed information on individual artists associated with Self Help Graphics. Included here, however, is a thin file folder with material that deals exclusively with the career of Carlos Bueno, one of the founding artists of Self Help Graphics.

Subseries VI: Photographs, Negatives, and Slides, 1973–1982, is housed in six archival boxes. The vast majority of the photographs in this subseries were taken by Self Help Graphics staff members. These photographs document many of the BMAS visits to schools and artists at work in the Self Help Graphics Avenida Cesar Chavez facilities. Two of the forty-five folders in this subseries consist of photographic prints purchased by Self Help Graphics. These are primarily comprised of photographs of pre-Columbian architectural ruins, sculpture, pottery, paintings, and other artifacts from Latin and South America. Also included are candid photographs of contemporary indigenous peoples from the regions noted above. The items noted above served as visual tools for artists wishing to study their cultural roots and incorporate old world techniques and subjects into contemporary Chicano art.

Subseries VII: Color Photocopies, Flyers, and Invitations, 1977–1978, holds seven file folders of color photocopies and one of flyers and invitations. Many of the color photocopies capture the activities of artists and children at work at the BMAS and in the Self Help Graphics studio. Others are of the works produced by the Self Help Graphics artists. Still others are photographic reproductions of well known pieces of art from a variety of cultures from several periods in the history of art. Included in this subseries are many color photocopies of photographs of Latin and South American indigenous peoples. Self Help Graphics sponsors numerous activities at its Avenida Cesar Chavez facility and receives a multitude of invitations from groups and institutions hosting workshops, art shows, and other community activities. Preserved in this subseries is both a selection of flyers distributed by Self Help Graphics announcing activities at its studio, and many of the invitations that it received.

Series III: El Día de los Muertos, (Day of the Dead), 1960–1991, is divided into seven subseries and is housed in six archival boxes.

Subseries I: Correspondence 1974–1987, consists of both incoming and outgoing correspondence and is held in two file folders. The incoming correspondence is primarily from children to members of the Self Help Graphics staff. These are "thank you" letters that were written in appreciation of the staff for visiting classrooms during the Día de los Muertos holiday season. The one folder in this subseries that holds the outgoing correspondence consists of three letters.

Subseries II: General 1971–1991, consists of nine file folders. This subseries contains a series of documents (such as applications for parade permits and insurance contracts) that reflect the bureaucratic processes involved in staging the Día de los Muertos celebration (technically a private event) on public property. Included in this subseries are copies of the itinerary of activities planned by Self Help Graphics for the Día de los Muertos celebration. Unlike Series II, the General subseries in Series III does not hold extensive or detailed information on the lesson plans that Self Help Graphics staff used when presenting Día de los Muertos to local elementary schools. Curriculum information of this kind is embedded in subseries III (please see its description for details).

Subseries III: Grant Proposals, Reports, and Applications 1976–1983, is the largest subseries in Series III. This subseries contains twenty-four file folders, most of which hold applications for federally supported grants. The applications seek support for the Día de los Muertos parade and celebration—the single most costly and widely attended event sponsored by Self Help Graphics up until 1985 when it discontinued being its primary organizer. Most of the grant applications in this subseries were to the National Endowment for the Arts (NEA) and to the National Endowment for the Humanities (NEH). In order to evaluate requests for financial support, both the NEA and NEH required that detailed reports attesting to a project's past or potential success and cultural value be submitted with the grant application. As a result of these reports, a wealth of detailed

information on the Día de los Muertos celebration may be found in this subseries. In addition to the detailed curriculum plans that deal with the Day of the Dead holiday that were used by the Barrio Mobile Art Studio staff, newspaper clippings, photographs, and negatives also accompany the reports and will be valuable to researchers.

Subseries IV: Magazine, Newspaper, Journal, and Miscellaneous Articles, 1968–1991, holds an extensive collection of materials that deal almost exclusively with the Día de los Muertos. Most of the articles in this subseries were originally featured in Spanish as well as English language publications; however, Self Help Graphics also produced several short articles for publicity and cultural education purposes. These articles are found in this subseries.

Subseries V: Photographs, Negatives, and Slides, 1960–1985, is contained in seventeen file folders. The vast majority of the photographs and slides were taken by Self Help Graphics staff members in an effort to document the festivities of Día de los Muertos celebration. Also included is a sampling of photographs of the holiday as celebrated in Mexico. See also series V.

Subseries VI: Color Photocopies, Flyers, Invitations, and Posters, 1975–1986, is contained in five file folders. Included in this subseries are photographs documenting activities at the Self Help Graphics facilities, posters and flyers announcing Self Help Graphics' upcoming events, and photocopies of Self Help Graphics-produced essays that inform potential celebration participants of the Día de los Muertos historical background and cultural significance. The flyers distributed by Self Help Graphics are in themselves illustrative of the type of art produced by Self Help Graphics during the Día de los Muertos celebration.

Subseries VII: Notecards, n.d., the final subseries in Series III, consists of two folders of notecards produced and sold by Self Help Graphics artists during the Día de los Muertos celebration.

Series IV: Magazine, Newspaper, Journal, and Miscellaneous Articles, 1963–1991, houses fifty-six file folders of documents that cover a wide variety of topics. Many of the articles in this collection do not deal exclusively with Self Help Graphics; rather, they address East Los Angeles community issues that indirectly affected Self Help Graphics. Others focus on Chicanos at the state, local, and national level. It should be noted that this collection is not limited to clippings; many of the file folders contain entire periodicals. These range from scholarly journals to other artists' newsletters and journals, and from community publications (such as social directories) to Chicano popular culture magazines. Included in this collection are a variety of pamphlets, booklets, and brochures that call attention to a multitude of Chicano concerns and issues. Of particular interest is a ninety-nine page booklet titled *Art in Education Approach*. This work was written by Self Help Graphics staff members and published by the organization in 1983. The illustrated booklet describes in detail the Exemplary Arts Project and the activities and approaches that Self Help Graphics developed to use in their elementary school multicultural education programs. This publication booklet was written to serve as a manual for teachers wishing to use art in the classroom.

Series V: Photographs, Negatives and Slides, 1920–1991, consists of four archival boxes that hold an impressive array of photographs capturing many subjects and spanning six decades. Additionally there are seventeen slide albums that contain a voluminous collection of visual images. Within this series are dozens of black and white photographs of members of the Los Angeles Chicano community. Many of these photographs are not dated, but most of them were presumably taken between 1920 and 1950. Notable among the many photographs of Self Help Graphics staff members in this series are several large, color, glossy prints of artist Linda Vallejo instructing senior citizens how to paint self-portraits. Unique to the Series V is a collection of several photographs of art shows that were held at Self Help Graphics' Galería Otra Vez. Of special interest in this series are several photographic proofs documenting United Farm Workers' leader, César Chavez, and episodes of the farm workers' movement, as well as an additional set of proofs that show members of the Chicano student organization, MECHA rallying in protest of the 1978 *Bakke v.*

the University of California Supreme Court decision. The series' prominent feature is a large collection of slides. Housed in 13 albums, these slides provide visual images of various art works such as assemblage, graphic arts, drawings, indigenous Chicano art, installation art, murals, paintings, performance and conceptual art, photographs, and sculptures related to the Self Help Graphics, and of center activities and programs. These slides are an unusually rich source of Chicano art and culture. **A separate catalog is available for this slide collection. See Appendices A and B covering the years 1973–2003.**

Series VI: Color Photocopies, Flyers, Invitations, and Posters, 1973–1992, is held in forty-one file folders housed in five archival boxes. Many of the color photocopies picture Self Help Graphics staff at work in the Avenida Cesar Chavez studio while others are of the artists' works. In some cases, the photocopies are mounted on paperboard. Also included in this collection is a multitude of invitations to community events both sent from, and received by, Self Help Graphics.

Series VII: Note Cards, n.d., housed in two archival boxes. This collection of notecards and postcards consists of cards whose cover designs were created by use of metal plate etchings and through the silkscreen process. While none of the notecards in this series are dated, the names of the particular artist or artists responsible for their creation are written on the flap of the glassine envelope in which they are stored. The images depicted on the covers of these cards range from animals, to humans, to Aztec designs, to abstract drawing. Folder four of box 40 is the only folder in this series that has postcards. Most of these announce some event sponsored by Self Help Graphics. The front of each card possesses an original design created by one of the many Self Help Graphics artists.

Series VIII: Graphic Arts and Poster Collection. Series VIII represents the voluminous serigraph and poster collections in this archive. The collection presently consists of 466 serigraphic prints and an assortment of posters. Self Help Graphics is one of the most active and prolific Chicano silk screen poster workshop collectives in the country. Nowhere is this more evident than in its Atelier Screen Print program, which began in 1983 to provide emerging artists with the opportunity to practice their creative talents and to help them gain exposure. The Atelier program has two goals: to bring some of California's best Chicano artists together in a collaborative atmosphere where they can create fine art serigraphs, and to generate income from the sales of their artwork to help perpetuate the program.

Many of the now-prominent Chicano/Latino artists produced their early work at Self Help Graphics; such artists include Carlos Almaraz, Michael Amescua, Barbara Carrasco, Yreina Cervantez, Richard Duardo, Diane Gamboa, Antonio Ibanez, Leo Limon, and Michael Ponce, to name a few. The silk screen collection is a rich source of documentation and reflects the evolution of the Chicano art movement. A diversity of themes, including social, political, and cultural issues, are represented in these intense and personal artistic statements.

There have been three master printers involved in the Atelier program from its inception in 1983 to the present. The first was Stephen Grace, responsible for producing Ateliers I through VII. His tenure as a master printer with the program is represented by sixty archival quality limited edition prints by forty-two artists. Grace's successor, Oscar Duardo, is the brother of the renowned artist and master printer Richard Duardo. In addition to maintaining Self Help Graphics' high standards of printing, the former Durado is someone whose talent and commitment has sparked considerable enthusiasm and creativity at Self Help Graphics. Duardo's successor José Alpuche continued Self Help Graphics fine print-making tradition. **A separate catalog is available for this series. See Appendix C for a complete guide.**

Oversize

Oversize materials (which include but are not limited to posters and flyers) that were too large to be included in legal sized archival boxes have been removed from their original series and placed in a flat box for preservation purposes. If an item has been removed from its original series and placed in oversize, a note indicating its location in oversize has been left in the original place of the item.

Container Listing for the Self Help Graphics & Art Archives

Series	Subseries	Sub-type	Box	Folder	Contents
Series I Internal Administrative Records, 1960–1992					
	Correspondence, Incoming, 1971–1984				
			1	1	About Productions-Aztlán Multiples
			1	2	Bakersfield College-Bustamante
			1	3	Cafe Cultural-(California, State of) Governors Office
			1	4	California State University, Dominguez Hills-Centro Cultural de la Raza
			1	5	Centro de Estudios Economicos y Sociales del Tercer Mundo A.C.-Cuadra
			1	6	Dallas, City of-Dorothy Chandler Pavilion
			1	7	East Long Beach Neighborhood Center, Inc.-The Exhibit Planners
			2	1	Family Health Center-Future Perfect
			2	2	Galería de la Raza-Guldeman
			2	3	Hakim-Hydro Engineering
			2	4	ICVC-Kramer
			2	5	Labate-Lorraine
			2	6	Los Angeles Area Chamber of Commerce (Los Angeles, City of) Los Angeles Street Scene Fest
			2	7	(Los Angeles, City of) Mayor's Office-Personnel Department
			2	8	Los Angeles City Schools-(Los Angeles, County of) Urban Affairs, Department of
			2	9	Los Angeles County Art Education Council-Los Angeles Weekly
			2	10	Los Dos Streetscapers-Lundgren
			3	1	Macías-The Music Center Mercado
			3	2	Nasrallah-Outram
			3	3	P & R Secretarial Service-Publishers Association of Southern California (PASCAL)
			3	4	Rafferty-Ryan
			3	5	Saint Josephs' School-System Development Corporation
			3	6	Taller Mexicano de Grabado-Trojan Security Services, Inc.
			3	7	Ukrainian Art Center-University of California, Irvine
			3	8	University of California, Los Angeles-University of Wollongong
			4	1	Vaca-Vracko Finishing
			4	2	Wachtell-Zucht
	Correspondence, Outgoing, 1960–1992				
			4	3	Inactive, 1960-1975
			4	4	Inactive, 1976
			4	5	Funding: Letters of Request, 1971-1976
			4	6	Campaign for Human Development(CHD), 1974
			4	7	Publicity Correspondence, 1974-1976
			4	8-9	1977
			4	10	1978
			5	1	1979
			5	2	1980-1982
			5	3	1983-1985
			5	4	1986-1988
			5	5	1989-1992
			5	6	n.d.
	Educational Programs, 1972–1992				
			5	7	Art Activity Workshop, 1977
			5	8	Artists in Schools and Communities, 1977
			5	9	Batik Classes, [1975]

Series	Subseries	Sub-type	Box	Folder	Contents
			5	10	Children's Exhibit-Rio Hondo College, Arrangements for Exhibition, 1983
			5	11	Children's Summer Arts Program, 1972-1974
			5	12	Contact Sheets, 1979-1980
			5	13	Etching Workshop, 1991
			5	14	Etching Workshop, 1992
			6	1	Evaluation Forms
			6	2	Exemplary Arts in Education Program-El Rancho School District, Pico Rivera, 1981-1982
			6	3	Exemplary Arts in Education Program-El Rancho School District, Pico River, 1982-1983
			6	4	Experimental Silkscreen Atelier Evaluation Form, 1985- 1986
			6	5	Life Drawing Workshop (Otis Art Institute of Parson's School of Design), Summer 1983
			6	6	Life Drawing Workshop, 1984-1985
			6	7	Los Angeles City College-Contracts and Information, 1977-1978
			6	8	Los Angeles City Schools Information (Bi-cultural Programs, Health Education and Welfare News-Los Angeles Unified School District), 1976-1977
			6	9	Maravilla Youth and Senior Citizen Organizational Project(MYSCOP) Food Co-op, 1980
			6	10	Monoprint Silkscreen Workshop, 1987-1988
			7	1	Multicultural Arts Program-Herb Workshop Packet, 1980
			7	2	Multicultural Arts Program-Workshop Packet, 1980-1981
			7	3	Multicultural Program Los Angeles School District Contacts, 1977-1979
			7	4	Multicultural School Contracts, Policies, Procedures, Responsibilities, Sample Forms, etc., 1979
			7	5	Multicultural School Contracts, 1980
			7	6	New Directions: Los Angeles City College, 1972-1974
			7	7	Packet for Presentation to Schools for Multicultural Program, 1978
			7	8	Printing Workshop, 1988-1990
			7	9	Resource Contact Sheets for Visiting Artists Program, 1984
			7	10	Self-Help Graphics & Art, Inc. Program Outlines, 1975
			7	11	Self-Help Graphics & Art, Inc. Workshops, 1973-1975
			7	12	Silkscreen/Watercolor Workshops, 1984-1985
			7	13	Tuesday Night Film Series-List of Film Titles, 1974
			7	14	Video Workshop, 1986-1990
	Exhibitions, 1980-1990				
			8	1	Arrangements for Exhibitions, 1984-1986
			8	2	Artists Donor Reports, n.d.
			8	3	Atelier Program, 1983-1986
			8	4	Chicano Art: Resistance & Affirmation (CARA) Exhibit at UCLA Wight Gallery, 1988
			8	5	Donation of Art Work to the Seminario de Estudios Chicanos, 1988
			8	6-7	Exhibition Print Program, 1990
			8	8	"Fusion" Exhibition, 1985
			8	9	Galeria Otra Vez Exhibitions, 1980-1981
			8	10	"Grafica Chicana" at Museo del Chopo, Mexico City, 1984
			8	11	International Exhibitions, 1987-1988
			8	12	Inventory List of Art Prints for Exhibits & Consignments, 1984-1985
			8	13	Letter from Seminario de Estudios Chicanos y Fronteras Requesting Donations of Art Work, 1990
			8	14	Loan Agreements, 1986-1987
			8	15	Prints on Consignment, 1984-1988
			9	1	Resource Contact Sheets, 1984-1986
			9	2	"Social Commentary-Selected Self-Help Graphic Prints," 1988
			9	3	"Taller de Seragrafia," IV International Festival de la Raza, Tijuana, Mexico, 1987
			9	4	"Taller de Seragrafia," Bills, 1987-1989
			9	5	Traveling Exhibitions, 1985-1986
			9	6	Miscellaneous, 1985-1986

Series	Subseries	Sub-type	Box	Folder	Contents
	General, 1973-1991				
			9	7	Articles of Incorporation, By-laws and Social Action Through Art Proposal, 1973
			9	8	Artists Union for Revolutionary Art(AURA) Minutes, 1975
			9	9	Atlantic Swimming Pool Mural, 1980-1981
			9	10	Bank of America Mural Contract, 1975
			9	11	California Arts Council-Bills, 1978
			9	12	California Coalition of Hispanic Organizations, 1978
			9	13	Caltrans Ceramic Tile Community Mural, 1979
			9	14	Centro Leadership, Training and Development Project Description, 1978
			9	15	Certificate of Appreciation, 1976
			9	16	"Cholo Film Treatment" by Moises Medina, 1976
			9	17	City Arts Program-Agreement, Invoices and Documentation Lists, 1979
			9	18	Community Arts Programs in Los Angeles-Draft, 1977-1978
			9	19	Concilio de Arte Popular, 1977-1978
			9	20	Donation Slips, 1976-1978
			9	21	Downtown Gallery Exhibits, 1983
			9	22	El Rancho Unified School District Directory, 1980-1981
			9	23	Estimates for Tile Mural, 1980
			10	1	Governor's Statewide Chicana Issues Conference, 1980
			10	2	Governor's Statewide Chicana Issues Conference- Invoices, 1980
			10	3	Guest Lectures-Speakers and Topics
			10	4	Los Angeles Task Force on the Arts, Preliminary Working Document, August 29, 1986
			10	5	Mailing List, 1984-1985
			10	6	Meeting of Chicano Artists on Bicentennial Committee, 1975
			10	7	Model Release Agreement, 1974
			10	8	National Association Pro-Spanish Speaking Elderly, 1976
			10	9	OJOS Mailing List, 1974-1975
			10	10	Our Lady of Guadalupe-Procession and Poster Contest, 1979-1984
			10	11	Photocopies of Stencils by Carlos Buenos, 1976-1977
			10	12	Photographic Study of La Cultura Del Barrio-Minutes of Meeting, 1974
			10	13	Press Releases, 1985-1990
			11	1	Prints Sold on the "Gil Plan," 1983-1987
			11	2	Report on The Task Force on Hispanic American Arts, 1979
			11	3	Schedule of Events, 1985-1986
			11	4	Self-Help Graphics Completed Hall Reservation Contracts, 1983-1986
			11	5	Self-Help Graphics & Art, Inc. Logos, 1974
			11	6	VEX Alternative Space for Musicians-Flyers and Concept Proposal, 1980
			11	7	Miscellaneous Items, 1976-1991
	Grant Proposals, Reports, & Applications, 1970-1989				
			11	8	Brody Arts Fund Application, 1988-1989
	California Arts Council(CAC)				
			11	9	Artistic and Administrative Development Grant, 1987-1989
			11	10	Artists in Residence Grant, Linda Vallejo, 1979
			11	11	Artists in Residence Grant, Margaret Garcia, 1987
			11	12	Artists in Residence Proposals, 1979-1980
			11	13	Artists in Schools and Community 1978-1979
			12	1	1979
			12	2-3	1980-1981
			12	4	Contract for Multicultural Technical Assistance Program, 1989
			12	5	Expanding Participation Funds Grant, 1980
			12	6	Grant Application and Correspondence, 1976-1977
			12	7	Miscellaneous Information, 1977

Series	Subseries	Sub-type	Box	Folder	Contents
			12	8	Multicultural Advancement Program Application, 1987-1989
			12	9	Multicultural Grant Application and Supporting Materials, 1987-1988
			12	10	Multicultural Grant Report, 1988-1989
	Organizational Grant				
			12	11-12	1977-1978
			13	1	1977-1978
			13	2-3	1978-1979
			13	4	1979-1980
			13	5	1982-1983
			13	6	1984-1985
			13	7	1986-1987
			13	8	Silkscreen Project, 1976-1977
			13	9	Technical Assistance Contract, Forms and Correspondence, 1978-1980
			13	10	California Community Foundation, Grant Application, 1987
	Campaign for Human Development (CHD)				
			13	11	Proposal, copies, 1975
			13	12	Proposal and Budget Sheet, 1976
			13	13	Proposal and California Arts Council(CAC) Grant Agreement, 1972-1977
			14	1	Proposal and Grant Application for Hispanic Filmmakers, 1975-1980
			14	2	Quarterly Reports/Applications for Funding, 1973- 1974
			14	3	CETA Title VI Grant (original), Affirmative Action Plan, Personnel Policies and Procedures, 1978
			14	4	CETA Title VI and Public Art as Education Proposals, 1978
			14	5	CETA Program-Yearly Summary Reports, 1980-1983
			14	6	City of Los Angeles Arts Support Grant Application, 1987
	City of Los Angeles Cultural Grant				
			14	7	1984-1985
			14	8	1985-1986
			14	9	1986-1987
			14	10	1987-1988
			14	11	Conrad Hilton Foundation, 1974
			14	12	Cultural News and Services Grant and CAC (original), 1977-1978
			14	13	Dutch Sisters Grant (original), 1978
			14	14	Ethnic Heritage Grant Application, Barrio Mobile Art Book and Xeroxed Pictures, 1980-1981
			15	1	Ethnic Heritage Studies Program, 1979
			15	2	Ethnic Heritage Studies Program-Concept Paper of Proposal, 1980-1981
			15	3	Funding Foundations, Information and Criteria, 1970-1977
			15	4	Funding Foundations, 1973-1975
			15	5	Foundation Replies, Incoming and Outgoing, 1972-1975
			15	6	Hollywood Turf Club Associated Charities, Inc., 1974
			15	7	Liberty Hill Foundation Proposal (original), 1979
			15	8	Los Angeles Clearing House, 197
			15	9	Los Angeles County Department of Community Development Funding, 1977-1978
			15	10	The *Los Angeles Times* Fund, 1975
	Mayor's Cultural Grant				
			15	11	Application and Inservice Training For Artists Materials, Barrio Mobile Art, 1976-1978
			15	12	1977
			16	1	1977-1978
			16	2-3	1978-1979
			16	4	1979-1980
			16	5	Mayors Grant and Correspondence, 1977-1980
			16	6	Metropolitan Life Foundation-Museum Grant for Minority Visual Arts, 1987

Series	Subseries	Sub-type	Box	Folder	Contents
			16	7	Mexican American Opportunity Foundation(MAOF) Proposal and Correspondence, 1977
			16	8	Mexico City Mural Project Support Material for Robert Delgado, 1987
			16	9	Mexico Mural Project Application and Letters of Rejection, 1988
			16	10	Municipal Arts Grant, City of Los Angeles, Office of the Mayor, 1977-78
			16	11	Municipal Arts Grant, City of Los Angeles, Office of the Mayor, 1979
			16	12	Municipal Arts Program Description and Budget, 1977- 1978
	National Endowment for the Arts (NEA)				
			16	13	Artist Spaces and Gallery Grant (Original), 1979- 1981
	Expansion Arts Grant				
			16	14	1985-86
			16	15	1986-87
			16	16	1987-88
			16	17	Individual Grant Application, 1980-1981
			17	1	Grant Application, 1982-1983
	"Ojos En Los/LA Through Our Eyes" (original)				
			17	2	1975
			17	3	1975-76
			17	4	Organization Grant Application, 1987-88
	Visual Arts Grant				
			17	5	1982-83
			v	6	1986-87
			17	7	1987-88
			17	8	1988-89
			17	9	National Endowment For The Humanities(NEH) Brochures and Guidelines, 1976-1977
			17	10	National/State/County Partnership Grant Application, 1985-86
			17	11	National/State/County Partnership Grant Application, 1987
			17	12	Poverello Fund, 1977
			17	13	Poverello Fund (original), 1978-1979
			17	14	Proposal Due Dates and Program Outline, 1974-1975
			17	15	Proposals-Pasadena Silkscreen Factory and Campaign for Human Development
			17	16	Revenue Sharing, 1972
			18	1	Revenue Sharing Request. Los Angeles County-Pasadena Community Service Commission Proposal Sample, 1973
			18	2	UNO/SCOC Olympic Legacy Proposal Application, 1985
			18	3	Miscellaneous Information, 1977-1979
	Newspaper, Magazine, and Miscellaneous Articles, 1971-1984				
			18	4	1971-1974
			18	5	1975-1977
			18	6	1978
			18	7	1979
			18	8	1980
			18	9	1983
			18	10	1984-n.d.
	Personnel, 1972-1990				
			18	11	Alma Family Services, 1984
			18	12	Applications and Resumes, 1977
			18	13	CETA-Past Workers, 1975-1983
			18	14	City Volunteer Corps, 1977
			19	1	Court Referral Community Service Program, 1975-1985
			19	2	Free-lance Application and Training Record, Richard Duardo, 1977
			19	3	Information on Artist Job Bank, 1976

Series	Subseries	Sub-type	Box	Folder	Contents
			19	4	In-Service Training, 1976-77
			19	5	Jessie Escobedo Work Study Contract, 1976
			19	6	Letter of Resignation: Gloria Amalia Flores, 1977
			19	7	Letters of Reference, 1984-1990
			19	8	Minutes, Board Meetings, 1977-1982
			19	9	Minutes, Staff Meetings, 1975
			19	10	Minutes, Staff Meetings, 1980
			19	11	The Music Commission, 1980-1981
			19	12	National Endowment for the Arts(NEA) Questionnaire for Contract Information, Miscellaneous Personnel Forms, 1978
			19	13	Pasadena City Art Center. CETA Workers, 1979-1981
			19	14-17	Resumes, Miscellaneous
			19	18	Resumes, Miscellaneous Photographs, 1972-1975
			19	19	Resumes of Humanists, 1977-1978
			19	20	Self-Help Graphics Studio and Personnel Policies, 1976
Series II **Barrio Mobile Art Studio, 1972-1988**					
	Correspondence, Incoming, 1974-1986				
			20	1	Benson-(Los Angeles, County) Board of Supervisors
			20	2	Los Angeles Philharmonic Association-United Teachers Los Angeles
	Letters of Support from Children				
			20	3	Assumption School
			20	4	Murchison St. School
			20	5	Misc. Schools
			20	6	Robert F. Kennedy School
	Correspondence, Outgoing				
			20	7	1975-1976
	General, 1975-1980				
			20	8	City of Los Angeles Bicentennial Award, July 4, 1976
			20	9	Guest Book, 1975-1976
			20	10	Mobile Art Project Concept Paper, n.d.
			21	1	Mobile Art Studio Aesthetic Workshop, n.d.
			21	2	Program Components: 6 months-5 day week, n.d.
			21	3	Program Components: 9 months-3 day week [1975]
	Program Records: Documentation, Curriculum Plans, Participants, Schedules, etc.				
			21	4-7	October 1975-August 1976
			22	1-4	March 1977-November 1977
			23	1-3	December 1977-December 1978
			23	4	April 1979-July 1980
			24	1	April 1979-July 1980
	Grant Proposals, Reports and Applications, 1974-1979				
			24	2	California Arts Commission Application (original), 1975-1976
			24	3	California Arts Council Proposal "Alternatives in Education Program" (original), 1976
			24	4	California Arts Council: Artists in Residence-- Linda Vallejo, 1978-1979
			24	5	Department of Community Development, Original Contract, 1977-1978
			24	6	General Revenue Sharing Program for Community Organizations, Budget and Program Description, 1975- 1976
			24	7	Mobile Arts Education and Training Proposal to City of Los Angeles, 1977-1978
			24	8	Program Description, Budget and School Visits Schedule, 1976
			24	9	Program Description for LA County Office of Urban Affairs, 1974

Series	Subseries	Sub-type	Box	Folder	Contents
			24	10	Program Proposal: Mayor's Office of Urban Development, 1976
			24	11	Revised Proposal, Original Submitted Through GLCAA, (original), 1975
			24	12	Revised Proposal, Original Submitted Through GLCAA, 1975 (copies)
	Newspaper and Magazine Articles, 1976-1978				
			25	1	1976
			25	2	1977-1978
			25	3	n.d.
	Personnel, 1972-1988				
			25	4	Blank Forms: Applications, Checklists, Evaluations and Studio Policies
			25	5	Carlos Bueno, 1972
			25	6	Employment Application, 1980
			25	7	Minutes of Meetings, 1975-1976
			25	8	Minutes of Meetings and Miscellaneous Documents, 1977-1988
			25	9	Miscellaneous Forms, Schedules, Staff Directory, etc.
			25	10	Orientation Materials and Program Description, 1975-1976
			25	11	Procedures, 1975-1976
	Photographs, Negatives, and Slides, 1973-1982:				
		Visual Tools			
			26		1974- n.d. [Oversize]
			27		n.d.
		Workshop Documentation			
			28	1	1973
			28	2-4	1975
			28	5-14	1976
			28	15	1977
			29	1	1977
			29	2-5	1978
			29	6	1980
			29	7	1982
			29	8-13	n.d.
			30	1-12	n.d.
			31	1-5	n.d.
	Color Photocopies, Flyers and Invitations, 1977-1978				
		Color Photocopies			
			31	6	1978
			31	7-11	n.d.
		Flyers and Invitations			
			31	12	1977-1978
Series III El Día De Los Muertos (Day of the Dead), 1960-1991					
	Correspondence, Incoming, 1974-1987				
			32	1	(Los Angeles, City) Mayor-Urbina
	Correspondence, Outgoing				
			32	2	1974-1991
	General, 1971-1991				
			32	3	Día de los Muertos Confirmation of Participation and Statements of Interpretation, 1991

Series	Subseries	Sub-type	Box	Folder	Contents
			32	4	Día de los Muertos Exhibition and Celebration, 1991
			32	5	Día de los Muertos Parade Application, 1978
			32	6	Día de los Muertos Youth Project, 1978
			32	7	Día de los Muertos Youth Project, Humanist's Evaluations, 1978
			32	8	Employment Regulations & Job Description for Program, n.d.
			32	9	Miscellaneous Information on Day of the Dead, 1971
			32	10	Printing Receipts, 1976
			32	11	Research by Participants in NEH Grant for Day of the Dead
	Grant Proposals, Reports & Applications, 1976-1986				
			32	12	City of Los Angeles Cultural Grant Application, 1979- 1980
			32	13	City of Los Angeles Folk Art Grant Application, Contract, Invoice and Final Report, 1985-1986
			32	14	National Endowment for the Arts (NEA)-Grant Application, 1976
	NEA Día de los Muertos				
			32	15-16	Report-Original and Copy, 1976
			33	1	Report, 1977
			33	2	Grant-Original, 1978
			33	3	Report, 1978
			33	4	Proposal-First Draft, 1979
			33	5	Proposal, 1979
			33	6	Report, 1979
			33	7	Grant-Copy, 1980
			33	8	Report, 1980
			33	9	NEA Expansion Arts Program Grant Application, 1981
			33	10	NEA Final Descriptive Report of Día de los Muertos, 1981
			33	11	NEA Expansion Arts Program Grant Application, 1982- 1983
			34	1	National Endowment for the Humanities (NEH), Día de los Muertos Youth Project-Original Grant Application, 1978
	NEH El Día de los Muertos Youth Project				
			34	2	Application Copy, 1978
			34	3	Proposal, 1978
			34	4	Proposal with Revisions, 1978
			34	5	Original Report, 1978
			34	6	Grant-Original, 1978-1979
			34	7	Proposed Concept Paper, 1979
			34	8	Report, 1979
	Magazine, Newspaper, Journal and Miscellaneous Articles,1968-1991				
			34	9	1968-1969
			34	10	1975-1976
			34	11	1977
			35	1	1978-1979
			35	2	1980-1981
			35	3	1982-1983
			35	4	1984-1987
			35	5	1988-1991
			35	6-7	n.d.
	Photographs, Negatives and Slides, 1960-1985				
			35	8	1960-1977
			35	9	1974
			35	10	1974-1978
			35	11	1976-1980
			35	12	1977
			35	13	1978
			36	1	1978
			36	2	1979-1980
			36	3	1985
			36	4-11	n.d.

Series	Subseries	Sub-type	Box	Folder	Contents
	Color Photocopies, Flyers, Invitations and Posters, 1975-1986				
		Color Photocopies			
			37	1	n.d.
		Invitations, Flyers and Posters			
			37	2	1975-1978
			37	3	1979-1986
			37	4	n.d.
			37	5	Pink Paper cutout/Papel Picado, Olvera Street, Los Angeles and poster
		Note Cards			
			37	6-7	n.d.
Series IV Magazine, Newspaper, Journal and Miscellaneous Articles, 1963-1991					
			38	1	1963-1964
			38	2	1970-1971
			38	3	1974
			38	4	1975
			38	5	1976
			38	6	1977
			38	7	1977-1978
			38	8	1978
			39	1	1978
			39	2	1979
			39	3-6	1980
			39	7	1981
			40	1	1981
			40	2-3	1982
			40	4-5	1983
			40	6-7	1984
			41	1-2	1985
			41	3-4	1986
			41	5-6	1987
			42	1-6	1988
			42	7-8	1989
			43	1-2	1989
			43	3-6	1990
			43	7	1991
			44	1	1991
			44	2-8	n.d.
			45	1-5	n.d.
Series V Photographs, Negatives and Slides, 1920-1986					
	Photographs				
			46	1	1920-1945
			46	2	1951-1972
			46	3	1973
			46	4	1978
			46	5	1979-1986
			46	6-11	n.d.
			47	1-14	n.d.
			48	1-14	n.d.
			49	1-4	n.d.
	Negatives				
			49	5	1973
			49	6	1975
			49	7	1976-1977
			49	8-15	n.d.

Series	Subseries	Sub-type	Box	Folder	Contents
	Slides				
	A separate guide to the SHG slides is available. See Appendix A.				
Series VI **Color Photocopies, Flyers, Invitations and Posters, 1973-1992**					
	Color Photocopies				
			50	1	1974-1979
			50	2-3	n.d.
	Flyers, Invitations and Posters				
			50	4	1973-1974
			50	5	1975-1976
			50	6	1977
			50	7	1978
			50	8	1979-1980
			50	9	1981-1982
			50	10	1983
			50	11	1984
			50	12	1985
			51	1-2	1986
			51	3-8	1987
			51	9-12	1988
			52	1-2	1988
			52	3-4	1989
			52	5-6	1990
			53	1-2	1990
			53	3	1991-1992
			53	4-7	n.d.
			54	1-4	n.d.
Series VII **Note Cards, N.D.**					
			55	1-5	n.d.
			56	1-6	n.d.
Series VIII **Graphic Arts and Poster Collection**					
	A separate guide to the SHG silkscreen prints is available. See Appendix B.				
	Oversize, Originally From...				
			57	1	Box 12 Folder 11
			57	2	Box 25 Folder 5
			57	3-4	Box 31 Folder 12
			57	5-6	Box 34 Folder 10
			57	7	Box 36 Folder 11
			57	8	Box 37 Folder 3
			57	9-12	Box 37 Folder 4
			57	13	Box 38 Folder 3
			57	14	Box 38 Folder 6
			57	16	Box 39 Folder 5
			57	17-18	Box 40 Folder 1
			57	19	Box 40 Folder 2
			57	20	Box 40 Folder 4
			57	21	Box 41 Folder 5
			57	22	Box 45 Folder 5
			57	23-24	Box 50 Folder 4
			57	25-27	Box 50 Folder 5
			57	28	Box 50 Folder 6
			57	29-31	Box 50 Folder 7
			57	32	Box 50 Folder 11
			57	33-35	Box 52 Folder 3
			57	36	Box 52 Folder 4
			57	37-39	Box 52 Folder 6
			57	40	Box 53 Folder 3
			57	41-44	Box 53 Folder 4
			57	45-46	Box 53 Folder 6

Codes:

Self-Help Graphics and Art, Inc. = SHG

Number of slides = #Slides

Number of prints = #Prints

Edition Number = Ed#

Identification Number in Catalog = Cat.

Center Activities and Programs = CAP

National Endowment for the Arts = NEA

Cross-reference with = Cross:

National Endowment for the Humanities = NEH

Image size = I-size

Print size = P-size

Appendix A: Slides 1972-1992

In catalog number order.

Assemblage

Artist Unknown; *(title unknown)*; November 1975; altar, ofrenda; Fund: NEA and SHG; #Slides: 6. Cat. 1 001(1-6).

Artist Unknown; *(title unknown)*; November 7, 1976; altar, ofrenda; Fund: SHG; #Slides: 3. Note: Altars and ofrendas for *Day of the Dead* celebration and exhibition at SHG. Cross: Installation Art and Indigenous Chicano Mediums and Art Forms. Cat. 1 002(1-13).

Artist Unknown; *(title unknown)*; November 7, 1976; altar, ofrenda; Fund: NEA and SHG; #Slides: 15. Note: Details of altars from *Day of the Dead-Altar* Exhibition at SHG. Cross: CAP and Indigenous Chicano Mediums and Art Forms. Cat. 1 003(1-15).

Artist Unknown; *(title unknown)*; November 6, 1977; altar, ofrenda; Fund: SHG and NEA; #Slides: 10. Note: Cross: Installation Art, CAP and Indigenous Chicano Mediums and Art Forms. Cat. 1 004(1-10).

Artist Unknown; *(title unknown)*; November 6, 1977; altar, ofrenda; #Slides: 11. Note: From *Day of the Dead-Altar* Exhibition at SHG. Cross: CAP and Indigenous Chicano Mediums and Art Forms. Cat. 1 005(1-11).

Artist Unknown; *(title unknown)*; November 6, 1978; altar, ofrenda; #Slides: 35. Note: From *Day of the Dead* Exhibition at SHG, organized by Michael M. Amescua and Linda Vallejo. Cross: CAP and Indigenous Chicano Mediums and Art Forms. Cat. 1 006(1-35).

Artist Unknown; *(title unknown)*; 1989; altar, ofrenda: Note: From *Day of the Dead '89* Exhibition at SHG. Cross: CAP and Indigenous Chicano Mediums and Art Forms. Cat. 1 007.

Artist Unknown; *Untitled;* November 7, 1982; altar, ofrenda; Fund: SHG and NEA; #Slides: 12. Note: Cross: Installation Art and Indigenous Chicano Mediums and Art Forms. Cat. 1 008(1-12).

Amescua, Michael M. Cecilia Castañeda Christopher Yáñez Cindy Honesto Sarah Pineda Linda Vallejo Karen Boccalero and Mari Yáñez; assistants: CSO Youth Program; *(title unknown)*; November 5, 1978; altar, ofrenda; Fund: SHG and NEA; #Slides: 20. Note: Cross: Indigenous Chicano Mediums and Art Forms. Cat. 1 009(1-20).

Cervantez, Yreina; *Untitled;* n.d. altar, ofrenda; #Slides: 16. Note: Cross: Indigenous Chicano mediums and Art Forms. Cat. 1 010(1-16).

Gomez, Pat; *Outside;* n.d.: Cat. 1 011.

Gomez, Pat; *Ritual Hand;* n.d.: Cat. 1 012.

Gomez, Pat; *Tabloid Figure;* n.d.: Cat. 1 013.

Los Cipotes; *Los Cipotes;* July 1987; mixed media; Fund: NEA Expansion Arts, SHG; #Slides: 1. Note: Cross: CAP and Installation Art and Indigenous Chicano Mediums and Art Forms. Cat. 1 014.

Urista, Arturo; *María Ester Urista 1942-1989;* 1989; mixed media: Note: From *Day of the Dead '89* Exhibition at SHG. Cross: CAP and Indigenous Chicano Mediums and Art Forms. Cat. 1 015.

Vallejo, Linda; *Day of the Dead Fan;* 1989; mixed media: Note: From *Day of the Dead '89* Exhibition. Cross: CAP and Indigenous Chicano Mediums and Art Forms. Cat. 1 016.

Yáñez, Larry; *(title unknown)*; n.d. altar, ofrenda: Note: Cross: Indigenous Chicano Mediums and Art Forms. Cat. 1 017.

Atelier

Aguirre, José Antonio; *Calaca Alucinada en L.A.* January 26-30, 1987; silkscreen; Fund: CAC, SHG, NEA Visual Arts; slide photographer: Adam Avila; #Slides: 1. Cat. 2 001.

Aguirre, José Antonio; *Firedream;* March 7-11, 1988; silkscreen; Fund: SHG, CAC, NEA Visual Arts; slide photographer: Color House; #Slides: 1. Note: "My work is closely related to personal experience. This visual poem tells the story of a relationship that was so intense that it was extinguished by the fire of passion. This love is being reborn through a new fire of life but it has to face a deconstruction of its past and in a cathartical experience overcome the present to be able to grow into the future." J.A. Aguirre. Cat. 2 002.

Aguirre, José Antonio; *It's Like the Song, Just Another Op'nin' Another Show..* January 8-12, 1990; silkscreen; Fund: SHG, CAC, NEA Visual Arts; slide photographer: Color House; #Slides: 1. Note: "This print is intended to be a tribute to the memory of Carlos Almaraz and to those that have also died from AIDS. The image of the cross coming from the head/photograph of Almaraz is combined/appropriated with a few symbols from Carlos' own iconography, developed with my own treatment and color perception." J.A. Aguirre. Cat. 2 003.

Alferov, Alex; *Icon;* February 15-20, 1987; silkscreen; Fund: CAC, SHG, NEA Visual Arts; slide photographer: Adam Avila; #Slides: 1. Cat. 2 004.

Alferov, Alex; *Koshka;* January 24-29, 1988; silkscreen; Fund: SHG, CAC, NEA Visual Arts; slide photographer: Color House; #Slides: 1. Note: "I live in Hollywood, in a part of the city that used to be residential but is now in a state of change. There are a lot of stray cats in this neighborhood. The cats are forced to survive on their own. The cities are in the same state of plight. I have used the stray cat as a symbol of what happens to a city in decline and to its inhabitants--an electric neon existence of surviving at any cost--casting an uncertain shadow to its future." A. Alferov. Cat. 2 005.

Alferov, Alex; *Oriental Blond;* October 3-7, 1988; silkscreen; Fund: NEA Visual Arts, SHG, CAC; slide photographer: Color House; #Slides: 1. Note: *Oriental Blond* is a portrait that speaks of the two diverse background cultures from which Mr. Alferov has come. The bright blond side of the face is the white cultural roots while the blue side represents his oriental ancestry. The body of Mr. Alferov's work speaks about the conflicts and resolutions of meeting middle ground through cultural and emotional diversity. Cat. 2 006.

Alicia, Juana; *Sobreviviente;* January 29-February 2, 1990; silkscreen; Fund: NEA Visual Arts, SHG, CAC; slide photographer: Color House; #Slides: 1. Note: "Originally done as a book illustration on the theme of 'Tales of survival and disappearance in Argentina', then as a pastel painting, a lithograph and now as a silkscreen, the image has evolved to mean an expression of the tenacity and spiritual inner light of all women who persevere in oppressive situations, be they imprisoned in concentration camps, jails or their own homes." J. Alicia. Cat. 2 007.

Amemiya-Kirkman, Grace; *Where's My Genie in the Bottle;* October 23, 1989; silkscreen; Fund: SHG, CAC, NEA Visual Arts; slide photographer: Color House; #Slides: 1. Note: Content of print: Depression, the escape--the glamour, addiction, the high--the hysteria--emptiness. Cat. 2 008.

Amescua, Michael M. *Mara 'akame;* January 10-15, 1988; silkscreen; Fund: NEA Visual Arts, SHG, CAC; slide photographer: Color House; #Slides: 1. Note: "Other shamans dream that someone wants to throw a cloud which will destroy all of the people. All of us will end from this cloud. Others say they dream that a giant animal will fall and, where it falls, everything will burn in a great fire. The only way to stop this is to renew the candles so the gods are contented. The shamans know how; they did this once a very

long time ago. Maybe they will do it again, maybe not. They will dream what they have to do." Ulu Temayk, *Mara'akame* (Huichol Shaman). Cat. 2 009.

Amescua, Michael M. *Toci;* January 14-19, 1989; silkscreen; Fund: SHG, CAC, NEA Visual Arts; slide photographer: Color House; #Slides: 1. Note: "'Toci' mother of the gods and heart of the earth. The divine grandmother. Mother Earth. She says, 'Look at me, I am beautiful, do not destroy me'." M. Amescua. Cat. 2 010.

Amescua, Michael M. *Xolotl;* January 2-6, 1990; silkscreen; Fund: SHG, CAC, NEA Visual Arts; slide photographer: Color House; #Slides: 1. Note: "Xolotl guides the sun thru the underworld. Here he is asking, 'Who will speak for the animals, will they all drown in mankind's pollution or will you speak and act now, today, this minute to pick up your own garbage?'" M. Amescua. Cat. 2 011.

Anton, Don; *The Single Word;* March 1983; silkscreen; Fund: NEA, CAC, SHG; slide photographer: Adam Avila; #Slides: 1. Cat. 2 012.

Avila, Glenna; *Plumas Para Paloma;* March 20-24, 1989; silkscreen; Fund: CAC, SHG, NEA Visual Arts; slide photographer: Color House; #Slides: 1. Note: "A personal piece celebrating the birth of my first child, Sara Paloma, depicted at 4 months. The 2 weavings are used to symbolize two cultures from her background-- Mexican and Indian--and also the textures and interweavings of one's life. The photographs symbolize her connections to her past (she is named for her great-grandmother Sarah) The feathers on the rug symbolize feathers of the dove which in Native American cultures stand for good deeds and power in one's life. This print represents gifts she has received from her past." G. Avila. Cat. 2 013.

Avila, Glenna; *Untitled;* March 3-6, 1986; silkscreen; Fund: CAC, SHG, NEA Visual Arts; slide photographer: Adam Avila; #Slides: 1. Cat. 2 014.

Baray, Samuel; *Advenimiento de Primavera;* February 5-9, 1990; silkscreen; Fund: CAC, NEA Visual Arts, SHG; slide photographer: Color House; #Slides: 1. Note: "*Advenimiento de Primavera--* the arrival of spring. Ancient and contemporary Angels of Los Angeles. There are very few angels that sing." S. Baray. Cat. 2 015.

Baray, Samuel; *Santuario;* March 9-13, 1987; silkscreen; Fund: CAC, SHG, NEA Visual Arts; slide photographer: Adam Avila; #Slides: 1. Cat. 2 016.

Bautista, Vincent; *Calaveras in Black Tie;* October 30-November 3, 1989; silkscreen; Fund: SHG, CAC, NEA Visual Arts; slide photographer: Color House; #Slides: 1. Note: Three calaveras attending a *Día de los Muertos* art opening, a party and celebration. Cat. 2 017.

Bert, Guillermo; *..And His Image Was Multiplied;* January 22-26, 1990; silkscreen; Fund: CAC, SHG, NEA Visual Arts; slide photographer: Color House; #Slides: 1. Note: "Refer[s] to the alienation of people who live in a super metropolis experience. Human beings are separated from direct contact with nature. The person becomes a mere reflection of self. These entities are defined by the image of them within the little box of a television set." G. Bert. Cat. 2 018.

Bert, Guillermo; *Dilemma in Color;* November 16-21, 1987; silkscreen; Fund: NEA Visual Arts, SHG, CAC; slide photographer: Adam Avila; #Slides: 1. Note: "The ambivalence of thoughts amid the strong influence of television and the hidden energy that makes it possible. The conflict is intensified by the aggressive, brilliant colors." G. Bert. Cat. 2 019. Atelier (Self-help Graphics and Art, Inc.)

Boccalero, Karen; *Without;* March 1983; silkscreen; Fund: NEA, CAC, SHG; slide photographer: Adam Avila; #Slides: 1. Cat. 2 020.

Botello, David; *Long Life to the Creative Force;* February 13-19, 1989; silkscreen; Fund: SHG, CAC, NEA Visual Arts; slide photographer: Color House; #Slides: 1. Note: "The elder represents long life in a peaceful setting. The plumed serpent is 'Quetzalcoatl' representing the 'creative force' but also 'chaos' which surrounds the elder and wants the heart as the final sacrifice of life. The braids on the heart are her/his life's story; the nopales cactus are new life still growing. The cat is the jaguar, 'Tezcatlipoca', death lingering over your left shoulder, waiting for the person giving up on life. Message: We must remain in balance, rest and soothe our hearts, not succumb to desires, etc., around us." D. Botello. Cat. 2 021.

Botello, Paul; *Reconstruction;* November 27-December 1, 1989; silkscreen; Fund: SHG, CAC, NEA Visual Arts; slide photographer: Color House; #Slides: 1. Note: "This piece is about the reconstruction of man with the help of a woman. Time swings back and forth, half man, half skeleton. The pregnant woman lying down shackled is a reference to the responsibility of motherhood." P. Botello. Cat. 2 022.

Brehm, Qathryn; *Untitled;* February 16-20, 1986; silkscreen; Fund: NEA Visual Arts, SHG, CAC; slide photographer: Adam Avila; #Slides: 1. Cat. 2 023.

Calderón, Rudy; *Manifestation of Trinity;* December 7-11, 1987; silkscreen; Fund: CAC, SHG, NEA Visual Arts; slide photographer: Adam Avila; #Slides: 1. Note: "*Manifestation of Trinity* is an attempt to portray analogies between the ancient and the universal concept of Trinity and recognizable manifestations in life that are triple in nature, the three primary colors from which all other colors emerge, and the family unit of father, mother and child from which all nations take form. Spirit endows matter with dynamic conscious life." R. CalderÙn. Cat. 2 024.

Cárdenas, Mari; *In Our Remembrance Is Our Resurrection;* December 10-11, 1983; silkscreen; Fund: ARCO, SHG; slide photographer: Adam Avila; #Slides: 1. Cat. 2 025.

Cárdenas, Mari; *Untitled;* ca. Fall 1983; silkscreen; Fund: SHG, ARCO; slide photographer: Adam Avila; #Slides: 1. Cat. 2 026.

Carrasco, Barbara; *Negativity Attracts;* March 26-30, 1990; silkscreen; Fund: CAC, SHG, NEA Visual Arts; slide photographer: Color House; #Slides: 1. Note: "The print is the result of minimalizing detail work in order to focus more clearly on color and content (form). *Negativity Attracts* reflects male-female relationships often seen as conflicting yet attracting because of, or in spite of, differences." B. Carrasco. Cat. 2 027.

Carrasco, Barbara; *Self-Portrait;* ca. 1984; silkscreen; #Slides: 2. Cat. 2 028(1-2).

Carrasco, Barbara; *Self-Portrait;* February 24-March 1, 1984; silkscreen; Fund: NEA Visual Arts, SHG, CAC; slide photographer: Adam Avila; #Slides: 1. Cat. 2 029.

Cervantez, Yreina; *Camino Largo;* February 6-March 27, 1985; silkscreen; Fund: CAC, SHG, NEA Visual Arts; slide photographer: Adam Avila; #Slides: 2. Note: Cross: Installation Art and Indigenous Chicano Mediums and Art Forms. Cat. 2 030(1-2).

Cervantez, Yreina; *Danze Ocelot;* ca. Fall 1983; silkscreen; Fund: NEA, CAC, SHG; slide photographer: Adam Avila; #Slides: 1. Cat. 2 033.

Cervantez, Yreina; *El Pueblo Chicano con el Pueblo Centroamericano;* March 1986; silkscreen; Fund: NEA Visual Arts, SHG, CAC; slide photographer: Adam Avila; #Slides: 1. Cat. 2 031.

Cervantez, Yreina; *La Noche y los Amantes;* February 1987; silkscreen; Fund: SHG, CAC, NEA Visual Arts; slide photographer: Adam Avila; #Slides: 1. Cat. 2 032.

Cervantez, Yreina; *Victoria Ocelotl;* December 4-10, 1983; silkscreen; Fund: SHG, ARCO; slide photographer: Adam Avila; #Slides: 1. Cat. 2 034.

Chamberlin, Ann; *Stadium;* February 21-26, 1988; silkscreen; Fund: CAC, SHG, NEA Visual Arts; slide photographer: Color House; #Slides: 1. Note: Soldiers playing and posing in a menacing manner. Cat. 2 035.

Coronado, Sam; *Pan Dulce;* November 7-11, 1988; silkscreen; Fund: SHG, CAC, NEA Visual Arts; slide photographer: Color House; #Slides: 1. Note: Based on distorted perspective creating abstract-like forms and accented by lines to frame the objects. Shadows are also incorporated into the design with use of shape and color. The subjects are familiar ones to most Mexican-Americans; they evoke an ethnic feeling unique to the culture which has introduced this type of pastry, "Molletes", to our society. "The subjects I paint are a reflection of the bi-cultural work that surrounds me. These subjects express the rebirth of ideas and feelings which are emerging in today's society." S. Coronado. Cat. 2 036.

Costa, Sam; *Media Madness;* March 1983; silkscreen; Fund: NEA, CAC, SHG; slide photographer: Adam Avila; #Slides: 1. Cat. 2 037.

Davis, Alonso; *Act on It;* March 5-14, 1985; silkscreen; Fund: NEA Visual Arts, SHG, CAC; slide photographer: Adam Avila; #Slides: 1. Note: The *Vote Series* is a group of paintings and prints that emphasize the vote. The artist reacted to apathy on the part of many of our citizens. He was born in the south when the right to vote was denied his family because of their race. "Many people.. particularly in the south have made great sacrifices to assure the right to vote for all people, and the *Vote Series* is intended to be

a nonpartisan motivator and consciousness raiser for all citizens." A. Davis . Cat. 2 038.

Davis, Alonso; *King Melon;* January 19-23, 1987; silkscreen; Fund: NEA Visual Arts, SHG, CAC; slide photographer: Adam Avila; #Slides: 1. Cat. 2 039.

Davis, Alonso; *Now Is the Time;* March 15-19, 1988; silkscreen; Fund: CAC, SHG, NEA Visual Arts; slide photographer: Color House; #Slides: 1. Note: "The print emphasizes the power and impact of the right to vote. This print is to raise the consciousness of the Jesse Jackson Presidential Campaign." A. Davis. Cat. 2 040.

De Batuc, Alfredo; *Comet Over City Hall;* December 9-12, 1985; silkscreen; Fund: NEA Visual Arts, CAC, SHG; slide photographer: Adam Avila; #Slides: 1. Cat. 2 041.

De Batuc, Alfredo; *Seven Views of City Hall;* January 13-16, 1987; silkscreen; Fund: NEA Visual Arts, CAC, SHG; slide photographer: Adam Avila; #Slides: 1. Cat. 2 042.

Delgado, Roberto; *Guatemala;* November 21-25, 1988; silkscreen; Fund: SHG, CAC, NEA Visual Arts; slide photographer: Color House; #Slides: 1. Note: "Pregnant female figure in anxious position with umbilical attachment to ground--fertility of people; of the earth. Soldier as a set piece in the game of exploitation between countries. The clown figure from pack of 'Payaso' cigarettes common to Guatemala. Three headed dog whose symbolism probably has some deep mythological story that has to do with Hades, the river Styx, Dante Alleghieri, and so on, but it's just an image from the Mexican state of Guerrero that looked cool." R. Delgado . Cat. 2 043.

Delgado, Roberto; *Loto;* December 19-20, 1985; silkscreen; Fund: NEA Visual Arts, SHG, CAC; slide photographer: Adam Avila; #Slides: 1. Cat. 2 044.

Delgado, Roberto; *Untitled;* March 5-14, 1984; silkscreen; Fund: CAC, SHG, NEA Visual Arts; slide photographer: Adam Avila; #Slides: 2. Note: Slide # 2, artist with print. Cat. 2 045(1-2).

Donis, Alex; *Champ de Bataille;* October 13-19, 1989; silkscreen; Fund: NEA Visual Arts, SHG, CAC; slide photographer: Color House; #Slides: 1. Note: "It was a dream, it was all a dream." A. Donis. Cat. 2 046.

Donis, Alex; *Río, por no llorar;* November 28-December 2, 1988; silkscreen; Fund: SHG, CAC, NEA Visual Arts; slide photographer: Color House; #Slides: 1. Note: "Basically my print is a statement about oppression. It's about people who struggle to survive while their lands are stripped away and their resources siphoned. I recently read the lyrics to a song which I think most clearly defines my piece: '..So take a good look at my face, you'll see my smile looks out of place, look even closer, it's easy to trace the track of my tears'." A. Donis. Cat. 2 047.

Duardo, Richard; *The Father, the Son and the Holy Ghost;* February 29-March 6, 1988; silkscreen; Fund: CAC, SHG, NEA Visual Arts; slide photographer: Color House; #Slides: 1. Note: "Well, it was quite a spontaneous activity indeed. The content of this image is totally appropriated from the commonplace of contemporary culture. Their layout is to indicate the following: Mickey, omnipotent god (benevolent and happy); the robot, man on earth, a replicant of god--Symbols: O.K, meaning everything is swell on earth." R. Duardo. Cat. 2 048.

Duardo, Richard; *Untitled;* January 27-February 2, 1984; silkscreen; Fund: NEA Visual Arts, CAC, SHG; slide photographer: Adam Avila; #Slides: 2. Note: Fourteen color image of Boy George . Cat. 2 049(1-2).

Duardo, Richard; *Untitled;* January 25-February, 1985; silkscreen; Fund: CAC, SHG, NEA Visual Arts; slide photographer: Adam Avila; #Slides: 1. Note: Female torso, on abstract field including Japanese characters, *Made in U.S.A.* Cat. 2 050.

Flores, Florencio; *Jaguar;* March 1983; silkscreen; Fund: NEA, CAC, SHG; slide photographer: Adam Avila; #Slides: 1. Cat. 2 051.

Gamboa, Diane; *Little Gold Man;* February 12-16,1990; silkscreen; Fund: NEA Visual Arts, CAC, SHG; slide photographer: Color House; #Slides: 1. Note: "I continued to build texture and detail. The Little Gold Man himself is the focal point of the other figures in the piece, but at the same time is one of the many figures involved in this print, as in other prints I have created through the Atelier program. I attempted to work on an image using a new technique that is very different from my other prints." D. Gamboa. Cat. 2 052.

Gamboa, Diane; *She's My Puppet;* October 21-23, 1983; silkscreen; Fund: CAC, NEA Visual Arts, SHG; slide photographer: Adam Avila; #Slides: 1. Cat. 2 053.

Gamboa, Diane; *Three;* March 17-20, 1986; silkscreen; Fund: CAC, SHG, NEA Visual Arts; slide photographer: Adam Avila; #Slides: 1. Cat. 2 054.

Gamboa, Diane; *Untitled;* January 9-18, 1984; silkscreen; Fund: NEA Visual Arts, CAC, SHG; slide photographer: Adam Avila; #Slides: 1. Cat. 2 055.

Gamboa, Diane; *Untitled;* October 6-9, 1986; silkscreen; Fund: SHG, CAC, NEA Visual Arts; slide photographer: Adam Avila; #Slides: 5. Cat. 2 056(1-5).

García, Lorraine; *Untitled;* November 6-11, 1984; silkscreen; Fund: NEA Visual Arts, CAC, SHG; slide photographer: Adam Avila; #Slides: 1. Cat. 2 057.

García, Margaret; *Anna Comiendo Salsa;* December 1-5, 1986; silkscreen; Fund: SHG, CAC, NEA Visual Arts; slide photographer: Adam Avila; #Slides: 1. Cat. 2 058.

García, Margaret; *Romance;* January 4-8, 1988; silkscreen; Fund: CAC, SHG, NEA Visual Arts; slide photographer: Color House; #Slides: 1. Note: "The print is symbolic of the sexual tensions in the first stages of 'Romance'. The fork foams on the appetite of those involved. Chili, sex, something that feels so good can burn so bad." M. García. Cat. 2 059.

García, Margaret; *Untitled;* February 24-27, 1986; silkscreen; Fund: SHG, NEA Visual Arts, CAC; slide photographer: Adam Avila; #Slides: 1. Cat. 2 060.

García, Margaret; *Untitled;* February 24-27, 1986; silkscreen; Fund: CAC, NEA Visual Arts, SHG; slide photographer: Adam Avila; #Slides: 1. Cat. 2 061.

Gil de Montes, Robert; *Movie House;* February 8-12, 1988; silkscreen; Fund: NEA Visual Arts, SHG, CAC; slide photographer: Color House; #Slides: 1. Cat. 2 062.

Gonzalez, Yolanda; *El Vaquero;* December 11-15, 1989; silkscreen; Fund: CAC, SHG, NEA Visual Arts; slide photographer: Color House; #Slides: 1. Note: "Designed for Plaza de la Raza Cultural Center. The legend of the cowboy, my concept is, 'life is to be lived' and El Vaquero is certainly living life. His motion is free; with the air blowing through his scarf and hair, he has no worries. Life should be as free and fun loving as El Vaquero." Y. Gonzalez. Cat. 2 063.

Gonzalves, Ricardo; *Don Juan's Got the Blues;* December 5-9, 1988; silkscreen; Fund: CAC, SHG, NEA Visual Arts; slide photographer: Color House; #Slides: 1. Note: "The image of the coyote is a representation of the brujo Don Juan as he is transformed into animal form. This work is an expression of an indigenous epistemological view that considers an alternative reality. Don Juan is presented here as an animal warrior on a mission to preserve and advance Chicano culture. ¿Y qué?" R. Gonzalves. Cat. 2 064.

Grace, Gerry; *Ancient Dreamers;* November 10-14, 1986; silkscreen; Fund: CAC, SHG, NEA Visual Arts; slide photographer: Adam Avila; #Slides: 1. Cat. 2 065.

Guerrero-Cruz, Dolores; *El Perro y la Mujer;* February 15-19, 1988; silkscreen; Fund: SHG, CAC, NEA Visual Arts; slide photographer: Color House; #Slides: 1. Cat. 2 067.

Guerrero-Cruz, Dolores; *La Mujer y el Perro;* February 15-19, 1988; silkscreen; Fund: SHG, CAC, NEA Visual Arts; slide photographer: Color House; #Slides: 1. Note: "The dog or perro symbolizes men or man. It's a concept of men chasing women. This woman does not want to be chased and therefore hides in her room, holding her body in despair." D. Guerrero-Cruz. Cat. 2 068.

Guerrero-Cruz, Dolores; *Mujeres y Perros;* March 2-6, 1987; silkscreen; Fund: NEA Visual Arts, CAC, SHG; slide photographer: Adam Avila; #Slides: 1. Cat. 2 069.

Guerrero-Cruz, Dolores; *Peacemakers;* November 4-7, 1985; silkscreen; Fund: NEA Visual Arts, SHG, CAC; slide photographer: Adam Avila; #Slides: 1. Note: This print depicts the irony of three Chicano children growing up in an Anglo society with images of the society, therefore losing their heritage. It also speaks to the idea that children can be taught to save the world from nuclear war with their peacemaking friends. Cat. 2 070.

Guerrero-Cruz, Dolores; *Perro en mi Cama;* October 31-November 4, 1988; silkscreen; Fund: CAC, SHG, NEA Visual Arts; slide photographer: Color House; #Slides: 1. Note: "This is part of my series on women and dogs. The other prints consist of the dogs on the

prowl for women. In this print, the dog accomplishes his goal. Here he lies comfortably with the woman with a smug smile on his face because of his achievement. These dogs represent men who continually harass women with their cat calls." D. Guerrero-Cruz. Cat. 2 071.

Guerrero-Cruz, Dolores; *Untitled (The Bride);* February 19-28, 1985; silkscreen; Site/Location : SHG 3802 Cesar E. Chavez Avenue, Los Angeles, CA 90063; Fund: NEA Visual Arts, CAC, SHG; slide photographer: Adam Avila; #Slides: 1. Note: "The bride is a statement about my struggle as an artist, who leaves the professional field of art in order to survive as a single parent. During this time, this woman feels like she is slowly dying because she is not able to be what she wants to be. This is not against marriage, but a statement that one must be what she really wants to be before she can be anything else. Women have a harder struggle than men simply because we are women; I hope that for the women of tomorrow the struggle will be easier to make their lives better." Dolores Guerrero-Cruz. Cat. 2 066.

Hamada, Miles; *Untitled;* November 5-6, 1983; silkscreen; Fund: ARCO, SHG; slide photographer: Adam Avila; #Slides: 1. Cat. 2 072.

Hamilton, Vijali; *Sight One;* February 23-27, 1987; silkscreen; Fund: SHG, CAC, NEA Visual Arts; slide photographer: Adam Avila; #Slides: 1. Cat. 2 073.

Healy, Wayne; *Sawin' at Sunset;* March 16-20, 1987; silkscreen; Fund: CAC, SHG, NEA Visual Arts; slide photographer: Adam Avila; #Slides: 1. Cat. 2 074.

Hernández, Ester; *The Cosmic Cruise;* January 15-18, 1990; silkscreen; Fund: NEA Visual Arts, SHG, CAC; slide photographer: Color House; #Slides: 1. Note: "The theme is our interconnectedness with each other and The Universe. The car represents movement in space and time is represented by the images of four women: La Virgen de Guadalupe (the driver), the Mexican Indian grandmother, the modern Chicano mother and child. The Aztec moon goddess Coyolxauqui signifies our link with the past. The print is part of my ongoing tribute to La Mujer Chicana." E. Hernández. Cat. 2 075.

Herrón, Willie; *Untitled;* October 23-November 1, 1984; silkscreen; Fund: NEA Visual Arts and CAC; slide photographer: Adam Avila; #Slides: 1. Cat. 2 076.

Hoyes, Bernard; *Journey to the Astral World;* October 19-23, 1987; silkscreen; Fund: SHG, NEA Visual Arts, CAC; slide photographer: Adam Avila; #Slides: 1. Note: "Revivalist sect of the new world conjuring ancient spirits through the releasing of doves. This ritual opens the door to the spiritual world, praying, prancing, dancing, clapping of hands; trumpeting in the night transcends the participants into the world of the Eternal." B. Hoyes. Cat. 2 077.

Hoyes, Bernard; *Macumba Ritual;* October 20-25, 1986; silkscreen; Fund: SHG, CAC, NEA Visual Arts; slide photographer: Adam Avila; #Slides: 1. Cat. 2 078.

LaMarr, Jean; *Some Kind of Buckaroo;* March 12-15, 1990; silkscreen; Fund: SHG, NEA Visual Arts, CAC; slide photographer: Color House; #Slides: 1. Note: "The warrior spirit continues in contemporary times. Encroachment on sacred land area of nature by people for U.S. military testing, and fencing off lands keeping Indian people from sacred areas." J. LaMarr. Cat. 2 079.

Lane, Leonie; *Vulcán de Pacaya;* March 6-10, 1989; silkscreen; Fund: SHG, CAC, NEA Visual Arts; slide photographer: Color House; #Slides: 1. Note: "This print is based on my New Year's Eve 1988-89 spent with 14 people on top of Vulcán de Pacaya just south of Guatemala City, Guatemala. The combination of the active volcano, fireworks, campfire and fireflies is a potent mixture of heat, light and symbols. The volcano is a symbol for many things--underlying tensions exploding to the surface--political, social, sexual and emotional. This night and this mountain serve as a stage for reflection on events of the present and future. Fire is a catalyst for change, ignition of passion, destruction of the old, commencement of the new." L. Lane. Cat. 2 080.

Leal, Steven; *Untitled;* October 29-30, 1983; silkscreen; Fund: ARCO, SHG; slide photographer: Adam Avila; #Slides: 1. Cat. 2 081.

Lenero Castro, José; *Camine, No Camine;* January 20-23, 1986; silkscreen; Fund: CAC, SHG, NEA Visual Arts; slide photographer: Adam Avila; #Slides: 1. Cat. 2 082.

Lenero Castro, José; *Susana;* January 24-30, 1986; silkscreen; Fund: NEA Visual Arts, CAC, SHG; slide photographer: Adam Avila; #Slides: 1. Cat. 2 083.

Limón, Leo; *Dando Gracias;* October 16-22, 1983; silkscreen; Fund: SHG, ARCO; slide photographer: Adam Avila; #Slides: 1. Cat. 2 084.

Limón, Leo; *Madre Tierra--Padre Sol I;* December 8-11, 1986; silkscreen; Fund: CAC, SHG, NEA Visual Arts; slide photographer: Adam Avila; #Slides: 1. Cat. 2 085.

Limón, Leo; *Madre Tierra--Padre Sol II;* December 8-11, 1986; silkscreen; Fund: CAC, SHG, NEA Visual Arts; slide photographer: Adam Avila; #Slides: 1. Cat. 2 086.

Limón, Leo; *Soñando;* January 6-9, 1986; silkscreen; Fund: SHG, CAC, NEA Visual Arts; #Slides: 1. Cat. 2 087.

Limón, Leo; *Wovoka's Corazón;* October 21-24, 1985; silkscreen; Fund: CAC, SHG, NEA Visual Arts; slide photographer: Adam Avila; #Slides: 1. Cat. 2 088.

Maradiaga, Ralph; *Lost Childhood;* October 1-9, 1984; silkscreen; Fund: NEA Visual Arts, CAC, SHG; slide photographer: Adam Avila; #Slides: 1. Cat. 2 089.

Martínez, Daniel; *The Promised Land;* November 10-14, 1986; silkscreen; Fund: NEA Visual Arts, SHG, CAC; slide photographer: Adam Avila; #Slides: 1. Cat. 2 090.

Montaño Valle, Ernest; *The Dream;* March 13-17, 1989; silkscreen; Fund: SHG, CAC, NEA Visual Arts; slide photographer: Color House; #Slides: 1. Note: "Primer trabajo realizado conjunto con ayuda Chicana, la característica principal se refiera a la situación real--abstracta del dibujo que interpreta el sueño, así como la utilización de colores con la elisura tónica, colores un tanto absurdos pero relacionados." E. Montaño Valle. Cat. 2 091.

Montoya, Dalilah; *Tijerina Tantrum;* February 27-March 3, 1989; silkscreen; Fund: NEA Visual Arts, CAC, SHG; slide photographer: Color House; #Slides: 1. Note: "The *Tijerina Tantru*m is about Reyes Tijerina, the Aloncia, the forest station and the U.S. Military. The image in the center symbolizes Shiva Energy that is through her dance of the Tijerina Tantrum; energy spins off igniting the tension between Reyes-Aloncia and the Forest Ranger-Military. In general this print embraces the energy generated by the politically turbulent 60's." D. Montoya. Cat. 2 092.

Montoya, Malaquías; *Sí Se Puede;* January 9-13, 1989; silkscreen; Fund: SHG, CAC, NEA Visual Arts; slide photographer: Color House; #Slides: 1. Note: "These images deal with struggle. I use the maguey plant as a symbol of strength. In this image the plant and its power are the manifestation of the frustration of the poor represented by the person looking out of the rectangular box. The maguey is ripping through the American flag, which I use here as a symbol of those things which oppress people." M. Montoya. Cat. 2 093.

Norte, Armando; *Savagery & Technology;* March 1983; silkscreen; Fund: NEA, CAC, SHG; slide photographer: Adam Avila; #Slides: 1. Cat. 2 094.

Norte, Armando; *Shadows of Ghosts;* December 18-22, 1989; silkscreen; Fund: CAC, SHG, NEA Visual Arts; slide photographer: Color House; #Slides: 1. Note: "We wear the scars of our past, bad experience, touch them and feel the fear, the anger, the pain, over and over again. Those moments from our past are but a collage of fading images. Shadows of ghosts. We must look forward, to life." A. Norte. Cat. 2 095.

Norte, Armando; *Untitled;* November 19-20, 1983; silkscreen; Fund: SHG, ARCO; slide photographer: Adam Avila; #Slides: 1. Cat. 2 096.

Ochoa, Victor; *Border Bingo/Lotería Fronteriza;* October 25-30, 1987; silkscreen; Fund: CAC, SHG, NEA Visual Arts; slide photographer: Adam Avila; #Slides: 1. Cat. 2 097.

Oropeza, Eduardo; *El Jarabe de los Muertianos;* January 16-February 17, 1984; silkscreen; Fund: CAC, SHG, NEA Visual Arts; slide photographer: Adam Avila; #Slides: 2. Cat. 2 098(1-2).

Oropeza, Eduardo; *Onward Christian Soldiers;* 1985; silkscreen; Fund: CAC, SHG, NEA Visual Arts; #Slides: 1. Note: Slide photograph from *Ateliers VI and VII* exhibition and reception at SHG, organized by SHG staff and Sister Karen Boccalero. (April 1986). Cat. 2 099.

Oropeza, Eduardo; *Onward Christian Soldiers;* December 15-18, 1985; silkscreen; Fund: CAC, SHG, NEA Visual Arts; slide photographer: Adam Avila; #Slides: 1. Cat. 2 100.

Perez, Jesús; *Arreglo;* October 8-9, 1983; silkscreen; Fund: SHG, ARCO; slide photographer: Adam Avila; #Slides: 1. Cat. 2 101.

Perez, Jesús; *The Best of Two Worlds;* November 9-13, 1987; silkscreen; Fund: CAC, SHG, NEA Visual Arts; slide photographer: Adam Avila; #Slides: 1. Note: "Mexican-Americans. These three generations formulated the passionate Mexican-American heritage. But the Mexican-American was to enter his own revolution: to fight for his identity; to establish his values in a country which differed in culture and in values from the three generations that had preceded him. Now the fifth generation has to respond to a new-age culture: electronics, space, sex, materialism, Ronald Reagan, etc. Like the cactus which supports the eagle on the Mexican flag, they are all undeniably Mexican-rooted!" J. Perez. Cat. 2 102.

Perez, Jesús; *Say Yes;* January 30-February 3, 1989; silkscreen; Fund: SHG, CAC, NEA Visual Arts; slide photographer: Color House; #Slides: 1. Note: "Between hope and hopelessness, any child, including the child within us, is fragile, vulnerable, and dependent on an external world for its very survival. Many factors will shape and mold its future. Needy children, through no fault of their own, are subject to a murky world of oppression. As a volunteer chair of a YMCA fundraising campaign, I see many campaigners and donors who are making a difference in many of these children's lives. I salute these volunteers who dare 'say yes' to the YMCA and help us to 'Say yes!' to life." J. Perez. Cat. 2 103.

Perez, Jesús; *Try Angle # 1;* November 2-6, 1986; silkscreen; Fund: SHG, CAC, NEA Visual Arts; slide photographer: Adam Avila; #Slides: 1. Cat. 2 104.

Perez, Jesús; *Untitled;* December 29-31, 1985; silkscreen; Fund: CAC, SHG, NEA Visual Arts; slide photographer: Adam Avila; #Slides: 1. Cat. 2 105.

Perez, Juan; *Vértigo;* November 24-28, 1986; silkscreen; Fund: CAC, SHG, NEA Visual Arts; slide photographer: Adam Avila; #Slides: 1. Cat. 2 106.

Perez, Louie; *Thinking of Jesus and Mary;* February 6-10, 1989; silkscreen; Fund: SHG, CAC, NEA Visual Arts; slide photographer: Color House; #Slides: 1. Note: "Based on series of pastel sketches on newspaper. The religious imagery of the sacred hearts of Jesus and Mary conveys personal religious convictions in a purely aesthetic approach. The print medium has recreated the newspaper accurately, while the image retains the immediacy of the original. I've also used monotype to enhance the attitude of making art at the moment. The overall piece conveys an irony in the juxtaposition of religious symbols and the disposable, temporary material on which they are executed." L. Perez. Cat. 2 107.

Ponce, Michael; *Familia;* March 1983; silkscreen; Fund: NEA, CAC, SHG; slide photographer: Adam Avila; #Slides: 1. Cat. 2 108.

Rodriguez, Elizabeth; *Untitled;* October 7-10, 1985; silkscreen; Fund: NEA Visual Arts; slide photographer: Adam Avila; #Slides: 1. Cat. 2 109. Atelier (Self-help Graphics and Art, Inc.)

Rodriguez, Elizabeth; *Untitled;* October 27-30, 1986; silkscreen; Fund: CAC, SHG, NEA Visual Arts; slide photographer: Adam Avila; #Slides: 1. Cat. 2 110.

Rodriguez, Joe Bastida; *Night Falls as I Lay Dreaming;* February 19-23, 1990; silkscreen; Fund: NEA Visual Arts, CAC, SHG; slide photographer: Color House; #Slides: 1. Note: "This print depicts a young girl who, while in her sleep, visualizes her fear of a snake curled close to her which may strike as it reaches towards the sunset. Images of unborn children within a tree (tree of life) and the dark clouds shaped like an eagle edge towards the sunset, reflecting an old Indian wise man that oversees her presence. Symbols relate to the notion of the fear of losing one's cultural identity and of the hope for children to maintain their heritage." J. Bastida-Rodriguez . Cat. 2 111. Atelier (Self-help Graphics and Art, Inc.)

Rodriguez, Reyes; *A Part of You and Me;* 1989; silkscreen; Fund: NEA Visual Arts; slide photographer: Color House; #Slides: 1. Note: "The print is inspired by my daughter. The coming together of two Latin cultures, one Brazilian and the other Chicano. The snake is transformed from an Aztec symbol to the streets of Rio. On the upper left corner is the diety Yemanja, Goddess of the Sea, and in front of her are lilies associated with Chicano and Mexican art. A calavera peeks through on the right hand side." R. Rodriguez. Cat. 2 112. Atelier (Self-help Graphics and Art, Inc.)

Romero, Frank; *Carro;* February 3-6, 1986; silkscreen; Fund: SHG, NEA Visual Arts, CAC; slide photographer: Adam Avila; #Slides: 1. Cat. 2 113.

Romero, Frank; *Cruz Arroyo Seco;* January 18-22, 1988; silkscreen; Fund: NEA Visual Arts, SHG, CAC; slide photographer: Color House; #Slides: 1. Note: The white cross standing in a field of yellow sunflowers exists in Arroyo Seco, New Mexico, in the local cemetery. Arroyo Seco is near Taos, New Mexico, and the background is an indication of the magic mountain sacred to the Pueblo Indians. Cat. 2 114.

Romero, Frank; *Cruz Hacienda Martínez;* January 18-22, 1988; silkscreen; Fund: NEA Visual Arts, CAC, SHG; slide photographer: Color House; #Slides: 1. Note: "The print depicts a small cross hanging in the Martínez Hacienda in Taos, New Mexico. I've tried to convey an emotional feeling this kind of imagery evokes." F. Romero. Cat. 2 115.

Romero, Frank; *Frutas y Verduras;* October 16-20, 1989; silkscreen; Fund: NEA Visual Arts, CAC, SHG; slide photographer: Color House; #Slides: 1. Cat. 2 116.

Romero, Frank; *Pingo con Corazón;* February 3-6, 1986; silkscreen; Fund: NEA Visual Arts, SHG, CAC; slide photographer: Adam Avila; #Slides: 1. Cat. 2 117.

Romero, Frank; *Untitled;* October 12-17, 1986; silkscreen; Fund: NEA Visual Arts, SHG, CAC; slide photographer: Adam Avila; #Slides: 1. Cat. 2 118.

Salazar, Daniel; *Eternal Seeds;* December 1989; silkscreen; Fund: NEA Expansion Arts; #Slides: 1. Cat. 2 119. Atelier (Self-help Graphics and Art, Inc.)

Salazar, Daniel; *Eternal Seeds;* December 4-8, 1989; silkscreen; Fund: CAC, SHG, NEA Visual Arts; slide photographer: Color House; #Slides: 1. Note: "The love and sacrifice of Jesus Christ is to plant seeds of eternal life." D. Salazar. Cat. 2 120.

Segura, Daniel; *Like Father, Like Son;* March 1983; silkscreen; Fund: NEA, CAC, SHG; slide photographer: Adam Avila; #Slides: 1. Cat. 2 121.

Segura, Daniel; *This Is Pain;* December 18-20, 1983; silkscreen; Fund: SHG, ARCO; slide photographer: Adam Avila; #Slides: 1. Cat. 2 122.

SHG Group Poster; *Atelier IV Group Poster;* November 6-December 13, 1984; silkscreen; Fund: CAC, SHG, NEA Visual Arts; slide photographer: Adam Avila; #Slides: 1. Cat. 2 123.

SHG Group Poster; *Atelier V Group Poster;* 1985; silkscreen, collage; Fund: NEA Visual Arts, CAC, SHG; slide photographer: Adam Avila; #Slides: 1. Cat. 2 124.

SHG Group Poster; *Untitled;* March 1-3, 1984; silkscreen; Fund: CAC, SHG, NEA Visual Arts; slide photographer: Adam Avila; #Slides: 1. Cat. 2 125.

Sparrow, Peter; *Omens;* March 1983; silkscreen; Fund: NEA, CAC, SHG; slide photographer: Adam Avila; #Slides: 1. Cat. 2 126.

Sparrow, Peter; *Untitled;* January 8-15, 1985; silkscreen; Fund: CAC, SHG, NEA Visual Arts; slide photographer: Adam Avila; #Slides: 1. Cat. 2 127.

Taylor, Neal; *Balance of Knowledge--Balance of Power;* October 11-16, 1987; silkscreen; Fund: SHG, CAC, NEA Visual Arts; slide photographer: Adam Avila; #Slides: 1. Note: "*Balance of Knowledge--Balance of Power* deals with the individual coming to a point in himself and society, being educated by its own example. The use of the arch for knowledge and balance; the spiral for inner strength, understanding and compassion; the lightning for physical strength and endurance. Power to the person." N. Taylor. Cat. 2 128.

Thomas, Matthew; *Cosmic Patterns Print II;* October 2-6, 1987; silkscreen; Fund: CAC, SHG, NEA Visual Arts; slide photographer: Adam Avila; #Slides: 1. Note: "The inner worlds made visible to our senses through symbols: form, color and line are used." M. Thomas. Cat. 2 129.

Thomas, Matthew; *Untitled;* October 11-14, 1985; silkscreen; Fund: CAC, SHG, NEA Visual Arts; slide photographer: Adam Avila; #Slides: 1. Cat. 2 130.

Torres, Eloy; *The Pope of Broadway;* November 19-30, 1984; silkscreen; Fund: CAC, SHG, NEA Visual Arts; slide photographer: Adam Avila; #Slides: 2. Cat. 2 131(1-2).

Torres, Eloy; *Untitled;* December 3-13, 1985; silkscreen; Fund: CAC, NEA Visual Arts, SHG; slide photographer: Adam Avila; #Slides: 1. Cat. 2 132.

Urista, Arturo; *Duel Citizenship;* November 23-27, 1987; silkscreen; Fund: NEA Visual Arts, SHG, CAC; slide photographer: Adam Avila; #Slides: 1. Note: "The fight represents the differences in ideologies concerning the decision-making about citizenship. The decision is either to maintain Mexican citizenship and deny any involvement in policy making in the United States or to give up Mexican citizenship and, much more, to become U.S. citizens. The images that I include are: A flag: a country's symbolic identity; el Apache: a reminder of the country's cultural roots; the drum: the disciplining of a country's ideologies; el valiente: the defender of one's country." A. Urista. Cat. 2 133.

Urista, Arturo; *El Llamado Dividido;* October 24-28, 1988; silkscreen; Fund: CAC, SHG, NEA Visual Arts; slide photographer: Color House; #Slides: 1. Note: "*El Llamado Dividido* or *The Divided Call* is images and messages that constitute a call for unity under cultural/social and political beliefs, but are divided because of social upbringing." A. Urista. Cat. 2 134.

Urista, Arturo; *The Travel Back;* 1989; silkscreen; Fund: NEA Visual Arts, CAC, SHG; slide photographer: Color House; #Slides: 1. Note: "The migration of the cultural from the logic of Blind Justice back to the spirituality of the Mayans. The imagery depicts women as the sole identity of the movement towards the roots of cultural awareness; from Mexico to the U.S. and back." A. Urista. Cat. 2 135.

Urista, Arturo; *Welcome to Aztlán;* February 2-6, 1987; silkscreen; Fund: CAC, SHG, NEA Visual Arts; slide photographer: Adam Avila; #Slides: 1. Cat. 2 136.

Valadez, John; *Untitled;* March 19-26, 1985; silkscreen; Fund: CAC, NEA Visual Arts, SHG; slide photographer: Adam Avila; #Slides: 1. Cat. 2 137.

Valdez, Patssi; *The Dressing Table;* November 14-18, 1988; silkscreen; Fund: SHG, CAC, NEA Visual Arts; slide photographer: Color House; #Slides: 1. Note: "Depict[s] a section of my environment." P. Valdez. Cat. 2 138.

Valdez, Patssi; *Scattered;* November 30-December 4, 1987; silkscreen; Fund: CAC, SHG, NEA Visual Arts; slide photographer: Adam Avila; #Slides: 1. Note: "This print is autobiographical: The breaking away of the old and the emergence of the new self." P. Valdez. Cat. 2 139.

Vallejo, Linda; *Black Orchid;* January 5-9, 1987; silkscreen; Fund: SHG, CAC, NEA Visual Arts; slide photographer: Adam Avila; #Slides: 1. Cat. 2 140.

Vallejo, Linda; *Untitled;* December 4-13, 1984; silkscreen; Fund: SHG, CAC, NEA Visual Arts; slide photographer: Adam Avila; #Slides: 2. Cat. 2 141(1-2).

Walker, J. Michael; *Mexico Frantico;* February 1-5, 1988; silkscreen; Fund: CAC, SHG, NEA Visual Arts; slide photographer: Color House; #Slides: 1. Note: "The print deals with ways of thinking of Mexico: the banner is tourist brochure style; the eagle is folk-artsy; the snake is designy; the cactus is just a cactus. The frame is a stream-of-consciousness field of images (visual, historical, narrative and musical and sensual) that I associate with Mexico and Mexicanos. The calaveras of Posada accompany the cantante on her guitar--her song of love becomes the lovers in a desert on the bottom of the frame. Hidden behind the eagle is the Virgen de Guadalupe, the unofficial symbol of Mexico." J. M. Walker. Cat. 2 142.

Yepes, George; *Amor Matizado;* October 17-21, 1988; silkscreen; Fund: NEA Visual Arts, CAC, SHG; slide photographer: Color House; #Slides: 1. Note: "The title *Amor Matizado* translates into *Blended Love,* hence a blending of thought, ideas, personal preference. The idea began as a skeleton and a woman kissing, then it became a man and a woman, then ultimately as both figures drew closer to completion, the end result was two women. My print as the artist on this design was that of an impartial observer." G. Yepes. Cat. 2 143.

Zains, Maria; *Phantom Fear II;* March 1983; silkscreen; Fund: NEA, CAC, SHG; slide photographer: Adam Avila; #Slides: 1. Cat. 2 144.

Zaragoza, Alex; *Raised in the U.S.A.* February 21-25, 1989; silkscreen; Fund: SHG, CAC, NEA Visual Arts; slide photographer: Color House; #Slides: 1. Note: "This work portrays passages of my life as a Mexican raised and educated in the U.S. Having left Mexico at a very young age, I had to adjust to a new culture, new environment, and hardest of all, a new language. Thinking back, it was an experience impossible to match, but easy to express. Mom

once said, 'Vamos a Estados Unidos, donde todo es color de rosa.' (We are going to the U.S. where everything is like paths covered with rose petals [sic]). It has not been that easy!" A. Zaragoza. Cat. 2 145.

Zoell, Bob; *Sunflowers for Gauguin;* October 14-17, 1985; silkscreen; Fund: NEA Visual Arts; slide photographer: Adam Avila; #Slides: 1. Cat. 2 146.

Center Activities and Programs

Boccalero; Karen; assistants: Mari Yáñez; *Day of the Dead '77 Bread-Making (Pan de Muerto) Workshop;* November 1977: Fund: NEA and SHG; #Slides: 5. Cat. 3 110(1-5).

Centro de Artistas Chicanos; Leo Limón; *CAC Workshop;* June 1982: slide photographer: Leo Limón; #Slides: 9. Cat. 3 001(1-9).

Los Angeles Cultural Affairs Department and SHG; *General Meeting to Discuss Artists' Needs;* April 13, 1989: Fund: SHG; slide photographer: Arturo Urista; #Slides: 1. Cat. 3 002.

SHG; *Atelier Exhibition;* January 20, 1984: #Slides: 4. Cat. 3 003(1-4).

SHG; *Atelier IX Workshop Meeting;* March 1987: Fund: CAC, Visual Arts, SHG; #Slides: 1. Cat. 3 004.

SHG; *Atelier VIII and IX Exhibition and Reception;* May 1987: #Slides: 29. Cat. 3 005(1-29).

SHG; *Atelier XIV;* April 8, 1990: Fund: NEA Visual Arts, CAC, SHG; #Slides: 14. Cat. 3 006(1-14).

SHG; *CAC Workshop;* December 1981: #Slides: 24. Cat. 3 007(1-24).

SHG; *CAC Workshop;* March 1982: Fund: CAC; #Slides: 18. Cat. 3 008(1-18).

SHG; Carlos Bueno Working on Mural; n.d.: Cat. 3 009.

SHG; *Cinco de Mayo Celebration;* May 5, 1985: #Slides: 27. Cat. 3 010(1-27).

SHG; *Day of the Dead '75;* November 1975: Fund: SHG and NEA; #Slides: 5. Note: Musicians, reception and exhibition. Cat. 3 011(1-5).

SHG; *Day of the Dead '75 Procession;* November 1975: Fund: SHG and NEA; #Slides: 5. Cat. 3 012(1-5).

SHG; *Day of the Dead '76;* November 7, 1976: #Slides: 4. Note: Musicians performing during *Day of the Dead* celebration. Cat. 3 013(1-4).

SHG; *Day of the Dead '76;* November 7, 1976: Fund: SHG and NEA; #Slides: 15. Note: Participants at Cemetery. Cat. 3 014(1-15).

SHG; *Day of the Dead '76;* November 7, 1976: Fund: SHG and NEA; #Slides: 16. Note: Participants. Cat. 3 015(1-16).

SHG; *Day of the Dead '76 Celebration;* November 7, 1976: Fund: SHG and NEA; #Slides: 12. Note: Celebration with priest at cemetery. Cat. 3 016(1-12).

SHG; *Day of the Dead '76 Celebration and Exhibition;* November 1976: Fund: NEA and SHG; #Slides: 2. Cat. 3 017(1-2).

SHG; *Day of the Dead '76 Procession;* November 7, 1976: #Slides: 6. Cat. 3 018(1-6).

SHG; *Day of the Dead '76 Reception;* November 1976: Fund: NEA and SHG; #Slides: 14. Cat. 3 019(1-14).

SHG; *Day of the Dead '77;* November 1977: Fund: SHG and NEA; #Slides: 1. Note: Musicians performing during *Day of the Dead* celebration. Cat. 3 020.

SHG; *Day of the Dead '77;* November 1977: Fund: SHG; #Slides: 33. Note: Participants. Cat. 3 021(1-33).

SHG; *Day of the Dead '77;* November 1977: #Slides: 7. Note: Priest at cemetery. Cat. 3 022(1-7).

SHG; *Day of the Dead '77;* November 6, 1977: Fund: SHG and NEA; #Slides: 16. Note: Participants at Cemetery. Cat. 3 023(1-16).

SHG; assistants: Leo Limón; *Day of the Dead '77 Celebration;* November 6, 1977: Fund: SHG and NEA; #Slides: 3. Note: Cross: Installation Art. Cat. 3 024(1-3).

SHG; *Day of the Dead '77 Procession;* November 6, 1977: #Slides: 28. Note: Procession from Evergreen Cemetery to SHG during a *Day of the Dead* celebration. Cat. 3 025(1-28).

SHG; *Day of the Dead '77 Reception;* November 1977: Fund: SHG; #Slides: 12. Cat. 3 026(1-12).

SHG; *Day of the Dead '78;* November 5, 1978: Fund: SHG and NEA; #Slides: 14. Note: Art left at cemetery and pictures of cemetery before event. Cat. 3 027(1-14).

SHG; *Day of the Dead '78;* November 5, 1978: #Slides: 33. Note: Participants at Cemetery. Cat. 3 028(1-33).

SHG; *Day of the Dead '78;* November 5, 1978: #Slides: 6. Note: Indian ceremony during *Day of the Dead '78* celebration. Cat. 3 029(1-6).

SHG; *Day of the Dead '78;* November 5, 1978: Fund: NEA and SHG; #Slides: 9. Note: Members of the community performing Aztec dances during a *Day of the Dead* Celebration. Cat. 3 030(1-9).

SHG; *Day of the Dead '78;* November 5, 1978: Fund: SHG and NEA; #Slides: 19. Note: Participants in the *Day of the Dead* Celebration. Cat. 3 031(1-19).

SHG; *Day of the Dead '78;* November 5, 1978: Fund: SHG and NEA; #Slides: 15. Note: Musicians performing during a *Day of the Dead* celebration. Cat. 3 032(1-15).

SHG; *Day of the Dead '78 Celebration;* November 5, 1978: Fund: SHG and NEA; #Slides: 11. Cat. 3 033(1-11).

SHG; *Day of the Dead 78' Celebration;* November 5, 1978: Fund: SHG and NEA; #Slides: 64. Cat. 3 034(1-64).

SHG; *Day of the Dead '78 Celebration and Exhibition;* November 6, 1978: Fund: NEH and SHG; #Slides: 2. Cat. 3 035(1-2).

SHG; *Day of the Dead '78 Celebration with Zoot Suit Group;* November 5, 1978: Fund: SHG and NEA; #Slides: 15. Note: Zoot Suit group among participants. Cat. 3 036(1-15).

SHG; *Day of the Dead '78 Procession;* November 5, 1978: Fund: SHG and NEA; #Slides: 11. Cat. 3 037(1-11).

SHG; *Day of the Dead '78 Procession;* November 5, 1978: Fund: SHG and NEA; #Slides: 10. Note: Procession with Teatro Campesino. Cat. 3 038(1-10).

SHG; *Day of the Dead '78 Procession;* November 5, 1978: Fund: SHG and NEA; #Slides: 20. Cat. 3 039(1-20).

SHG; *Day of the Dead '78 Procession with Performance by Xipe-Totec;* November 5, 1978: Fund: SHG and NEA; #Slides: 28. Note: Procession with performance of Aztec dancing by the group Xipe-Totec during a *Day of the Dead* Celebration. Cat. 3 040(1-28).

SHG; *Day of the Dead '78 Sugar Skull-Making Workshop;* November 1978: Fund: NEH and SHG; #Slides: 14. Cat. 3 041(1-14).

SHG; *Day of the Dead '79;* November 1979: Fund: SHG and NEA; #Slides: 28. Note: Participants at Cemetery. Cat. 3 042(1-28).

SHG; *Day of the Dead '79;* November 1979: Fund: SHG and NEA; #Slides: 57. Note: Performance of Aztec dances at cemetery during a *Day of the Dead* celebration. Cat. 3 043(1-57).

SHG; *Day of the Dead '79;* November 1979: Fund: SHG and NEA; #Slides: 1. Note: Musicians at reception. Cat. 3 044.

SHG; *Day of the Dead '79 Celebration and Exhibition;* November 2, 1979: Fund: NEA and SHG; #Slides: 2. Cat. 3 045(1-2).

SHG; *Day of the Dead '79 Exhibition and Reception;* November 1979: Fund: SHG and NEA; #Slides: 18. Cat. 3 046(1-18).

SHG; *Day of the Dead '79 Procession;* November 1979: Fund: SHG and NEA; #Slides: 6. Note: Performance by Aztec dances during a *Day of the Dead* procession. Cat. 3 047(1-6).

SHG; *Day of the Dead '79 Procession;* November 1979: Fund: SHG and NEA; #Slides: 31. Cat. 3 048(1-31).

SHG; *Day of the Dead '80;* November 1980: Fund: SHG and NEA; #Slides: 8. Note: Participants. Cat. 3 049(1-8).

SHG; *Day of the Dead '80;* November 2, 1980: Fund: SHG, NEA, ARCO, City of Los Angeles; #Slides: 3. Note: Musicians and dancers. Cat. 3 050(1-3).

SHG; *Day of the Dead '80;* November 2, 1980: Fund: SHG, NEA, ARCO, City of Los Angeles; #Slides: 48. Note: Participants . Cat. 3 051(1-48).

SHG; *Day of the Dead '80 Exhibition;* November 1980: Fund: SHG and NEA; #Slides: 27. Note: Cross: Photography. Cat. 3 052(1-27).

SHG; *Day of the Dead '80 Procession;* November 2, 1980: Fund: NEA, SHG, ARCO, City of Los Angeles; #Slides: 19. Cat. 3 053(1-19).

SHG; *Day of the Dead '80 Reception;* November 2, 1980: Fund: SHG, NEA, ARCO, City of Los Angeles; #Slides: 14. Cat. 3 054(1-14).

SHG; *Day of the Dead '81;* November 1981: Fund: SHG and NEA; #Slides: 21. Note: Participants at Cemetery. Cat. 3 055(1-21).

SHG; *Day of the Dead '81;* November 1981: Fund: SHG and NEA; #Slides: 3. Note: Musicians at reception. Cat. 3 056(1-3).

SHG; *Day of the Dead '81;* November 1981: Fund: NEA and SHG; #Slides: 11. Note: Performing dances. Cat. 3 057(1-11).

SHG; *Day of the Dead '81;* November 1981: Fund: NEA and SHG; #Slides: 41. Note: Participants at SHG and Evergreen Cemetery. Cat. 3 058(1-41).

SHG; *Day of the Dead '81 Procession;* November 1981: Fund: NEA and SHG; #Slides: 47. Cat. 3 059(1-47).

SHG; *Day of the Dead '81 Reception;* November 1981: Fund: NEA and SHG; #Slides: 85. Cat. 3 060(1-85).

SHG; *Day of the Dead '81 Workshop;* November 1981: Fund: NEA and SHG; #Slides: 90. Cat. 3 061(1-90).

SHG; *Day of the Dead '81Celebration and Exhibition;* November 1981: Fund: NEA and SHG; #Slides: 5. Cat. 3 062(1-5).

SHG; *Day of the Dead '82;* November 7, 1982: Fund: SHG and NEA; #Slides: 53. Note: Participants. Cat. 3 063(1-53).

SHG; *Day of the Dead '82;* November 7, 1982: Fund: SHG and NEA; #Slides: 13. Note: Play by ASCO Ballet Rouge. Cat. 3 064(1-13).

SHG; *Day of the Dead '82 Celebration;* November 7, 1982: Fund: SHG and NEA; #Slides: 3. Cat. 3 065(1-3).

SHG; *Day of the Dead '82 Reception;* November 7, 1982: Fund: SHG and NEA; #Slides: 4. Cat. 3 066(1-4).

SHG; *El Fin del Sol;* November 5, 1978: #Slides: 7. Note: Teatro Campesino's play. Cat. 3 067(1-7).

SHG; *Gamboa and Navarro Exhibition;* May 6, 1984: Fund: NEA Expansion Arts, SHG; #Slides: 17. Cat. 3 068(1-17).

SHG; *John Valadez Exhibition;* December 9, 1983: Fund: NEA Expansion Arts; #Slides: 22. Cat. 3 069(1-22).

SHG; *Maria Zains Exhibition;* June 1983: Fund: NEA Expansion Arts, SHG; #Slides: 12. Cat. 3 070(1-12).

SHG; *Míranos Exhibition;* June 1980: #Slides: 6. Cat. 3 071(1-6).

SHG; *Multi-Cultural Program;* March 1980: #Slides: 59. Cat. 3 072(1-59).

SHG; *Opening Reception for Atelier VI;* March 1986: Fund: NEA Expansion Arts, SHG; #Slides: 1. Cat. 3 073.

SHG; *Patssi Valdez's Painting Class;* February 1987: Fund: CAC; #Slides: 1. Cat. 3 074.

SHG; *Political Exhibition;* December 1988: Fund: NEA, CAC, and SHG; #Slides: 13. Cat. 3 075(1-13).

SHG; *Video Class;* February 1987: Fund: CAC resident artist and SHG; #Slides: 1. Cat. 3 076.

SHG; Alex Alferov; *Atelier at Los Angeles Nicole;* April 1988: #Slides: 17. Cat. 3 077(1-17).

SHG; Alex Alferov; *SHG Exhibition;* November 7-December 6, 1989: slide photographer: Dolores Guerrero-Cruz; #Slides: 8. Cat. 3 078(1-8).

SHG; artist: Diane Gamboa; *Day of the Dead '82;* 1982: Fund: SHG; #Slides: 1. Note: Celebration with fashion show of Paper Fashions. Cat. 3 079.

SHG; Arturo Urista and Paul Botello; *Algo Nuevo Exhibition;* March 11-April 8, 1988: Fund: NEA Expansion Arts, SHG; #Slides: 34. Cat. 3 080(1-34).

SHG; Beth Gregory and Mari Cárdenas; *AIC-CAC Workshop;* August 1982: #Slides: 30. Cat. 3 081(1-30).

SHG; Beth Gregory and Sarah Pineda-Rico; *Míranos Children's Exhibition of Soft-Sculpture/Batik;* June 1980: #Slides: 6. Cat. 3 082(1-6).

SHG; Beto de la Rocha, Carlos Almaraz, Frank Romero and Judith Hernández; *Los Four Exhibition;* October 7, 1974: Fund: Campaign for Human Development; #Slides: 1. Cat. 3 083.

SHG; Betty Lee and Richard Espinoza, *It's the Law Exhibition;* March 16, 1989-April 10, 1989: Fund: NEA Expansion Arts and SHG; #Slides: 8. Cat. 3 084(1-8).

SHG; Cecilia Castañeda; *Míranos Exhibition;* June 1980: #Slides: 39. Cat. 3 085(1-39).

SHG; Cecilia Castañeda; *Soft Mask Workshop;* n.d.: #Slides: 8. Cat. 3 086(1-8).

SHG; Consuelo Norte; assistants: Sandra Hahn and Frances España; *Day of the Dead '89 Exhibition;* November 3, 1989: Fund: SHG and NEA; #Slides: 11. Cat. 3 087(1-11).

SHG; curator: Michael M. Amescua; *Fire Show 1985;* October 19, 1985: Fund: NEA Expansion Arts, SHG; #Slides: 1. Cat. 3 088.

SHG; Diane Gamboa; *Day of the Dead '82;* November 7, 1982: Fund: SHG and NEA; #Slides: 13. Note: Paper Fashion by ASCO. Cat. 3 089(1-13).

SHG; Dolores Guerrero-Cruz and Michael M. Amescua; *1989 Christmas Fair;* December 10, 1989: Fund: NEA Expansion Arts; slide photographer: Dolores Guerrero-Cruz; #Slides: 4. Cat. 3 090(1-4).

SHG; Dr. Beverly Johnson; *Slide Presentation on Jean Canol;* October 1978: #Slides: 7. Cat. 3 091(1-7).

SHG; Edgar Aparicio; *Edgar Aparicio Exhibition;* December 5, 1986-January 18, 1987: Fund: NEA Expansion Arts and SHG; #Slides: 21. Cat. 3 092(1-21).

SHG; Eloy Torrez; *Hollywood Mural Presentation;* November 1983: #Slides: 7. Cat. 3 093(1-7).

SHG; Frances España; *L.A. Festival;* ca. 1989: Fund: L.A. Festival; slide photographer: Dolores Guerrero-Cruz and Michael M. Amescua; #Slides: 13. Cat. 3 094(1-13).

SHG; Frances España; *Video Class;* June 1989: Fund: NEA, CAC, and SHG; #Slides: 20. Cat. 3 095(1-20).

SHG; Gil Cárdenas; *Atelier Prints from Los Angeles Prints Contemporary Graphics Art;* November 1986: Fund: SHG; #Slides: 15. Cat. 3 096(1-15).

SHG; instructor: Beth Gregory; *Barrio Mobil Art Studio--Folk Tale--"How the Basilish Obtained His Crest";* April 1978: Fund: Community Development City of Los Angeles; #Slides: 1. Note: Mayan folk tale puppet show by students. Cat. 3 097.

SHG; instructor: Beth Gregory; *Puppet Show at Hamel Street School--Barrio Mobil Art Studio;* May 1978: Fund: Community Development, City of Los Angeles; #Slides: 1. Cat. 3 098.

SHG; instructor: Jean LaMarr; assistants: Michael M. Amescua; *Four Color Process Printing Workshop;* April 1990: Fund: NEA Expansion Arts, SHG; slide photographer: Michael M. Amescua; #Slides: 1. Cat. 3 099.

SHG; instructor: Joe Gatto; *Drawing Class;* 1985-86: Fund: CAC resident artist and NEA Expansion Arts; #Slides: 1. Cat. 3 100.

SHG; Jack Alexander; *Tile Workshop;* June 1980: #Slides: 3. Cat. 3 101(1-3).

SHG; Jesús Perez; *The Waitress Series Exhibition;* March 8-30, 1991: Fund: NEA Expansion Arts and SHG; #Slides: 18. Cat. 3 102(1-18).

SHG; Karen Boccalero; assistants: Stephen Grace; *Atelier I Workshop;* ca. 1983: #Slides: 18. Cat. 3 103(1-18).

SHG; Karen Boccalero; *Atelier III Workshop;* April 1984: Fund: NEA, CAC, SHG; #Slides: 9. Cat. 3 104(1-9).

SHG; Karen Boccalero; assistants: Stephen Grace; *Atelier III Workshop;* September 1984: Fund: CAC, NEA, SHG; #Slides: 15. Cat. 3 105(1-15).

SHG; Karen Boccalero; *Atelier IV and V Exhibition;* April 21, 1985: Fund: NEA, CAC, SHG; #Slides: 13. Cat. 3 106(1-13).

SHG; Karen Boccalero; assistants: Stephen Grace; *Atelier V Workshop;* ca. 1985: Fund: NEA, CAC, SHG; #Slides: 21. Cat. 3 107(1-21).

SHG; Karen Boccalero; *Atelier VI and VII Exhibition and Reception;* April 1986: #Slides: 10. Cat. 3 108(1-10).

SHG; Karen Boccalero; assistants: Sam Baray, Mitz Baray and Dolores Guerrero-Cruz; *Atelier XII and XIII 1989 Exhibition;* April 23, 1989: Fund: NEA Visual Arts, CAC, SHG; #Slides: 29. Cat. 3 109(1-29).

SHG; organizers: Karen Boccalero; assistants: Mari Yáñez; Day of the Dead '77 Bread-Making (Pan de Muerto) Workshop; November 1977. Site/Location: 1168 North Eastman, East Los Angeles, CA; fund: NEA and SHG; #slides: 5. New ID No. Cat. 3 110(1-5).

SHG; Karen Boccalero; *Day of the Dead '78 Bread-Making (Pan de Muerto) Workshop;* November 6, 1978: Fund: NEH and SHG; #Slides: 11. Cat. 3 111(1-11).

SHG; Karen Boccalero and members of El Colegio de La Frontera Norte; *Las Mujeres de la Raza Project Monoprint Workshop;* August 1989: slide photographer: Michael M. Amescua; #Slides: 12. Cat. 3 112(1-12).

SHG; Karen Boccalero; instructor: Jean La Marr; *Etching Workshop;* April 1990: slide photographer: Michael M. Amescua; #Slides: 12. Cat. 3 113(1-12).

SHG; Karen Boccalero; instructor: Jean La Marr; *Etching Workshop;* July 1990: slide photographer: Michael M. Amescua; #Slides: 10. Cat. 3 114(1-10).

SHG; Leo Limón; *Silkscreen Workshop;* August 1982: #Slides: 22. Cat. 3 115(1-22).

SHG; Mari Yáñez and Cecilia Castañeda; *Day of the Dead '78 Mask-Making Workshop;* October 1978: Fund: NEH and SHG; #Slides: 12. Cat. 3 116(1-12).

SHG; Michael M. Amescua; *Against Cocaine Paperwork;* March 1-28, 1987: Fund: NEA Expansion Arts, SHG; #Slides: 4. Cat. 3 117(1-4).

SHG; Michael M. Amescua; *Fire Show V;* May 12-23, 1989: Fund: NEA Visual Arts and CAC; slide photographer: Arturo Urista; #Slides: 7. Cat. 3 118(1-7).

SHG; Michael M. Amescua; *Fuego Nuevo Show;* November 1985: Fund: NEA Expansion Arts, SHG; #Slides: 19. Cat. 3 119(1-19).

SHG; Michael M. Amescua; assistants: Karen Boccalero and Leo Limón; *Michael M. Amescua Studio Exhibition;* April 16, 1984: Fund: NEA Expansion Arts, SHG; #Slides: 10. Cat. 3 120(1-10).

SHG; Michael M. Amescua; *New Fire Exhibition;* October 19, 1985: Fund: NEA Expansion Arts, SHG; #Slides: 7. Cat. 3 121(1-7).

SHG; Michael M. Amescua, Arturo Urista and Dolores Guerrero-Cruz; *Pintura Fresca Exhibition;* February 12-March 10, 1989: Fund: NEA Expansion Arts; #Slides: 6. Cat. 3 122(1-6).

SHG; Michael M. Amescua, Linda Vallejo and SHG Staff; assistants: Cecilia Castañeda; *Day of the Dead '78 Workshop;* September 1978: #Slides: 14. Note: Music jam. Cat. 3 123(1-14).

SHG; Ricardo Duffy; assistants: Sandra Hahn and Leonardo Ibañez; *Day of the Dead '90 Exhibition;* November 2, 1990: Fund: NEA Expansion Arts and SHG; slide photographer: Ed Carreon; #Slides: 3. Cat. 3 124(1-3).

SHG; Rick Raya and Richard Valdez; *For the Love of Art Exhibition and Reception;* January 6-26, 1991: Fund: NEA Expansion Arts; slide photographer: Gloria Westcoat; #Slides: 12. Cat. 3 125(1-12).

SHG; Rudy Calderón, Curtis Gutierrez and Nick Gadbois; *III Exhibition;* August 6-31, 1989: Fund: NEA Expansion Arts, SHG; #Slides: 7. Cat. 3 126(1-7).

SHG; Salvador Hernández, Luis Ituarte, Chaz Bojòrquez and Xavier Quijas; *Tradición y Futuro Exhibition;* February 8, 1991: Fund: SHG and NEA Expansion Arts; #Slides: 18. Cat. 3 127(1-18).

SHG; Sarah Pineda-Rico and Beth Gregory; *Batik/Silkscreen Workshop;* n.d.: #Slides: 38. Cat. 3 128(1-38).

SHG; Sarah Pineda-Rico and Beth Gregory; *Batik/Silkscreen Workshop for Adults;* n.d.: #Slides: 14. Cat. 3 129(1-14).

SHG; Sarah Pineda-Rico and Beth Gregory; *Batik/Silkscreen Workshop for Teenagers;* n.d.: #Slides: 16. Cat. 3 130(1-16).

SHG; Sergio Zenteno; *New Language Exhibition;* June 3, 1990: Fund: NEA Expansion Arts, SHG; #Slides: 4. Cat. 3 131(1-4).

SHG; Stephen Grace; Demonstration of Silkscreen Techniques to High School Students; 1986: Fund: SHG; #Slides: 1. Cat. 3 132.

SHG; Yreina Cervantez; *Workshop--Visiting Artist John Valadez;* June 1986: Fund: NEA, CAC, and SHG; #Slides: 11. Cat. 3 133(1-11).

SHG; Yreina Cervantez, Gloria Alvarez, Frances España, Maríalice Jacob, Norma Alicia Pino and Kay Torres; *Alerta Exhibition;* June 19, 1987: Fund: NEA Expansion Arts, SHG; slide photographer: Shifra Goldman; #Slides: 3. Cat. 3 134(1-3).

Drawings

Artist Unknown; *La Cruda;* n.d. pen and ink: Note: From *Day of the Dead '89* Exhibition at SHG, 3802 Brooklyn Ave, Los Angeles, CA (November 3, 1989). Cross: CAP. Cat. 4 001.

Aguirre, José Antonio; *Untitled;* n.d. dry point: Cat. 4 002.

Alicia, Juana; *(title unknown);* n.d.: #Slides: 2. Cat. 4 003(1-2).

Alicia, Juana; *Sin Hogar;* ca. 1986; pencil on paper: Cat. 4 004.

Audifred, Magda; *(title unknown);* n.d. ink; #Slides: 2. Cat. 4 005(1-2).

Bueno, Carlos; *Somos de la Vida Caliente (detail);* n.d. india ink on paper: Cat. 4 006.

Bueno, Carlos; *Somos de la Vida Caliente (detail);* n.d. india ink on paper: Cat. 4 007.

Bueno, Carlos; *Burla a la Gente;* n.d. india ink on paper: Cat. 4 008.

Bueno, Carlos; *Eduardo;* n.d.: Cat. 4 009.

Bueno, Carlos; *Homosexual;* n.d. india ink on paper: Cat. 4 010.

Bueno, Carlos; *Las Vanidosas;* n.d. india ink on paper: Cat. 4 011.

Bueno, Carlos; *Miedo;* n.d. india ink on paper: Cat. 4 012.

Bueno, Carlos; *Mujer;* n.d. india ink on paper: Cat. 4 013.

Bueno, Carlos; *La Ociocidad Es Madre De Todos Los Vicios;* 1974; india ink on paper: Cat. 4 014.

Bueno, Carlos; *Oh Shit;* n.d. india ink on paper: Cat. 4 015.

Bueno, Carlos; *Pensativa;* n.d. india ink on paper: Cat. 4 016.

Bueno, Carlos; *La que Ama Intensamente;* n.d. india ink on paper: Cat. 4 017.

Bueno, Carlos; *La que Está Muerta de Amor;* n.d. india ink on paper: Cat. 4 018.

Bueno, Carlos; *Somos de la Vida Caliente;* n.d. india ink on paper: #Slides: 3. Cat. 4 019.

Cuaron, Mita; *Dreaming;* n.d. pencil: Cat. 4 020.

García, Ed; *(title unknown);* 1970: #Slides: 5. Cat. 4 021(1-5).

Garza, José A. *(title unknown);* ca. 1975; pencil; #Slides: 6. Cat. 4 022(1-6).

Gonzalez, Yolanda; *Rest in Peace My Child;* n.d. pen and ink: <u>Note:</u> From *Day of the Dead '89* Exhibition at SHG, 3802 Brooklyn Ave, Los Angeles, CA (November 3, 1989). Cross: CAP. Cat. 4 023.

Gronk; *(title unknown);* n.d. pen and ink, markers; #Slides: 11. Cat. 4 024(1-11).

Hernández, Frank; *(title unknown);* n.d.: #Slides: 23. Cat. 4 025(1-23).

Limón, Leo; *(title unknown);* 1990: Cat. 4 026.

Limón, Leo; *(title unknown);* n.d. pen and ink, pencil and color pencils; #Slides: 10. Cat. 4 027(1-10).

Limón, Leo; *Agustin's Song;* n.d. pen and ink, pencil and color pencils: Cat. 4 028.

Limón, Leo; *Amor Flys Away;* 1989; pen and ink, pencil and color pencils: Cat. 4 029.

Limón, Leo; *Cortina of Smoke;* 1990: #Slides: 8. <u>Note:</u> From *Cortina of Smoke* series. Cat. 4 030(1-8).

Limón, Leo; *El Copycat;* 1990: Cat. 4 031.

Limón, Leo; *From 5 Puntos;* 1989; pen and ink, pencil and color pencils; #Slides: 2. Cat. 4 032(1-2).

Limón, Leo; *In the Light of La Luna;* 1990: #Slides: 3. Cat. 4 033(1-3).

Limón, Leo; *Locura;* ca. 1986; pen and ink on paper: Cat. 4 034.

Limón, Leo; *Los Fires;* n.d. pen and ink, pencil and color pencils: Cat. 4 035.

Limón, Leo; *Mirando Las Marigolds;* 1990: Cat. 4 036.

Limón, Leo; *Spiritual Cielos;* 1988; pen and ink, pencil and color pencils: Cat. 4 037.

Reyes, Miguel Angel; *(title unknown);* 1989: Cat. 4 038.

Reyes, Miguel Angel; *(title unknown);* 1989: Cat. 4 039.

Romero, Nancy; *Peppers #2;* 1989; monoprint: Cat. 4 040.

Starbuck, Peggi; *Eyefly;* n.d. pen and ink; #Slides: 2. Cat. 4 041(1-2).

Starbuck, Peggi; *Fish and the Mermaid;* n.d. pen and ink; #Slides: 2. Cat. 4 042(1-2).

Starbuck, Peggi; *Owl;* n.d. pen and ink; #Slides: 2. Cat. 4 043(1-2).

Starbuck, Peggi; *Porthole Fish;* n.d. pen and ink; #Slides: 2. Cat. 4 044(1-2).

Starbuck, Peggi; *Seahorse;* n.d. pen and ink; #Slides: 2. Cat. 4 045(1-2).

Starbuck, Peggi; *Unicorn;* n.d. pen and ink; #Slides: 2. Cat. 4 046(1-2).

Torrez, Eloy; *Mr. Penski;* n.d. pen on paper: Cat. 4 047.

Torrez, Eloy; *Untitled;* n.d. pen on paper: Cat. 4 048.

Torrez, Eloy; *Untitled;* n.d. pen on paper: Cat. 4 049.

Watanabe, Joan; *(title unknown);* n.d. oil, paint and pencil; #Slides: 5. Cat. 4 050(1-5).

Watanabe, Joan; *Roll Over;* n.d. pencil, charcoal and pastel: Cat. 4 051.

Watanabe, Joan; *Untitled;* n.d. oil, photos, straw, sticks and stones: Cat. 4 052.

Graphic Arts

Artist Unknown; *Resistencia Poster;* 1983: #Slides: 2. <u>Note:</u> Poster for *Resistencia* Exhibition of Willie Herrón at Galería Otra Vez, 3802 Brooklyn Avenue, Los Angeles, CA, organized by SHG (September 30, 1983). Cross: CAP. Cat. 5 001(1-2).

Artist Unknown; *(title unknown);* 1977; silkscreen; Fund: NEA and SHG; #Slides: 2. <u>Note:</u> Poster design for *Day of the Dead* celebration and exhibition at SHG (November 6, 1977). Cat. 5 002(1-2).

Artist Unknown; *(title unknown);* 1989; collage: Cat. 5 003.

Artist Unknown; *(title unknown);* n.d. mixed media: <u>Note:</u> From *Political* Exhibition at SHG, 3802 Brooklyn Avenue, Los Angeles, CA, during the month of December 1988. Cat. 5 004.

Artist Unknown; *(title unknown);* n.d. serigraphy: <u>Note:</u> From *Political* Exhibition at SHG, 3802 Brooklyn Avenue, Los Angeles, CA, during the month of December 1988. Cat. 5 005.

Artist Unknown; assistants: Design: Leo Límon; *Day of the Dead 1980 Poster;* November 1980: Fund: SHG, NEA, City of Los Angeles; #Slides: 1. <u>Note:</u> Cross: CAP. Cat. 5 006.

Artist Unknown; *Day of the Dead '74;* October 1974; silkscreen; Fund: SHG; #Slides: 1. <u>Note:</u> Poster for *Día de Los Muertos* celebration. Cat. 5 007.

Artist Unknown; *Mayan Bank--Past, Present, Future;* n.d.: #Slides: 8. <u>Note:</u> Details of works by children during the *Míranos* Exhibition of soft sculpture at SHG, organized by Sarah Pineda-Rico and Beth Gregory. Cross: CAP. Cat. 5 008(1-8).

Aguirre, José Antonio; *Ecos de Mayo..Nostalgia de mi Tierra;* August 1982; linoleum cut: Cat. 5 009.

Aguirre, José Antonio; *La Evolución de la Revolución;* 1987; linoleum cut: Cat. 5 010.

Aguirre, José Antonio; *No Tools;* 1987; relief etching: Cat. 5 011.

Aguirre, José Antonio; *Sacrifice;* 1987; linoleum cut: Cat. 5 012.

Alaniz, Cynthia; *Journey;* n.d. felt tip: Cat. 5 013.

Alferov, Alex; *(title unknown);* n.d. silkscreen; #Slides: 3. Cat. 5 014(1-3).

Alicia, Juana; *El Paseo del Siglo/The Ride of the Century;* 1984; silkscreen; #Slides: 2. Cat. 5 015(1-2).

Alicia, Juana; *La Ponkalavera Güera;* 1985; silkscreen : Cat. 5 016.

Ambris, Isaac H. *(title unknown);* n.d. serigraphy: Cat. 5 017.

Amemiya-Kirkman, Grace; *Behind the Woman;* 1989; monoprint: Cat. 5 018.

Amemiya-Kirkman, Grace; *Nature Becomes a Dream;* 1990; monoprint/linocut: Cat. 5 019.

Amemiya-Kirkman, Grace; *The Remembering;* 1990; monoprint: Cat. 5 020.

Amescua, Michael M. *(title unknown);* n.d.: Cat. 5 021.

Amescua, Michael M. *Día de los Muertos;* n.d. silkscreen: Cat. 5 022.

Amescua, Michael M. *Mariposo;* n.d. silkscreen: Cat. 5 023.

Aranda, Guillermo; *Visions of Dreams;* 1986; monotype: Cat. 5 024.

Arellanes, Antonio; *(title unknown);* n.d. silkscreen: <u>Note:</u> From *Day of the Dead '90* Exhibition at SHG, 3802 Brooklyn Ave, Los Angeles, CA (November 2, 1990). Cross: CAP. Cat. 5 025.

Audifred, Magda; *(title unknown);* n.d. serigraphy; #Slides: 2. Cat. 5 026(1-2).

Ayala, David; *(title unknown);* n.d. silkscreen; #Slides: 2. Cat. 5 027(1-2).

Ayala, David; *(title unknown);* n.d. silkscreen: <u>Note:</u> From *Day of the Dead '90* Exhibition at SHG, 3802 Brooklyn Ave, Los Angeles, CA (November 2, 1990). Cross: CAP. Cat. 5 028.

Ayala, David; *Queen of Hearts;* 1989; silkscreen: Cat. 5 029.

Baral, Joan Mall; *Albuquerque;* 1985; collage: Cat. 5 030.

Baral, Joan Mall; *Cruisin';* 1985; serigraphy: Cat. 5 031.

Baral, Joan Mall; *Gracias;* 1985; collage: Cat. 5 032.

Baral, Joan Mall; *Paradise Cove;* 1980; serigraphy: Cat. 5 033.

Baral, Joan Mall; *TV TImes;* 1981; serigraphy: Cat. 5 034.

Bejarano, Guillermo; *(title unknown);* n.d. silkscreen : Cat. 5 035.

Boccalero, Karen; *(title unknown);* n.d. silkscreen, various mediums; #Slides: 15. Cat. 5 036(1-15).

Boltuch, Glenna; *Growing Up in America;* 1986; mixed media: Cat. 5 037.

Boltuch, Glenna; *Portrait of Janine;* 1986; mixed media: Cat. 5 038.

Boltuch, Glenna; *Portrait of Rosa;* 1986; mixed media: Cat. 5 039.

Brehm, Qathryn; assistants: Untitled; *(title unknown);* n.d. silkscreen; #Slides: 4. Cat. 5 040(1-4).

Bueno, Carlos; *Al Cuidado de las Virgenes;* ca. 1973; silkscreen: Cat. 5 041.

Bueno, Carlos; *Baño del Narcizo;* ca. 1974; silkscreen: Cat. 5 042.

Bueno, Carlos; *Huichol;* n.d. silkscreen: Cat. 5 043.

Bueno, Carlos; *Invierno;* n.d. silkscreen: Cat. 5 044.

Bueno, Carlos; *Luna Vanidosa;* n.d. silkscreen: Cat. 5 045.

Bueno, Carlos; *Necesita Ayuda;* n.d. silkscreen: Cat. 5 046.

Bueno, Carlos; *Novia;* ca. 1973; silkscreen: Cat. 5 047.

Bueno, Carlos; *Novia en Feria;* ca. 1973; silkscreen: Cat. 5 048.

Bueno, Carlos; *Novia Roja;* n.d. silkscreen: Cat. 5 049.

Bueno, Carlos; *Novia Tipo Oriental;* n.d. silkscreen: Cat. 5 050.

Bueno, Carlos; *Novia Venadita;* n.d. silkscreen: Cat. 5 051.

Bueno, Carlos; *Otoño;* n.d. silkscreen: Cat. 5 052.

Bueno, Carlos; *Primavera;* n.d. silkscreen: Cat. 5 053.

Bueno, Carlos; *Vato Loco;* n.d. silkscreen: Cat. 5 054.

Bueno, Carlos; *Verano;* n.d. silkscreen: Cat. 5 055.

Cárdenas, Mari; *(title unknown);* n.d. silkscreen; #Slides: 32. Cat. 5 056(1-32).

Carrasco, Barbara; *(title unknown);* 1982; serigraphy: <u>Note:</u> Poster for *Día de las Madres* Celebration at Memorial Park, Pasadena, CA (May 9, 1982). Cat. 5 057.

Cervantez, Yreina; *Carmen Cortez;* 1975; lithography; #Slides: 3. Cat. 5 058(1-3).

Cervantez, Yreina; *Felicia and the Fox;* 1974; lithography; #Slides: 2. Cat. 5 059(1-2).

Chacón, Gloria; *(title unknown)*; ca. 1980; serigraphy: <u>Note:</u> Flyer for *Día de los Muertos* Celebration November 2, 1980 SHG (3802 Brooklyn Ave., Los Angeles, Ca.). Cat. 5 060.

Chacón, Gloria; *Xiconen;* 1980; serigraphy: Cat. 5 061.

Chamberlin, Ann; *Canoe, Talud-Tablero;* n.d. monotype on chine collé: Cat. 5 062.

Chamberlin, Ann; *Clouds, Green Things;* n.d. monotype with oil: Cat. 5 063.

Chamberlin, Ann; *Curtains, Hand;* n.d. monotype with oil on hand-made paper: Cat. 5 064.

Chamberlin, Ann; *Fire, Cape;* n.d. monotype with oil on handmade paper: Cat. 5 065.

Chamberlin, Ann; *Olla, Canoe, Coffee;* n.d. monotype: Cat. 5 066.

Chamberlin, Ann; *Olla, Little Lifeboat;* n.d. monotype: Cat. 5 067.

Chamberlin, Ann; *Olla, Loveboat, Icewater;* n.d. monotype: Cat. 5 068.

Chamberlin, Ann; *Olla, Spinning;* n.d. monotype with pencil : Cat. 5 069.

Chamberlin, Ann; *Olla, Volcanos;* n.d. monotype on gouache: Cat. 5 070.

Chamberlin, Ann; *Pennants, Smoke;* n.d. monotype with oil on hand-made paper: Cat. 5 071.

Chamberlin, Ann; *U.F.O.s;* ca. 1984; monotype: Cat. 5 072.

Christensen, Anna; *Judy Buffalo Reads "Portnoy's Complaint" (detail)*; 1988; monoprint: Cat. 5 073.

Christensen, Anna; *Rachel Sitting in the Big Red Chair (detail)*; 1988; monoprint: Cat. 5 074.

Christensen, Anna; *Dineh Elder;* n.d. monoprint: Cat. 5 075.

Christensen, Anna; *Joe Benally, Big Mountain;* 1987; monoprint: Cat. 5 076.

Christensen, Anna; *Judy Buffalo and the Spirit Wall;* 1988; monoprint: Cat. 5 077.

Christensen, Anna; *Judy Buffalo Reads "Portnoy's Complaint";* 1988; monoprint: Cat. 5 078.

Christensen, Anna; *Katharine Smith and Child;* 1987; monoprint: Cat. 5 079.

Christensen, Anna; *Larry Booth Takes a Coffee Break;* 1988; monoprint: Cat. 5 080.

Christensen, Anna; *Living on the Land;* 1987; monoprint: Cat. 5 081.

Christensen, Anna; *Mary and the Bougainvillea;* 1988; monoprint: Cat. 5 082.

Christensen, Anna; *Rachel Sitting in the Big Red Chair;* 1988; monoprint: Cat. 5 083.

Christensen, Anna; *We Are Told We Have To Move, But We Will Not Go;* n.d. monoprint: Cat. 5 084.

Christensen, Anna; *Woman With Her Sheep;* 1987; monoprint: Cat. 5 085.

Coronado, Sam; *Abuelito;* October 1985; silkscreen: Cat. 5 086.

Davenport, Margaret; *Cosmic Mixer;* 1986; paper on paper: Cat. 5 087.

Davenport, Margaret; *Reclining Figure;* 1986; paper on paper: Cat. 5 088.

Davenport, Margaret; *Weightless;* 1986; paper on paper: Cat. 5 089.

De Batuc, Alfredo; *Día de los Muertos 1981;* 1981; serigraphy: Cat. 5 090.

Duardo, Richard; *(title unknown)*; n.d. serigraphy: Cat. 5 091.

Ehrenberg, Felipe; *(title unknown)*; 1985; silkscreen: Cat. 5 092.

Fernández, Christina; *Oppression Series;* n.d. silkscreen: Cat. 5 093.

García, Margaret; *De Batuc;* n.d. monotype: Cat. 5 094.

García, Margaret; *Hyena I;* n.d. monotype: Cat. 5 095.

García, Margaret; *Hyena II;* n.d. monotype: Cat. 5 096.

García, Margaret; *Perro Fuego;* n.d. monotype: Cat. 5 097.

García, Margaret; *Viejo Perro;* n.d. monotype: Cat. 5 098.

García, Margaret; *Wolf-Dog Ceres [sic] Cactus;* n.d. monotype: Cat. 5 099.

García, Rupert; *Attica Is Fascismo;* 1976; serigraphy; ; Cat. 5 100.

García, Rupert; *Human Rights Day;* 1976; serigraphy: <u>Note:</u> For Amnesty International Human Rights Day December 10, 1976 based upon *El Grito Rebelde.* Cat. 5 101.

Gronk; *(title unknown)*; ca. 1981-1983; serigraphy; #Slides: 10. Cat. 5 102(1-10).

Guerrero-Cruz, Dolores; *Altar Madness;* 1991; monotype: Cat. 5 103.

Guerrero-Cruz, Dolores; *El Beso;* 1990; serigraphy: Cat. 5 104.

Guerrero-Cruz, Dolores; *Mujeres y Perros;* 1987; serigraphy: Cat. 5 105.

Guerrero-Cruz, Dolores; *Peace Makers;* 1985; serigraphy : Cat. 5 106.

Guerrero-Cruz, Dolores; *Untitled (The Bride);* 1985; serigraphy: Cat. 5 107.

Hernández, Ester; *La Ofrenda;* 1988; screenprint: Cat. 5 108.

Herrón, Willie; *Los Illegals;* n.d.: <u>Note:</u> From *Resistencia* Exhibition of Willie Herrón at Galería Otra Vez (3802 Brooklyn Avenue, Los Angeles, CA), organized by SHG (September 30, 1983). Cross: CAP. Cat. 5 109.

Hoyes, Bernard S. *Birthin;* n.d. monoprint: <u>Note:</u> From *Rag* Series. Cat. 5 110.

Hoyes, Bernard S. *Celestial Bodies in Eclipse;* n.d. monoprint: <u>Note:</u> From *Rag* Series. Cat. 5 111.

Hoyes, Bernard S. *Chicken in Rag;* n.d. monoprint: <u>Note:</u> From *Rag* Series. Cat. 5 112.

Hoyes, Bernard S. *Dying Bull;* n.d. monoprint: <u>Note:</u> From *Rag* Series. Cat. 5 113.

Hoyes, Bernard S. *Hands on Rags;* n.d. monoprint: <u>Note:</u> From *Rag* Series. Cat. 5 114.

Hoyes, Bernard S. *Rag Existence;* n.d. monoprint: <u>Note:</u> From *Rag* series. Cat. 5 115.

Hoyes, Bernard S. *Rag Nouveau;* n.d. monoprint: <u>Note:</u> From *Rag* Series. Cat. 5 116.

Hoyes, Bernard S. *Redemption Song;* n.d. multimedia: <u>Note:</u> From *Rag* Series. Cat. 5 117.

Ibañez, Antonio; *(title unknown)*; n.d. taffeta silkscreen: Cat. 5 118.

Ibañez, Antonio; *Día Alegre;* n.d. silkscreen: Cat. 5 119.

LaMarr, Jean; *The American Indians U.S. Constitution;* 1988; monotype: Cat. 5 120.

LaMarr, Jean; *From the Boudoir;* 1988; monotype: Cat. 5 121.

LaMarr, Jean; *Lighting Up No. 1;* 1988; monotype: Cat. 5 122.

LaMarr, Jean; *Only in America No. 3;* 1988; monotype: Cat. 5 123.

LaMarr, Jean; *She's Black Mountain;* 1988; monotype: Cat. 5 124.

Leal, Steven; *(title unknown)*; n.d. serigraphy; #Slides: 4. Cat. 5 125(1-4).

Limón, Leo; *(title unknown)*; 1978: <u>Note:</u> Poster for *Beto's Dream* by *Teatro Urbano.* Cat. 5 126.

Limón, Leo; *(title unknown)*; 1979: <u>Note:</u> Poster for *Teatro Urbano* play *The Silver Dollar.* Cat. 5 127.

Limón, Leo; *(title unknown)*; 1980: <u>Note:</u> Poster for 7th Annual International Film Festival: Los Angeles the Ethnic Experience 1980. Cat. 5 128.

Limón, Leo; *(title unknown)*; 1982: <u>Note:</u> Poster for Santa Monica Mountains Folklife Festival. Cat. 5 129.

Limón, Leo; *(title unknown)*; n.d.: #Slides: 20. Cat. 5 130(1-20).

Lucero, Linda; *Poster to Lolita Lebrón;* 1977; silkscreen : Cat. 5 131.

Maradiaga, Ralph; *(title unknown)*; ca. 1973; silkscreen: <u>Note:</u> Poster for *El Sol Nunca Muere* Exhibition at Galería de la Raza (September 7, 1973). Cat. 5 132.

Maradiaga, Ralph; *(title unknown)*; ca. 1973; photo silkscreen: Cat. 5 133.

Oropeza, Eduardo; *Onward Christian Soldiers;* December 1985; silkscreen; Fund: NEA and CAC; #Slides: 1. Cat. 5 134.

Ortega, Tony; *Amantes;* ca. 1985; silkscreen: Cat. 5 135.

Ortega, Tony; *Cholo con Blaster;* ca. 1987-1989; silkscreen: Cat. 5 136.

Ortega, Tony; *El Don y la Doña García;* ca. 1985; silkscreen: Cat. 5 137.

Ortega, Tony; *La Familia García;* ca. 1985; silkscreen: Cat. 5 138.

Ortega, Tony; *Grupo Folklórico;* ca. 1987-1989; silkscreen: Cat. 5 139.

Ortega, Tony; *Grupo Folklórico Mexicano;* ca. 1987-1989; silkscreen: Cat. 5 140.

Ortega, Tony; *Hombres con Ponchos;* ca. 1985; silkscreen: Cat. 5 141.

Ortega, Tony; *Los Musicos;* ca. 1987-1989; silkscreen: Cat. 5 142.

Ortega, Tony; *Puesto con Chicas;* ca. 1985; monotype: Cat. 5 143.

Ortega, Tony; *San Antonio Cinco de Mayo;* ca. 1985; silkscreen: Cat. 5 144.

Ortega, Tony; *La Troca Lowrider;* ca. 1987-1989; monotype: Cat. 5 145.

Ortega, Tony; *Unto con Cigarro;* ca. 1987-1989; monotype: Cat. 5 146.

Osorio; *(title unknown)*; n.d. airbrush on silk: Cat. 5 147.

Pinkel, Sheila; *(title unknown)*; 1983; serigraphy: Cat. 5 148.

Pinkel, Sheila; *(title unknown)*; 1985; serigraphy; #Slides: 8. Cat. 5 149(1-8).

Pinkel, Sheila; *(title unknown)*; n.d. serigraphy; #Slides: 10. Cat. 5 150(1-10).

Ponce, Michael D. *(title unknown)*; n.d. silkscreen: Note: *Día de los Muertos* Poster. Cat. 5 151.

Reyes, Miguel Angel; *(title unknown)*; n.d. silkscreen; #Slides: 6. Cat. 5 152(1-6).

Smith, Susan; *Craig and Kim;* 1974; silkscreen: Cat. 5 153.

Smith, Susan; *K Mart;* 1972; silkscreen: Cat. 5 154.

Smith, Susan; *Lucky;* 1973; silkscreen: Cat. 5 155.

Sparrow, Peter V. *(title unknown)*; n.d. silkscreen; #Slides: 6. Cat. 5 156(1-6).

Sparrow, Peter V. *(title unknown)*; n.d. silkscreen: Cat. 5 157.

Sparrow, Peter V. *Cleo;* n.d. linocut: Cat. 5 158.

Thylor, Neal; *Thank You Bucky;* n.d. collage: Cat. 5 159.

Uribe, Mario; *Plan B;* n.d. serigraphy: Cat. 5 160.

Uribe, Mario; *Plan III;* n.d. serigraphy: Cat. 5 161.

Uribe, Mario; *Plan IV;* n.d. serigraphy: Cat. 5 162.

Uribe, Mario; *Zen;* n.d. serigraphy: Cat. 5 163.

Urista, Arturo; *(title unknown)*; n.d. silkscreen: Cat. 5 164.

Urista, Arturo; *Amarillo;* n.d. silkscreen: Cat. 5 165.

Urista, Arturo; *Mosquito;* 1985; silkscreen: Cat. 5 166.

Urista, Arturo; *Statement #1;* 1984; ink: Cat. 5 167.

Urista, Arturo; *Statement #2;* 1984; ink: Cat. 5 168.

Urista, Arturo; *Statement #3;* 1984; ink: Cat. 5 169.

Urista, Arturo; *Vato;* 1985; silkscreen: Cat. 5 170.

Valadez, John; *Beautificado;* 1976; serigraphy: Cat. 5 171.

Valdez, Patssi; *(title unknown)*; n.d. silkscreen; #Slides: 6. Cat. 5 172(1-6).

Valdez, Patssi; *Altar for Day of the Dead;* 1988; silkscreen : Cat. 5 173.

Vallejo, Linda; *Conversation;* n.d. litho monotype: Cat. 5 174.

Vallejo, Linda; *Lofty Cynicism;* 1975; litho monotype: Cat. 5 175.

Vallejo, Linda; *Potato Prints;* n.d.: #Slides: 2. Note: From *Míranos Children* Exhibition of soft sculpture at SHG, organized by Sarah Pineda-Rico and Beth Gregory. Cross: CAP. Cat. 5 176(1-2).

Vallejo, Linda; *Ronald;* 1976; litho monotype: Cat. 5 177.

Valverde, Richard; *(title unknown)*; 1980; serigraphy: Note: Poster for *Día de los Muertos* Photography Exhibition at SHG (November 2, 1980). Cat. 5 178.

Watanabe, Joan; *Fault Line;* n.d. offset litho; #Slides: 2. Cat. 5 179(1-2).

Yáñez, Antonio; *(title unknown)*; n.d. serigraphy : Note: Poster designed for *Día de los Muertos* Exhibition at SHG. Cat. 5 180.

Yáñez, Larry; *(title unknown)*; n.d. mixed media; #Slides: 16. Cat. 5 181(1-16).

Yepez, George; *(title unknown)*; n.d. silkscreen; #Slides: 2. Cat. 5 182(1-2).

Yudell, Janice; *Mad Miss Whale;* n.d. color xerox: Cat. 5 183.

Zebala, Aneta; *Chamber Music;* 1984; silkscreen: Cat. 5 184.

Zenteno, Sergio; *(title unknown)*; n.d.: Note: From *New Language* Exhibition at Galería Otra Vez, 3802 Brooklyn Avenue, Los Angeles, CA, organized by SHG. Cross: CAP. Cat. 5 185.

Zenteno, Sergio; *(title unknown)*; n.d. silkscreen and paint: Cat. 5 186.

Installation Art

Artist Unknown; *(title unknown)*: Note: From *Political* Exhibiton at SHG during the month of December, 1988. Cat. 7 001.

Artist Unknown; *(title unknown)*; n.d.: Fund: NEA Expansion Arts and SHG; #Slides: 1. Note: From *New Fire* Exhibition, organized by Michael M. Amescua. Cross: CAP. Cat. 7 002.

Amado, Ofelia; *(title unknown)*; November 2, 1990: Note: From *Day of the Dead '90* Exhibition at SHG. Cross: CAP. Cat. 7 003.

Amescua, Michael M. *(title unknown)*; n.d.: Cat. 7 004.

Electra; *(title unknown)*; n.d.: #Slides: 2. Cat. 7 005(1-2).

Gomez, Pat; *(title unknown)*; November 2, 1990: Note: From *Day of the Dead '90* Exhibition at SHG. Cross: CAP. Cat. 7 006.

Gonsalves, Ricardo; *Fatal Contradiction;* n.d.: #Slides: 2. Cat. 7 007(1-2).

Lopez, José; *Untitled;* November 3, 1989: Note: From *Day of the Dead '89* Exhibition at SHG. Cross: CAP. Cat. 7 008.

Sparrow, Peter V. *L.A. Store;* n.d.: #Slides: 17. Cat. 7 009(1-17).

Yáñez, Larry; *(title unknown)*; n.d.: Cat. 7 010.

Murals

Artist Unknown; *(title unknown)*; June 1980; tile mural; #Slides: 2. Note: Details of tile murals during the *Tile Workshop* at SHG, organized by Jack Alexander. Cross: CAP. Cat. 8 001(1-2).

Artist Unknown; *(title unknown)*; June 1980; tile mural; #Slides: 26. Note: Details of tile murals during the *Tile Workshop* at SHG, organized by Jack Alexander. Cross: CAP. Cat. 8 002(1-26).

Artist Unknown; *(title unknown)*; June 1980; tile mural; #Slides: 3. Note: From *Míranos* Exhibition of tile mural at SHG (June 1980). Cross: CAP. Cat. 8 003(1-3).

Alicia, Juana; *Earth Book;* ca. 1987; skyline collage: Cat. 8 004.

Amescua, Michael M. *(title unknown)*; June 1980; tile mural: Note: From the *Tile Workshop* at SHG, organized by Jack Alexander. Cross: CAP. Cat. 8 005.

Amescua, Michael M. *(title unknown)*; n.d. tile mural; #Slides: 3. Note: From *Míranos* Exhibition of tile mural at SHG (June 1980). Cross: CAP. Cat. 8 006(1-3).

Boltuch, Glenna; *L.A. Freeway Kids Olympic Mural 1984;* 1984: Fund: Los Angeles Olympic Organizations; #Slides: 1. Cat. 8 007.

Boltuch, Glenna; *Black Folk Art Museum;* 1983: Cat. 8 008.

Bueno, Carlos; *(title unknown)*; n.d.: Note: Detail of mural. Cat. 8 009.

Chacón, Gloria; *(title unknown)*; June 1, 1980; tile mural: Note: From *Tile Workshop* at SHG, organized by Jack Alexander. Cross: CAP. Cat. 8 010.

Chacón, Gloria; *(title unknown)*; n.d. tile mural: Note: From *Míranos* Exhibition of tile mural at SHG (June 1980). Cross: CAP. Cat. 8 011.

Delgado, Roberto; *(title unknown)*; n.d.: Cat. 8 012.

Delgado, Roberto; *Hombre de Oxchue;* 1979: Note: A detail from Phil Meisinger's mural *Hombre de Oxchue* (7'x 5'). Cat. 8 013.

Garza, José A. *(title unknown)*; n.d. acrylic: Cat. 8 014.

Gonzalez, Frank; *(title unknown)*; June 1980; tile mural; #Slides: 4. Note: From the *Tile Workshop* at SHG, organized by Jack Alexander. Cross: CAP. Cat. 8 015(1-4).

Gonzalez, Frank; *(title unknown)*; June 1980; tile mural: Note: From the *Tile Workshop* at SHG, organized by Jack Alexander. Cross: CAP. Cat. 8 016.

Gonzalez, Frank; *(title unknown)*; June 1980; tile mural: Note: From *Míranos* Exhibition of tile mural at SHG (June 1980). Cross: CAP. Cat. 8 017.

Limón, Leo; *(title unknown)*; June 1980; tile mural: Note: From the *Tile Workshop* at SHG, organized by Jack Alexander. Cross: CAP. Cat. 8 018.

Limón, Leo; *(title unknown)*; June 1980; tile mural: Note: From *Míranos* Exhibition of tile mural at SHG (June 1980). Cross: CAP. Cat. 8 019.

Los Streetscapers; *(title unknown)*; n.d.: #Slides: 9. Cat. 8 020(1-9).

Los Streetscapers; *Education Suite;* 1981: #Slides: 2. Cat. 8 021(1-2).

Los Streetscapers; *La Familia;* 1977: Cat. 8 022.

Los Streetscapers; *Filling Up on Ancient Energies;* 1981: #Slides: 2. Cat. 8 023(1-2).

Pineda-Rico, Sarah; *(title unknown)*; June 1980; tile mural: Note: From the *Tile Workshop* at SHG, organized by Jack Alexander. Cross: CAP. Cat. 8 024.

Pineda-Rico, Sarah; *(title unknown)*; June 1980; tile mural: Note: From *Míranos* Exhibition of tile mural at SHG (June 1980). Cross: CAP. Cat. 8 025.

Pinkel, Sheila; *(title unknown)*; n.d. serigraphy mounted: Note: Mural from park, La Brea, CA. Cat. 8 026.

Romero, Frank; *Going to the Olympics 1984;* 1984; acrylic on concrete: Cat. 8 027.

Torrez, Eloy; *Hollywood Mural: Legends of Hollywood;* November 1983: #Slides: 3. Cat. 8 028(1-3).

Uribe, Mario; *Ramada Hotel Mural;* 1989: Cat. 8 029.

Vallejo, Linda; *(title unknown)*; June 1980; tile mural: Note: From *Míranos* Exhibition of tile mural at SHG (June 1980). Cross: CAP. Cat. 8 030.

Paintings

Artist Unknown; *(title unknown)*; n.d.: #Slides: 15. Note: From *Carnalismo* Exhibition at Tijuana, Mexico, organized by SHG (September 1987). Cross: CAP. Cat. 9 001(1-15).

Artist Unknown; *(title unknown);* n.d.: <u>Note:</u> From *New Fire* Exhibition at Galería Otra Vez, 3802 Brooklyn Avenue, Los Angeles, CA, organized by Michael M. Amescua through SHG (October 19, 1985). Cross: CAP. Cat. 9 002.

Artist Unknown; *(title unknown);* n.d.: #Slides: 5. <u>Note:</u> From *Day of the Dead* Exhibition at SHG (November 2, 1980). Cross: CAP. Cat. 9 003(1-5).

Alferov, Alex; *(title unknown);* n.d. acrylic; #Slides: 2. Cat. 9 004(1-2).

Alferov, Alex; *(title unknown);* n.d. acrylic: Cat. 9 005.

Alferov, Alex; *(title unknown);* n.d. acrylic: Cat. 9 006.

Alferov, Alex; *(title unknown);* n.d. acrylic: Cat. 9 007.

Alferov, Alex; *(title unknown);* n.d. acrylic: Cat. 9 008.

Alicia, Juana; *(title unknown);* ca. 1989: #Slides: 4. Cat. 9 009(1-4).

Alicia, Juana; *Auto-Vision;* 1987; pastel on paper; #Slides: 2. Cat. 9 010(1-2).

Alicia, Juana; *Corazón;* 1987; pastel on paper: Cat. 9 011.

Alicia, Juana; *Danzante;* 1987; watercolor on paper: Cat. 9 012.

Alicia, Juana; *Mi Dicotomía;* 1987; pastel on paper: Cat. 9 013.

Alicia, Juana; *Rosa;* 1987; pastel on paper: Cat. 9 014.

Ambris, Isaac H. *(title unknown);* n.d.: Cat. 9 015.

Amemiya-Kirkman, Grace; *(title unknown);* 1989: Cat. 9 016.

Amescua, Michael M. *(title unknown);* n.d. spray and enamel: Cat. 9 017.

Amescua, Michael M. *(title unknown);* n.d. spray and enamel on metal: Cat. 9 018.

Amescua, Michael M. *Xolotl;* n.d. spray enamel: Cat. 9 019.

Aranda, Guillermo; *(title unknown);* 1987: Cat. 9 020.

Aranda, Guillermo; *(title unknown);* n.d.: Cat. 9 021.

Aranda, Guillermo; *(title unknown);* n.d.: Cat. 9 022.

Aranda, Guillermo; *(title unknown);* n.d.: Cat. 9 023.

Aranda, Guillermo; *(title unknown);* n.d.: Cat. 9 024.

Aranda, Guillermo; *Calling the Dancers;* October 1986: Cat. 9 025.

Aranda, Guillermo; *Eagle Warrior;* May 1987: Cat. 9 026.

Aranda, Guillermo; *Mazatl Deerman;* 1984: Cat. 9 027.

Aranda, Guillermo; *White Hawk Maiden;* n.d.: Cat. 9 028.

Audifred, Magda; *(title unknown);* n.d. mixed media; #Slides: 3. Cat. 9 029(1-3).

Audifred, Magda; *(title unknown);* n.d. watercolor, ink: Cat. 9 030.

Audifred, Magda; *(title unknown);* n.d. oil, acrylic: Cat. 9 031.

Audifred, Magda; *(title unknown);* n.d. mixed media; #Slides: 2. Cat. 9 032(1-2).

Ayala, David; *Pieta;* n.d. acrylic-enamel on canvas: Cat. 9 033.

Ayala, David; *Untitled;* n.d. acrylic-enamel on canvas: Cat. 9 034.

Ayala, David; *Untitled;* n.d. acrylic-enamel on canvas: Cat. 9 035.

Baral, Joan Mall; *Abstraction #4;* 1986; watercolor: Cat. 9 036.

Baral, Joan Mall; *Self-Portrait;* 1984; oil: Cat. 9 037.

Bert, Guillermo; *Concurrent;* ca. 1988-1989; oil on canvas: Cat. 9 038.

Bert, Guillermo; *The Flasher;* 1987; oil on canvas: Cat. 9 039.

Bert, Guillermo; *Seeds of Illusion 1,2 and 3;* 1988; oil on canvas: Cat. 9 040.

Bert, Guillermo; *Seeds of Illusion #2;* 1988; oil on canvas: Cat. 9 041.

Bert, Guillermo; *Seeds of Illusion #3;* ca. 1988-1989; oil on canvas: Cat. 9 042.

Bert, Guillermo; *Two Silents Echos [sic];* 1987; oil on canvas; #Slides: 2. Cat. 9 043(1-2).

Bert, Guillermo; *The Warning;* 1987; oil on canvas: Cat. 9 044.

Bojórquez, Chaz; *(title unknown);* n.d.: Fund: NEA Expansion Arts and SHG; #Slides: 1. <u>Note:</u> From *Tradición y Futuro* Exhibition at Galería Otra Vez, 3802 Brooklyn Avenue, Los Angeles, CA, organized by SHG (February 8, 1981). Cross: CAP. Cat. 9 045.

Botello, David; *Self-Portrait with Jaguar and Serpent;* ca. 1978; acrylic on canvas: Cat. 9 046.

Botello, Paul J. *(title unknown);* ca. 1985-1986; acrylic on canvas: Cat. 9 047.

Botello, Paul J. *Bridge;* n.d. acrylic on canvas: Cat. 9 048.

Botello, Paul J. *For You;* 1989: <u>Note:</u> From *Day of the Dead '90* Exhibition at SHG, 3802 Brooklyn Avenue, Los Angeles, CA (November 3, 1989). Cross: CAP. Cat. 9 049.

Botello, Paul J. *Security;* 1984; acrylic on canvas: Cat. 9 050.

Botello, Paul J. *Temptation;* 1987; acrylic on canvas: Cat. 9 051.

Bueno, Carlos; *(title unknown);* n.d.: Cat. 9 052.

Bueno, Carlos; *Isabel, Novia de Pueblo;* n.d. acrylic: Cat. 9 053.

Bueno, Carlos; *Novia de Metepec;* n.d. acrylic: Cat. 9 054.

Bueno, Carlos; *Novia de Pueblo;* n.d.: Cat. 9 055.

Bueno, Carlos; *Remedios, Novia de Pueblo;* n.d. acrylic: Cat. 9 056.

Bueno, Carlos; *Tristeza;* n.d.: Cat. 9 057.

Calderón, Rudy; *(title unknown);* n.d.: Cat. 9 058.

Calderón, Rudy; *(title unknown);* n.d.: Cat. 9 059.

Calderón, Rudy; *(title unknown);* n.d.: #Slides: 3. Cat. 9 060(1-3).

Calderón, Rudy; *Innerman;* 1986; oil on window screen: Cat. 9 061.

Calderón, Rudy; *Walking With My Child;* 1984; oil and gold enamel on canvas: Cat. 9 062.

Carbajal, Ricardo; *(title unknown);* n.d.; #Slides: 2. Cat. 9 063(1-2).

Cervantez, Yreina; *Despedida a las Ilusiones;* 1985; watercolor: Cat. 9 064.

Cervantez, Yreina; *Homenaje a Frida Kahlo;* n.d. watercolor : Cat. 9 065.

Cervantez, Yreina; *La Muerte de Artemio Cruz;* 1974; watercolor: Cat. 9 066.

Cervantez, Yreina; *Self-Portrait;* n.d. watercolor; #Slides: 2. Cat. 9 067(1-2).

Cervantez, Yreina; *Still Life with Titere;* 1975; Prismacolor pencils; #Slides: 2. Cat. 9 068(1-2).

Chamberlin, Ann; *Pier;* n.d. oil on aluminum: Cat. 9 069.

Chamberlin, Ann; *Sacrifice;* n.d. oil on aluminum: Cat. 9 070.

Coronado, Sam; *(title unknown);* 1986: #Slides: 4. Cat. 9 071(1-4).

Coronado, Sam; *(title unknown);* n.d. acrylic: Cat. 9 072.

Coronado, Sam; *(title unknown);* n.d. oil on canvas; #Slides: 12. Cat. 9 073(1-12).

Cuarón, Mita; *Frida and Me;* n.d. watercolor: Cat. 9 074.

Cuarón, Mita; *Pulse of Life--Bite of Death;* n.d. watercolor: Cat. 9 075.

Cuarón, Mita; *La Vida, Días para Nacimiento, Amor y Morir;* n.d. watercolor: Cat. 9 076.

De La Sota, Raoul; *Acatlán Cross;* ca. 1990; acrylic on canvas: Cat. 9 077.

De La Sota, Raoul; *Flor de Nopal;* ca. 1990; oil pastel: Cat. 9 078.

De La Sota, Raoul; *Noche de Nopal;* ca. 1990; acrylic on canvas: Cat. 9 079.

Delgado, Roberto; *(title unknown);* ca. 1985; mixed media with oil and spray on vinyl: Cat. 9 080.

Delgado, Roberto; *(title unknown);* ca. 1985; oil on canvas: Cat. 9 081.

Delgado, Roberto; *(title unknown);* ca. 1985; oil on canvas: Cat. 9 082.

Delgado, Roberto; *(title unknown);* ca. 1985; mixed media monotype on paper: Cat. 9 083.

Delgado, Roberto; *(title unknown);* ca. 1985; mixed media monotype on paper: Cat. 9 084.

Delgado, Roberto; *(title unknown);* 1987; mixed media on masonite with oil and spray; #Slides: 2. Cat. 9 085(1-2).

Delgado, Roberto; *(title unknown);* 1987; mixed media with oil and spray on canvas; #Slides: 2. Cat. 9 086(1-2).

Delgado, Roberto; *(title unknown);* 1987; mixed media with oil and spray on paper; #Slides: 5. Cat. 9 087(1-5).

Delgado, Roberto; *(title unknown);* n.d.; #Slides: 7. Cat. 9 088(1-7).

Delgado, Roberto; *(title unknown);* n.d.; #Slides: 5. Cat. 9 089(1-5).

Donis, Alex; *(title unknown);* n.d.; #Slides: 6. Cat. 9 090(1-6).

Duffy, Ricardo; *(title unknown);* n.d.; #Slides: 9. Cat. 9 091(1-9).

Duffy, Ricardo; *(title unknown);* n.d.; #Slides: 3. <u>Note:</u> Cross: collage. Cat. 9 092(1-3).

Duffy, Ricardo; *Civilization;* n.d.: Cat. 9 093.

Duffy, Ricardo; *El Diablo in the Projects;* n.d.: Cat. 9 094.

Duffy, Ricardo; *Society;* n.d.: Cat. 9 095.

Duffy, Ricardo; *Triumph and Tragedy;* n.d.: <u>Note:</u> Cross: collage. Cat. 9 096.

Durazo, Martín; *Deterioration;* 1989; oil on canvas: Cat. 9 097.

Durazo, Martín; *Love and Good in Hollywood;* 1989; acrylic: Cat. 9 098.

Durazo, Martín; *Love/Hate;* 1989; mixed media: Cat. 9 099.

Durazo, Martín; *Unstill Life;* 1989; acrylic; #Slides: 2. Cat. 9 100(1-2).

East Los Streetscapers; *(title unknown);* July 1982; acrylic on canvas: Cat. 9 101.

Ehrenberg, Felipe; *(title unknown);* ca. 1983; #Slides: 4. Cat. 9 102(1-4).

Electra; *(title unknown);* n.d.: #Slides: 6. Cat. 9 103 (1-6).

Eysymontt, Olga; *Hidden Valley;* 1988; gouache: Cat. 9 104.

Eysymontt, Olga; *Starry Night I;* 1988; gouache: Cat. 9 105.

Eysymontt, Olga; *Tapestry Flow;* 1988; gouache: Cat. 9 106.

Fernández, Christina; *Alienation;* n.d.: Cat. 9 107.

Fernández, Christina; *Sea of Nails;* n.d.: Cat. 9 108.

Fernández, Christina; *Womb Series;* n.d.: Cat. 9 109.

Florez, Elsa; *(title unknown)*; 1987; gesso canvas: Cat. 9 110.

Florez, Elsa; *(title unknown)*; 1987; oil, acrylic on paper: Cat. 9 111.

Florez, Elsa; *Ecce Homo;* 1986; oil on canvas: Cat. 9 112.

Florez, Elsa; *The Healing;* 1987; oil on canvas: Cat. 9 113.

Gamboa, Diane; *Untitled;* ca. 1982: #Slides: 3. Cat. 9 114(1-3).

García, Margaret; *(title unknown)*; n.d.: Cat. 9 115.

García, Margaret; *Babies Sleeping;* n.d. pastel on monoprints: Cat. 9 116.

García, Margaret; *Dancing Calaveras;* 1987; oil on canvas: Cat. 9 117.

García, Margaret; *Marcos Monroy;* n.d. oil on canvas: Cat. 9 118.

García, Margaret; *Margaret Guzman;* n.d. oil on masonite: Cat. 9 119.

García, Margaret; *Oscar Duardo;* n.d. oil on canvas: Cat. 9 120.

García, Margaret; *Willie My Cousin;* n.d. oil on masonite: Cat. 9 121.

Garza, José A. *(title unknown)*; n.d. pastel: Cat. 9 122.

Garza, José A. *(title unknown)*; n.d. oil on paper: Cat. 9 123.

Garza, José A. *(title unknown)*; n.d. enamel: Cat. 9 124.

Garza, José A. *(title unknown)*; n.d. oil on posterboard; #Slides: 2. Cat. 9 125(1-2).

Garza, José A. *(title unknown)*; n.d. oil on paper: Cat. 9 126.

Garza, José A. *(title unknown)*; n.d. oil on posterboard: Cat. 9 127.

Gomez, Pat; *Belief;* 1988; oil and : Note: Cross: CAP. Cat. 9 128.

Gomez, Pat; *City Block;* 1988; oil and ; #Slides: 2. Note: Cross: CAP. Cat. 9 129(1-2).

Gomez, Pat; *Death Is a Breakthrough;* n.d. oil on canvas: Cat. 9 130.

Gomez, Pat; *Inner Calm;* 1985; oil on canvas: Cat. 9 131.

Gomez, Pat; *Iron Maiden;* 1989; oil and ; #Slides: 6. Note: Cross: CAP. Cat. 9 132(1-6).

Gomez, Pat; *Last Innocents;* 1989; oil and ; #Slides: 3. Cat. 9 133(1-3).

Gomez, Pat; *Lost in It;* n.d. oil and : Cat. 9 134.

Gomez, Pat; *Mother and Child;* 1988; oil on canvas; #Slides: 2. Cat. 9 135(1-2).

Gomez, Pat; *Mother and Child;* 1989; oil on board: Cat. 9 136.

Gomez, Pat; *Muddled by Detail;* 1989; oil and ; #Slides: 3. Note: Cross: CAP. Cat. 9 137(1-3).

Gomez, Pat; *Passages;* n.d. oil and : Cat. 9 138.

Gomez, Pat; *Passing Phases;* 1988; oil and ; #Slides: 2. Note: Cross: CAP. Cat. 9 139(1-2).

Gomez, Pat; *Ritual Hand;* 1989; oil and : Note: Cross: CAP. Cat. 9 140.

Gomez, Pat; *Tabloid Figure;* 1988; oil and : Note: Cross: CAP. Cat. 9 141.

Gomez, Pat; *Tabloid Figure II;* 1988; oil and : Note: Cross: CAP. Cat. 9 142.

Gomez, Pat; *Transition;* 1988; oil and : Note: Cross: CAP. Cat. 9 143.

Gomez, Pat; *Turn It On..Again;* 1987; oil pastel on canvas: Cat. 9 144.

Gonsalves, Ricardo; *(title unknown)*; n.d. acrylic: Cat. 9 145.

Gonsalves, Ricardo; *Compadres;* n.d. pen and ink: Cat. 9 146.

Gonsalves, Ricardo; *Coyote;* n.d. watercolor: Cat. 9 147.

Gonsalves, Ricardo; *Coyote Blue;* n.d.: Cat. 9 148.

Gonsalves, Ricardo; *Moonlight Nopales;* n.d.: Cat. 9 149.

Gonsalves, Ricardo; *Nopal;* n.d.: Cat. 9 150.

Gonsalves, Ricardo; *Nopales;* n.d.: Cat. 9 151.

Gonsalves, Ricardo; *Red Coyote;* n.d. pastel: Cat. 9 152.

Gonzales, Niva; *(title unknown)*; 1982; mixed media: Cat. 9 153.

Gonzales, Niva; *(title unknown)*; 1987; mixed media: Cat. 9 154.

Gonzales, Niva; *(title unknown)*; n.d. mixed media: Cat. 9 155.

Gonzales, Niva; *Man in White Turban; (title unknown)*; n.d. mixed media: Cat. 9 156.

Gonzalez, Yolanda; *The Memory of Our Embrace;* n.d. acrylic: Cat. 9 157.

Gonzalez, Yolanda; *Painful Thoughts;* n.d. acrylic: Cat. 9 158.

Gonzalez, Yolanda; *Santera Miau;* n.d. acrylic: Cat. 9 159.

Gonzalez, Yolanda; *Tino Cano;* n.d. acrylic: Cat. 9 160.

Guerrero-Cruz, Dolores; *(title unknown)*; 1990: Cat. 9 161.

Guerrero-Cruz, Dolores; *(title unknown)*; n.d.: Note: From *Day of the Dead '90* Exhibition at SHG, 3802 Brooklyn Ave, Los Angeles, CA (November 2, 1990). Cross: CAP. Cat. 9 162.

Guerrero-Cruz, Dolores; *Altar de Doña Lola;* April 1989; acrylic on canvas: Cat. 9 163.

Guerrero-Cruz, Dolores; *Altar de Doña Lola;* November 1989; acrylic on unstretched canvas; slide photographer: Michael M. Amescua; #Slides: 1. Cat. 9 164.

Guerrero-Cruz, Dolores; *Celebration Bride;* 1990; acrylic on canvas: Cat. 9 165.

Guerrero-Cruz, Dolores; *The Dressing Are Jewels;* 1990; acrylic on canvas: Cat. 9 166.

Guerrero-Cruz, Dolores; *The Heavy Heart;* February 1991; acrylic on canvas: Cat. 9 167.

Guerrero-Cruz, Dolores; *The Last Bride;* 1990; acrylic on canvas: Cat. 9 168.

Guerrero-Cruz, Dolores; *Liana mi Hija;* 1988; acrylic on canvas: Cat. 9 169.

Guerrero-Cruz, Dolores; *Lost Milagros;* 1990; acrylic on canvas: Cat. 9 170.

Guerrero-Cruz, Dolores; *Lydia y Silvia;* 1988; acrylic on paper: Cat. 9 171.

Guerrero-Cruz, Dolores; *Michael;* 1988; acrylic on paper: Cat. 9 172.

Guerrero-Cruz, Dolores; *Oscar;* 1988; acrylic on canvas: Cat. 9 173.

Guerrero-Cruz, Dolores; *Silla y Sarape;* 1990: Cat. 9 174.

Guerrero-Cruz, Dolores; *Unclaim My Heart;* February 1991; acrylic on canvas: Cat. 9 175.

Guerrero-Cruz, Dolores; *Walking with Death;* 1989; acrylic on canvas: Cat. 9 176.

Guerrero-Cruz, Dolores; *Wounded Heart;* February 1991; acrylic on canvas: Cat. 9 177.

Gutierrez, Robert; *The Leopard Colony;* 1990; acrylic paint on masonite, wood frame covered with fake leopard skin: Cat. 9 178.

Hahn, Sandra; *(title unknown)*; n.d.: Note: From *Day of the Dead '90* Exhibition at SHG, Brooklyn Ave, Los Angeles, CA (November 2, 1990). Cross: CAP. Cat. 9 179.

Hart, Jud; *Orígenes of Wisdom and Ignorance;* 1986; collage-construction with enamel: Note: Cross: Installation Art. Cat. 9 180.

Hernández, Salvador; *(title unknown)*; n.d.: Fund: NEA Expansion Arts and SHG; #Slides: 1. Note: From *Tradición y Futuro* Exhibition at Galería Otra Vez, 3802 Brooklyn Avenue, Los Angeles, CA, organized by SHG (February 8, 1981). Cross: CAP. Cat. 9 181.

Hernández, Salvador; *(title unknown)*; n.d.: Fund: NEA Expansion Arts and SHG; #Slides: 1. Note: From *Tradición y Futuro* Exhibition at Galería Otra Vez, 3802 Brooklyn Avenue, Los Angeles, CA, organized by SHG (February 8, 1981). Cross: CAP. Cat. 9 182.

Hernández, Salvador; *(title unknown)*; n.d.: Fund: NEA Expansion Arts and SHG; #Slides: 1. Note: From *Tradición y Futuro* Exhibition at Galería Otra Vez, 3802 Brooklyn Avenue, Los Angeles, CA, organized by SHG (February 8, 1981). Cross: CAP. Cat. 9 183.

Herrón, Willie; *Gronk and Herrón;* n.d. oil pastel : Note: From *Resistencia* Exhibition of Willie Herrón at Galería Otra Vez, 3802 Brooklyn Avenue, Los Angeles, CA, organized by SHG (September 30, 1983). Cross: CAP. Cat. 9 184.

Herrón, Willie; *Olympiadas;* n.d. acrylic: Note: From *Resistencia* Exhibition of Willie Herrón at Galería Otra Vez, 3802 Brooklyn Avenue, Los Angeles, CA, organized by SHG. Cat. 9 185.

Hoyes, Bernard S. *At the Table of Zion;* n.d. oils: Note: From *Revival* Series. Cat. 9 186.

Hoyes, Bernard S. *Banana with Lily;* n.d. watercolor: Cat. 9 187.

Hoyes, Bernard S. *Baptism by the Sea;* n.d. oils: Note: From *Revival* Series. Cat. 9 188.

Hoyes, Bernard S. *Bible Reading Under the Stars;* n.d. oils: Cat. 9 189.

Hoyes, Bernard S. *Closing Hymn;* n.d. oils: Note: From *Revival* Series. Cat. 9 190.

Hoyes, Bernard S. *Cow, Crane, Rainbow;* n.d. oils: Cat. 9 191.

Hoyes, Bernard S. *Day Passes in the Park;* n.d. watercolor : Cat. 9 192.

Hoyes, Bernard S. *Forest Offering;* n.d. oils: Cat. 9 193.

Hoyes, Bernard S. *Hexing Rites;* n.d. oils: Cat. 9 194.

Hoyes, Bernard S. *Hymn of the Puecomania;* n.d. oils: Note: From *Revival* Series. Cat. 9 195.

Hoyes, Bernard S. *Morning for Preparing Elixirs;* n.d. watercolor: Cat. 9 196.

Hoyes, Bernard S. *Oak on a Ridge;* n.d. watercolor on hand-made paper: Cat. 9 197.

Ituarte, Luis; *(title unknown)*; n.d.: Fund: NEA Expansion Arts and SHG; #Slides: 1. Note: From *Tradición y Futuro* Exhibition at Galería Otra Vez, 3802 Brooklyn Avenue, Los Angeles, CA, organized by SHG (February 8, 1981). Cross: CAP. Cat. 9 198.

Ituarte, Luis; *(title unknown)*; n.d.: #Slides: 31. Cat. 9 199(1-31).

Limón, Leo; *(title unknown)*; 1990: #Slides: 7. Cat. 9 200(1-7).

Limón, Leo; *East Side Locura;* acrylic on canvas: Cat. 9 202.

Limón, Leo; *Mujer.* #Slides: 1 . Cat. 9 203.

Limón, Leo; *La Nature's Light;* 1989; acrylic on canvas: Cat. 9 204.

Limón, Leo; *Ritmos Románticos;* 1986; pastels, graphite and shellae inks: Cat. 9 205.

Limón, Leo; *Sensational Visions;* 1986; pastels, graphite and shellae inks: Cat. 9 206.

Limón, Leo; *Tiempo 1989;* 1989; acrylic on canvas: Cat. 9 207.

Limón, Leo; *(title unknown);* n.d.: #Slides: 19. Cat. 9 201(1-19).

Loya, W. *Sugar Skulls;* n.d.: Note: From *Day of the Dead '90* Exhibition at SHG, 3802 Brooklyn Ave, Los Angeles, CA (November 3, 1989). Cross: CAP. Cat. 9 208.

Maruska, Pepe; *(title unknown);* n.d.: Note: From *Day of the Dead '90* Exhibition at SHG, 3802 Brooklyn Ave, Los Angeles, CA (November 2, 1990). Cross: CAP. Cat. 9 209.

Mincher, Sally; *(title unknown);* n.d. watercolor: Cat. 9 210.

Mincher, Sally; *(title unknown);* n.d. mixed media on paper : Cat. 9 211.

Mincher, Sally; *(title unknown);* n.d. oil and acrylic: Cat. 9 212.

Monroy, Marco; *(title unknown);* n.d.: Cat. 9 213.

Montaño, Ernesto; *(title unknown);* n.d. oil on paper: Cat. 9 214.

Montaño, Ernesto; *(title unknown);* n.d. ink and oil on paper: Cat. 9 215.

Montaño, Ernesto; *(title unknown);* n.d. oil on canvas: Cat. 9 216.

Norte, Armando; *(title unknown);* n.d.: #Slides: 12. Note: Group of paintings that conformed *Environmental Situation* work by Armando Norte at Galería Otra Vez, 3802 Brooklyn Ave., Los Angeles, CA (December 1983). Cross: CAP. Cat. 9 217(1-12).

Norte, Armando; *(title unknown);* n.d.: #Slides: 10. Cat. 9 218(1-10).

Norte, Armando; *(title unknown);* n.d. acrylic on canvas: Cat. 9 219.

Norte, Armando; *(title unknown);* n.d. ink and marker: Cat. 9 220.

Oropeza, Eduardo; *(title unknown);* n.d. cibachrome; #Slides: 27. Cat. 9 221(1-27).

Oropeza, Eduardo; *(title unknown);* n.d.: #Slides: 19. Cat. 9 222(1-19).

Oropeza, Eduardo; *Carla, Yolanda y Fulana;* n.d. cibachrome; #Slides: 2. Cat. 9 223(1-2).

Oropeza, Eduardo; *A Cual me Llevo;* n.d. cibachrome: Cat. 9 224.

Ortega, Tony; *Blaster Dichos;* n.d. oil: Cat. 9 225.

Ortega, Tony; *Dos Juntos;* n.d. oil: Cat. 9 226.

Ortega, Tony; *Pink Lowrider;* n.d. pastel: Cat. 9 227.

Ortega, Tony; *Super Siete;* n.d. pastel: Cat. 9 228.

Osorio; *(title unknown);* n.d. enamel on silver: Cat. 9 229.

Osorio; *(title unknown);* n.d. oil on canvas: Cat. 9 230.

Perez, Juan; *(title unknown);* n.d.: #Slides: 7. Cat. 9 231(1-7).

Perez, Louie; *(title unknown);* n.d.: Cat. 9 232.

Quijas, Xavier; *(title unknown);* n.d.: Fund: NEA Expansion Arts and SHG; #Slides: 1. Note: From *Tradición y Futuro* Exhibition at Galería Otra Vez, 3802 Brooklyn Avenue, Los Angeles, CA, organized by SHG (February 8, 1981). Cross: CAP. Cat. 9 233.

Quijas, Xavier; *(title unknown);* n.d.: Fund: NEA Expansion Arts and SHG; #Slides: 1. Note: From *Tradición y Futuro* Exhibition at Galería Otra Vez, 3802 Brooklyn Avenue, Los Angeles, CA, organized by SHG (February 8, 1981). Cross: CAP. Cat. 9 234.

Quijas, Xavier; *(title unknown);* n.d.: Fund: NEA Expansion Arts and SHG; #Slides: 1. Note: From *Tradición y Futuro* Exhibition at Galería Otra Vez, 3802 Brooklyn Avenue, Los Angeles, CA, organized by SHG (February 8, 1981). Cross: CAP. Cat. 9 235.

Quijas, Xavier; *(title unknown);* n.d.: Fund: NEA Expansion Arts and SHG; #Slides: 1. Note: From *Tradición y Futuro* Exhibition at Galería Otra Vez, 3802 Brooklyn Avenue, Los Angeles, CA, organized by SHG (February 8, 1981). Cross: CAP. Cat. 9 236.

Quinn, Linda; *(title unknown);* n.d.: Cat. 9 237.

Raya, Rich; *(title unknown);* n.d.: #Slides: 4. Note: From *For the Love of Art* Exhibition at Galería Otra Vez, organized for SHG members Rich Raya and Richard Valdez (January 6-January 26). Cross: CAP. Cat. 9 238(1-4).

Raya, Rich; *Despair;* 1990; oil on canvas: Cat. 9 239.

Raya, Rich; *María Lena;* 1981; oil on canvas: Cat. 9 240.

Raya, Rich; *Patricia;* 1989; oil on canvas: Cat. 9 241.

Raya, Rich; *Spectrums;* 1985; oil on canvas: Cat. 9 242.

Rodarte, Victor; *(title unknown);* n.d.: Note: From *Day of the Dead '90* Exhibition at SHG, Brooklyn Ave, Los Angeles, CA (November 2, 1990). Cross: CAP. Cat. 9 243.

Rodriguez, Reyes; *Así la Ví Yo (detail);* n.d. charcoal on paper: Cat. 9 244.

Rodriguez, Reyes; *Danzantes;* n.d. mixed media: Cat. 9 245.

Rodriguez, Reyes; *Desaparecido;* n.d. charcoal on paper: Cat. 9 246.

Rodriguez, Reyes; *Mother and Son;* n.d. charcoal on paper: Cat. 9 247.

Rodriguez, Reyes; *Shells;* n.d. mixed media: Cat. 9 248.

Romero, Frank; *(title unknown);* n.d.: Cat. 9 249.

Romero, Frank; *(title unknown);* n.d.: Note: From *Day of the Dead '90* Exhibition at SHG, 3802 Brooklyn Ave, Los Angeles, CA (November 2, 1990). Cross: CAP. Cat. 9 250.

Romero, Frank; *La Llorona;* 1982; acrylic on canvas: Cat. 9 251.

Romero, Frank; *Piso de Sangre;* 1986; oil on canvas: Cat. 9 252.

Romero, Frank; *Still Life with Red Car;* 1986; oil on canvas: Cat. 9 253.

Romero, Nancy; *(title unknown);* n.d.: Note: From *Day of the Dead '90* Exhibition at SHG, 3802 Brooklyn Ave, Los Angeles, CA (November 2, 1990). Cross: CAP. Cat. 9 254.

Romero, Nancy; *5 A.M.* 1989; oil on canvas: Note: From *Kitchen Art Series.* Cat. 9 255.

Romero, Nancy; *The Biological Clock;* 1990; oil on wood: Cat. 9 256.

Romero, Nancy; *Breakfast;* 1989; oil on canvas: Note: From *Kitchen Art* Series. Cat. 9 257.

Romero, Nancy; *Brown Pots;* 1989; oil on canvas: Note: From *Kitchen Art* Series. Cat. 9 258.

Romero, Nancy; *February;* 1990; oil on canvas: Cat. 9 259.

Romero, Nancy; *Geranium Lake;* 1990; oil on canvas: Cat. 9 260.

Romero, Nancy; *Kosshari Clowns;* 1989; oil on canvas: Cat. 9 261.

Romero, Nancy; *Life Journey;* 1990; oil on canvas: Cat. 9 262.

Romero, Nancy; *Out the Kitchen Window;* 1989; oil on canvas: Note: From *Kitchen Art* Series. Cat. 9 263.

Romero, Nancy; *Reflections;* 1990; oil on canvas: Cat. 9 264.

Romero, Nancy; *Taos Night;* 1989; oil on canvas: Cat. 9 265.

Roper, William; *Aunt Irma Prepares New Year's Dinner;* ca. 1988: #Slides: 1 . Cat. 9 266.

Roper, William; *The Big Top;* ca. 1988: Cat. 9 267.

Roper, William; *The Catch;* ca. 1988: Cat. 9 268.

Roper, William; *The Corruption of Love;* ca. 1988: Cat. 9 269.

Roper, William; *Cristo in the New World;* ca. 1988: Cat. 9 270.

Roper, William; *Din Din;* ca. 1988: Note: Cross: CAP. Cat. 9 271.

Roper, William; *Down to the Sea in Ships I Go, I Go;* ca. 1988: #Slides: 1 . Cat. 9 272.

Roper, William; *Ethiopia Saluting the Colors;* ca. 1988: Note: Cross: CAP. Cat. 9 273.

Roper, William; *Uptown Saturday Night;* ca. 1988: Cat. 9 274.

Roper, William; *Welcome;* ca. 1988: Cat. 9 275.

Ruiz, Cecilia; *Untitled;* n.d.: Cat. 9 276.

Ryan, Robin; *(title unknown);* n.d.: #Slides: 4. Cat. 9 277(1-4).

Salazar, Daniel Blake; *Ahead of the Game;* 1986; mixed media: Cat. 9 278.

Salazar, Daniel Blake; *Centerfold;* 1987; mixed media: Cat. 9 279.

Salazar, Daniel Blake; *Hundred Dollar Bit;* 1987; mixed media: Cat. 9 280.

Salazar, Daniel Blake; *Old;* 1987; mixed media: Cat. 9 281.

Salazar, Daniel Blake; *Out of Time;* 1987; mixed media: Cat. 9 282.

Salazar, Daniel Blake; *Redemption;* 1988; oil: Cat. 9 283.

Salazar, Daniel Blake; *Safe Sex;* 1987; mixed media: Cat. 9 284.

Salazar, Daniel Blake; *She's Got It;* 1986; ink: Cat. 9 285.

Salazar, Daniel Blake; *Shipwrecked;* 1987; mixed media: Cat. 9 286.

Sanchez, Leo; *Máscaras;* n.d. oil, spray paint, vinyl: Note: From *Day of the Dead '90* Exhibition at SHG, 3802 Brooklyn Ave, Los Angeles, CA (November 3, 1989). Cross: CAP. Cat. 9 287.

Sanchez, Olivia; *In Season;* n.d. graphite and watercolor on paper: Cat. 9 288.

Smith, Susan; *Edward in the Desert;* 1987; oil on canvas: Cat. 9 289.

Smith, Susan; *Father;* 1980; oil on canvas: Cat. 9 290.

Smith, Susan; *Grandpa and Grandma Watson;* 1987; oil on canvas: Cat. 9 291.

Solomon, David; *(title unknown);* n.d.: Note: From *Day of the Dead '90* Exhibition at SHG, 3802 Brooklyn Ave, Los Angeles, CA (November 2, 1990). Cross: CAP. Cat. 9 292.

Swift, M. T. *(title unknown);* ca. 1980-1984: #Slides: 12. Cat. 9 293(1-12).

Thomas, Matthew; *Relationship;* 1984; pastel and pencil: Cat. 9 294.

Torrez, Eloy; *(title unknown);* 1982: #Slides: 7. Cat. 9 295(1-4).

Torrez, Eloy; *(title unknown);* 1982: #Slides: 5. Cat. 9 296(1-5).

Torrez, Eloy; *Carlos and Sonia in the Rose Garden;* n.d. acrylic on canvas: Cat. 9 297.

Torrez, Eloy; *Exorcism of Cultural Inquisition;* n.d. acrylic on canvas: Cat. 9 298.

Torrez, Eloy; *Girl at the Beach;* n.d. acrylic on canvas; #Slides: 2. Cat. 9 299(1-2).

Torrez, Eloy; *Untitled;* n.d. acrylic on canvas: Cat. 9 300(1-2).

Torrez, Eloy; *Western Heroes;* n.d. acrylic on canvas: Cat. 9 301(1-3).

Torrez, Eloy; *Woman as Savior;* n.d. acrylic on canvas: Cat. 9 302.

Uribe, Mario; *Desert Scene #1;* 1987; acrylic on cast paper: Cat. 9 303.

Uribe, Mario; *Family Portrait;* 1989; mixed media: Cat. 9 304.

Uribe, Mario; *Forest Fire;* 1989; acrylic on wood: Cat. 9 305.

Uribe, Mario; *Landscape #15;* 1989; acrylic on paper: Cat. 9 306.

Uribe, Mario; *Landscape #18;* 1989; acrylic on paper: Cat. 9 307.

Uribe, Mario; *Mother and Child;* 1987; acrylic on handmade paper: Cat. 9 308.

Uribe, Mario; *La Mujer Dormida;* 1989; acrylic on wood: Cat. 9 309.

Uribe, Mario; *Night Madonna;* 1982; acrylic on handmade paper: Cat. 9 310.

Uribe, Mario; *Popo;* 1989; charcoal on paper: Cat. 9 311.

Uribe, Mario; *Red Door;* 1987; acrylic on handmade paper: Cat. 9 312.

Uribe, Mario; *La Rumorosa;* 1989; acrylic on paper: Cat. 9 313.

Uribe, Mario; *Salsa #1;* 1989; acrylic on handmade paper: Cat. 9 314.

Uribe, Mario; *Salsa #2;* 1989; acrylic on handmade paper: Cat. 9 315.

Uribe, Mario; *San Cristobal;* 1989; acrylic on wood: Cat. 9 316.

Urista, Arturo; *(title unknown);* 1988: #Slides: 16. Cat. 9 317(1-16).

Urista, Arturo; *Cha-Cha;* 1984; acrylic: Cat. 9 318.

Urista, Arturo; *In Spirit;* 1985; acrylic: Cat. 9 319.

Urista, Arturo; *Next Exit;* 1986; watercolor: Cat. 9 320.

Urista, Arturo; *Riugs;* 1986; watercolor: Cat. 9 321.

Urista, Arturo; *Sandino;* 1986; watercolor: Cat. 9 322.

Urista, Arturo; *Sun God;* 1985; acrylic: Cat. 9 323.

Urista, Arturo; *Sun Run;* 1986; watercolor: Cat. 9 324.

Urista, Arturo; *Suzi;* 1984; acrylic on canvas: Cat. 9 325.

Urista, Arturo; *Yo Soy;* 1985; acrylic: Cat. 9 326.

Valadez, John; *Myra;* 1982; pastel on paper: Cat. 9 327.

Valadez, John; *Pollo Macho;* 1983: Note: From *John Valadez Exhibition* at Galería Otra Vez, 3802 Brooklyn Avenue, Los Angeles, CA, organized by SHG (December 9, 1983). Cross: CAP. Cat. 9 328.

Valdes, Richard; *La Indiana;* n.d.: Cat. 9 329.

Valdes, Richard; *Japanese Dancer;* n.d. oil pastel: Cat. 9 330.

Valdes, Richard; *Old Women in Future;* n.d. watercolor: Cat. 9 331.

Valdes, Richard; *Sad Jester Landing on Earth;* n.d. acrylic: Cat. 9 332.

Valdez, Patssi; *(title unknown);* n.d.: Cat. 9 333.

Valdez, Patssi; *The Altar;* 1990; acrylic on canvas: Cat. 9 334.

Valdez, Patssi; *The Blue Rosas;* n.d.: Cat. 9 335.

Valdez, Patssi; *The Chalice;* 1989; acrylic on canvas: Cat. 9 336.

Valdez, Patssi; *The Glass (Self-Portrait);* 1990; acrylic on canvas: Cat. 9 337.

Valdez, Patssi; *The Goldfish;* 1990; acrylic on canvas: Cat. 9 338.

Valdez, Patssi; *The Headache;* 1989; acrylic on canvas: Cat. 9 339.

Valdez, Patssi; *The Kitchen;* 1990; acrylic on canvas: Cat. 9 340.

Valdez, Patssi; *The Masquerade;* 1990; acrylic on canvas: Cat. 9 341.

Valdez, Patssi; *Memories of France;* 1990; acrylic on canvas : Cat. 9 342.

Valdez, Patssi; *Mirror Mirror;* 1990; acrylic on canvas: Cat. 9 343.

Valdez, Patssi; *Ring of Fire;* 1990; acrylic on canvas: Cat. 9 344.

Valdez, Patssi; *Souvenirs of Spain;* n.d. acrylic on canvas : Cat. 9 345.

Valdez, Richard; *(title unknown);* n.d.: #Slides: 3. Note: From *For the Love of Art* Exhibition at Galería Otra Vez, organized for SHG members Rick Raya and Richard Valdez (January 6-January 26, 1991). Cross: CAP. Cat. 9 346(1-3).

Valdez, Richard and Rich Raya; *(title unknown);* n.d.: Note: From *For the Love of Art* Exhibition at Galería Otra Vez, organized for SHG members Rich Raya and Richard Valdez (January 6-January 26). Cross: CAP. Cat. 9 347.

Vallejo, Linda; *The Dance Of Life;* 1976; watercolor: Cat. 9 348.

Vallejo, Linda; *Man As His Complex Self;* 1976; watercolor : Cat. 9 349.

Vallejo, Linda; *A Sense Of Calmness;* 1976; watercolor: Cat. 9 350.

Yáñez, Larry; *(title unknown);* n.d.: #Slides: 8. Cat. 9 351(1-8).

Yáñez, Larry; *(title unknown);* n.d.: Cat. 9 352.

Zebala, Aneta; *Chicago Blue Skies;* 1986; mixed media: Cat. 9 353.

Zebala, Aneta; *Composition;* 1985; mixed media: Cat. 9 354.

Zebala, Aneta; *Composition II;* 1986; oil on canvas: Cat. 9 355.

Zebala, Aneta; *Composition III;* 1986; oil on canvas: Cat. 9 356.

Zebala, Aneta; *Composition IV;* 1985; oil on canvas: Cat. 9 357.

Zenteno, Sergio; *(title unknown);* n.d. oil on gator board: Cat. 9 358.

Zenteno, Sergio; *(title unknown);* n.d. oil on linen: Cat. 9 359.

Zenteno, Sergio; *(title unknown);* n.d. mixed media: Cat. 9 360.

Zenteno, Sergio; *(title unknown);* n.d. oil on panel: Cat. 9 361.

Zenteno, Sergio; *(title unknown);* n.d. oil on canvas: Cat. 9 362.

Zenteno, Sergio; *The Muse;* n.d. mixed media: Cat. 9 363.

Zermeño, Claire; *(title unknown);* n.d.: Note: From *Day of the Dead '90* Exhibition at SHG, 3802 Brooklyn Ave, Los Angeles, CA (November 2, 1990). Cross: CAP. Cat. 9 364.

Zermeño, Claire; *Celebration;* October 1989; oil: Cat. 9 366.

Zermeño, Claire; *King's Lair;* November 1989; oil: Cat. 9 367.

Zermeño, Claire; *The Land of Sassafrass Tea;* September 1988; acrylic: Cat. 9 368.

Zermeño, Claire; *Native Forms;* May 1989; oil: Cat. 9 369.

Zermeño, Claire; *Sandiwara;* January 1989; oil: Cat. 9 370.

Zermeño, Claire; *Untitled;* July 1986; acrylic: Cat. 9 371.

Zoell, Bob; *(title unknown);* n.d.: #Slides: 2. Cat. 9 372(1-2).

Photography

Artist Unknown; *(title unknown);* n.d.: #Slides: 4. Note: From *Political* Exhibition at SHG, 3802 Brooklyn Avenue, Los Angeles, CA, during the month of December 1988. These documentary pictures show diverse scenes of the political struggle during a Mexican presidential campaign. Cross: CAP. Cat. 11 001(1-4).

Artist Unknown; *Eloy Torrez and Mural;* ca. 1983-1984: Cat. 11 002.

Artist Unknown; *Untitled;* November 6, 1978: #Slides: 7. Note: Shots of an altar from an unknown community church at Los Angeles. Photos are part of the *Day of the Dead* Exhibition at SHG, organized by Michael M. Amescua and Linda Vallejo. Cross: CAP. Cat. 11 003(1-7).

Delgado, Roberto; *(title unknown);* n.d.: Cat. 11 004.

Fernández, Christina; *Alienation Series;* n.d.: Cat. 11 005.

Fernández, Christina; *Transition Series;* n.d.: Cat. 11 006.

Flores, Gloria Malia; *(title unknown);* n.d.: Cat. 11 007.

Gamboa, Harry; *Aura Cluster;* 1981; 5 x 7 polaroid pictures glued on canvas to conform a scene; #Slides: 3. Cat. 11 008(1-3).

Hahn, Sandra; *Stepping Phase;* n.d. computer animation and photography: Note: From *Day of the Dead '89* Exhibition at SHG, 3802 Brooklyn Ave, Los Angeles, CA (November 3, 1989). Cross: CAP. Cat. 11 009.

Jones, Patty Sue; *(title unknown);* n.d.: #Slides: 11. Cat. 11 010(1-11).

Martínez, Manuel; European Images '83-'84: A Celebration of Life; *(title unknown);* ca. 1983: #Slides: 8. Cat. 11 011(1-8).

Martínez, Manuel; *Lovers;* n.d.: Note: From *Europeans Images '83-'84 A Celebration of Life* Series. Cat. 11 012.

Martínez, Manuel; *Olympics '84--A View From the Street;* ca. 1984: #Slides: 11. Cat. 11 013(1-11).

Ponce, Michael D. *Untitled;* n.d. black and white on kodalith: Cat. 11 014.

Watanabe, Joan; *My Best, My Duty;* n.d. black and white photo; #Slides: 2. Cat. 11 015(1-2).

Zains, Marisa; *(title unknown);* n.d.: Note: From *Marisa Zains Exhibition* at Galería Otra Vez, 3802 Brooklyn Avenue, CA, organized by SHG (June 1983). Cross: CAP. Cat. 11 016.

Sculptures

Artist Unknown; *(title unknown);* November 1981: Fund: SHG and NEA; #Slides: 8. Note: From *Day of the Dead '81* Celebration at SHG, 3802 Brooklyn Avenue, Los Angeles, CA. Cross: Paintings and . Cat. 12 001(1-8).

Artist Unknown; *(title unknown);* November 7, 1982: Fund: NEA and SHG; #Slides: 9. Note: From *Day of the Dead '82* Celebration at SHG, 3802 Brooklyn Avenue, Los Angeles, CA (November 7, 1982). Cross: Paintings. Cat. 12 002(1-9).

Artist Unknown; *(title unknown);* n.d. wood and ceramic: Note: From *New Fire* Exhibition at Galería Otra Vez, organized by Michael M. Amescua through SHG. Cross: CAP. Cat. 12 003.

Artist Unknown; *(title unknown);* n.d.: Note: Part of an altar during the *Day of the Dead-Altar* Exhibition at SHG (November 1975). Cross: CAP. Cat. 12 004.

Amescua, Michael M. *(title unknown);* ca. 1989; metal: Cat. 12 005.

Amescua, Michael M. *(title unknown);* ca. 1989; metal: Cat. 12 006.

Amescua, Michael M. *(title unknown);* ca. 1989; metal: Cat. 12 007.

Amescua, Michael M. *(title unknown);* ca. 1989; metal: Cat. 12 008.

Amescua, Michael M. *(title unknown);* ca. 1989; metal: Cat. 12 009.

Amescua, Michael M. *(title unknown)*; November 1977: Fund: NEA and SHG; #Slides: 4. Note: Temporary sculpture for *Day of the Dead* celebration and exhibition at SHG. Cross: CAP. Cat. 12 010(1-4).

Amescua, Michael M. *(title unknown)*; 1989; ceramic: Cat. 12 011.

Amescua, Michael M. *(title unknown)*; n.d. wood; #Slides: 2. Cat. 12 012(1-2).

Amescua, Michael M. *(title unknown)*; n.d. relief on handmade paper; #Slides: 33. Cat. 12 013(1-33).

Amescua, Michael M. *(title unknown)*; n.d. steel: Cat. 12 014.

Amescua, Michael M. *(title unknown)*; n.d. relief on handmade paper: Cat. 12 015.

Amescua, Michael M. *(title unknown)*; n.d. relief on handmade paper; #Slides: 17. Cat. 12 016(1-17).

Amescua, Michael M. *(title unknown)*; n.d. relief on handmade paper; #Slides: 14. Cat. 12 017(1-14).

Amescua, Michael M. *(title unknown)*; n.d. ceramic: Cat. 12 018.

Amescua, Michael M. *(title unknown)*; n.d. metal: Cat. 12 019.

Amescua, Michael M. *(title unknown)*; n.d. relief on handmade paper; #Slides: 10. Cat. 12 020(1-10).

Amescua, Michael M. *(title unknown)*; n.d.: #Slides: 3. Cat. 12 021(1-3).

Amescua, Michael M. *(title unknown)*; n.d. metal: Cat. 12 022.

Amescua, Michael M. *(title unknown)*; n.d. metal: Cat. 12 023.

Amescua, Michael M. *(title unknown)*; n.d. ceramic : Cat. 12 024.

Amescua, Michael M. *(title unknown)*; n.d. steel and wood; #Slides: 3. Cat. 12 025(1-3).

Amescua, Michael M. *(title unknown)*; n.d. steel; #Slides: 2. Cat. 12 026(1-2).

Amescua, Michael M. *(title unknown)*; n.d. steel; #Slides: 13. Cat. 12 027(1-13).

Amescua, Michael M. *(title unknown)*; n.d. ceramic; #Slides: 2. Cat. 12 028(1-2).

Amescua, Michael M. *Before;* n.d. steel: Cat. 12 029.

Amescua, Michael M. *Birth of Xipe;* n.d. steel: Cat. 12 030.

Amescua, Michael M. *Birth of Xipe;* n.d. relief on handmade paper: Cat. 12 031.

Amescua, Michael M. *Bondage III Side 2;* n.d. welded, forged steel: Cat. 12 032.

Amescua, Michael M. *Corn Dance;* n.d. steel: Cat. 12 033.

Amescua, Michael M. *Culto Felino;* n.d. steel: Cat. 12 034.

Amescua, Michael M. *Dawn III;* n.d. relief on handmade paper: Cat. 12 035.

Amescua, Michael M. *Devotee;* n.d. welded, forged steel: Cat. 12 036.

Amescua, Michael M. *Devotee Side 2;* n.d. welded, forged steel: Cat. 12 037.

Amescua, Michael M. *Diving Eagle;* 1985; mixed media, handmade paper: Cat. 12 038.

Amescua, Michael M. *Dreamer and the Dream;* 1988; relief on handmade paper: Cat. 12 039.

Amescua, Michael M. *Drum Series;* 1977; ceramic and leather; #Slides: 2. Cat. 12 040(1-2).

Amescua, Michael M. *Drum Series Tlaloc;* 1977; ceramic and leather: Cat. 12 041.

Amescua, Michael M. *Happy Prophet;* 1985; relief on handmade paper: Cat. 12 042.

Amescua, Michael M. *Horse Bit;* 1984; relief on handmade paper: Cat. 12 043.

Amescua, Michael M. *Hummingbird on the Left;* n.d. steel: Cat. 12 044.

Amescua, Michael M. *Kiva Cycle;* n.d. steel: Cat. 12 045.

Amescua, Michael M. *Last Dance;* November 1989; iron sculpture; slide photographer: Michael M. Amescua; #Slides: 1. Cat. 12 046.

Amescua, Michael M. *Love Song;* 1984; relief on handmade paper: Cat. 12 047.

Amescua, Michael M. *Love Song;* n.d. steel: Cat. 12 048.

Amescua, Michael M. *Madwoman;* 1985; mixed media, relief on handmade paper: Cat. 12 049.

Amescua, Michael M. *Mariposo;* 1977; welded, forged steel: Cat. 12 050.

Amescua, Michael M. *Mariposo;* 1983; handmade paper relief : Cat. 12 051.

Amescua, Michael M. *Maya Ritual;* 1984; relief on handmade paper: Cat. 12 052.

Amescua, Michael M. *Maya Ritual;* n.d. steel: Cat. 12 053.

Amescua, Michael M. *Mirage;* 1984; relief on handmade paper: Cat. 12 054.

Amescua, Michael M. *Mirage II;* n.d. steel: Cat. 12 055.

Amescua, Michael M. *Nagual I;* 1984; relief on handmade paper: Cat. 12 056.

Amescua, Michael M. *Nopal Sunrise;* n.d. steel: Cat. 12 057.

Amescua, Michael M. *Penitente 2 Side 2;* n.d. welded, forged steel: Cat. 12 058.

Amescua, Michael M. *Penitente I Side 1;* n.d. welded, forged steel: Cat. 12 059.

Amescua, Michael M. *Penitente I Side 2;* n.d. welded, forged steel: Cat. 12 060.

Amescua, Michael M. *The Pledge;* n.d. steel: Cat. 12 061.

Amescua, Michael M. *Pueblo Lover;* 1985; mixed media, relief on handmade paper: Cat. 12 062.

Amescua, Michael M. *Quarter Moon;* 1987; relief on handmade paper: Cat. 12 063.

Amescua, Michael M. *San Carlos II;* 1982; handmade paper relief and acrylic: Cat. 12 064.

Amescua, Michael M. *The Scribe;* 1988; relief on handmade paper: Cat. 12 065.

Amescua, Michael M. *She Didn't Want to Talk About It;* 1985; relief on handmade paper: Cat. 12 066.

Amescua, Michael M. *Star Skirt;* n.d. steel: Cat. 12 067.

Amescua, Michael M. *Star Skirt;* n.d. relief on handmade paper: Cat. 12 068.

Amescua, Michael M. *Tlaloque;* n.d. steel: Cat. 12 069.

Amescua, Michael M. *Touches the Earth;* n.d. relief on handmade paper: Cat. 12 070.

Amescua, Michael M. *Touches the Sky;* n.d. relief on handmade paper: Cat. 12 071.

Amescua, Michael M. *Tribute Side 1;* n.d. welded, forged steel: Cat. 12 072.

Amescua, Michael M. *Tribute Side 2;* n.d. welded, forged steel: Cat. 12 073.

Amescua, Michael M. *Vietnam;* 1987; relief on handmade paper: Cat. 12 074.

Amescua, Michael M. *Vigil for a Strangler Candelabra/Incense Burner;* n.d. welded, forged steel. Cat. 12 075.

Amescua, Michael M. *Warrior at the Threshold;* n.d. relief on handmade paper: Cat. 12 076.

Amescua, Michael M. *Xipe;* n.d. relief on handmade paper: Cat. 12 077.

Amescua, Michael M. *Xipe 10;* n.d. relief on handmade paper: Cat. 12 078.

Amescua, Michael M. *Xipe Totec;* 1985; relief on handmade paper: Cat. 12 079.

Amescua, Michael M. *Young Corn;* n.d. welded, forged steel: Cat. 12 080.

Amescua, Michael M. *Young Corn I Side 1;* n.d. welded, forged steel: Cat. 12 081.

Amescua, Michael M. *Young Corn I Side 2;* n.d. welded, forged steel: Cat. 12 082.

Aparicio, Edgar; *(title unknown)*; n.d.: Fund: NEA Expansion Arts and SHG; #Slides: 3. Note: From *Edgar Aparicio Exhibition*, organized by the artist himself (December 5, 1986-January 18, 1987). Cross: Installation Art and , slide No 2: represents Chilean Nueva Cancion singer Victor Jara. Cat. 12 083(1-3).

Aranaydo, Cecilia; *Nudes #2;* n.d. soft-sculpture of fiber construction and apple heads: Cat. 12 084.

Bueno, Carlos; *Gorda;* n.d. ceramic; #Slides: 2. Cat. 12 085(1-2).

Calderón, Rudy; *Madre Sur America;* February 1986; ceramic--red alabaster: Cat. 12 086.

Chamberlin, Ann; *Catman and Batman;* n.d. oil on wood and aluminum: Cat. 12 087.

Chamberlin, Ann; *A & E;* n.d. oil on wood and aluminum: Cat. 12 088.

Chamberlin, Ann; *Lady in Limbo;* n.d. oil on wood and aluminum; #Slides: 2. Cat. 12 089(1-2).

Chamberlin, Ann; *Masked Man;* n.d. oil on wood and aluminum: Cat. 12 090.

Chamberlin, Ann; *Message From God;* n.d. oil on wood and aluminum: Cat. 12 091.

Chamberlin, Ann; *Nagging Angel;* n.d. oil on wood and aluminum: Cat. 12 092.

De la Loza, Alejandro; *(title unknown);* n.d.: Note: From *Day of the Dead '90* Exhibition at SHG, 3802 Brooklyn Ave, Los Angeles, CA (November 2, 1990). Cross: CAP. Cat. 12 093.

Duffy, Ricardo; *(title unknown);* n.d.: #Slides: 7. Cat. 12 094(1-7).

Duffy, Ricardo; *(title unknown);* n.d.: Note: From *Day of the Dead '90* Exhibition at SHG, 3802 Brooklyn Ave, Los Angeles, CA (November 2, 1990). Cross: CAP. Cat. 12 095.

Gadbois, Nick; *Aerial;* 1990; rust, earth, metal: Cat. 12 096.

Gadbois, Nick; *Beekeeper;* 1990; rust, earth, metal: Cat. 12 097.

Gadbois, Nick; *Dancers;* 1990; cement on wood: Cat. 12 098.

Gadbois, Nick; *Nerve;* 1990; sulfate, rust on metal: Cat. 12 099.

Gadbois, Nick; *Offering;* 1990; rust, cement on metal: Cat. 12 100.

Gadbois, Nick; *Tell;* 1990; cement, pigment, wood: Cat. 12 101.

Gadbois, Nick; *Union;* 1990; cement, pigment, wood: Cat. 12 102.

Gadbois, Nick; *Walker;* 1990; bluing, pigment, metal: Cat. 12 103.

Gallego, Ronnie; *(title unknown);* n.d.: #Slides: 4. Cat. 12 104(1-4).

Gamboa, Diane; *A Head of Our Time;* 1989; mixed media: Note: From *Day of the Dead '89* Exhibition at SHG, 3802 Brooklyn Ave, Los Angeles, CA (November 3, 1989). Cross: CAP. Cat. 12 105.

García, Tomás; *(title unknown);* n.d.: Note: From *Day of the Dead '90* Exhibition at SHG, 3802 Brooklyn Ave, Los Angeles, CA (November 2, 1990). Cross: CAP. Cat. 12 106.

Garza, José A. *(title unknown);* n.d. plaster; #Slides: 2. Cat. 12 107(1-2).

Gonsalves, Ricardo; *Barbed Wire;* n.d. mixed media; #Slides: 2. Cat. 12 108(1-2).

Howe, Brad; *Afrodiddy;* n.d.: Cat. 12 109.

Howe, Brad; *Bandiera Preta;* n.d. mobile: Cat. 12 110.

Howe, Brad; *Black Flora;* n.d. mobile: Cat. 12 111.

Howe, Brad; *Blue Skies;* n.d.: Cat. 12 112.

Howe, Brad; *de Caju;* n.d.: Cat. 12 113.

Howe, Brad; *Dumont;* n.d. mobile: Cat. 12 114.

Howe, Brad; *Galileo's Lecture;* n.d.: Cat. 12 115.

Howe, Brad; *Gramma's Sofa;* n.d.: Cat. 12 116.

Howe, Brad; *Gromfin's Wall;* n.d.: Cat. 12 117.

Howe, Brad; *King's Grin;* n.d.: Cat. 12 118.

Howe, Brad; *Llamas;* n.d.: Cat. 12 119.

Howe, Brad; *Number 5;* n.d.: Cat. 12 120.

Howe, Brad; *One Indian;* n.d.: Cat. 12 121.

Howe, Brad; *Scattered Blocks;* n.d.: Cat. 12 122.

Howe, Brad; *Sliding Panels;* n.d.: Cat. 12 123.

Howe, Brad; *Snake Feast;* n.d. mobile: Cat. 12 124.

Howe, Brad; *Sobre Verde;* n.d.: Cat. 12 125.

Howe, Brad; *Vegetables;* n.d.: Cat. 12 126.

Howe, Brad; *Vertical Orbit;* n.d.: Cat. 12 127.

Howe, Brad; *Wall Stack;* n.d.: Cat. 12 128.

Jurado, Milton; *(title unknown);* n.d. bread dough; #Slides: 4. Cat. 12 129(1-4).

Limón, Leo; *(title unknown);* ca. 1986; ceramic plate: Note: . Cat. 12 130.

Lorenzana, Ismael; *(title unknown);* n.d.: Note: From *Day of the Dead '90* Exhibition at SHG, 3802 Brooklyn Ave, Los Angeles, CA (November 2, 1990). Cross: CAP. Cat. 12 131.

Sparrow, Peter V. *(title unknown);* n.d.: Cat. 12 132.

Vallejo, Linda; *Anahuac;* 1981; m/m paper, mylar, silicon, fiber: Cat. 12 133.

Vallejo, Linda; *Blue Head-Dress;* 1983; printed handmade and dyed paper, fiber, silicon: Cat. 12 134.

Vallejo, Linda; *Bronzestar;* 1983; handmade paper, copper, banding, silicon, wood: Cat. 12 135.

Vallejo, Linda; *Butterfly Boy;* 1985; mixed media, handmade paper: Cat. 12 136.

Vallejo, Linda; *Cabroncito;* 1984; mixed media: Cat. 12 137.

Vallejo, Linda; *Calavera;* 1985; mixed media, handmade paper: Cat. 12 138.

Vallejo, Linda; *The Comedune;* 1983; ceramic: Cat. 12 139.

Vallejo, Linda; *Conception;* 1984; handmade and print paper, metal, bone shell, stone; #Slides: 2. Cat. 12 140(1-2).

Vallejo, Linda; *Dream Tree;* 1985; mixed media, handmade paper: Cat. 12 141.

Vallejo, Linda; *Feathered Head-Dress;* 1985; mixed media, handmade paper: Cat. 12 142.

Vallejo, Linda; *Food of the Gods;* 1984; mixed media, handmade paper: Cat. 12 143.

Vallejo, Linda; *Mariposa/Butterfly;* 1981; mixed media, paper: Cat. 12 144.

Vallejo, Linda; *Meditation;* 1983; printed and handmade paper, silicon, shell, bone, fiber: Cat. 12 145.

Vallejo, Linda; *Meditation II;* 1984; mixed media: Cat. 12 146.

Vallejo, Linda; *Mictlantecutli;* 1983; mixed media: Cat. 12 147.

Vallejo, Linda; *Mourning Old Man;* 1974; ceramic: Cat. 12 148.

Vallejo, Linda; *Olmeca Dream;* 1983; mixed media, handmade paper: Cat. 12 149.

Vallejo, Linda; *Palo de Fuego;* 1985; mixed media, handmade paper: Cat. 12 150.

Vallejo, Linda; *Quetzalcoatl;* 1984; handmade and print paper, wood, metal, shell, plastics: Cat. 12 151.

Vallejo, Linda; *Radiating Hand;* n.d. monotyped, dyed and handmade paper, silicon, doily: Cat. 12 152.

Vallejo, Linda; *Running Deer;* 1984; handmade and print paper, wood, acrylic, silicon: Cat. 12 153.

Vallejo, Linda; *Serpiente;* 1985; mixed media, handmade paper: Cat. 12 154.

Vallejo, Linda; *Spirit Bow;* 1983; handmade paper, wood, fabric, metal, silicon: Cat. 12 155.

Vallejo, Linda; *Spirit Cloak;* 1984; handmade and print paper, wood, metal, shell, plastics: Cat. 12 156.

Vallejo, Linda; *Sunstar;* 1983; wood, paper, silicon, acrylic: Cat. 12 157.

Yáñez, Larry; *(title unknown);* n.d.: Cat. 12 158.

Yáñez, Larry; *(title unknown);* n.d. mixed media; #Slides: 2. Cat. 12 159(1-2).

Yáñez, Mari; *(title unknown);* October 1978: Fund: NEH and SHG; #Slides: 3. Note: From *Day of the Dead Mask Workshop* at SHG, organized by Cecilia Castañeda and Mari Yáñez. Cross: CAP. Cat. 12 160(1-3).

Appendix B: Slides Supplement 1 (1991-2003)

In catalog number order.

Assemblage

Artist Unknown; *Altar; November* 1996; mixed media; Note: An altar with crosses, candles, flowers, papel picado, pan de muerto (pretzels) and images of the deceased and religious figures. "SHG collaborated with Glasgow Print Studio in their first ever Day of the Dead Celebration."; Cat. 1 001.

Artist Unknown; *Altar for the Day of the Dead at Galería Otra Vez*; November 1991; mixed media; Note: Altar under flower arches composed of framed photographs, small sculptures, flowers, candles, et cetera. "Golden Cempazuchiles [Zempoalxochitles—marigolds] are used in traditional altars. The name means 'twenty flowers.' They are associated with wisdom, beauty, truth, and 'the desire never to die.'"; Cat. 1 002.

Artist Unknown; *Altar a la Virgen*; n.d. mixed media; Note: Altar on the steps leading to the statue of la Virgen de Guadalupe is composed on many devotional candles, religious icons, marigolds, and flower petals. Cat. 1 003.

Artist Unknown; *Altar to Sister Karen Boccalero*; ca. 1990's; mixed media; Note: Altar is enormous, taking up an entire exhibition room, and is composed primarily of candles and flowers. "Sister Karen is respected and loved by many Chicano/a artists in Los Angeles. Sister Karen is the founder of SHG."; Cat. 1 004.

Artist Unknown; *Day of the Dead Altar*; October 1993; mixed media; Note: Altar is composed of items placed on two shelves. On the upper shelf is a framed photo of Cesar Chávez that has been altered to make it appear that Chávez is dressed as a calavera. Above his picture hangs the Lotería image of "El Valiente". Also on the shelf with the portrait is a vase of flowers, a statuette of La Virgen de Guadalupe, a bowl of nuts, a candle, and a sugar skull. On the lower shelf is a black-and-white photo of a Mexican family, a bowl of vegetables, candles, and a copy of the book *Conquering Goliath*. Cat. 1 005.

Artist Unknown; *Flores de Esperanza Altarpiece* (detail); November 2, 1996; mixed media; Note: Visible portion of the altar features a large yellow sculpture of a calavera, a Mexican Coca-Cola, a candle, a donut, and marigold petals. Cat. 1 006.

Artist Unknown; *Flowers*; n.d. mixed media; Note: Visible portion of an altar for the deceased is composed of an ear of dry corn, marigolds, a calavera sculpture, placards with the names of the dead, a ceramic candleholder, and a candle. Cat. 1 007.

Artist Unknown; (title unknown); ca. 1990's; mixed media; Note: An altar on a tabletop with marigolds, daisies, pottery, a candleholder, an ear of corn, a small sculpture, a Virgen veladora, and cards with peoples' names. "Cempazuchiles [Zempoalxochitles] (marigolds) are traditionally used in altars. The name means 'twenty flowers'."; Cat. 1 008.

Artist Unknown; (title unknown); ca. 1990's; mixed media; Note: A large altar composed of flowers, sarapes, photographs, food, skulls, candles, beer bottles, and many other items. Cat. 1 009.

Artist Unknown; (title unknown); ca. 1990's; Plastic crates, photographs, garments, flowers, artworks, candles; slide photo: Mario Lopez. Note: Altar to an unknown man composed of plastic crates, photographs, a fedora and jacket, flowers, artwork, and candles. Cat. 1 010.

Artist Unknown; (title unknown); 1977; mixed media; Note: Altar is composed of papel picado, calavera masks, flowers, small sculptures, devotional icons and statues, fruit, candles, etc. Cat. 1 011.

Artist Unknown; (title unknown) (detail); 1977; mixed media; Note: Visible portion of altar features pan de muerto, papel picado, marigolds, a candle, a straw sculpture, and an ojo de Dios. Cat. 1 012.

Artist Unknown; (title unknown); November 1, 1992; mixed media; 4 slides. Note: 1. An altar on steps embedded with pieces of ceramic pottery. Religious candles, marigolds, and flower petals. 2. Altar on steps embedded with pieces of ceramic pottery. The steps lead to a platform where a large statue of Our Lady of Guadalupe rests. In this photo, devotional candles surround the base of the statue, of which only the bottom is visible. 3. Altar at the base of a statue of La Virgen de Guadalupe composed of flowers and candles. 4. Altar in the form of a cross at the foot of a statue of la Virgen de Guadalupe composed of flowers and candles. Cat. 1 013(1-4).

Artist Unknown; (title unknown); 1994; mixed media; 3 slides. Note: An ofrenda/altar so large it fills an entire kitchen. In the third photo, detail is of a photograph of a man surrounded by flowers, sculptures, and candles, from the altar that fills an entire kitchen. Cat. 1 014(1-3).

Artist Unknown; (title unknown); 1994; mixed media; Note: Assemblage in a corner of an exhibition space consists of a large book that has been fixed open by the melted wax of candles. There are items pertaining to consumerism, beer bottles, an American flag, and a Mexican flag. Cat. 1 015.

Artist Unknown; (title unknown); November 1994; mixed media; : Note: An altar on a square table with a red tablecloth. An image of La Virgen de Guadalupe leans against a vase of flowers that sits in the center of the table and is surrounded by curios. The front of the table has hanging photographs, including one of Cesar Chávez with the word "¡Presente!"; Cat. 1 016.

Artist Unknown; (title unknown); November 2, 1996; mixed media; Note: From Day of the Dead, Flores de Esperanza Exhibition and Celebration. Work is composed of a painting of a nude woman in a purple chair with calaveras behind it and a bouquet of exotic flowers on a platform draped with blue cloth. A piece of blue cloth hangs above and on the sides of the painting and unifies the two elements. Cat. 1 017.

Artist Unknown; (title unknown) (detail); November 1994; mixed media; Note: Detail is of the lower part of an altar, with photographs, flowers, calaveras, and candles. Cat. 1 018.

Artist Unknown; asst: Chaz Bojórquez; *David Alfaro Siqueiros*; ca. 1990's; mixed media; Note: Photo is of an altar to muralist David Alfaro Siqueiros composed of a portrait painting of the artist surrounded by candles, flowers, artworks, and tools of the trade. Text forming an arc above the painting reads "David Alfaro Siqueiros" in graffiti script. Text beneath the name gives his lifespan. "Chaz has worked with graffiti since 1969. He usually works with a paint brush rather than a spray can."; Cat. 1 019.

Adams, Tanda -- Blaine Meyers, Roach McIntyre, and Steckermeirer; *Esta Noche*; ca. 1990's; mixed media; Note: Assemblage is composed of plastic covering the outside of a chickenwire cage in the form of a coffin. On top of the coffin is a calavera with flowers and leaves. Within the coffin is an altar behind red curtains with calavera diners. Surrounding the stand of the coffin are more flowers and vegetable matter. Cat. 1 020.

Beltran, Margaret; *Altar*; November 1994; mixed media; 6 slides. Note: Altar composed of items set atop wooden blocks painted pink and yellow. Items include framed photographs, flowers, pan de muerto, candles, sugar skulls, etc. Above the altar is an arch of marigolds, and on the wall behind it hang pieces of papel picado. The papel picado piece that hangs in the center has calaveras and the name "Blanche". It appears to be an exhibition installation. Cross: Installation Art. 4. Detail is of the lower center portion of the altar, with a cross, a plate with tamales, a basket of pan de muerto, and flowers. 5. Detail is of the center of the altar, with framed photographs, a statue of La Virgen de Guadalupe, cacti, calaveras, and pan de muerto. Cat. 1 021(1-6).

Bonfigli, Karen and Pat Gomez; (title unknown); 1998; mixed media; 2 slides. Note: "The Big Two Five, Day of the Dead Gallery Exhibit." 1. Photo is of a small statue of the Virgin of Guadalupe in a pot of flowers. 2. Photo is of flowers in ceramic pots. Cat. 1 022(1-2).

Esparza, Ofelia; *Altar*; November 1, 1996; mixed media; Site/Location: SHG and Glasgow Print Studio, Scotland; 3 slides. Note: "SHG collaborated with Glasgow Print Studio in their first ever Day of the Dead Celebration." 1. Detail of the front left corner of altar. 2. A multi-level altar set up like stairs has a few calaveras set on it. 3. Papel picado by Margaret Sosa features a calavera and reads "Dia de los Muertos Los Angeles Glasgow". 4. Full view of Glasgow altar. Cat. 1 023(1-4).

Mireles, Ruben; *East Side Spirit*; n.d. mixed media; Note: A caja containing a sculpture of a skull wearing a sombrero on top of a brown bottle with a label reading, "East Side Spirit" in a mix of Gothic and graffiti scripts. Behind the bottle is an image of La

Virgen de Guadalupe, and the visible interior side is affixed with shards of broken glass. Cat. 1 024.

Murdy, Ann and Alex Alferov; *Memory Altar*; November 1994; mixed media; 2 slides. Note: 1. An altar with photos and numerous fruits and vegetables is illuminated by candlelight. 2. Altar on a shelf and tabletop. On the shelves are framed photographs, candles, sugar skulls, a pack of cigarettes, a can of Budweiser, a bottle of Bombay Gin, and small sculptures. On the tabletop is a cornucopia of produce. Cat. 1 025(1-2).

Portillo, Rose; *A Day in the Sun*; November 5, 1994; mixed media; Note: Three-dimensional -painting features two calaveras amidst milagritos, hearts, and small vegetables. On top of the piece is a bunch of grapes, false roses, a UFW huelga flag, and three pins with the words "No Grapes". Cat. 1 026.

Rivas; (title unknown); 1992; mixed media; Note: Altar on a set of four shelves. The lowest shelf has small boxes that resemble coffins. The next shelf up has four items set on lace doilies. The second shelf from the top has a tray of pan de muerto and a framed black-and-white photograph. The top shelf has candles, calaveras, and an image of the Virgin of Guadalupe. Above the shelf are five ceramic calavera masks. Flowers are grouped at the base of the shelving. This photo is out of focus. "An offering of the deceased's favorite foods is traditional for altars."; Cat. 1 027.

Rodriguez, Enrique; *Santísima Muerte*; November 5, 1994; mixed media; 15" x 19": . Note: Three-dimensional painting depicts the Virgen de Guadalupe as a calavera. In her hands is a sacred heart with the face of Christ. The moon upon which she stands has a skeletal face and drinks a bottle of tabasco sauce. Small cherubim sit on guitars on either side of the moon. Interspersed among the rays of light that emanate from la Virgen are milagros in the shape of arms and legs. Small sculptures affixed to the outer edge of the piece form a border. At the top is a blue cross; the rest are bones, bottles, dishes, and flowerpots. The work is signed and dated in the lower right corner, but the signature is indecipherable. "Calaca as a virgin."; Cat. 1 028.

Rodriguez, John; *Luchando Con La Vida*; November 5, 1994; mixed media; Note: A caja with glass doors that are propped open. At the back of the caja is the painted or drawn image of a sorrowful woman clutching an icon of the sacred heart. In front of her are candles and flower petals. Painted on the front of the box is the artist's last name. "Agonized person (possibly dead) holding framed sacred heart, inside curio cabinet."; Cat. 1 029.

Atelier

AtNu: XXXVIII, AtYr: 2001; Aguilar, Laura; *Grandma*; April 10-21, 2001; silkscreen; 18" x 26"; 66 ed. prnt: José Alpuche; sign: Yes. Inscription: [illegible] Grandma Laura Aguilar 01; Fund: SHG; slide photo: UCSB Photography; copies: 2. Note: Photosilkscreened family photos on a yellow background with anecdotal text. "3 photographs. Grandma taken 1920-1923. Grandma, Aunt Bea, brother John, and self. Last of grandma and self. Text about grandma."—Laura Aguilar. Colors used: Cream White, LT White Yellow, Clear Gloss, Sepia, and Silver. From Maestras II. Cat. 2 001.

AtNu: XXXIX, AtYr: 2001; Alvarez, Jack; *Dos Mundos (Two Worlds)*; August 28-31, 2001; Coventry Rag, 290 gms. 15" x 21"; 84 ed. prnt: JoséAlpuche; sign: Yes. Fund: SHG; slide photo: UCSB photography; copies: 2. Note: "Hand Pulled Serigraph print. Six colors on Coventry rag paper. Art print contains; yellow background, blue/gray surface. Female/Virgin figure in center with halo-like shape over head. Symbolism includes; plant forms (3) crosses in and above the horizon. This print is based on the Christian religion's influence on the indigenous people of the America's mainly the Hispanic cultures. I hope to portray the surrealistic landscapes of the spiritual world. The iconography plays between the time before the Spanish conquest and the aftermath of it. It was a conquest of a way of life, but not a conquest of the spirit."—Jack Alvarez. Colors used: Light Yellow 1205, Charcoal Brown 497, Light Lavender 503, Gray Black 431, Orange 130, and Blue/Gray 5493. Cat. 2 002.

AtNu: XXXIII, AtYr: 1999; Alvarez, Laura; *The Double Agent Sirvienta Blow Up the Hard Drive*; 1999; 18" x 22"; 56 ed. prnt: José Alpuche; sign: Yes. Fund: SHG; slide photo: unknown; copies: 2. Note: Image is of a maid typing on a laptop and speaking into a communication device in her backpack. There is fire in the background and the entire print is covered in alphanumeric symbols that resemble lines of computer code. At the top of the print is a filetab with the text, "File:/Translation.underdone". "The Double Agent Sirvienta, surrounded by the computer goobledy gook is discovered while mixing up files on a laptop computer."—Laura Alvarez. From Maestras I. Cat. 2 003.

AtNu: XXXIII, AtYr: 1999; Alvarez, Laura; *Mission in the Garden*; March 27-30, 2001; Coventry Rag, 290 gms. 18"x 22"; 74 ed. prnt: José Alpuche; sign: Yes. Fund: SHG slide photo: UCSB Photography—Photography of duplicate by Marissa Rangel. copies: 2. Note: "The Double Agent Sirvienta, an international spy posing as a maid and expert in the field of domestic technology, looks after and involves a blond baby in secret missions while vacationing in a tropical garden landscape. The agent/gardener in the distance is really her childhood sweetheart from a small Mexican Colonial town, but with the plastic surgery after his accident, she doesn't recognize him. Her mission plan hovers in the grass with the promise of love and small explosions. A small toy hides the precioue [sic] data. Will the Double Agent Sirvienta be caught as she scrambles the files of a laptop while "cleaning" out a big wigs bedroom? Fire is in the background, gobbledy-goop surrounds her. She is a spy posing as a maid."—Laura Alvarez. This print is alternately titled *The Double Agent Sirvienta: Blow Up The Hard Drive*. Colors used: Light Green, Pink, Brown Skin, Sky Blue, Yellow, Light Flesh, Brown Skin (again), Dark Green, Black, and Clear Gloss. From Maestras II.: Cat. 2 004.

AtNu: XXXIX, AtYr: 2002; Amos; *98 (degrees) in the Shade*; January 6-12, 2002; Coventry Rag, 290 gms. 16" x 22"; 50 ed. prnt: Amos; sign: Yes. Fund: SHG slide photo: UCSB Photography. Note: "Prints shows el paletero (icecream man) huffing onward w/ achey [sic] feet/cloudy head/and running on empty. The blended background gives the illusion of extreme heart. With the sun beating down, symbols surround the figure showing what he is working for, what has been left behind, his hopes and his realities, and what is in the future."—Amos. Colors used: Blend Orange/Tan, Turquoise Blue, Red Sh. Blue, Yellow, Ochre, Sienna, Magenta, Grey (light), Black, Trans White (t.p.'s only), and Trans Black (t.p.'s only). Cat. 2 005.

AtNu: Special Project, AtYr: 2000; Arai, Tomie; *Double Happiness*; November 7-10, 2000; Coventry Rag 290 gms. 25" x 31"; 42 ed. prnt: José Alpuche; sign: Yes. Inscription: 10/42 Double Happiness Arai '00; Fund: SHG; slide photo: UCSB Photography; copies: 2. Note: "Image of an Asian woman eating with chopsticks; loteria cards and Japanese 'Hanfuda' playing cards, & map of East L.A. are set against a black background. Double Happiness is a piece about the mix of cultures that make up the East L.A. / Boyle Heights Community. In this piece a young Asian woman reflects while she is eating; the interplay of Japanese Chicano and Chinese from Boyle Heights and Monterey Park are represented through an array of Chicano loteria cards, Japanese 'Hanafuda' cards and Chinese English language flash cards."—Tomie Arai. Colors used: Yellow, Blue, Green, Pink, Red, Black, and Silver. Cat. 2 006.

AtNu: XXXVI, AtYr: 2000; Arai, Tomie; *Kaeru / Finding Home*; May 1-6, 2000; Coventry Rag 290 gms. 20 1/8" x 28 1/4"; 60 ed. prnt: José Alpuche; sign: Yes. Inscription: 60/60 Kaeru/Finding Home Arai '00; Fund: Mid Atlantic Arts Foundation, and the NEA; slide photo: UCSB Photography; copies: 4. Note: "7 color silkscreen was produced in conjunction with a two month residency at SHG through an Artist & Communities/Mid Atlantic Arts Foundation and NEA grant. In this piece, a young boy is pulling back a screen to reveal an array of images which represent memory and the passage of time. These images form a visual arc or lifeline which flow towards a taiko drum head with rose imprinted on it. The rose (an image symbolic of my stay in East LA) represents the heart and pulse. "KAERU/ FINDING HOME" is a piece which explores the construction of identity through a reconnection with the past."—Tomie Arai. Colors used: Yellow, Gray/Green, Light Gray Green, Blue, Pink, Black, and Yellow/Brown. Cat. 2 007.

AtNu: Special Project, AtYr: 2002; Attyah, David "Think Again"; *No Bullshit*; July 25-27, 2002; Coventry Rag, 290 gms. 16" x 22"; 88 ed. prnt: José Alpuche; sign: Yes. slide photo: UCSB Photography; copies: 2. Note: "An "invasion" of doorknobs gathering to resist displacement and eviction. "No Seremos Desalojados." In col-

laboration with the "We Shall No[t] Be Moved" project."—David "Think Again" Attyah. Colors used: Fire Red, Orange, Teal, Purple, Dark Purple, and Dark Fuscia. Cat. 2 008.

AtNu: XXIV, AtYr: 1994; Bojórquez, Chaz; *New World Order*; June 28-July 2, 1994; Silkscreen; 33 1/2" x 26"; 59 ed. prnt: José Alpuche; sign: Yes. Inscription: [illegible] New World Order Chaz Bojorquez 94; Fund: SHG; slide photo: unknown; copies: 2. Note: Black and white print features the names of conquistadors in graffiti script on the background of an Aztec stele. Cat. 2 009.

AtNu: XXXVIII, AtYr: 2001; Cardenas, Cristina; *Santa/Maguey;* March 20-24, 2001; Coventry Rag, 290 gms. 18" x 26"; 77 ed. prnt: José Alpuche; sign: Yes. Inscription: 20/44 Santa Maguey CCardenas 01; Fund: SHG; slide photo: UCSB photography—Photo of duplicate by Marissa Rangel; copies: 2. Note: Atelier silkscreen print depicts a woman, nude from the waist up, with her arms wrapped about her torso and her hands clutching leaves of the maguey plant behind her. Her head is tilted back and her eyelids droop. The background is made up of floral and vegetable images. Colors used: Light Yellow, Red Orange, Thalo Blue, Purple, Transparent Orange, Gold, Mid-T-Yellow, Off White, T-Sienna, T-Red Black, and Dark Burgundy. From Maestras II. Cat. 2 010.

AtNu: Special Project, AtYr: 1993; Cardenas, Cristina; *La Virgen de los Pescados;* April 2-9, 1993; Silkscreen; 34" x 26"; 75 ed. prnt: José Alpuche; sign: Yes. Inscription: 18/37 CCardenas 93; Fund: SHG; slide photo: unknown; copies: 2. Note: Image of a woman with Guadalupan attributes. She holds a bouquet of flowers hemmed in with fish. Text in script at the bottom of the print reads, "La Virgen de los Pescados". Cat. 2 011.

AtNu: XXXIII, AtYr: 1999; Carrasco, Barbara; *Dolores;* 1999; silkscreen; 18" x 26"; unknown ed. prnt: José Alpuche; sign: Yes. Fund: SHG; slide photo: unknown; copies: 2. Note: "Hard edge graphic image of Dolores Huerta, co-founder of the United Farm Workers Union, with her name, Dolores, printed above her portrait image."—Barbara Carrasco. From Maestras I. Cat. 2 012.

AtNu: XXXIII, AtYr: 2001; Carrasco, Barbara; *Primas;* April 18-20, 2001; Coventry Rag, 290 grms. 18" x 26"; 62 ed. prnt: José Alpuche; sign: Yes. Inscription: 20/62 "Primas" Carrasco 01; Fund: SHG; slide photo: UCSB photography; copies: 2. Note: "Portrait of the artist's daughter and niece in an embrace, surrounded by a braid (trensa) showering hearts around the portraits. The trensa represents the older women in the lives of the young girls, nurturing their love for each other and themselves as strong and independent females. The trensa also symbolizes traditional values and customs and rituals. The girls' hair is loose and flows freely next to the tightly braided trensa. The trensa is opening up to allow love to flow towards the girls. *Note: The clear varnish is not matched up (registered) with the background and every print color. The style is hard edge graphic with flat colors, no texture. Most of the color separations were hand-cut with amberlith with some ink work applied minimally as touch ups."—Barbara Carrasco. Colors used: Peach, Skin-Beige, Skin-LT. Brown, Lime Green, Turquoise, Purple, and Clear. Cat. 2 013.

AtNu: XXXIII, AtYr: 1999; Cervantez, Yreina D. *Mujer de Mucha Enagua: Pa' Ti Xicana;* 1999; silkscreen; 18" x 26"; 60 ed. prnt: José Alpuche; sign: No. Fund: SHG; slide photo: unknown; copies: 2. Note: Image is of poet Sor Juana Inés de la Cruz (a.k.a. Sor Juana de Asbaje) and E.Z.L.N. comandante Ramona. Between the two of them is a hand with a spiral and the words "mixik' balamil" in the palm. On Sor Juana's habit are many Nahuatl words and the English poem, "Blessed lady / do not go / Mother do not / Cause us woe / If to heaven / you ascend / will you still / your love extend? " On Ramona's dress is a quote from the Popol Vuh and the words, "Todos Somos Ramona". "Tan background with stylized stars, flowers, and spots representing the pelt of the sacred jaguar. Three main female figures: la mujer Zapatista con sus niños, Sor Juana with portrait of poet Rosario Castellanos in her bosom. The central image is the hand of the goddess. Various Nahua and Mayan symbols along with text and poetry."—Yreina D. Cervantez. From Maestras I. Cat. 2 014.

AtNu: XXXV, AtYr: 2000; Charette, Damian; *Bone Yard;* February 15-17, 2000; Coventry Rag, 290 gms. 16" x 13"; 91 ed. prnt: José Alpuche; sign: Yes. Fund: SHG; slide photo: UCSB photography; copies: 2. Note: "AZ sunset with old cars. The image is one of the many scenes of Reservations in Montana and AZ. Cars are kept in back yards, empty lots (ie LA, Phoenix, Etc..) for many different reasons

and they become a part of the landscape. The stories of many of the owners are varied. To me they represent time history and a place for occasional stray (man or beast) to live for a short time. Everyone seems to find their own story with in the image of days gone by or the possibilities held with in the cars frame work."—Damian Charette. Colors used: Blend (purple, red, yellow), Red, Green, Yellow, Blue, and Black. Cat. 2 015.

AtNu: Special Project, AtYr: 2002; Crute, Jerolyn; *The Key;* July 20, 23, and 24, 2002; Coventry Rag, 290 gms. 16"x 22"; 89 ed. prnt: José Alpuche; sign: Yes. Fund: SHG slide photo: UCSB Photography; copies: 2. Note: "Four adult figures plus one child pushing against green man with City Hall in his pocket. Two figures holding house with large key hole. Key up in the air between reaching hands with sky background." "Image designed for the "We shall not be moved" Project with anti-gentrification theme. The community is protecting their homes from greedy big business. Although big business has City Hall in it's pocket, the community has access as well if they pull their string. The struggle to gain control represented by the key is up in the air."—Jerolyn Crute. Colors used: Golden Yellow, Light Brown, Brown, Cyan, Red, and Dark Brown. Cat. 2 016.

AtNu: unknown, AtYr: 1981; de Batuc, Alfredo; *D.O.D. 1981: Las Cuatas;* 1981; silkscreen; 17" x 22"; 71 ed. prnt: unknown; sign: unknown. Fund: SHG; slide photo: unknown; copies: 2. Note: Print is a reinterpretation of Frida Kahlo's "The Two Fridas". In this version, the Frida on the left has the face of a calavera and holds a mask of Frida's face. The Frida on the right holds a calavera mask. They hold hands and are connected by a common circulatory system. Cherubim on either side of the Fridas hold a banner bearing the words, "Dia De Los Muertos 1981". Atop columns on either side of the print rest a rat, left, and a bird, right. Through three windows behind the Fridas three different scenes are visible: the Hollywood sign, City Hall, and Watts Towers. Cat. 2 017.

AtNu: XL, AtYr: 2002; Delgadillo; Victoria; *Knowingly Walking Through the Imaginary River Towards Divine Destiny;* April 30 and May 1-5, 2002; Coventry Rag, 290 gms. 18"x 26"; 82 ed. prnt: José Alpuche; sign: Yes. Fund: SHG slide photo: UCSB Photography; copies: 2. Note: Atelier silkscreen print depicts a woman crossing a river toward the viewer. Her skin and hair are multicolored. In her right hand she holds a black cylinder with an image of an anatomical heart. In her right hand she holds a yellow rectangle featuring the "Wheel of Fortune" card from the tarot deck. The background is a Los Angeles cityscape with a green sky, yellow sun, and black skyscrapers. Several sacred hearts dot the horizon. Colors used: Light Yellow, Dark Yellow, Pale Grey, Dark Green, Red, Dark Blue, Light Blue Transparent, Medium Yellow, Yellow-Green, Brown, Salmon Pink, Beige, Medium Yellow. From Maestras III. Cat. 2 018.

AtNu: XXIV, AtYr: 1994; Duffy, Ricardo; *Primavera;* May 31- June 3, 1994; Silkscreen; 27" x 37"; 82 ed. prnt: José Alpuche; sign: Yes. Inscription: 16/64 Primavera Ricardo Duffy; Fund: SHG; slide photo: unknown; Note: A stylized image of a mother jaguar in springtime. Cat. 2 019.

AtNu: XL, AtYr: 2002; Esparza; Elena; *I Know Her.. All About Her;* May 7-11 and 30, 2002; Coventry Rag, 290 gms. 16"x 22"; 67 ed. prnt: José Alpuche; sign: Yes. Inscription: 2/69 I know her ..All about her.. Elena Esparza '02; Fund: SHG slide photo: UCSB Photography—Photo of duplicate by Marissa Rangel; copies: 2. Note: "Woman in Central Figure surrounded by a corona of maguey plants. 2 spirits appear (L.L. corner) in the foreground while a third in the background tells (URHC) the story. A humming bird hovers above the woman, with LA central and the Belmont tunnel from the background as a point of reference."—Elena Esparza. Colors used: Orange/Red-Opaque, Sage Green-Opaque, Marigold-Semi Opaque, Lime Green- Transparent, Magenta-90% Opaque, Electric Blue-Semi Opaque, and Dark Maroon-90% Opaque. Cat. 2 020.

AtNu: XXXIX, AtYr: 2001; Esparza, Rubén; *Hyper Myth;* August 21-24, 2001; Coventry Rag, 290 gms. 10" x 20"; 70 ed. prnt: José Alpuche; sign: Yes. Fund: SHG; slide photo: UCSB photography; copies: 2. Note: ""hyper" against yellows background. "Myth" against blues background silkscreen "dyptich". commentary on mass media via recognizable packaged goods and advertising design inspired work-"—Rubén Esparza. Colors used: Clear Base, Warm Red, T.

Yellow, Baby Blue, T. White, Red Shade Blue, and Clear Gloss. Cat. 2 021.

AtNu: XL, AtYr: 2002; Flores, Lysa; *The Making of a Trophy Grrl!*; May 21-25, 2002; Coventry Rag, 290 gms. 16" x 22"; 75 ed. prnt: José Alpuche; sign: Yes. Fund: SHG slide photo: UCSB Photography—photo of dupe by Marissa Rangel; copies: 2. Note: Atelier silkscreen print is a mock movie poster for a film. Text reads, "Chicana Feminista Films presenta The Making of a Trophy Grrl! una drama de amor con Señora Tentacion como La Tina el mero mero La Peligrosa". Text in the lower left corner reads, "Bring Your Love 2002". A woman's face is depicted on the left side of the print. She is smoking a cigarette through a holder and the blue smoke spirals upward. On the right side of the print are three figures: a nude "Señora Tentacion" holding a fan and only wearing a blue rebozo around her shoulders. Her face is painted to resemble that of a geisha. Beneath her and to the left is a man (el mero mero) dressed in blue bellbottoms and pointing directly at the viewer. His stance and dress are reminiscent of Elvis Presley. To the right of "el mero mero" and beneath "Señora Tentacion" is the topless bust of "La Peligrosa". On her side is an image of an eagle with a serpent in its beak. The background is entirely red. Colors used: Red, Ivory/Beige, Pink Flesh Tone, Burgundy/Red, Blue, Purple, Black, Yellow, and White. Cat. 2 022.

AtNu: XXXVIII, AtYr: 2001; Flores, Yvette; *Greñuda*; April 3-7, 2001; Coventry Rag, 290 gms. 18" x 26"; 74 ed. prnt: José Alpuche; sign: Yes. Inscription: 20/64 Greñuda Yvette Flores; Fund: SHG; slide photo: UCSB photography—photo of duplicate by Marissa Rangel. Note: "A little girl is getting her hair done by her mother. The words surrounding the girl express the frustration being felt by her. The colors around her are messy and random, like her hair. The little girl in the print is going through what every little girl goes through. She's showing frustration and uneasiness as her mom is trying to comb her hair. The print also shows how women from an early age suffer to fit societies views to look good. The messy background is to represent anger and the messy way she'd rather have her hair."—Yvette Flores. Colors used: Yellow Light, Orangel Yellow, Red Orange, Ultra Marine Blue, Medium Flesh, Light Blue, Maroon, Ivory White, and Light Red Orange. From Maestras I. Cat. 2 023.

AtNu: XXXIII, AtYr: 1999; Gamboa, Diane; *Altered State*; 1999; silkscreen; 18" x 26"; 75 ed. prnt: José Alpuche; sign: Yes. Inscription: 1/1 S/P "Altered State" Gamboa 99; Fund: SHG; slide photo: unknown. Note: Image is of a nude woman with purple skin dressed in bondage gear. "Woman heavily drenched in accessory equipment and tattoos with a serpent around her right leg."—Diane Gamboa. From Maestras I. Cat. 2 024.

AtNu: XL, AtYr: 2002; Gamboa, Diane; *Revelation Revolution*; May 14-18, 2002; Coventry Rag, 290 gms. 16" x 22"; 88 ed. prnt: José Alpuche; sign: Yes. Inscription: 50/88 Revelation Revolution Gamboa 02; Fund: SHG slide photo: UCSB Photography—Duplicate photo by Marissa Rangel; copies: 2. Note: "The piece is set on the horizontal. The central figure is of a woman in her white lingerie, a ring on her right hand and she is holding a red handbag. Another woman is up front with a flower in her hair and tattoos across her shoulders. A third woman is in the background in black line over brown. To the right of the figures is a custom type pattern and to the left is another pattern with flowers. The artwork is trapped in a tight black." "REVELATION REVOLUTION is dedicated to the women of the past, present, and futures. To the women of great accomplishments if it be physically or intellectually and to the bad-ass women who don't take bull shit. It addresses the limitless imagination of the communication and it is a symbol of knowledge and wisdom. It is a look at enlightened women who do not fall into slavery of the stereotype of woman as object. This piece is dedicated to the broad spectrum of women who are changing the way we see ourselves and the world around us. It is for the innovators and challengers who are unafraid of leading and require us to think deeper. This piece looks at Urban Goddess as visionary. This piece is also about the medium of silk screen printing. It is about color, form, design and the love of art making."—Diane Gamboa. Colors used: Makeup beige, chicana brown, go-go girl yellow, martini olive green, not so red, gunmetal gray, urban goddess yellow, high heel green, cha-cha burgundy, million dollar green, and black as black. Cat. 2 025.

AtNu: unknown, AtYr: n.d. García, Margaret; *The Next Generation*; n.d. Coventry Rag, 290 gms. 25 1/2" x 31 1/2"; 70 ed. prnt: unknown; sign: Yes. Inscription: 4/70 The next Generation Margaret García; Fund: SHG slide photo: UCSB Photography; copies: 2. Note: Image is of a young child. Cat. 2 026.

AtNu: XXXV, AtYr: 2000; Gil; Xóchitl; *A Secret Garden*; February 10-11, 2000; Coventry Rag, 290 gms. 16" x 22"; 78 ed. prnt: José Alpuche; sign: Yes. Inscription: 20/7 A Secret Garden Xóchitl Gil; Fund: SHG; slide photo: UCSB photography; copies: 2. Note: "Three red hearts/Roses with yellow auras on a blued blend ground. "A Secret Garden" emerged from a series of works based on the innocence and exploitation of sexuality. Using childlike iconography it contains "roses" with exaggerated thorns on the stems and stylized picked hearts as the petals. The red roses allude to the stereotypes of idealizes [sic] romantic love while the thorns provide a harsh balance of pain. The title refers to the childrens story "The Secret Garden" by Francis B. Hodges, a tale about self-discovery and acceptance."—Xóchitl Gil. Colors used: Drk to light Blue, Red, Green, Yellow 1-Medium, Yellow 2-Light. Cat. 2 027.

AtNu: XXXIII, AtYr: 1999; Gomez, Pat; *The Trappings of Sor Juana*; 1999; silkscreen; 18" x 26"; 63 ed. prnt: José Alpuche; sign: Yes. Fund: SHG; slide photo: unknown; copies: 2. Note: Image is of roses in a vase with an image of Sor Juana. A red curtain and a rosary hang from the upper portion of the print. Beside the vase are a stack of books and a framed image of a brain imprisoned by brambles. Text in script in the lower right corner reads, "Liberty itself for me is no boon: If I hold it such, it will soon be my bane. No more worries for me over boons so uncertian [sic]: I will own my very soul, as if it [illegible]". From Maestras I, Sor Juana Series. Cat. 2 028.

AtNu: XVI, AtYr: 1991; Gomez, Pat; *War Stories*; March 4-8, 1991; Silkscreen; 26" x 35 1/2"; 56 ed. prnt: José Alpuche; sign: Yes. Fund: SHG; slide photo: unknown. Note: Repeating image of purple and red sacred hearts and roses. The pattern is repeated in the center of the image, however in blue and green. Over the pattern, text describes the stories of "my uncles and cousins."—Pat Gomez. Cat. 2 029.

AtNu: XLII, AtYr: 2003; Gonzalez, Cici Segura; *Props and Scenery*; May 27-31 and June 3, 2003; Coventry Rag, 290 gms; 22" x 16"; 78 ed. prnt: José Alpuche; sign: Yes. Fund: SHG; slide photo: UCSB photography—duplicate photo by Marissa Rangel. copies: 2. Note: "Multi-Colored Abst[r]act depicting minorities in background. Gold-yellow line symbolizes color barrier in advertisement and film industries. This abstract was created after observing first hand, how the media (adver[t]ising & film) reduces minorities to 'Props & Scenery' in ads and/or films. The absence of people of color, particularly in front of the camera, in the adver[t]ising & film world is alive and well in Los Angeles. The abstract here is the background is full of color yet there is a color barrier represented by the yellow-gold line in the foreground."—Cici Segura Gonzalez. Colors used: Blue, Red, Yellow, Orange, Lt. Purple, Dark Purple, and Black. From Maestras IV. Cat. 2 030.

AtNu: XLII, AtYr: 2003; Gonzalez, Yolanda; *La Reyna*; May 6-10, 2003; Coventry Rag, 290 gms; 22 1/2" x 15 1/2"; 72 ed. prnt: José Alpuche; sign: Yes. Inscription: 28/72 "La Reyna" Yolanda Gonzalez 03; Fund: SHG slide photo: UCSB Photography—Duplicate photo by Marissa Rangel; copies: 2. Note: "Female sitting arms crossed with a lovely head[d]ress and a colorful shall [sic]. her dress is adorned by lots of textures and colors. As he sits she's the Queen. "La Reyna"[.] The strength of the woman is always that of a queen. "La Reyna" is loving, stern, brilliant and always true to herself."—Yolanda Gonzalez. Colors used: Black, Blue, Red, Ochre, Light Yellow Ochre, Light Grey, Off White, Black, and Clear Gloss. From Maestras IV. Cat. 2 031.

AtNu: Special Project SC, AtYr: 2000; Greenfield, Mark Steven; *Cause and Effect*; 2000; Coventry Rag, 290 gms. 32" x 22"; 50 ed. prnt: José Alpuche; sign: Yes. Inscription: 13/40 Cause and Effect Mark Steven Greenfield; Fund: SHG slide photo: UCSB Photography; copies: 1. Note: Minstrel Orchestra in blackface with tornado in background and text. "Weel about turn about and da jis' so / Ebry/ time I weel about I jump Jim Crow". "Images of people in blackface have been a source of both disturbance and fascination to me. These images are intensely powerful in both their literal statements and in their ability to allow the viewer to create a context through the bias of their associations. Generations

of African Americans have suffered grievous injury at the hands of people whose livelihood was derived from creating and reinforcing stereotypes through blackface minstrelsy. The creation of a stereotype was an essential element in maintaining white America's illusion of superiority. It characterized us as buffoons and tricksters, as inherently lazy and immoral and perennial children who were dependent on the paternalism of our "masters" for survival. Slavery, even the post emancipation more subliminal variety, was contingent on making its victims appear to be less than human. The images I've used are taken from late nineteenth century photographs of vaudeville and minstrel show performers. Ironically, blackface minstrelsy, through its wholesale appropriation of African American culture, is recognized as the "America's first indigenous musical-theater genre." Manifestations exist to this day in everything from black stand-up comedy to the "crews" and "posses" of hip-hop. My work entreats the viewer to look at these images, while at the same time looking through them, to discover an alternate context. It is my hope that the work might offer a glimpse into the origins of some conscious or subconscious contemporary thinking with regard to race, color, and gender. If you are discomforted by what you see, I invite you to examine those feelings, for out of this examination will come enlightenment."—Mark Steven Greenfield. Colors used: Blue Green, Burgundy, Gray/Brown, and Eggshell Yellow. Cat. 2 032.

AtNu: Special Project SUBC, AtYr: n.d. Greenfield, Mark Steven; *Some Indignities Persist*; April 24 and May 8 (year unknown); Coventry Rag, 290 gms; 25" x 18"; 43 ed. prnt: SHG?; sign: Yes. Fund: SHG; slide photo: UCSB photography; copies: 2. Note: "Man in blackface holds up dress against wooden fence background with text over printed in the form of an eye chart reading "Some Indignities Persist". Images of people in blackface have been a source of both disturbance and fascination to me. These images are intensely powerful in both their literal statements and in their ability to allow the viewer to create a context through the bias of their associations. Generations of African Americans have suffered grievous injury at the hands of people whose livelihood was derived from creating and reinforcing stereotypes through blackface minstrelsy. The creation of a stereotype was an essential element in maintaining white America's illusion of superiority. It characterized us as buffoons and tricksters, as inherently lazy and immoral and perennial children who were dependent on the paternalism of our "masters" for survival. Slavery, even the post emancipation more subliminal variety, was contingent on making its victims appear to be less than human. The images I've used are taken from late nineteenth century photographs of vaudeville and minstrel show performers. Ironically, blackface minstrelsy, through its wholesale appropriation of African American culture, is recognized as the "America's first indigenous musical-theater genre." Manifestations exist to this day in everything from black stand-up comedy to the "crews" and "posses" of hip-hop. My work entreats the viewer to look at these images, while at the same time looking through them, to discover an alternate context. It is my hope that the work might offer a glimpse into the origins of some conscious or subconscious contemporary thinking with regard to race, color, and gender. If you are discomforted by what you see, I invite you to examine those feelings, for out of this examination will come enlightenment."—Mark Steven Greenfield. Colors used: Rust/Beige, Off White, Dark Gray, and Gray Black. Cat. 2 033.

AtNu: unknown, AtYr: 2000; Greenfield, Mark Steven; *Topsyturvy*; 2000; 22 1/2" x 18 3/4"; 43 ed. prnt: SHG?; sign: Yes. Fund: SHG; slide photo: UCSB photography; copies: 1. Note: "Photographic image of woman in blackface surrounded by a lavender ring with the word "Topsyturvy" in blue letters that get progressively smaller."—Mark Steven Greenfield. Color separations by Ed Almanzor. Colors used: Black, Blue, Lavendar, and Light Ochre. Cat. 2 034.

AtNu: XXXIV, AtYr: 2000; Greenfield, Mark Steven; *Untitled (So Tell Me Who's the Nigger Now)*; January 24-28, 2000; Coventry Rag, 290 gms. 16" x 23 3/4"; 40 ed. prnt: José Alpuche; sign: Yes. Fund: SHG; slide photo: UCSB photography; copies: 1. Note: Image of a man in drag in black face holding a feather duster with text arranged as an eye chart reading "So Tell Me Who's the Nigger Now". Colors used: Beige, Off White, Cold Gray/Brown, and Warm Brown/Black. Cat. 2 035.

AtNu: XXXIV, AtYr: 2000; Greenfield, Mark Steven; *Untitled (Sometimes We Become What We Hate)*; January 24-28, 2000; Coventry Rag, 290 gms. 18" x 23"; 50 ed. prnt: José Alpuche; sign: Yes. Fund: SHG; slide photo: UCSB photography; copies: 1. Note: Image four men in drag in black face holding golliwog dolls with text arranged as an eye chart reading "Sometimes We Become What We Hate". Colors used: Beige, Off White, Warm Dk Brown, and Warm Brown/Black. Cat. 2 036.

AtNu: unknown, AtYr: 1981; Gronk; *D.O.D. Commemorative 1981*; 1981; silkscreen; F/C; unknown ed. prnt: unknown; sign: No. Fund: NEA and the City of Los Angeles. Note: Image is of a skull with black hair and eye sockets in the shape of hearts. There are two red roses below the face. The print has been splattered with pink ink. Text beneath the image area reads, "Dia de Los Muertos, Commemorative Poster / Made Possible By Grants From The N.E.A., And The City Of Los Angeles / SHG copyright 81". Cat. 2 037.

AtNu: XXIII, AtYr: 1993; Gutierrez, Roberto; *Avenida Cesar Chavez*; November 17-20, 1993; Silkscreen; 16" x 22"; 60 ed. prnt: José Alpuche; sign: Yes. Inscription: 42/60 Cesar E. Chavez Avenida Roberto Gutierrez 94; Fund: SHG; slide photo: unknown. Note: "The local traffic patterns of local people, commemorates the former corners of Brooklyn and Gage Avenues which will change to Avenida Cesar Chavez. The conception of the piece was drawn on site over a period of 3 months."—Roberto Gutierrez. Cat. 2 038.

AtNu: XXXIII, AtYr: 1999; Guzman, Margaret; *Velo/Veil*; 1999; silkscreen; 18" x 26"; 65 ed. prnt: José Alpuche; sign: Unknown. Fund: SHG. Note: Image is of Sor Juana writing in a book. Her head is open, revealing her brain. She is enclosed by a wreath. Text in the lower right corner reads, "Sor Juana Inés de la (cross) (1669)". From Maestras I, Sor Juana Series. Cat. 2 039.

AtNu: XLI Special Project, AtYr: 2002; Healy, Wayne; *Achealy's Heel*; 2002; 22"x16"; 60ed. prnt: José Alpuche; sign: Yes. slide photo: UCSB photography; copies: 2. Note: "Buff is background color. Cerulean blue is delineated photo repro of Joe and WH printing. Yellow orange is text and arrows. Maroon is dwgs of dog, panther, and lounge lizard. A play on words, the artist's Acheille's [sic] tendon is savagely attacked by an evil Chihuahua named Wesley."—Wayne Healy. Colors used: Buff/Lt Cream, Cerulean Blue, Yellow orange, and Maroon. Cat. 2 040.

AtNu: Special Project, AtYr: 2001; Healy, Wayne; *Bolero Familiar*; December 4-7, 2001 and January 15-19, 22-26, and 29-31 2002; Coventry Rag, 290 gms; 36" x 50"; 79 ed. prnt: José Alpuche; sign: Yes. Inscription: 6/79 Bolero Familiar Healy; slide photo: UCSB Photography; copies: 2. Note: "Two guys sitting on living room couch play guitars and sing, one girl plays maracas and sings while other girl replaces low E-string on her guitar. A baby girl reaches for Chihuahua hiding under the coffee table. Nana cooks food in the kitchen. I grew up with musk in the house. My aunts and uncles would gather to play boleros made famous by Trio Los Panchos and Los Dandys. Grandma was always cooking food served with her corpus christi style tortillas. My wife has a Chihuahua and the miserable creature keeps showing up in my prints."—Wayne Healy. Colors used: OHCO-U, 523 U Lavender, 106 U Light Yellow, 345 U Light Green, 467 U Light Brown, 185 C Red, EF00 C Flesh, TSRO-C Brown, 300 C Blue, TL00-C Orange, OIRO-C Gray Blue, 468 C Khaki, 1000 U Yellow White, OZAF-U Purple, 165 C Orange, 266 C Violet, Black, Trans White, and 2100 Clear Gloss. Cat. 2 041.

AtNu: XXXVIII, AtYr: 2001; Hernandez, Ester; *Con Cariño, Lydia Mendoza*; May 15-19, 2001; Coventry Rag, 290 gms. 18" x 26"; 76 ed. prnt: José Alpuche; sign: Yes. Inscription: 20/76 "Con Cariño, Lydia Mendoza" Ester Hernandez 2001; Fund: SHG; slide photo: UCSB photography; copies: 2. Note: "A portrait of a Mexican American woman dressed in a full length Mexican "Folkloriko" [sic] dress. She is holding the top of an upright acoustic guitar. The entire image is framed by a red stripe."—Ester Hernandez. Colors used: Bluish Purple-Dark Blue Blended into Light Blue, White (w/ blue tint), Sierra, Ochre, Gold Pearlescents, Green, Red, Purple-Transparent, and Opaque Blue/Black. Cat. 2 042.

AtNu: XX, AtYr: 1992; Herrón III, Willie F. *Lecho de Rosas: Día de los Muertos 1992*; September 30-October 3, 1992; silkscreen; 41 1/8" x 28 1/2"; 55 ed. prnt: José Alpuche; sign: Yes. Inscription: 33/55 "Lecho de Rosas" WFHerrón 92; Fund: SHG; slide photo: unknown. Note: Three calaveras amidst rose bushes with bed

sheets. The entire image is framed by a "Border of sun, water and cricket (symbols)"(--Willie Herrón) as well as text. The text at the top reads, "Dia de los" and at the bottom "19-muertos-92". Cat. 2 043.

AtNu: XXXIX, AtYr: 2001; Herrón III; Willie F. *Seeds From a Hybrid Generation*; October 30-November 03, 2001; Coventry Rag, 290 gms. 18" x 24"; 129 ed. prnt: José Alpuche; sign: Yes. Inscription: 4/129 Seeds From a New Generation WFH; slide photo: UCSB Photography; copies: 2. Note: "Overlaying images and zine articles taken from various publications and flyers from THE VEX from 1980, including THE VEX stage back drop THE VEX HEAD. To Document SHG' contribution to the rise and fall of the influence THE VEX had on the hybrid Punk and New Wave Movement by Chicano Musicians for E.L.A."—Willie F. Herrón III. Colors used: Grey (Warm), Orange (Dull), Deep Red (Dull), Burgandy Red (Dark), and Black. Cat. 2 044.

AtNu: XXXIX Special Project, AtYr: 2002; Hoyes, Bernard; *Block Party Ritual*; April 2-10, 2002; Coventry Rag, 290 gms. 14" x 33"; 121 ed. prnt: José Alpuche; sign: Yes. slide photo: UCSB Photography. Note: "Central Figures swirling as conga players emerge as well as evoke the swirls, symbolizing the rhythm of the music. To the left figures in praising motion to the right, figures in chorus against cityscape of sky scrapers and palms over seen by concentric skies in rhythm."—Bernard Hoyes. Colors used: Green Pantone 355c, Orange Pantone 021c, Cyan (Process)-2c, Blue Pantone 286c, Yellow (warm) 2c, Transparent White, Warm Red C, Tan Pantone 158c, White 50%, Red Pantone 200c, Violet Pantone 70% bare, and Varnish (overall). Cat. 2 045.

AtNu: XXXIX Special Project, AtYr: 2001; Hoyes, Bernard; *Sanctified Dance*; August 14-19, 2001; Coventry Rag, 290 gms. 16" x 22"; 78 ed. prnt: José Alpuche; sign: Yes. slide photo: UCSB photography; copies: 2. Note: "Group of figures in a Revival Ritual that involves hand clapping, tambourines and dance. The print conveys a ceremonial dance. The figure in full motion, in the Spirit of Sanctified Joy, dance to celebrate their connection to the Astral world."—Bernard Hoyes. Colors used: Light Yellow (O), Ultramarine Blue, Green, Red (Dark), Trans White, Warm Red (Trans), Deep Yellow (Trans), Brown (trans), Transparent Magenta, and Gloss Varnish. Cat. 2 046.

AtNu: Special Project, AtYr: 2001; Huerta, Leticia; *Elegie*; March 13-17, 2001; Coventry Rag, 290 gms. 16" x 22"; 80 ed. prnt: José Alpuche; sign: Yes. slide photo: UCSB photography; copies: 2. Note: "Red roses with music sheet and 5 photos in cross configuration. This print is about my father's recent death. The Elegie is a piece that my son was learning and had wanted to play at his grandfather's funeral. He didn't get to do that so I have placed their images and the music on this print to, in a sense, give them both this last opportunity to share their music."—Leticia Huerta. Colors used: Clear Blue, Yellow, Light Green, Dark Green, Dark Red, Off White, Transparent White, Violet, Black, and Grey. Cat. 2 047.

AtNu: Special Project, AtYr: n.d. Huerta, Salomon; *Untitled (María Felix)*; May 28-June 1 and June 18; Coventry Rag, 290 gms. 16" x 22"; 120 ed. prnt: José Alpuche; sign: No. slide photo: UCSB Photography. Note: "Maria Felix on a red background. Homage to Maria Felix."—Salomon Huerta. Color separations by Miguel Angel Reyes. Colors used: Fusia 21u—232u, Dark Pink pr-63-semitrans, Light Dusty Purple, Pale Pink Opaque, Red 70% Opaque, White Opaque, Light Fusia Opaque, Black Opaque, Brown/Purple 70& opaque, Trans/White, and Clear Gloss. Cat. 2 048.

AtNu: XLII, AtYr: 2003; Jimenez Underwood, Consuelo; *La Virgen de los Nopales*; May 18-23, 2003; Coventry Rag, 290 gms. 22" x 16"; 72 ed. prnt: José Alpuche; sign: Yes. Inscription: 22/72 La Virgen De Los Nopales [illegible] '03; Fund: SHG slide photo: UCSB Photography—Duplicate photo by Marissa Rangel; copies: 2. Note: "Nopales with the Americas are under an intense barbed wire rain. The Virgens are watching. America is represented by the nopal. The continent is under attack. The barbed wire that cut up our land are still raining upon us. The virgen watches. The sun, moon, and flower below are uncertain and uncomfortable with the situation."—Consuelo Jimenez Underwood. Colors used: Green—warm-mid, Blue—Light Turq., Brown—Light warm, Magenta, Light Warm Grey, and Black Rain. From Maestras IV. Cat. 2 049.

AtNu: XXXIV, AtYr: 2000; Kemp, Randy; *Spiritual Warrior*; February 8-12, 2000; Coventry Rag, 290 gms. 16" x 22"; 75 ed. prnt: José Alpuche; sign: Yes. Inscription: 20/75 Spiritual Warrior Randy Kemp '00; Fund: SHG; slide photo: UCSB photography; copies: 2. Note: "Yellow/Orchor Figured and Background. Blue Angel Wings. Four Circular design elements at bottom foreground (Horse, Eagle, Turtle, and Buffalo). My works include both the raditional flat, two-dimensional depiction of tribal life, as well as works in contemporary Indian themes and views. Like many before me, the innate drive to become an artist is an away of life that has compelled me to be nothing other than an artist. It is an amazing period to share with a generation of American Indian artists who are utilizing today's worldwide mediums of art with the same continuous strength on "Indianness" as in generations before us. Thus, expressing and preserving the dignity, respect, purity and beauty of our Indian people."—Randy Kemp. Colors Used: Yellow Orchor, Dark Purple/Red, Light Blue, Red/Orange, and Deep Red/Black. Cat. 2 050.

AtNu: Special Project, AtYr: 2002; Kirkpatrick, Garland; *¡No Más Tratos! (No More Deals!)*; July 30-31, 2002; Coventry Rag, 290 gms. 16" x 16"; 91 ed. prnt: José Alpuche; sign: No. slide photo: UCSB Photography. Note: "A brown and black empowerment poster. Brown and black fists join in solidarity against corporate control of affordable housing."—Garland Kirkpatrick. Colors used: O-Fire Red, O-Dark Brown, and T-Flesh. Cat. 2 051.

AtNu: XXXIV, AtYr: 1999; Lee, Betty; *Seekers of Gold*; July 28-30, August 3, and December 7-8 1999; Coventry Rag, 290 gms. 16" x 20"; 51 ed. prnt: José Alpuche; sign: Yes. slide photo: UCSB photography; copies: 2. Note: "The background consists of four different vertical rectangles of men's faces in dark blue tones; an outline map of the United States in red with statistical dots and direction lines emanate from siljouettes [sic] of Chinese laborers circa early 1900. Seekers of Gold refers to the desire of statistical information in matters especially of immigration and its effect on commerce, population and culture. Real numbers and actually unavailable in this work, and the statistical symbols are misleading. And just as well- Americans seem to prefer the statistics in their imaginations. Seekers of Gold is intended for the viewer to recall the prevailing attributes given to Chinese immigrants who arrived in the United States in the 19th and 20th centuries. Despite laws intended to prevent discrimination in the workplace, the impact of the newly-arrived, then and now on American culture is uneasy."—Betty Lee. Colors used: Milori Blue, T-DK Cyan Blue, T-LT. Trans baby Blue, T-Ultra Marine Blue, O-Yellow, O-Red, and O-Black. Cat. 2 052.

AtNu: unknown, AtYr: 1980; Limón, Leo; *D.O.D. Commemorative 1980 (Parade)*; 1980; silkscreen. 25 ed. prnt: unknown; sign: Yes. Inscription: 6/25 Limón; Fund: NEA, Atlantic Richfield, and the City of Los Angeles. Note: Image is of celebrating calaveras in costumes. They stand behind a yellow rectangle with the announcement, "Come and celebrate with us, Vengan y Celebren con nosotros. Dia de los Muertos (Day of the Dead) November 2, 1980 SHG 3802 Brooklyn Ave., East Los Angeles, CA 90063 Phone 264-1259 or 268-2335 Traigan sus mascaras y ofrendas al altar." Text at the bottom of the print reads, "Los Angeles Bicentennial 1781-1981 Made Possible By Grants From N.E.A., Atlantic Richfield, and the City of Los Angeles. Design/Limon Copyright 1980". Cat. 2 053.

AtNu: unknown, AtYr: 1981; Limón, Leo; *DOD Commemorative 1981 (Legs)*; 1981; silkscreen; F/C; 25 ed. prnt: unknown; sign: Yes. Note: Image is of a woman's legs in white high-heeled shoes. She wears black leggings with purple calaveras. "Blue sky, white clouds and bubbles [are] in [the] background."—Leo Limón. Cat. 2 054.

AtNu: XXXIX, AtYr: 2001; Limón, Leo; *Morena Y Quetzalcoatl*; 2001; Coventry Rag, 290 gms. 16"x 22"; 78 ed. prnt: José Alpuche; sign: Yes. slide photo: UCSB Photography; copies: 2. Note: "La mujer, madre tierra y la jovencita sit at the bus bench. She's watching Quetzacoatl's word over-taking the huffing-puffing intervention horses as they approach our templo's in Aztlan movimiento is in the Air, the Sky. Young Native lady seated on bus bench. High rise hairdo. Green background. Serpent image on bench."—Leo Limón. Colors used: Blue, Tan, Blue (ultra-marine), Yellow (medium), Yellow Green, Red, Orange, Green-Eyes, Green-Bench, Gray, Light Blue, and Black. Cat. 2 055.

AtNu: XL, AtYr: 2002; Lopez, Alma; *Chuparosa*; June 11-15, 2002; Coventry Rag, 290 gms. 16" x 22"; 78 ed. prnt: Joe Alpuche; sign: Yes. Inscription: 50/78 Chuparosa Alma Lopez 2002; Fund: SHG

slide photo: UCSB Photography. Duplicate photo by Marissa Rangel; copies: 2. Note: Atelier silkscreen print depicts a photo-silkscreened image of a woman's back, arms akimbo. Her head is cocked to the side revealing part of her face. She has short hair and her shirt features two stylized Mayan females holding hands. This entire image is superimposed on an image of a red hummingbird that fills the rest of the space of the print. At the bottom of the print, in front of the woman, another stylized female Mayan sits with her legs open. She is seated in front of a recumbent Mayan deity. "A woman with hands on her hips (instead of pelvis), a reverse pose of the Earth goddess."—Alma Lopez. Colors used: Charcoal/grey, Red, Brown, Blue, Light Grey, Yellow Ochre/Mustard, Orange Red, Transparent White, Transparent Brown, Transparent Black, White, Black, and Gloss. From Maestras III. Cat. 2 056.

AtNu: XXXIV, AtYr: 1999; Lopez, Alma; *Mnesic Myths*; July 20-24, 1999; Coventry Rag, 290 gms. 16" x 20"; 47 ed. prnt: Joe Alpuche; sign: Yes. slide photo: UCSB photography. Note: "A young woman extends her hands to another young woman who lays/rests on the image of coyolxauhqui- the Aztec moon goddess. Behind them is a line drawing of coatlique- Earth Goddess, and Popocatepl and Ixtacihuatl. Below is a band of Aztec codex to symbolize the sky. Mnesic Myths is an adjective to describe something that is relative to memory. Mnesic myths, the title, refers to myths which may be remembered or recalled. This silkscreen has the myth of Coatlique and Coyolxauhqui, and the Romeo-Juliette type myth of Popocatepetl and Ixtacihuatl. Both are pre-Colombian myths which are places in western contemporary times with the image of two young homegirls."—Alma Lopez. Colors used: Off White, Beige/Brown, M. Brown, Red Brown, White, Blue Black, and Black. Cat. 2 057.

AtNu: XLI, AtYr: 2002; Lopez, Alma; *Our Lady of Controversy*; December 3-7, 2002; Coventry Rag, 290 gms; 22" x 16 1/4"; 73 ed. prnt: José Alpuche; sign: Yes. slide photo: UCSB photography; copies: 2. Note: "Image of a woman wearing flowers and blue cape, on a flowery-patterned background, held by a bare breasted butterfly angel."—Alma Lopez. Colors used: brown, orange, red brown, flesh, transparent white, blue, green, red, yellow, white, and black. Cat. 2 058.

AtNu: XXXIII, AtYr: 1999; Lopez, Yolanda; *Jaguar Woman Warrior: Woman's Work is Never Done*; 1999; silkscreen; 18" x 26"; 72 ed. prnt: José Alpuche; sign: Unknown. Fund: SHG; slide photo: unknown. Note: Image is of a female Aztec jaguar knight, a calavera, a hand writing a prescription, a heart, and two purple orchids. Text running sideways along the left side of the print reads, "Jaguar Woman Warrior Woman's Work Is Never Done". From Maestras I. Cat. 2 059.

AtNu: XLI, AtYr: 2003; Lopez Martinez, Aydee; *Moved by Your Rhythmic Eyes*; March 25-28 and April 1-3, 2003; Coventry Rag, 290 gms; 20" x 15 1/2"; 118 ed. prnt: unknown; sign: Yes. slide photo: UCSB photography. Note: "The print was created to represent the Grand Performances brochure for the 2003 Summer program in downtown Los Angeles."—Aydee Lopez Martinez. Colors used: Ultramarine Blue semi-trans., Yellow Ochre, Blue shade red, Sienna light, Semi-Opaque white, Magenta, Transparent white, Black, Ultramarine Blue, Transparent white, Magenta, and Gloss. Cat. 2 060.

AtNu: XXXIX, AtYr: 2002; Lozano, José; *El Ropero de Frida / Frida's Armoir*; March 19-23, 2002; Coventry Rag, 290 gms. 16" x 20 1/4"; 75 ed. prnt: José Alpuche; sign: Yes. slide photo: UCSB Photography; copies: 2. Note: "The image is of the artist Frida Kahlo. Its an homage to her talent and spirit. The image deals with the allure of Frida Kahlo. Its commenting on Frida becoming as popular as BARBIE. I'm drawn to her strength as an image maker and personality. I like the idea of her being portable and taking her along everywhere physically and spiritually. It's another one of my many homages to her."—José Lozano. Colors used: Black, Pink, Flesh, Light Blue, Brick Red, Dark Brown, Dark Blue, Dark Red, Olive Green, Yellow Ochre. Cat. 2 061.

AtNu: XVII, AtYr: 1991; Lozano, José; *Hero-Héroe*; 1991; 28" x 36 5/8"; 57 ed. prnt: José Alpuche; sign: Yes. Inscription: 34/57 Hero / Héroe José Lozano 91; slide photo: unknown; copies: 2. Note: The head of a Mexican wrestler in a mask. The background is made up of a repeating pattern of people's faces. Cat. 2 062.

AtNu: XXXV, AtYr: 2000; Manje, R. David; *Dreamers, Magicians, and Star Navigators*; February 1-2, 2000; Coventry Rag, 290 gms. 16" x 22"; 80 ed. prnt: José Alpuche; sign: Yes. Inscription: 20/80 Dreamers Magicians and Star Navigators David Manje; Fund: SHG; slide photo: UCSB photography; copies: 2. Note: "Stellae carving, fish, crosses, pyramid, multi-blend arch. This print depicts elements of the mayan civilization along with incongruous elements that yet portray their quest and achiev[e]ment in astrological navigational [sic] skills. The presentation of the crosses, burial fields and explosion burst add to the dream-like layers of incongruent dreams."—R. David Manje. Colors used: Blend-Purple to Cerulian bl., Yellow-Trans, Red Orange- Trans, Green-Trans, Green-Trans, Dk Violet/Black Opaque, Gold-Opaque, and Beige-Trans. Cat. 2 063.

AtNu: XXV, AtYr: 1995; Martínez, Isabel; *Raza y Cultura*; 1995; 30" x 41 7/8"; 58 ed. prnt: José Alpuche; sign: Yes. Inscription: 52/58 "Raza & Culture" Isabel Martinez 95. Note: Multicolored, active print has few distinguishable images. Among them are faces and a heart. Cat. 2 064.

AtNu: XXXVII, AtYr: 2001; Martínez, Isabel; *V.G. Got Her Green Card*; February 8-15, 2001; Coventry Rag, 290 gms. 22" x 16"; 80 ed. prnt: José Alpuche; sign: Yes. slide photo: UCSB photography; copies: 2. Note: "A Virgin of Guadalupe holding a green card."—Isabel Martínez. Colors used: T-Ultra Blue, T-Violet, T-Magenta, T-Yellow, T-Turquoise, T-Green Shade Yellow, T-Flesh, O-Black, O-Green, T-White, Clear Gloss, and T-Yellow-Orange. Cat. 2 065.

AtNu: XXIII, AtYr: 1993; Martinez, Paul; *In Memory of Cesar Chavez*; November 12-16, 1993; Silkscreen; 16" x 22"; 65 ed. prnt: José Alpuche; sign: Yes. Inscription: [illegible]; Fund: SHG; copies: 2. Note: "Memorial of Cesar Chavez consists of a "NO GRAPES" sticker on top left. Brahma bull on the lower left hand corner with four oval portraits of Cesar Chavez and falling typography on right side."—Paul Martinez. Cat. 2 066.

AtNu: Special Project, AtYr: 2002; Mejia-Krumbein, Beatriz; *Caution (Captive)*; 2002; Coventry Rag, 290 gms. 16" x 22"; 80 ed. prnt: José Alpuche; sign: Yes. slide photo: UCSB Photography; copies: 2. Note: "The image "CAPTIVE" reveals a close up of a face with wide open eyes. The face is framed by a red border filled with blue flowers, and green and yellow leaves. The pattern of flowers, leaves, and branches grows to form a layer in front of the face outlined in black. The face and frame (border) are mainly red. CAUTIVA 'Captive' (a) kept within bounds: confined b) held under control (c) extremely pleased or gratified (d) making departure difficult. (Webster's Collegiate Dictionary) The image "CAPTIVE" as the word's definition is ambiguous and has positive and negative implications. Although i[t]s formal elements are vivid and pleasant, the face is confined within a frame (and) the layer formed by the branches, flowers and leaves in front of the face represents elements of incarceration. Many women are confined and kept apparently gratified with material goods but their soul[s] are locked away."—Beatriz Mejia-Krumbein. Colors used: T-Skin, T-Yellow, T-Red, T-Light Gray, T-Dark Gray, T-Brown, T-Green, Blue, and T-Black. Cat. 2 067.

AtNu: Special Project, AtYr: 2002; Memphis; *Cliché Inversion*; July 17-19, 2002; Coventry Rag, 290 gms; 22" x 16"; 73 ed. prnt: José Alpuche; sign: Yes. slide photo: UCSB Photography; copies: 2. Note: "The shape of the tree is formed with the word "TU CASA ES MI CASA". Poring [sic] out from the leaves is a deranged pig wearing a poor ball helmet and holding a carfe football over the head of a dazed and angry canary who sits in his broken shell on the ground with egg yolk dripping off of his head from the other eggs the pig has cast to the ground." "CLICHE' inversion takes the familiar CLICHE 'MI CASA ES TU CASA' and flips it to now !AY 'TU CASA ES MI CASA'. This statement is the pigs spin in the phrase as he has scaled up a tree and kicked out its inhabitants (A SMALL CANARY) and its unhatched siblings with no regard to the fact that the birds were there first to say nothing of the fact that in general, trees are homes to birds, even squirrels but never pigs. Symbolically, the pig with his football helmet represent the greed of capitalistic developers—specifically the powers that be behind the football stadium currently being proposed for downtown Los Angeles. The helpless canary is both bewilder[ed] and angry at this hostile take over. The canary represents the people who live in the proposed stadium site. The Broken eggs that () the landscape are literally bird embryos. These represent the destruction

of dreams, futures and quite possibly the lives of those persons () in 'STADIUM LAND' and the ripple that this variety of displacement () has for the residents children/family."—Memphis. Colors used: Black, Bright Red, Crayola Yellow, Medium Brown, Forest Green, and Bubble gum Pink. Cat. 2 068.

AtNu: Special Project, AtYr: 2002; Mendoza, Ricardo; *Respect*; August 6-10, 2002; Coventry Rag, 290 gms. 16" x 21 1/2"; 91 ed. prnt: José Alpuche; sign: Yes. slide photo: UCSB Photography. Note: "A developer is hammering the spike of Gentrification into a building covered with the American flag and destroying it. The residents are facing the developer in silho[u]ette spelling out the word RESPECT across their backs. A larger figure represents "Justice & Dignity" has deNote:d expensive roots below which are being eaten by termites of greed and indifference. The developers hands also eat at the community by roots and are being showered with money." "The theme was developed with the goal to serve a dialogue for both the oppressor and the oppressed; The Development/Landlords and the resident tenants. I wanted to present illegal evictions as an Un-American act in response to the often one sided patriotism experienced today. The tenants in silhouette are dipicted [sic] as standing up to the developer, looming large figure with a football head. He is however, vulnerable in that he is plug in being pulled by the figure representing "Justice & Dignity" her roots are being eaten away by termites representing 'indifference' and 'greed'."—Ricardo Mendoza. Colors used: Black, Ultra Marine Blue, Cerulean/Cobalt Blue, Cadmium Red, Golden Sienna, and Cad Yellow. Cat. 2 069.

AtNu: XXXVIII, AtYr: 2001; Miguel-Mullen, Cristina; *Mangán Tayón-Food for Thought*; May 1-8th, 2001; Coventry Rag, 290 gms. 26"x 18"; 84 ed. prnt: José Alpuche; sign: Yes. Inscription: [illegible] "Food For Thought" [illegible] slide photo: UCSB Photography—Duplicate photo by Marissa Rangel. copies: 2. Note: "The central image of the piece is a woman cooking food and wearing an apron which reads "Mangán Tayón" which in Ilocano means "Let's Eat." Fields of gold surround her and feature portraits and images of the artist's grandparents, faces, and as farmworkers working in the fields. They are depicted in sepia and skin color/flesh tones to indicate a feeling of the past in comparison to the central figure of the woman who is shown in more intense colors with warmer flesh tones to indicate the present. In the foreground are plates of food, spices, sauces, fruit and vegetables used in the preparation of the food which are all symbolic to the artist family community and culture." "*The Mangan Tayon-Food for Thought* print was designed to conceptualize the process of food consumption, the labor of agriculture and importance of cuisine preparation to the family. The theme of food for the print was inspired by personal memory, identity and heritage. The images in the print brought together many different environments relating to food: the labor involved in bringing food to our tables in the kitchen and also in the agricultural fields we often take for granted. The work also represents the cultural and traditional significance that food represents to the artist's Pilipino culture and cross-cultural significance where food is a way to bring family together. Each image was based on family pictures taken in the kitchen of the artist's mother cooking, from old family photo albums showing the diaspora of the artist's grandfather who was a part of the historical first wave of immigrant farm-workers from the Philipines and her grandmother who was able to come here as a contracted nurse and personal domestic care-giver for a family of Multinational Chevron Oil Corporate Officer. This was rare due to the fact that this took place during a time when Asian Women were banned from immigrating to the US due to the Tydings McDuffy Law restricting them due to the threat of them marrying into the Anglo society. In addition historical photos were integrated into the piece depicting the early farm workers photos taken at Agbayani Village showing the significance of Pilipinos to the UFW movement specifically the early grape strikes where Chicanos, Mexicans and Pilipinos came together to fight against the injustices of the grape farm workers researched at Visual Communications in Los Angeles. There are culturally symbolic foods, spices, and produce on the table indicative of the Pilipino culture, showing how culture is passed on to future generations through the tradition of food preparation. Some of most favorite memories are those of working in the fields with my cousins and preparing food in the kitchen sharing stories with my sisters and mom. According to one's background and culture, food takes on different meanings. Due to multiculturalism and globalization the people of the world are continually interacting with each other and as a result are constantly being introduced to a diversity of customs, traditions and ways of life. With this work, I hope to reinforce a new sensitivity to a deeper understanding of one another based on tolerance and cross-cultural understanding. Mangan Tayon is about the familiar act of eating we all take part in and functions as a metaphor for life exploring different perspectives existing in our society on the theme of food. The work is about the experience of eating. I believe the process of producing this work was personally more important than the product which supported people sharing their own oral histories and family stories provoking discussion with the viewers about their own personal experiences surrounding the memories of their family on the theme of "food". Discussion was brought up in the process of creating this work deconstructing the issues of food and pertaining to how produce is grown, picked and distributed. Revealing personal accounts of injustice to workers, details of the hard work involved and personal accounts from family members of the artist in terms of exposure to pesticides and harmful working conditions were all provoked due to the subject matter of this piece. 'My mother remembers the foreman telling my lolo, my grandpa, to mix the pesticides with his own two hands before spraying the fields with it. My grandpa later died of cancer due to all the pesticides he had been exposed to while working in the fields.'; Their hard work often [went] unnoticed, unappreciated, and [was] often the subject of xenophobia and racism."—Cristina Miguel-Mullen. Colors used: Cyan, Magenta, Dark Yellow, Flesh Tone (orange, brown), Sepia, Jade Green, Flesh Tone Dark (orange, brown), Gold, Purple, Off White-Highlights. From Maestras II. Cat. 2 070.

AtNu: Special Project, AtYr: 2001; Mincher, Sally; *Echo Park*; July 24—27, 2001; Coventry Rag, 290 gms. 16"x 22"; 80 ed. prnt: José Alpuche; sign: Yes. slide photo: UCSB Photography; copies: 2. Note: "Landscape showing water lilies in bloom with foliage reflected in the water. Location Echo Park, Los Angeles. Landscape: view of the lake in Echo Park, Los Angeles showing water lilies in bloom, with reflections of foliage in the water. Developed from the original painting of hte [sic] same title. Original painting commissioned in 1986 by linda sessions."—Sally Mincher. Colors used: T. Salmon Pink, O. Lemon Yellow, O. Turquoise, T. Burnt Sienna, T. Lime Green, T. Powder Blue, T. Ivory warm-white, T. Magenta/Purple, and T. Dark blue/Green. Cat. 2 071.

AtNu: XLI, AtYr: 2003; Molina, Laura; *Cihualyaomiquiz, The Jaguar*; December 10-14, 2002 and March 18, 19, and 20, 2003; Coventry Rag, 290 gms. 22" x 16"; 46 ed. prnt: José Alpuche; sign: Yes. slide photo: UCSB photography; copies: 2. Note: "A leaping female figure wearing a skin-tight ocelot leotard, wrestling boots and a feathered Native-American headdress in front of a yellow star burst on a deep violet background. Upper left corner has "Insurgent Comix" logo with a clenched fist. The comic book title appares [sic] at the top with dialogue balloons around the figure and descriptive text in lower left corner."—Laura Molina. Colors used: Pink—Yellow Blend, Gold, Ocelot Orange, Flesh Tone, Red, Aqua, Violet, Orange, Black, Deep Gray, Transparent Black, Deep Blue, Block-Out White, Aqua and Gloss Clear. Cat. 2 072.

AtNu: XXXIII, AtYr: 1999; Montoya, Delilah; *El Guadalupano*; 1999; silkscreen; 18" x 26"; 51 ed. prnt: José Alpuche; sign: Unknown. Fund: SHG; slide photo: unknown. Note: "Photographic image depicting a "Pinto" (inmate) standing in front of prison bars with handcuffs on and a tattoo of the Virgen de Guadalupe on his back. A bouquet of roses with hand turned upward below the image."—Delilah Montoya. From Maestras I. Cat. 2 073.

AtNu: XXXVII, AtYr: 2000; Montoya, Richard; *Mickey Mao*; July 25-27, 2000; Coventry Rag, 290 gms. 26" x 40"; 100 ed. prnt: José Alpuche; sign: Yes. Inscription: 6/100 Mickey Mao Richard Montoya CC/RCAF 00; slide photo: UCSB photography; copies: 2. Note: ""Mickey Mao" simple use of corporate and communist images juxtaposed with humor and poetry. Corporate & communist cultures have merged in this millenium. The contradictions are here. I yearn secretly for both. I salute Mao and I enjoyed Coke in Chiapas."—Richard Montoya. Colors used: Electric Blue,

Fire Engine Red, Twinkie, Dark Purple, and Creamy Yellow. Cat. 2 074.

AtNu: XXXV, AtYr: 2000; Moreno, Martín; *Dualities*; February 17-18, 2000; Coventry Rag, 290 gms. 16" x 22"; 80 ed. prnt: José Alpuche; sign: Yes. Inscription: 20/80 Dualities Martín Moreno; slide photo: UCSB photography; copies: 3. Note: "Half of the image deals with life, the other with death showing the intricacy between life and death skeleton dropping seeds into life's hand (woman). The print deals with dualities night and day, life and death, light and dark. Dualities deals wit[h] the balance of life our life cycle. that from death comes life."—Martín Moreno. Colors used: O-Flesh Brown, T-Light Brown, T-Blue Shade Red, T-Baby Blue, T-Red Shade Yellow, and O-Dark midnite blue. Cat. 2 075.

AtNu: XX, AtYr: 1992; Norte, Armando; *Niña Héroe*; August 22-25, 1992; silkscreen; 24" x 30"; 68 ed. prnt: José Alpuche; sign: Yes. Inscription: Niña Héroe; Fund: SHG; copies: 2. Note: Image is of a young girl in calavera makeup holding a wooden rifle with a skeleton dangling from it. She wears a sombrero and bandolero and her arms are skeletal. A plush toy doll is on the ground beside her. The background is brown. Possibly a play on the "Niños Héroes of Chapultepec". Cat. 2 076.

AtNu: XXXIII, AtYr: 1999; Olabisi, Noni; *King James Version*; 1999; silkscreen; 18" x 26"; 58 ed. prnt: José Alpuche; sign: Unknown. Fund: SHG; slide photo: unknown. Note: A pregnant woman's hands are bound above her head to a post and her back is bloody. In the background is an African fetish. In the lower area is a revolver superimposed on two pages from the King James Version of the Bible. From Maestras I. Cat. 2 077.

AtNu: XXIX, AtYr: 1996; Oropeza, Eduardo; *Chicuelina*; 1996; silkscreen; 17" x 21"; 77 ed. prnt: José Alpuche; sign: No. Fund: SHG; slide photo: Unknown; copies: 2. Note: Image is of a bullfight where the spectators are calaveras. Cat. 2 078.

AtNu: VI, AtYr: n.d. Oropeza, Eduardo; (title unknown); n.d. silkscreen. Unknown ed. prnt: Unknown; sign: Yes. copies: 1. Note: A priest leads a funerary procession of calaveras. Cat. 2 079.

AtNu: XLT, AtYr: 2003; Orosco, Juanishi V. *Angel de la Vida*; June 17-21, 2003; Coventry Rag, 290 gms. 22" x 16"; 82 ed. prnt: José Alpuche; sign: Yes. slide photo: UCSB Photography; copies: 2. Note: "The figure of an Angel over a blue blend background. He is criss crossed with scars. There is the image of a Pre-Columbian face with Huelga Eagle designs on his face. I titled this print on a[n] on-going series of Meso-American Angels. These angels are male/female and they are indegnious [sic] to the America's! This Angel I title "Angel de la Vida." He has served his time here on earth by helping us in our daily pendejas! As symbolized by the scars on his body -! He is being brought back to his home as symbolized by a guardian gatekeeper ---- He served his time on Earth and is being rewarded by being allowed to go home -- back to his cante! (home) It's actually very simple, an angel served his time!"—Juanishi Orosco. Colors used: Blended Colors, P26C Violet 263 C, P.29C Ultra Blues 283 C, P.29C Ultra Blue 287 C, P.32C Light Tralo Blues 304C, P.33 Med. Thale Blues, Off White, Clear Gloss, and Black. Cat. 2 080.

AtNu: XVI, AtYr: 1991; Ortega, Tony; *Frida y Diego Nos Muestran Mexico*; March 25—29, 1991; silkscreen; 35" x 26"; 64 ed. prnt: Oscar Duardo; sign: Unknown. Fund: SHG; slide photo: unknown; copies: 2. Note: Image is of the artists Frida Kahlo and Diego Rivera. Kahlo holds a brush. In the background is a group of people, an automobile, and a pyramid (Chichen Itza). Cat. 2 081.

AtNu: XXXVIII, AtYr: 2001; Pérez, Elizabeth; *Blue Venus*; 2001; Coventry Rag, 290 gms. 18"x 22"; 70 ed. prnt: José Alpuche; sign: Yes. Inscription: 20/90 "Blue Venus Perez; Fund: SHG slide photo: UCSB Photography; copies: 2. Note: "A linear and cross-hatched version of Bottecelli's Venus (sans the half shell) holds paint brushes, their tips with the primary colors and gold, with her left arm. She puts her hand over her heart which has a tattoo with a small banner in Latin that is not entirely legible. Over her head is a full banner with the words on the tattoo- "Ars longa, vita brevis" (Art is long, life is short-Hippocrates). Yellow sunrays shine from behind her on a red background. In keeping with the theme of the Maestra's Atelier—nurturing. I wanted to show the nurturing aspect of art, how it cultuvates [sic] and promotes a culture or civilization. I've appropriated Botticellis image of Venis [sic] in part for its curva-linear qualities [sic] which I've often used in my work. Largely though, I've used this image as to me it represents Art and how it caresses and protects a culture. She is blue as the Greek god and the Hindu god, Vishnu were blue. I wanted to show the enlightened quality that women possess that passes on culture through the ages. Ancillary to the theme of nurturing are the banners over her tattoo and her head, a reassurance of the timelessness of art in the Latin phrase "Ars longa, vita brevis" (unless the Taliban rebels get it)."—Elizabeth Pérez. Colors used: Deep Crimson, Pale Yellow, Light Blue (warm), Medium Blue (warm), Grey, Gold, and Purple. From Maestras 2. Cat. 2 082.

AtNu: XXXIII, AtYr: 1999; Portillo, Rose; *Sor Juana Rebelling Once Again*; 1999; silkscreen; 18" x 26"; 64 ed. prnt: José Alpuche; sign: Yes. Inscription: 28/64 Sor Juana Rebelling Once Again Rose Portillo 99; Fund: SHG; slide photo: unknown; copies: 2. Note: Sor Juana wears a handkerchief veil and a manta like that of la Virgen de Guadalupe. From her head sprout two fiery roses. Text in the sky next to her reads, "plucking courage up from her very [illegible], she resolved, rebelling once again to see herself made sovereign in that half of the globe left unprotected from the sun.." Text running along the outside of her manta reads, "If There's One Thing Drives The Devil Up A Tree, Its Hearing Of A Woman Who's Smarter Than He.." Text on her handkerchief reads, "tears and sighs dissolve my heart and soul together, the soul reducing to wind, turning the heart to water". From Maestras I. Cat. 2 083.

AtNu: XXV, AtYr: 1995; Ramirez, Christopher; *Leading by Example*; January 28, 1995; Silkscreen; 26 1/4" x 36 1/4"; 49 ed. prnt: José Alpuche; sign: Yes. Inscription: "Leading By Example" 33/49 Christopher; Fund: SHG. Note: Image is of eyes. Text reads, "moderno, think, peace, power". Cat. 2 084.

AtNu: XXXIX, AtYr: 2001; Ramirez, Julio Cesar "Mi Yo"; *Hasta Que La..Los Separe*; November 6-10, 2001; Coventry Rag, 290 gms. 16"x 22"; 75 ed. prnt: José Alpuche; sign: Yes. slide photo: UCSB Photography; copies: 2. Note: "Bano, Mujer, Hombre, Ropa Interior, Zapatos y Collage."—Julio Cesar "Mi Yo" Ramirez. Colors used: Clear Base, (T. Blue Grey), T. Red, T. Olive Green, T. Turquiose Blue, T. Purplish Blue, T. Dark Blue, T. Grey (Charcoal), T. Violet, O. Black, and Clear Gloss. Cat. 2 085.

AtNu: XXXIX, AtYr: 2001; Ramirez, Omar and Chaz Bojorquez; *The Here & Now*; October 2-6, 2001; Coventry Rag, 290 gms. 21 1/2" x 35 1/2"; 80 ed. prnt: José Alpuche; sign: Yes. Inscription: Omar Ramirez Chaz Bojorquez; slide photo: UCSB Photography; copies: 2. Note: "DJ Calaca with titles (SHG Presents El Día De Los Muertos 2001, "The Here and Now")." "My contribution to the print is the DJ Calaca spinning records on two turntables. This image represents the Hip Hop Nation that has permeated all aspects of Chicano and Latino Culture. It expresses the voice of "The Here & Now" and my generation views on progressive culture, politics & philosophy."—Omar. "My contribution to the print is the addition of the lettering. My "Cholo" East Los Angeles style to reinforce our streetwise Latino heritage with the new millenium the title "The Here & Now" is what we are all about."—Chaz. Colors used: Light Blue Field, Green, Purple, Ochre, White, Ultramarine Blue, Black line drawing, Red, and Black Border. Cat. 2 086.

AtNu: XXXIV, AtYr: 1999; Rangel, Chuy "C/S"; *Día De Los Muertos 1999*; September 5-12, 1999; Coventry Rag 290 gms. 25 1/2" x 24"; 85 ed. prnt: José Alpuche; sign: Yes. Inscription: 4/85 Chuy C/S 99; slide photo: UCSB Photography; copies: 2. Note: "Día De Los Muertos com[m]emorative poster for SHG 1999. The Content of the Image deals with the Ford Anson Theatre towers in the background, because of the concert (to be held there) and the calacas driving to the concert. The driver is me (Chuy C/S) in my 1956 Chevy Bel Air, the passenger is my girlfriend, Belén throwing zempaxochitl out the window, blessing the path, and a rocker is jamming on the cab of my ranfla."—Chuy "C/S" Rangel. Colors used: O.P. Black, Red Purple, Drk Brown, Light Blue, Ultra Blue, Drk Green, Medium Green, Yellow Ochre, Maroon, Pink, Green Shade Yellow, T-White, T-Orange, and O. White. Cat. 2 087.

AtNu: XLII, AtYr: 2003; Rangel, Marissa; *Untitled*; May 13-16, 2003; Silkscreen; 16" x 20"; 66 ed. prnt: José Alpuche; sign: Yes. Fund: SHG; slide photo: UCSB Photography. Photo of duplicate by Marissa Rangel; copies: 2. Note: "Person looking up with hands in the air."—Marissa Rangel. Colors used: Eggplant purple—525U, Flesh—Creme, Magenta, Purple (220U), Purple—Dark (228U), Purple Darker (242U), Black, and Clear Gloss. From Maestras IV. Cat. 2 088.

AtNu: XXXV, AtYr: 2000; Ray, Joe; *Tacos Con Huevos!*; February 24, 2000; Coventry Rag, 290 gms. 16" x 22"; 80 ed. prnt: José Alpuche; sign: Yes. Inscription: 20/80 Tacos con Huevos [signature] 2000; Fund: SHG; slide photo: UCSB photography; copies: 2. Note: "Red Gallo Romantico eating a Nopal Taco- text in background- 3 hearts at bottom. A moment frozen in time- a tale of drunken[n]ess and babosadas of irresponsible youth. Dona Nati's house and anger along with 3 drunken cabrones who wanted something to eat. I wanted to tell a story about a collage of events that involved a lot of idiotic nonsense, some events and some fiction. the lingering song and/or tune ties in some emotion as do the three hearts."—Joe Ray. Colors used: Pale Yellow, Butterscotch Yellow, Purple, Green, Red, and Blue Black. Cat. 2 089.

AtNu: Unknown, AtYr: 2002; Reyes, Miguel Angel; *Epoca de Oro*; 2002; 22" x 16"; 84 ed. prnt: Unknown; sign: Yes. slide photo: UCSB Photography. Note: Atelier silkscreen print depicts 12 stars from the Golden Age of Mexican cinema in individual squares. Cat. 2 090.

AtNu: XXXVI, AtYr: 2000; Robledo Tapia, Honorio; *El Regalo*; March 28-30, 2000; Coventry Rag, 290 gms. 37" x 25 1/2"; 60 ed. prnt: José Alpuche; sign: Yes. Inscription: 4/60 El Regalo Honorio 2000; slide photo: UCSB Photography; copies: 2. Note: "Is a poster, but also a cartoon with the fantastic story about a woman who enter in the house for take care of the television. She become part of the family, but one time she transformes [sic] herself in cow. Then the family has fun for a while but the animal protector society take care of the cow and the family becomes like a normal family."—Honorio Robledo Tapia. Colors used: Blue, Yellow, Red, Pink, and Purple. Cat. 2 091.

AtNu: Special Project, AtYr: 2002; Rodriguez, Artemio; *Day of the Dead 2002*; September 10 and 11, 2002; Coventry Rag, 290 gms. 16" x 22"; 65 ed. prnt: José Alpuche; sign: Yes. slide photo: UCSB Photography. Note: "Text: Celebrating / Jose Guadalupe Posada/ 150 Anniversary/ SHG/ Day of the Dead/ MMII Border compose of calaveras (skeletons) by Jose Guadalupe Posada. Central Image: a copy of a linoleum cut by Artemio Rodriguez. Design: LA MANO Press" "The central image is a portrait (one of the only two that exist of the artist) of Jose Guadalupe Posada and his son. Around them are scenes and characters based on Posada's imagery. The border is composed of skeletons for which Posada is more well known."—Artemio Rodriguez. Colors used: Orange, Red, and Black. Cat. 2 092.

AtNu: Unknown, AtYr: n.d. Rodriguez, Artemio; *Father Time*; n.d. Coventry Rag, 290 gms. 23 7/8" x 23 3/4"; 100 ed. prnt: José Alpuche; sign: Yes. Inscription: 6/100 "Father Time" Artemio Rodriguez MM; slide photo: UCSB Photography; copies: 2. Note: Winged beings in woodcut style. Cat. 2 093.

AtNu: Special Project, AtYr: 2001; Rodriguez, Artemio; *The King of Things (Poster)*; June 9, 2001; Coventry Rag, 290 gms. 20 3/4" x 26 1/4"; 97 ed. prnt: José Alpuche; sign: Yes. Inscription: 4/10 Artemio Rodriguez; slide photo: UCSB Photography; copies: 2. Note: "Using the loteria game, I wrote this short prose where a child likes so much his loteria game that he imagines and believes all the loteria characters are part of his personal and unique world."—Artemio Rodriguez. Colors used: O. Light Blue, T. Red, T. Magenta, O. Flesh, T. Yellow, T. Green, T. Off White, T.White, and O. Black. Cat. 2 094.

AtNu: Special Project, AtYr: 2002; Rodriguez, Favianna; *Community Control of the Land*; July 9-12, 2002; Coventry Rag, 290 gms. 22" x 16"; 85 ed. prnt: José Alpuche; sign: Yes. slide photo: UCSB Photography; copies: 2. Note: "A business executive is standing over the city of Los Angeles, with a rolled up bunch of eviction notices. There are two devil horns protruding from his bald head, and his eyes are red with evilness. Around his feet are cockroaches and a rat. On the left side of the print is the resistance, the Latina woman organizer speaking into a megaphone, calling all neighbors to raise up against the redevelopment forces and protect their homes. In the lower center of the print there is an African American woman with her child, staring at the viewer. These are the people who will be displaced. The poster reads "Alto A Los Desalojos!" and "Stop the Evictions!" Housing is a human right. For many people of color, the issue of land and housing is one that dates back to over 500 years, beginning with the rape of land and housing is one that dates back to over 500 years, beginning with the rape of Indian land by white colonizers,

the theft of Mexican territories, the racist policies that prohibited black people from owning land. Today, working class people of color are at the mercy of big business and corporate greed, which exploit the land for profit and destroy communities. The basic demand for community control of the land, which was set forth by our revolutionary predecessors, is still relevant to us today. Black Panther Party 13 Point Platform Program #4: We want decent housing that is fit for shelter of human beings. We believe that if the white landlords will not give decent housing to our black community, then the housing and land should be made into cooperatives, so that our community, with government aid, can build and make decent housing for its people. Brown Beret Platform #9[:] We demand housing fit for human beings. Red Guard Platform #2[:] We want decent housing and help in child care. Young Lords Platform[:] We want community control of our institutions and land. The Figueroa Corridor in Downtown Los Angeles is in [a] large battle with city redevelopers."—Favianna Rodriguez. Colors used: Yellow, Flesh, Orange, Red, Ultramarine Blue, and Black. Cat. 2 095.

AtNu: XXXIII, AtYr: 1999; Rodriguez, Favianna; *Del Ojo No Se Escapa Nadie*; 1999; silkscreen; 18" x 26"; 64 ed. prnt: José Alpuche; sign: Yes. Inscription: 12/64 "Del ojo no Se Escapa Nadie" Favianna Rodriguez [illegible]; Fund: SHG; slide photo: unknown. Note: Image is of a nude woman with a long, curled tongue on a bed. She has eyes instead of her breasts and generative organ. To the left of the woman is a horned serpent. Text reads, "Real..Pulsing Drama! Primitive Passion! El Ojo De Dios No creas que no me doy cuenta que tu lengua es una rapiña.. que tus huesos me destrozan..que tu cuerpo me incinera. No creas que no me doy cuenta de las 185 cosas que no me dices. de las formas en que me has cambiado, de las cosas que ma has robado, no creas que no me doy cuenta de que miras a otros cuerpos..de que juegas con otras [illegible] enseñando a ser una bestia humana..". From Maestras I. Cat. 2 096.

AtNu: XXXIX, AtYr: 2001; Rodriguez, Favianna; *Margarita*; Nov. 13-17, 2001; Coventry Rag, 290 gms. 16"x 22"; 66 ed. prnt: José Alpuche; sign: Yes. slide photo: UCSB Photography; copies: 2. Note: "Woman with a mask and a big black hairdo. Woman is surrounded by colorful orchids. Inside her head, there are figures of people giving birth, losing a child, throwing ashes to sea, receiving a letter, and reuniting. On the top of the print there are two names, Richard and Margarita. On 10.5.01 my mother mother was reunited with a son she had given up for adoption in 1970. She got pregnant with my uncle (father's brother[]) and he was an alcoholic, so he did not want to take responsibility [sic] for the child. She realized she had to give him up for adoption. This tormented her for 31 years. In September 1999, my brother's adopted father died, and that's when he realized he wanted to find my mother, who [was] his blood mother. So he searched and searched and found her in 10/2001. He wrote her a letter and then the two were reunited in 10/5/01. I depicted her with a mask because of the secret she held in for 31 years."—Favianna Rodriguez. Colors used: Clear Gloss, Red Blended into Yellow, O. Flesh, O. Sienna, O. Light Blue, O. Green, O. Gray, O. Pink, O. Light Yellow, and O. Black. Cat. 2 097.

AtNu: XL, AtYr: 2002; Rodriguez, Isis; *Self-Portrait with Muse*; June 3-8, 2002; Coventry Rag, 290 gms. 16" x 22"; 70 ed. prnt: José Alpuche; sign: Yes. Inscription: 50/70 "Self-Portrait With Muse" Isis Rodriguez '02; Fund: SHG slide photo: UCSB Photography. Duplicate photo is by Marissa Rangel; copies: 2. Note: "Woman recieving lapdance from her cartoon self." "The statement "Upraise fo the Urban Goddess" inspired me to create an image of a tomboy embracing her sexuality, benefit[t]ing from it, and at the same time defending herself from freeloaders. I drew this cartoon as a reaction to the jealous ones, you know the drive by jerks who hang their heads out their windows shouting obs[c]enities and their female companions who quietly look on with disgust and ridicule and then later pretend to be her friend."—Isis Rodriguez. Colors used: brick red, blue, ochre, lime green, flesh, transp. black, black, and transp. white. From Maestras III. Cat. 2 098.

AtNu: Special Project, AtYr: 1993; Romero, Alejandro; *Curandero*; April 1993; Silkscreen. 75 ed. prnt: José Alpuche; sign: Yes. Inscription: Curandea 57/75 Alejandro Romero L A 1993; Fund: SHG; slide

photo: unknown. Note: Image is of two human figures during a curación. Cat. 2 099.

AtNu: Special Project, AtYr: 2001; Romero, Frank; *California Plaza*; June 12-25, 2001; Coventry Rag, 290 gms. 38" x 26"; 140 ed. prnt: José Alpuche; sign: Yes. Inscription: FE Rom 6/140; slide photo: UCSB Photography; copies: 2. Note: "A 16 color print celebrating the California Plaza Summer Concerts in Downtown Los Angeles. The print was made in commemoration of their 15th anniversary!"—Frank Romero. Colors used: Lt Blue, Magenta, Red Orange, Middle Blue, Deep Green, Pink, Turquoise, Deep Purple/Brown, Grey—Transparent, Bright Orange, Blue Black, Bright Red, Yellow, Lt. Med. Blue, Gloss, and White. Cat. 2 100.

AtNu: Special Project, AtYr: 2000; Romero, Frank; *Cruising*; April 15, 18, and 20, 2000; Coventry Rag, 290 gms. 16" x 22"; 31 ed. prnt: José Alpuche; sign: Yes. slide photo: UCSB photography; copies: 2. Note: "A very active rendition of a couple out for a spin in their vintage jalopy! Monotypes series utilizing three screens. 1. Hand printed by artist 2. 5-7 color split fountain 3. Blue Line Drawing"—Frank Romero. Cat. 2 101(1-2).

AtNu: Special Project, AtYr: 2000; Romero, Frank; *Grand Father's House*; October 19-21 and November 14-15, 2000; Coventry Rag, 290 gms. 16" x 22"; 47 ed. prnt: José Alpuche; sign: Yes. slide photo: UCSB photography; copies: 2. Note: "A picture of the family gathering house (grandfather's) near First and State streets in Boyle Heights. A recollection done from memory."—Frank Romero. Colors used: Blue blended into White & Yellow, Green Blended into Brown w/ hand painted Red, Opaque Pink, Trans Blue, Trans Yellow/Red, and Lt Grey. Cat. 2 102.

AtNu: XXXIX, AtYr: 2002; Romero, Frank; *Heart*; 2002; Coventry Rag, 290 gms. 17" x 23"; 75 ed. prnt: José Alpuche; sign: Yes. slide photo: UCSB photography; copies: 2. Note: "Heart Series—1-15, Hand embellished by the artist. One of a series of heart images, going back 30 years."—Frank Romero. Colors used: Light Blue, Light Orange, Deep Red, Turquoise Blue, and Clear Gloss. Cat. 2 103.

AtNu: Special Project, AtYr: n.d. Romero, Frank; *Starry Night*; July 18-22; Coventry Rag, 290 gms. 16" x 22"; 40 ed. prnt: José Alpuche; sign: Yes. slide photo: UCSB photography; copies: 2. Note: "A family driving through a magical starry night!"—Frank Romero. Colors Used: Blended B/g Dr. Blue to Light Blue, Blended Orange to Yellow Orange, Engine Red, Hand-painted Blue Grey-White & Green, Trans-Dark Purple, Black, and Blue. Cat. 2 104.

AtNu: Unknown , AtYr: 2002; Rubio, Alex; *La Placa*; November 5-13, 2002; Coventry Rag, 290 gms. 16" x 22"; 72 ed. prnt: José Alpuche; sign: Yes. slide photo: UCSB Photography. Note: "The image depicts my hand holding my old homemade tattoo machine, I clipped the roller ball point pen off a bic pen and threaded a sharpened guitar wire through the pen tube. The wire was the N attached to the spindle of a hair dryer motor which were taped to a bent spoon which served as a handle. I used to work on homemade tattoos with original designed, back in the early to mid eighty, in my barrio at the Mirasol Courts in the Westside of San Antonio."—Alex Rubio. Colors used: Pantone AOOE-C, Pantone 414C, Pantone 416C, Pantone 417C, Pantone 418C, Pantone 418C, Pantone Black, T-Black, and Clear Gloss. Cat. 2 105.

AtNu: XXXVII, AtYr: 2000; Saldamando, Shizu; *Poster Girl*; December 12-14, 2000; Coventry Rag, 290 gms. 22" x 16"; 75 ed. prnt: José Alpuche; sign: Yes. slide photo: UCSB photography; copies: 2. Note: "Woman standing in front of a graffittied [sic] wall. This print is based off a photo taken of a close friend while waiting in line for Morrissey's autograph."—Shizu Saldamando. Colors used: Ultramarine Blue, Cool Grey, Taupe, Warm Yellow, Red, and Black. Cat. 2 106.

AtNu: XXXVIII, AtYr: 2001; Saldamando, Shizu; *Snapshot*; May 8-11, 2001; Coventry Rag, 290 gms. 18"x 26"; 66 ed. prnt: José Alpuche; sign: Yes. Inscription: 20/66 Snapshot Shizu Saldamando; Fund: SHG slide photo: UCSB Photography. Duplicate slide photography by Marissa Rangel; copies: 2. Note: "Three young women strike a pose with their finely plucked eyebrows and matching ensembles. This print comes from a frustration at the lack of diversity in mainstream/pop culture. This print is about friendship, representation and commercialism."—Shizu Saldamando. Colors used: Mint Green, Blue, Drk Brown, Light Brown, Pink, Pale Yellow, Silver, and Drk Grey. From Maestras II. Cat. 2 107.

AtNu: XXI, AtYr: 1999; Sarnecki, Tomasz and Wayne Healy; *Smoker's Game*; September 19-23, 1999; Coventry Rag 290 gms. 34 3/8" x 23 1/2"; 78 ed. prnt: José Alpuche; sign: Yes. Inscription: 4/78 Szausa na sukies Toman Sarnecki '99 Healy 99; slide photo: UCSB Photography. Note: "Its a picture with a strong gun, bullet-cigarette, skeleton with big sombrero; smoke, fire, and deathly habit. Its the ideological poster; the habit like Russian R[o]ulette- Smoker's Game like the unknown end -- for every one and every where; its the big challenge for tobacco companies: Which cigarette is the last? For Death or life?"—Tomasz Sarnecki. "Major Image; A revolver with a cigarette in the open cylinder. Above is skeleton with a big sombrero holding a cigarette. All are on a background of fire and smoke, fire of the deadly habit. The content of the print is to compare smoking with Russian Roulette, Ergo, Smoker's Game."—Wayne Healy. Colors used: Cream White, Orange Red, Powder Blue, Blood Red, and Black. Cat. 2 108.

AtNu: XXVI, AtYr: 1995; Serrano, David; *Fandango*; May 2- 6, 1995; Silkscreen; 26" x 38"; 58 ed. prnt: José Alpuche; sign: Yes. Inscription: 18/58 'Fandango' David Serrano 95; Fund: SHG. Note: Image of three dancers in animal suits, consisting of a jaguar, parrot, and rooster. Cat. 2 109.

AtNu: XXXIV, AtYr: 1999; Sigüenza, Herbert O. *Culture Clash=15 Years of Revolutionary Comedy*; June 29-July 1, 1999; Coventry Rag, 290 gms. 20" x 26"; 78 ed. prnt: José Alpuche; sign: Yes. slide photo: UCSB photography. Note: "Commemorative print celebrating Culture Clash's 15th Anniversary. Pictures of the three members of Culture Clash and three performance pictures surrounding a full figure of Cantinflas. Photos of Ric Salinas, Richard Montoya y Herbert Siguenza[.] Photos of "A Bowl of Beings" and "The Mission"."—Herbert Sigüenza. Colors used: Beige (base), Primary Yellow, Primary Red, Primary Blue, Primary Green, Black, and Transparent Gray. Cat. 2 110.

AtNu: Unknown, AtYr: 2002; Teruya, Weston Takeshi; *They Mistook the Determination in our Eyes for Hopelessness*; August 2, 3, and 6, 2002; Coventry Rag, 290 gms. 16" x 22"; 83 ed. prnt: José Alpuche; sign: Yes. slide photo: UCSB Photography. Note: "Hand lettered text at top of print within speed bubble reads "Si no hay lucha no hay victoria". Image is distorted such that it appears to have been taken through a fish eye lens. A woman stands on a side walk with her child in one arm at the center of the print. In the other hand she holds a small iconic home. In simple gray lettering "home" floats below it. In back of her you can see a wall with a mural of stylized figures raising fists and identical men in suits painted over. "To put it simply, this print was inspired by and created for the residents of the Figueroa Corridor area of Los Angeles as they struggle for their homes and dignity in the face of gentrification. In conversations with some residents, it became clear that there was a great deal of frustration that they live in direct view of LA's financial district they felt they [were] very marginalized from any decision making processes and power. Therefore I felt it very important to feature the residents, represented by the woman and her child at the center of the piece; further accentuated by the fish eye—like distortion of perspective. The representations of financial power—the stamp-like men men in suites [sic]—are marginal and partially obscured. Their clone-like appearance accentuates the other homogenizing effect of gentrification—the displacement of locally owned businesses in favor of corporate mono culture. The statement "no hay lucha, no hay victoria" was pulled directly from translated conversations amongst residents and represents their passion and determination to keep their homos and take back their voices."—Weston Teruya. Colors used: light violet, warm orange (trans), mustard yellow (trans), gray violet, purple, and transparent white (trans). Cat. 2 111.

AtNu: XIX, AtYr: 1992; Torrez, Eloy; *Under the Spell*; 1992; silkscreen; 16" x 24"; Unknown ed. prnt: Unknown; sign: Yes. Inscription: "Under the Spell" Studio Proof Eloy Torrez 92; Fund: SHG. Note: Image is of a skeleton embracing a nude woman from behind. There are curtains on either side of them. Cat. 2 112.

AtNu: XX, AtYr: n.d. Valadez, John M. *Novelas Kachina*; n.d. silkscreen; 24 1/4" x 38"; 52 ed. prnt: Unknown; sign: Yes. Inscription: Novelas Kachina; Fund: SHG. Note: Multiple images superimposed on one another. Images are of men's faces and Native American kachina figures. Cat. 2 113.

AtNu: XX, AtYr: n.d. Valdez, Patssi; *Calaveras de Azucar*; n.d. silk-screen; 25 1/4" x 34"; 55 ed. prnt: Unknown; sign: Yes. Inscription: Calaveras de Azucar 33/55 Patssi Valdez; Fund: SHG. <u>Note:</u> Image is of three calaveras in party hats in a yellow circle with alcoholic beverages. Along the upper edge of the circle are two calaveras. The one on the left is feminine and yellow; the one on the right is masculine and green. On the bottom half of the circle is a red fan-like extension with blue spirals. There are framing designs in the bottom corners and upper portion of the print. Six crosses fill the space between the bottom of the fan and the lower border. Cat. 2 114.

AtNu: XXXVII, AtYr: 2000; Valdez, Patssi; *Dia de los Muertos 2000*; September 5-13, 2000; Coventry Rag, 290 gms. 21" x 14"; 80 ed. prnt: José Alpuche; sign: Yes. slide photo: UCSB photography. <u>Note:</u> "Table alter [sic] for day of the dead. Chocolate skulls and calaveras, angeles, black cat, candles, marigolds, 2 copal burners, basket of candied fruit, dollie, steamers."—Patssi Valdez. Colors used: Light Cerullean Blue, Dark Blue, Dark Brown, T Magenta, Marigold, T White, Light Purple, T Red, T Yellow, T Midtone Blue, Opaque White, T Drk Turquoise Blue, D Chocolate Brown, Clr Bse, Ivory White, Brown Blck. Cat. 2 115.

AtNu: Special Project, AtYr: 2002; Valdez, Vincent; *Suspect: Dark Hair, Dark Eyes, Dark Skin*; November 14 and 21-27, 2002; Coventry Rag, 290 gms. 22" x 16"; 77 ed. prnt: José Alpuche; sign: Yes. slide photo: UCSB photography; copies: 2. <u>Note:</u> "The context of this print deals with ideas and communities, social and political. The idea stemmed from several elements, particularly individual figures and incidents in society, For example, St. Sebastian was a religious martyrs, [sic] perseated [sic] and profiled for his religious beliefs, which is where the pose comes from. Bullet holes replaced the arrows which were shot into Sebastian. Second, his T-shirt identifies Bin Laden and is portraying a stereotypical and profiled Middle [Ea]stern male "This is the enemy"—Not only is this another type of racial profiling and brainwashing done in America, it is also a [sic] another hypocritical stone that America takes. Obviously we have foreign enemies, yet we presente [sic] our own and abuse our own. Finally this image was done in memory of , who was gunned down by several off-duty officers in Brooklyn, . He was stopped while walking on the sidewalk for no reason and as he reached into his pocket, he was shot 42 times and killed. He reached into his pocket for his I.D. "It is a dangerous time and a dangerous place to have dark clothes, dark hair, dark eyes, and dark skin."—Vincent Valdez. [Note: the artist seems to be referring here to Amadou Diallo.] Colors used: 120C Yellow, 167C Orange, 032C Red, 000Z-C Black, ZN)R-C Brown, OSZN-C Dark Brown, 277C Light Black, 000Z-C Black, and Clear Gloss. Cat. 2 116.

AtNu: XXXVIII, AtYr: 2001; Vargas, Tecpatl; *The Mercury Weeps*; February 27- March 1, 2001; Coventry Rag, 290 gms. 18" x 22"; 62 ed. prnt: José Alpuche; sign: Yes. Inscription: 20/62 The Mercury Weeps Tecpatl Vargas; Fund: SHG slide photo: UCSB Photography. Photography of duplicate by Marissa Rangel; copies: 2. <u>Note:</u> "Half-tone images from 1930's-1950's Popular Science, Popular Mechanics issues. Man wearing goggles, woman playing organ; woman playing organ, woman with the head of a chicken; fluorescent light bulbs; feet in high heels, xerox enlargements, cut and paste, five color separations with ruby lith and stat film."—Tecpatl Vargas. Colors used: Light Blue, Dark Blue, Green, Yellow Green, Dark Grey Green. From Maestras II. Cat. 2 117.

AtNu: Special Project, AtYr: 1993; Vega, Salvador; *Volador*; 1993; Silkscreen. 76 ed. prnt: José Alpuche; sign: Yes. Inscription: 20/76 "Volador" Salvador Vega 93; Fund: SHG. <u>Note:</u> Image is of a face inside a circle with colorful wings surrounding it. Cat. 2 118.

AtNu: XLI, AtYr: 2003; Villa, Esteban; *Homefront Homeboy*; June 10-14, 2003; Coventry Rag, 290 gms. 22" x 16"; 72 ed. prnt: José Alpuche; sign: Yes. slide photo: UCSB Photography; copies: 2. <u>Note:</u> "Close-up head and shoulder side view of a young Chicano man. His white T-shirt is used as a blind fold. Against a midnight-blue background are what appears to be bullet casings and blood drops metamorp[h]ized into hot jalapenos. "Homefront Homeboy" Street wars are happening. Boys are playing with guns. Like the Civil War its brother against brother. The blind fold on this young Chicano is symbolic of blind fury blind date blind execution blind presecution [sic] blind justice."—Esteban Villa. Colors used: Clear

Base, Ultra Blue, Sienna Flesh, Off White, Yellow Ochre, Red, Black, and Clear Gloss. Cat. 2 119.

AtNu: XXXVI, AtYr: 1999; Yáñez, Larry; *Cama Na My Howze*; December 14 and 17, 1999; Coventry Rag 290 gms. 26 1/2" x 31 7/8"; 72 ed. prnt: José Alpuche; sign: Yes. slide photo: UCSB Photography. copies: 2. <u>Note:</u> "Bedroom Scene[.] Part of the Dream Chicano House—each room based on childhood memories—elements from different homes of my mother and many many tias + cousins, ninas + amigas de mi madre."—Larry Yáñez. Colors used: Pink, Blue, Purple, Red, Green, Yellow, Brown, Gray, Black, and Trans/Gloss. Cat. 2 120.

AtNu: XXXV, AtYr: 2000; Ybarra, Frank; *Our Lady of Guadalupe, Arizona*; 2000; silkscreen. 80 ed. prnt: José Alpuche; sign: Yes. Inscription: 20/80 Our Lady of Guadalupe, Arizona Ybarra 2000; Fund: SHG; slide photo: unknown. <u>Note:</u> "Our Lady of Guadalupe, Street Scene, landscape in background, rays extending our on upper third of print. My piece represents the town of Guadalupe, Arizona. A small town located south-east of Phoenix. Guadalupe has remained a small traditional community untouched by big development, surrounded by Mega malls and typical modern suburban living."—Frank Ybarra. Colors used: Dk. Violet Black, Yellow, Blue, Red, Purple, Green, and Beige/Transparent. Cat. 2 121.

Center Activities and Programs

SHG; *Artist's Community Meeting*; n.d. slide photo; <u>Note:</u> Artist's Community Meeting. Cat. 3 001.

SHG; *Artist Signing Silkscreens*; n.d. slide photo; <u>Note:</u> Michiko Furukawa. Cat. 3 002.

SHG; *Arts of Mexico Atelier XVI*; February 1991; slide photo; 10 slides. <u>Note:</u> 1. David Botello matching color for the workshop. 2. David Botello at the orientation meeting. 3. Photo from the orientation meeting. Right to left: Karen Boccalero, Yolanda Gonzalez, Dolores Guerrero Cruz, Alex Donis, Oscar Duardo, Daniel Salazar, Yreina Cervantez, Margaret Garecia, Pat Gomez, Leo Limón, Miguel Angel Reyes, and unknown. 4. Right to left: Yolanda Gonzalez, Alex Donis, Daniel Salazar, Oscar Duardo, Yreina Cervantez, Leo Limón, Margaret Garcia, and Michael Amescua. 5. Right to left: Pat Gomez, Daniel Salazar, Raul de la Sota, unknown, Leo Limón, Yreina Cervantez, Margaret Garcia, Miguel Angel Reyes, Michael Amescua, and David Botello. 6. Printing in progress. Right to left: Oscar Duardo and Yolanda Gonzalez. 7. Leo Limón holds a finished silkscreen. 8. Yolanda Gonzalez poses in front of Oscar Duardo's silkscreen. 9. Oscar Duardo and David Botello preparing to run color on print. 10. Silkscreening in process. Right to left: Oscar Duardo and Pat Gomez. Cat. 3 003(1-10).

SHG; *Arturo and Endina Casares Vasquez*; n.d. slide photo; <u>Note:</u> Arturo and Endina Casares Vasquez. Cat. 3 004.

SHG; *Barbara Carrasco and José Alpuche*; February 1999; slide photo; <u>Note:</u> Barbara Carrasco and José Alpuche. Cat. 3 005.

SHG; *Barbara Carrasco Standing Next to her Print "Self-Portrait" Made in 1984*; 1984; slide photo; <u>Note:</u> Barbara Carrasco. Cat. 3 006.

SHG; *Barrio Mobile Art Studio, Community Workshops*; ca. 1970's; slide photo; Site/Location: East Los Angeles. <u>Note:</u> An unidentified woman in an apron stands before the Barrio Mobile Art Studio van during a workshop. Cat. 3 007.

SHG; *Barrio Mobile Art Studio, Papier-mâché Mask Workshop*; June 1976; slide photo; <u>Note:</u> Unidentified workshop participants hold their masks up to their faces. Photo is slightly blurred. Cat. 3 008.

SHG; *Birthday Party*; n.d. slide photo: ; slide photo: unknown; 4 slides. <u>Note:</u> Birthday party at SHG, Los Angeles. 1. Right to left: Karen Boccalero, Bertha Velasquez, unidentified student, Maria Elena Espinoza, and Tomás Benítez. 2. Maria Elena Espinoza. 3. Right to left: Maria Elena Espinosa, Bertha Velasquez, and Karen Boccalero. 4. Right to left: Maria Elena Espinosa, Bertha Velasquez, and Karen Boccalero. Cat. 3 009(1-4).

SHG; *Cathy Gallegos*; September 1998; slide photo; <u>Note:</u> Cathy Gallegos. (This slide is damaged.); Cat. 3 010.

SHG; *Ceramic Tile Project*; 1995; slide photo; <u>Note:</u> Christina Perez (center). Cat. 3 011.

SHG; *Children's Workshop*; n.d. slide photo; <u>Note:</u> Unidentified women and a child. Cat. 3 012.

SHG; *Cleaning Screen*; n.d. slide photo; <u>Note:</u> José Alpuche. Cat. 3 013.

SHG; *Consuelo Flores and Armando Norte and Sons*; August 1998; slide photo; <u>Note:</u> Consuelo Flores and Armando Norte and sons. Cat. 3 014.

SHG; *Costume*; n.d. slide photo; <u>Note:</u> An unidentified woman in calavera makeup wears a skeleton costume. Cat. 3 015.

SHG; *Day of the Dead*; ca. 1990's; slide photo; 4 slides. <u>Note:</u> "Day of the Dead is an annual event where there is a gallery exhibition and several performances. Guests participate in creating a festive atmosphere celebrating the lives of deceased loved ones. Children learn to accept death as a part of the circle of life, celebrating Day of the Dead." 1. A woman in calavera makeup at a Dia de los Muertos celebration. This photo is out of focus. 2. A man in calavera makeup at a Día de los Muertos celebration with fire in the background. This photo is out of focus. 3. Four girls in calavera makeup holding calavera masks and sugar skulls. 4. Two danzantes Aztecas in calavera makeup lay on grass. Cat. 3 016 (1-4).

SHG; *Day of the Dead*; n.d. slide photo; slide photo: Mario Lopez. <u>Note:</u> Two unidentified women wear papier-mâché calavera masks. "Guests are encouraged to attend in calavera attire."; Cat. 3 017.

SHG; *Day of the Dead 1974*; 1974; slide photo; <u>Note:</u> Two dancing calaveras painted on cardboard. Cat. 3 018.

SHG; *Day of the Dead 1975*; October-November, 1975; slide photo; slide photo: Unknown; 3 slides. <u>Note:</u> 1. Children painting calaveras on cloth or butcher paper. October 29, 1975. 2. Children and adults surround a table covered with pan de muerto with calavera designs. November 1975. 3. A priest gives mass for the dead in a cemetery. November 1975. Cat. 3 019 (1-3).

SHG; *Day of the Dead 1976*; 1976; slide photo; 6 slides. <u>Note:</u> 1. A woman serves pan de muerto with calavera icing to Day of the Dead participants. 2. Photo is of cardboard painted calavera masks leaning against graves in a cemetery. 3. Two women and two children stand in an alley watching an approaching procession. 4. Photo is of ASCO artists (Harry Gamboa, Jr., Gronk, Willie Herrón, and Patssi Valdez) performing on the streets of East Los Angeles. 5. Photo is of a crowd in a cemetery. 6. A bride and a groom wear calavera makeup outside a church. Cat. 3 020(1-6).

SHG; *Day of the Dead 1977*; 1977; slide photo: ; 6 slides. <u>Note:</u> 1. A man paints a sculpture of a calavera. 2. Photo of a Día de los Muertos procession. The truck was designed by Leo Limón and Los Four, East L.A. 3. A sculpture of a skeleton is pushed in a cart during a Día de los Muertos procession. 4. A calavera "priest" and several other procession participants. 5. A priest gives mass for the dead in a cemetery. 6. Processioners carry large effigies of calaveras. Cat. 3 021(1-6).

SHG; *Day of the Dead 1979*; 1979; slide photo; 7 slides. <u>Note:</u> 1. Photo of a large sugar skull on aluminum foil. 2. Aztec dancers process in Los Angeles streets secured by L.A. County Sheriffs. 3. Day of the dead processioners carry a large image of La Virgen de Guadalupe. 4. Photo is of a procession for Día de los Muertos. 5. A calavera at the top of a flight of stairs holds a calavera doll. 6. Photo is of bouquets of marigolds around the base of a headstone. 7. Photo is of three Day of the Dead participants in calavera masks. Cat. 3 022(1-7).

SHG; *Day of the Dead 1980*; 1980; slide photo; slide photo: #2 Mary McNally, the rest unknown; 4 slides. <u>Note:</u> 1. Calaveras having fun. 2. A calavera in a straw hat drinks from a large glass bottle. 3. Photo is of children in calavera makeup. 4. Photo is of a man with his face painted red and black. His nametag bears the appellation "Michael". Cat. 3 023(1-4).

SHG; *Day of the Dead 1982*; 1982; slide photo; 3 slides. <u>Note:</u> 1. Photo is of an unidentified woman in calavera makeup. 2. Photo is of a man in calavera makeup wearing a breastplate. 3. Photo is of artist Diane Gamboa. Cat. 3 024(1-3).

SHG; *Day of the Dead 1991*; November 1, 1991; slide photo: ; 9 slides. <u>Note:</u> 1. From right to left: Rose Portillo and Mita Cuarón at SHG. 2. Pat Gomez during Day of the Dead at SHG. 3. Lalo Lopez (of the Chicano Secret Service), in a brown beret, holds a microphone. "Chicano Secret Service started in the late 1980's in Berkeley. Lalo proceeded to write for Culture Clash, the legendary skit show." 4. Rick Salinas from Culture Clash. "Culture Clash is the country's leading Chicano/Latino theatre group." 5. Raquel Salinas stands in front of the Altar for Day of the Dead at Galería Otra Vez. "Raquel has been depicted as "Our Lady" in the piece by Alma Lopez." 6. La Vida & La Gloria Performance for Day of the Dead. Raquel Salinas in an Alma Lopez performance art or teatro piece at SHG. She is dressed as La Virgen de Guadalupe and she stands behind a row of flames. 7. Evelina Fernandez and her daughter Valentina in calavera makeup at SHG. "Evelina is a writer, actress, and motivational speaker." 8. An elegantly-dressed Yolanda Gonzalez at SHG. Behind her is a man dressed as the devil. "Yolanda started creating art in the late 1980's. She studied at SHG and was introduced to the public at the First Annual Nuevo Chicano Los Angeles Art Exhibition at Plaza de la Raza in 1988." 9. Raquel Salinas dressed as the Virgen de Guadalupe for a Day of the Dead teatro piece entitled "La Vida y la Gloria". Cat. 3 025(1-9).

SHG; *Day of the Dead 1992*; 1992; slide photo: ; slide photo: 6 slides. <u>Note:</u> 1. Unidentified Day of the Dead celebrants, a man and a woman, with their faces painted as calaveras. "Day of the Dead is a celebration of life." 2. Señora Rivas lights a candle on a shelf serving as a temporary altar. "Señora Rivas was a neighbor of SHG who built an altar for her deceased husband. She devotedly displayed it for several years, until her death." 3. Three sculptures and several two-dimensional pieces at an exhibition. "The gallery is open during the Day of the Dead." 4. Photo is of a large crowd of exhibition attendees. "Every year there is an open call for artists to exhibit Day of the Dead-themed art." 5. Seven unidentified Aztec dancers in full regalia perform. "Danza costumes usually include the colors of the four directions. Traditionally black, white, red, and yellow (or blue)." 6. Photo is of three masked performers on stage. "'Chusma' is a Chicano theatre group. The performances concentrate on the unique life experiences of the community."; Cat. 3 026 (1-6).

SHG; *Day of the Dead 1994*; November 1994; slide photo; 11 slides. <u>Note:</u> Photos from Day of the Dead 1994. 1. Preparation for celebration. "From right to left: Sister Karen Boccalero and her cousin Toni Guadagnoli." 2. Sister Karen Boccalero (left) and other unidentified Day of the Dead activity participants, including one in calavera makeup. 3. A filing cabinet is set with framed photos of people in calavera makeup. The photo is out of focus. 4. Slide photo of a man in calavera makeup and an elaborate costume. 5. November 5 Day of the Dead performance. A woman reads into a microphone on a stage where a guitarist also performs. The backdrop features the words, "Luchando con la Vida". 6. Galeria Otra Vez exhibition opening on November 1. A woman admires works at the exhibition. 7. Another Gallery opening photograph. Diane Gamboa, in white makeup, stands behind an installation composed of a giant heart bound in chains resting on small white pillows on the floor of a structure resembling a small boxing ring. "Diane has been creating art for more than twenty years." 8. Photo is of exhibition attendees. "The gallery is open during the Day of the Dead." 9. Christina Ochoa and Diane Gamboa stand behind Diane Gamboa's Altar Installation, of which only the top is visible. "Diane has been involved with SHG since the 1980's. Christina Ochoa is the Galería Otra Vez gallery director." 10. Photo is of two Day of the Dead participants in calavera makeup. 11. Exhibition photo of a large altar and several works on the walls of the gallery. Cat. 3 027(1-11).

SHG; *Day of the Dead Celebration*; ca. 1998; slide photo; <u>Note:</u> Jose Luis Valenzuela and Nancy de la Santos regard one another fondly. "Nancy is a writer and producer originally from Chicago. Jose Luis is a performer and director."; Cat. 3 028.

SHG; *Day of the Dead Celebration*; 1993; slide photo; slide photo: Ann Murdy: <u>Note:</u> Beatris de Alba and her son in calavera makeup. Cat. 3 029.

SHG; *Day of the Dead Celebration*; n.d. slide photo: ; slide photo: Mario Lopez. <u>Note:</u> An adult in a wedding veil and two children all have their faces painted. In the background is an artwork with the face of Jerry Garcia. "Day of the Dead is a family tradition for many people in Los Angeles."; Cat. 3 030.

SHG; *Day of the Dead Children's Workshop Calavera Masks*; ca. 1990's; slide photo; <u>Note:</u> A display of many calavera masks. "Children are very involved with the preparation and celebration of the Day of the Dead."; Cat. 3 031.

SHG; *Day of the Dead Exhibit in Galería Otra Vez*; ca. 1990's; slide photo; Site/Location: Galería Otra Vez, SHG **3802 Cesar E.**

Chavez Ave, Los Angeles CA 90063. Note: Photo is of several works at an exhibition. "The gallery is open during the Day of the Dead."; Cat. 3 032.

SHG; *Day of the Dead Exhibition*; n.d. slide photo; Site/Location: SHG; 1 slide. Note: Photo is of six works at the exhibition. Two are cajas, two are s, and two are paintings or prints. Cat. 3 033.

SHG; *Day of the Dead Exhibition*; n.d. slide photo; Note: A view of three works at the exhibition. "Day of the Dead is an annual event where there is a gallery exhibition and several performances."; Cat. 3 034.

SHG; *Day of the Dead Exhibition at Galería Otra Vez*; ca. 1990's; slide photo; slide photo: Mario Lopez; 2 slides. Note: Photos are wide views of the exhibition. "A gallery exhibit is held in conjunction with performances and a procession on the Day of the Dead."; Cat. 3 035 (1-2).

SHG; *Day of the Dead Flores de Esperanza*; November 2, 1996; slide photo; Site/Location: Cinco Puntos, Los Angeles; 11 slides. Note: 1. Gathering for procession at Cinco Puntos. Photo is of an unidentified man in a sarape with a calavera mask and Felicia Montes holding a wooden sculpture of a female calavera. She holds her fist in the air, as in protest. They stand before an architectural column. "Felicia Montes is a cultural activist from Los Angeles. She creates, documents, and organizes Xicana feminist multimedia art events." 2. A young child gets his face painted at Flores de Esperanza. "Many adults and children get their faces painted as calaveras to honor the dead." 3. Aztec Blessing at Cinco Puntos, the gathering point for processioners. A young female danzante Azteca holds an incensario out to Felicia Montes, who holds a wooden sculpture of a female calavera. 4. Photo is of a man in a sarape and calavera mask and Felicia Montes holding a wooden sculpture of a female calavera. Montes holds her fist in the air. 5. A woman in calavera makeup holds an infant close to her body. "Guests participate in creating a festive atmosphere celebrating the lives of deceased loved ones." 6. Danza Azteca performance at Flores de Esperanza, Day of the Dead. "Danza costumes usually include the colors of the four directions. Traditionally black, white, red, and yellow (or blue)." 7. Unidentified procession participant in calavera makeup. This photo is out of focus. 8. Danzantes Aztecas in calavera makeup carry incense during Día de los Muertos procession. 9. Photo is of an unidentified Aztec dancer in calavera makeup. 10. Photo is of an unidentified girl in calavera makeup and a red dress. 11. Aztec dancer Felicia Montes is performing copal blessing before procession. Burning copal represents the binding together of heaven, earth, and air. Cat. 3 036(1-11).

SHG; *Day of the Dead Gallery Exhibit*; 1998; slide photo; Note: 1. Photo is of Karen Bonfigli seated in a room. 2. Photo is of Pat Gomez and Karen Bonfigli seated in a room full of potted flowers. 3. Photo is of Karen Bonfigli and Pat Gomez seated in a room full of potted flowers. 4. Photo is of Karen Bonfigli and Pat Gomez seated in a room full of potted plants. "Karen has been a curator and teacher in Los Angeles. Pat specializes in installation-based work. She has exhibited nationally and internationally and has also been an arts administrator, curator, and associate director of SHG."; Cat. 3 037(1-4).

SHG; *Day of the Dead Musical Performance*; 1990s; slide photo; 2 slides. Note: A band in black and white gabanes plays on a stage. Behind them are images of a clown, a skull, and the Devil. A sign on stage reads, "Puto Wilson Act V". Cat. 3 038.

SHG; *Day of the Dead Performers Exhibiting a Day of the Dead Silkscreen*; 1995; slide photo; slide photo: Mario Lopez. Note: A man in calavera makeup speaks into a microphone as he holds up a print with the text, "Day of the dead Día de los Muertos 1995". "Every year a print is produced to commemorate the Day of the Dead event." A Gronk temporary mural forms the backdrop for the scenario. Cat. 3 039.

SHG; *Day of the Dead Procession*; 1981; slide photo; Site/Location: SHG; 2 slides. Note: 1. Photo is of a male processioner in calavera makeup holding a Día de los Muertos poster. 2. Three children in calavera makeup. Cat. 3 040(1-2).

SHG; *Day of the Dead Procession*; 1990s; slide photo; 2 slides. Note: 1. Two figures, an unidentified woman (right) and Margaret Limon (left), wearing calavera makeup. 2. At the procession gathering point, a woman paints a man's face with calavera makeup. They both wear sombreros. Cat. 3 041(1-2).

SHG; *Day of the Dead Procession*; n.d; slide photo; Note: Día de los Muertos processioners carry a large dragon with a calavera in its mouth. Cat. 3 042.

SHG; *Drying Screens in the Sunshine*; March 2001; slide photo; Note: Two screens lean against the SHG building. Cat. 3 043.

SHG; *Etching*; n.d. slide photo; Note: Unidentified workshop participants. Cat. 3 044.

SHG; *Etching Class, Visit by Diego Marcial Rios*; 1993; slide photo; Note: Visiting artist Diego Marcial Rios, center, looks at work by unidentified artist. He is surrounded by unidentified people. Cat. 3 045.

SHG; *Etching Workshop*; 1992; slide photo; 3 slides. Note: Etching Workshop led by Janet Kassner. 1. Ana Gomez. 2. Right to left: Cathy Gallegos, Antonio Ibañez, and Linda O'Hagan. 3. Cathy Gallegos. Cat. 3 046(1-3).

SHG; *Examining Silkscreen*; March 1991; slide photo; Note: Raúl de la Sota. "The Fourth Estaciones", atelier XVI. Cat. 3 047.

SHG; *Examining Silkscreens*; ca. 1990's; slide photo; Note: José Alpuche and Paul Martinez. Cat. 3 048.

SHG; *Exhibition, Galería Otra Vez*; n.d. slide photo; Note: An exhibition photo of cajas and altares. Cat. 3 049.

SHG; *Filing Down a Copper Plate*; ca. early 1990's; slide photo; Note: The hands of an unidentified person. Cat. 3 050.

SHG; *Filming of, "Blood in, Blood Out"*; September 17, 1991; slide photo; Site/Location: Evergreen Park; 2 slides. Note: "This is not a SHG event. Slides should not be included." 1. Giawe and Alan Norte in calavera attire at Blood in Blood Out at Evergreen Cemetery. 2. Gloria Westcott and Consuelo Norte put their arms around a large gravestone with cross. The name on the marker is "Charnock". Cat. 3 051 (1-2).

SHG; *Gallery Exhibit*; ca. 1990's; slide photo; Note: Tomás Benítez. Cat. 3 052.

SHG; *Gallery Exhibit*; n.d. slide photo; Note: Elizabeth (last name unknown). Cat. 3 053.

SHG; *Gallery Exhibit*; n.d. slide photo; : Note: John Valadez and his son. Cat. 3 054.

SHG; *Gallery Exhibit "Automatic Shutdown"*; March 8, 1992; slide photo; Note: Sandra P. Hahn and Armando Norte at an exhibition at Galería Otra Vez. Cat. 3 055.

SHG; *Gallery Exhibit, Galería Otra Vez*; n.d. slide photo; Note: Linda Lopez. Cat. 3 056.

SHG; *Gil Cardenas*; n.d. slide photo; Note: Photo is of scholar and art collector Gilberto "Gil" Cardenas. Cat. 3 057.

SHG; *Glasgow Print Studio Day of the Dead Workshops and Festivities*; October 1996; slide photo; Site/Location: Glasgow Print Studio, Scotland; 29 slides. Note: "SHG collaborated with Glasgow Print Studio in their first ever Day of the Dead Celebration." 1. Margaret Sosa, sitting on the ground, is surrounded by papel picado. 2. Ofelia Esparza (right) and unidentified art students. 3. From the 31st, Yolanda Gonzalez holds up two small flags made of papel picado. 4. From the November 1 exhibition, a man in calavera makeup plays the saxophone. 5. Margaret Sosa, atop a ladder, hangs papel picado. 6. Ofelia Esparza holds a bouquet of marigolds. 7. Painting calaveras. 8. Margaret Sosa hangs strings of papel picado. 9. From November 1, a woman in calavera makeup wears a sombrero and an embroidered vest. 10. Ofelia Esparza adds to the altar, still in its early stages. 11. Yolanda Gonzalez and Ofelia Esparza create an arch decorated with marigolds. 12. A photo from opening night of (right to left): John Ferry's wife, John Ferry, (Board members from Glasgow print studio) and Ofelia Esparza. 13. Band players and Yolanda Gonzalez (center, with camera). 14. On a table covered with bubble wrap, Yolanda Gonzalez writes. 15. Photo from October 30: Papel picado with flowers and a calavera and title text. 16. Right to left: Margaret Sosa and Janie Nicoll. 17. Unidentified parade participants. 18. From right to left: John and Sue Mackechnie, person unknown, Janie Nicoll and Margaret Sosa. 19. Taken November 2, this photo is of Glasgow with the ocean in the background. 20. Taken November 1, (right to left): Sue, Janie, and John Mackechnie. 21. Yolanda Gonzalez holds a guitar painted with a nude woman. 22. Taken November 1, this photo is of a man dressed as Frida Kahlo with carnations in his hair and a picture of a monkey on his jacket. 23. Altar in progress, work by Ofelia Esparza. 24. Margaret Sosa and Ofelia Esparza at the Necropolis Cemetery, Glasgow. 25. Margaret Sosa holding pieces of papel picado. 26. Margaret

Sosa in Glasgow. 27. Photo is of a Day of the Dead participant named Janie. 28. Ofelia Esparza creates an altar for an Installation in Glasgow, Scotland. 29. Photo is of a man in calavera makeup wearing a suit that makes it appear that he's riding a horse. He holds a toy rifle in one hand. Many parade participants are visible in the background. Cat. 3 058(1-29).

SHG; *Greta Diderich and Nikki Joentze*; n.d. slide photo; Note: Greta Diderich and Nikki Joentze. Cat. 3 059.

SHG; *Making a Monoprint*; n.d. slide photo; Note: Ofelia Esparza and Alejandro de la Loza. Cat. 3 060.

SHG; *Making a Silkscreen*; n.d. slide photo; Note: Oscar Duardo and Yreina Cervantez. Cat. 3 061.

SHG; *Making a Silkscreen*; n.d. slide photo; Note: José Alpuche and Alejandro Romero. Cat. 3 062.

SHG; *Making of a Monoprint*; ca. 1990's; slide photo; Note: Ofelia Esparza and José Alpuche. Cat. 3 063.

SHG; *The Making of "Dolores" by Barbara Carrasco*; n.d. slide photo; Note: Barbara Carrasco. Cat. 3 064.

SHG; *Mask*; n.d. slide photo; Note: An unidentified woman in calavera makeup, a long black dress, and gold-colored gloves holds a mask of a 'living' face on a handle shaped like a human arm and hand. Cat. 3 065.

SHG; *Mask-Making Workshop*; ca. 1990's; slide photo; slide photo: Mario Lopez; 3 slides. Note: 1. Calavera masks, some colored and some blank, and a sign reading "Create Your Own Mask $2.00 ea." are posted on the exterior wall of the SHG building. "A favorite children's workshop which dates back to the 1970's." 2-3. Unidentified children participate in workshop. "SHG conducts arts workshops for both children and adults on the Day of the Dead and in the weeks prior to the event."; Cat. 3 066(1-3).

SHG; *Masks*; October 1978; slide photo: Site/Location: SHG. Note: Photo is of three unidentified Day of the Dead participants in elaborate masks. Cat. 3 067.

SHG; *Meeting*; n.d. slide photo; Note: Right to left: Noni Olabisi, Laura Alvarez, and Barbara Carrasco. Cat. 3 068.

SHG; *Michael Amescua Painting*; n.d. slide photo; Note: Michael Amescua. Cat. 3 069.

SHG; *Miranos Workshop*; n.d. slide photo; Note: Unidentified workshop participants. Cat. 3 070.

SHG; *Monoprint Silkscreen Production*; n.d. slide photo; Note: Wayne Healy. Cat. 3 071.

SHG; *Monoprint Silkscreen Workshop*; April 27, 1991; slide photo; 2 slides. Note: Patssi Valdez. Cat. 3 072 (1-2).

SHG; *Monoprint Workshop*; November 1993; slide photo; Site/Location: SHG; 6 slides. Note: 1. Making a monoprint. Right to left: unknown, Roberto Gutierrez, and Gina (last name unknown). 2. Patricia Lazalde. 3. Teddy Sandoval. 4. Patricia Lazalde pulls a fresh monoprint off a plate. 5. Unidentified artist. 6. Patricia Lazalde. Cat. 3 073(1-6).

SHG; *Monoprint Workshop*; March 2000; slide photo; Site/Location: SHG; 18 slides. Note: 1. Chuy Rangel. 2. Unidentified workshop participant. 3. Chopmark embossed on a print. 4. Chuy Rangel. 5. Paul Botello. 6. Unidentified artist. 7. Otoño Luján. 8. Otoño Luján and unknown. 9. Jerry Ortega drying a monoprint. 10. A student drying a monoprint. 11. Wayne Healy. 12. Wayne Healy eats lunch. 13. Unidentified artists. 14. Unidentified artist. 15. Paul Botello. 16. Unidentified artist. 17. Wayne Healy. Cat. 3 074(1-18).

SHG; *Monoprint Workshop*; n.d. slide photo; Note: Alejandro Dela, master printer José Alpuche. Cat. 3 075.

SHG; *Murals in Motion Exhibit*; April 1993; slide photo; Note: 1. Three men squat in front of a lowrider in mid-hop. 2. Photo is of an airbrushed painting on the spare tire holder of a Chevrolet depicting a male and a female Aztec with a pyramid in the background. Cat. 3 076(1-2).

SHG; *Music Center*; 1993; slide photo; slide photo: copyright 1993 Ann Murdy. Note: Photo is of a family of Aztec dancers. Cat. 3 077.

SHG; *New Identities of Los Angeles: Artist Talk*; April 1996; slide photo; Note: Artist's talk and monosilkscreen collaboration. 1. Tomás Benítez (left), Roderick Sykes (center) and Jackie Alexander (right [both from St. Elmos Village]) sit at a table with microphones. 2. Roderick Sykes (left), Jackie Alexander (center), and Miguel Angel (right) from "Viva G & L Latino Artists Collective." 3. From Right to Left: Jackie Alexander, Roderick Sykes, José Antonio Aguirre, Sister Karen Boccalero, and Leda Ramos. 4. Roundtable discussion. From Right to Left: José Antonio Aguirre, Sister Karen

Boccalero, Leda Ramos, and Diane Gamboa. 5. From Left to Right (background): Miguel Angel Reyes, Sister Boccalero, Jose Antonio Aguirre, Leda Ramos, Diane Gamboa. 6. Miguel Angel Reyes, Sister Boccalero, Tomás Benitez, Jose Antonio Aguirre, and Diane Gamboa. 7. Roundtable discussion between collaboration participants. Right to left: unknown, Tomás Benítez, Sister Karen Boccalero, and Leda Ramos. 8. Roundtable discussion between collaboration participants. Right to left: Tomás Benítez, Sister Karen Boccalero, and Leda Ramos. 9. Roundtable discussion between Mathew Thomas, from the Watts Tower Art Center, and two unidentifiable participants. 10. Roundtable discussion between unidentified collaboration participants, three of whom are pictured. 11. Three unidentified collaboration participants. 12. Seven collaboration participants including (starting from the right), Jackie Alexander and Roderick Sykes. Second and third from the left are Karen Boccalero and Tomás Benítez. 13. Three unidentified collaboration participants. The other two participants include Raymundo Tonatiuh Reynoso and Lois Ramirez. 14. 3 unidentified collaboration participants and Raymundo Tonatiuh Reynoso. 15. One unidentified collaboration participant and Karen Kimura. 16. Collaboration participants include Karen Kimura, one unidentified participant, and Mahara T. Sinclaire. 17. Diane Gamboa addresses artists, including Ulysses Diaz, at roundtable discussion. 18. Three collaboration participants, including Ulysses Diaz, Mahara T. Sinclaire and one unidentified participant. 19. Three collaboration participants, including Ulysses Diaz, Mahara T. Sanchez and one unidentified participant. 20. Four collaboration participants, including (starting from the right) Dean Sameshima, June Edmunds, Ruben Esparza and Miguel Angel Reyes. 21. Four collaboration participants, including Ruben Esparza and Miguel Reyes. 22. Four collaboration participants, including (starting from the right) Mathew Thomas, Dean Sameshima, June Edmunds, and Ruben Esparza. 23. Three collaboration participants, including (starting from the right) Mathew Thomas, Dean Sameshima, and June Edmunds. 24. Roundtable discussion between collaboration participants including Miguel Angel Reyes and Ruben Esparza (in the foreground). 25. Roundtable discussion between collaboration participants, including Miguel Angel Reyes (in the front) and Diane Gamboa (in the back). 26. Roundtable discussion between collaboration participants. Right to left: unknown, Tomás Benítez (second from right), and Sister Karen Boccalero. 27. Roundtable discussion between collaboration participants. From right to left, the participants include Ruben Esparza, Miguel Angel Reyes, two unidentified participants, Tomás Benítez and Sister Karen Boccalero. (Bad slide). 28. Roundtable discussion between collaboration participants. The two people on the left are Sister Karen Boccalero, Tomás Benítez, and an unidentified participant. 29-31. Roundtable discussion between collaboration participants, including Sister Karen Boccalero, and Tomás Benítez (on the left). 32. Two artists, Jaqueline Alexander and Roderick Sykes, in SHG aprons. (bad slide) 33. Unidentified collaboration participant. 34. An unidentified artist, Jaqueline Alexander, Diane Gamboa, and Sister Karen Boccalero stand around a tray of inks. 35. Three unidentified artists. 36. Slide photo of artist Ulysses Diaz. 37. Unidentified artist. 38. Slide photo of artists Sister Karen Boccalero and Roderick Sykes. 39-41. Sister Karen (center) talks to artists. 42. Four artists including Jaqueline Alexander, Roderick Sykes, and two others that are unidentified. 43. Image of artist Roderick Sykes. 44. Two unidentified collaboration participants. 45. Artists examine a print. 46. Roundtable discussion among artists. 47. Roundtable discussion among artists. Tomás Benítez, left. 48. Roundtable discussion among artists. 49. Unidentified artists. 50. Sister Karen and an unidentified artist. 51. Unidentified collaboration participant. 52. Unidentified artist at work. 53. Five unidentified collaboration participants. 54-55. Roundtable discussion among collaboration participants. 56. Prints drying on racks. 57. Unidentified artist silkscreening. 58. Leda Ramos. 59-60. Unidentified artist. 61. Leda Ramos and another artist express joy at their handiwork. 62. Tomás Benítez speaks at a roundtable discussion among collaboration participants. 63. Diane Gamboa (left) and unknown. 64. Two artists hold up a print. 65-66. An artist signs a print. 67-68. Roundtable discussion among collaboration participants. 69. New Identity of Los Angeles scheduling with Sister Karen. 70. Left to right: Diane Gamboa and unknown.

71. José Alpuche and unknown. 72. Four collaboration participants. 73. Three artists hold a print. 74. Sister Karen moves prints drying on racks. 75. Sister Karen speaks with an unidentified artist. 76. An unidentified artist at work. 77. Roundtable discussion among collaboration participants. 78. An artist signs a print. 79. Leda Ramos and another artist hold a print. 80. An artist signs a print. Cat. 3 078(1-80).

SHG; *Ofelia Esparza Holding her Monoprint*; ca. early 1990's; slide photo; Note: Right to left: José Alpuche and Ofelia Esparza. Cat. 3 079.

SHG; *Ofelia Esperanza and Altar*; 1990s; slide photo; Note: Ofelia Esparza stands next to a large altar. The photo is out of focus. Cat. 3 080.

SHG; *Papel Picado Workshop for Day of the Dead*; ca. 1990's; slide photo; Note: "Carving tools are hammered into papel to produce the delicate design."; Cat. 3 081.

SHG; *Papel Picado Workshop for Day of the Dead*; 1998; slide photo; slide photo: Alex Alferov. Note: Margaret Sosa gives a papel picado workshop. "Margaret Sosa has been the main papel picado instructor for several years."; Cat. 3 082.

SHG; *Paper Flores*; n.d. slide photo; Note: Ofelia Esparza makes flowers out of paper. Cat. 3 083.

SHG; *Papier-Mâché Workshop*; 1998; slide photo: Site/Location: SHG; slide photo: Alex Alferov. Note: Unidentified workshop participants with a giant skeleton in the background. "Papier-mâché calacas decorate SHG and provide a festive atmosphere on the Day of the Dead."; Cat. 3 084.

SHG; *Papier-Mâché Workshop for Day of the Dead*; 1998; slide photo; slide photo: Alex Alferov. Note: Photo is of Leo Limón and an unidentified child. "Artists volunteer for arts workshops during the Day of the Dead event every year."; Cat. 3 085.

SHG; *Quetzal*; November 1, 1995; slide photo; slide photo: Mario Lopez. Note: Two people in blue overalls speak or sing into microphones. One wears calavera face paint. "Quetzal is a Los Angeles-based music group led by brother and sister Martha and Gabriel Gonzalez."; Cat. 3 086.

SHG; *Readying the Screen for Printing*; n.d. slide photo; : Note: Right to left: Tomás Benítez, Joe Alpuche, photographer and Margaret Garcia. Cat. 3 087.

SHG; *Reception at Galería Otra Vez for Day of the Dead*; 1992; slide photo; Note: Unidentified reception attendees. Cat. 3 088.

SHG; *Roberto Delgado*; n.d. slide photo; Note: Roberto Delgado. Cat. 3 089.

SHG; *Silkscreening*; July 1991; slide photo; Note: Oscar Duardo and Yreina Cervantez silkscreening the print "Mas Allá", atelier XVII. Cat. 3 090.

SHG; *Silkscreening*; n.d. slide photo; Note: José Alpuche. Cat. 3 091.

SHG; *Silkscreening Process*; 1991; slide photo; Note: Carlos Gonzalez Castro. Cat. 3 092.

SHG; *Sister Karen Boccalero*; n.d. slide photo; Site/Location: SHG; slide photo: unknown. Note: Sister Karen Boccalero. Cat. 3 093.

SHG; *Sketching out a Mural*; n.d. slide photo; Site/Location: Honduras. Note: Roberto Delgado. Cat. 3 094.

SHG; *Students in Advanced Etching Class*; May 1993; slide photo; 5 slides. Note: 1-2. Unidentified students in an advanced etching class. 3. Unidentified student in an advanced etching class. 4. Unidentified students in an advanced etching class. 5. An etching by an unknown artist. Cat. 3 095(1-5).

SHG; *Sugar Skulls*; n.d. slide photo; Note: Photo is of sugar skulls. Text before that reads, "Buy 1 and I'll put the name."; Cat. 3 096.

SHG; *UK / LA Reception at Galería Otra Vez*; October 1994; slide photo; 14 slides. Note: 1. Right to left: Janie Nicoll, members of the British Consulate, British Council General—John (last name unknown), Ashley Cook, and Tomás Benítez. 2-3. Ashley Cook. 4. Janie Nicoll. 5. José Alpuche and Wayne Healy. 6. Wayne Healy. 7. José Alpuche and unknown. 8. Unidentified artist cleaning a screen. 9. Right to left: unknown, José Alpuche, Janie Nicoll, Wayne Healy, and unknown. 10. José Alpuche and Wayne Healy. 11. Right to left: Janie Nicoll, José Alpuche, and Ashley Cook. 12. Ashley Cook and Wayne Healy. 13. Right to left: José Alpuche, Ashley Cook, Wayne Healy, and Janie Nicoll. 14. Janie Nicoll and Ashley Cook. Cat. 3 097 (1-14).

SHG; *Unidentified People*; n.d. slide photo; Note: A man and a woman, both unidentified. Cat. 3 098.

SHG; *Virgen*; n.d. slide photo; Note: Photo is of an impromptu altar at the base of a statue of La Virgen de Guadalupe composed of large masks. Cat. 3 099.

SHG; *Watching a Film*; n.d. slide photo; Note: An unidentified person watches a film while two others work at a computer. Cat. 3 100.

SHG; *Workshop*; n.d. slide photo; Note: Pedro Rios Martinez. Cat. 3 101.

SHG; *Workshop*; n.d. slide photo; Note: Unidentified workshop participants. Cat. 3 102.

SHG; *Workshop*; n.d. slide photo; Note: Oscar Duardo (holding print). Cat. 3 103.

SHG; *Workshop and Gallery Exhibit*; August 1997; slide photo; 5 slides. Note: 1. Christina Perez. 2. Unknown photographer and Rose Portillo. 3. Consuelo Flores at the exhibit. 4. Peter Tovar. 5. Jose Antonio Aguirre. Cat. 3 104(1-5).

SHG; *Yolanda Gonzalez*; n.d. slide photo; Note: Yolanda Gonzalez. Cat. 3 105.

Graphic Arts

Aguirre, Jose Antonio; *Ave Sin Fronteras*; 1995; monosilkscreen; Note: Image of a red bird (quetzal) in flight. Night is represented by stars and three comets flying overhead, with a design of a Mexican flag and skulls. Two chain-link fences converge at the bird's beak. Cat. 5 001.

Aguirre, Jose Antonio; *Las Califas del 2000*; 1996; monosilkscreen; 20" x 26": Note: Print depicts two abstracted faces. The background is blue and violet. Cat. 5 002.

Aguirre, Jose Antonio; *Con Máscara O Sin Máscara, Siempre Vivire*; 1995; monosilkscreen; Note: A Zapatista and a calavera are inside a purple square with a red border. A bearded man in a bandolero is inside a red trapezoid beside the square. In the background are a cross, a moon, stars, and designs. Cat. 5 003.

Aguirre, Jose Antonio; *Cyber Pink Calaca*; 1996; monosilkscreen; 22"x 16": Note: Image is of a stylized calavera with pink designs outlined in yellow on a blue and black background. Cat. 5 004.

Aguirre, Jose Antonio; *Guadalupe at the End of the Millenium*; 1995; monoprint; 20" x 26 1/2": Note: An abstract image of la Virgen de Guadalupe, somewhat resembling a calavera. She has no body and her head rests on an inverted crescent moon. The rays that emanate from her body are red and jagged, and one protrudes from her mouth. Cat. 5 005.

Aguirre, Jose Antonio; *New World Border (After Guillermo Gomez-Peña)*; 2000; monosilkscreen; Note: Image is of the face of a man wearing a wrestling mask with a leopard print. At the top of the mask, feathers protrude, making it resemble an Aztec or Native American headdress. Text at the bottom of the print beneath the image reads, "Free Trade Art". Cat. 5 006.

Aguirre, Jose Antonio; *Ode to Siqueiros*; ca. 1997-1998; monosilkscreen; 14' x 16': Note: Work is composed of 18 silkscreened panels arranged in the form of a diamond. Image is of Siqueiros holding an indeterminate tool. Opposite him is a bloody body on a track leading to a swirling mass. There is one eye on either side of the work to form the points of the diamond. Cat. 5 007.

Alexander, Jacqueline; *Fertility*; 1996; monosilkscreen; 20" x 26": Note: Print depicts an African fetish and the Venus of Wittendorf on a green background. Cat. 5 008.

Alferov, Alex; *Olivia*; 1998; monoprint; 16" x 22": Note: Image is of a woman's face. Cat. 5 009.

Alferov, Alex and Michael Amescua; *Our Lady*; 1995; serigraph; 30" x 44": Note: Image of the Virgin's face, slightly tilted, in yellow and purple. It is framed by a purple and black border with faces. From the Virgen de Guadalupe project. Cat. 5 010.

Alpuche, José; *Untitled (Abstract)*; 1998; monoprint; 16" x 20": Note: Abstract print in black, yellow, purple, and green. Cat. 5 011.

Amescua, Michael; *Gift*; 1998; monoprint; 16" x 22": Note: Print depicts an anthropomorphic winged figure holding a staff or other long object in a Pre-Columbian style. Cat. 5 012.

Amescua, Michael; *Nagual 00120*; 1996; monosilkscreen; 22"x 16": Note: Image is of a face in a circle with four long brushstrokes coming down from it, causing it to resemble a Native American war shield. Predominant color is yellow. Cat. 5 013.

Aparicio Chamberlin, Vibiana; *Las Dos Grandes—Frida y Sor Juana*; ca. 2000-2001; woodcut and watercolors; Note: Two female faces

share a common eye. On the forehead of one is an image of la Virgen de Guadalupe. Cat. 5 014.

Aparicio Chamberlin, Vibiana; *Estrellas*; 1995; monoprint; 20" x 26 1/2": Note: Stylized image of la Virgen de Guadalupe with pink skin, large earrings, and a light green manta. Her eyes are closed and yellow rays emanate from her. The background is light blue. Cat. 5 015.

Aparicio Chamberlin, Vibiana; *El Orgullo de Cesar*; 1994; mixed media; 29 1/2" x 22": Note: Image is of Cesar Chávez's face. In all four corners are iconographic symbols, some of animals, some of people. Text near his head reads, "Cesar Chavez Labor Leader". Cat. 5 016.

Aparicio Chamberlin, Vibiana; *No Le Hagan Daño*; 1995; etching; Note: Image is of a woman in an apron above a landscape. A bird with the number "2727" sits on her shoulder. Text at the top of the print reads, "Moore No Le Hagan Daño A La Viuda Ni Al Huerfano". Cat. 5 017.

Audifred, Magdalena; *Alumbramdo Mi Entrada*; 1995; etching: Note: Image is of a woman under an arch topped with candles. In the background, another woman is visible through a window, backdropped by a cityscape. Cat. 5 018.

Audifred, Magdalena; *Disfrutando de la Vida*; October 15, 1994; monosilkscreen; Note: Image is of a person's face beneath an arch. Background is blue, purple, and white. Cat. 5 019.

Audifred, Magdalena; *Dreaming*; October 15, 1994; monosilkscreen; Note: Black and white image is of a face. Created as a part of the UK/LA workshop. Cat. 5 020.

Audifred, Magdalena; *Wondering Above the Ocean*; 1996; lithograph; Note: Image is of a heart suspended above water surrounded by a spiral of barbed wire. On either side of it, buildings crumble. Cat. 5 021.

Baray, Sam; *Coming of Youth*; 1998; monoprint; 16" x 22": Note: Image is of a stylized face on a blue, green, and red background. Cat. 5 022.

Baray, Sam; *Virgen de la Guarda*; 1995; serigraph; Note: Image of the virgin protecting a neighborhood with her arms. In between the rays of light emanating from her body are faces reminiscent of indigenous warriors. Cat. 5 023.

Baron, Agustin; *Mayo 2, 1998*; 1998; woodcut and watercolor; 14 3/4" x 18 1/2": Note: Woodblock print depicts five blue human figures hanging their heads. Two pieces of barbed wire encircle them. Cat. 5 024.

Baron, Agustin; *Nagual*; n.d. plate monoprint; 16" x 22": Note: In the center of the print is an anthropomorphic crow on a yellow background. Other images include cacti and a lizard. Colors create the impression of a desert. Cat. 5 025.

Baron, Agustin; *La Vida No Es Un Juego*; 2001; monosilkscreen; 5" x 6": Note: Image is of a calavera at the end of a hopscotch court. Cat. 5 026.

Beltrán, Richard; *Deer Heart And a Declaration of Interdependence II*; 1995; monoprint; 16" x 20": Note: Black-and-white image of an anatomical heart with antlers on each side. On the heart are three small globes, two of which are not whole. Cat. 5 027.

Beltrán, Richard; *Deer Heart And a Declaration of Interdependence III*; 1995; monoprint; 16" x 20": Note: Image is of an anatomical heart (in color) with antlers on either side. On the heart are three small globes, two of which are not whole. Cat. 5 028.

Beltrán, Richard; *Sunrise Girl III*; 1995; monoprint; 16" x 20": Note: Image is of a woman with yellow hair with her eyes closed. Cat. 5 029.

Beltrán, Richard; *Sunrise Girl IV*; 1995; monoprint; 16" x 20": Note: Image is of a woman in black with her eyes closed. The background is blue with yellow circles. Cat. 5 030.

Bojorquez, Chaz; *Los Avenues*; 1987; silkscreen; Note: Print depicts a calavera in a fedora with a cross above its head. Text in graffiti script beneath the skull reads, "Los Avenues". Cat. 5 031.

Bojorquez, Chaz; *Mi Hijo*; 1998; monosilkscreen; Note: Image is of a man with his arms extended outward. The image is cropped so that the torso dominates the print. Created as part of the AIDS project. Cat. 5 032.

Botello, Paul; *All in One*; 2000; monosilkscreen; Note: Image is of five faces and two partial faces side-by-side in blue, green and yellow. Created as part of the "Y Tú Qué Más" special project. Cat. 5 033.

Brown; Ada Pullini; *Unassimilable*; 1995; photo etching; Note: A young woman in front of a dark background shields her eyes with her left arm. Cat. 5 034.

Calvano, Mario; *Maria Montez*; 2001; monosilkscreen; Note: Image is of the face of Dominican actress Maria Montez. Created as a part of the "Los Perspectivos de Hollywood" project. Cat. 5 035.

Calvano, Mario; *Portrait of a Sumo Judge*; 2000; monosilkscreen; Note: Image is of a man's face. His eyelids are lowered, as if closed or reading. He appears to be Asian or Asian American. Created as a part of the "Y Tú Qué Más" special project. Cat. 5 036.

Capistran, Silvia; *Agreeable Encounter*; 1995; etching; Note: Image is of an angel appearing to three children, as seen through a hole in a chain-link fence. Created for the La Raza Festival. Cat. 5 037.

Cardenas, Cristina; *Myself*; 1997; monosilkscreen; 16" x 22": Note: Cropped image of a woman's face. Three hearts at the bottom. Created as a part of the Arizona Xicanindio project. Cat. 5 038.

Cardenas, Cristina; *Tan Lejos de mi Vida*; 1997; monosilkscreen; 16" x 22": Note: Image is of a woman's face. Text in cursive surrounding the face reads, "tan lejos de mi vida, tan cerca de mis ojos". Created for the Arizona Xicanindio project. Cat. 5 039.

Cardenas, Cristina; *Yearning II*; 1997; monosilkscreen; 22" x 16": Note: Image is a portrait of a woman. Cat. 5 040.

Cortez, Xavier Cázares; *¡Dámelo!*; 1995; monosilkscreen; Note: A white hand in a business suit hands a torch to an athlete whose face is cropped. Created for the La Raza Festival. Cat. 5 041.

Cortez, Xavier Cázares; *¡Sal Si Puedes!*; 1995; monosilkscreen; Note: A hand reaches out to a crowd on the other side of some barbed wire. The background is red. Created for the La Raza Festival. Cat. 5 042.

Cuarón, Mita; *Colores del Muerte*; 1996; monosilkscreen; 16" x 20": Note: Image is of a calavera with red lips on the right side of the print. The background is made up of curved swaths of various colors. Cat. 5 043.

Cuarón, Mita; (title unknown); October 1994; media unknown; Note: Image is of a multitude of calaveras in different colors with different designs under a full moon. Cat. 5 044.

de Batuc, Alfredo; *Kyrie Eleison (Raining Roses)*; 2001; monosilkscreen; 16" x 22": Note: Image is of two human figures, one with its arms around the other. All around them, roses fall like rain. Created as a part of the AIDS project. Cat. 5 045.

de Batuc, Alfredo; *Mexican Bombshell*; 2001; monosilkscreen; 16" x 22": Note: Image is of the face of María Félix laying down with her hair spread around her head. From Los Perspectivos de Hollywood. Cat. 5 046.

de Batuc, Alfredo; *Navarro Rema*; 2001; monosilkscreen ghost print; 22" x 16": Note: Image is of actor Carlos Navarro rowing. Cat. 5 047.

de Batuc, Alfredo; *The Persistence of Images*; 1995; monoprint; 32" x 41": Note: Print depicts Madonna (the material girl) on the left side. On the right side is an empty, luminous manta like the one the Virgen de Guadalupe wears. In between the two images is de Batuc's City Hall, which pokes up above the horizon. From the Virgen de Guadalupe project. Cat. 5 048.

de Batuc, Alfredo; *Sailing 1*; 2001; monosilkscreen; 16" x 22": Note: Image is of two men in water up to their chests. A flame burns in front of the man in the foreground. In between the two men, a paper boat floats. AIDS project. Cat. 5 049.

De La Loza, Ernesto and Ricardo Duffy; *Capitalista*; ca.1997-1998; monosilkscreen; 7' 2 1/2" x 7' 9": slide photo: Ann Murdy. Note: Work is composed of 20 silkscreen panels and depicts George Washington riding the monster of Eurocentrism. A jaguar looks on as indigenous people confront this beast. In the background, the Capitol"ista" Records building looms. In the sky above George Washington is a seal with Caesar's quote "Veni Vidi Vici". Cat. 5 050.

De Rosa, Judy; *Keep Your Word*; 1995; etching; Note: The left side of the image consist of a stylized crow whose body encompasses the cosmos and two ears of corn. Two human arms protrude from the crow's body toward the right, where a dragonfly and butterfly fly, and seem to embrace the Earth. From the "La Raza Festival."; Cat. 5 051.

Defazio, Christian; *Where I Stand*; 1996; monosilkscreen; 20" x 26": Note: Two footprints and two smears in a salmon tone. New Identity of Los Angeles project. Cat. 5 052.

Delgadillo, Victoria; *Dia de los Muertos*; 1996; monosilkscreen; 22" x 16": Note: Image is of two faces in calavera makeup. Cat. 5 053.

Delgado, Roberto L. "Tito"; *La Calaca Embarazada*; 1996; monosilkscreen; 22" x 16": Note: Image is of a pregnant body wrapped in chains with the head of a skull. The background is green and the print is bordered with shapes of bones and diamonds. Cat. 5 054.

Delgado, Roberto L. "Tito"; *La Escalera*; 2000; monosilkscreen; Note: Image is composed of two photosilkscreened images in the center and faces looking inward on the outsides. Photos are of a WWII-era machine gun, top, and a large group of workers performing manual labor. From the special project "Y Tú Qué Más". Cat. 5 055.

Delgado, Roberto L. "Tito"; *El Nuevo Mundo Valiente*; 2001; monosilkscreen; 22" x 16": Note: Two photosilkscreened images in the center of the print depict a child sneaking through a hole in a fence and a military helicopter. Designs around the outside bring the eye to the center. From the "Los Perspectivos de Hollywood" project. Cat. 5 056.

Delgado, Roberto L. "Tito"; *Siquieros En El Bote* (detail); ca. 1997-1998; monosilkscreen; 5' 4" x 9' 2": Note: Photosilkscreened images of Siqueiros are repeated in different colors. Cat. 5 057.

Diaz, Ulisis; *House/Car Registration*; 1996; monosilkscreen; 20" x 26": Note: Image of a yellow house and a round symbol. New Identity of L.A. project. Cat. 5 058.

Duffy, Ricardo; *Mi Corazón*; 1994; etching; Note: A stylized jaguar or other big cat with its mouth wide open. In the foreground is an anatomical heart. Cat. 5 059.

Duffy, Ricardo; *Washington En Tijuana*; 1995; monosilkscreen; Note: Image is of George Washington in a Speedo or blue briefs, through which his genitals are visible. He stands next to a Chihuahua in front of the border. Text behind him reads, "United States [B]order Inspection Sta[tion]". La Raza Festival. Cat. 5 060.

Echavarria, Val; *Whats in a Face? (VI)*; 1995; monoprint; 20" x 26 1/2": Note: Inclined face of la Virgen de Guadalupe with her eyes half-closed. Virgen de Guadalupe project. Cat. 5 061.

Edmonds, June; *Know What I'm Sayin'? #4*; 1996; monosilkscreen; 20" x 26": Note: Image of a smiling woman wearing a red blouse. She has purple skin, which stands out from the yellow background. From the New Identities of L.A. project. Cat. 5 062.

Eller, Lence; *Logging Miles*; 1997; monosilkscreen; 16" x 22": Note: A child has an airplane on its head and cars on its shoulders. In the background, clouds are blue, pink, and yellow. From the Arizona project. Cat. 5 063.

Emerson, Sy; *Hope*; 1995; etching; Note: Image is of a crucified nude woman. At her feet is a nude infant. The sun rises (or sets) in the background. From La Raza Festival. Cat. 5 064.

Emily; *Red Worms*; 1997; monosilkscreen; 16" x 22": Note: Image is of white and yellow tubes resembling worms. The background is red. From the Arizona project. Cat. 5 065.

Enriquez, John A. *Allied*; 1997; monosilkscreen; 16" x 22": Note: Image is of stylized human figures in white on a black background. Text behind the figures reads, "Allied". The print is framed in yellow and red. Arizona project. Cat. 5 066.

Escobar Contreras, Gregorio; *Zapata ¡Vive Culeros!*; ca. 1999-2000; Monosilkscreen; 22" x 16": Site/Location: SHG; slide photo: unknown. Note: Image is of Zapata's face of a red, white, and green gradated background. Cat. 5 067.

Esparza, Ofelia; *Diosa de la Vida*; 1996; monosilkscreen; 22" x 16": Note: Image is of a woman's face on a red square. At the bottom of the print are three ears of corn with designs on them behind a calavera. Behind the red square are celestial bodies. Cat. 5 068.

Esparza, Ofelia; *Diosa de Maiz*; 1998; woodcut and watercolors; Note: A female figure with snakes on her head holds a flower. Her plaited hair resembles rows of corn. From the 25th anniversary woodcut/watercolor project. Cat. 5 069.

Esparza, Ofelia; *La Linea I*; 1995; monoprint collograph; 12" x 16": Note: A red wall and a black row of soldiers separate a crowd of people from the United States flag. Text in the crowd reads, "Dignidad Y Justicia", "Libertad", and "En contra del sistema injusto". Created for La Raza Festival. Cat. 5 070.

Esparza, Ofelia; *Lo Que Es Justo (What Is Fair)*; 1998; monosilkscreen; Note: Image is of a man with blue hair with a UFW huelga eagle on his shoulder. Text forming an arc over his head reads, "El dere-

cho del trabajador de mantener a su familia es justo y necesario". Cat. 5 071.

Esparza, Ofelia; *Neighborhood Watch I*; 1995; monoprint collograph; 12" x 16": Note: An anciano and two children look out a window. Behind them, a luminous Virgen de Guadalupe is visible. La Raza Festival. Cat. 5 072.

Esparza, Ofelia; *Neighborhood Watch II*; 1995; monoprint; 12" x 16": Note: An anciano and two children look out a window. Behind them, a luminous Virgen de Guadalupe is visible. This print differs from version I in that the frame of the window is green rather than brown. Created for La Raza Festival. Cat. 5 073.

Esparza, Ofelia; *Neighborhood Watch III*; 1995; monoprint collograph; 12" x 16": Note: An anciano and two children look out a window. Behind them, a luminous Virgen de Guadalupe is visible. This print differs from versions I and II in coloration. La Raza Festival. Cat. 5 074.

Esparza, Ofelia; *Nuestra Madre Guadalupe-Tonantzín*; 1995; monoprint; 20" x 26 1/2": Note: A woman wearing a blue mantle inclines toward the viewer. In her hands she holds a single rose. The lower portion of the print is filled with vegetation and the upper portion depicts yellow, orange, and red rays emanating from the Virgin. There is also a bird and several faces. From the Virgen de Guadalupe project. Cat. 5 075.

Esparza, Ofelia; *Ofrenda a la Madre*; 1998; monoprint; 16" x 22": Note: Print depicts a small altar surrounded by papel picado on top, marigolds on the right, and calla lilies on the bottom. Altar is composed of an image of la Virgen de Guadalupe, a framed photograph, roses, candles, and a sugar skull. From the "El Big 25" monoprint project. Cat. 5 076.

Esparza, Ofelia; *Quetzal De La Libertad (Quetzal of Liberty)*; 1998; monosilkscreen; Note: Image is of a quetzal (meaning "beautiful" in Azteca) behind a female Zapatista with a rifle over her shoulder. From the fall 1998 taller: Tierra, Libertad, e Independencia. Cat. 5 077.

Esparza, Rubén; *Invisible*; 2001; monosilkscreen; 16" x 22": Note: On a light-dark blue gradated background, the letters of the word "Invisible" are arranged like the letters of the Hollywood sign. From the "Los Perspectivos de Hollywood" project. Cat. 5 078.

Esparza, Rubén; *New Identity of Los Angeles*; 1996; monosilkscreen; 20" x 26": Note: Print depicts a sarape in black, green, yellow, and red. Ghosted text and logo read, "NILA". From the "New Identities of L.A." project. Cat. 5 079.

Esparza, Rubén; *Pecado*; 2001; monosilkscreen; 16" x 22": Note: Image is of flames on a black background. In the center of the print is the word "Pecado" with the "TM" symbol. Created as part of the AIDS project. Cat. 5 080.

Esparza, Rubén; *SI DA*; 2001; monosilkscreen; 16" x 22": Note: Background to the word "sida" and the "Registered" symbol is a gradation from black to pink to white to pink back to black. AIDS project. Cat. 5 081.

Esparza, Rubén; *Sin ®*; 2001; monosilkscreen; 16" x 22": Note: On a blue-to-white gradated background appears the word "Sin" and the "Registered" symbol (®). From the AIDS project. Cat. 5 082.

Espinosa, Gonzalo; *Azul Desesperado*; 1997; monosilkscreen; 22" x 16": Note: Image is of a face composed of white geometric figures superimposed on another, undistinguishable, image. The background is black. Arizona project. Cat. 5 083.

Espinoza, Eduardo; *Palabras a la Brava*; 1997; monosilkscreen; 16" x 22": Note: In the upper right corner, a green-faced man speaks. A UFW huelga eagle appears to be rolling over two other people. Cat. 5 084.

Flores, Lysa; *Be Love*; 2000; monosilkscreen; Note: Image is of a woman in purple negligé. She has gray skin and red hair. From the "Y Tú Qué Más" special project. Cat. 5 085.

Gallego, Adriana; *Favor No Tocar*; 2000; monosilkscreen; Note: Image is of a young girl's head and shoulders. She wears a white headband and the background is divided into yellow and purple areas. From the "Y Tú Qué Más" special project. Cat. 5 086.

Gallego, Adriana; *No Me Desampares*; 1997; monosilkscreen; 16" x 22": Note: Image is of a man in a hat and a woman in a rebozo. Arizona project. Cat. 5 087.

Gallego, Adriana; *Transcender*; 1997; monosilkscreen; 22" x 16": Note: Image is of a Virgen of Guadalupe with bare shoulders and blue rebozo against a yellow circular aura. Cat. 5 088.

Gamboa, Diane; *Education*; 1996; monosilkscreen; 20" x 26": <u>Note:</u> Image is of two turquoise men. From the "New Identities of Los Angeles" project. Cat. 5 089.

Gamboa, Diane; *Family, Lies, Disfunctions and Denials*; ca. 1997-1998; monosilkscreen; 6' x 9' 3 1/2": <u>Note:</u> Work consists of twelve silkscreened panels and depicts four women among thorny flowerbushes. The background is turquoise. Cat. 5 090.

Garcia; Margaret; *Joe & the Girls from Glasgow*; 1996; monosilkscreen; 16" x 22": <u>Note:</u> "Blue black, and white image of Joe Alpuche and girls from Glasgow, Scotland as calacas."; Cat. 5 091.

Garcia, Margaret; *Rita Hayworth*; 2001; monosilkscreen; 22" x 16": <u>Note:</u> Image is of the actress Rita Hayworth. The background is violet. From "Los Perspectivos de Hollywood" project. Cat. 5 092.

Garcia, Margaret; *The Seduction*; n.d. monosilkscreen; 16" x 22": <u>Note:</u> Two high-heeled shoes and four jalapeños on a yellow background. Cat. 5 093.

Garcia, Margaret; *Sister Karen*; 1998; monoprint; <u>Note:</u> Image is of Sister Karen Boccalero. Cat. 5 094.

Garcia, Margaret; *With Attitude*; 2000; monosilkscreen; 16" x 22": <u>Note:</u> Image is of the torso and head of a nude woman with yellow skin. The background is blue. From the "Y Tú Qué Más" special project. Cat. 5 095.

García, Martín V. *Con el SeñoreEn Frente*; 1995; etching; <u>Note:</u> Image is of Christ wearing a crown of thorns. A man looks over his shoulder at the viewer. From the La Raza Festival. Cat. 5 096.

García, Martín V. *La Despedida*; 1995; etching; <u>Note:</u> Image is of a man with a sack clung over his shoulder with his back to a woman in an attitude like that of La Virgen de Guadalupe and a child. From La Raza Festival. Cat. 5 097.

García, Martín V. *Mi Familia*; 1995; etching; <u>Note:</u> Image is of a child and a woman resembling La Virgen de Guadalupe. Cat. 5 098.

García, Martín V. *Observando*; 2000; monosilkscreen; <u>Note:</u> Image is of a man's face with intent eyes. From the "Y Tú Qué Más" special project. Cat. 5 099.

García, Martín V. *Somos Cuatachos*; 1996; monosilkscreen; 16" x 22": <u>Note:</u> Image is of a woman with her arm around a calavera in a red beret. Cat. 5 100.

Garcia, Rebecca; *Buenas con El*; 2001; monosilkscreen; 22" x 16": <u>Note:</u> Image is of an unused condom on a blue background. Text at the top of the print reads, "el condón". From the AIDS project. Cat. 5 101.

Gil, Xóchitl; *Enredada En Sueños del Cuerpo*; 1997; monosilkscreen; 16" x 22": <u>Note:</u> Image is of a woman's body wrapped in barbed wire and draped with leaves or seaweed. Arizona project. Cat. 5 102.

Gomez, Ignacio; *Chavez*; n.d. photo etching; <u>Note:</u> The face of Cesar Chávez in the sky above a group of protesters carrying the UFW Huelga flag. The man at the front of the group carries a flag with the image of Our Lady of Guadalupe. Cat. 5 103.

Gomez, Ignacio; *Dolores Huerta*; 1998; plate monoprint; <u>Note:</u> Image is of Huerta's face superimposed on an agricultural landscape. Cat. 5 104.

Gomez, Pat; *DOD at SHG*; 1998; monoprint; 16" x 22": <u>Note:</u> Image is of a skeleton in a window and three lit candles. Cat. 5 105.

Gomez, Pat; *Virgen de Guadalupe*; 1995; monoprint; 20" x 26 1/2": <u>Note:</u> Stylized image of la Virgen de Guadalupe on a yellow background with red roses. From the Virgen de Guadalupe project. Cat. 5 106.

Gonzalez, Art "Temoc"; *I Wait*; 1998; photo etching and hand painting; <u>Note:</u> A woman with calavera makeup wearing the traditional dress of Veracruz. Cat. 5 107.

Gonzalez, Art "Temoc"; *The Light Covers All (La Luz Cubre Todo)*; 1998; monosilkscreen; <u>Note:</u> Image is of a woman in traditional Mexican dress holding a torch (resembling the statue of liberty). Mexican and U.S. flags in the background meld with her dress. From "Taller: Tierra, Libertad y Independencia". Cat. 5 108.

Gonzalez, Art "Temoc"; *No Matter Where You Are, There You Are (No Importa Donde Estés, Allí Estarás)*; 1998; monosilkscreen; <u>Note:</u> Image is of a man wearing a Mexican Flag bandanna. A U.S. flag appears in the background. Text forming a border around the image is illegible. From the "Taller: Tierra, Libertad, y Independencia". Cat. 5 109.

Gonzalez, C.M. *Corona y Cruz*; 1995; monoprint; 20" x 26 1/2": <u>Note:</u> La virgen has a red face and wears a crown and a cross. The background is gray and blue. Virgen de Guadalupe project. Cat. 5 110.

Gonzalez, C.M. *Electric Altar*; 1995; monoprint; <u>Note:</u> On a television screen are images of the Statue of Liberty, the Virgen de Guadalupe, devotional candles, and partial faces in distress. In front of the television, a man stands with his hand on the image of La Virgen. From La Raza Festival. Cat. 5 111.

Gonzalez, C.M. *Tango Negro*; n.d. etching; <u>Note:</u> A man and woman are dancing. The colors are black and white. Cat. 5 112.

Gonzalez, Cici Segura; *Above The Sky*; 1998; monosilkscreen; <u>Note:</u> Print depicts a woman with her back to the viewer hovering in the air in front of a red, white, and green flag. A René Magritte-style bowler hat floats above her head. From the project "Taller: Tierra, Libertad y Independencia."; Cat. 5 113.

Gonzalez, Cici Segura; *Angel De Libertad (Angel of Liberation)*; 1998; monosilkscreen; <u>Note:</u> An angel with braided hair appears before a red, white, and green flag. Two bowler hats float above its head. The background is blue. From the project "Taller: Tierra, Libertad, y Independencia."; Cat. 5 114.

Gonzalez, Cici Segura; *Baile Rojo*; 1998; woodcut and watercolors; <u>Note:</u> Image is of a matador and a bull. From the 25th anniversary project. Cat. 5 115.

Gonzalez, Yolanda; *El Hombre y La Mujer II*; May 1998; woodcut and watercolor; 22 1/4" x 29 1/4": <u>Note:</u> Painted woodblock depicts a woman and an inverted man. Cat. 5 116.

Gonzalez, Yolanda; *Hombre Siqueiros*; ca. 1997-1998; monosilkscreen; 9' 6 1/2" x 5' 7 1/2": <u>Note:</u> Work is composed of 12 silkscreened panels and depicts a stylized man wearing a sombrero. Cat. 5 117.

Gonzalez, Yolanda; *Jose, el Indio*; 1998; monoprint; 16" x 22": <u>Note:</u> Image is of a boy's face with green skin and spiked hair. The background consists of black and light blue horizontal stripes. From "The Big 25" monoprint project. Cat. 5 118.

Gonzalez, Yolanda; *Jose Luis*; 1997; monosilkscreen; 22" x 16": <u>Note:</u> A man's face in primary colors. Cat. 5 119.

Gonzalez, Yolanda; *Maria Felix*; 2001; monosilkscreen; 22" x 16": <u>Note:</u> Image is of the face of María Félix. She looks toward the viewer's right and the background is red. From the "Los Perspectivos de Hollywood" project. Cat. 5 120.

Gonzalez, Yolanda; *Mi Pasado Muerto*; 1996; monosilkscreen; 22" x 16": <u>Note:</u> Image is of the partial figure of a nude woman. She wears a red hat with a red circle on it. She is surrounded in yellow and the background is red. Cat. 5 121.

Gonzalez, Yolanda; *Pedro Infante*; 2001; monosilkscreen; 22" x 16": <u>Note:</u> Image is of actor/singer Pedro Infante. The background is red. From the "Los Perspectivos de Hollywood" project. Cat. 5 122.

Gonzalez, Yolanda; *Rosie*; November 2000; monosilkscreen; <u>Note:</u> Image is of a nude woman with olive green skin and purple hair. She has a red garment draped around her arms and the background is yellow. From the "Y Tú Qué Más" special project. Cat. 5 123.

Gonzalez, Yolanda; *Rosie Series*; July 2001; monosilkscreen; <u>Note:</u> Image is of a nude woman with orange hair. She has a red garment draped over her right shoulder and left arm. The background is yellow. From the AIDS project. Cat. 5 124.

Gonzalez, Yolanda; (title unknown); ca. 1999; monosilkscreen; <u>Note:</u> Image is of four red flowers in a blue vase. Background is yellow. Cat. 5 125.

Gonzalez, Yolanda; *Vida de Santos*; 1995; monoprint; 32" x 41": <u>Note:</u> The face of the Virgen de Guadalupe is represented in non-representational colors. From the Virgen de Guadalupe project. Cat. 5 126.

Gonzalez, Yolanda; *Virgen de Guadalupe*; 1995; monoprint; 20" x 26 1/2": <u>Note:</u> Print depicts la Virgen de Guadalupe with roses. The background is red. From the Virgen de Guadalupe project. Cat. 5 127.

Guerrero-Cruz, Dolores; *Chiapas*; 1995; monosilkscreen; <u>Note:</u> Image is of a woman with a child on her back. Behind them are four stylized soldiers surrounded by fire. Created for the La Raza Festival. Cat. 5 128.

Guerrero-Cruz, Dolores; *Culture, Identity & Self Preservation*; 1998; monoprint; <u>Note:</u> Print depicts a woman wearing a sombrero on a blue-yellow-green gradated background. From the "Big 25" monoprint project. Cat. 5 129.

Guerrero-Cruz, Dolores; *The Falling of America*; 1995; monosilkscreen; Note: Image of the Statue of Liberty blindfolded. Strings attach her limbs to handles like those used to manipulate marionettes. The handles are controlled by red hands. Created for the La Raza Festival. Cat. 5 130.

Gutierrez, Roberto; *The 8th Street Off Ramp*; 1997; monosilkscreen; 16" x 22": Note: Image is of a colorful freeway offramp with buildings, palm trees, and a red sky. Cat. 5 131.

Gutierrez, Roberto; *Pan Dulce y Cafe*; 1996; monosilkscreen; 22" x 16": Note: Image is of an altar to La Virgen de Guadalupe with photos, a flower, pandulce, and a cup of coffee on a tray. Beneath the tray two candles burn. The background is a garden and the exterior of a building. Cat. 5 132.

Gutierrez; Roberto; *Self Help Graphics*; 1998; monosilkscreen; 16" x 22": Note: Image is of the SHG building in East L.A. Above the building flies a paletero or elote man. This print is also known by the title "SHG". From the "El Big 25" monoprint project. Cat. 5 133.

Gutierrez, Roberto; *The Spirit Guide*; 1995; monoprint; 32" x 41": Note: The Virgin of Guadalupe watches over the SHG building. From the Virgen de Guadalupe project. Cat. 5 134.

Gutierrez, Roberto; *La Trenza*; 1996; woodcut; Note: A woman with a long braid waits at a bus stop. Cat. 5 135.

Haro; Dolores; *Calla Lilies*; 1998; woodcut and watercolor; 22 1/8" x 29 3/4": Note: A woman's face appears behind three Calla lilies. From the "El Big 25" monoprint project. Cat. 5 136.

Healy, Wayne; *Cool Calavera*; 1991; monosilkscreen; 22" x 16": Note: Image is of a calavera in a yellow zoot suit. Cat. 5 137.

Healy, Wayne; *¿De Veras?*; 2000; monosilkscreen; Note: Two women in red dresses sit chismeando. From the "Y Tú Qué Más" special project. Cat. 5 138.

Healy, Wayne; *Excuse U.S.* 1995; monosilkscreen; Note: Image is of a soldier in a Mexican War-era uniform holding up a dotted line between the U.S. and Mexico, which is a pink background. On the Mexican side, a man in a sombrero holds a green stick. Cat. 5 139.

Healy, Wayne; *Intravenous Suicide*; 2001; monosilkscreen; 22" x 16": Note: Image is of a man and a skeleton holding a needle. From the AIDS project. Cat. 5 140.

Healy, Wayne; *Jarabe Tapatio Muerto*; 1993; monoprint; 20" x 26": Note: Print depicts two calaveras dancing the Jarabe Tapatío. Cat. 5 141.

Healy, Wayne; *Jaripeo Nacional (National Rodeo)*; 1998; monosilkscreen; Note: Image is of a woman in a sombrero and pink dress with a Mexican flag in one hand and a U.S. flag in the other riding a bronco. From the project: "Tierra, Libertad, e Independencia."; Cat. 5 142.

Healy, Wayne; *La Mano de Siqueiros*; ca. 1997-1998; monosilkscreen; 8' 5 1/2" x 12' 2": Note: Work is an ensemble of twenty silkscreen prints and depicts Siqueiros. In his hand are two children who hold a large paintbrush. Cat. 5 143.

Healy, Wayne; *Reet Zoot Drape*; 1991; monosilkscreen; 22" x 16": Note: Image is of a pachuco in a yellow Zoot Suit twirling his chain. Cat. 5 144.

Healy, Wayne; *The Scottish-Mexican Thorn Conspiracy*; October 15, 1994; Note: Black and white print features an image of a nude woman holding a champagne glass. She is moving toward a field filled with burrs. Behind her follows a dinosaur dressed as a pachuco. He emerges from a field of nopales. From the UK/LA monoprint collaboration. Cat. 5 145.

Healy, Wayne; *South Wall, SHG*; 1998; monoprint; 16" x 22": Note: Print depicts a man at the top of a ladder. From the "El Big 25" monoprint project. Cat. 5 146.

Healy, Wayne; *Tierra y Libertad*; 1998; monosilkscreen; Note: Emiliano Zapata wears a sombrero with the word "Tierra". A banner crossing in front of his chest reads, "Libertad". From the project "Taller: Tierra, Libertad, y Independencia."; Cat. 5 147.

Healy, Wayne; (title unknown); October 15, 1994; silkscreen; Note: Images of soccer players are framed by World Cup tickets. Spelled out in more tickets are the words USA Mundial 94. A hand holding a trophy emerges from the lower right corner. On either side of the hand are the words "Brasil" and "Campeon". Possibly from the UK/LA monoprint collaboration. Cat. 5 148.

Healy, Wayne; *Tunas Sangrando*; 1992; etching; 6" x 9": Note: A conquistador carries a sword that has skewered nopales. A rattlesnake follows closely behind. Cat. 5 149.

Healy, Wayne; *La Virgen de la Cancha*; 1995; monoprint; 32" x 41": Note: Image is of la Virgen de Guadalupe doing a reverse slam dunk. The background is red. From the Virgen de Guadalupe project. Cat. 5 150.

Healy, Wayne; *La Virgen del Mandado*; 1995; monoprint; 32" x 41": Note: A child tugs on the Virgen's mantle as she holds bags at a bus stop. A sign behind them reads "Grand Centra[l] Marke[t]". The child's shirt reads, "Jesus Salva". From the Virgen de Guadalupe project. Cat. 5 151.

Hebert, Patrick "Pato"; *Sin Título*; 2001; monosilkscreen; 16" x 22": Note: Image is of an eye on a butterfly wing. From the AIDS project. Cat. 5 152.

Hernandez, Dora; *Just for Fun*; 1997; monosilkscreen; 22" x 16": Note: Image is of tableware in a sideboard. The background is yellow. From the Arizona project. Cat. 5 153.

Herrera, Ernie; *La Causa*; 1998; woodcut and watercolors; Note: Print depicts Cesar Chávez on a farmland with grapes and a UFW flag in the background. Text in the upper left corner reads "La Causa". From the "Big 25" monoprint workshop. Cat. 5 154.

Herrera, Ernie; *Sister's Dream*; ca. 2000-2001; woodcut; Note: The face of Sister Karen Boccalero in front of the SHG building. Cat. 5 155.

Herrera, Ernie; *The Wave*; n.d. plate monoprint; 16" x 22": Note: Image is of an ocean wave. Colors are red, orange, and violet. Cat. 5 156.

Huerta, Salomon; *Brando*; 2001; monosilkscreen; 22" x 16": Note: Image is of the face of Marlon Brando. Text within the image area reads, "Viva Zapata Brando". From "Los Perspectivos de Hollywood" project. Cat. 5 157.

Huerta, Salomon; *Chicana Boy*; 1998; monoprint; 22" x 16": Note: Image is of an androgynous person with a pink top hat, purple jacket, and a ruffled pink collar on a dark green background. From "El Big 25" monoprint project. Cat. 5 158.

Huerta, Salomon; *Diego*; 1998; monoprint; 16" x 22": Note: Image is of the face of muralist Diego Rivera. From the "Héroes" series. Cat. 5 159.

Huerta, Salomon; *Frida*; 1998; monoprint; 16" x 22": Note: Image is of the face of painter Frida Kahlo. From the "Héroes" suite. Cat. 5 160.

Huerta, Salomon; *El Indio*; ca. 2000; monosilkscreen; Note: Image is of a man's face. He wears a mustache and a sombrero and the background is blue. From the "Héroes" series. Cat. 5 161.

Huerta, Salomon; *M-M*; n.d. monosilkscreen; 22" x 16": Note: Image is of a Mexican wrestler wearing a mask that doesn't cover his mustache. Text in script on his chin reads, "Mil Máscaras". From the "Héroes" suite. Cat. 5 162.

Huerta, Salomon; *La Novela*; 2001; monosilkscreen; 23" x 29": Note: Image is of two stylized telenovela actors, one man and one woman, in a passionate embrace. The background is red with yellow streaks. From the AIDS project. Cat. 5 163.

Huerta, Salomon; *Orozco*; 1998; monoprint; 16" x 22": Note: Image is of the face of muralist José Clemente Orozco. From the "Héroes" suite. Cat. 5 164.

Huerta, Salomon; *Pancho Villa*; 2000; monosilkscreen; Note: Image is of the face of Pancho Villa. The background is blue. Cat. 5 165.

Huerta, Salomon; *Siqueiros (1)*; 1998; monosilkscreen; 16" x 22": Note: Image is of the face of muralist David Alfaro Siqueiros. From the "Héroes" suite. Cat. 5 166.

Huerta, Salomon; *Tin Tan*; 2001; monosilkscreen; 22" x 16": Note: Image is of the actor Germán Valdés (Tin-Tán) with a gun to his head and a cigarette in his mouth. Text beneath his face reads, "TIN TAN". From the "Los Perspectivos de Hollywood" project. Cat. 5 167.

Huerta, Salomon; *Untitled*; 2000; monosilkscreen; Note: Image is of the head and chest of a man with red skin. He has his eyes closed and his arms are cropped. From the "Y Tú Qué Más" special project. Cat. 5 168.

Huerta, Salomon; *Untitled (Che)*; 1998; monoprint; 16" x 22": Note: Image is of Che Guevara's face on a red, white, and green gradated background. From the "Héroes" suite. Cat. 5 169.

Huerta, Salomon; *Untitled (Frida)*; 1998; monoprint; 16" x 22": Note: Image is of the face of painter Frida Kahlo. She wears yellow flowers in her hair. From the "Héroes" suite of prints. Cat. 5 170.

Huerta, Salomon; *Untitled (Zapata)*; 1998; monoprint; 16" x 22": Note: Image is of Emiliano Zapata's face on a red, white, and green gradated background. Text beneath the image reads, "¡Raza!" From the "Héroes" suite of prints. Cat. 5 171.

Iñiguez, Virgi; *The Border Crossed Us*; 1995; monoprint; 16" x 21": Note: Three overlapping female figures split into two sides, with half American and Mexican flags on each side. Created for the La Raza Festival. Cat. 5 172.

Iñiguez, Virgi; *From the Beginning We Have Been Here I*; 1995; monoprint; 16 1/2" x 21 1/2": Note: Cornstalks, handprints, and figures resembling indigenous petroglyphs. Repeated text forming a border aroud the image area reads, "From The Beginning We Have Been Here, We Didn't Cross The Border, The Border Crossed Us!" Created for the La Raza Festival. Cat. 5 173.

Iñiguez, Virgi; *From the Beginning We Have Been Here III*; 1995; monoprint; 16 1/2" x 21 1/2": Note: Images of botanical plants, hands, and the moon. From the La Raza Festival. Cat. 5 174.

Iñiguez, Virgi; *We Didn't Cross the Border I*; 1995; monoprint; 16" x 21": Note: The featureless figure of a woman split in the middle. Her left side is the Mexican flag, her right the U.S flag. The left side of the background is night, the right, day. Cat. 5 175.

Ituarte, Luis; *Metamorfosis de Quetzalcoatl*; ca. 1997-1998; monosilkscreen; 8' 5 1/2" x 12' 2": Note: Work is composed of twenty silkscreened prints and depicts abstract shapes on a blue background. Cat. 5 176.

Kemp, Randy; *Untitled*; 1997; monosilkscreen; Note: Image is of the face of a Native American man. From the Arizona project. Cat. 5 177.

Kim, Sojin; *Chung King Road*; 1997; etching; Note: A view along Chung King Road of small Asian American shops. Cat. 5 178.

Kim, Sojin; *Gin Ling Way*; 1998; color woodblock; Note: Woodblock print depicts an Asian American business. Signs read, "Chinese Wearing Apparel Dress Kimonos", "Chen Yuen Co.", and "Art Goods & Jewelry 469". From the 25-year anniversary project. Cat. 5 179.

Kim, Sojin; *Lings, 974 Chung King Rd.* 1999; color woodcut; Note: Print depicts an Asian-American market. Cat. 5 180.

Kim, Sojin; *Mei Ling Way*; 1998; woodcut and watercolors; Note: Street scene in an Asian-American neighborhood. Cat. 5 181.

Kimura, Karen; *One in Each Hand V*; 1996; monosilkscreen; 20" x 26": Note: Print is in two halves. The left side is dark orange and features a yellow hand holding an indistinguishable object. The right side is yellow and features a brown hand holding the same object. From the New Identity project. Cat. 5 182.

Lacámara; Laura; *El Baile con la Muerte*; 1996; monosilkscreen; 22" x 16": Note: A woman in a green dress dances with a skeleton on a moonlit night. Cat. 5 183.

Lacámara, Laura; *Nacimiento de mi Corazón*; 2000; monosilkscreen; Note: A blue child with a red heart on its chest seems to emerge from a squatting woman with red skin. The child stands above a blue and red spiral. From the "Y Tú Qué Más" special project. Cat. 5 184.

Lacámara, Laura; *La Salsa*; 1996; woodblock; 22" x 15": Note: Image is of two dancers. Colors are orange and green. From the Arizona project. Cat. 5 185.

Lazalde, Pat; *Juan Diego mi Corazon*; 1995; monoprint; 20" x 26": Note: Image is of a kneeling Juan Diego with his head bowed. From the Virgen de Guadalupe project. Cat. 5 186.

Ledesma, Andy; *Day of the Dead*; 1996; silkscreen; 30" x 21": Note: Print depicts many calaveras dancing and playing music. One prays at an altar de muerto. Text reads, "SHG Dia De Los Muertos—1996 Flores De Esperanza Day Of The Dead". Cat. 5 187.

Lee, Hyun Jin; *Racial Harmonization*; 1996; monosilkscreen; 20" x 26": Note: Abstract print features two hands among unidentifiable objects. From the New Identity project. Cat. 5 188.

Limón, Leo; *Barrio Mobile Art Studio*; 1998; monoprint; 16" x 22": Note: Two images depicted on successive frames of a length of film are hands and art utensils pointing to a heart and the national symbol of Mexico. At the bottom of the film there are wheels. From the "El Big 25" monoprint project. Cat. 5 189.

Limón, Leo; *Destiny (Destino)*; 1998; monosilkscreen; Note: Against a backdrop of flags, a family joins others on the other side of a barbed wire border. From the "Taller: Tierra, Libertad, y Independecia" project. Cat. 5 190.

Limón, Leo; *Fertile Corazones (Fertile Hearts)*; 1998; monosilkscreen; Note: A length of barbed wire crosses the image area vertically. Hooked on the barbs are bleeding green hearts. From the "Taller: Tierra, Libertad, y Independecia" project. Cat. 5 191.

Limón, Leo; *Lunas Appearance*; 1996; monosilkscreen; 16" x 22": Note: Image is a woman wearing a corn headdress. She holds a war shield in one hand and pencils in the other. In the background are two houses containing "Aztec indigenous symbols..(Flint and Techtli)."; Cat. 5 192.

Limón, Leo; *Musica del Corazon (Music of the Heart)*; 1998; monosilkscreen; Note: Print depicts three musicians: a guitarist, a trumpet player, and a clarinet player. Dancers and city buildings are in the background. From the "Taller: Tierra, Libertad, y Independencia" project. Cat. 5 193.

Lohrer; Betsy; *Prayer*; 1996; monosilkscreen; 20" x 26": Note: Image is of two yellow stylized hands folded in prayer. The background is sea green. From the "New Identity" project. Cat. 5 194.

Lopez Martinez, Aydee; *Abuelita Fights for Her Son (Abuelita Lucha Por Su Hijo)*; 1998; monosilkscreen: Note: A female revolutionary wearing a bandolero and a blue rebozo holds a rifle and looks down at a child. Colors used: Blue, White, and Yellow (background). From the "Taller: Tierra, Libertad, Y Independencia" project.: Cat. 5 195.

Lopez Martinez, Aydee; *La Dulce Imagen de Independencia (The Sweet Image of Independence)*; 1998; monosilkscreen; Note: Image is of a brown hand holding an image of la Virgen de Guadalupe. From the "Taller: Tierra, Libertad, y Independencia" project. Cat. 5 196.

Lopez Martinez, Aydee; *Feeling the City*; 2000; monosilkscreen; Note: A woman's face hovers above a cityscape with tall buildings. From the "Y Tú Qué Más" special project. Cat. 5 197.

Lopez Martinez, Aydee; *El Grito Se Oye en las Calles Aun (You Can Still Hear the Cry Out in the Streets)*; 1998; monosilkscreen; Note: Print depicts three people walking in front of a large image of Miguel Hidalgo y Costilla holding a knife in front of a Mexican flag. From the "Taller: Tierra, Libertad, y Independencia" project. Cat. 5 198.

Loya, Carlos; *Las Dos Damas I*; 1995; monoprint; 16" x 20": Note: Image is of La Virgen de Guadalupe in the sky above a desert highway. A nopal on the side of the road resembles the Statue of Liberty. Nopal leaves form a border for the upper part of the print. From the La Raza Festival. Cat. 5 199.

Loya, Carlos; *Las Dos Damas II*; 1995; monoprint; 16" x 20": Note: Image is of La Virgen de Guadalupe in the sky above a desert highway. A nopal on the side of the road resembles the Statue of Liberty. Nopal leaves form a border for the upper part of the print. In this version of the print, La Virgen's skin is darker than in "Las Dos Damas" I. From the "La Raza Festival". Cat. 5 200.

Loya, Carlos; *Las Dos Damas III*; 1995; monoprint; 16" x 20": Note: Black-and-white print is of La Virgen de Guadalupe in the sky above a desert highway. A nopal on the side of the road resembles the Statue of Liberty. Nopal leaves form a border for the upper part of the print. From the "La Raza Festival". Cat. 5 201.

Loya, Carlos; *Las Dos Damas IV*; 1995; monoprint; 16" x 20": Note: Black-and-white print is of La Virgen de Guadalupe in the sky above a desert highway. A nopal on the side of the road resembles the Statue of Liberty. Nopal leaves form a border for the upper part of the print. From the "La Raza Festival". Cat. 5 202.

Loya, Carlos; *Las Dos Damas V*; 1995; monoprint; 16" x 20": Note: Black-and-white print is of La Virgen de Guadalupe in the sky above a desert highway. A nopal on the side of the road resembles the Statue of Liberty. Nopal leaves form a border for the upper part of the print. From the "La Raza Festival". Cat. 5 203.

Loya, Carlos; *Las Dos Damas VI*; 1995; monoprint; 16" x 20": Note: Black-and-white print is of La Virgen de Guadalupe in the sky above a desert highway. A nopal on the side of the road resembles the Statue of Liberty. Nopal leaves form a border for the upper part of the print. From the "La Raza Festival". Cat. 5 204.

M., Rosa; *Chicana Rites of Passage*; 1995; etching; Note: A spiraling indigenous design surrounds an image of Frida Kahlo, a girl with books entitled "History of the Xicanos" and "Aztlan", a woman

and child, and a girl with a book entitled "Feminist Studies". Other images include a cross atop a sacred heart, the sun, la Virgen de Guadalupe, an American flag, three running silhouettes, and Pete Wilson in a dunce cap holding signs reading, "No Education For Mexicans" and "No Human Rights for Wetbacks". From the "La Raza Festival". Cat. 5 205.

Marichal; Poli; *Este Dato No Está en las Estadísticas Oficiales*; 2001; monosilkscreen; 23" x 29": slide photo: Marissa Rangel. Note: Image is of a red angel whose wings become arms. Text above the image reads, "Todos somos ángeles caídos". From the AIDS project. Cat. 5 206.

Marichal, Poli; *Muerte Dolorosa*; 1996; monosilkscreen; 22" x 16": Note: Image is of personified Death carrying a dying young man. The background is black, red, orange, and yellow. Cat. 5 207.

Marichal, Poli; *...Porqué Soy Como el Arbol Talada Que Retoño*; 2000; monosilkscreen; Note: Image is of an anthropomorphic green tree that grows from a purple cityscape with a red sky. From the "Y Tú Qué Más" special project. Cat. 5 208.

Marquez, Daniel; *Angelito*; 1995; monoprint; 20" x 26 1/2": Note: Print depicts the cherub under the moon upon which the Virgin stands. The background is red. From the Virgen de Guadalupe project. Cat. 5 209.

Marquez, Daniel; *En la Madre Patria (In the Motherland)*; 1998; mono-silkscreen; Note: Image is of a recumbent woman with her hands on her face. A Mexican flag is visible behind her. The remainder of the background is black. From the "Taller: Tierra, Libertad y Independencia" project. Cat. 5 210.

Marquez, Daniel; *Nuestra Señora de Guadalupe*; 1995; monoprint; 20" x 26": Note: La Virgen de Guadalupe, seen from the hands up, posed in a traditional manner and wearing a crown. The background is red. From the Virgen de Guadalupe project. Cat. 5 211.

Marquez, Daniel; *Sendero de Gloria*; 1998; monosilkscreen; Note: Image is of a Native American reaching his hand out as he crawls away from the viewer. From the "Taller: Tierra, Libertad, y Independencia" project. Cat. 5 212.

Marquez, Daniel; *Te Veo Siqueiros*; ca. 1997-1998; monosilkscreen; 5' 7" x 9' 5 3/4": Note: Work is composed of twenty silkscreen panels and depicts an eye. A pencil curves in toward the pupil, from whence emerge two arms, one of which is bloody. The other holds a paintbrush. Cat. 5 213.

Marquez, Daniel; *Travesías—El Reptil*; 1994; monosilkscreen; 16" x 22": Note: Image is of a green-skinned man creeping under a barbed wire fence. Cat. 5 214.

Marquez, Daniel; *Travesías—La Cerca de Picos*; 1994; monosilkscreen; 22" x 16": Note: A man climbing a barbed wire fence makes up the negative space of a black-purple-red gradation. Cat. 5 215.

Marquez, Daniel; *Travesías—Río Bravo*; 1994; monosilkscreen; Note: Image is of a man wading across the Río Bravo (Rio Grande), the river separating Texas from Chihuahua. Cat. 5 216.

Marquez, Daniel; *Villa*; 1998; monosilkscreen; Note: Image is of the Mexican revolutionary Pancho Villa. From the "Taller: Tierra, Libertad, e Independencia". Cat. 5 217.

Marquez, Daniel; *Welcome to L.A.* 2000; monosilkscreen; Note: Image is of a celestial human figure traced in constellations holding a city. Its head is radiant. Palm trees make ud the lower third of the image. From the "Y Tú Qué Más" special project. Cat. 5 218.

Martínez, Isabel; *A Mi Hermano*; 1996; monosilkscreen; 22" x 16": Note: Image is of the face of a young girl framed by an oval. Beneath her portrait are flowers and candles. The print was made for the artist's brother. Cat. 5 219.

Martínez, Isabel; *Diferentes Culturas, Diferentes Dioses*; 1995; mono-print; 32" x 41": Note: An image of la Virgen de Guadalupe is contained with in a diamond-shaped frame. Beneath it and to the right is a sideways face with a band across the forehead. Beneath la Virgen is a sideways indigenous face. From the Virgen the Guadalupe project. Cat. 5 220.

Martínez, Isabel; *Es Este El Mundo Que Me Dejas*; 2000; monosilk-screen; Note: Image is of a child's face with blue and orange skin. It wears a yellow hat and jacket. From the "Y Tú Qué Más" special project. Cat. 5 221.

Martínez, Isabel; *Looking for a New Home*; 1995; monosilkscreen; Note: Multicolored image of three faces and a mask. From the "La Raza Festival". Cat. 5 222.

Martínez, Isabel; *No Strings Attached*; 2001; monosilkscreen; 22" x 16": Note: Image is of a female marionette in a sun hat and a summer dress. There are strings connected to all her limbs. From "Los Perspectivos de Hollywood". Cat. 5 223.

Martínez, Isabel; *Our Goddess (Nuestra Diosa) (Four Panels)*; 1998; monosilkscreen; 4 slides. Note: First panel is of the goddess' head. Second panel is of a calavera beneath the goddess' folded hands. Third panel depicts the goddess' dress above her feet. Fourth panel depicts the goddess' luminous feet. From the "Taller: Tierra, Libertad y Independencia" project. Cat. 5 224(1-4).

Martínez, Isabel; *The Spiritual World*; ca. 1997-1998; monosilkscreen; 8' 6" x 12' 2": Note: Work is composed of twenty silkscreen panels and depicts a woman with arms outreached on either side of a fire. Other images include anthropomorphic animals and a tree. Cat. 5 225.

Martínez, Isabel; *La Virgen de la Esperanza (The Virgen of Hope)*; 1998; monosilkscreen; Note: Print depicts the Virgen de Guadalupe holding a lit candle. Her manta is pink, rather than green, and the background is red. From the "Taller: Tierra, Libertad y Independencia" project. Cat. 5 226.

Martinez, Julio; *Carlos Gonzalez Castro*; 1998; monoprint; 16" x 22": Note: Image is of a boy's face. Text in the upper left corner reads, "Think Differently". From the "El Big 25" monoprint project. Cat. 5 227.

Martinez, Julio; *Untitled*; 2000; monosilkscreen; Note: Image is a blue woman's face with white designs. Her hair is pink and the back-ground is light pink with brown and white circles. From the "Y Tú Qué Más" special project. Cat. 5 228.

Martinez, Julio; *Viaje Sin Fronteras*; 1995; etching; Note: A man and a woman with elongated necks stand before a railroad track with a locomotive on it. From the "La Raza Festival". Cat. 5 229.

Martinez, Pablo; *Untitled*; September 28, 2001; monosilkscreen; 22" x 16": Note: The Orpheum Theater. Sign reads, "Gratis Caliente". From "Los Perspectivos de Hollywood". Cat. 5 230.

Martinez, Pablo; *Watching Over You*; ca. 1997-1998; monosilkscreen; 9' x 6': slide photo: Ann Murdy. Note: An image of Siqueiros, in a style reminiscent of analytical cubism. Cat. 5 231.

Martinez, Paul; *Ciros*; 1998; monoprint; 16" x 22": Note: Image is of a shop exterior. From the "El Big 25" monoprint workshop. Cat. 5 232.

Montelongo, John; *Esperanza*; n.d. woodcut; Note: A young woman draped in a blanket resting her head on her knee. Cat. 5 233.

Montelongo, John; *El Gran Dos Cinco*; 1998; monoprint; 16" x 22": Note: Image is of an angel holding the number twenty-five. From the "El Big 25" monoprint project. Cat. 5 234.

Montelongo, John; *Maria Resting*; 1997; monosilkscreen; 16" x 22": Note: A woman on her hands and knees rests. She is partially covered by a blanket. Cat. 5 235.

Montelongo, John; *Para Karen*; 1998; woodcut and watercolors; 29 3/8" x 22 1/4": Note: Image is of La Virgen de Guadalupe. Cat. 5 236.

Montelongo, John; *The Rescue (El Rescate)*; 1998; monosilkscreen; Note: Image is an indigenous version of the descent from the cross. All four figures removing the Christ are nude. The back-ground is red, white, and green. From the "Taller: Tierra, Libertad, y Independencia" project. Cat. 5 237.

Montelongo, John; *Total Liberation (Liberacion Total)*; 1998; mono-silkscreen; Note: Image is of a nude person surrounded by green, red, white, and yellow color fields. From the "Taller: Tierra, Libertad, y Independencia" project. Cat. 5 238.

Montelongo, John; *La Virgen de Guadalupe*; 1995; monoprint; 20" x 26 1/2": Note: Print depicts the crowned Lady of Guadalupe with a yellow halo. Two angels fly in the background, which is a grada-tion from blue to white to blue. From the Virgen de Guadalupe project. Cat. 5 239.

Moreno, Martín; *Your Love Is Killing Me*; 1997; monosilkscreen; 22" x 16": Note: A winged sacred heart bleeds as it flies. The back-ground is a gradation from white to blue to red. From the Arizona project. Cat. 5 240.

Munguia, Julio; *La Identidad de los Recuerdos*; 1996; monosilkscreen; 20" x 26": Note: This print depicts two people as if they were pho-tographs. The image on the left is of a man, framed. The image on the right is a woman who is only partially visible; only the upper left half is present. In lieu of the other half is a pink ellipse

containing a double-sided arrow. From the "New Identities of Los Angeles" project. Cat. 5 241.

Murdy, Ann; *Calavera Virgen de Guadalupe*; 1994; monoprint/mixed media; <u>Note:</u> Image is of la Virgen de Guadalupe as a calavera. Cat. 5 242.

Novelo, Efrain; *Border Lights*; 1995; monosilkscreen; 18" x 24": <u>Note:</u> Row of human figures in red, white, and blue aligned in the center opening of a fence. They are surrounded by yellow lights. From the "La Raza Festival". Cat. 5 243.

Novelo, Efrain; *Border Lights Divided By Lights*; 1995; monoprint; 12" x 16": <u>Note:</u> Row of human figures aligned in the center between a fence, with a red and blue sun on each side. From the "La Raza Festival". Cat. 5 244.

Novelo, Efrain; *Border Lights—Flag Reflection*; 1995; monosilkscreen; <u>Note:</u> Row of abstract figures aligned in the center opening of a fence. There is an image of a U.S. flag on the chest of the first person in line. Ahead of them two suns are on the horizon. From the "La Raza Festival". Cat. 5 245.

Novelo, Efrain; *Faced Suns*; 1995; monosilkscreen; 18" x 24": <u>Note:</u> Image is of two faces placed in the center, in opposite directions. Each gazes at a radiating sun in the corner. From the "La Raza Festival". Cat. 5 246.

Novelo; Efrain; *Give Me Your Poor-- Give me Your Weak..* 1995; monosilkscreen; 19" x 22": <u>Note:</u> Image is of a Mexican and American flag split diagonally by a barbed wire. A Statue of Liberty is shown on the U.S. side with a crowd of people watching on the Mexican side divided by a fence. From the "La Raza Festival". Cat. 5 247.

Novelo, Efrain; *Ribbon of Life*; 2001; monosilkscreen; 22" x 16": <u>Note:</u> Two hands hold a ribbon that surrounds the globe. The background is formed by the colors of the rainbow. Created as part of the AIDS project. Cat. 5 248.

O'Hagan, Linda; *El Pitero*; 1998; plate monoprint; <u>Note:</u> Image is of a Mexican man holding a trumpet. Cat. 5 249.

O'Hagan, Linda; *Trucos del Matrero*; 1998; plate monoprint; 16" x 22": <u>Note:</u> Image is of two horses, one of which has a rider, in a show ring. Cat. 5 250.

Ochoa, Jaime; *Me Pico (He Bit Me)*; 1998; monosilkscreen; <u>Note:</u> Image is of a rooster in front of a U.S. flag. Barbed wire appears on the white stripes. From the "Taller: Tierra, Libertad e Independencia" project. Cat. 5 251.

Ochoa, Jaime; *Paz (Peace)*; 1998; monosilkscreen; <u>Note:</u> Two hands hold a stylized rose beneath the words "Paz". The background is red. From the "Taller: Tierra, Libertad, y Independencia" project. Cat. 5 252.

Ochoa, Jaime; *Xipe-Totec Warrior with Flesh of Victim*; 1998; monoprint; 16" x 22": <u>Note:</u> Image is of a man with yellow arms. From the "El Big 25" monoprint project. Cat. 5 253.

Organista, Eddika; *El Nacimiento*; 1998; woodcut and watercolors; <u>Note:</u> Print depicts a woman surrounded by rays of the sun growing from the root of a plant. A border frames the entire image. Cat. 5 254.

Ortega, Jerry; *Armas al Frente*; 1998; monoprint; 16" x 22": <u>Note:</u> Image is of a zapatista holding a rifle in front of his or her face. From the "El Big 25" monoprint project. Cat. 5 255.

Ortega; Jerry; *Guerrilleras*; 1997; monosilkscreen; 16" x 22": <u>Note:</u> Image is of four women with bandannas covering their faces holding rifles. Cat. 5 256.

Ortega, Jerry; *Poetas de la Revolucion (Poets of the Revolution)*; 1998; monosilkscreen; <u>Note:</u> Image is of the Flores-Magón brothers. Text in the lower right corner reads, "Think Different". From the "Taller: Tierra, Libertad, Y Independencia" project. Cat. 5 257.

Ortega, Jerry; *Por Un Mundo Donde Cabrán Muchos Mundos*; 1998; monosilkscreen; <u>Note:</u> Image is of a saluting Zapatista. From the "Taller: Tierra, Libertad, y Independencia" project. Cat. 5 258.

Ortega, Jerry; *El Sup*; 1997; monosilkscreen; 22" x 16": <u>Note:</u> Image is of Subcomandante Marcos sitting on a log smoking a pipe. Cat. 5 259.

Ortega, Jerry; *Untitled*; 2000; monosilkscreen; <u>Note:</u> Image is a rendition of the Aztec god Mictlantecuhtli. From the "Y Tú Qué Más" special project. Cat. 5 260.

Ortega, Jerry; *..Y De La Tierra Crece El Maiz*; 1997; monosilkscreen; 16" x 22": <u>Note:</u> A woman with a kerchief covering the lower half of her face holds four ears of corn out to the viewer. Background is a gradation from red to white to green. Cat. 5 261.

Ortega, Jerry and Jaime Ochoa; *1,111.. La Marcha de El E.Z.L.N. Hacia Mexico*; ca. 1997-1998; monosilkscreen; 5' 9" x 9' 8 1/2": <u>Note:</u> Work is composed of twenty silkscreen prints and depicts the Zapatista march to the D.F. Cat. 5 262.

Ortega, Tony; *Untitled*; 1998; monoprint; 16" x 22": <u>Note:</u> Print is split into two halves. The left half depicts a red Olmec head on a green and purple background. The right half depicts two vaqueros chasing a blue horse on a blue and yellow background. From the "El Big 25" monoprint project. Cat. 5 263.

Perez, David; *Knife*; 1997; monosilkscreen; 22" x 16": <u>Note:</u> Image is of a knife resembling a fountain pen. The background is yellow. From the Arizona project. Cat. 5 264.

Perez, Elizabeth; *Las Mascaras I*; 1995; plate monoprint; 16" x 22": <u>Note:</u> Image is split by a river that runs diagonally. There are blue masks with long noses on either side of the river. The background of the left side is urban and dark, while the background of the right side is a brightly-colored desert. Cat. 5 265.

Perez, Eva Cristina; *Atada A Ti (Fasten To You)*; 1998; monosilkscreen; <u>Note:</u> Image is of two hearts in boxes that share a common artery. The background is blue. From the "Taller: Tierra, Libertad y Independencia" project. Cat. 5 266.

Perez, Eva Cristina; *Creo en Ti Patria (I Believe in You Homeland)*; 1998; monosilkscreen; <u>Note:</u> Image is of a medieval close helmet and sword in a cube and the Mexican national symbol. The background is orange. From the "Taller: Tierra, Libertad e Independencia" project. Cat. 5 267.

Perez, Eva Cristina; *El Encierro de Cortez (The Enclosure of Cortez)*; 1998; monosilkscreen: <u>Note:</u> Image is of a boy on a yellow background. To the right of the boy is the Mexican national seal. From the "Taller: Tierra, Libertad, Y Independencia" project. Cat. 5 268.

Perez, Eva Cristina; *Esperanza*; 1994; monosilkscreen; <u>Note:</u> Image is of a woman wearing a rebozo. Background is violet. Cat. 5 269.

Portillo; Eddie; *Santana*; 1995; monosilkscreen; 22" x 16": <u>Note:</u> Image is of Carlos Santana wearing a bandanna looking upward. Cat. 5 270.

Portillo, Eddie; *Virgen with Hazel Eyes*; 1995; monoprint; 20" x 26 1/2": <u>Note:</u> Image is of a luminous Virgen de Guadalupe looking directly at the viewer. From the Virgen de Guadalupe project. Cat. 5 271.

Portillo, Rose; *Godzilla Lives*; 1996; monosilkscreen; 22" x 16": <u>Note:</u> A calavera with green scales down its back breathes smoke and fire. Cat. 5 272.

Posadas, Refugio; *..the Dead*; 1996; monosilkscreen; 16" x 22": <u>Note:</u> Text in script in upper left corner reads "the." Four hands spell out the word "Dead" in American Sign Language. A luminous oval in the center of the print apparently represents the threshold between life and death. A human figure approaches it alone and is accompanied on the other side. In the lower left corner a hand holds a heart, a cross, and an anchor. Cat. 5 273.

Quiroz, Alfred; *El Pepe*; 1997; monosilkscreen; 16" x 22": <u>Note:</u> Image is of a man in a business suit wearing a calavera mask with the word "Pepe" on the brow. The background is yellow. From the Arizona project. Cat. 5 274.

Ramirez, Cristopher; *Untitled*; 2001; monosilkscreen; <u>Note:</u> Print consists of three main images: At the top is the photosilkscreened face of an unidentified woman. In the lower right is the photosilkscreened image of a young charro. And in the lower right is a photosilkscreened image of a Lucha Libre wrestler. Text in the lower right corner of the image area reads, "Latino Hollywood. Latinos have contributed to the American film industry since its earliest days. During the silent and early talkie era, latinos were almost always stereotyped as tempestuous lovers, bandidos, or cantina girls. This program remembers many of the early Latino actors and actresses and examines some of the stereotypical roles they portrayed. Mexican American Studios and Research Center, University of Arizona, 1994. 31 min. Video/C4428.." From the "Los Perspectivos de Hollywood" project. Cat. 5 275.

Ramirez, Jose; *El Fin*; 2001; monosilkscreen; 16" x 22": <u>Note:</u> Image is of a cinema screen with the words "El Fin". Three people are in the audience. From the "Los Perspectivos de Hollywood" project. Cat. 5 276.

Ramirez, Jose; *Untitled*; 2001; monosilkscreen; <u>Note:</u> Image is of a calavera in bed. It has crosses instead of eye sockets. There is a red heart on the bedspread, and the bedposts are also crosses. From the AIDS project. Cat. 5 277.

Ramirez, Lois; *Welcome*; 1996; monosilkscreen; 20" x 26": Note: In this print, letters are connected together to spell out the word *"Bienvenue"*. The background consists of patches of pink, yellow, green, and red. From the "New Identities of Los Angeles" project. Cat. 5 278.

Ramirez, Rose; *La Troka*; 2000; monosilkscreen; Note: Image is of an orange pickup truck with eight people in the bed. The background is red and black. From the "Y Tú Qué Más" special project. Cat. 5 279.

Ramos, Leda; *Tigres Del Norte*; 1996; monosilkscreen; 20" x 26": Note: Image is of a girl with a frightened look on her face. She seems to be looking at something tall and blue with a semblance of a face. The background of the print is formed by brushstrokes and ink globs. From the "New Identities of Los Angeles" project. Cat. 5 280.

Rangel, Chuy; *The Big Two-Five*; 1998; monoprint; 16" x 22": Note: Print depicts the SHG emblem (a bird with a yin-yang symbol on its body) flying over a row of palm trees. Two other birds appear in the lower right corner. Cat. 5 281.

Rangel, Chuy; *La Calavera Oaxaqueña (The Oaxaqueña Skull)*; 1998; monosilkscreen; Note: Image is of a skeleton in a sombrero in midair holding a machete. From the "Taller: Tierra, Libertad, y Independencia" project. Cat. 5 282.

Rangel, Chuy; *Carlos Almaraz, 1941-89*; 2001; monosilkscreen; Note: Image is of the artist Carlos Almaraz. From the AIDS project. Cat. 5 283.

Rangel, Chuy; *La Carmen*; 2001; monosilkscreen; 22" x 16": Note: Image is of an unidentified woman. From the "Los Perspectivos de Hollywood" project. Cat. 5 284.

Rangel, Chuy; *Don Quixote*; 1998; monosilkscreen: Note: Silkscreen of a skeletal Don Quijote riding a horse is based on José Guadalupe Posada's *La Calavera de Don Quijote*. From the "Talelr: Tierra, Liberad y Independencia" project. Cat. 5 285.

Rangel, Chuy; *Dressed to Kill*; 1996; monosilkscreen; 22" x 16": Note: A calavera in a red zoot suit with a red background. Cat. 5 286.

Rangel, Chuy; *Father Luis Olivares*; 2001; monosilkscreen; 22" x 16": Note: Image is of AIDS victim Father Luis Olivares. From the AIDS project. Cat. 5 287.

Rangel, Chuy; *L.A. Pop #4*; 1999; monosilkscreen; 22" x 26": Note: Image is of a statue of a baseball player in a Dodgers uniform. Text on the statue's base reads, "Los Angeles".: Cat. 5 288.

Rangel, Chuy; *Nonunion Worker*; 2001; monosilkscreen; 22" x 16": Note: Image is of a Chihuahua on a blue background. From the "Los Perspectivos de Hollywood" project. Cat. 5 289.

Rangel, Chuy; *Señor Gonzalez*; 2001; monosilkscreen; 22" x 16": Note: Image is of cartoon character Speedy Gonzalez. From the "Los Perspectivos de Hollywood" project. Cat. 5 290.

Rangel, Chuy; *Spanish Inquisition*; 2001; monosilkscreen; 22" x 16": slide photo: Marissa Rangel. Note: Image is of two copulating figures (appears to be a male and a female) that appear to be indigenous statues. The one on top is brown and the one on the bottom is pink. The background to the upper portion is pink, while the background of the lower portion is dark blue. From the AIDS project. Cat. 5 291.

Rangel, Chuy; *Trinidad*; 1995; monoprint; 20" x 26 1/2": Note: Two skeletons in sombreros hold a framed image of la Virgen de Guadalupe. Beneath them are eleven red roses. The background is black with calaveras and designs. From the Virgen de Guadalupe project. Cat. 5 292.

Rangel, Chuy; *Untitled (2 Eagles Fighting)*; 1998; monosilkscreen; Note: Image is of a Mexican Eagle and a Bald Eagle locked in aerial combat. Behind the Mexican Eagle are the colors red, white, and green, and behind the Bald Eagle is the U.S. flag. From the "Taller: Tierra, Libertad, y Independencia" project. Cat. 5 293.

Rangel, Pete; *Fever*; 1998; woodcut and watercolors; Note: Two monsters in a bedroom where an ill person suffers. His or her face has drops on it, as if of sweat. From the 25th anniversary project. Cat. 5 294.

Rangel, Pete; *March for Liberty (Marcha por Libertad)*; 1998; monosilkscreen; Note: Print depicts a demonstration march in which participants hold signs, including one with an image of a clenched fist. From the "Taller: Tierra, Libertad, y Independencia" project. Cat. 5 295.

Rangel, Pete; *Solitude*; n.d. color woodcut; Note: Woodcut print depicts a person huddled in a corner with their face in their hands. Cat. 5 296.

Rangel, Pete; *You Can't Stop the Revolution (No Puedes Parar la Revolucion)*; 1998; monosilkscreen; Note: Stylized image of a man behind a podium with his fist in the air addressing a crowd of demonstrators with signs. Blue buildings form the skyline in the background. From the "Taller: Tierra, Libertad Y Independencia" project. Cat. 5 297.

Raphael, Victor; (title unknown); 1998; monosilkscreen; 22" x 16": Note: Print composed of two separate images, both of buildings, one above the other. The building in the upper portion bears the text "Wilshire Boulevard Temple". The other appears to be a church. Buildings are brown and the background is blue. Cat. 5 298.

Raphael, Victor; (title unknown); 1998; monosilkscreen; 22" x 16": Note: Print composed of two separate images, both of buildings, one above the other. The building in the upper portion bears the text "Wilshire Boulevard Temple". The other appears to be a church. Outline of buildings is black and the background of the entire print is a gradation from black to red to yellow. Cat. 5 299.

Ray, Joe; *Couch Nopal*; 1997; monosilkscreen; 16" x 22": Note: A man sitting with his arms spread across the top of a sofa has a nopal cactus instead of a head. The background is yellow. From the Arizona project. Cat. 5 300.

Reyes, Miguel Angel; *Beso Transparente*; 2001; monosilkscreen; 16" x 22": Note: Image is of two men kissing. Superimposed on the kiss is an equilateral cross, like that of the Red Cross. Within this cross, the image is clearer than outside of it. From the AIDS project. Cat. 5 301.

Reyes, Miguel Angel; *Cantinflas*; 2002; monosilkscreen; Note: Image is of the face of Mario Moreno, Cantinflas. From the "Latin Golden Age" suite. Cat. 5 302.

Reyes, Miguel Angel; *Cantinflas II*; 2001; monosilkscreen; 16" x 22": Note: Image is of the actor Mario Moreno (Cantinflas). Written in script in the image area is "Cantinflas". The background is light green. From the "Los Perspectivos de Hollywood" project. Cat. 5 303.

Reyes, Miguel Angel; *Dolores del Rio*; 2002; monosilkscreen; Note: Image is of the face of Dolores del Rio. The background is pink and yellow. From the "Latin Golden Age" suite of prints. Cat. 5 304.

Reyes, Miguel Angel; *Informate o Inflamate*; 2001; monosilkscreen; 29" x 23": Note: Image is of a muscular young man. Text in script in the image area reads, "Infórmate o Inflamate". From the AIDS project. Cat. 5 305.

Reyes, Miguel Angel; *Jorge Negrete*; 2002; monosilkscreen; Note: Image is of the face of Jorge Negrete. The background is green. From the "Latin Golden Age" suite. Cat. 5 306.

Reyes, Miguel Angel; *Liquido*; 1996; monosilkscreen; 20" x 26": Note: Image of a male's face with blue skin resembling water, with superimposed images of fish and feathers in white. The background is red. From the "New Identities of Los Angeles" project. Cat. 5 307.

Reyes, Miguel Angel; *Lupe Velez*; 2002; monosilkscreen; Note: Image is of the face of Lupe Velez. The background is blue. From the "Latin Golden Age" suite. Cat. 5 308.

Reyes, Miguel Angel; *Maria Felix*; 2002; monosilkscreen; Note: Image is of the face of María Félix. The background is blue. From the "Latin Golden Age" suite. Cat. 5 309.

Reyes, Miguel Angel; *Maria Montez*; 2002; monosilkscreen; Note: Image is of the face of María Montez. The background is blue-green. From the Latin Golden Age suite. Cat. 5 310.

Reyes, Miguel Angel; *Olmos I*; 2001; monosilkscreen; 16" x 22": Note: Image is of Edward James Olmos as the Pachuco from Luis Valdez's Zoot Suit. The background is green. From the "Los Perspectivos de Hollywood" project. Cat. 5 311.

Reyes, Miguel Angel; *Pedro Armendariz Jr.* 2002; monosilkscreen; Note: Image is of the face of Pedro Armendáriz, Jr. The background is green. From the "Latin Golden Age" suite. Cat. 5 312.

Reyes, Miguel Angel; *Pedro Infante*; 2002; monosilkscreen; Note: Image is of the face of Pedro Infante. From the "Latin Golden Age" suite. Cat. 5 313.

Reyes, Miguel Angel; *Raquel II*; 2001; monosilkscreen; 16" x 22": Note: Image is of Raquel Welch in a bathing suit. From the "Los Perspectivos de Hollywood" project. Cat. 5 314.

Reyes, Miguel Angel; *Rita*; 2001; monosilkscreen; 16" x 22": Note: Image is of the actress Rita Hayward holding what appears to be a whip. From the "Los Perspectivos de Hollywood" project. Cat. 5 315.

Reyes, Miguel Angel; *Rita Hayward*; 2002; monosilkscreen; Note: Image is of the face of Rita Hayward. The background is green. From the "Latin Golden Age Suite". Cat. 5 316.

Reynoso, Raymundo Tonatiuh; *Los Angeles Unified*; 1996; monosilkscreen; 20" x 26": Note: Cropped image of a schoolbus in the center, framed by a red border. From the "New Identity of Los Angeles" project. Cat. 5 317.

Rios Martinez, Pedro; *Chicano Less? IV*; 2001; monosilkscreen; 16" x 22": Note: Image is of a multicolored 'director' holding a clapperboard. From the "Los Perspectivos de Hollywood" project. Cat. 5 318.

Rios Martinez, Pedro; *Cruces de Fuego*; 1996; monosilkscreen; 16" x 22": Note: "Landscape of field of crosses with a fire burning in the distance."; Cat. 5 319.

Rios Martinez, Pedro; *Independencia y Libertad (Series V)*; 1998; monosilkscreen; Note: A boy rides on a man's shoulders on a red, white, and green background. From the "Taller: Tierra, Libertad, y Independencia" project. Cat. 5 320.

Rios Martinez, Pedro; *Independencia y Libertad (series I) (Independence and Liberty)*; 1998; monosilkscreen; Note: Image is of a mother chasing a child who pursues a globe. The background is blue, red, white, and green. From the "Taller: Tierra, Libertad, y Independencia" project. Cat. 5 321.

Rios Martinez, Pedro; *Juan Diego*; 1995; monoprint; 20" x 26 ": Note: An image of la Virgen de Guadalupe appears on Juan Diego's chest. The background is blue. From the Virgen de Guadalupe project. Cat. 5 322.

Rios Martinez, Pedro; *Puente de Conveniencia*; 1995; etching; Note: Image is of a large crowd of people standing on an American flag. To the left of them is the Virgin of Guadalupe and an open palm. To the right of the crowd is a pair of chained hands in front of skyscrapers. Beneath the flag, two hands grasp an eagle's claws. At the bottom of the print is a snake, also held by two hands. From the "La Raza Festival". Cat. 5 323.

Rios Martinez, Pedro; *Virgen con Guitarra*; 1995; monoprint; 32" x 41": Note: A person kneels as they hold a guitar bearing an image of la Virgen de Guadalupe. From the Virgen de Guadalupe project. Cat. 5 324.

Rodriguez, Artemio; *Quiubole!*; 1995; etching; Note: Image is of two girls holding hands in a playground. The playground is inhabited by small animals, people, and plants. In the background are hills with trees and a few houses. A winged Zapata hovers between the two girls. His sombrero reads, "Libertad". From the "La Raza Festival". Cat. 5 325.

Rodriguez, Artemio; *Untitled*; 1995; monoprint; 32" x 41": Note: La Virgen de Guadalupe wears an orange dress with red flowers and wings. She is surrounded by winged cherub heads, dog's heads, and small demons. From the Virgen de Guadalupe project. Cat. 5 326.

Rodriguez, Cece; (title unknown); 1994; monoplate; 15" x 11": Note: Image is of an indigenous human figure above a dolmen with a curved lintel. Cat. 5 327.

Rodriguez, Israel; *Apparition I*. 1996; woodblock; 30" x 45": Note: Black and white woodblock print of la Virgen de Guadalupe. On the left side of her manta are a weeping eye and a flower. On the right side of her manta are four anatomical hearts. There is another anatomical heart in the center of her chest, and below it, a skeletal hand. There is a white anatomical heart in the upper right corner of the print. The background is black. From the Virgen de Guadalupe project. Cat. 5 328.

Rodriguez, Israel; *Apparition II*; 1996; woodblock; 30" x 45": Note: Black and white woodblock print of la Virgen de Guadalupe. The background is split into black (right) and white (left) halves. On the Virgen's chest is a winged rectangle containing skeletal hands folded in prayer position. Toward the bottom of her body two hands hold a heart. She is supported by two crescent moons. Hands and faces fill the background. From the Virgen de Guadalupe project. Cat. 5 329.

Rodriguez, Israel; *Apparition III*; 1996; woodblock; 30" x 45": Note: On a disc before la Virgen de Guadalupe, with her arms up, is an anatomical heart with a cross in it. A black bird and a white bird hang in the opposite upper hand corners and connect, by what looks to be a string. Faces line the side of the "road" surrounding the disc with the heart. From the Virgen de Guadalupe project. Cat. 5 330.

Rodriguez, Israel; *Noches En Una Frontera Abstracta*; 1995; woodblock; Note: Woodcut print depicts several abstract images. Among them are two people in front of a sun, animals, a woman with four arms, and a disembodied head. From the "La Raza Festival". Cat. 5 331.

Rodriguez, Israel; *Los Postes*; 1998; monoprint; 16" x 22": Note: Image is a cityscape in silhouette in which telephone poles tower above buildings. The background is red and orange. From the "El Big 25" monoprint project. Cat. 5 332.

Rodriguez, Israel; *Sadness I*; 1996; monoprint; 16" x 22": Note: Three yellow faces behind five lit candles. Cat. 5 333.

Rodriguez, Ixrael; *Anonimos*; 2001; monosilkscreen; 22" x 16": Note: Print consists of nine separate images divided into equally-sized squares. Four are faces, two of which have four eyes, and the other five are human figures in various poses. The background is dark green. From the AIDS project. Cat. 5 334.

Rodriguez, Ixrael; *Diversidad*; 2001; monosilkscreen; 22" x 16": Note: Print area is divided in nine equal portions, each one containing an anatomical heart of a different color. From the AIDS project. Cat. 5 335.

Rodriguez, Ixrael; *Quien Dirije*; 2001; monosilkscreen; 22" x 16": Note: Image is of an empty director's chair. From the "Los Perspectivos de Hollywood" project. Cat. 5 336.

Rodriguez, Maria; *Pieceworker*; 1995; etching; Note: Etching is of a woman working with a sewing machine. From the "La Raza Festival". Cat. 5 337.

Rodriguez, Maria; *Today's Special Bargain*; 1995; etching; Note: Etching is of a girl in overalls or an apron, with both hands on her left hip. From the "La Raza Festival". Cat. 5 338.

Rodriguez, Maria; *Untitled*; 1997; monosilkscreen; 22" x 16": Note: Image is of a girl riding a bicycle. Cat. 5 339.

Romero, Frank; *Carro de Muerte*; n.d. silkscreen; Note: Print depicts a skeleton holding a bow and arrow seated on top of a car. Text beneath the car reads, "Carro De Muerte."; Cat. 5 340.

Romero, Frank; *Spring Flowers*; n.d. monotype; Note: Yellow flowers in a blue vase against a red background. Cat. 5 341.

Romero, Frank; (title unknown); ca. 1999-2000; monosilkscreen; 16" x 22": Note: Image is of an automobile in blue, black, and red as seen from the side. Background is red. Cat. 5 342.

Romero, Frank; *Untitled*; 1996; monosilkscreen; 22" x 16": Note: Image is of a skeleton with its arms up. Text on its forehead reads, "¡Paco!" The background is brown with rows of "red, yellow, and green zig-zag stripes."; Cat. 5 343.

Romero, Frank; *Untitled*; 2000; monosilkscreen; Note: Image is of a red car seen from the side. Its occupants are two people and a dog. The blue background is filled with white circles. From the "Y Tú Qué Más" special project. Cat. 5 344.

Romero, Frank; *Untitled*; 2001; monosilkscreen; 16" x 22": Note: Image is of a man and a woman kissing. From the "Los Perspectivos de Hollywood" project. Cat. 5 345.

Romero, Frank; *Untitled*; n.d. monosilkscreen; 29" x 23": Note: Image is of an abstracted face. Dominant color is red. From the AIDS project. Cat. 5 346.

Romero, Frank; *Untitled (Car)*; 1998; monoprint; 16" x 22": Note: Image is of an orange and pink car as seen from the side on a blue background. From the "El Big 25" monoprint project. Cat. 5 347.

Sadowski, Marianna; *Fiesta de San Miguel*; 1998; woodcut and watercolor; 14 3/4" x 18 1/2": Note: Woodblock print depicts a woman with a wire hat. Behind her flies an angel, likely the Archangel Michael. Cat. 5 348.

Saldamando, Shizu; *El Bandito*; 2001; monosilkscreen; 22" x 16": Note: Image is of a "stereotypical Mexican" in a sombrero and bandolero. Text above the image reads, "El Bandito". The background is red and full of flames. From the "Los Perspectivos de Hollywood" project. Cat. 5 349.

Saldamando, Shizu; *La Cha Cha*; 2001; monosilkscreen; 22" x 16": Note: Image is of a seated Hispanic woman in a red dress. Text

above her reads, "La Cha Cha". From the "Los Perspectivos de Hollywood" project. Cat. 5 350.

Saldamando, Shizu; *El Cholo*; 2001; monosilkscreen; 22" x 16": Note: Image is of a cholo in a bandanna and sunglasses. Text above him reads, "El Cholo". From the "Los Perspectivos de Hollywood" project. Cat. 5 351.

Saldamando, Shizu; *Mary Janes*; 1999; monosilkscreen; 22" x 16": Note: Image is of a girl's legs from the knee down. She is wearing Mary Janes (shoes). Cat. 5 352.

Saldamando, Shizu; *Road Line*; 2000; monosilkscreen; Note: Image is of a man laying across the dotted yellow line that separates directions of traffic in a street. From the "Y Tú Qué Más" special project. Cat. 5 353.

Sameshima, Dean; *Untitled*; 1996; monosilkscreen; 20" x 26": Note: In the negative space of a black background, a white silhouette of a person looking down wearing a cap similar to a police officer's. From the "New Identity of Los Angeles" project. Cat. 5 354.

Sandoval, Teddy; *Cuidado Con Los Coyotes*; 1995; monosilkscreen; Note: A coyote sits with its back to the viewer and another sits in profile. The one in profile has the face of a man. The background is divided in two, with the top being red and the bottom a mixture of pink, yellow, and orange. From the "La Raza Festival". Cat. 5 355.

Serrano, David; *Nuestra Señora en el Mar*; 1995; monoprint; 20" x 26 1/2": Note: The Virgen de Guadalupe on a seashell à la Botticelli. The background is a gradation of blue and white. From the Virgen de Guadalupe project. Cat. 5 356.

Sinclaire, Mahara T. *Sisters*; 1996; monosilkscreen; 20" x 26": Note: Image of two smiling sisters represented in bright colors. From the "New Identities of Los Angeles" project. Cat. 5 357.

Snyder, *Los Deid*; n.d. silkscreen?; Note: Calaveras in traditional Scottish dress march in a band. One leads, one plays bagpipes, and two play drums. From the SHG/Glasgow print studio collaboration. Cat. 5 358.

Sohn-Lee, Angela; *Infant Joy*; 1996; monosilkscreen; 20" x 26": Note: Four purple hands hold an infant with a smile that extends beyond the perimeter of its face. The background is in two shades of blue. From the "New Identities of Los Angeles" project. Cat. 5 359.

Sykes, Roderick; *City Mask*; 1996; monosilkscreen; 20" x 26": Note: Abstract print in red, white, and black. From the "New Identity" project. Cat. 5 360.

Thomas, Matthew; *Universe*; 1996; monosilkscreen; 20" x 26": Note: Upper portion of image area depicts planetary orbits. The lower portion is a series of designs, possibly intended to represent stars. From the "New Identities of L.A." project. Cat. 5 361.

Tovar, Peter; *Untitled*; 1998; monoprint; 16" x 22": Note: Central image of black-and-white print is abstract. Image in the upper left corner is of a billboard over a house, in the upper right corner is of a piñata, and in the lower right corner is of a cholo and his tattoo. From the "El Big 25" monoprint project. Cat. 5 362.

Valdes, Richard; *Eagle Warrior Ready for Battle (Guerrero de Aguila Listo para Batalla)*; 1998; monosilkscreen; Note: Image is of the head of an Aztec Eagle knight. From the "Taller: Tierra, Libertad, y Independencia" project. Cat. 5 363.

Valdes, Richard; *Peace, Earth, and Love (Paz, Tierra y Amor)*; 1998; monosilkscreen; Note: Image is of a female figure resembling the Virgin Mary. Floating in front of her are an orb, possibly a representation of the Earth, and a dove. A white circle in the upper right corner may represent the moon. The background is red. From the "Taller: Tierra, Libertad, y Independencia" project. Cat. 5 364.

Valdez, Patssi; *Ruby*; 2000; monosilkscreen; Note: Image is of a woman's head and shoulders. Her hair sticks up and her shoulder is a spiral. The background is red. From the "Y Tú Qué Más" special project. Cat. 5 365.

Valdez, Patssi; *Sleepy Payaso*; 1998; monoprint; 16" x 20": Note: Clouds rain on a horizontal clown's face with closed eyes and a funny hat. From the "El Big 25" monoprint project. Cat. 5 366.

Valdez, Patssi; *Untitled*; 1992; silkscreen; 25 1/4" x 34": Note: Papel picado hangs above a tables set with elements of a altar: a photograph surrounded by marigolds, four sugar skulls, two of which have candles, a small sarape, and candy. Cat. 5 367.

Valdez, Richard; *Santana & Our Lady*; 1995; monoprint; 20" x 26 1/2": Note: Print depicts Carlos Santana playing guitar and wearing a shirt with an image of la Virgen de Guadalupe. From the Virgen de Guadalupe project. Cat. 5 368.

Valdez, Richard; *She Appeared to US*; 1995; monoprint; 20" x 26 1/2": Note: La Virgen de Guadalupe appears to an archer in a wood. From the Virgen de Guadalupe project. Cat. 5 369.

Vallejo, M M; *Child's Calavera*; 1977; silkscreen; Note: Silkscreened image of a calavera in a sombrero. Cat. 5 370.

Vasquez, Cesar; *Justicia Para los Secuestrados de Canathlan*; n.d. woodcut: Note: A blind-folded Goddess, personifying justice, carrying balanced scales in one hand. In the other hand, she carries four blindfolded men away from a city.: Cat. 5 371.

Yáñez, Larry; *The Great White Goddess*; 1998; monoprint; 16" x 22": Note: Image is of a refrigerator. From the "El Big 25" monoprint project. Cat. 5 372.

Yáñez, Larry; *Reclinando*; 1997; monosilkscreen; 22" x 16": Note: A man with hearts in his palms wearing glasses. Nopales are in the background, which is made up of a zig-zag rainbow of dots. From the Arizona project. Cat. 5 373.

Yáñez, Larry; *Trock of Harts*; 1997; monosilkscreen; 16" x 22": Note: Image is of a truck filled with hearts. From the Arizona project. Cat. 5 374.

Zender Estrada; John, *Surviving Q*; 1998; monoprint; 16" x 22": Note: Abstract print in which the only distinguishable image is the face of Quetzalcoatl. From the "El Big 25" monoprint project. Cat. 5 375.

Zuno, José; *Monotony*; 1998; woodcut and watercolor; 21 1/4" x 29": Note: Print depicts a bearded man with five stylized images of la Virgen de Guadalupe in the background. Cat. 5 376.

Installation Art

Artist Unknown; *Day of the Dead Exhibition;* 1990s; mixed media; Site/Location: Galería Otra Vez, SHG 3802 Cesar E. Chavez Ave, Los Angeles CA 90063: Note: Installation in two corners of an exhibition room. In the left corner, a shelf unit has been adorned with photographs, garments, artworks, and candles. In the right corner is an installation that resembles a classroom, with a calavera in a small chair. Papel picado hangs above words affixed to the wall reading, "Nuestra Muerte Ilumina Nuestra Vida". Cat. 7 001.

Artist Unknown; (title unknown); ca. 1990's; paper cutouts; Note: Installation piece set in an architectural arch. At the top of the arch hangs a paper semicircle. On the semicircle are paper cutout images of a skull and two hands. Hanging from both sides of the semicircle are strips of paper with more calavera paper cutouts. In the center between the two strips of paper is a mirror surrounded by stencilled images of the same calaveras. Cat. 7 002.

Artist Unknown; (title unknown); ca. 1990's; Paper bags, feathers, Lotería cards, string, paint; Note: Installation piece composed of brown lunch bags painted with hearts and skulls hanging from a ceiling painted blue. The bags have white downfeathers on their sides. From the bags dangle lotería cards on pieces of string. Cat. 7 003.

Artist Unknown; (title unknown); ca. 1990's; media unknown; Note: Installation piece set in a window. Streamers hanging from the top of the window have images of hearts and Lotería cards adhered to them. The hearts and cards have messages written on them. Cat. 7 004.

Artist Unknown; (title unknown); ca. 1996-1997; mixed media; Note: Installation in a corner is composed of a piece of blue cloth with calaveras on it that serves as a backdrop. In front of it is a table set with a vase, flowers, and feathers. Flowers and feathers are also under the table. Hanging from above are strings with loteria cards and heart-shaped cut-outs. Cat. 7 005.

Alferov, Alex; (title unknown); ca. 1998; painted cut-outs arranged to form an installation; Note: A number of painted cut-outs have been arranged in a room to form an installation. The one in front depicts three cholo calaveras driving a lowrider. Others include a nopal, a calavera, a large pack of cigarettes called "Lucky Zapatista" with a picture of a Zapatista and the text "Hecho en Aztlan Tabaco Marcos", large pieces of fruit, a shotglass and bottle of tequila, a large devotional candle, another calavera, and a three-dimensional coffin. Cat. 7 006.

Gamboa, Diane; *Altar Installation*; November 5, 1994; mixed media; 2 slides. Note: A large heart is bound in chains and placed on small

white pillows within a wooden structure somewhat resembling a small boxing ring. There are lit red candles atop each of the four posts of the ring. "Boxing ring with bleeding heart inside, red candles on each corner. ". Cat. 7 007 (1-2).

Murals

Artist Unknown; *Celebration of Life*; November 5, 1994; unknown; <u>Note:</u> Portable mural in unknown media depicts a woman whose bones and organs are visible through her skin. Corn, calla lillies, nopales, and mushrooms grow beneath her. The moon encloses the woman and the plants. A banner across the moon with calaveras reads, "Celebration of Life". In the upper left corner is a purple calavera, in the upper right an orange sun. In the lower left corner is a Yin-Yang symbol, in the lower right is a red scarab beetle. Cat. 8 001.

Paintings

Artist Unknown; (title unknown); 1989; unknown; <u>Note:</u> Work in unknown media depicts a round table set with skulls with the words "Paz" and "Amor" written on them, a flower vase, a glass of wine, and fruit. Behind the table hangs a tapestry with a Christ-like figure, a blindfolded angel, and a woman. All three figures are composed of diagonal lines of alternating colors. Next to the table stands a woman with a yellow flower on her abdomen. She shares her face with a skull. Cat. 9 001.

Artist Unknown; (title unknown); 1989; mixed media; <u>Note:</u> Painting of three skeletons on a fan features a three-dimensional yellow sculpture of a face in unknown media at the handle. Cat. 9 002.

Artist Unknown; (title unknown); 1993; media unknown; slide photo: copyright 1993 Ann Murdy. <u>Note:</u> Painting of Cesar Chávez with half his face a calavera. Agricultural fields form the background. Cat. 9 003.

Artist Unknown; (title unknown); 1996; acrylic on wood; <u>Note:</u> Acrylic painting on an irregularly-shaped piece of wood depicts two calaveras. One has orange hair and holds popcorn; the other wears a bandanna. Cat. 9 004.

Bojorquez, Chaz; *Somos Vatos Locos*; ca. 1990's; acrylic; <u>Note:</u> Text in three-dimensional lettering reads, "Somos Vatos Locos De-V-LA". Background is red with black strokes. Cat. 9 005.

Gutierrez, Robert; *La Junta*; 1994; Dr. Martin watercolor, gouache, and pastel; 22" x 30": <u>Note:</u> Four calaveras in rebozos surround a statue or apparition of La Virgen de Guadalupe. Cat. 9 006.

Tovar, Peter; (title unknown); 1994; unknown; <u>Note:</u> Painting in unknown media depicts three calaveras on the North American continent. On their heads grow three cactuses. Above the cacti are strings of papel picado and jalapeños. Cat. 9 007.

Sculpture

Artist Unknown; *Mask*; 1978; media unknown; <u>Note:</u> Gold-colored calavera mask. Cat. 12 001; Sculpture

Artist Unknown; *Sugar Skulls*; November 2, 1996; sugar skull casting; 2 slides. <u>Note:</u> From Day of the Dead Flores de Esperanza. Photos are of sugar skulls. Cat. 12 002(1-2); Sculpture

Artist Unknown; (title unknown); 1979; media unknown; slide photo: Unknown. <u>Note:</u> A calavera mask on a stick has a feather head-dress. Cat. 12 003; Sculpture

Fernandez Velasquez; Jose; *R.I.P.* n.d. papier-mâché; slide photo: Mario Lopez. <u>Note:</u> Sculpture of a calavera bride and groom. Behind them are two other calavera sculptures. Text on a sign beneath the sculptures reads, "R.I.P. Jose Fernandez Velasquez Escuela de Arte San Carlos Mexico [illegible]". "Traditional papier-mâché calaveras."; Cat. 12 004; Sculpture

Holguin, Cesar A. *Cathedral Calaveras*; November 1994; medium unknown; <u>Note:</u> Sculpture in unknown media is in the form of a tall cathedral. Calaveras sit on window ledges. The entire cathedral is painted with ornate designs. Cat. 12 005; Sculpture

Ibanez, Antonio; *Day of the Dead Mask*; 1976; media unknown; <u>Note:</u> Decorated calavera mask features the name "Milton Antonio". Cat. 12 006; Sculpture

Luna Cleveland, Joe; (title unknown); 1994; stone and metal; 2 slides. <u>Note:</u> A round, flat stone carved with the image of Mictlantecuhtli, the Aztec lord of Mictlán, the ninth and lowest realm of the underworld. This stone is mounted on a metal stand. Cat. 12 007(1-2); Sculpture

Appendix C: Silk Screen Prints (1983-2003)

Alphabetical Listing by Artist's Name

Artist Unknown, *Mama Said There'd Be Day'z [sic] Like This;* n.d. I-size: 14 7/8" x 21"; P-size: 19" x 25"; Ed#: 20/50; Signed, Inscription in pencil below image area reads: "20/50, 'Mama said there'd be day'z [sic] like this, signature [illegible]". <u>Note:</u> On a yellow background there is a black and white image of a group of three women of different generations (one old and two young) and one man. In the right hand side there is an enlarged image of a 'green card' with information related to 'Maria Clara Ramirez' and a picture of a woman and two children. Artist may be Armando Cid?.

Artist Unknown, *Monthly Calendar;* 1979; I-size: 6 5/8" x 16 1/2"; P-size: 7" x 17 1/4"; Ed#: unknown ed. unsigned. located at bottom of the print, red type reads: "SHG" / and / Art Inc. / 2111 Brooklyn Ave. / Los Angeles, Calif. 90033-264.1259 / 268.2335."; <u>Note:</u> Monthly Calendar. On a green background, the image of a sun is delineated on red ink. Outside of the image area, red type reads: "Tawa, the Sun Kachina." There are two versions of this print: lime green and dark blue in the background. #Prints: 4.

Aguilar, Laura; *Grandma;* April 10-21, 2001; Maestras 2; Coventry Rag, 290 gms. I-size: 18" x 26"; P-size: 22" x 30"; Ed#: 4/66, 6/66; prnt: José Alpuche; mtrx: destroyed; signed. lower left; <u>Note:</u> 3 Photographs -one of my grandma taken 1920-1923 -one of my grandma, Aunt Bea my brother John and myself -one with my grandma and myself text about my grandma Colors used: Cream White, LT White Yellow, Clear Gloss, Sepia, Silver.

Aguirre, José Antonio; *Firedream;* (Mar 7-11) 1988; Atelier 11; I-size: 24" x 36 1/2"; P-size: 26" x 38 1/2"; Ed#: 4/45, 43/45; Signed, Inscription reads: "4/45, title, signature, date" Signed, Inscription in pencil on the area between the two sections of the print reads: "43/45, Firedream, J A Aguirre, 88". "SHG" chops located below the main image area; <u>Note:</u> Central image of five black and white firemen, a fire truck with four firemen and an abstract border. The lower part of the print contains a sleeping yellow nude female and a profile of a face with a nose in the act of smelling. "My work is closely related to personal experience. This visual poem tells the story of a relationship that was so intense that it was extinguished by the fire of passion. This love is being reborn through a new fire of life but it has to face a deconstruction of its past and in a cathartical experience overcome the present to be able to grow into the future." J.A. Aguirre: #Prints: 2.

Aguirre, José Antonio; *It's Like The Song, Just Another Op'nin' Another Show..* (Jan 8-12) 1990; Atelier 15; Westwind (heavyweight); I-size: 24" X 36"; P-size: 26 1/4" X 39"; Ed#: 4/62, 16/62; prnt: Oscar Duardo; mtrx: Destroyed; Signed, Inscription in pencil below image area reads: "4/62, title & signature" Inscription in pencil on the bottom reads: "It's Like The Song, Just Another Op'nin' Another Show.., 16/62, J A Aguirre, 90". embossed "SHG" on the lower left; <u>Note:</u> A large red cross dominates the center of the print. On the upper part of the cross there is a plaque with "SIDA". At its base is a portrait of a bearded man. Behind the cross on the top there is a landscape of Echo Park. "This print is intended to be a tribute to the memory of Carlos Almaraz and to those that have also died from AIDS. The image of the cross coming from the head/photograph of Almaraz is combined/appropriated with few symbols from Carlos own iconography, developed with my own treatment and color perception." J.A. Aguirre. #Prints: 2.

Aguirre, José Antonio; *Postcard From 'Elei';* 1992; Atelier 19 L.A. Riots; I-size: 24 3/4" x 19"; P-size: 26 1/8" x 20"; Ed#: 4/64, 22/64; Signed, Inscription in pencil below image area reads: "Postcard From 'Elei', 4/64, J Aguirre, 92". embossed "SHG" chopmark located at the bottom left corner inside image area; <u>Note:</u> A human figure on profile next to an image of City Hall in L.A. intertwined with what looks like sharp knife blades of fire and/or blood. At the bottom are three hands with drops of blood. #Prints: 2.

Aguirre, José Antonio; *Santa Patria;* 1995; Atelier 29-31 #4 & #6; I-size: 38 1/2" x 26 1/2"; P-size: 44" x 30"; Ed#: 18/60; Signed. lower left; <u>Note:</u> Nude masked woman tied to a cross.

Aguirre, José Antonio, and José Alpuche; *Mongo Santamaria;* 1997; Atelier 29-31 #4 & #6; I-size: 16" x 21 7/8"; P-size: 20" x 26"; Ed#: 4/60, 6/60; Signed. "SHG" insignia at lower left hand corner; <u>Note:</u> Cesar Chavez with zig zag bolts of red, orange, and blue. The other print is done in all green. Both Jose Antonio Aguirre and Jose Alpuche created the poster. Atelier 31. #Prints: 2.

Alcalá, Manuel C. *El Canto de Quetzalcoatl;* 1995; Atelier 3; poster; I-size: 32" x 24 1/2"; P-size: 38 1/4" x 30"; Ed#: 56/65, 58/65; Signed. lower left hand corner; <u>Note:</u> Abstract profile of a multicolored human face with an abstract feather headdress. Red crescent moon in upper right corner with blue planet and comet zooming in. On top of the human head is a green bird. #Prints: 2.

Alcalá, Manuel C. *La Partida;* 1996; Atelier 29; I-size: 25 5/8" x 38"; P-size: 30" x 44"; Ed#: 4/59; prnt: José Alpuche; Signed. lower left; <u>Note:</u> Nomadic family (father, mother, and son) travel across the barren land with a fire and a tornado in the background.

Alcaraz, Lalo Lopez; *White Men Can't;* 1992; Atelier 19 L.A. Riots; I-size: 21 1/2" x 16 5/8"; P-size: 28" x 20"; Ed#: 4/59, 22/59; Signed, Inscription in pencil below image area reads: "White Men Can't, 4/59, Lalo Alcaraz, [cross symbol]". embossed "SHG" chopmark located in the lower right corner; <u>Note:</u> George Bush and Daryl Gates dressed in sports outfits. A wire fence and the City Hall in flames are behind them. Gates' basketball player t-shirt reads: "property of / LAPD". Bush's runner t-shirt reads: "White / men / can't / run / the system" White text on a red background underneath the image area reads: "From the courts of Simi Valley, / to the streets of L.A., (c) copyright 1992 Lalo." "It is one of my series of dwgs. (sic.) titled 'Chicano Movie Posters,' in which I create parodies of L.A./Hollywood movie posters w/ (sic.) Chicano themes. This one was inspired by the riots/insurrection in L.A. and the inability of the establishment to do anything about their society's crack up. 'Nero Fiddles '92'." L. Alcaraz: #Prints: 2.

Alcaraz, Lalo; *Ché;* 1997; Atelier 31; I-size: 22" x 16"; P-size: 26" x 20"; Ed#: 4/65, 6/65; prnt: Amos Menjivar, supervised by José Alpuche; Signed. SHG insignia at lower left corner; <u>Note:</u> Ché wearing beret with a Nike emblem on the front. Print in red and black. #Prints: 2.

Alferov, Alex; *Koshka;* (Jan 24-29) 1988; Atelier 11; Westwinds; I-size: 24" x 36"; P-size: 26" x 40"; Ed#: 4/52; prnt: Oscar Duardo; mtrx: Destroyed; Signed, Inscription in pencil located at the bottom below the image area reads: "4/52, title and signature". "SHG" chops located in the lower right hand corner; <u>Note:</u> "A city cat, twilight casting its shadow at the doorway of a stranger. I live in Hollywood, in a part of the city that used to be residential but is now in a state of change. There are a lot of stray cats in this neighborhood. The cats are forced to survive on their own. The cities are in the same state of plight. I have used the stray cat as a symbol of what happens to a city in decline and to its inhabitants--an electric neon existence of surviving at any cost--casting an uncertain shadow to its future." A. Alferov.

Alferov, Alex; *Love Potion #9;* 1992; Atelier 19 L.A. Riots; I-size: 24" x 36"; P-size: 28" x 40"; Ed#: 18/28; Signed, Inscription in pencil at the bottom inside image area reads: "love potion #9, 18/28, Alferov". embossed "SHG" insignia located in lower right corner inside image area; <u>Note:</u> Juxtaposition of what looks like the enlarged face of person and a lying torso of another. The composition is blurred. Main colors are pink, yellow, blue and purple.

Alferov, Alex; *Oriental Blond;* (Oct 3-7) 1988; Atelier 12; Westwind (heavyweight); I-size: 24" x 31"; P-size: 26" x 33"; Ed#: 46/58; prnt: Oscar Duardo; mtrx: Destroyed; Signed; Inscription in pencil on the bottom reads: "46/58, Oriental Blond, Alferov". embossed "SHG" on the lower right; <u>Note:</u> Portrait of a man (yellow and blue), next to a window (dark magenta to red). Outside are bare trees with a split fountain background. Walls are purple to pastel green.

Alferov, Alex; *Passport;* 1993; Images Of The Future; I-size: 15 1/8" x 16"; P-size: 26" x 20"; Ed#: 4/78, 14/78; Signed, Inscription in pencil below image area reads: "signature [illegible], 93, passport, 4/78". embossed "SHG" insignia in lower right corner; <u>Note:</u> On a multi-colored background, the green outline of a face is visible within layers of other lines and shapes. The face seems superimposed--as if it is not the focus although it is the only image. #Prints: 2.

Alferov, Alex; *Without You;* n.d. Atelier 29-31 #4 & #6; I-size: 39 1/4" x 24 1/4"; P-size: 44" x 30"; Ed#: 4/60, 6/60; prnt: José Alpuche; Signed. lower left corner of image; <u>Note:</u> Mahatma Gandhi quotes

in multicolor, "Wealth without work.." rising sun towards bottom of the poster. Co-artist Michael Amescua. #Prints: 2.

Alicia, Juana; *Sobreviviente;* (Jan 29-Feb 2) 1989; Atelier 15; Westwinds (heavyweight); I-size: 29 1/2" x 24"; P-size: 32 1/4" x 26"; Ed#: 41/60, 42/60; prnt: Oscar Duardo; mtrx: Destroyed; Signed, Inscription in pencil on the bottom reads: "Sobreviviente, 41/60, Juana Alicia". Signed, Inscription in pencil located below the image area at the bottom reads: "Title, 42/60, signature". embossed "SHG" on the lower right side; Note: Image of a blind-folded woman, rays of light emanating from her eyes beneath the blindfold. A large building looms behind her, and a bit of sunset filled sky is seen above and beyond the building. #Prints: 2.

Alpuche, José; *Another Aftershock Hits LA;* 1992; Images Of The Future; I-size: 22 1/8" x 16"; P-size: 26 1/8" x 20"; Ed#: 4/54, 16/54; Signed, Inscription in pencil below image area reads: "4/54,'Another aftershock hits La', José Alperche [illegible], 92". embossed "SHG" insignia located in lower left corner; Note: Image of 'The Thinker' by August Rodin in green and black in the center of the composition. Along the top and left edges are newspaper clip-pings in gold, superimposed on the purple-blue background. Big lettering reads: "..Studio City wants police to sweep out home-less.. / ..Convicted in Shooting of Girl, 11, Wounded in Heart.. / ..Choosing Unemployment.. / ..Food / Love" At the bottom of the print, smaller type reads: "Another Aftershock Hits Desert": #Prints: 2.

Alpuche, José; *El Espíritu Azteca;* 1995; Atelier 16; poster; I-size: 22" x 16"; P-size: 26" x 20"; Ed#: 42/57, 44/57; prnt: José Alpuche; mtrx: Destroyed; Signed. lower right hand corner; Note: Colors of the Mexican flag in the background fading vertically from green to white to red. In the foreground is an Indian holding a bow and arrow kneeling down on the ground. His chest is exposed and he is wearing a feather headband. #Prints: 2.

Alpuche, José; *Material Girl;* 1997; Atelier 29; I-size: 24" x 18"; P-size: 26" x 20"; Ed#: 11/32; Signed. Note: Picture of Madonna--the singer of the hit song "Material Girl.".

Alvarez, Jack; *Dos Mundos (Two Worlds);* August 28-31, 2001; Coventry Rag, 290 gms. I-size: 15" x 21"; P-size: 26" x 30"; Ed#: 4/84, 6/84; prnt: José Alpuche; mtrx: destroyed; signed. lower left; Note: Hand Pulled Serigraph print. Six colors on Coventry rag paper. Art print contains; yellow background, blue/gray surface. Female/ Virgin figure in center with halo-like shape over head. Symbolism includes; plant forms (3) crosses in and above the horizon. Colors used: Light Yellow 1205, Charcoal Brown 497, Light Lavender 503, Gray Black 431, Orange 130, Blue/Gray 5493.

Alvarez, Laura E. *Mission in the Garden;* March 27-30, 2001; Maestras 2; Coventry Rag, 290 gms. I-size: 18"x 22"; P-size: 22"x 30"; Ed#: 4/74, 6/74; prnt: José Alpuche; mtrx: unknown; signed. lower left; Note: The Double Agent Sirvienta, an international spy posing as a maid and expert in the field of domestic technology, looks after and involves a blond baby in secret missions while vacationing in a tropical garden landscape. The agent/gardener in the dis-tance is really her childhood sweetheart from a small Mexican Colonial town, but with the plastic surgery after his accident, she doesn't recognize him. Her mission plan hovers in the grass with the promise of love and small explosions. A small toy hides the precious data. Colors used: Light Green, Pink, Brown Skin, Sky Blue, Yellow, Light Flesh, Brown Skin (again), Dark Green, Black, and Clear Gloss.

Alvarez, Laura E. *The Double Agent Sirvienta: Blow up the Hard Drive;* 1999; Atelier 33; silkscreen; I-size: 25 3/4" x 18"; P-size: 30 1/4" x 22"; Ed#: 4/56, 6/56; Signed, Inscription in pencil below image reads: "4/56, The Double Agent Sirvienta: Blow up the Hard Drive, Laura E. Alvarez '99.". Note: Image is of a girl in a waitress uni-form. The background is a folder with title "File://Translations. underdone" with letters and characters as a second background. There is a red flame that fades from orange to yellow to bottom of image. "Alvarez uses humor to scramble the gendered and raced codes of the culture of domestic labor economics, with the sirvienta doubling as an agent of subversive intelligence"- *-Maestras Atelier XXXIII 1999.* #Prints: 2.

Amemiya Kirkman, Grace; *Where's My Genie In The Bottle;* (Oct 23-27) 1989; Atelier 14; Westwinds (heavyweight); I-size: 24" x 36"; P-size: 24 3/4" x 37"; Ed#: 4/55, 10/55; prnt: Oscar Duardo; mtrx: Destroyed; Signed, Inscription in pencil on the bottom reads: "Where's My Genie In The Bottle, 10/55, Grace Amemiya Kirkman".

embossed "SHG" on the lower left; Note: Image is "very wild, freeforms". The colors are very bright-red, blue, lavender, gold, yellow, white, green, orange, magenta. "There's a central figure in oranges & ochre". Also there are some identifiable objects, such as, a mirror, a ruler, envelopes and a vile. "Depression/ The escape, the glamour/ Addiction/ The high, the hysteria/ Emptiness." G Amemiya Kirkman: #Prints: 2.

Amemiya, Grace; *From Within Ourselves, The Phoenix Arises;* (May 23—27) 1992; Atelier 19; Westwinds; I-size: 17 1/2" x 24"; P-size: 18 1/8" x 25 1/2"; Ed#: 63; prnt: Richard Balboa; mtrx: Destroyed (sic.); Lower left of paper; Note: Phoenix rising from fire/Destruction of its egg. Colors used: 1. Silver mettalic (sic.), 2. gold mettalic (sic.), 3. Yellow, 4. Process Magenta, 5. Split fountain Blue/Green, 6. Maroon. "From within Ourselves, the Phoenix Arises. Like many young children now, i too was a child during a riot—the Watts riot. And like most children, didn't understand what it meant to be discriminated or hated because of one's heritage or color. We didn't know about "Being disadvantaged". My friends then all had smiles and knew how to laugh. Another riot, now in 1992, called the L.A. riot. I hear the words of Rodney King, "Can't we all get along?" And it makes you wonder "Can We?" The media sen-sationlizes (sic.). Next thing we know, we are all caught up in this frenzy. Fear grips us. We all have different pasts. We are all here for different reasons. Understanding why we are here and how we can love or at least have compassion is a start. But the real beginning is to look within, to treat ourselves with self-respect and respect for others. Only then will real change can happen (sic.). Only then, our phoenix can rise." G. Amemiya.

Amescua, Michael; *Buenos Días;* 1994; I-size: 38" x 26"; P-size: 44" x 30"; Ed#: 4/68, 20/68; Signed, Inscription in pencil on the bot-tom reads: "4/68, Buenos Dias, Michael Amescua, 94". embossed "SHG" on the bottom right; Note: Image of a hare playing an instrument stepping on a stag (both in brown). Both animals are on an abstract blue, yellow, orange and light green background. #Prints: 2.

Amescua, Michael; *Día de los Muertos, Announcement Poster for;* 1973; I-size: 21 1/4" x 16"; P-size: 22 1/8" x 17"; Ed#: unknown ed. unSigned. stamped on lower left corner: "Silkscreen by / SHG / and Art, Inc."; Note: Announcement Poster for "Día de los Muertos." Red, green, and blue colors. On the upper left hand side is a skeleton head outlined in blue ink with its tongue stick-ing out. Glitter is adhered to the skull's red mouth. Two geometric fields-one red and the other green. On the lower right-hand side it says "Dia De Los Muertos". Lower left corner is stamped with "Silkscreen by SHG": #Prints: 2.

Amescua, Michael; *Fire in the Forest;* 1996; Atelier 28; poster; I-size: 30" x 26"; P-size: 36 1/4" x 30"; Ed#: 16/55, 18/55; prnt: José Alpuche; mtrx: Destroyed; Signed. lower left; Note: Animal sitting on limb facing left with swirls around him. Colors appear to be applied with spray painting. Colors present on this print are: light yellow, foam green, red shade yellow, cerulean and midnight blue, and emerald green. #Prints: 2.

Amescua, Michael; *Mara'akame;* (Jan 10-15) 1988; Atelier 11: Westwinds; I-size: 36" x 24"; P-size: 40" x 26"; Ed#: 4/45; prnt: Oscar Duardo; mtrx: Destroyed; Signed, Inscription in pencil located at the bottom in the blue border reads: "Signature, title and 4/45". "SHG" chops located in the lower right hand corner; Note: Monotype off metal plates on a royal blue field, deer meta-morphosed into a human. "Other shamans dream that someone wants to throw a cloud which will destroy all of the people. All of us will end from this cloud. Others say they dream that a giant animal will fall and, where it falls, everything will burn in a great fire. The only way to renew the candles so the gods are contented. The shamans know how; they did this once a very long time ago. Maybe they will do it again, maybe not. They will dream what they have to do." Ulu Temayk, mara'akame (Huichol Shaman).

Amescua, Michael; *Toci;* (Jan 14-19) 1989; Atelier 13; Westwinds (heavyweight); I-size: 38 1/2" x 25 1/2"; P-size: 38 1/2" x 25 1/2"; Ed#: 49/55; prnt: Oscar Duardo; mtrx: Destroyed; Signed, Inscription in pencil on the bottom of image reads: "Michael Amescua, Toci, 49/55". embossed "SHG" on the lower right; Note: There is a purple mountain and a blue sky. There is a pregnant anthropomorphic deer skipping from right to left wearing stock-ings.

Amescua, Michael; *Touches The Sky;* (April 29-May 4) 1991; Atelier 16; I-size: 25 1/2" x 35 1/2"; P-size: 25 1/2" x 25 1/2"; Ed#: 4/59; prnt: Oscar Duardo; mtrx: Destroyed; Signed, Inscription in pencll located at the bottom reads: "4/59, title and signature". "SHG" chops located in the lower right corner; <u>Note:</u> Full bleed. Two very abstracted yellow figures with four feathers. There is a yellow-orange mass towards the bottom. There is a 2" tear in the top center.

Amescua, Michael; *Xólotl;* (Jan 2-6) 1990; Atelier 15; Westwinds (heavyweight); I-size: 35" x 22"; P-size: 35" x 22"; Ed#: 4/58, 44/58; prnt: Oscar Duardo; mtrx: Destroyed; Signed, Inscription in pencil on the bottom of the image reads: "Michel Amescua, 44/58, Xólotl" Signed, Inscription in pencil at the bottom reads: "Signature, 4/58 and title". embossed "SHG" on the lower right; <u>Note:</u> Full bleed. Blue abstracted Mayan god with a pink, yellow, red and white floral lace patterned femur. From a blue disc in upper right hand corner the colors yellow and orange ripple outward. "Xolotl guides the sun thru the underworld. Here he is asking, "Who will speak for the animals, will they all drown in mankinds pollution, or will you speak and act now, today, this minute to pick up your own garbage." M. Amescua. #Prints: 2.

Amescua, Michael, and Alex Alferov; *Untitled;* 1995; Atelier 7; poster; I-size: 38" x 25 3/4"; P-size: 44" x 30"; Ed#: 22/50, 26/50; prnt: José Alpuche; mtrx: partially Destroyed; Signed. lower left side of print; <u>Note:</u> Alferov's Byzantine Virgin surrounded by Amescua's sculptural symbols and ancient faces giving homage to the Virgin. A blend of Eastern European religious icon in contrast to ancient Aztec anthropological imagery. Dark blues and purple dominate the print. Sensuous yet caring. #Prints: 2.

Amos, *98 (degrees) in the Shade;* Jan. 6-12, 2002; Coventry Rag, 290 gms. I-size: 16" x 22"; P-size: 20" x 26"; Ed#: 4/50, 6/50; prnt: Amos; mtrx: destroyed; signed. lower left; <u>Note:</u> Prints shows el paletero (ice-cream man) huffing onward w/ achy feet/cloudy head/and running on empty. The blended background gives the illusion of extreme heart. With the sun beating down, symbols surround the figure showing what he is working for, what has been left behind, his hopes and his realities, and what is in the future. Colors used: Blend Orange/Tan, Turquoise Blue, Red Sh. Blue, Yellow, Ochre, Sienna, Magenta, Grey (light), Black, Trans White (t.p.'s only), Trans Black (t.p.'s only).

Amos, *Things to Come;* 1999; Atelier 33; silkscreen; I-size: 20" x 9 1/2"; P-size: 22 1/8" x 12"; Ed#: 4/65, 6/65; Signed, Inscription in pencil under image reads: "4/65, Amos 99.". <u>Note:</u> Image is of a blue cartoon-like creature that is bowling with an ignited canon ball aiming for green glass bottles. The background is yellow with a thinking bubble of an alien/robot demolishing a city. Poster reads "Things to Come..& things that never will be. Prints, Paintings, & Illustrations by: Amos." At bottom of poster in grey reads "March 1999 Delirium-Tremens-1553 Echo x Parque.": #Prints: 2.

Ancona Ha, Patricia; *Night Vision;* ca. 1992; Atelier 14 L.A. Riots; I-size: 24" x 16"; P-size: 28" x 20"; Ed#: 4/55, 22/55; Signed, Inscription in pencil below image area reads: "Night Vision, 4/55, Ancona Ha, [Chinese symbol]". embossed "SHG" chopmark located below image area; <u>Note:</u> A female Goddess in profile surrounded by a dragon-headed snake in a multicolored jungle-like scenario. The goddess is sitting like a Buddha on a stone engraved with indigenous symbols. It is night time and we can see the moon and a star. #Prints: 2.

Anton, Don; *The Single Word;* (March) 1983; Atelier 1; Artprint; I-size: 19 1/4" x 19"; P-size: 23" x 35"; Ed#: 21/60; prnt: Stephen Grace; mtrx: Destroyed; Signed, Inscription in pencil reads: "21/60, title and signature [illegible]". Blue "SHG" at the bottom; Fund: partially funded by NEA and the CAC. <u>Note:</u> Image of a white face with closed eyes and white branches radiating from the face into a blue background. Yellow and orange sporadic lines.

Arai, Tomie; *Double Happiness;* November 7-10, 2000; Coventry Rag 290 gms. I-size: 25" x 31"; P-size: 30" x 35"; Ed#: 4/42, 10/42; prnt: José Alpuche; mtrx: Destroyed. signed. Inscription in pencil reads, "10/42 Double Happiness Arai '00". lower left; <u>Note:</u> Image of an Asian woman eating with chopsticks; loteria cards and Japanese 'Hanfuda' playing cards, & map of East L.A. are set against a black background. Double Happiness is a piece about the mix of cultures that make up the East L.A. / Boyle Heights Community. In this piece a young Asian woman reflects while she is eating; the interplay of Japanese Chicano and Chinese from Boyle Heights

and Monterey Park are represented through an array of Chicano loteria cards, Japanese 'Hanafuda' cards and Chinese English language flash cards. Colors used: Yellow, Blue, Green, Pink, Red, Black, and Silver. #Prints: 2.

Arai, Tomie; *Kaeru / Finding Home;* May 1-6, 2000; Coventry Rag 290 gms. I-size: 20 1/8" x 28 1/4"; P-size: 27 1/8" x 34 1/4"; Ed#: 4/60, 6/60, 58/60, 60/60; prnt: José Alpuche; mtrx: Destroyed. signed. Inscription in pencil reads, "60/60 Kaeru/Finding Home Arai '00". lower left. <u>Note:</u> 7 color silkscreen was produced in conjunction with a two month residency at SHG through an Artist & Communities/Mid Atlantic Arts Foundation and NEA grant. In this piece, a young boy is pulling back a screen to reveal an array of images which represent memory and the passage of time. These images form a visual arc or lifeline which flow towards a taiko drum head with rose imprinted on it. The rose (an image symbolic of my stay in East LA) represents the heart and pulse. "KAERU/ FINDING HOME" is a piece which explores the construction of identity through a reconnection with the past. Colors used: Yellow, Gray/Green, Light Gray Green, Blue, Pink, Black, and Yellow/Brown. #Prints: 4.

Argyropoulos, Maria Antionette; *The Labyrinth of the Soul;* 1996; Atelier 28; poster; I-size: 21 3/4" x 16"; P-size: 26" x 20"; Ed#: 36/50, 37/50; prnt: José Alpuche; mtrx: Destroyed; Signed. lower left; <u>Note:</u> There are two large black tires in this image, one in the bottom center and the other in the upper left-hand corner. Two large images of St. Ludovia and one repetition of St. Ludovia. Type style in orange reads "a" "it" and "L'Unita." Colors include: magenta, yellow, orange, blue, green, and black. #Prints: 2.

Arreguin, Alfredo; *Encantacion;* 1988; National Chicano Screenprint Atelier; I-size: 36" x 24"; P-size: 40 1/2" x 26 1/4"; Ed#: 17/60; Signed, Inscription in pencil on the lower right reads: "signature [illegible] and edition". <u>Note:</u> Patterned design. The image seems to be a candelabra, with a Mexican eagle in its center. The background is brown with a gold lyrical pattern. Frogs, bird and fish line the fringe.

Attyah, David "Think Again"; *No Bullshit;* July 25-27, 2002; Coventry Rag, 290 gms. I-size: 16" x 22"; P-size: 20" x 26"; Ed#: 4/88, 6/88; prnt: José Alpuche; mtrx: destroyed; signed. lower left; <u>Note:</u> An "invasion" of doorknobs gathering to resist displacement and eviction. "No Seremos Desalojados." Colors used: Fire Red, Orange, Teal, Purple, Dark Purple, Dark Fuscia.

Audifred, Magda; *El Teatro;* 1992; Atelier 19 L.A. Riots; I-size: 24" x 16"; P-size: 28" x 20"; Ed#: 4/46, 22/46; Signed, Inscription in pencil below image area reads: "4/46, El Teatro, Magda Audifred, M 92". embossed "SHG" chopmark located below image area; <u>Note:</u> An elongated face of an androgynous person wearing a blue shirt with a red collar. A theater-like design is in the upper section of the print and around the person's head. It is not clear whether the person is a cut out paper or three-dimensional. #Prints: 2.

Avila Boltuch, Glenna; *Plumas Para Paloma;* (Mar 20-24) 1989; Atelier 13; Westwinds (heavyweight); I-size: 32 1/2" x 21 1/4"; P-size: 37" x 26"; Ed#: 30/64; prnt: Oscar Duardo; mtrx: Destroyed; Signed, Inscription in pencil on the bottom reads: "30/64, Glenna Avila". embossed "SHG" on the bottom right; <u>Note:</u> The print includes a central figure of a baby (unclothed) laying on a Navajo rug with many feathers. The baby is surrounded by five photographs of her grandparents and great grand parents (two photos are of children, two are wedding photos and one is a current photo of her great grandmother). The central area is printed primarily in a variety of grays. The print is bordered by a colorful Mexican serape on all four sides.

Baitlon, Jon; *Para Karen, Eastlos;* n.d. Atelier 29-31 #4 & #6; I-size: 26" x 38"; P-size: 30" x 44"; Ed#: 4/59, 6/59; Signed. <u>Note:</u> Cathedral-like stain glass window with La Virgen de Guadalupe in the center. #Prints: 2.

Balboa, Richard; *Cordova's Candle;* n.d. studio proof; I-size: 22 1/2" x 16 1/4"; P-size: 22 1/2" x 16 1/4"; Ed#: 2/2; Signed, Inscription in pencil located at the bottom of the print reads: "Cordovas Candle, s/p, 2/2, R. Balboa [illegible]". <u>Note:</u> The mutilated body of a naked woman represents a candle melting. It has no arms and in the place of the head is the wick . The melted wax is red and drips over the yellow body. The background is a bright orange with splashed drips of black.

Baltazar, Raul, and Zack de la Rocha; *Culture Of Consumption;* (Jun 21-25) 1994; Atelier 24; Coventry Rag 290 grm. I-size: 35 1/2" x 26";

P-size: 44" x 30"; Ed#: 20/56; prnt: José Alpuche; mtrx: Destroyed; Signed, Inscription in pencil on the bottom reads: "Raul Baltazar, Culture Of Consumption, De La Rocha, 20/56". embossed "SHG" on the bottom right; Note: The image is an altar with dollar signs, text, and a television that tops the altar. Text is written by Zack De La Rocha. #Prints: 2.

Baray, Samuel A. *Advenimiento de Primavera;* (Feb 5-9) 1990; Atelier 15; Westwinds (heavyweight); I-size: 34" x 23 1/2"; P-size: 36 3/4" x 26"; Ed#: 4/79, 18/79, 47/79; prnt: Oscar Duardo; mtrx: stored by artist; Signed, Inscription in pencil on the bottom reads: "Advenimiento De Primavera, 47/79, S.A. Baray, 1990". embossed "SHG" on the lower right within the image; Note: Large female figure dressed in an ornate dress in blue, brown, and pink. In her left hand she is holding blue rosary beads and with her right hand she is propping up an elaborate spray of pink flowers which produce a halo effect. She is surrounded by tropical growth and religious cross. A woman with a maroon, blue and pink dress in the center ground embracing the surrounding green leaves. Pink and white calla lilies. Fifteen colors. "The arrival of Spring. Ancient and contemporary Angels of Los Angeles. There are very few angels that sing." S. Baray. #Prints: 3.

Baray, Samuel A. *Aurora-El Primer Milagro del Día;* (Mar 8-15) 1994; Atelier 24; I-size: 27" x 42"; P-size: 30" x 44"; Ed#: 4/58, 20/58; prnt: José Alpuche; mtrx: Destroyed; Signed, Inscription in pencil on the black black border within the image reads: "4/58, Aurora El Primer Milagro Del Dia, S A Baray, 1994". embossed "SHG" on the black border within the image on the lower left. Note: Central female bust in a colorful costume. Her hands are brown with green triangles on the palms. She is in a smaller frame within a larger round topped frame. This outer frame is decorated with gold trimming. Flowers and plants emerge from behind the smaller inner frame. The background is a radiant blue. Finally, this composition is surrounded by a wide black border. #Prints: 2.

Baray, Samuel A. *Santuario;* (March 3-13) 1987; Atelier 9; Westwinds; I-size: 35 1/2" x 19 3/4"; P-size: 40" x 30"; Ed#: 4/46; prnt: Oscar Duardo; mtrx: Destroyed; Signed, Inscription in pencil located below image area reads: "4/46, title, signature and date". Fund: funded in part by the CAC, NEA and the City of Los Angeles. Note: Floral arrangement of saturated colors on a black and maroon background.

Baray, Samuel A. *Señora en su jardín--Harvest;* 1996; Atelier 9; poster; I-size: 16 1/4" x 22"; P-size: 20" x 26"; Ed#: 40/59, 44/59; prnt: José Alpuche; mtrx: Destroyed; Signed. lower left; Note: Depiction of a woman with braids working. Abstract scenery which appears to be surrounded by flowers. One of the prints is in dark green, lavender, and light green, while the other print is deep blue, bright orange, and off-white. Next to the Ed# reads "Var.": #Prints: 2.

Baray, Samuel A. *Virgen de la Guarda;* 1997; Atelier 30; I-size: 26 1/4" x 19 7/8"; P-size: 30 3/8" x 24"; Ed#: 4/54; prnt: José Alpuche; Signed. lower left corner; Note: Woman with elaborate headdress containing eagles, faces, and sun rays protects a village. Jagged edges with black background.

Bautista, Vincent; *Calavera's In Black Tie;* (Oct 30-Nov 3) 1989; Atelier 14; Westwinds (heavyweight); I-size: 36" X 24 1/2"; P-size: 38 1/2" X 26 1/2"; Ed#: 4/55, 18/55; prnt: Oscar Duardo; mtrx: Destroyed; Signed, Inscription in pencil located below the image area reads: "Title, 4/55, signature and 89" Signed, Inscription in pencil on the bottom reads: "Calavera's In Black Tie, 18/55, Bautista, 89". "SHG" embossed insignia located in the lower right corner; Note: Three calaveras wearing black ties and tux in the foreground. Red, yellow, green, purple, and white abstracted background with crosses and little calaveras. #Prints: 2.

Bautista, Vincent; *Ethereal Mood;* (Dec 3) 1993; Atelier 25 (Special Project); Coventry Rag 290 grms. I-size: 16" x 24"; P-size: 17 7/8" x 26"; Ed#: 4/74, 20/74; prnt: José Alpuche; mtrx: Destroyed; Signed, Inscription in pencil on the bottom reads: "4/74, Etheral Mood, Bautista, 93". embossed "SHG" on the lower left; Note: An angel sitting on a rock with ribbon flowing. Also, three winged hearts coming towards the angel. #Prints: 2.

Bautista, Vincent; *Imágenes De La Frontera: El Coyote;* 1992; I-size: 16 1/4" x 24 1/4"; P-size: 20" x 28"; Ed#: 4/56; Signed, Inscription in pencil below image area reads: "Imágenes de la frontera: 'El Coyote', 4/56, Bautista 92". "SHG" embossed chopmark located at the bottom right of the print; Note: Enlarged face of a coyote wearing a suit and whose tongue has become the U.S.A. flag.

There are several dollar bills in his pocket and a skeleton pin in his suit. In the background, there is a gray fence against a dark sky with a sun or a moon.

Bert, Guillermo; *..And His Image Was Multiplied..* (Jan 22-26) 1990; Atelier 14; Westwinds (heavyweight); I-size: 35 1/2" X 24 1/2"; P-size: 37 1/2" X 26"; Ed#: 5/55, 16/55; prnt: Oscar Duardo; mtrx: Destroyed; Signed, Inscription in pencil located below the image area reads: "4/55, signature and 90" Signed, Inscription in pencil on the bottom reads: "16/55, Giullermo Bert/90". "SHG embossed insignia" located in the lower left corner underneath the image; Note: Six collaged images. Four photo-silkscreened, large 1 1/2" letters at the bottom. Colors are magenta, red, black, gold, green, blue, yellow, and white. Center blue television has an image of "The Creation," Michelangelo's Sistine Chapel's forearms, two fingers touching. There also is a negative image of agricultural workers from the Philippines on a light green background. "The print is called..AND HIS image was multiplied..and is referred to the alienation that the people who live in a super metropolis experience. Human beings are separated from a direct contact with nature. The 'her son' became a mere reflection of self, these entities are defined by the image of them within the little box of a television set." G. Bert. #Prints: 2.

Bert, Guillermo; *Dilemma In Color;* (Nov 16-21) 1987; Atelier 10; Westwinds; I-size: 34 1/2" x 23 1/2"; P-size: 26" x 40"; Ed#: 4/49; prnt: Oscar Duardo; mtrx: Destroyed; Signed, Inscription in pencil at the bottom below image area reads: "4/49, signature and title". "SHG" chops located in the right hand corner outside the image; Note: A dual image of a sitting man with a background of TV screens and power lines embedded in brilliant colors. "The ambivalence of thoughts amid the strong influence of television and the hidden energy that makes it possible. The conflict is intensified by the aggressive, brilliant colors.

Boccaccio, Poupée; *El Político;* 1993; Images Of The Future; I-size: 22 1/8" x 16"; P-size: 26" x 20"; Ed#: 4/79, 14/79; Signed, Inscription in pencil below image area reads: "4/79, El Politico, Paupée? Boccaccio? [illegible], '93". embossed "SHG" insignia located in lower left corner; Note: An abstract figure of a person, arm extended holding a saxophone, wearing a crown, is the primary image amongst a black background with wavy blue, yellow, and pink lines. The figure is standing on a blue circle outlined in pink as if it is the spotlight or stage on which the figure performs. #Prints: 2.

Boccalero, Sister Karen; *In Our Remembrance In Our Resurrection;* (Dec 10-11) 1983; Atelier 11; Artprint 25% rag; I-size: 21 3/4" x 24 3/4"; P-size: 22" x 34 1/4"; Ed#: 4/77; prnt: Stephen Grace; mtrx: custody of the artist; Signed, Inscription in pencil located at the bottom "4/77, title, signature and '83.". Yellow "SHG" located at the bottom; Fund: partially funded by Atlantic Richfield Foundation. Note: Abstracted gold, magenta, and blue design on a white and yellow background.

Boccalero, Sister Karen; *Without;* (March) 1983; Atelier 1; I-size: 19" x 25 1/4"; P-size: 23" x 35"; Ed#: 52/60; prnt: Stephen Grace; mtrx: Unknown; Signed, Inscription in pencil below the image area reads: "52/60, '83 without, SKB.". Blue "SHG" at the bottom; Fund: funded in part by the CAC and the NEA. Note: Text reads: "There were seven sins in the world. Wealth without work, Pleasure without conscience, Knowledge without character, Commerce without morality, Science without humanity, Worship without sacrifice, and Politics without principle. Mahatma Gandhi.".

Bojórquez, Chaz; *L.A. Mix;* 1997; Atelier 30; I-size: 30" x 24"; P-size: 36" x 30"; Ed#: 4/58; prnt: José Alpuche; Signed. lower left; Note: Gold skull smiling with gold and red-purple frills surrounding "L.A." which is written on the lower right corner.

Bojórquez, Chaz; *New World Order;* (Jun. 28-July 2) 1994; Atelier 24; Coventry Rag 290; I-size: 33 1/2" x 26"; P-size: 44" x 30"; Ed#: 4/60, 20/60; prnt: José Alpuche; mtrx: Destroyed; Signed, Inscription in pencil on the bottom of image reads: "4/60, New World Order, Chaz Bojorquez, 94". embossed "SHG" on the lower left; Note: "Dark graffiti conquistador names over image of Aztec "Stella" (carved painted wood sculpture by artist). Colors are monochromatic black, white, silver. Roll call of conquistadors: Cristobal Colon with Christian cross, Cortez, Cabeza De Vaca, Alvarado, Cordoba, Ferny, Izzy, Año Loco, XIV92, c/s, por Dios y oro. Stella: Religion, ritual, language, numbers, male, female, architecture, city states, God. Division of World: E/P (España, Portugal), V'Papa

(Varrio Pope), V'España, V'Portugal, V'France, V'E. Unidos (Varrio United States).": #Prints: 2.

Boltuch, Glenna; *(title unknown); (March 3-6) 1986; Atelier 7; Accent 290 gram—white; I-size: 32" x 21"; P-size: 38" x 25"; Ed#: 4/45, 43/45; prnt: Stephen Grace; mtrx: Destroyed; Signed, Inscription in pencil located at the bottom reads: "4/45 and signature.". Fund: funded in part by the CAC, NEA and the City of Los Angeles. Note: Child with dolls on a silver background. #Prints: 2.

Botello, David (Rivas); *Long Life To The Creative Force;* (Feb 13-19) 1989; Westwind (heavyweight); I-size: 23 5/8" x 36"; P-size: 25 1/2" x 38 1/4"; Ed#: 34/61; prnt: Oscar Duardo; mtrx: Destroyed; Signed, Inscription in pencil at the bottom reads: "34/61, Long Life To The Creative Force, copyright 89, David Botello". embossed "SHG" at the bottom right; Note: "The image focuses on three figures rendered with ink and brush, scratching and china marker on mylar sheeting. The edges of the artwork are free form with rounded corners. An elder sit[s] in meditation in the center, holding a heart in large hands, and is surrounded by swirls of green feathers which are part of a plumed serpent who wants to gobble the heart. Behind, looking forward, is a large night cat with a skull mask on it's [sic] face.".

Botello, Paul J. *Draw;* (July 01-05) 1991; Atelier 21; Westwinds; I-size: 36" x 24"; P-size: 40" x 28"; Ed#: 16/66; prnt: Oscar Duardo; mtrx: Destroyed; Signed, Inscription in pencil on the bottom reads: "16/66, Draw, Paul J. Botello, 1991. embossed "SHG" on the lower right; Note: "The central character is a head of an Aztec queen connected at the hip to a Spanish king. 1/2 of a man's body is joined by a ribbon to 1/2 a woman's body [--] Both are seen from the back.".

Botello, Paul J. *Inner Nature;* 1999; Atelier 33; silkscreen; I-size: 30 1/2" x 23 5/8"; P-size: 38 1/8" x 30"; Ed#: 4/75, 6/75; Signed, Inscription in pencil below image reads: "4/75, 'Inner Nature', Paul Botello 99.". embossed "SHG" insignia at lower left-hand corner of poster; Note: Centered on the poster is an image of a man and a woman surrounded by animals, two trees at opposite ends, and nopales in the foreground. The image is created by sun rays coming from the woman's praying hands. #Prints: 2.

Botello, Paul J. *Reconstruction;* (Nov 27-Dec 1) 1989; Atelier 14; Westwinds (heavyweight); I-size: 36" X 24"; P-size: 38" X 26 1/2"; Ed#: 4/56, 41/56; prnt: Oscar Duardo; mtrx: Destroyed; Signed, Inscription in pencil located below the image reads: "4/56, title, signature and 89" Signed, Inscription in pencil on the bottom of print reads: "41/56, Reconstruction, Paul J. Botello, 89". "SHG embossed insignia" located in the lower right corner of the image; Note: Three geometric heads with multicolored hatching. One with sunglasses. Three female torsos in motion. A reclining figure on top of the black and orange head. A cracked woman's face is part of the sunglassed figure's chest. "The piece is about the reconstruction of man with the help of a woman. Time swings back and forth, half man, half skeleton. The pregnant woman lying down shackled is reference to the responsibility of motherhood." Paul Botello. #Prints: 2.

Brehn, Qathryn; *Untitled;* (Feb 16-20) 1986; Atelier 7; Accent 290 gram—white; I-size: 24" x 36 1/4"; P-size: 24 1/4" x 36 1/2"; Ed#: 4/45; prnt: Stephen Grace; mtrx: Destroyed; Signed, Inscription on the right side of the image in sky area reads: "4/45 and signature". Fund: funded in part by the CAC, NEA and the City of Los Angeles. Note: Collage of downtown Los Angeles. Image on a floating triangle.

Calderón, Alfredo; *Manto a Tamayo;* 1995; Atelier 26; poster; I-size: 38" x 26 1/4"; P-size: 44" X 30"; Ed#: 16/55; prnt: José Alpuche; mtrx: Destroyed; Signed. lower left; Note: Manto a Tamayo is in homage to Maestro Rufino Tamayo. As master, Tamayo brought painting to its most ephemeral intensity. The central figure wears a Tehuana costume from Oaxaca and ascends to a cosmic realm facing one of Tamayo's works of the separation of night and day and arched with Mayan architecture with Frida's tropical monkeys.

Calderón, Rudy; *Earth's Prayer;* 1992; Atelier 19 L.A. Riots; I-size: 23 7/8" x 15 7/8"; P-size: 28" x 20"; Ed#: 22/61; Signed, Inscription in pencil below image area reads: "22/61, 'Earth's Prayer', Calderón, 92". embossed "SHG" insignia located at the lower left corner outside image area; Note: Landscape image of the top of a mountain resembling a human profile pointing towards the sky. A big white bird is flying against a sunset background with some smoke and clouds.

Calderón, Rudy; *Manifestations Of Trinity;* (Dec 7-11) 1987; Atelier 10; Westwinds; I-size: 24 1/2" x 36 1/2"; P-size: 26" x 37 5/8"; Ed#: 4/55; prnt: Oscar Duardo; mtrx: Destroyed; Signed, Inscription in pencil located at the bottom below the image area reads: "4/55, title, signature and 87". "SHG" chops located in the lower right hand corner; Note: Three figures in primary colors emerging from a mountain range. "Manifestation of Trinity is an attempt to portray analogies between the ancient and universal concept of Trinity and recognizable manifestations in life that are triple in nature, the three primary colors from which all other colors emerge, and the family unit of father, mother and child from which all nations take form. Spirit endows matter with dynamic conscious life." R. Calderon.

Calderón, Rudy; *Omnipresence;* 1996; Atelier 28; poster; I-size: 22" x 16"; P-size: 26" x 20"; Ed#: 38/65, 39/65; prnt: José Alpuche; mtrx: Destroyed; Signed. lower right; Note: Landscape with arched ocean horizon, parting clouds, blue sky, and five pointed swirling star. Colors that predominate are: magenta, cyan, green shade yellow, violet, ultramarine, and pearl white. #Prints: 2.

Calvano, Mario; *Portrait Of The Artist's Mother;* ca. 1991; I-size: 39 1/2" x 24 1/8"; P-size: 41 1/2" x 26 1/4"; Ed#: 35/58, 39/58; Signed, Inscription in pencil below image area reads: "35/58, 'Portrait of the Artist's Mother', Mari Cabamo [illegible] ". embossed "SHG" insignia located in lower right corner, outside of image area; Note: Portrait of a smiling woman in a light green and blue dress. In the foreground is an antique record player, a skull wearing a diadem of roses, and groupings of calla lilies that lead to the upper part of the image where two black silhouettes resemble the scene from Michelangelo's "Adam's Creation." Below image area, uppercase black lettering reads: "Lovedarlings.": #Prints: 2.

Cardenas, Cristina; *La Virgen De Los Pescados;* (Feb 11-July 11) 1993; Atelier 23; Coventry Rag 290 grms. I-size: 23" x 34"; P-size: 30" x 44"; Ed#: 4/57, 20/57; prnt: José Alpuche; mtrx: Destroyed; Signed, Inscription in pencil below the image reads: "4/57, C Cardenas, 93." And in ink within the image the title reads: "La Virgen De Los Pescados". embossed "SHG" on lower left; Note: "Woman with flowers and fishes looking at you." Colors are: gold, light brown, dark brown, white, dark blue, aqua blue, ultra blue, brown, yellow orange, majenta, cyan blue, and yellow. #Prints: 2.

Cardenas, Cristina; *Santa/Maguey;* March 20-24, 2001; Maestras 2; Coventry Rag, 290 gms. I-size: 18" x 26"; P-size: 20" x 30"; Ed#: 4/77, 6/77; prnt: José Alpuche; mtrx: destroyed; signed. lower right; Note: Colors used: Light Yellow, Red Orange, Thalo Blue, Purple, Transparent Orange, Gold, Mid-T-Yellow, Off Whie, T-Sienna, T-Red Black, Dark Burgundy.

Cardenas, Mari; *(title unknown);* (title unknown); (Nov 4-5) 1983; Atelier 2; Artprint 25% Rag Archival; I-size: 18 1/2" x 24 1/2"; P-size: 22" x 34"; Ed#: 4/77; prnt: Stephen Grace; mtrx: Destroyed; Signed, Inscription in pencil located at the bottom reads: "4/77 and signature". Cerise "SHG" located at the bottom; Fund: partially funded by the Atlantic Richfield Foundation. Note: Six color print: two greys, green, magenta. Cerise and yellow bird.

Carrasco, Barbara; *Dolores;* 1999; Atelier 33; silkscreen; I-size: 26" x 18"; P-size: 30 1/8" x 22"; Ed#: 4/66, 6/66; Signed, Inscription in pencil below image reads: "4/66, Dolores, Carrasco '99.". Note: Close-up portrait "pays tribute to the indefatigable UFW Vice-President, Dolores Huerta." She is wearing a pink shirt with a button saying "¡Si Se Puede!" which "reflects the clarity and power of Huerta's non-violent politics of social change." The background is aquagreen with 'Dolores' in pink block lettering at top of image. --*Maestras Atelier XXXIII 1999.* #Prints: 2.

Carrasco, Barbara; *Negativity Attracts;* (March 26-30) 1990; Atelier 15; Westwinds (heavyweight); I-size: 36" X 24"; P-size: 40" X 26"; Ed#: 4/62, 16/66; prnt: Oscar Duardo; mtrx: Destroyed; Signed, Inscription in pencil below the image reads: "4/62, title, signature and 90" Signed, Incription in pencil below the image reads: "16/66, Negativity Attracts, Carrasco, 90. "SHG" embossed insignia located in the lower left corner; Note: Two faces facing towards each other. Pink face with the open eye. Turquoise face w/ closed eye. "The print is the result of minimalizing detail work in order to focus more closely on color and content (form). Negativity, attracts & reflects male-female relationships after seen as con-

flicting yet attracting because of, or in spite of differences." B. Carrasco. #Prints: 2.

Carrasco, Barbara; *Primas;* April 18-20, 2001; Maestras II; Coventry Rag, 290 grms. I-size: 18" x 26"; P-size: 22" x 30"; Ed#: 4/62, 6/62; prnt: José Alpuche; mtrx: Destroyed; signed. in lower left; Note: Portrait of the artist's daughter and niece in an embrace, surrounded by a braid (trensa) showering hearts around the portraits. The trensa represents the older women in the lives of the young girls, nurturing their love for each other and themselves as strong and independent females. The trensa also symbolizes traditional values and customs and rituals. Colors used: Peach, Skin-Beige, Skin-LT. Brown, Lime Green, Turquoise, Purple, and Clear.

Carrasco, Barbara; *Self Portrait;* (Feb 24-Mar 1) 1984; Atelier 3; Somerset 320 gram 100% Rag Archival; I-size: 23" x 34 1/2"; P-size: 28" x 40"; Ed#: 2/70, 11/70; prnt: Stephen Grace; mtrx: Destroyed; Signed, Inscription in pencil below the image area reads: "2/70, title and signature". Note: Light blue grid background. White paint roller. Large green paint brush. Female figure with a green to white #2 t-shirt. Atelier information on the back. #Prints: 2.

Carrasco, Barbara, Roberto Delgado, Richard Duardo, Diane Gamboa and Eduardo Oropeza; *Atelier III, Announcement Poster for;* ca. 1984; Atelier 3; Somerset 320 gram 100% Rag; I-size: 22" x 32"; P-size: 29" x 40"; Ed#: unknown ed. unSigned. Note: Announcement Poster for "Atelier III, Spring 1984: Carrasco, Delgado, Duardo, Gamboa, Oropeza. SHG And Art Inc., East Los Angeles, California." Collage of images by the artists participating in Atelier III. On the left hand side of the print there is a fragmented image of the singer Boy George. The bottom image is a brush by Barbara Carrasco. #Prints: 2.

Carrillo, Juan M. *Imagenes De Ayer;* 1987; I-size: 15" x 21"; P-size: 19" x 25"; Ed#: 20/50; Signed, Inscription in pencil below image area reads: "Juan M. Carrillo, Oct., '87.". Note: On a light grey background there are several images resembling enlarged 'Kodak' negative film and 'Ektachrome' slides. The images from left to right and top to bottom are: "Juan Cervantes / Southside Park / Mural / August, 1977"; "Rudy / Día del Barrio / Oakland / Oct., '78"; "Stan / Día de los Muertos / St. Mary's Cemetary [sic] / Sacramento / Nov., 1977"; "Richard / 16th. of September / Centro de artistas / 1977"; "Jose / March on Gallo / Modesto / 3/75"; "Esteban / at the Centro / 1978"; "Ishi & Gina / Centro Retreat / Lake Tahoe / 10/77"; "me / Fort Bnnag / Sept., 1977"; "Louie's Birthday / Centro de Artistas Chicanos / August, 1976"; "Armando / Centro de Artistas Chicanos' / Mercado / June, 1975"; Irma / at home / May, 1976.".

Castillo, Mario; *Resistance To Cultural Death, An Affirmation Of My Past;* (July 18-23) 1988; Westwinds (heavyweight); I-size: 36" x 24"; P-size: 36" x 24"; Ed#: 17/60; prnt: Oscar Duardo; mtrx: in possession of the artist; Signed, Incription in pencil within the image: "17/60, Resistance to Cultural Death, An Affirmation Of My Past" and "Castillo, 88 [illegible]" in blue ink within the image on lower right. embossed "SHG" on the bottom right; Note: The image is dense with elements, some of which are: parallel vertical yellow stripes; step pattern in lower half; white/black skull in circle with rising undulating serpent; face behind skull and lines; floating triangles; additional geometric forms.

Cepeda, Armando; *Una noche en Tejas;* 1997; Atelier 30; I-size: 16 7/8" x 23"; P-size: 20" x 26"; Ed#: 4/65, 6/65; prnt: José Alpuche; Signed. Note: Couples dancing with band in background and bar. #Prints: 2.

Cepeda, Manuel; *Buenos Días;* 1993; Atelier 14; poster; I-size: 22" x 16"; P-size: 26" x 20"; Ed#: 8/64; Signed. lower right corner; Note: Two graduates wearing black mortarboards stand in the center of this print holding an oversized diploma. At their feet are scattered a number of open books. The trunks of the trees are pencils. Fields, clouds, and blue sky are the backdrop. A rooster standing on a wooden stump is in the lower left hand corner of the image. Text in gold and white reads "8th Annual Conference California's Heritage. 'Setting the Agenda for Latino Leadership in Education.' September 23-26, 1993 Mission in Riverside, California. Hispanic Caucus of the California School Boards Association.".

Cervantes, Juan; *De Colores;* 1987; I-size: 15" x 21"; P-size: 19" x 25"; Ed#: 20/50; Signed, Inscription below image area reads: "Juan Cervantes, 1987, (c).". located on the background there is the RCAF symbol. In the lower right hand side, ink type reads: "Juan Cervantes, (c) 1987, RCAF."; Note: The composition is diagonal

and shows two groups of images. The upper section shows two men; one of them is an indigenous person. The background depicts Aztec pyramids on right hand side, and contemporary buildings on left hand side. The lower section of composition shows a group of school children. The background is red.

Cervántez, Yreina D. *Camino Largo;* (Feb 6-Mar 27) 1985; Atelier 5; Stonehenge 320 gram-white; I-size: 37" x 24 1/2"; P-size: 41 3/4" x 28 1/2"; Ed#: 4/88, 35/88, 50/88; prnt: Stephen Grace; mtrx: Destroyed; Signed, Inscription in pencil below the image area reads: "4/88, title, signature and '88" Signed, Inscription in pencil below the image reads: "Camino Large, 50/88, Yreina D. Cervantez, 85". Note: Central figure of a light-radiating individual with outstretched arms and large exposed heart. At the figure's right side a devilish cat snarles with sharp fangs and claws. At the figure's left are two drama masks, one yellow and one white, which are set between three burning candles. At the figure's feet are three portraits of an old woman holding a gun. Surrounding the outside of the poster are small gold figures. Text in Spanish at the top of the poster. "Multiple human images juxtaposed on a multicolored textured field, with lettering at the top of the piece." (original cataloger Note:): #Prints: 4.

Cervántez, Yreina D. *Danza Ocelotl;* 1983; Atelier 1; Artprint 25% rag; I-size: 22" x 34"; P-size: 22" x 34"; Ed#: 18/60; prnt: Stephen Grace; mtrx: Destroyed; Signed, Inscription in pencil located below the image area reads: "18/60 and signature". Fund: funded in part by the CAC, NEA, and the City of Los Angeles. Note: Female face image made up of different icons: the nose is a jaguar, cheeks are skulls and hearts, red lips, green background, and a black border with nine yellow jaguars.

Cervántez, Yreina D. *El Pueblo Chicano Con El Pueblo Centroamericano;* 1986; Atelier 7; Accent 290 gram-white; I-size: 24" x 37"; P-size: 25" x 38"; Ed#: 4/45; prnt: Stephen Grace; mtrx: Destroyed; Signed, Inscription in pencil located below the image area reads: "4/45, date and signature". Fund: funded in part by the CAC, NEA and the City of Los Angeles. Note: Freeway underpass with Mesoamerican motifs and Chicano iconography.

Cervántez, Yreina D. *La Noche Y Los Amantes;* 1987; Atelier 9; Westwinds; I-size: 25 1/2" x 19 1/2"; P-size: 25 1/2" x 19 1/2"; Ed#: 4/45; prnt: Oscar Duardo; mtrx: Destroyed; Signed, Inscription located at the bottom of image area reads: "4/45, title, date and signature". Fund: funded in part by the CAC, NEA and the City of Los Angeles. Note: Fantasy images on a purple/magenta background. Frida Kahlo, jaguar and calaveras.

Cervántez, Yreina D. *Mujer de Mucha Enagua: Pa' ti Xicana;* 1999; Atelier 33; silkscreen; I-size: 17 7/8" x 26"; P-size: 22" x 30 1/8"; Ed#: 4/60, 6/60; Signed, Inscription in pencil below image reads: "4/60, 'Mujer de Mucha Enagua': Pa' ti Xicana, Yreina D. Cervántez.". embossed "SHG" insignia on lower left-hand corner of poster; Note: To the right of the poster is a black and white photograph of a woman on Sor Juana Ines de la Cruz's nunnery dress. A Popul Vuh excerpt, "Nahuatl and Mayan Pre-Colombian glyphs address female experiences and texts from Sor Juana and Rosario Castellanos revail a lineage of female struggle and accomplishment continued in both the women of the Zapatista National Liberation Army and Xicanas"--*Maestras Atelier XXXIII 1999.* #Prints: 2.

Cervántez, Yreina D. *Victoria Ocelotl;* (Dec 4-10) 1983; Atelier 2; Artprint 25% Rag; I-size: 18" x 24"; P-size: 22" x 34"; Ed#: 4/77; prnt: Stephen Grace; mtrx: Destroyed; Signed, Inscription in pencil below the image area reads: "4/77, 12-83, title and signature". "SHG" logo below the image area in purple; Fund: funded in part by the CAC and the NEA. Note: Brown, blue, dark purple, green, gold, ochre, black background. Images of guns, helicopters, a sphere, and black glitter animals.

Cervántez, Yreina D., and Leo Limón; *Estrella Of The Dawn;* (Aug 29-Sept 2) 1988; Westwinds (heavyweight); I-size: 36" x 24"; P-size: 40" x 26"; Ed#: 17/60; prnt: Raul Castillo (Rolo); mtrx: Destroyed; Signed, Inscription in pencil located at the bottom of the print reads: "17/60, Estrella Of The Dawn, Yreina D. Cervantez y Limón -Dos De Los-' 88". embossed "SHG" on the lower right side; Note: "Cat at bottom, bird on top, open lozenge in center, corazón at upper left, people running, barbed wire in center." The major colors are: green, orange, yellow, dark blue, and light blue. Colors used: transparent red, light blue/dark blue split ftn (sic.), transparent yellow, red violet, lime green, yellow orange, red, prussion

(sic.) blue, blue green, orange yellow, transp. brown/deep red, split ftn. (sic.).

Chamberlin, Ann; *Stadium;* (Feb 21-26) 1988; Atelier 11; Westwinds; I-size: 35" x 23"; P-size: 35" x 23"; Ed#: 4/46; prnt: Oscar Duardo; mtrx: Destroyed; Signed, Inscription in faint pencil located at the bottom reads: "4/46, Stadium and signature". "SHG" chops located in the lower right corner; Fund: funded by the CAC, SHG, the NEA Visual Arts program. Note: Full Bleed. Image of seven male military figures: two are on stilts; one is balancing on a beam; one is on a table waving a red cape like a bullfighter; one is smoking a cigarette; and two are chatting.

Chamberlin, Vibiana Aparicio; *La Chola Blessed Mother;* 1998; Atelier 33; silkscreen; I-size: 19 2/8" x 15 7/8"; P-size: 26" x 20"; Ed#: 4/60, 6/60; Signed, Inscription in pencil below image reads: "4/60, La Chola Blessed Mother, Vibiana-Aparicio Chamberlin.". embossed "SGH" insignia at lower left-hand corner beneath image. Note: Colorful cartoon-like figure of a chola with two green reptiles crawling down the side of her face. The background is composed of stars and Lotería cards such as la Vibora, el Diablo, el Payaso, and la Sirena. #Prints: 2.

Charette, Damien; *Bone Yard;* February 15-17, 2000; Coventry Rag, 290 gms. I-size: 16" x 13"; P-size: 19" x 22"; Ed#: 4/91, 6/91; prnt: José Alpuche; mtrx: destroyed ex. black; signed. lower right; Note: AZ sunset with old cars. Colors used: Blend (purple, red, yellow), Red, Green, Yellow, Blue, and Black.

Charette, Damien; *Many Horses;* 1999; Atelier 33; silkscreen; I-size: 24 6/8" x 16 1/2"; P-size: 30 1/8" x 22"; Ed#: 4/69, 6/69; Signed, Inscription in pencil below image reads: "4/69, Many Horses, Damian Charette 99 ©.". embossed "SHG" insignia at lower left hand corner of poster; Note: Picture is of an indigenous woman standing to the right of the poster. She is wearing a purple skirt with moon and stars, and a white top with stars lined across her chest. There are three horses: a shadow, an outline, and a complete horse. The background is blue and the foreground is green grass. #Prints: 2.

Chavez, Roberto; *Jueves;* ca. 1992; Atelier 19 L.A. Riots; I-size: 21" x 16 1/4"; P-size: 26" x 20"; Ed#: 4/70, 22/70; Signed, Inscription in pencil below image area reads: "Jueves, 4/70, Chavez? [illegible]". embossed "SHG" chopmark in lower right corner; Note: The back view of a child in a scene of flames, fire, and what looks like broken pieces of glass. #Prints: 2.

Colacion, Lawrence; *Veterano;* 1995; poster; I-size: 38" x 26"; P-size: 44" x30"; Ed#: 40/48, 42/48; prnt: José Alpuche; Signed. bottom left corner under Ed#; Note: Drawing of a man wearing a blue bandana and a white sleeveless shirt tucked into blue slacks. His arms are outstretched with is palms turned upward. The background is surrounded by gold and blue stripes. #Prints: 2.

Cook, Ashley; *"I Will Never Be Satisfied, Will I Ever Be Satisfied?";* 1994; I-size: 21 1/4" x 24 1/2"; P-size: 38 1/2" x 29 1/4"; Ed#: 4/66, 20/66; Signed, Inscription in pencil located below the print reads: "4/66 'I will never be satisfied, will I ever be satisfied ?', Ashley Cook, '94". Note: The image is a game board with 100 squares with a black and blue/green checkered pattern. Five women, four nude, are displayed on the board with snakes and ladders. #Prints: 2.

Cooling, Janet L. *The World Is On Hard;* 1993; Images Of The Future; I-size: 16" x 22"; P-size: 20" x 26"; Ed#: 4/78, 14/78; Signed, Inscription in pencil below image area reads: "4/78, The World Is On Hard, J.[illegible] L. Cooling, 1993". embossed "SHG" insignia located in the lower left corner outside image area; Note: The central figure is an oversized rabbit--as if a genetic experiment gone wrong. The scene is a meeting of science fiction and industrialization. Factories emit smoke. A dinosaur smaller than the rabbit is running is the foreground. U.F.O.'s shine streams of light upon the city. In one stream of light a realistic looking heart is being taken from the land below. Two strips of words which look like they are cut out of newspapers state, "The worlds the" and "The world's on hard.". #Prints: 2.

Coronado, Pepe; *Bailando Con el Sol;* 1996; Atelier 29; poster; I-size: 22" x 15"; P-size: 26" x 20"; Ed#: 52/62, 54/62; prnt: José Alpuche; mtrx: Destroyed; Signed. lower left corner; Note: The earth, an emotional human figure with decorative tribal design, sunrays and the sun. Quote from Certificate of Authenticity reads "When the sun's rays touch a human being it transmits energy, that is generally manifested in happiness and positive energy."

Colors: red, green, orange, light green cream for the background. #Prints: 2.

Coronado, Sam; *The Struggle;* (Apr 22-26) 1991; Atelier 16; Stonehenge (heavyweight); I-size: 36" x 26"; P-size: 38 1/2" x 28 1/2"; Ed#: 14/65; prnt: Oscar Duardo; mtrx: Destroyed; Signed, Inscription in pencil below the image area reads: "Sam Coronado, The Struggle, 14/65". embossed "SHG" located at the right hand corner of paper; Note: "Dark figure with serpent entwined with moon in background." The major colors are: green and purple.

Cortéz, Xavier; *$.$.$ American Güey Of Life;* 1992; Atelier 19 L.A. Riots; I-size: 24 1/8" x 18 1/8"; P-size: 26 1/4" x 20"; Ed#: 4/55, 22/55; Signed, Inscription in pencil below image area reads: "$.$.$ American Güey Of Life, 4/55, X. Cortéz, .92". "SHG" embossed chopmark located on bottom right of the print; Note: The Statue of Liberty rendered in red and black and carrying a pack an waht looks like a paper in her hands. Underneath it, three images depict dollar bills, human shaped targets, and abstract images and shapes. #Prints: 2.

Costa, Sam; *Media Madness;* 1983; Atelier 1; Artprint; I-size: 19" x 25"; P-size: 23" x 35"; Ed#: 12/60; prnt: Stephen Grace; mtrx: Destroyed; Signed, Inscription in pencil "12/60, title and illegible signature". Blue "SHG" located at the bottom; Fund: funded by the NEA and the CACs. Note: Red, yellow, blue, tints and shades of all three colors on a white background. Abstracted collage effect with torn book pages and folded color relief.

Crute, Jerolyn; *The Key;* July 20, 23, and 24, 2002; Coventry Rag, 290 gms. I-size: 16"x 22"; P-size: 20"x 26"; Ed#: 4/89, 6/89; prnt: José Alpuche; mtrx: destroyed; signed. lower left; Note: Four adult figures plus one child pushing against green man with City Hall in his pocket. Two figures holding house with large key hole. Key up in the air between reaching hands with sky background. Colors used: Golden Yellow, Light Brown, Brown, Cyan, Red, Dark Brown.

Cruz, Manuel Gomez; *Barrio Flag;* 1996; poster; I-size: 25 7/8" x 38"; P-size: 30" x 44"; Ed#: 50/57, 52/57; prnt: José Alpuche; Signed. lower left corner near Ed#; Note: Drawing of a brown eagle with outstretched wings. Above the eagle is a red star-shaped image. Below the eagle's fanned tail is a green wreath with four outstretched arms touching a book. Below in a gold banner reads "Barrios United is Peace and Power." Below text is a red bar with a black cross on either end of the bar. #Prints: 2.

Cuaron, Mita; *Virgen de la Sandía;* 1996; Atelier 29; poster; I-size: 22" x 16"; P-size: 26" x 20"; Ed#: 26/63, 28/63; prnt: José Alpuche; mtrx: Destroyed; Signed. lower left; Note: A nude woman centers the print. She is surrounded by a watermelon with red, orange, yellow, and white glow. She is standing on a crescent-shaped object of what appears to be a peach colored moon. Surrounding the scene is a midnight blue sky with golden stars. #Prints: 2.

Cuellar, Rodolfo; *Artist's Daughters Gema Y Perla;* n.d. I-size: 15" x 21"; P-size: 19" x 25"; Ed#: 27/50; Signed, Inscription in pencil below image area reads: "R.O. Cuellar". Note: Enlarged photographic images of two little girls looking at the viewer in a frontal position. The background is a gradation of violet.

Davis, Alonzo; *Act On It;* (Mar 5-14) 1985; Atelier 5; Stonehenge 320 grams—white; I-size: 24" x 36"; P-size: 24" x 36"; Ed#: 4/88,30/88, 35/88; prnt: Stephen Grace; mtrx: Destroyed; Signed, Inscription in pencil below the magenta area reads: "4/88, title and signature" Signed, Inscription in pencil on the image surface on the bottom reads: "30/88, Act On It, Alonzo Davis". Note: The word VOTE on yellow, red, orange ochre background. Small photographic image in center of O. The "Vote Series" is a group of paintings and prints that emphasize the vote. The artist created apathy on the part of many of our citizens. He was born in the south when the right to vote was denied to his family because of their race. "Many people..particularly in the south have made great sacrifices to assure the right to vote for all people, and the 'Voter Series' is intended to be a nonpartisan motivator and consciousness raiser for all citizens.": #Prints: 3.

Davis, Alonzo; *King Melon;* (Jan 19-23) 1987; Atelier 9; Westwinds; I-size: 36" x 23 3/4"; P-size: 36" x 23 3/4"; Ed#: 4/45; prnt: Oscar Duardo; mtrx: Destroyed; Signed, Inscription in pencil located below the image area reads: "4/45, King Melon, signature and '87". Fund: funded in part by the CAC, NEA and the City of Los Angeles. Note: Textured field of blue, peach, green, red and pastel orange with arrows and watermelon. Full bleed.

Davis, Alonzo; *Now Is The Time;* 1988; Atelier 11; I-size: 36" x 25"; P-size: 40" x 26 1/2"; Ed#: 4/55; Signed, Inscription in pencil located at the bottom of the image area reads: "4/55, title, signature and date". "SHG" chops located in the lower left hand corner; Note: Multicolored postage stamp image that reads: "VOTE." "The print emphasizes the power and impact of the right to vote. This print is to raise the consciousness of the Jesse Jackson Presidential Campaign." A. Davis.

De Batuc, Alfredo; *Día de los Muertos 79, Announcement Poster for;* ca. 1979; I-size: 15" x 22 1/4"; P-size: 19" x 25"; Ed#: unknown ed. Signed, Inscription in blue ink below image area reads: "debatuc". Note: A male skeleton in a green and red shirt is holding a 'XX' can of beer. A female skeleton in a red, non-sleeved dress is wearing hoop earrings. They are smiling, holding each other's waist, and dancing against an oval composition consisting of a moon, a sun, and a starry night. Above them, a banner in red-white-green reads: "Viva la vida / viva el amor / muera la muerte" The four corners of the larger composition present one skull each with specific symbols for the seasons, described in individual banners: flowers for "Primavera"; leaves for "Verano"; corn for "Otoño", and snow balls for "Invierno". #Prints: 2.

De Batuc, Alfredo; *Emiliano con suecos;* (June 21-25) 1994; Atelier 24; Coventry Rag 290 grms. I-size: 36 7/8" x 24"; P-size: 44" x 30"; Ed#: 4/62, 20/62; prnt: José Alpuche; mtrx: Destroyed; Signed, Inscription in pencil below the image reads: "Emiliano con suecos, 20/62, debatuc, 1994". embossed "SHG" on the lower left; Note: "Emiliano Zapata, after one of his most famous photographic portraits, holding an umbrella instead of a rifle, and naked from the waste down and wearing wooden clogs. Surrounded by text in English and Spanish that read: Stock Cultural Images and Symbols; Cultural and Political Symbols that are Easily Recognizable; Unfortunately Overuse Has Rendered Many Of These Symbols Inane." Main colors are yellow, red and light blue. #Prints: 2.

De Batuc, Alfredo; *Seven Views Of City Hall;* (Jan 13-16) 1987; Atelier 9; Westwinds; I-size: 24" x 36"; P-size: 26" x 40"; Ed#: 12/45; prnt: Oscar Duardo; mtrx: Destroyed; Signed, Inscription in pencil located below the image area reads: "12/45, title, signature and '87". Fund: funded in part by the CAC, NEA and the City of Los Angeles. Note: Los Angeles City Hall in the center surrounded by six small City Halls in ovals.

De la Loza, Ernesto; *Siqueiros, Announcement Poster for;* 1994; I-size: 34" x 19 1/2"; P-size: 35" x 23"; Ed#: A/P 15/17, A/P 16/17; Signed, Inscription in pencil located at the bottom reads: "A/P 15/17, Ernesto Cokos [illegible], 94'". embossed "SHG" at the bottom left; Note: Announcement Poster for *"Siqueiros--July 26, 1994-- Back On The Street.* Silk Screen in black and red ink. Central image of an indigenous man being crucified. There is an eagle with its wings open at the top of the cross. Large lettering at the top of the print reads: "Siqueiros". Below the main image in red reads: "'America Tropical' Olvera St. L.A. 1932". #Prints: 2.

De la Sota, Raoul; *Spanish History;* 1993; Images Of The Future; I-size: 22 1/8" x 16 1/8"; P-size: 26" x 20"; Ed#: 4/72, 12/72; Signed, Inscription in pencil below image area reads: "4/72, Spanish History, Raoul De la Sota '93". embossed "SHG" insignia located in lower left corner outside image area; Note: The print is divided into four boxes or "windows." The two upper boxes are shorter and have a blue frame. The view inside is of a night sky or outer space. In the upper left-hand side a moon, a meteor, colored dots which could be planets or stars are shown against a black and purple background. A shape of a mountain or another large object begins in this box and continues into the box on the upper right-hand side. The same scene continues without the moon and meteor. The lower boxes are framed in yellow. Again the scenes are similar. The lower half of the boxes depict yellow land with churches, other buildings and abstract shapes dotting the landscape. The upper half of each box is yellow sky. Dark clouds obscure the yellow. #Prints: 2.

De Montes, Robert Gil; *Movie House;* (Feb 8-12) 1988; Atelier 11; Westwinds; I-size: 36" x 24"; P-size: 36" x 24"; Ed#: 4/49; prnt: Oscar Duardo; mtrx: Destroyed; Signed, Inscription in pencil located at the bottom reads: "4/49, signature and 88". "SHG" chops located in the lower right hand corner; Note: Image of a single figure, a man in front of the sea. Separate frame design. "A man is standing in front of the sea with his eyes closed, his arms extended, the sky is at sunset, the end of a happy day." R.G. De Montes.

Delgadillo, Victoria; *Knowingly Walking Through the Imaginary River Towards Divine Destiny;* 4/30, 5/1-5, 2002; Coventry Rag, 290 gms. I-size: 16"x 22"; P-size: 20"x 26"; Ed#: 4/82, 6/82; prnt: José Alpuche; mtrx: destroyed; signed. lower left; Note: Colors used: Light Yellow, Dark Yellow, Pale Grey, Dark Green, Red, Dark Blue, Light Blue Transparent, Medium Yellow, Yellow-Green, Brown, Salmon Pink, Beige, Medium Yellow.

Delgado, Roberto; *Guatemala;* n.d. I-size: 37" x 25"; P-size: 37 3/4" x 25 7/8"; Ed#: 31/53; Signed, Inscription in pencil below image area reads: "signature [illegible], Guatemala, 31/53". embossed "SHG" insignia located in lower left corner inside image area; Note: The print is a multi-colored abstract piece. Orange figures converge on top of pale green and yellow figures. It seems as if heads of various animals--lizards, birds--erupt from a place directly in the middle of the print.

Delgado, Roberto; *Loto;* (Dec 19-20) 1985; Atelier VI; Accent 290 gram—white; I-size: 38" x 24 1/2"; P-size: 38 1/2" x 25"; Ed#: 4/45; prnt: Stephen Grace and Roberto Delgado; mtrx: Destroyed; signature/inscription: Signed; Inscription in pencil located in the lower right in white area reads: "Initials, 86, and 4/45". Note: Abstract imagery is composed of a stylized portrait of a green man superimposed on a yellow silhouette of a human figure. Upon these images is a large red flower and surrounding them are abstract fields of color and shapes. "Monoprint edition over silkscreen and spray enamel stenciling."--Roberto Delgado.

Delgado, Roberto; *Untitled;* (March 14-15) 1984; Atelier 3; Somerset 320 gram, textured white 100% Rag. I-size: 21 1/2" x 31"; P-size: 26 1/2" x 37"; Ed#: 2/70, 11/70; prnt: Stephen Grace; mtrx: Destroyed; Signed, Inscription in pencil below image area reads: "2/70, signature and '84". Note: Two female glyph (Mayan ornamental carving). Tints and shades of secondary color group. Atelier information on the back. #Prints: 2.

Donis, Alex; *Between The Lines;* 1992; Atelier 19 L.A. Riots; Westwinds; I-size: 21 5/8" x 35"; P-size: 21 5/8" x 35"; Ed#: 22/49; prnt: Richard Balboa; mtrx: Destroyed; Signed, Inscription in pencil below image area reads: "22/49, Maria [illegible], 92". lower left corner; Note: Full bleed image vertically divided into two main areas, purple to the left, vanilla color to the right. In the left area is a pink form in the shape of a heart which allows to see through a photograph of a young man from the bust and up. In the center of the composition is a bigger photograph of a person, probably a man, who seems to be lying down. To the right is an enlarged photograph of a tree leaf. Enlarged hand written text in gold color extends all over the composition. Colors used: 1. Biege, 2. (Red Shade) Yellow, 3. Flouresent (sic.), 4. Cyan Blue, 5. Purple, 6. Fouresent (sic.) Green, 7. Gold (Metalic). "This image mirrors various memories of my past and acts as a catalist (sic.) between dark episodes in my life and a new found hope. The dried leaf and petal act as testament to [the] fact that if you live in the past you can't make yourself availalble to the future and will surely wither away. I've also explored the everlasting implications that the written word has and in this case it finds it's metaphor in the form of a 'Dear John' letter." A. Donis.

Donis, Alex; *Champ De Bataille;* (Oct 9-13) 1989; Atelier 14; Westwinds; I-size: 36" x 24"; P-size: 38" x 26"; Ed#: 4/61, 14/61; prnt: Oscar Duardo; mtrx: Destroyed; Signed, Inscription in pencil below the image reads: "14/61, Champ de Bataille, A Donis" Signed, Inscription in pencil located below the image area reads: "4/61, title, and signature". Bottom right hand corner of paper. Note: "There are two angels with wings, one is red-orange in color, the other is blue-green. They are holding each other close by the arms and each one is holding a sword over-head. The background color is purple with gold colored writing." Colors used: 1. Tran. Lt. Powder Blue, 2. Tran. Milorie (sic.) Blue, 3. Tran. Violet, 4. Golden Yellow, 5. Peach, 6. Lt. Pastel Yellow, 7. Lt. Pastel Magent (sic.), 8. Tran. Lime Green, 9. Red-Orange, 10. Purple, 11. Gold, 12. Tran. Peralesence (sic.) White. "It was a dream, it was all a dream." A. Donis. #Prints: 2.

Donis, Alex; *David and Dalilah;* (April 15-19) 1991; Atelier 16; Westwinds; I-size: 35" x 26"; P-size: 40" x 28"; Ed#: 56/63; prnt: Oscar Duardo; mtrx: Destroyed; Signed, Inscription in pencil below the image reads: "56/63 'David and Dalilah', A Donis, 91". Bottom center of image; Note: "This is an oval shaped print

boardered by yellow drapery, angels, and stars. With in [sic] this boarder [sic] stands a central man, standing on a platform, swinging a sling-shot. A bed is behind him with a woman seated on it. Beneath the platform lay a woman and a nude man, who is facing down." Colors used: 1. Tran. Lt. Brown, 2. Tran. Flesh, 3. Tran. Golden Yellow Ochar (sic.), 4. Tran Cyan, 5. Tran. Magenta, 6. Tran. Lt. Blue, 7. Tran. Lt. Pastel Yellow, 8. Tran. Lt. Pale Pink, 9. Tran. Vilot (sic.), 10. Tran. Dr. Cobalt Green, 11. Yellow shade Gold. "This print represents my reaction toward the battles we wage against each other in the arena of human relations. The wounds we inflict cut deeper than any sword and the pain we endure is just as overwhelming. As all of the David's and the Dalilah's have proven throughout the ages, there are no victors in the games of love and war[,] only victims." A. Donis.

Donis, Alex; *LA Queen;* (Sept 14-15) 1991; Special Project; Westwinds; I-size: 35" x 26"; P-size: 40" x 28"; Ed#: 11/40; prnt: Richard Ball..[illegible]; Signed, Inscription in pencil within the image's lower ribbon reads: 11/40, 'La Queen', A Donis, 91". Lower right hand corner. <u>Note</u>: Colors used: 1. Red Oxide Brown, 2. Light Ochre Flesh Tone, 3. Yellow, 4. Cyan Blue, 5. Magenta, 6. Crimson Red, 7. Black. "A beauty queen in a blue gown stands befor [sic] red curtains and below a theatrical marquee which displays in brilliant red lettering 'L.A. Queen.['] The entire piece is framed by playful cherub angels.".

Donis, Alex; *Rio, Por No Llorar;* (Nov 28-Dec 2) 1988; Atelier 12; Westwinds (heavyweight); I-size: 36" x 23"; P-size: 39" x 26"; Ed#: 30/59; prnt: Oscar Duardo; mtrx: Destroyed; Signed, Inscription in pencil below the image reads: "30/59, Rio, Por No Llorar, A Donis". Lower right hand corner of image; <u>Note</u>: "A Brazilian (or Latin) woman in carnival costume & fruit headdress [slice of water-melon, can of coffee, bunch of bananas, etc.] entwined in barbed wire & thorns. The figure [is] bordered by a film strip & musical instruments." Colors used: 1. Green/Light Lime Green, 2. Grown, 3. Red, 4. Flesh, 5. Orange-Yellow, 6. Purple/Magenta, 7. Lt. Pastel Green, 8. Yellow, 9. Tran. Light Flesh, 10. Blue (Tran.), 11. Black, 12. Tran. White. "Basically my print is a statement about oppression. It's about poeple who struggle to survive while thier lands are stripped away and her (sic.) resources siphoned. I recently read the lyrics to a song which I think most clearly defines my piece: '..So take a good look at my face, You'll see my smile looks out of place, Look even closer it's (sic.) easy to trace, The track (sic.) of my tears." A. Donis.

Duardo, Richard; *The Father, The Son And The Holy Ghost;* (Feb 29-Mar 6) 1988; Atelier 11; Westwinds (heavyweight); I-size: 36 3/4" x 23 3/4"; P-size: 36 3/4" x 23 3/4"; Ed#: 4/45; mtrx: Destroyed; Signed, Inscription in pencil at the bottom of the image area reads: "signature, In the Beggining [sic], Disney Created God, and 4/45". "SHG" chops located in the lower left hand corner; <u>Note</u>: Portrait of Mickey Mouse hovering over a robot. Colors used: 1. Yellow, 2. Red/Purple (split fountain), 3. Colbalt (sic.) Blue, 4. Mint Green, 5. White, 6. Black. "Well, it was quite a spontaneous activity indeed. The content of this image is totally appropriated from the com-monplace of contemporary culture. Their layout is to indicate the following: Mickey, omnipotent god (benevolent and happy); the robot, man on earth, a replicant of god---Symbols: O.K., meaning everything is well on earth." R. Duardo.

Duardo, Richard; *Untitled;* (Jan 25-Feb) 1985; Atelier 5; Stonehenge 320 gram-white; I-size: 25" x 36"; P-size: 28 3/4" x 41"; Ed#: 4/88, 6/88, 35/88; prnt: Stephen Grace; mtrx: Destroyed; Signed, Inscription in pencil below the image area reads: "4/88, and signature" Signed, Inscription in pencil located below the image reads: "6/88, Richard Duardo". <u>Note</u>: Female torso in a black bathing suit on a blue, light green, and pink background. Green Japanese characters. (Made in U.S.A.). #Prints: 3.

Duardo, Richard; *Untitled;* (Jan 27-Feb 2) 1984; Atelier 3; Somerset 320 gram, textured 100% Rag. I-size: 24" x 35"; P-size: 27 1/2" x 39 1/2"; Ed#: 2/80, 8/80, 11/80; prnt: Stephen Grace; mtrx: Destroyed; Signed, Inscription in pencil below image area reads: "2/80, and signature". <u>Note</u>: "Fourteen color image of boy (sic.) george (sic.): white, light flesh, pink, light green, metallic gold, light blue, yel-low, fire red, metallic silver, dark metallic silver, metallic silver blue, metallic silver red, medium flesh, and black." Atelier infor-mation on the back. Image of Boy George wearing a hat. There is a light green cross behind his image. Symbols resembling heiro-gliphics partially frame Boy George. A small light green image of

the world is situated under Boy George's head. Main colors are: light green, yellow, black and pink. #Prints: 3.

Duardo, Richard; *Veronika's Flight;* (Mar 14-19) 1994; Atelier 24; Coventry Rag 290 grms; I-size: 28 1/2" x 41"; P-size: 29 1/2" x 43 1/2"; Ed#: 4/72, 20/72; prnt: José Alpuche; mtrx: Destroyed; Signed, Inscription in pencil below the image reads: "4/72, Richard Duardo". lower left corner; <u>Note</u>: "Horizontal format, nude female figure with wings moving thru [sic] stylized aqua environment left to right w/ a gold and black border of fragmented metal." Colors used: 1. Mint green, 2. Pastel green, 3. Salmon, 4. Powder blue, 5. Magenta, 6. Purple, 7. Pastel Red, 8. Metalic (sic.) gold, 9. Blue, 10. Black, 11. Ultramarine, 12. Emerald green. "Portrait of [a] nude female figure in a horizontal flight thru either air or water." R. Duardo: #Prints: 2.

Duardo, Richard; *Zen;* 1998; Atelier 31; I-size: 36" x 27 1/2"; P-size: 38 3/8" x 30"; Ed#: 4/70, 6/70; prnt: José Alpuche; Signed. lower left; <u>Note</u>: "Abstract with central box of text: "Art, Fun, God" stencils were greated in a generative process. The print was fully deter-mined by a collaborative effort by both participating artist and master printer, Alpuche. Last two colours pulled were selected by printer. A zen exercise in process." R. Duardo. Colors used: 1. Rich Brown, 2. Brick (t), 3. Lt. Yellow, 4. Lt. Grey, 5. Black, 6. Maroon, 7. Silver. "Elaboration is indescriptoin section. But to add; the end result of the graphic created was my least consideration. I approached this with the intent and purpose of working for a fixed amount of time with a community of craftmen skilled in a process (print making) to interact and react to what was unfold-ing on the sheet ofpaper as our time progressed. The piece was finished wwhen our time ran out at which point in keeping with my intent, the piece was resolved." R. Duardo. #Prints: 2.

Duffy, Ricardo; *Beaning Indigenous;* (Mar 10-15) 1991; Atelier 16; Westwinds; I-size: 34 5/8" x 23 5/8"; P-size: 38 1/4" x 27"; Ed#: 14/64; prnt: Oscar Duardo; mtrx: Destroyed; Signed, Inscription in pencil located below the image reads: "14/64, 'Beaning Indigenous', Richardo Duffy". Bottom left-hand corner of bottom (sic.); <u>Note</u>: "A Pinto Bean Floating in the night sky with stars out. The background with corn stalks behind the Bean, futher back the corn is a black back drop." Colors used: 1. Light transparent tan, 2.Cyan Blue, 3. Transparent Lime, 4. Transparent Tan-Red, 5. Dark Brown, 6. Ochore (sic.), 7. Yellow, 8. Black, 9. Sandy Brown, 10. Red Brown, 11. Trands (sic.) White, 12. Trans Beige. "My prints pay homage to the staple diet that nourishes the native peoples of Meso-America. In my own home while cleaning pinto beans I was intrigued that no two beans were alike, then I suddenly invisioned a huge Pinto Bean to represent the oneness and the uniqueness of my people. Besides representing another staple, the corn, also symbolizes growth, life, death, renewal, and our ties to mother earth. The stars refelct my feelings tjat (sic.) we are bound to universal law." R. Duffy.

Duffy, Ricardo; *Primavera;* (May 31-June 3) 1994; Atelier 24; Coventry Rag 290 grms; I-size: 24" x 37"; P-size: 30" x 44"; Ed#: 4/64, 20/64; prnt: José Alpuche; mtrx: Destroyed; Signed, Inscription in pen-cil below the print reads: "4/64, 'Primavera', Richardo Duffy". lower left; <u>Note</u>: "Jaguar at spring time done in earth tones with mucho breastsesesese's" R. Duffy. Colors used: 1. Orange-yellow, 2. Red Cadmium, 3. Burnt Umber, 4. Burnt Siena (sic.), 5. Yellow Cadmium, 6. Gold, 7. Black, 8. Maphthol (sic.) Red. 9. Magenta. "The Jaguar is an ancient symbol of the Americas which I use to make a timeless statement about Sprint (Primavera) one of the four seasons in our yearly cylce on earth." R. Duffy. #Prints: 2.

Duffy, Ricardo; *The New Order;* n.d. Atelier 29; I-size: 22" x 16"; P-size: 26" x 20"; Ed#: 4/75; Signed. lower left; <u>Note</u>: Desert cliffs in back-ground with "Marlboro County," George Washington smoking a cigarette, Prop 187, and a caution sign.

Durazo, Martin Philip; *General Electric;* (July 1-3) 1992; Atelier 19 L.A. Riots; Westwinds; I-size: 17" x 24 1/2"; P-size: 20" x 28"; Ed#: 4/57, 22/57; prnt: Richard Balboa; mtrx: Destroyed; Signed, Inscription in pencil below image area reads: "General Electric, 4/57, Durazo, 1992". lower lt (sic.) under vase; <u>Note</u>: Multicolored image com-posed of glasses, dollar signs, circles (coins?). The center of the composition is a vase with flowers. To the right is the enlarged symbol for General Electric company. Colors used: 1. Blue, 2. Yellow, 3. White, 4. Lt. Purple, 5. Red, 6. Green. "General Electric is a multi level comment on the abusive behavior of humans

toward their surroundings because of greed and stupidity." M.P.Durazo: #Prints: 2.

Ehrenberg, Felipe Enriquez; *Anafre;* (March 7) 1998; Atelier 31; Coventry Rag, 290 grms; I-size: 21" x 26 1/2"; P-size: 25 1/2" x 30 1/8"; Ed#: 4/56, 6/56; prnt: José Alpuche; mtrx: Destroyed; Signed. lower right; Note: Nude woman sitting under a tree with some books at her side, a coal burner (Anafre) on right. Colors used: 1. Green, 2. Red, 3. Dark Brown, 4. Peach, 5. Yellowish White. "See 'Paella' Certificate." F. Ehrenberg: #Prints: 2.

Ehrenberg, Felipe Enriquez; *Mi Hogar en Istelei;* 1995; poster; I-size: 10" x 38"; P-size: 15" x 44"; Ed#: 36/47, 40/47; prnt: José Alpuche; mtrx: Destroyed; Signed. lower right; Note: The print is long and horizontal in shape. On the left is an architect's blue-print ground plan for a one-room house with outdoor attachments. On the right, against a sunsetting sky, is the same stone house in perspective. A cross and a necktie hanging from it, tower over the house. #Prints: 2.

Ehrenberg, Felipe Enriquez; *Nudos-Ties-SHG L.A. (x-95);* 1995; Atelier 13; poster; I-size: 16 7/8" x 11"; P-size: 22" x 15"; Ed#: 32/47; prnt: José Alpuche; mtrx: Destroyed; Signed. yes; lower left hand corner; Note: A rectangular shaped object is the focus of this print with a white cloth covering it. There are different colored ties over this object with a dark string holding them in place. Colors: red, black, and cream white.

Ehrenberg, Felipe Enriquez; *Otra Canelita;* (Feb 12-17) 1994; Atelier 24; Coventry Rag 290 grms; I-size: 22 3/8" x 38"; P-size: 30" x 44"; Ed#: 4/66, 20/66; prnt: José Alpuche; mtrx: Destroyed; Signed, Inscription in pencil below the image reads: "Ehrenberg, Otra Canelita, 4/66, '94". lower right; Note: "A large room. Two windows on the lef (sic.) allow the light to fall on [a] young woman, on right, covered by towel and wearing [a] turban, who stands before a mirror. Greenish specks of light dance in the room, in the middle." Colors used: 1. Dark Orange, 2. Burnt Umber (Deep), 3. Off White, 4. Light Green, 5. White. "'Otra Canelita' is [a] second silkscreen work, one of a series of very intimate, very loving, portraits of [a] wife, Lourdes, always in a home cirmustance." F. Ehrenberg: #Prints: 2.

Ehrenberg, Felipe Enriquez; *Paella;* (Mar. 7) 1998; Atelier 31; Coventry Rag, 290 grms; I-size: 15"x 25"; P-size: 18' x 30"; Ed#: 4/55, 6/55; prnt: José Alpuche; mtrx: Destroyed; Signed. lower right; Note: Nude woman with one arm up in the air and the other is around her neck. Colors used: 1. Green, 2. Red. 3. Dark Brown, 4. Peach, 5. Yellowish White. "This one was printed at the same time as 'Anafre'. Both 'Paella' and 'Anafre' form part of a larger series of drawings and prints (mostly nudes) of my 'calendar—comic book style' of work." F. Ehrenberg. #Prints: 2.

Ehrenberg, Felipe Enriquez; *Primero De Enero-I;* (Feb 12-17) 1994; Atelier 24; Coventry Rag 290 grms; I-size: 18" x 26"; P-size: 22" x 28"; Ed#: 4/55, 22/55; prnt: José Alpuche; mtrx: Destroyed; Signed, Inscription in pencil located below the print reads: "Ehrenberg, Primero de Enero-I, 4/55". lower right; Note: "An [enormous] amount of crutches rises from the ground and marches across the horizon, as the light of dawn begins to rise." Colors used: 1. Mango Orange, 2. Night Blue, 3. Burnt Umber, 4. Off White, 5. White. "The crutch is a recurren (sic.) ikon (sic.) in most current works. It is a metaphor: Invalids [who] throw away crutches are healed --- [I] have used crutches in drawings, installations, now screenprint. This peice marks the excitement produced by the war in Chiapas. It is also a suggestion for new installations." F. Ehrenberg: #Prints: 2.

Ehrenberg, Felipe Enriquez; *Primero De Enero-II;* (Feb 12-17) 1994; Atelier 24; Coverntry 290 grms; I-size: 18" x 26"; P-size: 22" x 28"; Ed#: 4/55, 22/55; prnt: José Alpuche; mtrx: Destroyed; Signed, Inscription in pencil below the image reads: "Ehrenberg Primero de Enero-II, 4/55, '94". lower right; Note: "In the background, the faintest suggestion of jungle land; in the foreground, long planks are violently pushed up and splinter in the air, suggesting a volcano." Colors used: 1. Mango Orange, 2. Night Blue, 3. Burnt Umber, 4. Off White, 5. White, 6. Transparent Dark Green. "This work is also a suggestion for an installation planned on Jan 8th for a show, that was then cencelled, it will require 7 long, thick planks that will be snapped in half by force, then layed out over a pile of earth and coals. In doing this print I also develop the idea (sic.)." F.Ehrenberg. #Prints: 2.

Ehrenberg Enriquez, Felipe; *Tiankistli;* (Oct 2-6) 1995; Coventry; I-size: 35 1/2" x 25 5/8"; P-size: 38" x 28 5/8"; Ed#: 24/54, 26/54, 30/54, 32/54; prnt: José Alpuche; mtrx: Destroyed; Signed. lower right corner below signature; Note: In the center of the poster is a wood structure which is supporting a large piece of yellow cloth. The structure is standing on a yellow circle with flames radiating from the object. Next to the structure is a book shelf with legs in the compartments. In the background are a series of lines which appear to be barbed wire. Two multicolored neck ties rest on the wires. The poster also contains ink splotches and illegible text. It is a study for large installation shown in "Todos Santos, October 1995 Exhibit." Colors used: 1. O. Red, 2. O. Black, 3. T. Cream White. "A joyfull vaiation on large tiankistli print, based on installation pi (sic.) presented in 'all souls' exhibition, October 1995 Galeria Otra Vez, SHG." F. Ehrenberg Enriquez: #Prints: 3.

Esparza, Elena; *I Know Her.. All About Her;* May 7-11 and 30, 2002; Coventry Rag, 290 gms. I-size: 16"x 22"; P-size: 20"x 26"; Ed#: 4/67, 6/67; prnt: José Alpuche; mtrx: destroyed; signed. lower left; Note: Woman in Central Figure surrounded by a corona of maguey plants. 2 spirits appear (L.L. corner) in the foreground while a third in the background tells (URHC) the story. A humming bird hovers above the woman, with LA central and the Belmont tunnel from the background as a point of reference. Colors used: Orange/Red-Opaque, Sage Green-Opaque, Marigold-Semi Opaque, Lime Green- Transparent, Magenta-90% Opaque, Electric Blue-Semi Opaque, Dark Maroon-90% Opaque.

Esparza, Ofelia; *Cesar Vive;* (Sept 28-Apr 15) 1993-94; Atelier 24; Coventry Rag 290 grms; I-size: 22" x 16"; P-size: 26" x 20"; Ed#: 4/60, 20/60; prnt: José Alpuche; mtrx: Destroyed; Signed, Inscription in pencil below the image reads: "4/60, Cesar Vive, Ofelia Esparza, '94". lower left; Note: "The Image of Cesar Chavez appears integrated into an ear of corn in yellows + greens within a a [sic] red circle where a blk. Aztec Eagle Soars. All this against a blue backgorund with an outlined, eagle pattern. The script: "Cesar Vive" flows along the rt. side of the circle dowward [sic], from where it has surged along w/a large ear of corn composed of skull kernals. Below, new ones sprout w/figures bearing farmworkers flags. The leaves and flowing plant grow out of the earth and skulls." Colors used: 1. Flesh (beige), 2. Yellow, 3. Bright Blue, 4. Red, 5. Sage Green, 6. Dark Blue, 7. Rust-Orange, 8. Black. "Cesar Vive (sic.)—is an allegorical composition which signifies what it states. Cesar Chavez lives in the symbolic Corn (Maiz) plant—nurtured by the new workers (new sprouts) who will carry on his work—they are nurtured by the ones who have gone before them (the skulls in the earth) who continue the cycle—as in the corn plant—to keep not only Cesar's memory alive—but his struggle for farmworkers and other poor laborers continues—reseeding itself to begin again with new seedlings—thus the red circle—the Aztec Eagle, of course, stands for the Farm Workers Union. The skull kernals signify the cycle of life and death—Cesar's death awakens the new and old people to bring the struggle to life again and again." O.Esparza: #Prints: 2.

Esparza, Rubén; *Hyper Myth;* August 21-24, 2001; Coventry Rag, 290 gms. I-size: 10" x 20"; P-size: 20" x 26"; Ed#: 4/70, 6/70; prnt: José Alpuche; mtrx: destroyed; signed. lower left; Note: "hyper" against yellows background. "Myth" against blues background silkscreen "dyptich" Colors used: Clear Base, Warm Red, T. Yellow, Baby Blue, T. White, Red Shade Blue, and Clear Gloss.

Espinosa, Carlota; *We The People;* (Aug 22-26) 1988; National Chicano Screenprint Taller, Wight Art Gallery, UCLA; Westwinds (heavyweight); I-size: 36" x 24"; P-size: 40" x 26"; Ed#: 17/65; prnt: Oscar Duardo; mtrx: Destroyed; Signed, Inscription in pencil below the image reads: "We The People, 88, Carlota Espinoza, 17/65". bottom left hand corner; Note: There is a woman holding a dove. The background is a flag dripping black, red, and blues. Colors used: 1. Trans. Ultramarine Blue, 2. Trans. Light Brown, 3. Reddish Brown, 4. Trans. Pink, 5. Red, 6. Ultramarine Blue, 7. Black, 8. Flesh, 9. Rusty Red, 10. Cerulean Blue (50% transparent).

Favela, Ricardo; *Aqui Estamos..,* 1987; I-size: 15 1/2" x 21"; P-size: 19" x 25"; Ed#: 20/50; Signed, Inscription in pencil below image area reads: "Richardo Favela 87'". blue ink repeats the logo 'RCAF'; Note: Three men (who?) in black and white looking at the viewer and showing images of `Día de los Muertos', and 'Tiburcio Vasquez'. The men are inscribed in an orange-yellow gradation where blue ink repeats the logo 'RCAF'. In the background there

is a blue gradation where pink-violet type reads: "Aqui estamos.. / Y no nos vamos!!! / 'We're still here.. 18 years later.'.

Fe, Sonya; *Don't Become a Dish to a Man.. You Will Soon Break;* 1996; Atelier 29; poster; I-size: 16" x 22"; P-size: 20" x 26"; Ed#: 26/63; prnt: José Alpuche; mtrx: Destroyed; Signed. lower left corner; Note: Scene of a broken doll with cracked dishes in the background. Doll has orange skin and long dark hair. Dishes are colored gray-green.

Flores, Florencio; *Jagar;* (March) 1983; Atelier 1; Artprint; I-size: 19" x 25"; P-size: 23" x 35"; Ed#: 37/60; prnt: Stephen Grace; mtrx: Destroyed; Signed, Inscription in pencil reads: "37/60 and signature". No chop; Fund: partially funded by the NEA and the CAC. Note: Red, blue, and gray car in the center. Burnt umber background with white "SCOT" and yellow "REX" letters on a gray and black dotted foreground. Colors used: 1. Red, 2. Blue, 3. Yellow, 4. Black, 5. Rust.

Flores, Lysa; *The Making of a Trophy Grrl!;* May 21-25; Coventry Rag, 290 gms. I-size: 16" x 22"; P-size: 20"x 26"; Ed#: 4/75, 6/75; prnt: José Alpuche; mtrx: destroyed; signed. lower right; Note: Colors used: Red, Ivory/Beibe, Pink Flesh Tone, Burgundy/Red, Blue, Purple, Black, Yellow, and White.

Flores, Yvette; *Greñuda;* April 3-7, 2001; Maestras 2; Coventry Rag, 290 gms. I-size: 18" x 26"; P-size: 22" x 30"; Ed#: 4/74, 6/74; prnt: José Alpuche; mtrx: destroyed; signed. lower left; Note: A little girl is getting her hair done by her mother. The words surrounding the girl express the frustration being felt by her. The colors around her are messy and random, like her hair. Colors used: Yellow Light, Orangel Yellow, Red Orange, Ultra Marine Blue, Medium Flesh, Light Blue, Maroon, Ivory White, and Light Red Orange.

Furukawa, Michiko; *Obsesión De La Muerte;* (Apr) 1994; Atelier 24; Coventry Rag 290 grms; I-size: 18" x 23 1/4"; P-size: 20" x 26"; Ed#: 4/55, 20/55; prnt: José Alpuche; mtrx: Destroyed; Signed, Inscription in pencil below the image reads: "4/55, 'Obsesión de la Muerte', Michiko, '94". lower left; Note: "Arbol de la vida." Spanish text encircles a purple linear tree/trail. Candles stand on seven upper curved areas. Figures, skeletons, flowers and birds perform along the branches/trails. Colors used: 1. Yellow, 2. Magenta, 3. Cyan Blue, 4. Flesh, 5. Gray, 6. Black, 7. Gold, 8. Dark Green. "Depicted as an 'Arbol de la Vida' which at the same time is an 'Arbol de la muerte'. It is a representation of how one Mexico died. A society that had existed centuries, along with it's culture, religion and language was all but extinguished and a new social order was instituted using Christianity as the cement which hold[s] it together." M. Furukawa: #Prints: 2.

Gallego, Adriana Yadira; *Luna Roja;* (May 5, 6, 7, 8 and June 9) 1998; Atelier 29-31 #4 & #6; Coventry Rag, 290 grms. I-size: 22 1/8" x 17 1/4"; P-size: 26" x 20"; Ed#: 4/52, 6/52; prnt: José Alpuche; mtrx: Destroyed; Signed. Lower left corner; Note: Headless woman's torso wrapped in barbed wire. Two green leaves are around her and a red moon behind her body. Colors used: 1. Yellow, 2. Green, 3. Red, 4. Purple, 5. Sienna, 6. Light Sienna, 7. Dark Green, 8. Burgandy—Crimson, 9. Brown. "'Luna Roja' is part of a border series representing the psychological manifestation of the border experience on the body. Here the woman is incomplete, standing between borders. The barbed wire pierces her as it does the leaves of the maguey plant growing out of her. Her experience is recorded and witnessed by the red moon.": #Prints: 2.

Gamboa, Diane; *Altered State;* 1999; Atelier 33; silkscreen; I-size: 18" x 26 1/4"; P-size: 22" x 30 1/4"; Ed#: 4/75, 6/75; Signed, Inscription in pencil below image reads: "4/75, 'Altered State', Gamboa 99.". embossed "SHG" insignia lower right next to signature. Note: "The poster creates a scenario where the boundaries between love, sexuality, and the religious are blurred, while exploring the centrality of women, and the power of the feminine in these spheres"--*Maestras Atelier XXXII 1999.* #Prints: 2.

Gamboa, Diane; *Little Gold Man;* (Feb 12-16) 1990; Atelier 15; Westwinds (heavyweight); I-size: 36" X 24"; P-size: 38" X 26"; Ed#: 2/73, 4/73, 16/73; prnt: Oscar Duardo; mtrx: Destroyed; Signed, Inscription in pencil below image area reads: "2/73, title, signature and 90" Signed, Inscription in pencil located below the image reads: "16/73, Little Gold Man, Gamboa, 90". Outside right-hand corner of image. Note: Eight light-green skinned figures, whose focus is a gold horned pink creature with a tail, and a small gold man on the top of his hat. Very elaborately decorated interior with tables, chairs, curtains, etc. "A black line drawing of figures

in an interior setting is used in trapping eleven other colors:" tan, mint green, aqua, lime green, pink/red, blue/grey, green, light violet, dark green, gold, dark violet, and black. "[At the] center right is a Little Gold Man dancing on the head of a boy/dog like figure." Colors used: 1. Tan, 2. Mint Green, 3. Aqua, 4. Lime Green, 5. Pink/Red, 6. Blue/Gray, 7. Green, 8. Light Violet, 9. Dark Green, 10. Gold, 11. Dark Violet, 12. Black. "The image/artwork for this print was spcifically designed for the Atelier 15 program. The original drawing was created directly onto the acetate with and inked bruch and technical pen. Through a series of overlappng and underlapping the positive/acetate for each color, I continued to build texture and detail. The LITTLE GOLD MAN himself is the focal point of the other figures in th epiece but at the same time is only on of the many figures invovled in this print. As in all the other pints I have created thorugh the Atelier program I have attempted to work on an image using a new technique that is very different from my other prints." D.Gamboa. #Prints: 3.

Gamboa, Diane; *Lost And Found;* 1994; I-size: 26" x 30"; P-size: 30" x 34"; Ed#: 4/49, 20/49; Signed, Inscription in pencil below the image reads: "4/49, Lost and Found, Gamboa, 94". embossed "SHG" below the image on the bottom right side; Note: Many figures make up the image. The central figure is a male wearing a crown with a heart pierced by a dagger. On the upper left is a man wearing a suit with gold pinstripes and circles on the lapels. A red headed female figure with exposed breasts is situated behind another heart with a dagger piercing it. These figures seem to be inside a palace with curtains, rugs and pillars. Main colors are: purple, light yellow, avocado green, gold and red. #Prints: 2.

Gamboa, Diane; *Malathion Baby;* (June 18-29) 1990; L.A. Festival; Westwinds (heavyweight); I-size: 48" x 36"; P-size: 50" x 38"; Ed#: 4/79; prnt: Oscar Duardo; mtrx: Destroyed; Signed, Inscription in pencil below the image reads: "4/79, Malathion Baby, Gamboa, 90". bottom of left-hand corner of image; Note: "Eight figures in malathion yellow are grouped for a snap shot. Flowers in pink and red with gold throughout image. Malathion Baby is traped with a black outline." Colors used: 1. Dark Yellow, 2. Yellow, 3. Red, 4. Blue, 5. Bark Green, 6. Gray, 7. Green, 8. Pink, 9. Brown, 10. Tan, 11. Dark Blue, 12. Gold, 13. Black.

Gamboa, Diane; *Revelation Revolution;* May 14-18, 2002; Coventry Rag, 290 gms. I-size: 16" x 22"; P-size: 20"x 26"; Ed#: 4/88, 6/88; prnt: José Alpuche; mtrx: destroyed; signed. lower left; Note: The piece is set on the horizontal. The central figure is of a woman in her white lingerie, a ring on her right hand and she is holding a red handbag. Another woman is up front with a flower in her hair and tattoos across her shoulders. A third woman is in the background in black line over brown. To the right of the figures is a custom type pattern and to the left is another pattern with flowers. The artwork is trapped in a tight black. Colors used: Makeup beige, chicana brown, go-go girl yellow, martini olive green, not so red, gunmetal gray, urban goddess yellow, high heel green, cha-cha burgundy, million dollar green, and black as black.

Gamboa, Diane; *Self Portrait;* (Jan 9-18) 1984; Atelier 3; Somerset 320 gram, textured 100% Rag. I-size: 23 1/2" x 35"; P-size: 28" x 40"; Ed#: 2/78, 11/78, 18/78; prnt: Stephen Grace; mtrx: Destroyed; Signed, Inscription in pencil below the image area reads: "2/78, and signature" Signed, Inscription in pencil below the image reads: "18/78, Diane Gamboa". Note: Twelve color image. Self portrait on a black background. Atelier information on the back. Emerging from the black background are a face and hand. Squares of different colors break up or add to the face. This image is a self-portrait of Diane Gamboa. 11/78 print has cracked ink in the gray box area lower right. #Prints: 3.

Gamboa, Diane; *She's My Puppet;* (Oct 21 & 23) 1983; Atelier 2; Artprint Archival 25% Rag; I-size: 15" x 21"; P-size: 22" x 34"; Ed#: 4/77, unknown ed. prnt: Stephen Grace; mtrx: Destroyed; Signed, Inscription in pencil below image area reads: "4/77 and signature" "B.A.T.Z., Diane Gamboa". Fund: partially funded by Atlantic Richfield Foundation. Note: Announcement Poster for "Experimental Screen Print II: Self Help Graphics and Art Inc.: Fall 1983". Silkscreen image of two figures--a man holding a woman. Both figures are facing the viewer. Her dress is lime green and his suit is black. Purple scratches frame the man and woman. #Prints: 2.

Gamboa, Diane; *Three;* (March 17-20) 1986; Atelier 7; Accent 290 grams—white; I-size: 24" x 32"; P-size: 25" x 24"; Ed#: 4/45; prnt: Stephen Grace; mtrx: Destroyed; Signed, Inscription in pencil below image area reads: "4/45, title, signature and 86". None; Fund: funded in part by the CAC, NEA and the City of Los Angeles. Note: Three fantastic characters on a black background.

Gamboa, Diane; *Untitled (I);* (Oct 6-9) 1986; Westwinds; I-size: 11" x 9"; P-size: 18 1/2" x 13"; Ed#: 4/45; prnt: Oscar Duardo; mtrx: Destroyed; Signed, Inscription in pencil below the image area reads: "4/45, Diane Gamboa, 86". Fund: funded in part by the CAC, NEA and the City of Los Angeles. Note: Blue, red, yellow, green, orange and black colors. There is a face on the left-hand side.

Gamboa, Diane; *Untitled (II);* (Oct 6-9) 1986; Westwinds; I-size: 11" x 9 1/2"; P-size: 18 1/2" x 13"; Ed#: 4/45; prnt: Oscar Duardo; mtrx: Destroyed; Signed, Inscription in pencil below the image area reads: "4/45, Diane Gamboa, 86". Fund: funded in part by the CAC, NEA and the City of Los Angeles. Note: Pink, blue and yellow. On the right-hand side is the blue and yellow face of a woman and on the left-hand side is a small man's face.

Gamboa, Diane; *Untitled (III);* (Oct 6-9) 1986; Westwinds; I-size: 11" x 9"; P-size: 18 1/2" x 12 1/2"; Ed#: 4/45; prnt: Oscar Duardo; mtrx: Destroyed; Signed, Inscription in pencil below the image area reads: "4/45, Diane Gamboa, 86". Fund: funded in part by the CAC, NEA and the City of Los Angeles. Note: Man with a green face and red hair. He is wearing a pink shirt, and a green and brown jacket. Gray background.

Gamboa, Diane; *Untitled (IV);* (Oct 6-9) 1986; Westwinds; I-size: 11" x 9"; P-size: 18 1/2" x 12 1/2"; Ed#: 4/45; prnt: Oscar Duardo; mtrx: Destroyed; Signed, Inscription in pencil below the image area reads: "4/45, Diane Gamboa, 86". Fund: funded in part by the CAC, NEA and the City of Los Angeles. Note: Face with red, orange, green, blue and yellow colors.

Garcia, Lorraine; *Untitled;* (Nov 6-11) 1984; Atelier 4; Stonehenge 245 gram—white; I-size: 24" x 35 1/2"; P-size: 28" x 40 3/4"; Ed#: 4/86, 30/86, 34/86; prnt: Stephen Grace; mtrx: Destroyed; Signed, Inscription in pencil below image area reads: "4/86, & Lorraine Garcia", "30/86, & Lorraine Garcia". None; Note: Photo silkscreen with blue tape on a beige, pink, and orchid textured background. Smudge on the lower left outside of the image area. Colors used: 1. Pink/White font, 2. Lavender, 3. Light Pink, 4. Light Grey, 5. Light Lavender, 6. Grey, 7. Grey/Blue, 8. Magenta, 9. Light Grey, 10. Light Blue, 11. Light Pink, 12. Light Yellow. #Prints: 3.

Garcia, Lorraine, Herrón, Maradiaga, Torrez, and Vallejo; *Atelier IV, Announcement Poster for;* (Nov 3-Dec 13) 1984; Atelier 4; Stonehenge 245 grams—white; I-size: 24" x 36"; P-size: 29" x 41 3/4"; Ed#: 2/21, 6/21; prnt: Stephen Grace; mtrx: Destroyed; Signed, Inscription in pencil below image area reads: "2/21, copyright and SHG". "SHG" chops below image area; Note: Announcement Poster for "Atelier IV". Five images representing the work of these artists done during this atelier on a blue and gray background. Yellow, gray, and blue type. #Prints: 2.

García, Margaret; *Anna Comiendo Salsa;* (Dec 1-5) 1986; Atelier 8; Westwind; I-size: 32 1/4" x 22"; P-size: 36" x 24"; Ed#: 4/46, 10/46; prnt: Oscar Duardo; mtrx: Destroyed; Signed, Inscription in pencil located below image area reads: "4/46, title & signature.". None as of yet; Fund:in part by the CAC, NEA and the City of Los Angeles. Note: Image of a woman which consists mainly of thick strokes of gold, purple and yellow. The background is light blue with watery lines of dark blue streaking it. The image represents: "girl seated at a table mopping up salsa with a tortilla." M. García. Full bleed. Hand torn edges. Colors used: 1. Yellow, 2. Purple, 3. Peacock Blue, 4. Light Turquoise, 5. Vermillion, 6. Ultramarine Blue, 7. Light Green, 8. Orange/Yellow, 9. Primrose Yellow, 10. Dark Green. #Prints: 2.

García, Margaret; *De Colores;* (July 5-9) 1994; Atelier 24; Coventry Rag 290 grms; I-size: 25 6/8" x 37"; P-size: 25 6/8" x 37"; Ed#: 4/66, 20/66; prnt: José Alpuche; mtrx: Destroyed; Signed, Inscription in pencil along the left hand edge within the image reads: "Margaret Garcia, De Colores, 4/66". Right bottom corner; Note: Full bleed silk screen image of a "Man with Red Hat w/farm workers' eagle." Colors used: 1. Red, 2. Brown, 3. Manilla, 4. Light Purple, 5. Phtalo (sic.) Blue, 6. Dk Green, 7. Yellow—Orange, 8. Dk. Trans. Purple, 9. Light Green, 10. Trans. White, 11. Black. "Danny de la Paz posed for it. It doesn't look as much like him. But it

is not about him. It is about the determination of the struggle." M.García: #Prints: 2.

García, Margaret; *F. Emilio And Mom;* (May 27-31) 1991; Atelier 17; Westwinds; I-size: 23 1/2" x 30"; P-size: 23 1/2" x 30"; Ed#: 4/64; prnt: Oscar Duardo; mtrx: Destroyed; Signed, Inscription in pencil located at the bottom reads: "4/64 and signature". "SHG" chops located in the lower left hand corner; Note: Full bleed. Image of a woman holding a baby. Colors used: 1. Grape, 2. Phalo Green, 3. Magenta, 4. Cad. Red, 5. Blue, 6. Yellow, 7. Ultramarine, 8. Orange, 9. White, 10. Purple, 11. Phalo Blue, 12. Pink. "It is my nephew and sister-in-law Gia Garcia. Because I love my family and because my nephew is symbolic of our future. We desire not to continue our family traditions and heritage but to establish new traditions, new contributions. It is our hope." M. García.

García, Margaret; *Memory of a Haunting;* 1999; Atelier 33; silkscreen; I-size: 17" x 23 1/4"; P-size: 20" x 26 1/8"; Ed#: 4/71, 6/71; Signed, Inscription in pencil below image reads: "4/71, Memory of a Haunting, Margaret Garcia.". embosedd "SHG" insignia at lower left-hand corner of poster. Note: Painting of a close-up of a skeleton with red hair. Background is purple. The bones are grey, silver, and white. #Prints: 2.

García, Margaret; *My Ego Is Devil, My Ego Is My Demon;* n.d. studio proof; I-size: 23" x 34"; P-size: 23" x 34"; Ed#: 3/6; Signed, Inscription in pencil at the bottom inside image area reads: "3/6, My Ego is Devil, my Ego is my Demon, s/p, 3/6, Margaret Garcia". embossed "SHG" insignia located in lower right corner inside image area; Note: More than half of the print is the face of a woman, red eyes, purple hair, facing the viewer. A hand with sharp, claw-like fingers is holding a red mask outlines in purple of a devil's face. Behind the mask is a green background. Full bleed image.

García, Margaret; *Romance;* (Jan 4-8) 1988; Atelier 11; Westwinds; I-size: 35 1/2" x 24 1/2"; P-size: 40" x 26 1/2"; Ed#: 4/36; prnt: Oscar Duardo; mtrx: Destroyed; Signed, Inscription reads: "Title, signature, 4/36". "SHG" chops located at the bottom below the image area; Note: Image of magenta, blue, green and orange shoes, peppers, and a fork on a yellow background. Colors used: 1. Yellow, 2. Emerald Green, 3. Lime Green, 4. Magenta, 5. Powder Blue, 6. Ultramarine Blue, 7. Purple, 8. Dark Blue, 9. Medium Yellow, 10. Vermilion Red, 11. Iridescent Purple. "The print is symbolic of the sexual tensions in the first stages of 'Romance.' The fork foams on the appetite of those involved. Chili, sex, something that feels so good can burn so bad." M. García.

García, Margaret; *SiDa Que Amor Eterno;* 1992; Images Of The Future; I-size: 22 1/2" x 17"; P-size: 26 1/8" x 20"; Ed#: 4/61, 16/61; Signed, Inscription in pencil below image area reads: "4/61, SiDa que Amor Eterno, Margaret Garcia". embossed "SHG" located in lower left corner of the print; Note: A figure--half human-half skeleton is embracing a woman who is wearing a red dress and red lipstick and whose skin color is yellow. It is night time and one can see the full moon in a dark blue sky. #Prints: 2.

García, Margaret; *The Next Generation;* n.d. Coventry Rag, 290 gms. I-size: 25 1/2" x 31 1/2"; P-size: 30" x 37 1/2"; Ed#: 4/70, 6/70; signed. Inscription in pencil reads, "4/70 The next Generation Margaret García". lower left. Note: Image is of a young child.

García, Margaret; *Title unknown;* (Feb 24-27) 1986; Atelier 7; Accent 290 gram-white; I-size: 24 1/4" x 18 1/4"; P-size: 24 1/4" x 18 1/4"; Ed#: 4/45; prnt: Stephen Grace; mtrx: Destroyed; Signed, Inscription in pencil below image area: "4/45 and signature". Fund: funded in part by the CAC, NEA and the City of Los Angeles. Note: A red dog. A desert night. Full bleed. Hand torn top and bottom edges.

García, Margaret; *Untitled;* (Feb 24-27) 1986; Atelier 7; Accent 290 gram—white; I-size: 14 1/4" x 17 1/4"; P-size: 14 1/4" x 17 1/4"; Ed#: 4/45, 33/45; prnt: Stephen Grace; mtrx: Destroyed; Signed, Inscription in pencil below image area "4/45 and signature". None; Fund: funded in part by the CAC, NEA and the City of Los Angeles. Note: Portrait of a woman against a blue background. Full bleed. #Prints: 2.

Garcia, Martín V. *Amor Eterno;* (May 6-8) 1997; Atelier 30; Coventry Rag 290 grms; I-size: 16" x 22"; P-size: 20" x 26"; Ed#: 4/55; prnt: José Alpuche; mtrx: Destroyed; Signed. Lower left corner; Note: Nude man is holding nude woman. Predominant colors: yellow and black. Colors used: 1. Dark Purple/Opaque, 2. Wine Red/ Trans, 3. Yellow Orange/ Trans, 4. Yellow Green/Trans, 5. Purple/

Trans, 6. Dark Purple/ Trans. "Love is eternal. Even death is an extension of its existence. They become one totality. Every effect a creation of their passion." M. García.

Garcia, Martín V. *Observando;* (July 19-21) 1994; Atelier 24; Coventry Rag white; I-size: 16" x 22"; P-size: 20" x 26"; Ed#: 4/69, 20/69; prnt: José Alpuche; mtrx: Destroyed; Signed, Inscription in pencil located at the bottom reads: "4/69, Observando, Martin V. Garcia, 1994". lower right; Note: "Faces shown looking" at the viewer. There is a large face in orange with black details on the right side. The composition is divided by a yellow column, several art frames and a figure falling through an hour glass. Colors used: 1. Orange, 2. Red, 3. Yellow, 4. Blue, 5. White, 6. Black. "To make correct coices one must observe the direction of those decisions." M. García: #Prints: 2.

Gastelum, Victor; *Dos Caras A.D.* (June 24-28) 1997; Atelier 30; Coventry Rag, 290 grms; I-size: 19 1/8" x 12 7/8"; P-size: 26" x 20"; Ed#: 4/65; prnt: José Alpuche; mtrx: Destroyed; Signed. Lower left; Note: Action-figure head in blue, silver, and black with a silver speckled background and "Dos Caras" written on top. Colors used: 1. True White, 2. Off White, 3. Silver, 4. Black, 5. Blue, 6. Gray (Dk). "'Dos Caras' is a Mexican pro werstler on 'Luchandon' from 'Lucha Libre'. 'Dos Caras' is brother to 'Mil Mascaras' legendary Mexican wrestler. I do these wrestlers for many reasons. I like the wrestlers themselves, Mosly (sic.) masked ones. I also like the idea of the mask as a universal tradition. I believe that alot (sic.) of Mexican Pop Culture (including Mexican wrestlers) had international influence, but rarely receives (sic.) credit." V. Gastelum.

Gil, Xóchitl; *A Secret Garden;* February 10-11, 2000; Coventry Rag, 290 gms. I-size: 16" x 22"; P-size: 20" x 26"; Ed#: 4/78, 6/78; prnt: José Alpuche; mtrx: destroyed; signed. lower left; Note: Three red hearts/Roses with yellow auras on a blued blend ground. Colors used: Drk to light Blue, Red, Green, Yellow 1-Medium, Yellow 2-Light.

Gomez, Pat; *Stay Tuned;* (Aug. 11-12) 1992; Atelier 19 L.A. Riots; Westwinds; I-size: 16 6/8" x 22 6/8"; P-size: 20" x 28"; Ed#: 22/63; prnt: Richard Balboa; mtrx: Destroyed; Signed, Inscription in pencil below image area reads: "22/63, 'Stay Tuned', Pat Gomez [illegible]". lower right of print; Note: A black and white photo silkscreened image of the debris and destruction of a city in a background of what looks like fire. Juxtaposed are nine lavender colored t.v. monitors showing selected areas of the previous image, enhanced by pointing arrows. To the right and underneath it are more t.v. monitors, ochre colored, showing the palm of a hand--as in a 'stop' sign, in an orange background had thick brushstrokes and dripping strings of red. Superimposed is text with the artist's recollection of her experience of the riots. Colors used: 1. Orange, 2. Red, 3. Yellow, 4. Indigo, 5. Lavender, 6. Purple. "Based on my riot experiences, I wanted to highlight the role the media played in inciting the violence and looting. I also wanted to tie together my own panic and T.V. reporting of mass spreading destruction. The hopelessness and tension of those affected was also a prime consideration." P. Gomez.

Gomez, Pat; *The Trappings of Sor Juana;* 1999; Atelier 33; silkscreen; I-size: 26 1/8" x 18"; P-size: 30 1/4" x 22"; Ed#: 4/63, 6/63; Signed, Inscription in pencil below image reads: "4/63, The Trappings of Sor Juana, Pat Gomez [illegible] 99.". embossed "SHG" insignia at lower left-hand corner of poster; Note: The center piece of the poster is of an altar-like composition with a vase that has a picture of Sor Juana Ines de la Cruz. Pink flowers are held in the vase. There is a red scarf that creates the border and rosaries that hang from the top of poster. There are two books to the right and a framed picture of thorny stems entrapping a brain like a jail cell. The lower right-hand corner of image is an excerpt form Sor Juana's *Disillusionment.* #Prints: 2.

Gonzales, David Mercado; *Untitled;* (Sept 11-15) 1988; Westwinds (heavyweight); I-size: 34" x 21"; P-size: 40" x 26"; Ed#: 17/60; prnt: Oscar Duardo; mtrx: Destroyed; Signed, Inscription in pencil below the image reads: "17/60, D M Gonzales". embossed "SHG" on the lower left hand corner; Note: At the top there are two celestial figures, an angel and a demon. In the middle there are one human and one skeletal figure in combat. At the bottom there is a "ollin" sign. Colors used: 1. Light tan, 2. Dark tan, 3. Light blue, 4. Dark blue, 5. Purple, 6. Green, 7. Orange, 8. Red, 9. Yellow, 10. Biege, 11. Black.

Gonzalez, Carlos Castro; *Día de los Muertos 97: Viva la Vida!!;* n.d. Atelier 29-31 #4 & #6; I-size: 19 1/2" x 22"; P-size: 25 1/2" x 26"; Ed#: unknown ed. prnt: José Alpuche; unSigned. Lower left; Note: Skeleton figures standing at a Chavez shrine/altar offering gifts of fruit and plants. "SHG" at the bottom of the print.

Gonzalez, Carlos Castro; *La Madona;* 1995; I-size: 18 1/4" x 10 1/2"; P-size: 22" x 13"; Ed#: 4/41, 20/41; Signed, Inscription in pencil below the image reads: "4/41, La Madona, Gonzales Castro, 95". embossed "SHG" on the lower left; Note: Silk screen in black ink. Image of the SHG altar with the Virgin Mary. Four Children play near the altar. Above the Virgin Mary are two angels (good and evil) boxing each other. The sun radiates bright on the upper left. #Prints: 2.

Gonzalez, Cici Segura; *Props and Scenery;* May 27-31 and June 3, 2003; Maestras 4; Coventry Rag, 290 gms; I-size: 22" x 16"; P-size: 26" x 20"; Ed#: 4/78, 6/78; prnt: José Alpuche; mtrx: destroyed; signed. lower left; Note: "Multi-Colored Abst[r]act depicting minorities in background. Gold-yellow line symbolizes color barrier in advertisement and film industries. This abstract was created after observing first hand, how the media (adver[t]ising & film) reduces minorities to 'Props & Scenery' in ads and/or films. The absence of people of color, particularly in front of the camera, in the adver[t]ising & film world is alive and well in Los Angeles. The abstract here is the background is full of color yet there is a color barrier represented by the yellow-gold line in the foreground." Colors used: Blue, Red, Yellow, Orange, Lt. Purple, Dark Purple, and Black. #Prints: 2.

Gonzalez, Louie 'The Foot'; *Concrete Bilingual Cancion De Ansia;* 1987; I-size: 15" x 20 7/8"; P-size: 19" x 25"; Ed#: 20/50; Signed, Inscription in pencil below image area reads: "20/50, Concrete Bilingual Cancion de Ansia, Louie the Foot, c/s, 1987.". Note: On a textured background, white type reveals fragments of a bilingual poem and reveals the profile of a woman.

Gonzalez, Yolanda; *Alma de una Mujer;* 1995; Atelier 26; poster; I-size: 37" x 26"; P-size: 44" x 30"; Ed#: 12/55; prnt: José Alpuche; mtrx: Destroyed; Signed. lower left; Note: Woman in red and yellow embracing herself. Her arms are crossed against her chest as she holds her shoulders. Blue background. She needs only her force or belief in herself to continue her battle of a world filled with sadness and struggle. She lives with power!.

Gonzalez, Yolanda; *El Vaquero;* (Dec 11-15) 1989; Atelier 14; Westwinds (heavyweight); I-size: 30" x 21"; P-size: 35 1/2" x 26"; Ed#: 14/20, 4/70; prnt: Oscar Duardo; mtrx: Destroyed; Signed, Inscription in pencil below the image reads: "14/20, El Vaquero, Yolanda Gonzalez". Bottom left side of image; Note: Expressionistic male figure riding a yellow horse on a purple background. Red boots, dark blue pants, gray hat and a red vest. Colors used: 1. Red, 2. Lt. Pastel Violet, 3. Tran. Milori Blue, 4. Yellow, 5. Tran. Tan, 6. Purple (Tran.), 7. Tran. Gray, 8. Tran. Blue, 9. Tran. Violet, 10. Tran. White, 11. Tran. Gray-Green, 12. Tran. Maroon. "Designed for Plaza de la Raza Cultural Center. The legend of the cowboy, my concept is, 'life is to be lived' and El Vaquero is certainly living life. His motion is free; with the air blowing through his scarf and hair, he has no worries. Life should be as free and fun loving as El Vaquero." Y. Gonzalez. #Prints: 2.

Gonzalez, Yolanda; *La Reyna;* May 6-10, 2003; Maestras 4; Coventry Rag, 290 gms; I-size: 22 1/2" x 15 1/2"; P-size: 26" x 20"; Ed#: 4/72, 6/72; prnt: José Alpuche; mtrx: destroyed; signed. lower right; Note: "Female sitting arms crossed with a lovely head[d]ress and a colorful shall [sic]. her dress is adorned by lots of textures and colors. As he sits she's the Queen. "La Reyna"[.] The strength of the woman is always that of a queen. "La Reyna" is loving, stern, brilliant and always true to herself". Colors used: Black, Blue, Red, Ochre, Light Yellow Ochre, Light Grey, Off White, Black, and Clear Gloss. #Prints: 2.

Gonzalez, Yolanda; *Mi Indio;* (Feb 18-22) 1991; Atelier 16; Westwinds; I-size: 36" x 26"; P-size: 39" x 28"; Ed#: 4/70, 18/70; prnt: Oscar Duardo; mtrx: Destroyed; Signed, Inscription in pencil below the image reads: "18/70, Mi Indio, Yolanda Gonzalez" Signed, Inscription in pencil located at the bottom below image area: "4/70, title and signature". bottom left hand corner of paper; Note: "Expressionistic indian figure on [a] yellow horse. [Done in a] painterly style [with] very bold colors. [The] indian [is] holding a shield with [the] left hand, [and] holding [a] spear with [the] right hand." (from original certificate of authenticity) Colors used:

1. Phalo Green, 2. Yellow, 3. Phalo Blue, 4. Violet, 5. Cad. Orange Mediom (sic.), 6. Red, 7. Cad. Orange Light, 8. Cad. Orange Med, 9. White, 10 Phalo blue/violet. "This print being (sic.) a war peice (sic.). Unfortunatly (sic.) war (battle) is sometimes condoned almost nesecarrl y (sic.) yet the sadness of battle cannot be ignored. The conten of this print is that of battle dealing with blood, lives, and sadness. This man is eager to fight yet there is a sense of gloom." Y. Gonzalez: #Prints: 2.

Gonzalez, Yolanda; *"Women Know Your Strength!"*; (Nov. 13-17) 1992; Images Of The Future; Coventry Rag, 290 grms; I-size: 23" x 18"; P-size: 26" x 20"; Ed#: 4/54, 18/54; prnt: José Alpuche; mtrx: Destroyed; Signed, Inscription in pencil below image area reads: "4/54, 'Women Know Your Strenght!', Mohada Pegg [illegible], 92". lower left; Note: The faces of two women looking at the viewer are the only image. The one on the left is African looking and is wearing a blue turban and long straight earrings; the one in the right is Chicano looking, and is wearing hoop earrings. The upper right corner reveals a vivid red colored background. Colors used: 1. Lt. Trans. Yellow, 2. Lt. Trans. Red, 3. Trans. Magenta, 4. Trans Ultra Blue, 5. Trans Medium Yellow, 6. Trans Purple, 7. Transparet (sic.) Emerald Green. "The print describes about womens (sic.) strength, within. Women are extremely powerful, strong, intelligent beings. I feel its time women believe and acknowledge this strength." Y. Gonzalez. #Prints: 2.

Grace, Gerry; *Ancient Dreamers;* (Nov 10-14) 1986; Atelier 8; Westwind; I-size: 22" x 30"; P-size: 22" x 30"; Ed#: 4/45; prnt: Oscar Duardo; mtrx: Destroyed; Signed, Inscription in pencil below the image area: "Title, signature and 4/45". None as of yet; Fund:Funded in part by the CAC, NEA and the City of Los Angeles. Note: Two maroon tinted figures on a blue and yellow textured background. Black letters read: "Most stencils were monoprints." Colors used: 1. Peacock Blue, 2. Turquoise, 3. Dark Blue, 4. Yellow Iron Oxides, 5. Pastel Maroon. 6. Yellow Iron Oxide/Prime Yellow, 7. Turquoise/White/Raw Umb., 8. Maroon/White/Raw Umb., 9. White/Silver, 10. Peacock Blue/Maroon/Raw Umb., 11. Yellow/White.

Greenfield, Mark Steven; *Cause and Effect;* 2000; Coventry Rag, 290 gms. I-size: 32" x 22"; P-size: 30" x 40"; Ed#: 13/50; prnt: José Alpuche; mtrx: Destroyed. signed. Inscription in pencil reads, "13/40 Cause and Effect Mark Steven Greenfield". lower right; Note: Minstrel Orchestra in blackface with tornado in background and text. "Weel about turn about and da jis' so / Ebry/ time I weel about I jump Jim Crow". Colors used: Blue Green, Burgundy, Gray/Brown, and Eggshell Yellow. #Prints: 1.

Greenfield, Mark Steven; *Some Indignities Persist;* April 24 and May 8 (year unknown); S/P SUBC; Coventry Rag, 290 gms; I-size: 25" x 18"; P-size: 30" x 22"; Ed#: 28/43, 29/43; prnt: SHG?; mtrx: destroyed; signed. lower right; Note: "Man in blackface holds up dress against wooden fence background with text over printed in the form of an eye chart reading "Some Indignities Persist". Images of people in blackface have been a source of both disturbance and fascination to me. These images are intensely powerful in both their literal statements and in their ability to allow the viewer to create a context through the bias of their associations. Generations of African Americans have suffered grievous injury at the hands of people whose livelihood was derived from creating and reinforcing stereotypes through blackface minstrelsy. The creation of a stereotype was an essential element in maintaining white America's illusion of superiority. It characterized us as buffoons and tricksters, as inherently lazy and immoral and perennial children who were dependent on the paternalism of our "masters" for survival. Slavery, even the post emancipation more subliminal variety, was contingent on making its victims appear to be less than human. The images I've used are taken from late nineteenth century photographs of vaudeville and minstrel show performers. Ironically, blackface minstrelsy, through its wholesale appropriation of African American culture, is recognized as the "America;s first indigenous musical-theater genre." Manifestations exist to this day in everything from black stand-up comedy to the "crews" and "posses" of hip-hop. My work entreats the viewer to look at these images, while at the same time looking through them, to discover an alternate context. It is my hope that the work might offer a glimpse into the origins of some conscious or subconscious contemporary thinking with regard to race, color, and gender. If you are discomforted by what you see, I invite you to examine those feelings, for out of this examination will come enlightenment." Colors used: Rust/Beige, Off White, Dark Gray, and Gray Black.

Greenfield, Mark Steven; *Topsyturvy;* n.d. I-size: 22 1/2"x18 3/4"; P-size: 30"x22"; Ed#: 42/65, 43/65; signed.

Greenfield, Mark Steven; *Untitled (So Tell Me Who's the Nigger Now);* January 24-28, 2000; Coventry Rag, 290 gms. I-size: 16" x 23 3/4"; P-size: 20" x 26"; Ed#: 4/40, 6/40; prnt: José Alpuche; mtrx: destroyed; signed. lower right; Note: Image of a man in drag in black face holding a feather duster with text arranged as an eye chart reading "So Tell Me Who's the Nigger Now". Colors used: Beige, Off White, Cold Gray/Brown, Warm Brown/Black.

Greenfield, Mark Steven; *Untitled (Sometimes We Become What We Hate);* January 24-28, 2000; Coventry Rag, 290 gms. I-size: 18" x 23"; P-size: 20" x 26"; Ed#: 4/50, 6/50; prnt: José Alpuche; mtrx: destroyed; signed. lower right; Note: Image four men in drag in black face holding golliwog dolls with text arranged as an eye chart reading "Sometimes We Become What We Hate". Colors used: Beige, Off White, Warm Dk Brown, Warm Brown/Black.

Gronk, *Dumbbell;* (Aug 14-20) 1992; Coventry; I-size: 34" x 25"; P-size: 34" x 25"; Ed#: 47/60, 48/60; prnt: Richard Balboa; mtrx: Destroyed; Signed, Inscription in pencil below image area reads: "Dumbbell, 47/60, Gronk". lower right corner; Note: The image is of thick black, blue and light blue lines layered to create a jumbled effect. Upon closer examination, figures such as skulls, leaves and lips are visible within the chaos of the whole. The central focus is a calavera head. Colors used: 1. Light Blue Royal, 2. Dark Blue Navy, 3. White, 4. Black. "Layers of ink crossing out each other. Defining the paper with a visual no-language (sic.)" Gronk: #Prints: 2.

Gronk, *Untitled Number One;* (Dec 16-24) 1982; Atelier 3; Arches, w/ water marks; I-size: 25" x 17"; P-size: 29 1/2" x 21 1/2"; Ed#: 18/25, 22/25, 25/25; prnt: Stephen Grace; mtrx: Destroyed; Signed, Inscription in pencil located below the image reads: "Untitled No One, 18/25, Gronk, 83". Note: There is a pink cross with light green details. #Prints: 4.

Gronk, *Untitled Number Two;* (Dec 16-24) 1982; Atelier 4; Arches, with water marks; I-size: 25" x 17"; P-size: 29 1/2" x 21 1/2"; Ed#: 12/25, 18/25, 22/25, 25/25; prnt: Stephen Grace; mtrx: Destroyed; Signed, Inscription in pencil located below the image area reads: "Untitled No Two, 12/25, Gronk, 83". Note: Pink cross with many blue details using photo stencils: #Prints: 4.

Gronk, *Untitled Number Three;* (Dec 16-24) 1982; Atelier 4; Arches, with water marks; I-size: 25" x 17"; P-size: 29 1/2" x 21 1/2"; Ed#: 12/25, 18/25, 22/25, 25/25; prnt: Stephen Grace; mtrx: Destroyed; Signed, Inscription in pencil located below the image reads: "Untitled No Three, 12/25, Gronk, 83". Note: Light pink cross with blue-black details: #Prints: 4.

Guerrero-Cruz, Dolores; *Angels Over L.A.—The Falling Heart;* (May 20-25) 1991; Atelier 17; Westwinds; I-size: 36" x 26"; P-size: 36" x 26"; Ed#: 4/64; prnt: Oscar Duardo; mtrx: Destroyed; Signed, Inscription in pencil located at the bottom reads: "4/64, title and signature". bottom right hand corner; Note: Two angels in a cloudy sky with yellow lightening in the corners. The angels are flying to the center where a red flaming heart is falling. Colors used: 1. Tran Light Ochar (sic.), 2. Tran. Brown, 3. Tran. Purple, 4. Yellow, 5. Tran. Red, 6. Tran. Ultra Blue, 7. Lt. Orange, 8. Tran. Violot (sic.), 9. Tran. White, 10. Tran. Red, 11. Pastel Yellow, 12. Tran. Grape, 13. Tran. Bronze, 14. Gold, 15. White-Silver, 16. Purple, 17. Red. "The content of this print is; The Angels (sic.) represent people of Los Angeles whom are always willing to rescure a heart in trouble. The hearts can be someone in love with a broken hart or a concern that affects the masses of people. [An e]xample is the decline of education in Los Angeles. Everyone has a different convern and the heart represent that concern. The Angels (sic.) are the Heros." D. Guerrero-Cruz.

Guerrero-Cruz, Dolores; *El Perro Y La Mujer;* (Feb 15-19) 1988; Atelier 11; Westwinds (heavyweight); I-size: 24 1/4" x 16"; P-size: 26" x 18"; Ed#: 4/48; prnt: Oscar Duardo; mtrx: Destroyed; Signed, Inscription in pencil below image area reads: "4/48, El Perro y La Mujer, Dolores Guerrero-Cruz, 2/88". Bottom right hand corner of image. Note: Image of a dog howling at a woman in the window. Colors used: 1. Ocher (sic.) (Flesh), 2. Ocher (sic.) (Flesh), 3. Melon (split fountain), 4. Light Purple, 5. Yellow, 6. Yellow Orange (Peach), 7. Red, 8. Dark Purple, 9. Blue, 10. Green, 11. Ocher (sic.), 12. Dark Blue. "The dog or Perro symbolizes men or man. It's a

concept of men chasing women. This woman does not want to be chased and, therefore, hides in her room holding her body in despair. This is Print A." D. Guerrero-Cruz.

Guerrero-Cruz, Dolores; *Fall of the Innocent;* (June 21, July 17) 1997; Atelier 30; Coventry Rag 290 grms; I-size: 16" x 22"; P-size: 20" x 26"; Ed#: 4/58; prnt: José Alpuche; Signed. Left hand corner; Note: Woman in nightgown sits up in her bed as a red dog gazes at her. Colors used: 1. Black, 2. Red, 3. Yellow, 4. White, 5. Blue, 6. Yellow Ochre Light, 7. Bark Yellow Ochre. "A continuation of Mujer y Perros series. Currently I'm working on a comic book with High School students that deals with Teen pregnancy and domestic values. the (sic.) story deals with [a] Teenage (sic.) girl and [a] young adult male. He is abusive, drinks too much and cheats. Still this young woman decides to have this baby. The question is do women give into this situation or is the dog so seductive that we are blinded by love." D. Guerrero-Cruz.

Guerrero-Cruz, Dolores; *Flores Para Las Mexicana's;* (Sept) 1987; I-size: 24 1/4" x 17 1/2"; P-size: 26" x 20"; Ed#: 37/55; prnt: Oscar Duardo; Signed, Inscription in pencil located below the image reads: "37/55, Flores Para Las Mexicana's, Dolores Guerrero-Cruz, 10/78". embossed "SHG" located within the image on the lower left side; Note: There is an open window through which a town can be seen. A flower vase with flowers, and two small photographs are on a table. The main colors are: orange, yellow, purple, and aqua blue. "Again this is a tribute to the women of Mexican heritage. The scene in the background is where my father and grandparents were born. This scene involves two women of the same culture coming together in the homeland." D. Guerrero-Cruz.

Guerrero-Cruz, Dolores; *Jugo De Naranja;* (July 12-16) 1994; Atelier 24; Coventry Rag 290 grms; I-size: 26" x 38"; P-size: 30" x 44"; Ed#: 4/58, 20/58; prnt: José Alpuche; mtrx: Destroyed; Signed, Inscription in pencil located below the image reads: "4/58, Juego de Naranja, Dolores Guerrero-Cruz, '94". center; Note: "Red Dog in foreground. Orange [colored] orange in background. Dark clouds in sky and green Palm on side of Dog." Colors used: 1. Orange, 2. Yellow Orange, 3. Transp. Red, 4. Blue Green, 5. Dark Red, 6. Varnish, 7. Purple, 8. Trans White, 9. Deep Purple. #Prints: 2.

Guerrero-Cruz, Dolores; *La Mujer Y El Perro;* (Feb 15-19) 1988; Atelier 11; Westwinds (heavyweight); I-size: 22" x 18"; P-size: 24 1/4" x 20 1/4"; Ed#: 4/48; prnt: Oscar Duardo; mtrx: Destroyed; Signed, Inscription in pencil below image area reads: "4/48, La Mujer y El Perro, Dolores Guerrero-Cruz, and 2/88". "SHG" chops located in the bottom left hand corner of the image; Note: Image of a woman sitting on a bed with her back towards you. She's facing the window looking at a dog outside the window. "The dog or perro symbolizes men or man. It's a concept of men chasing women. This woman does not want to be chased and therefore hides in her room, holding her body in despair. This is print A." D. Guerrero-Cruz.

Guerrero-Cruz, Dolores; *Mujeres Y Perros;* (March 3-6) 1987; Atelier 9; Westwind; I-size: 36" x 24"; P-size: 40" x 26"; Ed#: 4/45; prnt: Oscar Duardo; mtrx: Destroyed; Signed, Inscription in pencil below image area reads: "4/45, signature and 1987". Fund: funded in part by the CAC, NEA and the City of Los Angeles. Note: Reclining nude female on a blue bed. Gray background. A window and two red dogs.

Guerrero-Cruz, Dolores; *Peacemakers;* (Nov 4-7) 1985; Atelier 6; Accent 290 gram—white; I-size: 27 3/4" x 22 11/16"; P-size: 27 3/4" x 22 11/16"; Ed#: 45/45; prnt: Stephen Grace; mtrx: Destroyed; Signed, Inscription in pencil on lower edge of image reads: "45/45, title, signature and '85". None; Fund: funded in part by the CAC, NEA and the City of Los Angeles. Note: Full bleed. Three children with "Superman", "Spiderman", and "Batman" on a yellow background with red dots. This print depicts the irony of three Chicano children growning up in an Anglo society with images of the society, therefore losing the heritage. It also speaks to the idea that children can be taught to save the world of nuclear war with their peacemaking friends." D. Guerrero-Cruz.

Guerrero-Cruz, Dolores; *Phoenix;* (Nov. 18-24) 1992; Images Of The Future; Coventry Rag, 290 grms; I-size: 16 1/4" x 22 3/8"; P-size: 20" x 26"; Ed#: 4/60, 18/60; prnt: José Alpuche; mtrx: Destroyed; Signed, Inscription in pencil below image area reads: "4/60, 'Phoenix', Dolores Guerrero-Cruz, '92". left hand corner; Note: Image of a fire burning and six dark silhouettes of human figures with purple hard hats. A bent street sign reads: "Soto St."

Oversized busts of a woman and a child appear behind the courtain of fire, both of them smiling and looking at the viewer. A yellow moon is in the upper right corner against a black background. Colors used: 1. Lt. Yellow, 2. Trans Flesh, 3. Trans Red, 4. Trans Blue Purple, 5. Trans Orange, 6. Trans Red Purple, 7. Metallic Blue. "The concept of this print is to educate our children, so they have something to look forward [to] instead [of] riots. The Phoenix symbolizes a new beginning." D. Guerrero-Cruz. #Prints: 2.

Guerrero-Cruz, Dolores; *Sometimes..* (May 8-13) 1992; Atelier 14 L.A. Riots; Westwinds; I-size: 20 1/2" x 14 1/4"; P-size: 28" x 20"; Ed#: 4/52, 22/52; prnt: Richard Balboa; mtrx: Destroyed; Signed, Inscription in pencil located below image area reads: 'Sometimes..', 4/52, Dolores Guerrero-Cruz, '92'. lower right of paper; Note: A male angel who seems to be coming out of a vibrant red fire is carrying a fainted woman in his arms. Three small angels fly around the couple. The sky is dark and cloudy containing several light pink horses blending in with the clouds. Colors used: 1. Process Yellow, 2. Process Magenta, 3. Process Cyan, 4. Metallic Gold (transparent), 5. Lavender (touch up), 6. Process Black. "I guess this image can be looked at as a love story. It can also be looked at as a social story, with the women in distress while the angel would be the solution. Either way the women (sic.) or social problem is being recused. The horses indicate the seriousness of this problem and love can be so serious." D. Guerrero-Cruz. #Prints: 2.

Guerrero-Cruz, Dolores; *The Bride;* (Feb 19-28) 1985; Atelier 5; Stonehenge 320 gram-white; I-size: 22" x 33 3/4"; P-size: 27 3/4" x 39 3/4"; Ed#: 4/88, 26/88, 35/88; prnt: Stephen Grace; mtrx: Destroyed; Signed, Inscription in pencil below image area reads: "4/88, & Dolores Guerrero-Cruz". Note: Adult female figure with a skull face wearing a white dress. Child wearing white dress with flowers. Textured purple, blue, magenta and ochre background. "The bride is a statement about my struggle as an artist, who leaves the professional field of art in order to survive as a single parent. During this time, this woman feels like she is slowly dying because she is not able to be what she wants to be. This is not against marriage, but a statement that one must be what she really wants to be before she can be anything else. Women have a harder struggle than men simply because we are women; I hope that for the women of tomorrow the struggle will be easier to make their lives better." D. Guerrero-Cruz. #Prints: 3.

Gutiérrez, Robert; *SHG In East Los;* (Nov 10-12) 1992; Images Of The Future; Coventry Rag, 290 grms; I-size: 16" x 22"; P-size: 20" x 26"; Ed#: 4/28, 16/58; prnt: José Alpuche; mtrx: Destroyed; Signed, Inscription in pencil below image area reads: "4/58, Robert Gutiérrez, 92". lower left; Note: Multicolored image of a neighbourhood and streetscape. The main building is yellow and green. A woman is sitting on a bench in front of it. A bus full of people is coming through the adjacent street, where a street sign reads: "Brooklyn Av.". In the background one can see houses, palm trees, the moon, stars, and two shooting stars. It is night time and the bus has its lights on. Colors used: 1. Lt. Trans Yell, 2. Lt Trans. Blue, 3. Lt Trans. Red, 4. Lt Trans. Magenta, 5. Lt. Trans. Ultra Blue, 6. Opaque Violet. "The idea for this print started 3 yrs earlyer (sic.) when I first saw the buildig (sic.) is which Self Help Graphics is in. I have buildings, structures and fell in love with [the] shape of the building. Also it's home for me growing up in East Los "and once more seing (sic.)" East L.A. with fresh eyes after a long time of absence. I've painted this building many times before in various forms and nedias. the time was right and I was given the opportunity. The palms (sic.) trees, people in crowded buses, people whiting (sic.) for their bus, the many phones (sic.) poles. It's Home!" R. Gutiérrez: #Prints: 2.

Gutiérrez, Roberto; *Avenida Cesar Chavez;* (Nov 17-20) 1993; Atelier 23; Coventry Rag, 290 grms; I-size: 16" x 22"; P-size: 20" x 26"; Ed#: 60; Robero Gutiérrez, 1993. Note: Signed print. Busy street scene. A bus that says "Av Cesar Chavez" is the central focus. Lots of orange, red, yellow and pink are used. Black border. Colors used: 1. Yellow, 2. Blue, 3. Magenta, 4. Gry (sic.) 5. White, 6. Brown, 7. Dark Blue, 8. Black, 9. T-Medium Yell., 10. T-Dark Brown. "The print Avenida Cesar E. Chavez is in commemeration (sic.) of the name change from Brooklyn Ave to Cesar E. Chavez Ave, in recognition of the peaceful leader Cesar Chavez of the United Farm Workers. The print is also about documenting, in a small way of fashion a

period of time, about a particular place and nehborhood (sic.), its people. Trying to capture the local color, fashion and sprite (sic.). The Latinos sprite (sic.), the Chicano sprite (sic.)." R. Gutiérrez.

Gutiérrez, Roberto; *Cesar E. Chavez Avenida;* (Nov 17-20) 1993; Atelier 23; Coventry Rag 290 grms; I-size: 16" x 22"; P-size: 20" x 26"; Ed#: 4/60, 20/60; mtrx: José Alpuche; Signed, Inscription in pencil on the bottom of the print reads: "4/60, Cesar E. Chavez Avenida, Robert Gutiérrez, 94". embossed "SHG" located on the bottom left; Note: "The local traffic patterns of both local people, commerace [sic] on the former corners of Brooklyn and Gauge Aves wlch [sic] well [sic] change to Avenida Cesar Chavez. The conception of the peace was drawn on site over a period of 3 months." White border. #Prints: 2.

Guzmán, Margaret; *Veil/Veil;* 1999; Atelier 33; silkscreen; I-size: 26 1/8" x 18"; P-size: 30 1/4" x 22"; Ed#: 4/65, 6/65; Signed, Inscription in pencil below image reads: "4/65, 'Veil/Veil,' M. Guzmán 1999.". embossed "SHG" insignia at lower left-hand corner of poster. Note: Focal point of poster is a picture of Sor Juana Ines de la Cruz reading to a child and at the same time protecting her. They are both framed by a circular wreath of leaves. The background appears to be roots at the bottom and red and yellow leaves at the top. There appears to be dark writing in lower portion of poster. Guzman "connects the trajectory of the celebrated Juana to Every Woman"--*Maestras Ateiler XXXIII 1999.* #Prints: 2.

Hamada, Miles; *Untitled;* (Nov 5-6) 1983; Atelier 2; Artprint 25% Rag Archival; I-size: 19" x 25"; P-size: 22" x 34"; Ed#: unknown ed. prnt: Stephen Grace; mtrx: Destroyed; Signed, Inscription in pencil reads: "4/77 and signature". "SHG" in blue; Fund: partially funded by the Atlantic Richfield Foundation. Note: Three color print: Red, black and transparent. Two figures on an abstracted flag background.

Hamilton, Vijali; *Sight One;* Feb 23-27, 1987; Atelier 9; Westwinds; I-size: 24 x 36; P-size: 26 x 40; Ed#: 45; prnt: Oscar Duardo; mtrx: Destroyed; None; Note: Medicine Wheel of Rocks and Four Diorections (sic.), Red, Black, White, Yellow. Colors: 1. Black/Brown, 2. Red/Orange, 3.Ultra Blue, 4. Transparent Light Blue, 5. Yellow, 6. Gray, 7. Transparent Brown, 8. Transparent Yellow Ochre, 9. Transparent, 10. Transparent Orange, 11. Transparent Gray/Umber, 12. Transparent Sienna.

Healy, Wayne; *Achealy's Heel;* 2002; I-size: 22"x16"; P-size: 20"x26"; Ed#: 4/106, 6/106; signed.

Healy, Wayne; *Bolero Familiar;* December 4-7, 2001 and January 15-19, 22-26, and 29-31 2002; Coventry Rag, 290 gms; I-size: 36" x 50"; P-size: 36" x 50"; Ed#: 4/79, 6/79; prnt: José Alpuche; mtrx: Destroyed; signed. Inscription in marker in image area reads "6/79 Bolero Familiar Healy". lower right; Note: Two guys sitting on living room couch play guitars and sing, one girl plays maracas and sings while other girl replaces low E-string on her guitar. A baby girl reaches for Chihuahua hiding under the coffee table. Nana cooks food in the kitchen. I grew up with musk in the house. My aunts and uncles would gather to play boleros made famous by Trio Los Panchos and Los Dandys. Grandma was always cooking food served with her corpus christs style tortillas. My wife has a Chihuahua and the miserable creature keeps showing up in my prints. Colors used: OHCO-U, 523 U Lavender, 106 U Light Yellow, 345 U Light Green, 467 U Light Brown, 185 C Red, EF00 C Flesh, TSRO-C Brown, 300 C Blue, TL00-C Orange, OIRO-C Gray Blue, 468 C Khaki, 1000 U Yellow White, OZAF-U Purple, 165 C Orange, 266 C Violet, Black, Trans White, and 2100 Clear Gloss. #Prints: 2.

Healy, Wayne; *Domingo Deportivo;* (Apr 19-23) 1994; Atelier 24; Coventry Rag 290 grms; I-size: 26" x 37 1/2"; P-size: 30" x 44"; Ed#: 4/51, 20/51; prnt: José Alpuche; mtrx: Destroyed; Signed, Inscription in pencil below the image reads: "4/51, Domingo Deportivo, Healy, '94". embossed "SHG" below the image on the lower left side; Note: There is a lady making tacos on the left side. In the middle, there is a soccer game being played. On the right hand side, there is a soccer player with her daughter. Colors used: 1. Violet, 2. Magenta, DK, 3. Green, Mint, T, 4. Beige, 5. DK Blue, 6. Red, 7. Orange, 8. Yellow, 9. Green, Cad (sic.), 10. Trans Purple, 11. Trans Magenta, 12. Dark Brown, 13. Trans White. Information on the content of the print: "Designed during the USA World Cup 94 Soccer Tourney, the image is an autobiographical image of the artist's experience as a soccer player on Sunday games for company teams. As la señora prepares tacos, la hija comforts her injured papacito while the game plays on. Ancient Mexican

players of ulama are seen in the upper rt hand corner."—Wayne Healy: #Prints: 2.

Healy, Wayne; *Sawin' at Sunset;* March 16-20, 1987; Westwinds; I-size: 23 1/2 x 35 1/2; P-size: 26 x 40; Ed#: 46; prnt: Oscar Duardo; mtrx: Destroyed; None; Note: Street fiddler against L.A. skyline. Colors used: 1. Yellow ochre/split fount in yellow, Orange-red, Blue/brown--orange split fount, Gray-blue, Red-pink, Ultra-blue, Lt. blue, Lt. yellow, Dk. blue, Flesh tone, Black, Yellow-orange, Yellow-cream.

Healy, Wayne; *Smokers' Game;* Sept. 19-20, 1999; Coventry Rag, 290 grms. (sic.); I-size: 34 3/8 x 23 1/2; P-size: 44 x 30; Ed#: 78; prnt: José Alpuche; mtrx: Destroyed; Lower Left; Note: Major Image; A revolver with a cigarette in the open cylinder. Above is a skeleton with a big sombrero and holding a cigarette. All are on a background of smoke, fire of the deadly habit.

Hernandez, Ester; *"If This Is Death, I Like It";* Westwinds; I-size: 32" x 26"; P-size: 34 3/4" x 28"; Ed#: 70; prnt: Oscar Duardo; mtrx: Destroyed; bottom right hand corner; Note: "Portrait of Frida Kahlo as a 'Calaca' with a watermelon headdress, & watermelon leaves and flower emanating from her." E. Hernandez "This print is part on my ongoing homage to Chicana-Mexicana women, in thi scase Frida Kahlo. It acknowledges that we are just passing by in time & space and that we are part of everything—the flora, fauna, air, etc. It also makes reference to the fact that after Frida's death, like many artist, she is 'flowering.' This print also symbolizes the transition & release of one's spirit upon death." E. Hernandez. Colos used: 1. Pink, 2. Bright Red, 3. Lime Green, 4. Green, 5. Orange-ochar (sic.), 6. Yellow, 7. Tran. Yellow/orange, 8. Med. poweder blue, 9. Phaylo (sic.) blue, 10. Purple, 11. Tran. purple, 12. Black, 13. Off White.

Hernandez, Ester; *Con Cariño, Lydia Mendoza;* May 15-19, 2001; Maestras 2; Coventry Rag, 290 gms. I-size: 18" x 26"; P-size: 22" x 30"; Ed#: 4/76, 6/76; prnt: José Alpuche; mtrx: destroyed; signed. lower left; Note: A portrait of a Mexican American woman dressed in a full length Mexican "Folkloriko" dress. She is holding the top of an upright acoustic guitar. The entire image is framed by a red stripe. Colors used: Bluish Purple-Dark Blue Blended into Light Blue, White (w/ blue tint), Sierra, Ochre, Gold Pearlescents, Green, Red, Purple-Transparent, Opaque Blue/Black.

Hernandez, Ester; *La Ofrenda;* (Sept 4-9) 1988; Westwinds (heavyweight); I-size: 33 1/4" x 23 1/4"; P-size: 34" x 25"; Ed#: 17/62; prnt: Oscar Duardo; mtrx: Destroyed; Signed, Inscription in pencil below the image reads: "17/62, 'La Ofrenda', Ester Hernandez". embossed "SHG" on the lower left hand corner; Note: Nude woman with Virgen de Guadalupe tattooed on her back. Coming in from the lower left part of the image is a hand holding a rose. The background is dark blue with gold marks. Nos. (sic.) 61 and 62 and the 2 exemplars (sic.) are in the possession of the artist. Colors used: sienna, burnt sienna, yellow, transparent red, transparent green, transparent blue, pink, black, cobalt blue/dark cobalt, gold, transparent cobalt blue.

Hernandez, Ester; *The Cosmic Cruise;* (Jan 15-18) 1990; Atelier 15; Westwinds (heavyweight); I-size: 36" x 24"; P-size: 38" x 26"; Ed#: 4/60, 16/60; prnt: Oscar Duardo; mtrx: Destroyed; Signed, Inscription in pencil located at the bottom of the image reads: "4/60, title, signature, copyright 90" Signed, Inscription in pencil below the image reads: "16/60, 'The Cosmic Cruise', Ester Hernandez (c), '90". embossed "SHG" located on the bottom on the left hand corner; Note: Four females in a light and dark blue vintage car (Model T). Background gradation magenta/purple. Border of dark blue. The lower part has several gold circular images of the Aztec moon godess. "The theme is our interconnectedness with each other and the universe. The car represents movement in space, and time is represented by the images of the women. "La virgen de Guadalupe" (the driver) the Mexican-Indian grandmother, the modern Chicana mother and child. The Aztec moon goddess-Coyolxauqui signifies our link with the past. The print is part of my ongoing tribute to la Mujer Chicana." E. Hernandez. "The main central image is of four women in a 'model T' car cruising through the cosmos. The lower part has several gold circular images of the Aztec moon godess." E. Hernandez. Colors used: 1. Pink/Pastel light yellow ochre, 2. Phalo Blue. Tran. Phalo Blue, 3. Trans. Sienna, 4. Indigo Blue, 5. Violet, 6. Magenta/Trans. Magenta, 7. Black, 8. Ultramarine Blue, 9. Purple, 10. Trans. Maroon, 11. Gold. #Prints: 2.

Hernandez, Laura; *The Encuentro Astral;* Aug. 14-17, 1991; Westwinds; I-size: 26" x 36"; P-size: 28" x 40"; Ed#: 55; prnt: Oscar Duardo; mtrx: Destroyed; Bottom Left Hand Corner; <u>Note</u>: "The moon with her locks of birds represents the wind, the sun, the fire, the fish, water and veins of the earth sympolize the natural elements that gives life to mankind." L. Hernandez "I use animal elements to configurate in a human concept the sun and the moon in an amorous reunion in time and space. The motive was due to the two eclipses we had in Mexico, on of the sun and the other the moon." L. Hernandez Colors used: 1. Red, 2. Violet, 3. Med. Yellow, 4. Phalo Blue, 5. Indigo Blue, 6, Black, 7. Light Red, 8. Brown, 9. Gold, 10. Silver, 11. Blue, 12. Lt Ultra Blue, 14. Gold, 15. Orange, 16. Yellow, 17. Silver, 18. White.

Herrón III, Willie F. *Seeds From a Hybrid Generation;* October 30-November 03, 2001; Coventry Rag, 290 gms. I-size: 18" x 24"; P-size: 22" x 30"; Ed#: 4/129, 6/129; prnt: José Alpuche; mtrx: Destroyed. signed. Inscription in pencil reads, "4/129 Seeds From a New Generation WFH". lower right. <u>Note</u>: Overlaying images and zine articles taken from various publications and flyers from THE VEX from 1980, including THE VEX stage back drop THE VEX HEAD. To Document SHG' contribution to the rise and fall of the influence THE VEX had on the hybrid Punk and New Wave Movement by Chicano Musicians for E.L.A. Colors used: Grey (Warm), Orange (Dull), Deep Red (Dull), Burgandy Red (Dark), and Black. #Prints: 2.

Herrón, Willie; *Lecho De Rosas;* Sept. 30—Oct 3, 1992; Coventry Rag, 290 grams; I-size: 23 3/4" x 35 3/4"; P-size: 28 1/2" x 41 1/8"; Ed#: 39/55, 43/55; prnt: José Alpuche; Signed, Inscription in pencil below image area reads: "39/55, "Lecho de Rosas", WG Herrón [illegible], 92". embossed "SHG" insignia located in lower left corner outside of image area; <u>Note</u>: Announcement Poster for "Día de los Muertos." Three skulls amongst flowers in a rose bed. The image resembles stained glass and is framed by patterns that remind of traditional craft work on wood boxes. "Three skeletons with bed sheet sitting ona bed of roses. Border of sun, water, and crickets (symbols)." W. Herrón Colors used: Lt opaque yell (sic.), 2. Lt semi opacque (sic.) green, 3. Lt trans-blue, 5. Lt trans violet, 6. Metallic gold. #Prints: 2.

Herrón, Willie; *Untitled;* (Oct 23-Nov 1) 1984; Atelier 4; White Stonhenge 245 grams; I-size: 22 1/2" x 27 3/8"; P-size: 26 1/4" x 32"; Ed#: 4/82, 34/82; prnt: Stephen Grace; mtrx: positives were Destroyed by printer subsequent to being out of printer possession for two weeks after edition was completed. Signed, Inscription in pencil below image area reads: "4/82 and signature". None; <u>Note</u>: Two foreground figures, two background figures surrounded by green seaweed. Green, yellow, and pink fish and mountains. Transparent colors used: yellow ochre, red, light blue, yellow and a varnish. Colors used: 1. Greyish white, 2. Light green, 3. Light ochre, 4. Light Tan, 5. Light Turquoise, 6. Light Orange, 7. Light Blue, 8. Light Yellow, 9. Grey, 10. Light Magenta, 11. Light Purple. #Prints: 2.

Hoyes, Bernard; *Block Party Ritual;* April 2-10, 2002; Coventry Rag, 290 gms. I-size: 14" x 33"; P-size: 20"x 26"; Ed#: 4/121, 6/121; prnt: José Alpuche; mtrx: destroyed; signed. centered; <u>Note</u>: Central Figures swirling as a conga players emerge as well as evoke the swirls, symbolizing the rythm of the music. To the left figures in praising motion to the right, figures in chorus against city scape of sky scrapers and palms over seen by concentric skies in rhythm. Colors used: Green Pantone 355c, Orange Pantone 021c, Cyan (Process)-2c, Blue Pantone 286c, Yellow (warm) 2c, Transparent White, Warm Red C, Tan Pantone 158c, White 50%, Red Pantone 200c, Violet Pantone 70% bare, and Varnish (overall).

Hoyes, Bernard; *Journey To The Astral World;* (Oct 19-23) 1987; Atelier 10; Westwinds; I-size: 36" x 24"; P-size: 36" x 24"; Ed#: 4/51; prnt: Oscar Duardo; mtrx: Destroyed; Signed, Inscription in pencil located in the bottom left on the image area reads: "Title, signature and 4/51". "SHG" chops located in the bottom left hand corner; <u>Note</u>: "Dark starry skies, with white doves flyng beside and above an arched window. Looking out into a seascape as revivalist figures dance in possession, conjuring the spirit world in candlelight." B. Hoyes "Revivalist sect of the new world conjuring ancient spirits through the releasing of doves. This ritual opens the door to the spiritual world, seen only through mediums possessed by spirits of the astral world, praying, prancing, dancing, clapping of hands, trumpeting in the night transends the

participants into the world of the Eternal." B. Hoyes. Full Bleed. Colors used: 1. Blue, 2. Medium Yellow, 3. Green, 4. Light Yellow, 5. Red, 6. Transperent (sic.) Orange, 7. Ceureulen (sic.) Blue, 8. Tranperent (sic.) Light Blue, 9. Transperent (sic.) White, 10. Black/Dark Blue—split fountin (sic.), 11. White/Medium Yellow—split fountin (sic.), 12. Brown.

Hoyes, Bernard; *Mystic Drummer;* 1996; Atelier 28; poster; I-size: 22 1/2" x 16 1/2"; P-size: 26" x 20"; Ed#: 39/57, 46/57; prnt: José Alpuche; mtrx: Destroyed; Signed. below image center; <u>Note</u>: Old Rastafarian in tattered rags beating a drum, with coal iron stove behind him. In front, kerosene tin lamp burns. Over head a Bob Marley poster taped to the wall. Symbolic reference to living a humble, mystical life. Colors which predominate are: red, green, yellow, blue, and violet. #Prints: 2.

Hoyes, Bernard; *Sanctified Dance;* August 14-19, 2001; Coventry Rag, 290 gms. I-size: 16" x 22"; P-size: 20" x 26"; Ed#: 4/78, 6/78; prnt: José Alpuche; mtrx: destroyed; signed. centered; <u>Note</u>: Group of figures in a Revival Ritual that involves hand clapping, tambourines and dance. Colors used: Light Yellow (O), Ultramarine Blue, Green, Red (Dark), Trans White, Warm Red (Trans), Deep Yellow (Trans), Brown (trans), Transparent Magenta, and Gloss Varnish.

Huerta, Leticia; *Elegie;* (Mar. 13-17) 2001; Special Project; Coventry Rag, 290 gms. I-size: 16" x 22"; P-size: 20" x 26"; Ed#: 4/80, 6/80; prnt: Joe Alpuche; mtrx: Destroyed; Lower Left; <u>Note</u>: Red roses with music sheet and 5 photos in cross configuration. "This print is about my father's recent death. The Elegie is a piece that my son was learning and had wanted to play at his grandfather's funeral. He didn't get to do that so I have placed their images and the music on this print to, in a sense, give them both this last opportunity to share their music."—L. Huerta Colors used: 1. Clear blue, 2. Yellow, 3. Light green, 4. Dark green, 5. Dark red, 6. Off White, 7. Transparent white, 8. Violet, 9. Black, 10, Grey.

Huerta, Salomon; *Cara de Chiapas;* n.d. Atelier 26; poster; I-size: 15" x 12 7/8"; P-size: 26" x 19 7/8"; Ed#: 43/58, 44/58; prnt: José Alpuche; mtrx: Destroyed; Signed. lower right; <u>Note</u>: Sketch in black of a child with closed eyes centers the print. Light peach brush strokes surround the head with symbol in cerulean blue. Unidentified mark at lower left. #Prints: 2.

Huerta, Salomon; *Untitled (María Felix);* May 28-June 1 and June 18; Coventry Rag, 290 gms. I-size: 16" x 22"; P-size: 20"x 26"; Ed#: 4/120, 6/120; prnt: José Alpuche; mtrx: destroyed; unsigned. lower left; <u>Note</u>: Maria Felix on a red background. Colors used: Fusia 21u—232u, Dark Pink pr-63-semitrans, Light Dusty Purple, Pale Pink Opaque, Red 70% Opaque, White Opaque, Light Fusia Opaque, Black Opaque, Brown/Purple 70& opaque, Trans/White, and Clear Gloss.

Ibañez, Leonardo; *Sueños Y Mitos;* 1992; Atelier 19 L.A. Riots; I-size: 24 1/4" x 16 1/4"; P-size: 28" x 20"; Ed#: 4/58, 22/58; Signed, Inscription in pencil below image area reads: "'Sueños Y Mitos', 4/58, Leonardo Ibañez, 92". embossed "SHG" chopmark located on the lower right corner; <u>Note</u>: Multicolored composition of a horse, a guitar, a sun, and two cocks facing each other. The background is dark purple. "My print is related with images who came from our South-American mythology. Images representing the struggle for a better and dignify (sic.) way of living, those images are fundamental because will (sic.) find them everywhere—the sun (Maya, Inca, Deguita, Aztec, et. (sic.))—the horse symbol of how the struggle is passing from one generation to other. The bird our nature and the guitar is a symbol of our natural song." L. Ibañez. #Prints: 2.

Jimenez Underwood, Consuelo; *La Virgen de los Nopales;* May 18-23, 2003; Atelier XLII—Maestras 4; Coventry Rag, 290 gms. I-size: 22" x 16"; P-size: 26" x 20"; Ed#: 4/72, 6/72; prnt: José Alpuche; mtrx: destroyed. signed. lower right; <u>Note</u>: "Nopales with the Americas are under an intense barbed wire rain. The Virgens are watching. America is represented by the nopal. The continent is under attack. The barbed wire that cut up our land are still raining upon us. The virgen watches. The sun, moon, and flower below are uncertain and uncomfortable with the situation." Colors used: Green—warm-mid, Blue—Light Turq., Brown—Light warm, Magenta, Light Warm Grey, and Black Rain". #Prints: 2.

Kemp, Randy; *Spiritual Warrior;* (Feb 8—12) 2000; Atelier 35; Coventry Rag, 290 grams; I-size: 16" x 22"; P-size: 20" x 26"; Ed#: 4/75, 6/75; prnt: José Alpuche; mtrx: Destroyed; Lower Left; <u>Note</u>: Yellow/Orchor (sic.) Figured and Background. Blue Angel Wings. Four

Circular design elements aat bottom foreground (Horse, Eagle, Turtle, and Buffalo). Colors used: 1. Yellow Orchor (sic.) (Fig./ Backrd), 2. Dark Purple/ Red, 3. Light Blue (Wings) 4. Red/Orange, 5. Deep Red/ Black.

Kirkpatrick, Garland; ¡No Más Tratos! (No More Deals!); July 30-31, 2002; Coventry Rag, 290 gms. I-size: 16" x 16"; P-size: 20"x 26"; Ed#: 4/91, 6/91; prnt: José Alpuche; mtrx: destroyed; unsigned. lower left; Note: A brown and black empowerment poster. Brown and black fists join in solidarity against corporate control of affordable housing.

Kittredge, Nancy; More Than We Seem; 1993; Images Of The Future; I-size: 15 7/8" x 22"; P-size: 20" x 26"; Ed#: 4/73, 14/73; Signed, Inscription in pencil below image area reads: "4/73, 'More Than We Seem', Kittredge, '93. embossed "SHG" insignia located in lower left corner of the print; Note: The print is divided by a scene which takes place on a stage and the scene below it. A pale body in the middle of the stage floats in a stream of light towards a cross. Figures hide behind or hold the curtains through which we view the scene. Stairs descend from the stage to the place beneath. Three figures stuggle in turbulent waves which crash against the stage. "'More Than We Seem' is a focus for man's triumphant ability through faith to overcome all the adversities one encounters in human existence. Man is a spiritual being with power for good (or evil). But we can break through the prisons (stage left and right giants) of war, famine, greed, illness, etc by using our powers for good. Those who do not are destined to fall (the first two falling figures), but always have the option to change for the better, as St. Paul did. The nature beyond the set represents the spirit world. The set, the natural or earthly life." N. Kitterage: #Prints: 2.

La Marr, Jean; I Heard the Song of My Grandmothers; (July 23—Aug. 3) 1990; L.A. Festival; Westwind (heavyweight); I-size: 35" x 47"; P-size: 38" x 50"; Ed#: 67; prnt: Oscar Duardo; mtrx: Destroyed; Bottom left hand corner; Note: World collage with three women, Indain grandmothers juxatposed (sic.) 3 variations from the picture plane. Earth is in the background with silver and off white clouds. Designs of Indain culture are placed around the bottom. Colors used: 1. Tran. Milori blue, 2. Mauve, 3. Magenta, 4. Blue-Purple, 5. Tran. Magenta, 6. Aqua blue, 7. Gold, 8. Silver, 9. Beigh (sic.)—Cream, 10. Purple, 11. Silver-Black. "The content refers to the connection of the North and Central American Indians through some linguistic group, Uto-Aztecan. The designs (sic.), largest, is a mountain-climbing design (traveling), and design on the woman on the right is symbolic for the diamond back snake. The design (serpent) at the bottom is from Mitlah, Central Mexico, same language group as the Paiute. The grandmother in the front is also symbolic of the displaced people in L.A. by the white man. The Helicopters (sic.) refer to the spraying and the intimidation by the govt (sic.) which Indian people have experienced for 500 years. North American Indians migrated thousands of years ago, and this migration is continuing today as evidenced by the numbers of Mexican Indian in Los Angeles." J. La Merr.

La Marr, Jean; Some Kind Of Buckaroo; (Mar 12-15) 1990; Atelier 15; Westwinds (heavyweight); I-size: 24" x 36"; P-size: 26" x 38"; Ed#: 4/58, 16/58, 44/58; prnt: Oscar Duardo; mtrx: Destroyed; Signed, Inscription in pencil below the image reads: "16/58, 1990, Some Kind of Buckaroo, La Marr". embossed "SHG" on the bottom right corner; Note: Nine colors. A purple and yellow polarized "buckaroo" behind three strands of gray metalic barbed wire. Middle ground of earth's horizon in beige with alace pattern. Background of two planes flying east. Purple/gray metalic sky. "The warrior spirit continues in contemporary times. Encroachment on sacred land area of nature by people for U.S. military testing, and fencing off lands keeping Indian people from sacred areas. Indian cowboy is the symbol of Indian resistance. Lace is symbolic of the feminine relating to mother earth, beauty and delicacy. Nature people, indigenous people are knowledgable of the care of mother earth. Nature people are being cast off from their traditional land." J. LaMarr. #Prints: 3.

Lane, Leonie; Vulcán de Pacaya; (Mar. 6-10) 1989; Atelier 13; Westwinds (heavyweight); I-size: 24" x 36"; P-size: 27 1/2" x 25"; Ed#: 55; prnt: Oscar Duardo; mtrx: Destroyed; Bottom right side of image; Note: A vetical format, 24" x 36", divided into 2 contained sections. The larger setion on the left is the main image area featuring a might scene illuminated by a (sic.) active volcano (Vulcán de Pacaya), fireworks, campfires and fireflies. Two figures stack the fire. A silhouetted throny bush separates them from a smoke winding its way along the base of the image, a dry branch, leading into the slender vertical section on the right—a detail of the inside of the volcano (sic.). "This print is based on my New Year's Eve 1988-89 spend with a small crowd of 14 people on top of Vulcán de Pacaya just south of Guatemala City, Guatemala. The combination of the active volcano, fireworks, campfire + fireflies is a potent mixture of heat and night—+ symbols. the volcano alone, is a symbol for many things—underlying tensions exploding to the surface—political, social, sexual and emotional. This particular night + this particular mountain serves as a stage for reflection or events of the present + future. Fire is a catalyst for change, ignition of passion, destruction of the old, commencement of the new." L. Lane. Prints distrubuted (sic.) as follows: Nos. 35 thru 50—SHG/ Nos. 1,3,5,7,9,11,13,15, 17,19,21 and 50 thru 55—Artists/ Nos. 2 & 4—Archieves (sic.)/ Nos.6, 8, 10, 12—Collectors/ Nos. 14, 16, 18—Documentation/ Nos. 23 thru 31—Atelier members/ Nos. 20, 22, 32, 33 & 34—Exhibition.

Leal, Steve; Untitled; (Oct 29-30) 1983; Atelier 2; Artprint Archival 25% rag; I-size: 19" x 25"; P-size: 22" x 34"; Ed#: 4/77; prnt: Stephen Grace; mtrx: Destroyed; Signed, Inscription in pencil in the lower right reads: "4/77 and signature". "SHG" purple logo at the bottom; Fund: partially funded by the Atlantic Richfield Foundation. Note: Five color image: light green, dark green, gray blue woman. White lilies on a light blue background.

Ledesma, Andy; Day of the Dead; 1996; not in Atelier 26 or 28; poster; I-size: 31" x 21"; P-size: 36 3/4" x 28"; Ed#: unknown ed. lower left corner before the title; Note: A scene of a group of skeletons celebrating. Some are playing instruments while others are dancing. Scene primarily in shades of blue. Around the edges of the print are square shaped pieces colored in green, yellow, and white. Text in capital dark blue letters reads "SHG Day of the Dead. Dia de los Muertos 1996. Flores de Esperanza.": #Prints: 3.

Ledesma, Andy; Flor de Esperanza; S/P Atelier 29; Coventry Rag 2909R981; I-size: 21" x 30"; P-size: 28" x 36 1/2"; Ed#: 82; prnt: José Anponche; mtrx: Destroyed; Lower Left; Note: Dia de Los Muertos theme, graphic design on a multi-colored flooed monoprint background. "This print is a homage to Posada, it features the calavera figures involved in various activities. From dancing to worshiping at the altar. Dancing figures throughout a a (sic.) dancing mariachi band in the background. A special feature of thse prints is the colorful floods used in teh (sic.) screening process proved for a very colorful color combinations." A. Ledesma.

Ledesma, Andy; Flores de Esperanza; n.d. Atelier 29-31 #4 & #6; I-size: 31" x 21"; P-size: 37 1/4" x 26 5/8"; Ed#: unknown ed. not Signed. Note: Skeletons in rainbow colors playing instruments and celebrating. In a scroll banner it says "Dia de los Muertos 1996 Flores de esperanza.".

Lee, Betty; Seekers Of Gold; 1999; Atelier 34; Coventry Rag, 290 grams; I-size: 16" x 20"; P-size: 20" x 26"; Ed#: 4/51, 6/51; prnt: José Alpuche; mtrx: Destroyed; Lower right; Note: The background consists of four different vertical rectangles of men's faces in dark blue tones; an outline map of the United States in red with statistical dots and directional lines emanate from siljouettes (sic.) of Chinese laborers circa early 1900. Colors used: 1. Milori blue, 2. T-DK Cyan Blue, 3. T-LT Trans baby blue, 4. Y-Ultra Marine blue, 5. O-Yellow, 6. O-Red, 7. O-Black. "Seekers of Gold refers to the desire of statistical information in matters especially of immigration and its effect on commerce, population and culture. Real numbers and actually unavailable (sic.) in this work, and the statistical symbols are misleading. And just as well—Americans seem to prefer the statistics in their imaginations. Seekers of Gold is intended for the viewer to recall the prevailing attributes given to Chinese immigrants who arrived in the United States in the 19th and 20th centuries. Despite laws intended to prevent discrimination in the workplace, the impact of the newly-arrived, then and now on American culture is uneasy.

Leñero, Alberto Castro; Susana; (Jan 27-30) 1986; Atelier 7; Accent 290 gram-white; I-size: 24" x 37"; P-size: 25" x 38"; Ed#: 40/45; prnt: Stephen Grace; mtrx: Destroyed; Signed, Inscription in pencil below image area reads: "40/45, title, signature and '86". Fund: funded in part by the CAC, NEA and the City of Los Angeles. Note: Woman's lower torso in shades of gray. Beige worked

background. Green facial image in the lower left. On the lower right-hand side is a triangle.

Leñero, Jose Castro; *Camine, No Camine;* (Jan 20-23) 1986; Atelier 7; Accent 290 gram-white; I-size: 33" x 17 1/2"; P-size: 38" x 25"; Ed#: 4/44; prnt: Stephen Grace; mtrx: Destroyed; Signed, Inscription in pencil below image area reads: "4/44, title, signature and 1986". Fund: funded in part by the CAC, NEA and the City of Los Angeles. Note: Multi-panel grid of Industrial images. Eighteen juxtaposed images. Colors: orange, blue, gold, red, green, gray, yellow, brown and black.

Lerma-Barbosa, Irma C. *Sacra-Momento;* 1987; I-size: 15 x 1/2" x 21 1/2"; P-size: 19" x 25"; Ed#: 20/50; Signed, Inscription in pencil below image area reads: "Irma C. Lerma-Barbosa, c/s, 10/'87. Note: In a room there is a Mexican flag and some people on military attire. On the wall there is an image of the 'Virgen de Guadalupe' underneath which it reads: "Free / of the city of / Sacramento by his friends through the / cooperation and efforts of / the southside improvement club / civil works administration of the / United States City of Sacramento / and county of Sa(crame)nto.".

Limón, Leo; *Bailando Together;* (Aug 3-7) 1987; Westwinds; I-size: 19" x 25"; P-size: 20" x 26"; Ed#: 39/59; prnt: Oscar Duardo; mtrx: Destroyed; Signed, Inscription in pencil below the image reads: "39/59, Bailando Together, Limón, 87". embossed "SHG" on the lower right hand side; Note: "Figures around large green nopales with blue sky with small red hearts." Colors used: 1. Red, 2. Blue, 3. Yellow (straight), 4. Purple (transparent), 5. Green, 6. Blanco "Incorporating a geographical area of the U.S.A. and Mexico with dancers surrounding nopales gives the humanistic qualities of relations and of being as one." L.Limón.

Limón, Leo; *Buenos Días The Los Angeles River I and II;* (Feb. 12—Mar. 3) 1992; Special Project; Westwinds; I-size: 12 1/4" x 38 1/4"; P-size: 28" x 40"; Ed#: 50/50; prnt: Richard Duardo; Lower Left; Note: Visual trip of the Los Angeles River in the future, Diptych (two-part print) four bridges (Olympic, Macy, North Broadway and Summynook) Blue sky, white clouds, three giant palm trees, Queen Mary on the left. Colors used: 1. Red, 2. Grey, 3. Blue, 4. Grey, 5. Grey, 6. Yellow, 7. Flesh Color, 8. Blue, 9. Green, 10. Black "—F O L A R—Friends of the Los Angeles River commissioned this screenprint. It depicts the vision I see of the river. FOLAR is trying to start the ball rolling to turn this city's dead river back to life. The changes of the wallss (sic.) into pyramid step like structures (gabions) and the fish, bird and human life that can someday exsist from one point to another in harmony and fun from the mountains to the sea, and fifty-fivemile river park can become reality only if you start spreading the word about it." L.Limón.

Limón, Leo; *Chusma/The Mission;* 1999; Atelier 33; silkscreen; I-size: 26" x 18"; P-size: 30 1/4" x 22"; Ed#: 4/100, 6/100; Signed, Inscription in pencil below image reads: "4/100, signature [illegible].". embossed "SHG" insignia on top of signature at lower right of poster; Note: There are various images that compose the poster. There are theatrical comedy and tragedy masks, and a Mexican cowboy wearing a brown sombero sticking his tongue out. There are other frames from various skits. To the bottom left is an image of a skeletal friar holding a sword in one hand while wrapping the other arm around an Indian boy. #Prints: 2.

Limón, Leo; *Cultura Cura!;* 1992; Atelier 19 L.A. Riots; I-size: 15 7/8" x 23 7/8"; P-size: 20" x 28"; Ed#: 4/62, 22/62; Signed, Inscriptionin pencil below image area reads: "4/62, Cultura Cura!, Leo Limon [illegible], '92". embossed "SHG" chopmark located in lower right corner; Note: Interior scene with out-of-scale drawings. On the left corner are three small black silhouettes carrying an enlarged heart, a sun, and what looks like a birthday cake. The bending tip of a pencil is coming out of a hole on the floor. A gigantic picture with the image of a woman in profile with her lips and finger nails in red, wearing a Mexican hat and a braid, and pointing out to the three smaller figures is hanging on the wall. The background is light gray. Colors used: 1. White, 2. Red, 3. Blue, 4. Yellow, 5. Lt. Grey, 6. Blk (sic.). "Within the blue frame is the cosmic chicana that is coming from space pointing to the three figures that are holding Xochitl (precious flower), the Corazon (your heart) and the Olin (Earthquake), the Quetzal pencl of knowledge goes through the wall and come up through the floor and points as the corn stock." L.Limón: #Prints: 2.

Limón, Leo; *Dando Gracias;* 1983; Atelier 2; Artprint 25% Rag; I-size: 18" x 28"; P-size: 22" x 34"; Ed#: 4/74 numbered 77; prnt: Stephen Grace; mtrx: unknown; Signed, Inscription in pencil below image area reads: "Title, 4/77 and signature". "SHG" chopmark in silver metalic below the image; Fund: funded in part by CAC and the NEA. Note: A god holding a yellow, red and green fruit and cactus. White moon. Blue background. "Certain incorrectly numbered-actual edition length is 74, not 77".

Limón, Leo; *Día de los Muertos, Announcement Poster for;* 1979; I-size: 38 3/4" x 24 3/8"; P-size: 40" x 26"; Ed#: unknown ed. Signed, Inscription in ink inside image area reads: " (c) Imagen por Limón.". below image area reads: "Printing: Hecho en Aztlan Multiples"; Note: Announcement Poster for "Día De Los Muertos, 4 Nov., 1979." The image is of Virgen De Guadalupe surrounded by a roses crown and two skulls at each side. The background consists of a color gradation of black, purple, and violet. Below image area gray and black lettering announces several events, such as: "A quiet Indigenous Ceremonial"; "Candle Light Parade"; "Parade"; "Mass at Our Lady Of Guadalupe Church"; "Entertainment"; "Public Art Center." There are two versions of this print: the second copy presents a navy blue, purple and violet gradation in the background, and black lettering. #Prints: 3.

Limón, Leo; *Espíritu De Olvera Street;* 1994; Atelier 24; Coventry Rag 290 grms; I-size: 17" x 22 1/2"; P-size: 17" x 22 1/2"; Ed#: 4/60, 20/60; prnt: José Alpuche; mtrx: Destroyed; Signed, Inscription in pencil within the image reads: "Espíritu de Olvera Street, 4/60, Limón, 13x-94". embossed "SHG" within the image on the lower right; Note: Full bleed. "Indoor scene, door way with cross above it, large woman pointing at a cross with [her] hand. Boat on water with person rowing boat with passenger that is a giant heart with tic-tac-toe image on the inside on far right side is [a] deity Tezcatlipoca." Colors used: 1. Magenta, 2. Primrose Yellow, 3. Cyan, 4. P (sic.) Ultra Marine Blue, 5. White, 6. Light Pink, 7. Ochre/Yellow, 8. Pink, 9. Red (Blue), 10. Light Brick Brown, 11. Ochre (light brown), 12. Orange yellow, 13. Green (Blue shade). "Olvera Street is a Mexican land mark (sic.) that gets my support—education the the masses on its struggle is shown by the woman pointing to the Olvera Street cross—the illustioinary landscape mothernature following behind her, the womans corazon been rowed toward the cross image and at the far right side I have put in the deity "Tezcatlipoca" as uducator with shield and pencils and as woman." L.Limón. #Prints: 2.

Limón, Leo; *Hermanos Del Fuego;* (Aug 3-7) 1987; Westwinds; I-size: 19" x 25"; P-size: 20" x 26"; Ed#: 40/61; prnt: Oscar Duardo; mtrx: Destroyed; Signed, Inscription in pencil below the image reads: "40/61, Hermanos del fuego, Limón, 87". embossed "SHG" below the image on the right hand side; Note: Many pairs of hands gesturing. Palm trees are in the middle area. At the bottom corners of image are two women pushing baby buggies. Colors: 1. Red, 2. Yellow, 3. Violet Blue, 4. Blue (medium), 5. Green, 6. White "Hands clasped in various positions in the sky.. Bottom center corazon has 4 inter-pointing hands.. Women and baby carriages walking through different landscape." L.Limón "A friendly hand shake states recognition of self and respect. Mamas have babies and men and women face all directions. Corazon that signifies inner-self as the spirit of life and love." L.Limón.

Limón, Leo; *Hummingbird Spirit;* (Mar 21-25) 1995; Atelier 25; Coventry Rag-290 grms; I-size: 26" x 40"; P-size: 30" x 44"; Ed#: 4/56, 20/56; prnt: José Alpuche; mtrx: Destroyed; Signed, Inscription in pencil below the image reads: "Hummingbird Spirit, 4/56, Limón, '95". embossed "SHG" below the image on the right hand side; Note: "Large central figure of feline woman holding swirling scroll that raps [sic] around a corazón. Large green leaf froms at left bottom with hummingbird sucking beautiful flower.": #Prints: 2.

Limón, Leo; *La Crusada;* (Apr 1-5) 1991; Atelier 16; Westwinds; I-size: 35 1/2" x 23"; P-size: 40" x 26"; Ed#: 16/60; prnt: Oscar Duardo; mtrx: Destroyed; Signed, Inscription in pencil on the right side of image reads: "La Crusada, 16/60, Limón, '91." embossed "SHG" under catus on the bottom right center; Note: "Woman with basket of hearts (corazones) on her head, Nopales on both her sides (with red tuna fruit) Bridge with cars and figures with sombreros. Tic-Tac-Toe of love cards, indigenous motifs, horseriders two palm trees (one on each side), Two large silouette [sic] faces with speech symbols. Liberty bell-flying fish, artists paletts [sic] with flags." Colors used: 1. Trans. Powder Blue, 2. Violet, 3. Bright Red,

4. Transparent Brown, 5. Phaylo (sic.) Blue, 6. Trans. Light Brown, 7. Green, 8. Off-White, 9. Yellow, 10. Dark Marine Blue. "The story is about my nana when she crossed over to the U.S.A. in 1915. The royal sombrero society crosses over the bridge and the Tic-Tac-Toe of love game we all play. The indigenous symbols which show that we are as one, the horseriders (sic.) show the conquistadores and the anglo-saxon pilgrim then and now as the greenhouse effect manufactures (red truck with greenhouse camper.) The spirit of Wovoka in the ksy (buffalos). The artist paletts (sic.) with flags show us as chicanos an the large silouette (sic.) faces with speech symbols talk of uity (sic.) through the covenent (pledge) belt which on thier sides with the small people with the small people holding hands." L.Limón.

Limón, Leo; *La Ozone Burns II;* 1987; Westwinds from Paper Source; I-size: 11" x 35 3/4"; P-size: 13" x 38"; Ed#: 45; prnt: Oscar Duardo; Note: "Four hands point down, small T.V. sets float across with women and palm trees and a man cruising in his car, bottom of print show a large corazon with a woman, three women and palm trees." L.Limón.

Limón, Leo; *Madre Tierra—Padre Sol;* (Dec 8-11) 1986; Atelier 8; Westwind; I-size: 35 3/4" x 11"; P-size: 37 1/2" x 13"; Ed#: 4/53; prnt: Oscar Duardo; mtrx: Destroyed; Signed, Inscription in pencil below image area reads: "4/53 I, II, title, signature and 86". None as of yet; Fund: funded in part by the CAC, NEA and the City of Los Angeles. Note: Diptych. Horizontal landscape. Images of Los Angeles, Statue of Liberty, hearts, palm trees and a buffalo, all on a blue and pink textured background. Colors: 1. trans -gray silver, 2. trans—rodine, 3. overal dark outline silver violet, 4. light red, 5. light blue, 6. yellow green, 7. opaque yellow, 8. ultramarine blue, 9. violet, 10. overall dark outline dark blue, 11. 1/2 trans white: #Prints: 2.

Limón, Leo; *Morena Y Quetzalcoatl;* n.d. Coventry Rag, 290 gms. I-size: 16"x 22"; P-size: 20"x 22"; Ed#: 4/78, 6/78; prnt: José Alpuche; mtrx: with artist; signed. lower right; Note: La mujer, madre tierra y la jovencita sit at the bus bench. She's watching Quetzacoatl's word over-taking the huffing-puffing intervention horses as they approach our templo's in Aztlan movimiento is in the Air, the Sky. Colors used: Blue, Tan, Blue (ultra-marine), Yellow (medium), Yellow Green, Red, Orange, Green-Eyes, Green-Bench, Gray, Light Blue, Black.

Limón, Leo; *Mosaic Corazon;* (July 2-3) 1990; L.A. Fest; I-size: 35" x 46"; P-size: 38" x 50"; Ed#: 76; prnt: Oscar Duardo; Lower right side; Note: "Giant yellow corazon with red rim in center—chair with bust at lower left, bluish/black feline with earring on lower right, three large figures holding corazones in the lower center, purple/violet figures with sombreros across center horizontaly." Colors used: 1. Light blue sky, 2. Red, 3. Yellow, 4. Orange, 5. Medium Blue, 6. Red, 7. Green, 8. Light Trans Tan, 9. Light Trans Yellow, 10. #5 Blue based down, 11. Green, 12. Violet, 13. Trans DK. Blue 14. Trans black, 15. Tan + White. "The corazon symbol which is universal to us all is depicted here with people inside home and around Tipis (sic.). People with their corazones in hand and peace dove flys outside with four direction silhouettes speaking smboles of the four world color groups—red, black, white and yellow. The bust image is of Dr. Carlos D. Almaraz looking across the composition to the sly-eyed feline which sits calm and wagging its tail. Chicano-Meciano sombrero people dance with other colored figures around the corazon." L.Limón.

Limón, Leo; *Muchachas Talk;* Summer 1987; Special Project; Westwinds from Paper Source (L.A.); I-size: 35 5/8" x 24 "; P-size: 37" x 26; Ed#: 40; prnt: Oscar Duardo; Note: "22 color run, fig-ures and faces at bottom, corazon with person climbing stairs, corazon with 2 lovers kissing, flying curved art pencils in the sky" L.Limón.

Limón, Leo; *Soñando;* (Jan 6-9) 1986; Atelier 7; Accent 290 gram-white; I-size: 35" x 22"; P-size: 38" x 25"; Ed#: 4/45, 45/45; prnt: Stephen Grace; mtrx: Destroyed; Signed, Inscription in pencil below image area reads: "4/45, Leo Limon [illegible], '86". Fund: funded in part by the CAC, NEA and the City of Los Angeles. Note: A woman sleeps. Her breasts, arm and stomach are exposed, but a blanket covers her below the waist. An image of the upper part of a heart sits behind her--as if it is the rising sun. Small carpets (sarapes) fly above her and around the heart. #Prints: 2.

Limón, Leo; *The Sun Burns, The Stars Shine;* (Mar. 30—April 3) 1987; Westwinds; I-size: 11" x 35 3/4"; P-size: 13" x 38"; Ed#: 45; prnt:

Oscar Duardo; mtrx: Destroyed; None; Note: West coast scene of Venice Beach, small Colonial ships, California brown bear and yellow star, Santa Barbara church, condor in the sky and small flying corazones; other side shows dark sky with large heart with stars.

Limón, Leo; *Vida Y Muerte;* 1986; I-size: 25 1/2" x 20"; P-size: 30 1/8" x 22 1/8"; Ed#: 53/75, 55/75, 56/75; Signed, Inscription in pencil below image area reads: "53/75, 'Vida y Muerte', Leo Limon [illeg-ible], '86". Note: The print is a horizontal compostion separated into two parts. The upper half has a multi-colored four-chamber heart as the focus. Two black figures are climbing stairs within the heart. Two figures of women kneel before the heart, making an offering of a smaller heart. Sky surrounds the image--dark blue with clouds and a moon. Stalks of corn grow beside the heart. The lower half is an image of underground bones and shells above a yellow and orange semi-circle which suggests fire. #Prints: 3.

Limón, Leo; *Wovoka's Corazon;* (Oct. 21-24) 1985; Atelier 6; Accent 290 gsm (sic.) white; I-size: 34 3/4" x 23"; P-size: 25" x 38"; Ed#: 45; prnt: Stephen Grace; mtrx: Destroyed; None; Note: Ten color image; stylised heart, with buffalo and other figures. Colors used: 1. Light cerise trans/mixed, 2. Greyish purple trans/mixed, 3. Purple trans/ mixed, 4. light lbue super trans/mixed 5. Yellow straight, 6. Yellow Orange, 7. Red Straight, 8. Blue Violet, 9. Purple 10. Dark Ultra- Marine Blue.

Longval, Gloria; *La Curandera;* (Feb 13-16, 17-19) 1993; Atelier 22; Coventry Rag 290 grms; I-size: 16" x 22"; P-size: 20" x 26"; Ed#: 78; prnt: José Alpuche; mtrx: Destroyed; Lower Left; Note: "Strong woman's face looking out at viewer—wearing earrings and rebozo. Top of her head a chicken stands and also looks at viewer. To the woman's right a bird like mask with a rose comingout of its mouth." G. Longval. Colors used: 1. Cigar Base, 2. Opaque Pink, 3. Opaque Rich Brown, 4. T Blue Shade Red, 5. T Stone Grey, 6. T Blue Grey, 7. Lt Trans. Orange, 8. T magenta, 9. Opaque Yellow. "This print is a homage to my grandmother and all the other curand-eras (healers) of my cuban barrio. They were the strong women, my role models of my childhood. The chicken-mask, rose were used as spiritual symbols for healing purposes. Abugla's rebozo served as shelter, disguise or garment. The image was epseically created for the atelier program." G. Longval.

Lopez, Alma; *Chuparosa;* June 11-15, 2002; Coventry Rag, 290 gms. I-size: 16" x 22"; P-size: 20"x 26"; Ed#: 4/78, 6/78; prnt: Joe Alpuche; mtrx: destroyed; signed. lower left; Note: Colors used: Charcoal/ grey, Red, Brown, Blue, Light Grey, Yellow Ochre/Mustard, Orange Red, Transparent White, Transparent Brown, Transparent Black, White, Black, and Gloss.

Lopez, Alma; *Genesis ;* 1992; Images Of The Future; I-size: 23" x 17"; P-size: 26" x 20"; Ed#: 4/60, 18/60; Signed, Inscription in pencil below image area reads: "4/60, Genesis [female genetic symbol], Alma Lopez, 92". embossed "SHG" located in lower left corner outside image area; Note: A young woman who is wearing a white dress is looking up, her right hand about to touch a wom-an's hand coming from heaven, the left one joining hands with an older woman who represents a virgen and is wearing a green shawl with a golden aura around her. On the ground there is an image of Death wearing a black shawl. The background shows a pattern inside of which there is one more image of a woman with little chicks playing around her. These images are intertwined in a ground of flames, fire, hearts, apples, and a big green snake. The sky is light blue. #Prints: 2.

Lopez, Alma; *Genesis Woman;* (Dec 10-12) 1992; Atelier 21; Coventry Rag, 290 grms; I-size: 16" x 22"; P-size: 20" x 26" mtrx: Destroyed; Note: "A woman rising from flames, tempted by the serpent and death, holding hands with a mother/guadalupe figure. In the backgourd is a picture frame with a mother and her children/ chickens. In the foreground, are apples turning into sacrered heart. Meaning: women helping women or women finding/searching for spirituality + God." A. Lopez. Colors used: 1. Primrose yellow, 2. Trans Red Flesh, 3. Blue Blended into T-Base, 4. Trans Fire Red, 5. Lt Trans Green, 6. Trans Yell (sic.) Orange. "The central figure is a woman, who rises from flames and is tempted by death and the serpent. She holds hands with a mother/guadalupe figure, while reaching to touch a god/goddess hand. Meaning: A woman reaches out to a woman, therefore women are helping women. Also, there is direct reference to the Bible and genesis, therefore

there is a search to reinvite the blaming of Eve/women. But also for women to reach a center/spirituality in a belief that does not hold them responsible for the face of man." A. Lopez.

Lopez, Alma; *Mnesic Myths;* (July 20-24) 1999; Atelier 34; Coventry Rag, 290 grms; I-size: 16" x 20"; P-size: 22" x 30"; Ed#: 4/47, 6/47; prnt: Joe Alpuche; mtrx: Destroyed; signed: Lower Left; Note: A young woman extends her hands to hold another young woman who lays/rests on the images of coyolxauhqui—the Aztec moon goddess. Befind (sic.) them is a line of drawing coatlique—Earth Goddess, and Popocatepl and Ixtacihuatl. Below is a hand of Aztec codex to symbolize the sky. Colors used: 1. Off White, 2. Beige/Brown, 3. M. Brown, 4. Red Brown, 5. White, 6. Blue Black, 7. Black. "Mnesic Myths is an adjective to describe something that is relative to memory. Mnesic myths, the title, refers to myths which may be remembered or recalled. This silkscreen has the myth of Coatlique and Coyolxauhqui, and the Romeo-Juliette type myth of Popocatepetl and Ixtacihuatl. Both are pre-Colombian myths which are places in western contemporary times with the image of two young homegirls." A. Lopez.

Lopez, Alma; *Our Lady of Controversy;* December 3-7, 2002; Atelier XLI; Coventry Rag, 290 gms; I-size: 22" x 16 1/4"; P-size: 26" x 20"; Ed#: 4/73, 6/73; prnt: José Alpuche; mtrx: destroyed; signed. lower left; Note: "Image of a woman wearing flowers and blue cape, on a flowery-patterned background, held by a bare breasted butterfly angel." Colors used: brown, orange, red brown, flesh, transparent white, blue, green, red, yellow, white, and black.

Lopez, Aydee; *Sadness, Madness, Anger, Hate!;* 1998; Atelier 33; silkscreen; I-size: 16" x 22 1/2"; P-size: 20" x 26"; Ed#: 4/61, 6/61; Signed, Inscription in pencil below image reads: "4/61, 'Sadness, Madness, Anger, Hate', Aydee". embossed "SHG" insignia at lower left-hand corner of poster. Note: Image on poster is composed of four colorful theatrical masks. From left to right they symbolize sadness, madness, anger, and hate. The background is blue. #Prints: 2.

Lopez Martinez, Aydee; *Moved by Your Rhythmic Eyes;* March 25-28 and April 1-3, 2003; Atelier XLI; Coventry Rag, 290 gms; I-size: 20"x15 1/2"; P-size: 26"x20"; Ed#: 4/118, 6/118; mtrx: destroyed; signed. lower left; Note: "The print was created to represent the Grand Performances brochure for the 2003 Summer program in downtown Los Angeles." Colors used: Ultramarine Blue semi-trans., Yellow Ochre, Blue shade red, Sienna light, Semi-Opaque white, Magenta, Transparent white, Black, Ultramarine Blue, Transparent white, Magenta, and Gloss.

Lopez, Yolanda; *"Woman's Work is Never Done";* 1999; Atelier 33; silkscreen; I-size: 18" x 26"; P-size: 22" x 30 1/4"; Ed#: 4/73, 6/73; Signed, Inscription in pencil below image reads: "4/73, 'Woman's Work is Never Done', Thank you, Dr. Sandra Hernandez and Dr. Nilda Alverio, Yolanda M. Lopez 1999.". embossed "SHG" insignia in lower left-hand corner of poster; Note: The focus of the poster is a woman dressed in a jaguar suit. There are purple flowers to the right of the poster while a hand writes "Rx" on a piece of paper to the left of the image. To the far left is the title "Jaguar Woman Worrier: Woman's Work is Never Done" written sideways on pink background. "Her piece is dedicated to two women who have doctored the social body during our times through policy making and community activism, as well as through their medical practice, Latina doctors Sandra Hernandez and Nilda Alverio"-- *Maestras Atelier XXXIII 1999.* #Prints: 2.

Lopez, Yolanda; *Woman's Work is Never Done: Your Vote has Power;* 1996; Atelier 28; poster; I-size: 19" x 16 1/4"; P-size: 25" x 24"; Ed#: 31/45, 32/45; prnt: José Alpuche; mtrx: Destroyed; Signed. lower left; Note: Two young women from mid chest facing forward. One with her arm around the other. Background image of women from circa 1919 carrying signs in city street, signs read "Votes for Women." Text reads: Right "From: South Africa to North America." Left: "Amy Biehl · Melanie Jacobs." Bottom: "Woman's Work is Never Done.": #Prints: 2.

Lozano, José; *El Ropero de Frida / Frida's Armoir;* March 19-23, 2002; Coventry Rag, 290 gms. I-size: 16" x 20 1/4"; P-size: 20"x 26"; Ed#: 4/75, 6/75; prnt: José Alpuche; mtrx: destroyed; signed. lower left; Note: The image is of the artist Frida Kahlo. Its an homage to her talent and spirit. The image deals with the allure of Frida Kahlo. Its commenting on Frida becoming as popular as BARBIE. I'm drawn to her strength as an image maker and personality. I like the idea of her being portable and taking her along every-

where physically and spiritually. It's another one of my many homages to

Lozano, José; *La familia que nunca fue;* 1995; Atelier 26; poster; I-size: 33 7/8" x 26"; P-size: 39" x 30"; Ed#: 12/47; prnt: José Alpuche; mtrx: Destroyed; Signed. lower right; Note: A scene of a family in paper doll format with an audience in the background.

Lozano, José; *La Sonambula;* 1998; Atelier 33; silkscreen; I-size: 20 1/4" x 16"; P-size: 26" x 20"; Ed#: 4/58, 6/58; Signed, Inscription in pencil below image reads: "4/58, La Sonambula, José Lozano 1998.". embossed "SHG" insignia at lower left-hand corner of poster; Note: There is a woman canoeing in a river with trees in the background. There are super-imposed outlines of a woman's face which covers the entire image, including the red border. #Prints: 2.

Lucas, Daniel; *Koo Koo Roo;* (Jan 26-28) 1993; Country Rag 290 grams; I-size: 16" x 22"; P-size: 16" x 22"; Ed#: 4/82, 12/82; prnt: Jose Alpuche; mtrx: Destroyed; Signed; Inscription in pencil on the bottom of the image area reads: "4/82, LUCAS, 93". Embossed "SHG" on lower left. Note: "With "Images of the future" the theme for Atelier XXII[sic.] I choose tradition being kepted[sic] alive in the future. The title of the peice[sic] is "Coo Coo Roo." The tree growing into the form of a schull[sic] represents Mexican tradition/heritage. The young boy (actually is grandfather as a young boy, Grandpa is in his 90's know[sic], the first of the family to com to U.S. from Mexico). The boy is tending to the tree making sure it is watered properly and the tree is growing and very alive in a barren land. As the sun raises the rooster gives his call to everyone to get up, CooCooRoo, Get up it is a new day, Get up and go out into this brand new day, a fresh start and make something good happen. The young boy (Francisco) has always listened to the rooster. Francisco is keeping the tradition alive and will pass on the garden hose that supplies the water to keep the tree rooted in his heritage alive to his son and so on. May we never forget the past of our people but learn to live a better lIfe from it. Keep the tradition alive.": #Prints: 2.

Lujan, Gilbert 'Magu'; *Cruising Turtle Island;* (March 10-14) 1986; Atelier 7; Accent 290 grams—white; I-size: 37" x 24"; P-size: 38" x 25"; Ed#: 4/45; prnt: Stephen Grace; mtrx: Destroyed; Signed, Inscription in pencil below image area reads: "4/45, title, signature and '86". Fund: funded in part by the CAC, NEA and the City of Los Angeles. Note: Multicolored figure in a blue car. White road. Blue and yellow textured background. Multicolored icons and symbols.

Luján, Otoño; *Break It!;* (Sept 10-14) 1993; Atelier 23; Coventry Rag 290 grms; I-size: 14" x 20"; P-size: 20" x 26"; Ed#: 4/56, 40/56; prnt: Otoño Luján; mtrx: Destroyed; Signed, Inscription in pencil below the image reads: "4/56, 'Break It', Otoño Luján, c/s, 1993". embossed "SHG" below the image on the lower right; Note: A man and a woman are staring at the viewer ready to fight. In the background are red and white jagged stripes with light blue barbed wire running in the white area. Colors used: 1. Red (opaque), 2. Blue-grey (opaque), 3. Yellow-Ochre (transparent), 4. Lavendar (transparent). "The young Chicano and young Chicana in this print represent two of many young people who have had enough shit from this gov't (sic.) and have united with a plan for a new society. They have realized that before they can change it (sic.) they must BREAK IT! (sic.)" O.Luján: #Prints: 2.

Manje, R. David; *Dreamers, Magicians, and Star Navigators;* February 1-2, 2000; Atelier XXXV; Coventry Rag, 290 gms. I-size: 16" x 22"; P-size: 20" x 26"; Ed#: 4/80, 6/80; prnt: José Alpuche; mtrx: destroyed; signed. lower left; Note: Stellae carving, fish, crosses, pyramid, multi-blend arch. Colors used: Blend-Purple to Cerulian bl., Yellow-Trans, Red Orange- Trans, Green-Trans, Green-Trans, Dk Violet/Black Opague, Gold-Opague, Beige-Trans.

Maradiaga, Ralph; *Lost Childhood;* (Oct 1-9) 1984; Atelier 4; Stonehenge 245 gram; I-size: 22" x 30"; P-size: 28" x 36"; Ed#: 4/88, 28/88, 34/88; prnt: Stephen Grace; mtrx: Destroyed by printer; Signed, Inscription in pencil below the image area reads: "4/88, title, signature and '84" Signed, Inscription in pencil below the image area reads: "28/88, Lost Childhood, Ralph Maradiaga, 84". Note: Images are of a red toy fire truck, a "Land of the Lost" lunch box, yellow/brown rocking horse and a blue rectangle in a field of green grass. Gloss varnish over entire image. #Prints: 3.

Marichal, Poli; *Arbol de la Sabiduría;* 1997; Atelier 31; I-size: 26 7/8" x 19 1/8"; P-size: 30" x 22"; Ed#: 158/170, 167/170; Signed. lower

left; Note: Human figure forms molded to create a tree. Four triangular sections create: earth, wind, fire, and air. "The compistion plays with polarities and female symbols. The tree is composed of stylized human figures in silver. The tree crown is make of three golden orbs. The sapce is divided by two perpendicular lines that cross creating four triangular spaces that stand for the four elements: Air, Fire, Water, Earth. On the extreme upper corners, two ores (sic.) represent the sun and the moon." Colors used: 1. Blue, 2. Silver, 3. Magenta, 4. Yellow, 5. Black. "The composition, where the rpedominant figure is a tree formed by stylized human figures, is divided in four spaces by perpendicular lines that cross at the center. The four spaces stand for the four elements. On the extreme upper corners, two orbs represent the sun and the moon. The design plays with cabalistic symbols for the sexes and universal polarities. The silkscreen was commissioned by the Puerto Rican Branch of the American Association for Advanced Science. On the lower right corner, the initials A.A.A.S. stant for the aforementioned organization." P.Marichal: #Prints: 2.

Marquez, Daniel; *Enseñanza del Sahuaro;* 1996; Atelier 28; poster; I-size: 16 1/8" x 22"; P-size: 20" x 26"; Ed#: 56/57; prnt: José Alpuche; mtrx: Destroyed; Signed. lower right; Note: A myriad of images make up this print. On the bottom of the print are a row of bricks with Aztec images painted on them. Above the bricks are a green snake, two white eagles, three red roses, a pyramid, a woman, a cluster of skulls, a Native American Indian with an elaborate headdress, boats at sea in the background, and the Virgen Guadalupe.

Marquez, Daniel; *Por Qué;* n.d. Atelier 30; I-size: 16" x 22"; P-size: 20" x 26"; Ed#: 4/55; Signed. lower left; Note: Man praying with sun on top of his head, stained glass window pieces from a church with an angel carrying one of them. Below is a farmer and barbed wire. Colors used: 1. Light Blue, 2. Yellow, 3. Green, 4. Orange, 5. Ocre (sic.), 6. Purple, 7. Sky Blue, 8. Drk Blue, 9. Light Yellow. "'Por Que' on the edge of the abyss education without defenses drowning man's struggle born into reality metropolitan crime conquest religion death prophecy codes deciphered four directions four races green neutral center journeys without destiny diversely lines barriers walls fences mutilated culture mother country nostalgia there is no return fleeting angel prayer faith energy sun God who are we?" D. Marquez.

Martinez, Daniel J. *The Promised Land;* (Nov 10-14) 1986; Atelier 8; Westwinds; I-size: 36" x 24"; P-size: 38" x 26"; Ed#: 4/46; prnt: Oscar Duardo; mtrx: Destroyed; Signed, Inscription in pencil below image area reads: "4/46, title, signature and 86". Fund: funded in part by the CAC, NEA, and the City of Los Angeles. Note: Green, yellow, blue, and purple landscape. Royal blue sky. Figures, boxes, skeletons. Colors used: 1. gray, 2. blue, 3. red, 4. primrose yellow, 5. transparent yellow, 6. yellow oxide, 7. green, 8. tran. lime green, 9. orange, 10. peacock blue, 11. tran. purple, 12. medium yellow.

Martinez, Isabel; *Raza & Culture;* (Jan 24-Feb 1) 1995; Atelier 25; Coventry Rag 290 grms; I-size: 26" x 38"; P-size: 30" x 41 3/4"; Ed#: 4/58, 20/58; prnt: José Alpuche; mtrx: Destroyed; Signed, Inscription below the image reads: "4/58, 'Raza & Culture', Isabel Martinez, '95". embossed "SHG" below the image on the bottom left; Note: A multi-colored abstract image with many faces/masks and a large heart on the left side. Colors used: 1. Opaque orange, 2. T-Primrose Yell., 3. T-Cadmio Yellow, 4. Cadmio Red, 5. Covalto Blue, 6. T-Shape Green, 7. T-Magenta, 8. T-Shape Green, 9. T-Dark Magenta, 10. Covalto Blue, 11. Black, 12. P. White, 13. O. White. "This print is about my Indian heritage that I have flowing in my blood. I take colors of Indans of my country Mexico. The heard represents to love & pride for my race & culture." I. Martinez: #Prints: 2.

Martínez, Isabel; *V.G. Got Her Green Card;* February 8-15, 2001; Atelier XXXVII; Coventry Rag, 290 gms. I-size: 22" x 16"; P-size: 26" x 20"; Ed#: 4/80, 6/80; prnt: José Alpuche; mtrx: destroyed; signed. lower left; Note: A Virgin of Guadalupe holding a green card. Colors used: T-Ultra Blue, T-Violet, T-Magenta, T-Yellow, T-Turquoise, T-Green Shade Yellow, T-Flesh, O-Black, O-Green, T-White, Clear Gloss, and T-Yellow-Orange. #Prints: 2.

Martinez, Isabel; *Woman of Color;* 1997; Atelier 29-31 #4 & #6; I-size: 26" x 37 7/8"; P-size: 30 1/8" x 44 1/8"; Ed#: 4/63; Signed. lower left; Note: Woman of many colors surrounded by many different colored flowers. "'Women of Color' is a representation of a strong woman who has to fight against adversities. Her smile & flowers represent hope to keep going. This print is the Metaphor (sic.) of Life (sic.) as a constant fight." I. Martinez.

Martinez, Julio; *..del altar a la tumba..* n.d. Atelier XXIX; poster; I-size: 22" x 16"; P-size: 26" x 20"; Ed#: 18/61; Signed. lower left corner; Note: Drawing of a woman with a blue face and short, straight black hair. She has brown eyes, red lips, and streaks of blue and red in her hair. The background is brown and there are crosses in the background.

Martinez, Paul; *In Memory of Cesar Chavez;* (Nov 12-16) 1993; Atelier 23; Coventry Rag 290 grms; I-size: 16" x 22"; P-size: 20" x 26"; Ed#: 4/65, 20/65; prnt: José Alpuche; mtrx: Destroyed; Signed, Inscription in pencil below the image reads: "4/65, 'Cesars Memory', Paul Martinez. embossed "SHG" below the image on the right; Note: A "No Grapes" sticker on the top left side, a Brahma Bull on the lower left had side, and four images of Cesar Chavez in oval poartait frames. Also, there are falling letters on the right side. Colors used: 1. Ruby Red, 2. Rusty Brown, 3. Tiel (sic.) Green, 4. Yellow, 5. Orange, 6. Mint Green, 7. Green: #Prints: 2.

Martinez, Paul; *Mi Amor;* 1995; Atelier 26; poster; I-size: 38" x 26"; P-size: 44" x 30"; Ed#: 22/41; prnt: José Alpuche; Signed. center bottom; Note: Yellow background with orange splashes. Green yellow spikes/halo encircle the head of a virgen with a lavender robe draped around her head and body. At the base of poster is a batch of roses with angels.

Martinez, Rudy; *Kill;* (July 28-30) 1992; Atelier 19 L.A. Riots; Westwinds; I-size: 24 1/4" x 18 1/4"; P-size: 26" x 20"; Ed#: 4/61, 22/61; prnt: Richard Balboa; mtrx: Destroyed; Signed, Inscription in pencil below image area reads: "Kill, 4/61, Rudy Martinez, 1992". embossed "SHG" chopmark located in the lower right corner; Note: A skeleton in yellow and red in a gesture of pain and with knife blades coming out from behind his neck. Behind him is an insignia encircled by flames with a United States flag, the California bear, olives, grapes.. The background is purple. Colors used: 1. Violet, 2. Blue, 3. Red, 4. Yellow, 5. Mett. Gold, 6. Black. "The print is about death, horror, the total destruction of the human raise (sic.) in the city of Los Angeles, Riots of L.A. 92." R. Martinez: #Prints: 2.

Martinez, Rudy; *Legend;* 1998; Atelier 30; I-size: 31 3/4" x 23"; P-size: 38 3/4" x 30"; Ed#: 4/54, 6/54; Signed. lower left; Note: Lime green skull with 4 arms taking the place of the crossbones. Emblem of "City of Los Angeles Founded in 1787" surrounded by flames on a hot pink background. Colors used: 1. black, 2. magenta, 3. gold, 4. red, 5. blue, 6. silver, 7. green, 8. yellow. "Legend is a clear thundering representation of an uncomfortable reminder that things are not as pleasant as they may seem in the city of Los Angeles, CA. By adding a diverse ultra twist of both dream like and self destruction, the Legend (Print) has captured an ultra pop culture live (sic.) style." R. Martinez: #Prints: 2.

Mejia-Krumbein, Beatriz; *Caution (Captive);* 2002; Coventry Rag, 290 gms. I-size: 16" x 22"; P-size: 20" x 26"; Ed#: 4/80, 6/80; prnt: José Alpuche; mtrx: destroyed; signed. lower left; Note: The image "CAPTIVE" reveals a close up of a face with wide open eyes. The face is framed by a red border filled with blue flowers, and green and yellow leaves. The pattern of flowers, leaves, and branches grows to form a layer in front of the face outlined in black. The face and frame (border) are maily red. Colors used: T-Skin, T-Yellow, T-Red, T-Light Gray, T-Dark Gray, T-Brown, T-Green, Blue, and T-Black.

Memphis, *Cliché Inversion;* July 17-19, 2002; S P; Coventry Rag, 290 gms; I-size: 22" x 16"; P-size: 26" x 20"; Ed#: 4/73, 6/73; prnt: José Alpuche; mtrx: destroyed; signed. lower left; Note: "The shape of the tree is formed with the word "TU CASA ES MI CASA". Poring [sic] out from the leaves is a deranged pig wearing a poor ball helmet and holding a carfe football over the head of a dazed and angry canary who sits in his broken shell on the ground with egg yolk dripping off of his head from the other eggs the pig has cast to the ground." "CLICHE' inversion takes the familiar CLICHE 'MI CASA ES TU CASA' and fups it to now !AY 'TU CASA ES MI CASA'. This statement is the pigs spin in the phrase as he has scaled up a tree and kicked out its inhabitants (A SMALL CANARY) and its unhatched siblings with no regard to the fact that the birds were there first to say nothing of the fact that in general, trees are homes to birds, even squirrels but never pigs. Symbolically, the pig with his football helmet represent the greed of capitalistic

developers—specifically the powers that be behind the football stadium currently being proposed for downtown Los Angeles. The helpless canary is both bewilder[ed] and angry at this hostile take over. The canary represents the people who live in the proposed stadium site. The Broken eggs that () the landscape are literally bird embryos. These represent the destruction of dreams, futures and quite possibly the lives of those persons () in 'STADIUM LAND' and the ripple that this variety of displacement () has for the residents children/family." Colors used: Black, Bright Red, Crayola Yellow, Medium Brown, Forest Green, and Bubble gum Pink. #Prints: 2.

Mendoza, Ricardo; *Respect;* August 6-10, 2002; Coventry Rag, 290 gms. I-size: 16" x 21 1/2"; P-size: 20" x 26"; Ed#: 4/91, 6/91; prnt: José Alpuche; mtrx: destroyed; signed. lower left; Note: A developer is hammering the spike of Gentrification intop a building covered with the American flag and destroying it. The residents are facing the developer in silhouette spelling out the word RESPECT across their backs. A larger figure represents "Justice & Dignity" has deNote:d expensive roots below which are being eaten by termites of greed and indifference. The developers hands also eat at the community by roots and are being showered with money.

Miguel-Mullen, Cristina; *Mangán Tayón- Food for Thought;* May 1-8th, 2001; Maestras 2; Coventry Rag, 290 gms. I-size: 26"x 18"; P-size: 22"x 30"; Ed#: 4/84, 6/84; prnt: José Alpuche; mtrx: destroyed; signed. lower left; Note: The central image of the piece is a woman cooking food and wearing an apron which reads "Mangán Tayón" which in Ilocano means "Let's Eat." fields of gold surround her and feature portraits and images of the artist's grandparents, faces, and as farmworkers working in the fields. They are depicted in sepia and skin color/flesh tones to indicate a feeling of the past in comparison to the central figure of the woman who is shown in more intense colors with warmer flesh tones to indicate the present. In the foreground are plates of food, spices, sauces, fruit and vegetables used in the preparation of the food which are all symbolic to the artist family community and culture. Colors used: Cyan, Magenta, Dark Yellow, Flesh Tone (orange, brown), Sepia, Jade Green, Flesh Tone Dark (orange, brown), Gold, Purple, Off White-Highlights.

Mincher, Sally; *Echo Park;* 24th, July—27th July, 2001; Coventry Rag, 290 gms. I-size: 16"x 22"; P-size: 20"x 26"; Ed#: 4/80, 6/80; prnt: José Alpuche; mtrx: destroyed; signed. lower left; Note: Landscape showing water lilies in bloom with foliage reflected in the water. Location Echo Park, Los Angeles. Colors used: T. Salmon Pink, O. Lemon Yellow, O. Turquiose, T. Burnt Sienna, T. Lime Green, T. Powder Blue, T. Ivory warm-white, T. Magenta/Purple, T. Dark blue/Green.

Molina, Laura; *Cihualyaomiquiz, The Jaguar;* December 10-14, 2002 and March 18, 19, and 20, 2003; S—P; Coventry Rag, 290 gms. I-size: 22" x 16"; P-size: 26" x 20"; Ed#: 4/46, 6/46; prnt: José Alpuche; mtrx: destroyed; signed. lower left; Note: "A leaping female figure wearing a skin-tight ocelot leaotard, wrestling boots and a feathred Native-American headdress in front of a yellow star burst on a deep violet background. Upper left corner has "Insurgent Comix" logo with a clenched fist. The comic book title appares [sic] at the top with dialogue balloons around the figure and descriptive text in lower left corner." Colors used: Pink—Yellow Blend, Gold, Ocelot Orange, Flesh Tone, Red, Aqua, Violet, Orange, Black, Deep Gray, Transparent Black, Deep Blue, Bolck-Out White, Aqua and Gloss Clear.

Montaño, Ernesto; *Divine Pollution;* 1996; Atelier 28; I-size: 22" x 37"; P-size: 24" x 37 2/3"; Ed#: 20/52; Signed; at bottom of third panel. A stamp of *"The Divine Pollution"* is on the left side of the signature. Note: Four separate panels make up this print, each with its own idea and image. An audience of onlookers rest at the top and bottom of the print.

Montelongo, John V. *El Día De Una Vida;* 1994; Coventry Rag 290 grms; I-size: 18" x 24"; P-size: 22'' x 30"; Ed#: 4/64, 20/64; prnt: José Alpuche; mtrx: Destroyed; Signed, Inscription in pencil below the image area reads: "4/64, El día de una vida, J. V. Montelongo, 94". embossed "SHG" below the image area on the lower right; Note: Text encircles the image upon a blue-grey, yellow, purple, and red-brown strip. The day, in yellow and red-brown, is in transition with the night, in blue. "At the upper right the moon appears with angel forms." "Print represents the human life cycle trhough

a day, from morning to night. Poem in Spanish was written by the artist." J. Montelongo: #Prints: 2.

Montelongo, John V. *Lenguaje de mis Padres;* 1996; Atelier 28; poster; I-size: 16 1/8" x 22 1/8"; P-size: 20" x 26"; Ed#: 42/64, 43/64; prnt: José Alpuche; mtrx: Destroyed; Signed. lower left; Note: Open flower coming out of a pair of hands with two organic forms coming out of it. Two faces representing the meeting of two symbols, a person and lost language. Text around the exterior of the print in Spanish reads: "Nacimos juntos y entre los años nos perdimos, cuando un día te encontré, eramós extraños, paso el tiempo y al final, fue mi buena suerte encontrarte otra vez, lenguaje de mis padres.": #Prints: 2.

Montoya, Delilah; *El Guadalupano;* 1999; Atelier 33; silkscreen; I-size: 25" x 17 1/4"; P-size: 30 1/4" x 22"; Ed#: 4/51, 6/51; Signed, Inscription in pencil below image reads: "4/51, El Guadalupano, Delilah Montayo 99.". embossed "SHG" insignia at lower left-hand corner; Note: Image is of a man kneeling with his back to the audience to reveal his hands cuffed. There is a colorful tattoo of the Virgen de Guadalupe on his black and white skin. The background is a prison cell and the foreground is covered in pink flowers. *"El Guadalupano* illuminates the blindness and contradictions of our own times, in a visually seductive, holy-card style print"--*Maestras Atelier XXXIII 1999.* #Prints: 2.

Montoya, Delilah; *They Raised All of Us; City Terrace, L.A. CA, 1955;* 1996; Atelier 28; poster; I-size: 11 1/8" x 15 7/8"; P-size: 22" x 28"; Ed#: 18/48; prnt: José Alpuche; mtrx: Destroyed; Signed. lower right; Note: An old faded family portrait centers this print against a green and blue floral background.

Montoya, José; *Chicano Elder;* n.d. I-size: 15" x 21 1/2"; P-size: 19" x 25"; Ed#: 20/50; Signed, Inscription in pencil below image area reads: "José Montoya, RCAF, c/s". Note: Rendering of Andrés Zepeda. In the background there is an image of a soldier and a house. Colors: gradation of red to yellow, and ochre. On the top, white type reads: "!Toda una vida / al pie de / lucha!." At the bottom, black type reads: "Don / Andrés / Zepeda / 1898-1979 / Defensor del / Centro Mexicano.".

Montoya, Richard; *Mickey Mao;* July 25-27, 2000; Coventry Rag, 290 gms. I-size: 26" x 40"; P-size: 30" x 44"; Ed#: 4/100, 6/100; prnt: José Alpuche; mtrx: destroyed; signed. Inscription in pencil reads, "6/100 Mickey Mao Richard Montoya CC/RCAF 00". lower left; Note: "Mickey Mao" simple use of corporate and communist images juxtaposed with humor and poetry. Colors used: Electric Blue, Fire Engine Red, Twinkie, Dark Purple, and Creamy Yellow. #Prints: 2.

Moreno, Martín; *Dualities;* February 17-18, 2000; Coventry Rag, 290 gms. I-size: 16" x 22"; P-size: 20" x 26"; Ed#: 4/80, 6/80; prnt: José Alpuche; mtrx: destroyed exc. drk blue; signed. lower right; Note: Half of the image deals with life, the other with death showing the intricacy between life and death skeleton dropping seeds into life's hand (woman).

Murdy, Ann; *Life As A Doll: Cracked Doll;* (May 4-6) 1993; Coventry Rag 290 grms; I-size: 19" x 16"; P-size: 24 1/4" x 20"; Ed#: 4/55, 20/55; prnt: José Alpuche; mtrx: Destroyed; Signed, Inscription in pencil below the image area reads: "4/55, Life As A Doll: Cracked Doll, Ann Murdy, '93". embossed "SHG" located below the image on the right; Note: Image of a doll in a white dress with red jagged cracks on its forehead. Blue background on which is hovering a pink ribbon with text. Colors used: 1. Op. Ultramarine blue blended to baby blue, 2. Op. dusty rose blended to flesh, 3. T yellow orche (sic.), 4. T mint green, 5. T Fire red, 6. Op. charcoal gray. "Print deals with 'Life as a Doll.' This doll is the cracked doll. I plan on doing [this] as series of doll prints where each doll is dysfunctional in one way or anofher. #Prints: 2.

Nicoll, Janie; *Monuments, Machinery and Memorials;* (Oct 10-14) 1994; Atelier 25; Coventry Rag 290 grms; I-size: 37 1/4" x 27 1/4"; P-size: 43" x 30"; Ed#: 4/56, 20/56; prnt: José Alpuche; mtrx: Destroyed; Signed, Inscription in pencil below the image reads: "4/56, 'Monuments, Machinery, and Memorials', Janie Nicoll, '94". embossed "SHG" below the image on the right; Note: "This print uses images of monuments, machinery and memorials in a phallic shaped arrangement. It deals with the masculine nature of war; manipulation and depersonalisation by the state and the destruction of lives and society." At the top there is an image of a machine; below it are three monuments; below these are two portraits of soldiers in oval frames; below these are plants that

spring out. Colors used: 1. Pale blue, 2. Mid blue, 3. Crimson, 4. Bright yellow, 5. Orange, 6. Pale yellow, 7. Creamy white, 8. Purple grey, 9. Bright red, 10. Orange red, 11. Dark blue, 12. Pale green, 13. Sienna/orange. "The images used in this print were collected during a year spent in Eastern Europe. The two young men were Russian soldiers killed while liberating Hungary in 1945. The steam powered maching was from an old negative on glass (daguerrotype) (sic.)." J.Nicoll. #Prints: 2.

Norte, Armando; *Día de los Muertos, Announcement Poster for;* 1982; I-size: 23 1/4" x 17 1/2"; P-size: 30 3/4" x 23 1/8"; Ed#: unknown ed. Signed, Inscription in pencil below image area reads: "Norte, 82". Fund: partially funded by N.E.A. Note: Announcement Poster for "Día de los Muertos." Rendering of a skull as a woman facing the viewer. Images of bones and a small skull in woman's hair are amongst pink and white streamers. Black lettering on bottom of poster reads: "Dia de los Muertos / Day of the Dead, 10th Anniversary / November 7, 1982, SHG, Los Angeles, CA / Partially Funded by N.E.A.": #Prints: 2.

Norte, Armando; *Niña Héroe;* (Aug 22-25) 1992; Atelier 20; Coventry Rag; I-size: 30" x 24"; P-size: 36 1/8" x 30 1/8"; Ed#: 47/68, 60/68; prnt: Richard Balboa; Signed, Inscription in pencil below image area reads: "47/68, 'Niña Héroe', Norte, 92". embossed "SHG" insignia located in lower right corner outside of image area; Note: A skull rendered as a girl, probably 'Adelita', is holding a gun and staring at the viewer. The figure is wearing a hat, hoop earrings, two braids and two rows of bullets accross her chest. A doll is lying on the ground by the girl's feet. Colors used: 1. Lt Brown, 2. Burgandy, 3. Pink, 4. Blk (sic.), 5. Tan (flesh), 6. Dk. Brown. "'Niña Héroe' represents a modern female spirit with the traditional elements of the Mexican past. A little girl in a (tattered) pink party dress, calavera make-up and bone-ainted body stocking, dicards her doll for a wooden toy rifle. A heart and skull loom behind her. Love and Death. She stands proud, facing the future with a sense of strength and hope." A.Norte: #Prints: 2.

Norte, Armando; *Savagery & Technology;* 1983; Atelier 1; Artprint 25% Rag; I-size: 19" x 24 7/8"; P-size: 22" x 34"; Ed#: 22/60; prnt: Stephen Grace; Signed, Inscription in pencil below image area reads: "Norte 83, 22/60, title, copyright insignia, 1983, SHG East LA, CA". Blue "SHG" at the bottom. Fund: partially funded by NEA and the CAC. Note: Lime green, gray, white, black, turquoise technological figure on a black background. Writting on poaster reads "Experimental Screenprint Atelier.".

Norte, Armando; *Shadows of Ghosts;* (Dec 18-22) 1989; Atelier 14; Westwinds (heavyweight); I-size: 22 1/4" X 32 1/4"; P-size: 26 1/4" X 36 1/4"; Ed#: 4/64, 16/64; prnt: Oscar Duardo; mtrx: Destroyed; Signed, Inscription in pencil below image reads: "4/64, title, signature and 89" Signed, Inscription in pencil below the image reads: "16/64, 'Shadows of Ghosts', Norte, 89". "SHG" embossed insignia located in the lower right corner; Note: Blue female with dark blue web pattern on her dress. She has her head turned looking back at a purple, pink, blue, abstracted area. Three dark lines separate the woman from the background. "We wear the scars of our past bad experiences. Touch them and feel the fear, the anger, the pain, over and over again. Those moments from our past are but a collage of fading images. Shadows of ghosts. We must look forward, to life." A. Norte: #Prints: 2.

Norte, Armando; *Untitled;* (Nov 19-20) 1983; Atelier 2; Artprint 25% Rag; I-size: 18" x 30"; P-size: 22" x 34"; Ed#: 4/77; prnt: Stephen Grace; mtrx: Destroyed; Signed, Inscription in pencil below the image area reads: "4/77 and signature". Black "SHG" logo included on the print surface; Fund: partially funded by the CAC and the NEA. Note: Face of a woman in black & red. There is a white web over her face.

Nuke, *Todos Somos Chusma;* 1998; Atelier 29-31 #4 & #6; I-size: 22" x 15 3/8"; P-size: 26" x 20"; Ed#: 4/129, 6/129; Signed. lower left; Note: Audience members to a performance are dressed up in costume as are the actors on stage. "Chusma" is written at the top of the print in bold, brown letters. #Prints: 2.

Ochoa, Victor; *Border Bingo/Loteria Fronteriza;* 1987; Atelier 10; I-size: 23 1/2" x 33"; P-size: 26" x 37"; Ed#: 4/53; Signed, Inscription in pencil below image area reads: "4/53, title, signature and date". "SHG" chops located in the lower left corner; Note: Nine images: El Vato, La Migra, El Nopal, La Turista, La Criada, El Marine, La Facil, El Indio, La Punk. Colors used: 1. Yellow, 2. Red, 3. Blue, 4. Green,

5. Pink, 6. Orange, 7. Gray, 8. Purple, 9. Brown, 10. Turquoise blue, 11. Dark Brown.

Olabisi, Noni; *King James Version;* 1999; Atelier 33; silkscreen; I-size: 26 1/2" x 19 1/4"; P-size: 30 1/4" x 22"; Ed#: 4/58, 6/58; Signed, Inscription in pencil below image area reads: "4/58, King James Version, Noni Olabisi 1999.". Note: Image is of a man kneeling with his hands tied above him. There are blood spots on his shirt. To the left of the image is a female figure. The background is red. The foreground is an open book with the scripture of Lebiticus, Chapter 26 and a hand gun resting on top of it. "The physical, cultural, and spiritual survival of the African diaspora is embodied in the visually dominating fertility figure from Ghana, even as slavery was grounded in an institutionalized, Eurocentric version of Christianity"--*Maestras Atelier XXXIII 1999.* #Prints: 2.

Oropeza, Eduardo; *Chicuelina;* 1996; Atelier 17; poster; I-size: 17" x 21"; P-size: 22" x 26"; Ed#: 32/97, 34/97; prnt: José Alpuche; mtrx: Destroyed; Signed. yes; lower left hand corner; Note: Scene of two bullfighters waving a red cape in front of a bull's face while he charges at them. The scene is surrounded by what appears to be fire. Skeleton faces line the background. #Prints: 2.

Oropeza, Eduardo; *El jarabe muertiaño;* (Jan 16-Feb 17) 1984; Atelier 3; Somerset 320 gram, textured 100% Rag; I-size: 24 1/2" x 34"; P-size: 24 1/2" x 34"; Ed#: 2/73, 11/73; prnt: Stephen Grace; mtrx: Destroyed; Signed, Inscription in pencil located in the lower left bottom of the print reads: "2/73, and signature". "SHG" info on the back; Note: Three skeleton costumed figures. #Prints: 2.

Oropeza, Eduardo; *Onward Christian Soldiers;* (Dec 15-18) 1985; Atelier 6; Accent 290 gram-white; I-size: 33" x 24"; P-size: 33" x 24"; Ed#: 4/45; prnt: Stephen Grace; mtrx: Destroyed; Signed, Inscription in pencil located in the lower left corner reads: "4/45 and signature". Note: Skeleton figures in costume. One wears a cardinal outfit. Full bleed. Hand torn edges.

Orosco, Juanishi V. *Angel de la Vida;* June 17-21, 2003; Atelier XLT; Coventry Rag, 290 gms. I-size: 22" x 16"; P-size: 26" x 20"; Ed#: 4/82, 6/82; prnt: José Alpuche; mtrx: unknown. signed. lower left; Note: "The figure of an Angel over a blue blend background. He is criss crossed with scars. There is the image of a Pre-Columbia face with Huelga Eagle designs on his face. I titled this print on a on-going series of Meso-American Angels. These angels are male/female and they are indeginous [sic] to the America's! This Angel I title "Angel de la Vida." He has served his time here on earth by helping us in our daily pendejas! As symbolized by the scars on his body -! He is being brought back to his home as symbolized by a guardian gatekeeper ---- He served his time on Earth and is being rewarded by being allowed to go home -- back to his cante! (home) It's actually very simple, an angel served his time!" Colors used: Blended Colors, P26C Violet 263 C, P.29C Ultra Blues 283 C, P.29C Ultra Blue 287 C, P.32C Light Tralo Blues 304C, P.33 Med. Thale Blues, Off White, Clear Gloss, and Black. #Prints: 2.

Orosco, Juanishi; *Madre Santa, Tierra Sol, Madre Santa, Libertad!;* 1987; I-size: 15" x 21"; P-size: 19" x 25"; Ed#: 37/50; Signed, Inscription in pencil below image area reads: "Juanishi Orosco 10/87". Note: The composition is organized around an orange and hot pink cross shape. There is an indigenous woman at the center. Two deers at each corner of the image area are looking at her. The background shows two Aztec comets crossing the sky and a section of the globe showing the United States, Mexico, and the ocean.

Ortega, Jerry; *Neo-Mexico;* (Mar. 19-21 & 31) 1998; Atelier 31; I-size: 22 1/8" x 16 1/2"; P-size: 26 1/8" x 20"; Ed#: 4/63, 6/63; prnt: José Alpuche; mtrx: Destroyed; one of two posters Signed. lower left; Note: Man with scarf over mouth is walking through corn fields with the city in the background. Colors used: 1. cyan blue (t), 2. magenta (t), 3. yellow shade green (t), 4. violet (t), 5. ochre orange (t), 6. white dark blue (t). "In relation to Siqueiros, 'America Tropical.' The indigenous peoples of Mexico battling the U.S. Corporation sweet thanks to N.A.F.T.A. the power of nature (corn, land, sun) against (sic.) the nan-created elements (helicopters, big-money Corps. (sic.), tanks, destruction of Tiocoli, temples/pyramids). Continues.." "Neo-Mexico like Neo-Liberalism, the new style city making way for new bisineses down to the tip of its country. But the E.Z.L.N will not let this be another exploitation game by the corrupt Government (sic.). The indigenous woman calling the power of Ishim (Maize) breaking through a

Mowey sign highway dropping the tanker, the attack of heavy helicopters sent by the U.S. to supposedly stop Narco-trafficing when, in reality, they are killing its native people The struggle continues.." J. Ortega: #Prints: 2.

Ortega, Tony; *A la Frontera de Aztlán;* (Feb 28-Mar 3) 1995; Atelier 25; Coventry Rag 290 grms; I-size: 26 1/2" x 38"; P-size: 30" x 44"; Ed#: 4/64, 20/64; prnt: José Alpuche; mtrx: Destroyed; Signed, Inscription in pencil within the image in the middle reads: "A Frontera de Aztlán, 4/64, Ortega, (c)". embossed "SHG" on the lower right; Note: "Street scene with two fold up impala Lowrider cars; Chicano & Mexican Icons." Main colors are: orange, yellow, purple, and lime green. Colors used: 1. T. Yellow (light), 2. T.Orange, 3. T. Red Purple, 4. T. Green, 5. T. Blue, 6. T. Brown (warm), 7. T. Pink (cool), 8. T. Yellow Green, 9. T Blue Green (light), 10. T. Blue Purple, 11. T. Red Orange, 12. T. Dark Blue. "Northwest Denver Barrio scene with Meixican & Chicano Iconography." "This print is dedicated to the memory of my grandmother Trinnie Ortega who past (sic.) away on Feb. 14, 1995, who gave me love and culture during my time with her." T. Ortega: #Prints: 2.

Ortega, Tony; *Frida y Diego Nos Muestran México;* (Mar 25-29) 1991; Atelier 16; Westwinds; I-size: 35" x 26"; P-size: 37 1/2" x 28"; Ed#: 16/64, 18/64; prnt: Oscar Duardo; mtrx: Destroyed; Signed, Inscription in pencil below the image reads: Frida y Diego nos Muestra México, 18/64, Ortega, 91 (c)". embossed "SHG" below the image on the right hand corner; Note: Portraits (in three quarters) of Frida Kahlo and Diego Rivera in the foreground. Frida is holding a paintbrush and they are standing side by side, looking at something in the distance. Behind them is a group of people (tourists) beside a car. In the background there is the Chichen Itza pryamid. Colors used: 1. Black, 2. Pastel Purple, 3. Pastel powder blue, 4. Light pastel yellow, 5. Drk. barn red, 6. Drk. ultramarine blue, 7. Drk. Red, 8. Paste (sic.) peace-pink, 9. Pastel Milori blue, 10. Aqua pastel blue, 11. Lt. pastel orange, 12. Lt. lime green. "Great Mixican painters Frida Kahlo + Diego Rivera show us our Mexican history + heritage (US—The Barrio, youth, etc.)." T. Ortega: #Prints: 2.

Ortega, Tony; *Los De Abajo;* (May 20-22) 1993; Atelier 23; Coventry Rag, 290 grms; I-size: 22 3/8" x 32 1/4"; P-size: 25 1/2" x 35"; Ed#: 4/58, 6/58; prnt: José Alpuche; mtrx: Destroyed; Signed, Inscription in white below image area reads: "Los de Abajo, 4/58, Ortega, (c) copyright". Lower right; Note: Two trucks--one pink, one purple--are the central image before a deep green and light green background of rolling hills and grass. People load or unload the purple truck while others stop beside the pink truck, whose driving plate reads: "UFW" (United Farmers Workers). There is yellow sky with a small blue plane in the upper left-hand corner of the print. Colors used: 1. Process cyan blue, 2. Process magenta, 3. Process Yellow, 4. Process Orange, 5. Process Violet, 6. Light Green, 7. Black. "'Los de Abajo'—the underdogs or the ones from below. Migrant workers are often see (sic.) as out of sight and not important, but the provide important work for our society, that is the colletion of our food. This peice is dedicated in memory of Cesar Chaves who help (sic.) the migrant worker." T. Ortega: #Prints: 2.

Padilla, Stan; *Tree Of Understanding;* 1987; I-size: 15 1/4" x 21"; P-size: 19" x 25"; Ed#: 20/30; Signed, Inscription in pencil below image area reads: "Stan Padilla '87". Note: The images shows three indigenous, one adult, and two children, gathered around a symbolic tree. Around the image there is a number of personal and Aztec symbols and patterns. Colors: gradation of blue and dark brown.

Pérez, Elizabeth; *Blue Venus;* 2001; Maestras 2; Coventry Rag, 290 gms. I-size: 18"x 22"; P-size: 22"x 30"; Ed#: 4/70, 6/70; prnt: José Alpuche; mtrx: destroyed; signed. lower left; Note: A linear and cross-hatched version of Bottecelli's Venus (sans the half shell) holds paint brushes, their tips with the primary colors and gold, with her left arm. She puts her hand over her heart are which has a tattoo with a small banner in Latin that is not entirely legible. Over her head is a full banner with the words on the tattoo- "Ars longa, vita brevis" (Art is long, life is short-Hippocrates). Yellow sunrays shine from behind her on a red background. Colors used: Deep Crimson, Pale Yellow, Light Blue (warm), Medium Blue (warm), Grey, Gold, Purple.

Perez, Jesus; *Arreglo;* (Oct 8-9) 1983; Atelier 2; Artprint 25% Rag; I-size: 17" x 23"; P-size: 22" x 34"; Ed#: 4/78; prnt: Stephen Grace;

mtrx: Destroyed; Signed, Inscription in pencil below atelier logo reads: "4/78 and signature". SHG logo below the image area in blue; Fund: funded in part by CAC and the NEA. Note: Abstract design of red, orange, yellow, blue, pink. The eyes and vase are blue. Title about the print is in orange.

Perez, Jesus; *The Best Of Two Worlds;* (Nov 9-13) 1987; Atelier 10; Westwinds; I-size: 24" x 38"; P-size: 24" x 38"; Ed#: 4/59; prnt: Oscar Duardo; mtrx: Destroyed; Signed, Inscription in pencil located at the bottom reads: "4/59, title, signature and 87". "SHG" chops located in the lower right hand corner; Note: Image of a cactus resting on a male bust with his hands holding his collar. The cactus contains photo images of five generations; documentation of two cultures. Colors used: 1. Gray, 2. Dark Red/Vermillion, 3. Opaque Turquoise, 4. Opaque Aqua Transaqua (sic.), 5. Bluegreen, 6. Opaque Moss Green, 7. Red/Gray, 8. White, 9. Magenta, 10. Process Blue. "Best of Two Worlds acknowledges the contributions fo five generations and two cultures in the formation of yet a third culture, the Mexican-American. A generation of parents watched some of their offspring die, other become war heroes, and others edged into the U.S. under difficult circumstances during the Mexican Revolution. But those who made it into the U.S. brought Mexican-born children who were destined to parent the first generation of Mexican-Americans. These three generations formulated the Mexican-American high-spirited passionate heritage. But the Mexican-American-- born of Mexican descent and United States citizenship-- was to enter his own revolution: to fight for his identity; to establish his values in a country which differed in culture and in values from the three generations that had preceded him. Bitterness and success can be found in this fourth generatin. Some long --even protest-- for (sic.) the past, others abandon the past entirely, while others seek ways to merge the best of two worlds. Generations continue and now the fifth generation will have the opportunity to act out their response to a culture which offers new-age thoughts: electronic, space, sex, materialism and Ronald Reagan, etc. Some will concern themselves with their heritage and others will continue to abandon it. One thing sure (sic.): like the cactus which supports the eagle on the National Mexican flag they are all undeniably mexican-rooted!" J. Perez.

Perez, Jesus; *Try-Angle #1;* (Nov 2-6) 1986; Atelier 8; Westwinds; I-size: 36 3/8" x 24 3/4"; P-size: 36 3/8" x 24 3/4"; Ed#: 4/45, 12/45; prnt: Oscar Duardo; Signed, Inscription in pencil at the bottom within the image area reads: "12/45, Try-Angle #1, Perez, '86". None as of yet. Fund: funded in part by the CAC, NEA and the City of Los Angeles. Note: "Pyramid-triangular shape with tube-like form twisting around and through it." Colors used: 1. Blue, 2. Red, 3. Yellow, 4. Blue/Green/Red, 5. Orange/Yellow, 6. Black/Blue, 7. Purple, 8. White, 9. Red, 10. Yellow/Red, 11. Sepia, 12. Blue. #Prints: 2.

Perez, Jesus; *Untitled;* (Oct 29-31) 1985; Atelier 6; Accent 290 gram—white; I-size: 25" x 36"; P-size: 25" x 36"; Ed#: 17/44; prnt: Stephen Grace; mtrx: Destroyed; Signed, Inscription in pencil located vertically in the upper left reads: "17/44, 85 and signature". Fund: funded in part by the CAC, NEA, and the City of Los Angeles. Note: Human figure in four parts, each part when put together completes the whole image. This piece is the upper right corner. Colors used: 1. Blue and orange, 2. Ivory, 3. Black, brown, and blue.

Perez, Juan; *Vértigo;* (Nov 24-28) 1986; Atelier 8; Westwind; I-size: 25 3/4" x 37 3/4"; P-size: 26" x 38"; Ed#: 4/45; prnt: Oscar Duardo; mtrx: Destroyed; Signed, Inscription at the bottom of the image area reads: "4/45, title and signature". None as of yet. Fund: funded in part by the CAC, NEA and the City of Los Angeles. Note: Abstract figure holding a vase on a light yellow/peach colored background. Colors used: 1. Cream, 2. Blue/White/Lavendar, 3. Grey, 4. Brown, 5. Salmon, 6. Aqua/Green/Yellow/Red, 7. Purple, 8. Emerald Green, 9. Red/Purple, 10. Pearl.

Pérez, Louie; *Thinking of Jesus and Mary;* (Feb 6-10) 1989; Atelier 13; Westwinds (heavyweight); I-size: 22 1/4" x 26 1/2"; P-size: 26" x 30 3/4"; Ed#: 45/62; prnt: Oscar Duardo; mtrx: Destroyed; Signed, Inscription in pencil below the image area reads: "45/62, Louie Pérez". Bottom of lower left hand corner of image. Note: "Two hearts (one red-one purple) with newsprint backround [sic], monotyped "coffee stain"-lower right corner—signed and numbered or (sic.) printed page." Colors used: 1. Tran. Lt. Gray, 2.

Tran. Lt. Milori Blue, 3. Tran. Red, 4. Tran. Charcoal Black, 5. Pink, 6. Purple, 7. Tran. Blue, 8. Magenta-red, 9. Magenta-cerise, 10. Tran. Lt Powder Blue, 11. White, 12. Dr. Tran. Purple "'Jesus and Mary' is based on a series of pastel drawings on news paper. I've used the religious imagery of the secred (sic.) hearts of Jesus and Mary to convey persoanl convitions to religion in a purely aesthetic approach. The print medium has recreated the news paper accurately, while the draen image retains the immediacy of the orignal. I've also used mono type to further enhance the attitude of making art of making art (sic.) at the moment. They overall piece conveys a feeling of irony in the Justa position (is.c) of reliquious (sic.) symbols and the disposable, temporary material on which they are executed." L. Perez.

Pineda, Sara?; *Monthly Calendar;* ca. 1979; I-size: 6 5/8" x 16 1/8"; P-size: 7" x 16 3/4"; Ed#: unknown ed. Signed, Inscription inside image area reads: "Pineda". located at the bottom of the print violet type reads: "SHG / and / Art Inc. / 2111 Brooklyn Ave. / Los Angeles, Calif. 90033-264.1259 / 268.2335."; <u>Note:</u> Monthly Calendar. Urban landscape showing the wall of a house, palm trees, and a cloudy sky. There are six differently colored versions of this print in combinations of lime-red, green-blue, white-red. #Prints: 6.

Ponce, Michael; *Familia;* 1983; Atelier 1; Artprint; I-size: 19" x 25"; P-size: 23" x 35"; Ed#: 4/60; prnt: Stephen Grace; mtrx: Destroyed; Signed, Inscription in pencil reads: "4/60, title, and signature". No chop. Fund: partially funded by the NEA and the CAC. <u>Note:</u> Two large faces in the background. Seven burnt sienna figures in the middle ground. Blue grid pattern with green circular pattern in the foreground. Smudge on upper right corner.

Portillo, Rose; *Sor Juana Rebelling Once Again;* 1999; Atelier 33; silkscreen; I-size: 24" x 18 1/4"; P-size: 30 1/4" x 22"; Ed#: 4/65, 6/65; Signed, Inscription in pencil below image area reads: "4/65, 'Sor Juana, Rebelling Once Again', Rose Portillo '99.". embossed "SHG" insignia in lower left-hand corner of poster; <u>Note:</u> Image is of Sor Juana dressed in the Virgin of Guadalupe's blue cloak with yellow stars. Sor Juana also has a red bandana covering her mouth and a tear falls from her right eye. There are two red horns with intertwined leaves and flower on top of her head. "The artist portrays her simultaneously as goddess, saint, and heroine and surrounds her with text taken from her own writings that historically, finally had the last word"--*Maestras Atelier XXXIII 1999.* #Prints: 2.

Posadas, Refugio; *Festín de Aromas;* 1996; Atelier 28; poster; I-size: 21 1/2" x 15 1/4"; P-size: 26" x 20"; Ed#: 12/49; prnt: José Alpuche; mtrx: Destroyed; Signed. lower left corner; <u>Note:</u> The print combines images of Mexican popular culture (Mexican calendar of roses as background), everyday life, catholicism (cross), and sexual repression (14th cent. chastity belts). Colors: magenta, cyan, yellow, black, and violet. "Through juxtaposing the images I intend to suggest an organic/open-ended narrative about the politics of representation in gender and culture in this place and time."--Refugio Posadas.

Pullini Brown, Ada; *Mother of Sorrow;* 1996; Atelier 28; poster; I-size: 22 1/4" x 33"; P-size: 29" x 42"; Ed#: 41/70, 42/70; prnt: José Alpuche; mtrx: Destroyed; Signed. lower right; <u>Note:</u> Multiple images of the Virgin with Nicole Simpson and Ron Goldman. Colors that predominate are yellows and browns, turquiose Madonna on right hand side in blue. #Prints: 2.

Pullini Brown, Ada; *The Fruit of Discord;* 1995; Atelier 26; poster; I-size: 37 1/2" x 26"; P-size: 44" x 30"; Ed#: 37/56, 38/56; prnt: José Alpuche; mtrx: Destroyed; Signed. lower left corner; <u>Note:</u> Woman in a blue dress holds a red apple with text and vase in the background. #Prints: 2.

Ramirez, Christopher; *Alpha-Omega;* ca. 1993; Images Of The Future; I-size: 21" x 14"; P-size: 25 1/8" x 18"; Ed#: 4/37, 12/37; Signed, Inscription in pencil below image area reads: "4/37, 'alpha/ omega', Christopher [illegible]". embossed "SHG" insignia in lower right corner; <u>Note:</u> The entire print is dominated by the image of a head (skull) in profile. It looks as if it is a colored x-ray or computer image. Abstract images and bubbles float beside the skull. #Prints: 2.

Ramirez, Christopher; *Leading By Example;* ca. 1992; Atelier 19 L.A. Riots; I-size: 21" x 16 1/4"; P-size: 24 1/2" x 19"; Ed#: 4/49, 22/49; Signed, Inscription in pencil located below image area reads: "'Leading By Example', 4/49, Christopher [illegible]". "SHG" embossed chopmark located on bottom right of the print; <u>Note:</u>

A distorted face divided in quarters on a red background. In the upper and bottom section of the print, green type reads: "moderno / power". A horizontal section across the print shows an image of two enlarged eyes on a yellow background. On each eye, white type reads: "think / peace": #Prints: 2.

Ramirez, Christopher; *Target Market;* (Oct 18-Oct) 1993; Atelier 23; Coventry Rag 290 grms; I-size: 36" x 20"; P-size: 39 5/8" x 24 1/2"; Ed#: 4/61, 20/61; prnt: José Alpuche; mtrx: Destroyed; Signed, Inscription in pencil below the image reads: "4/61, 'Target Market', Christopher, '93". Center; <u>Note:</u> A skeleton situated centrally. Its bones are red-brown in color with white outlines. The background is brown/black with eyes scattered throughout. Colors used: 1. T-Cyan Blue, 2. T-Magenta, 3. T-Fire Red, 4. T-Primrose Yellow, 5. T-Ultra-Blue, 6. T-Violet, 7. T-Orange, 8. T-Orche (sic.), 9. T-Salmon Pink, 10. O-Ivory Wht (sic.), 11. O-Black, 12. O-Fire Red. "This title has been selected to intentially (sic.) imply the dangers of the recent acknowledgement of the Chicano community as an emerging political and economical force. Currently this recognition has yet to actually benefit the communities. With the potential benefits come the risks of exploitation. This print was intended to serve as a wake-up call and force the viewers to realize that all eyes are on 'us' and our future generation of 'raza'." C. Ramirez: #Prints: 2.

Ramirez, Jose; *25 Calakas, Announcement Poster for;* 1998; Atelier 33; silkscreen; I-size: 21 3/4" x 15 1/4"; P-size: 26" x 20"; Ed#: 4/79, 6/79; Signed, Inscription in pencil below image area reads: "4/79, 25 Calakas, J. Ramirez 1998.". embossed "SHG" insignia at lower left-hand corner; <u>Note:</u> Image is of 25 skulls of different shapes, color, and design. Writing in silver on black background reads "SHG presents Day of the Dead/Dia de los Muertos Annual Exhibition and Celebration November 1-22, 1998 el big two-five 25th Anniversary.": #Prints: 2.

Ramirez, Julio Cesar "Mi Yo"; *Hasta Que La..Los Separe;* Nov. 6-10, 2001; Coventry Rag, 290 gms. I-size: 16"x 22"; P-size: 20"x 26"; Ed#: 4/75, 6/75; prnt: José Alpuche; mtrx: destroyed; signed. lower left; <u>Note:</u> Bano, Mujer, Hombre, Ropa Interior, Zapatos y Collage. Colors used: Clear Base, (T. Blue Grey), T. Red, T. Olive Green, T. Turquiose Blue, T. Purplish Blue, T. Dark Blue, T. Grey (Charcoal), T. Violet, O. Black, Clear Gloss.

Ramirez, Omar and Chaz Bojorquez, *The Here & Now;* October 2-6, 2001; Coventry Rag, 290 gms. I-size: 21 1/2" x 35 1/2"; P-size: 30" x 44"; Ed#: 4/80, 6/80; prnt: José Alpuche; mtrx: On file; signed. Inscription in marker in image area reads, "Omar ramirez Chaz Bojorquez". lower left. <u>Note:</u> DJ Calaca with titles (SHG Presents El Día De Los Muertos 2001, "The Here and Now"). "My contribution to the print is the DJ Calaca spinning records on two turntables. This image represents the Hip Hop Nation that has permeated all aspects of Chicano and Latino Culture. It expresses the voice of "The Here & Now" and my generation views on progressive culture, politics & philosophy."—Omar. "My contribution to the print is the addition of the lettering. My "Cholo" East Los Angeles style to reinforce our streetwise Latino heritage with the new millenium the title "The Here & Now" is what we are all about."—Chaz. Colors used: Light Blue Field, Green, Purple, Ochre, White, Ultramarine Blue, Black line drawing, Red, and Black Border. #Prints: 2.

Ramos, Vincent; *Por Vida;* (Sept 12-14) 1993; Atelier 23; Coventry Rag 290 grms; I-size: 22" x 16"; P-size: 26" x 20"; Ed#: 4/54, 20/54; prnt: José Alpuche; mtrx: Destroyed; Signed, Inscription in pencil below the image reads: "Vincent Ramos, Por Vida, 4/54". embossed "SHG" located below the image to the right; <u>Note:</u> A man and a woman gaze at the viewer. The man wears a bandana with text which reads: "somos como somos". Her hair is black and very long. There is a sign post behind them which reads: "B--Venice--X 3": #Prints: 2.

Rangel, Chuy "C/S"; *Día De Los Muertos 1999;* September 5-12, 1999; Coventry Rag 290 gms. I-size: 25 1/2" x 24"; P-size: 31 1/2" x 30"; Ed#: 4/85, 6/85; prnt: José Alpuche; mtrx: Destroyed. signed. Inscription in pencil reads, "4/85 Chuy C/S 99". lower left. <u>Note:</u> Día De Los Muertos com[m]emorative poster for SHG 1999. The Content of the Image deals with the Ford Anson Theatre towers in the background, because of the concert (to be held there) and the calacas driving to the concert. The driver is me (Chuy C/S) in my 1956 Chevy Bel Air, the passenger is my girlfriend, Belén throwing zempaxochitl out the window, blessing the path, and a

rocker is jamming on the cab of my ranfla. Colors used: O.P. Black, Red Purple, Drk Brown, Light Blue, Ultra Blue, Drk Green, Medium Green, Yellow Ochre, Maroon, Pink, Green Shade Yellow, T-White, T-Orange, and O. White.

Rangel, Jesus "Chuy"; *Puro Lovers Lane;* 1998; Atelier 31; I-size: 15 3/4" x 18 5/8"; P-size: 20" x 26 1/4"; Ed#: 4/63, 6/63; prnt: José Alpuche; Signed. lower left; Note: Two skeletons on either side of a heart watching a car go by. Colors predominantly blue and green. "'Puro Lovers Lane' is a piece on the isue of true love vs. lust. As the two lovers are on a lonely stretch of pavement away from the busy streets of east los (sic.), they engage in a passionate moment of love making in a 56 Chevy. The question is whether their actions are being carried out by desire of the act of true love? Is their heart really speakign out to one another? As the conscience of the indivuduals are over looking (sic.) actions they ponder this question." J."Chuy". Rangel: #Prints: 2.

Rangel, Marissa; *Untitled;* May 13-16, 2003; Atelier XLT; Coventry Rag, 290 gms. I-size: 20" x 16"; P-size: 26" x 20"; Ed#: 4/66, 6/66; prnt: José Alpuche; mtrx: unknown. signed. lower left; Note: "Person looking up with hands in the air.": #Prints: 2.

Ray, Joe; *Tacos Con Huevos!;* February 24, 2000; Coventry Rag, 290 gms. I-size: 16" x 22"; P-size: 20" x 26"; Ed#: 4/80, 6/80; prnt: José Alpuche; mtrx: destroyed; signed. lower left. Note: Red Gallo Romantico eating a Nopal Taco- text in background- 3 hearts at bottom. Colors used: Pale Yellow, Butterscotch Yellow, Purple, Green, Red, and Blue Black.

Rendon, Maria; *Trinidad;* (Nov 9-11) 1993; Atelier 23; Coventry Rag 290 grms; I-size: 24" x 19"; P-size: 26" x 20"; Ed#: 4/38, 20/38; prnt: José Alpuche; mtrx: Destroyed; Signed, Inscription in pencil below the image reads: "4/38, Trinidad, M. Rendón, 94". embossed "SHG" below the image on the lower right; Note: An arch with three angels in the center. A cross is on the top done in two types of red. "As a symbol of three Important 'Forces' 'Persons' (sic.), 'Meanings' in Life (sic.). It is a personal piece." M. Rendon: #Prints: 2.

Reyes, Miguel Angel; *Dozena;* 1999; Atelier 33; silkscreen; I-size: 18 5/8" x 24 3/4"; P-size: 22" x 30 1/4"; Ed#: 4/67, 6/67; Signed, Inscription below image area reads: "6/67, 'Dozena', signature [illegible] 99.". embossed "SHG" insignia at lower left-hand corner; Note: Image is of 12 faces aligned in three rows of four. There are six women and six men in yellow and orange tones. Every square alternates gender. Background is brown with black borders. #Prints: 2.

Reyes, Miguel Angel; *Epoca de Oro;* 2002; I-size: 22" x 16"; P-size: 26" x 20"; Ed#: 4/84, 6/84; signed. lower left:

Reyes, Miguel Angel; *Herido;* (Aug 6-8) 1992; Atelier 19 L.A. Riots; Westwinds; I-size: 24" x 18"; P-size: 28" x 20"; Ed#: 4/64, 22/64; prnt: Richard Balboa; mtrx: 0; Signed, Inscription in pencil below image area reads: "Herido, 4/64, Miguel Angel Reyes ". Lower left next to title; Note: A green winged-man bending on his knees and touching his shoulder and the lower part of his leg. His face has an expression of pain. The background is covered in curled designs resembling flames. Colors used: 1. Brick (Red), 2. Lemon Yellow, 3. Moss (Green), 4. Tangerine, 5. Charcoal, 6. White Cream. "One of the inhabitants of the city of angels has been wounded and is caught in the fire." M.A. Reyes: #Prints: 2.

Reyes, Miguel Angel; *Tension;* 1991; Atelier 17; Westwinds; I-size: 30 1/8" x 24 1/4"; P-size: 34 1/4" x 28 1/8"; Ed#: 4/61, 42/61; prnt: Oscar Duardo; mtrx: Destroyed; Signed, Inscription in pencil located at the bottom below the image area reads: "Signature, title and 4/61" Signed, Inscription in pencil below the image reads: "Miguel Angel Reyes, 'Tension', 42/61". "SHG" chops located in the bottom right hand corner; Note: "[A] figure in starting runner's position on top of a blue electrical pole. Red background with multicolor transparent stars, orange plus and minus signs on lower left and right of image--eye with a circle on top of pole.."; "Man awaits not knowing for his AIDS test results, not knowing what the outcome will be. He feels the watchful eye of everyone around him. He's in a situation from which he can't run away from. The sky becomes his blood stream and the stars his white cells, some are fading away as they are killed by the virus. The electrical pole represents the similarity of the positive and negative energies that flow in our bodies." M. Reyes. #Prints: 2.

Rios, Pedro Martinez; *Mexico sin Espinas;* 1997; Atelier 29-31 #4 & #6; I-size: 21 3/8" x 16"; P-size: 26" x 20"; Ed#: 4/59; Signed. lower left; Note: A nude woman holds a snake in one hand and the Mexican flag in the other. An eagle behind her holds on to both objects as well.

Robledo Tapia, Honorio; *El Regalo;* March 28-30, 2000; Coventry Rag, 290 gms. I-size: 37" x 25 1/2"; P-size: 40 1/4" x 28"; Ed#: 4/60, 6/60; prnt: José Alpuche; mtrx: Destroyed. signed. Inscription in pencil reads, "4/60 El Regalo Honorio 2000". lower left; Note: Is a poster, but also a cartoon with the fantastic story about a woman who enter in the house for take care of the television. She become part of the family, but one time she transformes herself in cow. Then the family has fun for a while but the animal protector society take care of the cow and the family becomes like a normal family. Colors used: Blue, Yellow, Red, Pink, and Purple. #Prints: 2.

Rodriguez, Anna M. *Spinach;* (April 24-25 & 30) 1992; Atelier 19 L.A. Riots; Westwinds; I-size: 32" x 24 1/2"; P-size: 40" x 28"; Ed#: 22/44; prnt: Richard Balboa; mtrx: Cut; Signed, Inscriptionin pencil below image area reads: "Spinach, 22/44, Anna M. Rodriguez". Bottom right hand; Note: The center of the composition is a conglomeration of anthropomorphic forms of legs and feet, and hands and arms in black and white. The top shows a curtain rod with a hanging fabric over which blue type reads: "Spinach never appealed to me / I decided to give it a try" Pink and green type that curves around reads: "I wasn't getting much younger, / so I made the change / No longer is the stuff on the shelf. / But now somehow i [sic] can't get enough / somehow its [sic] always hitting the spot, / especially when they bring it in hot." Red type reads: "I Guess / I Was / Mighty / Green." Smaller blue type at the bottom of the print reads: "hitting the spot by Anna Rodriguez (c. 1992) song by Julia Lee (c. 1949)" Colors used: 1. Transparent Yellow, 2. Transparent Magenta, 3. Transparent Blue, 4. Black. "Women gaining independence and strength by accepting this sexuality. No longer denying or letting people control or surpress their desires. She can now express virility without denying her womanhood. A woman exploring and enjoying her sexuality with no shame and no need to deny it." A. Rodriguez.

Rodriguez, Artemio; *Day of the Dead 2002;* September 10 and 11, 2002; Coventry Rag, 290 gms. I-size: 16" x 22"; P-size: 20"x 26"; Ed#: 4/65, 6/65; prnt: José Alpuche; mtrx: unknown; signed. centered; Note: Text: Celebrating / Jose Guadalupe Posada/ 150 Anniversary/ SHG/ Day of the Dead/ MMII Border compose of calaveras (skeletons) by Jose Guadalupe Posada. Central Image: a copy of a linoleum cut by Artemio Rodriguez. Design: LA MANO Press Colors used: Orange, Red, and Black.

Rodriguez, Artemio; *Father Time;* n.d. Coventry Rag, 290 gms. I-size: 23 7/8" x 23 3/4"; P-size: 37 3/4" x 30"; Ed#: 4/100, 6/100; signed. Inscription in pencil reads, "6/100 "Father Time" Artemio Rodriguez MM". lower left. Note: Winged beings in woodcut style.

Rodriguez, Artemio; *La Tarde;* 1995; I-size: 17 1/4" x 10"; P-size: 22" x 13"; Ed#: 4/43, 20/43; Signed, Inscription in pencil below the image reads: "4/43, 'La Tarde', Artemio [illegible] R ?, 1995. embossed "SHG" on the bottom left corner; Note: Black and white silk screen with two boys, a book, a drum, and a cat. Above them is a falling sun. #Prints: 2.

Rodriguez, Artemio; *The King of Things (Poster);* June 9, 2001; Coventry Rag, 290 gms. I-size: 20 3/4" x 26 1/4"; P-size: 27 1/2" x 35"; Ed#: 4/97, 6/97; prnt: José Alpuche; mtrx: Destroyed. signed. Inscription in pencil reads, "4/10 Artemio Rodriguez". centered. Note: Using the loteria game, I wrote this short prose where a child likes so much his loteria game that he imagines and believes all the loteria characters are part of his personal and unique world. Colors used: O. Light Blue, T. Red, T. Magenta, O. Flesh, T. Yellow, T. Green, T. Off White, T.White, and O. Black. #Prints: 2.

Rodriguez, Favianna; *Community Control of the Land;* July 9-12, 2002; Special Project; Coventry Rag, 290 gms. I-size: 22" x 16"; P-size: 26" x 20"; Ed#: 4/85, 6/85; prnt: José Alpuche; mtrx: destroyed. signed. lower left; Note: "A business executive is standing over the city of Los Angeles, with a rolled up bunch of eviction notices. There are two devil horns protruding from his bald head, and his eyes are red with evilness. Around his feet are cockroches and a rat. On the left side of the print is the resistance, the Latina woman organizer speaking into a megaphone, calling all neighbors to raise up against the redevelopment forces and protect

their homes. In the lower center of the print there is an African American woman with her child, staring at the viewer. These are the people who will be displaced. The poster reads "Alto A Los Desalojos!" and "Stop the Evictions!" Housing is a human right. For many people of color, the issue of land and housing is one that dates back to over 500 years, beginning with the rape of land and housing is one that dates back to over 500 years, beginning with the rape of Indian land by white colonizers, the theft of Mexican territories, the racist policies that prohibited black people from owning land. Today, working class people of color are at the mercy of big businessand corporate greed, which exploit the land for profit and destroy communities. The basic demand for community control of the land, which was set forth by our revolutionary predecessors, is still relevant to us today. Black Panther Party 13 Point Platform Program #4: We want decent housing that is fit for shelter of human beings. We believe that if the white landlords will not give decent housing to our black community, then the housing and land should be made into cooperatives, so that our community, with government aid, can build and make decent housing for its people. Brown Beret Platform #9[:] We demand housing fit for human beings. Red Guard Platform #2[:] We want decent housing and help in child care. Young Lords Platform[:] We want community control of our institutions and land. The Figueroa Corridor in Downtown Los Angeles is in [a] large battle with city redevelopers" Colors used: Yellow, Flesh, Orange, Red, Ultramarine Blue, and Black.

Rodriguez, Favianna; *Del Ojo No Se Escapa Nadie;* 1999; Atelier 33; silkscreen; I-size: 26" x 18"; P-size: 30 1/4" x 22"; Ed#: 4/64, 6/64; Signed, Inscription below image reads: "4/64, 'Del Ojo No Se Escapa Nadie', Favianna Rodriguez 99.". embossed "SHG" insignia at lower left-hand corner; Note: Image is of a woman sitting at the edge of a pink bed with her legs straddled. There are eyes covering her private areas. To the left of her is a green devil-like snake. "Rodriguez renders the *panocha* a site of sacred knowledge, boldly staring the patriarchal legacy that demonizes the sexual body and denies it as a source of truth and goodness right to the face"--*Maestras Atelier XXXIII 1999.* #Prints: 2.

Rodriguez, Faviana; *Margarita;* Nov. 13-17, 2001; Coventry Rag, 290 gms. I-size: 16"x 22"; P-size: 20"x 28"; Ed#: 4/66, 6/66; prnt: José Alpuche; signed. lower left corner; Note: Woman with a mask and a big black hairdo. Woman is surrounded by colorful orchids. Inside her head, there are figures of people giving birth, losing a child, throwing ashes to sea, receiving a letter, and reuniting. On the top of the print there are two names, Richard and Margarita. Colors used: Clear Gloss, Red Blended into Yellow, O. Flesh, O. Sienna, O. Light Blue, O. Green, O. Gray, O. Pink, O. Light Yellow, O. Black.

Rodriguez, Isis; *Self-Portrait with Muse;* June 3-8, 2002; Coventry Rag, 290 gms. I-size: 16" x 22"; P-size: 20"x 26"; Ed#: 4/70, 6/70; prnt: José Alpuche; mtrx: destroyed; signed. lower left; Note: Woman recieving lapdance from her cartoon self. Colors used: brick red, blue, ochre, lime green, flesh, transp. black, black, and transp. white.

Rodriguez, Israel; *Armagedon;* (April 22-26) 1997; Atelier 29; Coventry Rag, 290 grms; I-size: 26" x 37 7/8"; P-size: 30 1/4" x 44"; Ed#: 4/97; prnt: José Alpuche; mtrx: Destroyed; Signed. lower left; Note: Multi-faced creatures with fire swords ride horses in the sky overlooking the city. "Four Horses, Four Horsemen, Buildings, Four Swords of Fire." Colors used: 1. Trans Baby Blue, 2. Trans Ultra Marine, 3. Trans Blue Shade Red, 4. Trans Bronw (sic.) Sienna, 5. Trans Yellow Ochre, 6. Trans Light Blue Green, 7. Trans Light Trans Lilac (sic.), 8. Red Shade Yellow, 9. Trans Yellow Red, 10. Trans Drk Ultra Blue, 11. Trans White, 12. T Metallic Black. "'Armagedon', taking from Apolocalipsis (sic.), the 4 horsemen that represent harm and infestation that destroy humanity and which have been present throughout history. The present society affected by infestation, wars, contamination, over populations, epidemics and hunger, which all take us to death and somehow we are responsible. For more information I recomment to read (sic.) the chapters of Apolocalipsis (sic.), also to see the movie 'Apolocalipsis Now' or call 666 Satin (sic.)." I. Rodriguez.

Rodriguez, Israel; *Extraño tu Boca;* 1996; Atelier 28; poster; I-size: 25 1/4" x 18 5/8"; P-size: 32 7/8" x 24 5/8"; Ed#: 18/51; prnt: José Alpuche; mtrx: Destroyed; Signed. lower right; Note: A myriad of images make up this print including: faces, cups of coffee, a boat, ladders, hands, a fish, a mouth, heart, horse, window, and city. Black background.

Rodriguez, Joe Bastida; *Night Fall As I Lay Dreaming;* (Feb 19-23) 1990; Atelier 15; Westwinds (heavyweight); I-size: 28" X 19 1/2"; P-size: 33" X 25"; Ed#: 4/60, 18/60; prnt: Oscar Duardo; mtrx: Destroyed; Signed, Inscription in pencil below image area reads: "18/60, Night Fall As I Lay Dreaming, Bastida". Outside of right hand corner of image. Note: An image of a woman lying with her eyes closed and holding a rosary. Colors are blue, red, ochre, yellow, green, purple, pink, red & orange. Purple, blue & yellow sky. A snake is in the foreground coiled facing the sunset. Southwestern type mountains with a quarter moon with deep blue clouds. River on the right side from foreground to sunset. "This print depicts a young girl who, while in her sleep, visualizes her fear of a snake curled close to her which may strike as it reaches towards the sunset. Images of unborn children within a tree (tree of life) and the dark clouds shaped like an eagle edge towards the sunset, reflecting an old Indian wise man that oversees her presence. Symbols relate to the notion of the fear of losing one's cultural identity and of the hope for children to maintain their heritage." J. Bastida Rodriguez.

Rodriguez, Liz; *(title unknown);* Untitled [diptych]; (Oct 27-30) 1986; Atelier 8; Westwind; I-size: 35 1/2" x 47 1/4"; P-size: 35 1/2" x 47 1/4"; Ed#: 4/27; prnt: Oscar Duardo; mtrx: Destroyed; Signed, Inscription in silver located near the lower left corner: "4/27". None; Fund: funded in part by the CAC, NEA, and the City of Los Angeles. Note: Lavender, yellow/gold background along with a mixture of black with silver additive. Photo xerox and Kodalith transfer to screen. Full bleed. Diptych. Colors used: 1. Rose, 2. Yellow/Gold, 3. Lavender, 4. Black (with silver additive), 5. Grey (with gold additive), 6. Grey, 7. Grey, 8. Silver—hand applied.

Rodriguez, Liz; *Untitled;* 1985; Atelier 6; I-size: 35 1/2" x 23"; P-size: 35 1/2" x 23"; Ed#: 45/45; Signed, Inscription in pencil at the bottom of the image reads: "45/45 and signature". Note: Full bleed. Xerox image. Kodalith transfer of a contemporary woman in a wedding dress and a male torso with female legs. The background is a woman's face.

Romero, Alejandro; *Curandera (The Healer);* (April 2-9) 1993; Special; Coventry; I-size: 26" x 34"; P-size: 30" x 38"; Ed#: 5/75, 7/75, 24/75; prnt: José Alpuche; mtrx: Destroyed; Signed, Inscription in pencil below image area reads: "Curandera, 5/75, Alejandro Romero, L.A., 1993". Lower Right; Note: Within the multicolored, image-packed print, there is a man with a jaguar in his shoulders who is placing his hands on another man's forefront. The background is a jungle with superimposed images of animals, skulls, fruits, and mythological figures, among others. There are two versions of this print: one where the skull at the bottom right is green-yellow, and the other where it is pink-blue. Colors used: 1. Process Yellow, 2. Process Magenta, 3. Process Magenta, 4. Process Black, 5. Turquoise Blue, 6. Trans, Green Blue, 7. Trans. Pearl White. "An allegorical representation of the blending of myth and religion in Latin America. The central rigures represent the act of healing as taking place an (sic.) the surrounding figures are the constant evocation of two forces in perpetual motion." A. Romero: #Prints: 3.

Romero, Alejandro; *L.A. California;* 1993; I-size: 37" x 26"; P-size: 40 1/2" x 29"; Ed#: 4/66, 20/66; Signed, Inscription in pencil below the image reads: "4/66, Alejandro Romero, L.A. California, 1993". Note: An image of the Madonna with Little Jesus; both are wearing crowns. She has an intricate robe. Its weave is that of figures, animals, Aztec iconography, and a hand holding an object. Water flows below this robe, with a woman's face peaking above the water line. Boats float on the water. At the right bottom corner there is a bearded man reading a book. Shades of green, blue, orange and yellow make up the image. #Prints: 2.

Romero, Frank E. *(title unknown);* (title unknown); (Oct 12-17) 1986; Atelier 8; Westwind; I-size: 30" x 25"; P-size: 38" x 26"; Ed#: 4/48; prnt: Oscar Duardo; mtrx: Destroyed; Signed, Inscription in pencil located in the upper left corner on the image reads: "4/48 and signature". Fund: funded in part by the CAC, NEA and the City of Los Angeles. Note: Red landscape view with a multicolored car. Yellow and peach City Hall.

Romero, Frank E. *(title unknown);* (title unknown); n.d. I-size: 38" x 26 1/4"; P-size: 41" x 29 1/4"; Ed#: unknown ed. Signed, Inscription in pencil below the image reads: "F E Romero". Note: A transarent

green/brown flower pot with transparent light blue, beige and black (centers) flowers; background is a deep red.

Romero, Frank E. *(title unknown);* (title unknown); n.d. I-size: 36" x 24"; P-size: 40" x 26"; Ed#: 6/26, 12/26, 20/25; mtrx: Signed, Signature in pencil located in the lower left corner below the image area reads: "FE Romero, [symbol], 20/25" Signed, Inscription in pencil below the image reads: "F E Romero, (-) 12/26" Signed, Inscription in pencil in the lower left corner below the image area reads: "FE Romero, [symbol], 6/26". "SHG" embossed chopmark in lower right corner below the image; <u>Note:</u> Skeleton woman in pink wearing a long dress with a silver outlined holster in a purple background. One of the prints has no Ed#. #Prints: 4.

Romero, Frank E. *(title unknown);* (title unknown); n.d. I-size: 35" x 26"; P-size: 37 1/2" x 27 1/2"; Ed#: 4/63; prnt: Oscar Duardo; Signed, Inscription in pencil located in the lower left corner reads: "4/63 and signature". "SHG" chops located in the lower right hand corner; <u>Note:</u> Image of blue cars driving down a street. Sky scrapers and city hall is in the background.

Romero, Frank E. *(title unknown);* (title unknown); n.d. I-size: 36" x 24"; P-size: 39" x 26"; Ed#: 8/10, 4/30, 18/30; Signed, Inscription in pencil located at lower left hand corner reads: "signature and edition". "SHG" chops located at the lower right hand corner; <u>Note:</u> Image of an old Model T Ford with three passangers and a dog. White background. The car is tan and lavender in the 8/10 edition, and purple and violet in the 4/30 and 18/30 editions. #Prints: 3.

Romero, Frank E. *Ayanna;* (June 7) 1991; I-size: 22 3/4" x 30"; P-size: 22 3/4" x 30"; Ed#: 19/20; prnt: Oscar Duardo; mtrx: Destroyed; Signed, Inscription in pencil located in the lower right corner reads: "19/20 and signature". "SHG" chops located in the bottom right hand corner; <u>Note:</u> Image of a woman lying on a purple field with her eyes closed. Hand torn edges. Full bleed image. Colors used: 1. Dr Purple, 2. Tran. Tan, 3. Tran Brown, 4. Tran. Lt. Lavendar, 5. Tran. Lt. Rose, 6. Lt Tran. Magenta.

Romero, Frank F. *Carro;* (Feb 3-6) 1986; Atelier 7; Accent 290 gram-white; I-size: 18 1/2" x 25"; P-size: 18 1/2" x 25"; Ed#: 4/52; prnt: Stephen Grace; mtrx: Destroyed; Signed, Inscription in pencil located below the image area reads: "Signature, 4/52 and 3/6/86". Fund: funded in part by the CAC, NEA and the City of Los Angeles. <u>Note:</u> A blue and silver car on a multicolored background. Full bleed.

Romero, Frank E. *Cruz Arroyo Seco;* (Jan 18-22) 1988; Atelier 11; Westwinds; I-size: 17" 1/2" x 13"; P-size: 25" x 19 1/4"; Ed#: 4/45, 16/45, 43/45; prnt: Oscar Duardo; mtrx: Destroyed; Signed, Inscription in pencil located below the image area reads: "F E Romero, 16/45". embossed "SHG" located at the lower right hand corner; <u>Note:</u> Image of a white cross, sunflowers, and a magic mountain. The title of the piece is in ink within the image. Colors used: 1. Iron Oxide Yellow, 2. Turquious (sic.) Green, 3. Marion Blue, 4. Tran. White, 5. Tran. Green, 6. Brown, 7. Yellow, 8. White, 9. Orange. "The white cross standing in a field of yellow sunflowers exists in Arroyo Seco, New Mexico, in the local cemetery. Arroyo Seco is near Taos New Mexico and the the [sic] background is an indication of the magic mountain sacred to the Pueblo Indians." F. Romero. #Prints: 3.

Romero, Frank E. *Cruz Hacienda Martinez;* (Jan 18-22) 1988; Atelier 11; Westwinds; I-size: 17 1/2" x 13"; P-size: 25" x 19 1/4"; Ed#: 4/45, 16/45, 42/45; prnt: Oscar Duardo; mtrx: Destroyed; Signed, Inscription in pencil below the image reads: "F E Romero, 16/45" Signed, Inscription in pencil located below the image area reads: "Signature and 4/45". embossed "SHG" located on the lower left hand corner; <u>Note:</u> A blue cross on active hot pink background. The title of the work is in ink within the image. Colors used: 1. Iron Oxide Yellow, 2. Pink, 3. Marion Blue, 4. Gray, 5. Tran. Red, 6. Blue Gray, 7. Violet, 8. Magenta, 9. Orange. "The print depicts a small cross hanging in the Martinez hacienda in Taos, New Mexico. I've tried to convey an emotional feeling this kind of imagery evokes." F. Romero. #Prints: 3.

Romero, Frank E. *Frutas Y Verduras;* (Oct 16-20) 1989; Atelier 14; Westwind (heavyweight); I-size: 36" X 24"; P-size: 36" X 24"; Ed#: 4/70; prnt: Oscar Duardo; mtrx: Destroyed; Signed, Inscription in pencil located at the top of the print reads: "Signature and 4/70". "SHG" embossed insignia in the lower right corner; <u>Note:</u> Full bleed. Blue transparent, Model A fruit and vegetable truck with a red sign reading: "Frutas y Verduras." Blue, yellow, pink, orange

and a magenta tinted background. Colors used: 1. Baby Blue/Pasetel (sic.) Yellow/Peach/Orange/Pastel Magenta, 2. Magenta/Lt. Lavende (sic.)/Lime Green/Blue-Green, 3. Tran. Blue-Green, 4. Miloie (sic.) Blue, 5. Orange, 6. Varnish (double pass), 7. Silver (double pass), 8. Silver (double pass).

Romero, Frank E. *Pingo Con Corazón;* (Feb 3-6) 1986; Atelier 7; Accent 290 gram-white; I-size: 18 1/2" x 25"; P-size: 18 1/2" x 25"; Ed#: 4/52; prnt: Stephen Grace; mtrx: Destroyed; Signed, Inscription in pencil located below the image area reads: "Signature, 4/52 and 3/6/86". Fund: funded in part by the California Art Council, NEA and the City of Los Angeles. <u>Note:</u> A blue abstract dragon head on a textured background of blue, pink, light orange. Full bleed.

Romero, Frank E. *Untitled;* 1999; Atelier 33; silkscreen; I-size: 22 1/2" x 16 3/8"; P-size: 26" x 20"; Ed#: 4/81, 6/81; Signed; in black marker in lower-left hand corner. embossed "SHG" insignia below right hand corner of image; <u>Note:</u> Image is of a stylized caricature of a woman in mutli-colored lines. She has full red lips and hair parted down the middle with two braids circled at each side of the face. Background is green with red lines. (Day of the Dead): #Prints: 2.

Romero, Frank E.; *California Plaza;* June 12-25, 2001; Coventry Rag, 290 gms. I-size: 38" x 26"; P-size: 38" x 26"; Ed#: 4/140, 6/140; prnt: José Alpuche; mtrx: On file; signed. Inscription in marker in image area reads, "FE Rom 6/140". lower right. <u>Note:</u> A 16 color print celebrating the California Plaza Summer Concerts in Downtown Los Angeles. The print was made in commemoration of their 15th anniversary! #Prints: 2.

Romero, Frank E.; *Cruising;* April 15, 18, and 20, 2000; S.P. Coventry Rag, 290 gms. I-size: 16" x 22"; P-size: 20" x 26"; Ed#: 6/31; prnt: José Alpuche; mtrx: destroyed. signed. lower right; <u>Note:</u> "A very active rendition of a couple out for a spin in their vintage jalopy! Monotypes series utilizing three screens. 1. Hand printed by artist 2. 5-7 color split fountain 3. Blue Line Drawing". This photo is of the final print.

Romero, Frank E.; *Cruising;* April 15, 18, and 20, 2000; S.P. Coventry Rag, 290 gms. I-size: 16" x 22"; P-size: 20" x 26"; Ed#: 6/11; prnt: José Alpuche; mtrx: destroyed. signed. Inscription in marker in lower left corner reads, "TP 6/11 FE Romero". lower right; <u>Note:</u> "A very active rendition of a couple out for a spin in their vintage jalopy! Monotypes series utilizing three screens. 1. Hand printed by artist 2. 5-7 color split fountain 3. Blue Line Drawing". This photo is of the blue line drawing of an automobile, a progressive proof.

Romero, Frank E.; *Grand Father's House;* October 19-21 and November 14-15, 2000; S-P; Coventry Rag, 290 gms. I-size: 16" x 22"; P-size: 20" x 26"; Ed#: 4/47, 6/47; prnt: José Alpuche; mtrx: destroyed. signed. lower left; <u>Note:</u> "A picture of the family gathering house (grandfather's) near First and State streets in Boyle Heights. A recollection done from memory." Colors used: Blue blended into White & Yellow, Green Blended into Brown w/ hand painted Red, Opaque Pink, Trans Blue, Trans Yellow/Red, and Lt Grey. #Prints: 2.

Romero, Frank E.; *Heart;* 2000?; Atelier XXXIX; Coventry Rag, 290 gms. I-size: 17" x 23"; P-size: 20" x 26"; Ed#: 4/75, 6/75; prnt: José Alpuche; mtrx: destroyed. signed. lower right; <u>Note:</u> "Heart Series—1-15, Hand embellished by the artist. One of a series of heart imags, going back 30 years." Colors used: Light Blue, Light Orange, Deep Red, Turquoise Blue, and Clear Gloss. #Prints: 2.

Romero, Frank E.; *Starry Night;* July 18-22; S/P; Coventry Rag, 290 gms. I-size: 16" x 22"; P-size: 20" x 26"; Ed#: 4/40, 6/40; prnt: José Alpuche; mtrx: destroyed. signed. lower right; <u>Note:</u> "A family driving through a magical starry night!": #Prints: 2.

Rubio, Alex; *La Placa;* November 5-13, 2002; Coventry Rag, 290 gms. I-size: 16" x 22"; P-size: 20" x 26"; Ed#: 4/72, 6/72; prnt: José Alpuche; mtrx: destroyed; signed. lower left; <u>Note:</u> The image depicts my hand holding my old homemade tattoo machine, I clipped the roller ball point pen off a bic pen and threaded a sharpened guitar wire through the pen tube. The wire was the N attached to the spindle of a hair dryer motor which were taped to a bent spoon which served as a handle. I used to work on homemade tattoos with original designed, back in the early to mid eighty, in my barrio at the Mirasol Courts in the Westside of San Antonio. Colors used: Pantone AOOE-C, Pantone 414C, Pantone

416C, Pantone 417C, Pantone 418C, Pantone 418C, Pantone Black, T-Black, and Clear Gloss.

Ruiz, Annette Maria; *Sagrada Sandía;* (May 26, 29)1998; Atelier 29-31 #4 & #6; I-size: 22" x 16"; P-size: 26" x 20"; Ed#: 4/68, 6/68; prnt: José Alpuche; mtrx: Destroyed; Signed. lower left; Note: A heart with barbed wire wrapped around it and a band of fire surrounding it. A cross on top and a night sky background. Colors used: 1. Cyan Blue, 2. Magenta, 3. Yellow, 4. Baby Blue, 5. Dark Purple, 6. Red. "The Sagrada Corazon has been an image that amazed me since childhood, along with the excitement of fire/flames. The watermelon is depicted in many of my works and its design has a certain magic in it's ray-like imagery which seem to fit well with the corazon. To be placed in the night time, I think, brings out the brightness of the flames and corazon and the colorful sandia shell." A.M.Ruiz: #Prints: 2.

Salazar, Daniel; *Eternal Seeds;* (Dec 4-8) 1989; Atelier 14; Westwinds (heavy weight); I-size: 35" x 24"; P-size: 38" x 26"; Ed#: 4/59, 18/59; prnt: Oscar Duardo; mtrx: Destroyed; Signed, Inscription in pencil below the image reads: "title, 4/59, signature & 89" Signed, Inscription in pencil below the image reads: "Eternal Seeds, 18/59, Daniel Salazar". "SHG" embossed chopmark in right corner of image. Image has been silkscreened over embossing; Note: Central image of a rose. Walter w/rose stems in the lower right. Upper right background is a cross with fire behind it. Multi-colored tears are falling down behind the tears in an angle from right to left. Colors used: 1. Gold, 2. Green (Tran.), 3. Blue (Tran.), 4. Purple (Tran.), 5. Brown (Tran.), 6. Red (Tran.), 7. Orange (Tran), 8. Yellow, 9. Aqua Blue (Trans.). "The love and sacrifice of Jesus Christ is to plant seeds of eternal life." D.Salazar: #Prints: 2.

Salazar, Daniel; *One Nation Under God;* (May 6-9) 1991; Atelier 16; Westwinds (heavyweight); I-size: 24" x 34 1/2"; P-size: 28" x 38 1/4"; Ed#: 16/66; prnt: Oscar Duardo; mtrx: Destroyed; Signed, Inscription in pencil below the image reads: "'One Nation Under God', 16/66, Daniel Salazar, 1991". embossed "SHG" on the lower left hand corner; Note: From the right to the left there are: a muscular woman, an american flag, an eagle, and a sunset framed by roses. Colors used: 1. Tran. Powder Blue, 2. Tran. Phaylo Blue, 3. Tran. Purple, 4. Tran. Brown, 5. Tran. Red, 6. Tran. Green, 7. Tran. Gray, 8. Tran. Tan, 9. Tran. Yellow, 10. Tran. Off-White, 11. Tran. Lt. Peach, 12. Tran. Burgundy. [In response to a question about information on the content of the print:] "To show american pride and to give thanks for having been born in this great country." D. Salazar.

Saldamando, Shizu; *Poster Girl;* December 12-14, 2000; Atelier XXXVII; Coventry Rag, 290 gms. I-size: 22" x 16"; P-size: 26" x 20"; Ed#: 4/75, 6/75; prnt: José Alpuche; mtrx: destroyed. signed. lower left; Note: "Woman standing in front of a graffittied [sic] wall. This print is based off a photo taken of a close friend while waiting in line for Morrissey's autograph." Colors used: Ultramarine Blue, Cool Grey, Taupe, Warm Yellow, Red, and Black. #Prints: 2.

Saldamando, Shizu; *Snapshot;* May 8-11, 2001; Maestras 2; Coventry Rag, 290 gms. I-size: 18"x 26"; P-size: 22"x 30"; Ed#: 4/66, 6/66; prnt: José Alpuche; mtrx: destroyed; signed. lower left; Note: Three young women strike a pose with their finely plucked eyebrows and matching ensembles. Colors used: Mint Green, Blue, Drk Brown, Light Brown, Pink, Pale Yellow, Silver, Drk Grey.

Sánchez Duarte, Cecilia; *Chacahua;* (Dec 2-4); Atelier 21; Coventry Rag, 290 gr. I-size: 17 1/8" x 18 3/4"; P-size: 20" x 26"; Ed#: 4/52, 16/52; prnt: José Alpuche; mtrx: Destroyed; Signed, Inscription in pencil below image area reads: "4/52, Chacahua, Cecilia Sánchez Duarte [the smaller 'u' inside the bigger 'D'], '92". lower right; Note: "'Chacahua' is a fisherman's village in the State of Oaxaca, México. It is surrounded by the sea and salt lagoons full of animal and vegetation life. It's magic comes from teh harmonie (sic.) people have with their ambiance, so I wanted to rpresent (sic.) it, talking in my own language (visually) about this. Also the composition rmindes (sic.) of the way ancient people (prehispanics) used to describe their lives on 'amatl' (amate) paper called codices." C. Sánchez Duarte. Colors used: 1. Trans cyan, 2. Trans primrose yell (sic.), 3. Blend; red + orange, 4. Blend: rose + purple, 5. Emerald green, 6. Indigo. #Prints: 2.

Sandoval, Teddy; *Angel Baby;* (April 11) 1995; Atelier 25; Coventry Rag 290 grms; I-size: 38" x 26"; P-size: 44" x 30"; Ed#: 4/55, 20/55; prnt: José Alpuche; mtrx: Destroyed; Signed, Inscription in pencil below the image reads: "4/55, 'Angel Baby', Teddy Sandoval,

95". lower left; Note: "Main figure is a winged boxer framed by a snake wrapped around a curtain. There is a floating palm in a cloudy sky." (Taken from Certificate of Authenticity) Colors used: 1. Yellow, 2. Lavender, 3. Sky blue, 4. Magenta, 5. Transparent Flesh, 6. Light Red, 7. Dark Red, 8. Lime Green, 9. Warm Grey, 10. Dark Flesh, 11. Dark Brown, 12. Purple, 13. Dark Blue, 14. Trans Royal Blue, 15. Trans. Pink. "My print 'Angel Baby' is about the concerns I have regarding the state of well being. There is plenty to pull from; violence, aids, war, and discrimination of all kinds. We as individuals must begin to change our thoughts within our hearts and our souls. We must do this if we want to live in peace and harmony. 'Angel Baby' is a guardian angel and he is here to help you accomplish this." T. Sandoval. #Prints: 2.

Sarnecki, Tomasz, and Wayne Healy, *Smoker's Game;* September 19-23, 1999; Coventry Rag 290 gms. I-size: 34 3/8" x 23 1/2"; P-size: 44" x 30"; Ed#: 4/78, 6/78; prnt: José Alpuche; mtrx: Destroyed. signed. Inscription in pencil reads, "4/78 Szausa na sukies Toman Sarnecki '99 Healy 99". lower left. Note: "Its a picture with a strong gun, bullet-cigarette, skeleton with big sombrero; smoke, fire, and deathly habit. Its the ideological poster; the habit like Russian R[o]ulette- Smoker's Game like the inknown end -- for every one and every where; its the big challenge for tobacco companies: Which cigarette is the last? For Death or life?" Tomasz Sarnecki. "Major Image; A revolver with a cigarette in the open cylinder. Above is skeleton with a big sombrero holding a cigarette. All are on a background of fire and smoke, fire of the deadly habit. The content of the print is to compare smoking wiht Russian Roulette, Ergo, Smoker's Game." Wayne Healy Colors used: Cream White, Orange Red, Powder Blue, Blood Red, and Black.

Schuette, Lynn; *"Cross Fire/Truth" From the Bloodstorm Series;* (Jan 21-23) 1992; Atelier 22; Coventry Rag, 290 grms; I-size: 22" x 16 1/8"; P-size: 26 1/8" x 20"; Ed#: 4/67, 14/67; prnt: José Alpuche; mtrx: Destroyed; Signed, Inscription in pencil below image area reads: "4/67, 'Cross Fire/Truth', signature [illegible], '93". Note: The image of a person's back, shoulders and head without skin (as if an anatomy lesson--drawn to show false-looking muscles, arteries, spine, etc.) is visible through the window of a three-dimensional cross. The words "boxer", "judge", "bodies" and "truth" are written with different lettering across the body. Colors used: 1. Clear Base, 2. Trans Rust Red, 3. Blend Lt Yellow-Magenta Lt. Yell (sic.), 4. Lt Trans Grey. "'Crossfire:Truth' is from 'Bloodstorm' a series of painting (sic.), drawings, and prints based on the art of boxing. Started in 1990, the series incorporates figurative imagery an (sic.) text from verious literary and sports sources. This image refers to the Mike Tyson rape trial, the Clarence Thomas confirmation hearings, and our bodies. The works explore violence and social, political and gender issues using boxing as a vehicle." L. Schuette. #Prints: 2.

Segura, Dan; *Like Father Like Son;* 1983; Atelier 1; Artprint; I-size: 15 1/2" x 20 1/2"; P-size: 22 7/8" x 35"; Ed#: 45/60; prnt: Stephen Grace; mtrx: unknown; Signed, Inscription in pencil below the image area reads: "45/60, copyright, signature/83". Blue "SHG" at bottom with participating artists; Fund: funded in part by the NEA and the CAC. Note: Red, turquoise, ochre, yellow on a gray background. Image of a gray father, ochre wind-up child, and yellow houses.

Segura, Dan; *This Is Pain;* (Dec 18-20) 1983; Atelier 2; Artprint 25% Rag; I-size: 17 1/2" x 23"; P-size: 22" x 34"; Ed#: 4/77; prnt: Stephen Grace; mtrx: Destroyed; Signed, Inscription in pencil below the print: "4/77 and title". Fund: funded in part by Atlantic Richfield Foundation. Note: Light yellow figure on a black background.

Serrano, David; *Fandango;* 1995; Atelier 26; poster; I-size: 26" x 38"; P-size: 30" x 44"; Ed#: 37/58, 43/58; prnt: Jose Alpuche; mtrx: Destroyed; Signed. lower left; Note: Three dancers, one in a jaguar suit, another with a parrot suit, and one more with a rooster outfit stands on his own egg. The stage they stand on is composed of golden panels and the background is made up of green speckles. #Prints: 2.

Serrano, David; *Rapto;* 1996; Atelier 28; poster; I-size: 26 1/4" x 30"; P-size: 30" x 34 3/4"; Ed#: 38/64, 39/64; prnt: José Alpuche; mtrx: Destroyed; Signed. lower left; Note: Zeus. Rapes. Europa in a stage like the woods. Light, shows an autumn day. Europa wears a straight-jacket. Colors that predominate are orange, blue, green, lemon yellow, ochre dark, and flesh. #Prints: 2.

Shimotsuma, Sister Frances F. *Los Angeles;* (July 10-14) 1992; Special Project (Atelier 19 L.A. Riots); Westwinds; I-size: 16 1/8" x 24"; P-size: 20" x 28 1/8"; Ed#: 4/55, 22/55; prnt: Richard Balboa; mtrx: Destroyed; Signed, Inscription in pencil located below image area reads: "Los Angeles [illegible sign], 4/55, Sister Shimotsuma, '92". Note: A series of concentric and broken yellow circles resembling strata. The center is an outlined apple containing half an orange surrounded by worms. Two lizards watch the scene from right and left sides. Colors used: 1. Light Lavender, 2. Baige (sic.), 3. Yellow, 4. Orange, 5. Brown, 6. Blue (Process). "In the print I tried to capture the powerful force I experienced in the recent California earthquake, together with the graphic description of it shown on television shortly thereafter. I intended to portray the rupture of the earth and disturbance of all nature. Included in the print is an orange invaded by a worm which symbolizes California and the recnet destructive riots. The apple depicts the human condition." Sister F.F.Shimotsuma. #Prints: 2.

Shimotsuma, Sister Francis F. *Obon;* (Oct 21-23) 1992; Special Project (Images Of The Future); Coventry Rag, 290 grms; I-size: 23 3/4" x 16"; P-size: 26 1/8" x 20"; Ed#: 4/55, 18/55; prnt: José Alpuche; Signed, Inscription in pencil located below image area reads: "Obon, 4/55, Sister Shitmotsuma, '92". lower left; Note: An spherical shape that looks like a yellow Chinese lantern with the image of a skull in the center. Two butterflies and a dragon-flie fly around it and above red and yellow flames on a cyan blue background. Colors used: 1. Trans Lt Yell (sic.), 2. Trans Lt. Blue, 3. Trans. Red, 4. Trans. Violet, 5. Lt Pink Flesh, 6. Dark Pink Flesh. "Obon or 'Feast of the Dead' or 'Festival of Souls' is observed yearly in Japan on July, 13, 14 and 15./ It's (sic.) purpose is to perpetuate the memory of their ancestors. the living pay homage to thier dead relations by hanging lighted paper lanterns, having conversations with them, providing a meal of theri favorite dishes, and having a Buddisht priest chant sutras for them./ Finally, on the last day 'Farewell Fires' are lighted at the house front as beacons to show the way home." Sister F.F.Shimotsuma. #Prints: 2.

Sigüenza, Herbert O. *Culture Clash=15 Years of Revolutionary Comedy;* June 29-July 1, 1999; Coventry Rag, 290 gms. I-size: 20" x 26"; P-size: 22" x 30"; Ed#: 4/78, 6/78; prnt: José Alpuche; mtrx: destroyed; signed. lower left; Note: Commemorative print celebrating Culture Clash's 15th Anniversary. Pictures of the three members of Culture Clash and three performance pictures surrounding a full figure of cantinflas. Colors used: Beige (base), Primary Yellow, Primary Red, Primary Blue, Primary Green, Black, and Transparent Gray.

Sparrow, Peter; *Omens;* 1983; Atelier 1; Artprint; I-size: 19 1/2" x 25"; P-size: 23" x 35"; Ed#: 10/60; prnt: Stephen Grace; mtrx: Destroyed; Signed, Inscription in pencil below the image area reads: "10/60, title and signature". Blue "SHG" located at the bottom; Fund: partially funded by the NEA and the CAC. Note: Purple, dark blue, gray, and florescent orange graffiti. Symbols on a white background.

Sparrow, Peter; Untitled; (Jan 8-15) 1985; Atelier 5; Stonehenge 320 gram-white; I-size: 36" x 24"; P-size: 36" x 24"; Ed#: 4/89, 35/89; prnt: Stephen Grace; mtrx: Destroyed; Signed, Inscription in pencil located below the image area reads: "4/89, and signature". None; Note: Light brown and gray circle. Three purple bars on a blue/gray field with red accents. Full bleed. Hand torn edges. #Prints: 2.

Taylor, Neal; *Balance Of Knowledge/Balance Of Power;* (Oct 11-16) 1987; Atelier 10; Westwinds; I-size: 36" x 24"; P-size: 36" x 24"; Ed#: 4/45; prnt: Oscar Duardo; mtrx: Destroyed; Signed, Inscription in pencil at the bottom reads: "Title, 4/45, signature and 87". bottom left hand; Note: A blue stone arch with red spirals and yellow lightning. Colors used: 1. Blue, 2. Red, 3. Green, 4. Yellow, 5. Black, 6. White, 7. Silver. " 'Balance of Knowledge/Balance of Power' deals with the individual coming to a point in himself and society, being educated by its own example. The use of the arch for knowledge and balance; the spiral for inner strength, understanding and compassion; the lightning for physical strength and endurance. Power to the person." N. Taylor. Full Bleed.

Teruya, Weston Takeshi; *They Mistook the Determination in our Eyes for Hopelessness;* August 2, 3, and 6, 2002; Coventry Rag, 290 gms. I-size: 16" x 22"; P-size: 20" x 26"; Ed#: 4/83, 6/83; prnt: José Alpuche; mtrx: destroyed; signed. lower left; Note: Hand lettered text at top of print within speed bubble reads "Si no hay lucha no hay victoria". Image is distorted such that it appears to have been taken through a fish eye lens. A woman stands on a side walk with her child in one arm at the center of the print. In the other hand she holds a small iconic home. In simple gray lettering "home" floats below it. In back of her you can see a wall with a mural of stylized figures raising fists and identical men in suits painted over. Colors used: light violet, warm orangs (trans), mustard yellow (trans), gray violet, purple, and transparent white (trans).

Thomas, Matthew; *Cosmic Patterns Print II;* (Oct 2-6) 1987; Atelier 10; Westwinds; I-size: 36" x 23"; P-size: 26" x 23"; Ed#: 4/48; prnt: Oscar Duardo; mtrx: Destroyed; Signed, Inscription in pencil located below the image area on the purple border reads: "Signature, 11/87 and 4/48". bottom right hand corner; Note: Full bleed. Image of two Egyptian mummies flanking the center image of four purple and two yellow X's. Colors used: 1. Yellow, 2. Gold, 3. Purple, 4. Magenta, 5. Burgandy, 6. Pink, 7. Light Blue, 8. Tran. Blue-Gray, 9. Peralecence (sic.) White, 10. Perlecence (sic.) Yellow, 11. Gold. "The inner worlds made visible to our senses through symbols: form, color and line are used." M. Thomas.

Thomas, Matthew; *Untitled;* (Oct 11-14) 1985; Atelier 6; Accent 290 gram-white; I-size: 21 1/4" x 34 1/4"; P-size: 21 1/4" x 34 1/4"; Ed#: 4/45; prnt: Stephen Grace; mtrx: Destroyed; Signed, Inscription on a pink line located in the lower left reads: "4/45 and signature". None; Note: Two figures on abstracted yellow field. Pink, red, green, and gray background.

Torres, Salvador; *Viva La Raza;* 1998; Atelier 33; silkscreen; I-size: 30 3/8" x 23 3/4"; P-size: 35 1/2" x 28 1/8"; Ed#: 4/129, 6/129; Signed, Inscription in pencil below image reads: "4/129, Viva La Raza, © Salvador Roberto Torres 98.". embossed "SHG" insignia at lower left-hand corner; Note: The center of the poster is a depiction of the United Farm Workers Union eagle in red and purple. Background colors are various shades of green and white. Poster reads "Viva La Raza" in large letters. #Prints: 2.

Torrez, Eloy; *Deceit Under The Lurking Eye;* (Nov 1-3) 1994; Atelier 25; Coventry Rag 290 grms; I-size: 29 1/2" x 21"; P-size: 38 3/4" x 25"; Ed#: 4/40, 20/40; prnt: José Alpuche; mtrx: Destroyed; Signed, Inscription in pencil below the image reads: "4/40, Deceit Under The Lurking Eye, Eloy Torrez, 94". Lower left; Note: "Angel under a lurking eye surrounded by clouds and the red ocean." (Taken from Certificate of Authenticty) Colors used: 1. Off White, 2. Light Blue, 3. Light Ochre, 4. Light Pink, 5. Light Ultra Blue, 6. Rust Red, 7. Amarillo Ochre, 8. Light Green Yellow, 9. Light Yellow Flesh, 10. Trans. Magenta Brown, 11. Black Magenta Brown, 12. Cool White. "The intent of the peice (sic.) in (sic.) independence. The creator desires his creation but has given her a mind of her own. So now she has the power to accept or reject the creators secret lust." E. Torrez: #Prints: 2.

Torrez, Eloy; *The Pope Of Broadway;* (Nov 19-30) 1984; Atelier 4; Stonehenge 245 gms White; I-size: 36" x 24"; P-size: 40 1/2" x 28"; Ed#: 4/85, 28/85, 34/85; prnt: Stephen Grace; mtrx: Destroyed; Signed, Inscription in pencil below the image reads: "Eloy Torrez, 28/85". None; Note: "Full-length portrait of Anthony Quinn standing in front of a theatre." (Taken from Certificate of Authenticity) Colors used: 1. White, 2. Dark Purple, 3. Orange Ochre, 4. Light Magenta, 5. Medium Navy Blue, 6. Light Ochre, 7. Light Yellow, 8. Yellow, 9. Brown, 10. Dark Blue, 11. Light Blue, 12. Purple, 13. Red, 14. Yellow, 15. Light Orange, 16. Dark Blue. #Prints: 3.

Torrez, Eloy; *Under The Spell;* (May 19-21) 1992; Atelier 19 L.A. Riots; Westwinds; I-size: 24" x 16"; P-size: 28" x 20"; Ed#: 4/65, 22/65; prnt: Richard Balboa; mtrx: Destroyed; Signed, Inscription in pencil located below image area reads: "'Under the Spell', 4/65, Eloy Torrez, 92". Under woman's left leg; Note: A skeleton representing Death is holding a naked woman by her waist and carrying her away. Two red curtains with golden tassels frame the scene. Colors used: 1. Terracotta, 2. Yellow Fleshtone, 3. Yellow Gold, 4. Black, 5. Burgandy, 6. Lime-Green. "I am interested in the dichotomy of life and how they interact and effect on another. Life and Death, List and Love, Spiritual and Physical, Black and White, Male and Female, ect." E.Torrez: #Prints: 2.

Torrez, Eloy; *Untitled;* (Dec 3-13) 1985; Atelier 6; Accent 290 gram-white; I-size: 37" x 24 1/2"; P-size: 37" x 24 1/2"; Ed#: 4/45; prnt: Stephen Grace; mtrx: Destroyed; Signed, Inscription in pencil located at the bottom on the back of the print reads: "4/45 and

signature". <u>Note:</u> Woman and child on a gray textured background. Full bleed.

Tovar, Peter; *L.A./ 92;* (May 5-7) 1992; Atelier 19 L.A. Riots; I-size: 24 1/2" x 16 1/2"; P-size: 28" x 20"; Ed#: 4/55, 22/55; prnt: Richard Balboa; mtrx: Cut; Signed, Inscription in pencil located below image area reads: "LA/92, 4/55, P. Tovar". Lower right corner; <u>Note:</u> Multicolored collage of images depicting a moon, a heart, a cactus, an eye, and a fish among others. On the lower left corner, black type on a dark purple background reads: "Can we get along.." Colors used: 1. Yellow (Transparent), 2. Red (Transparent), 3. Green Opaque, 4. Orange Opaque, 5. Blue Transparent, 6. Black Opaque, 7. Red Touch Up. "The large fish at the bottom is the base for everything above it. It represents Christ he is the backbone of our worl and way of life. The one eye is god who see's everything we do—good or bad. the catus (sic.) and chili represents our sinful nature which is spiraling out of hand. Even our city's are burning with the R.King thing. I'm trying to say what R.King said [']Can we get along['].": #Prints: 2.

Tovar, Peter; *No Tears No Nada;* (Oct 8-10) 1992; Coventry Rag, 290 grms; I-size: 33" x 24 1/4"; P-size: 40 7/8" x 30 1/8"; Ed#: 43/61, 47/61; prnt: José Alpuche; mtrx: Destroyed; Signed, Inscription in pencil below image area reads: "43/61, No Tears No Nada, P. Tovar, '92". Lower left; <u>Note:</u> Composition made of a conglomeration of oversized figures such as a Nopal, a dagger, a chile, a slice of watermelon, and a long narrow-neck glass, among others. Colors used: 1. Lt. Medium Yell, 2. Lt Pink, 3. Trans-Green, 4. Lt Trans. Blue, 5. Trans. Magenta, 6. Opaque Black. "The print has to do with people trying to run away from there (sic.) problems, people being someone or something they aren't. I don't want to see these people ending up as a name on a sugar skull. Let's rejoyce (sic.) over positive thing (sic.) no (sic.) over how they went or why they left so soon." P. Tovar. #Prints: 2.

Uribe, Mario; *The Voyage Of The Akatsuki Maru;* (Feb 23-25) 1993; Images Of The Future; Coventry Rag, 290 grms; I-size: 16 1/8" x 22 1/8"; P-size: 20" x 26"; Ed#: 4/69, 12/69; prnt: José Alpuche; mtrx: Destroyed; Signed, Inscription in pencil below image area reads: "4/69, 'The Voyage of The Akatsuki Maru', signature [illegible], '93". Lower left (SHG); <u>Note:</u> A black ship sails on light green and dark green sea. The green sky has white clouds--one which dominates and overlooks the ship, roughly the shape and demeanor of a skull. The cloud is reflected in the sea with an ominous black shadow--larger than the cloud which seems to merge with the black ship as if it is consuming the ship or a part of the ship. The symbol which is used to warn people of the presence of hazardous waste is in the lower right-hand corner of the print below Japanese characters which state the title of the print. Colors used: 1. Clear Base, 2. Blend: Blue Green to Light Green, 3. Red (Twice), 4. Trans. Med. Grey, 5. Dark Blue Green, 6. Very Dark Blue. "'The Voyage of the Akatsuki Maru' was created in objection to the Japanese Government's insensitive disregard of worldwide concern and outcry over the severe environmental risks of transporting massive amounts of deadly radiotoxic plutonium. One ounce can kill one million people. The Akatsuke Maru carried 1.7 tons of plutonium; a total of 30 tons are (sic.) scheduled to be transported. The imagery is intended to convey the risk which such a shipment represents." M.Uribe: #Prints: 2.

Urista, Arturo; *Califas State Badge;* (Apr 12-14) 1994; Atelier 24; Coventry Rag 290 grms; I-size: 26" x 17"; P-size: 30" x 21"; Ed#: 4/70, 19/70; prnt: José Alpuche; mtrx: Destroyed; Signed, Inscription in pencil below the image reads: "4/70, Califas State Badge, Arturo Urista, 94". Bottom center; <u>Note:</u> "3 poles intersecting a ribbon over an eagle-symbol." Text frames and makes up most of the compostion. Colors used: 1. Bright Yellow, 2. Deep Green, 3. Deep Magenta Red, 4. Light Yellow Green, 5. Magenta-Red, 6. Black. #Prints: 2.

Urista, Arturo; *Chicano P.D. Badge;* (Apr 12-14) 1994; Atelier 24; Coventry Rag 290 grms; I-size: 26" x 17"; P-size: 30" x 21"; Ed#: 4/70, 20/70; prnt: José Alpuche; mtrx: Destroyed; Signed, Inscription in pencil below the image reads: "4/70, Chicano P.D. Badge, Arturo Urista, 94". Bottom center; <u>Note:</u> "An East Los police department badge of Chicanos." Central image of a "shield" with a figure in the middle. Text frames and makes up most of the composition. Colors used: 1. Bright Yellow, 2. Deep Green, 3. Deep Magenta Red, 4. Ligh (sic.) Yellow Green, 5. Magenta Red, 6. Black. #Prints: 2.

Urista, Arturo; *Commonalities;* (July 22-24) 1987; I-size: 19" x 25"; P-size: 20" x 26"; Ed#: 49/61; prnt: Oscar Duardo; mtrx: Destroyed; Signed, Inscription in pencil on the right hand corner of the image reads: "Arturo Urista, 87, 49/61, Commonalities". 15 + 55: No Chop; <u>Note:</u> "The imagery has 3 elements; [sic] The helicopter beaming down it's light (top left), 2 obscure figures facing one way and a directional target mark (top right). The three figures carry common religious related symbols. The fist figure to the left has the soul (The common philosophies that search for the inner self). The second carries the Virgin Mary the most popular identity in Mexico's Catholism. The last figure carries the most communicative media the television. The target, top right gives the direction of where the figures are heading to." Triangles and text frame the compostion. Colors used: 1. Ligh (sic.) Green, 2. Red, 3. Yellow, 4. Pink, 5. Blue, 6. Black. "'Commonalities' is a visual statement pertaining to common issues I have shared with family and friends in East Los Angeles and in Tujuana, Mexico. The imagery has 3 elements; the helicpoter beaming down it's (sic.) light (top left), 3 obscure figures facing one way and a directional target mark (top right). The three figures carry common religious related symbols. The fist (sic.) figure to the left has the soul (the common philosophies that search for the inner self). The second carries the Virgin Mary the most popular identity in Mexico's Catholism (sic.). The last figure carries the most communicative media the television. The target, top right gives the direction of where the figures are heading to. The helicopter beams down it's (sic.) light on middle figure the one I most relate to and is also is (sic.) a statement of the violation of privacy and the search for the undocumented." A. Urista.

Urista, Arturo; *Duel Citizenship;* (Nov 23-27) 1987; Atelier 10; Westwinds; I-size: 36" x 24"; P-size: 37" x 26"; Ed#: 4/53, 33/53; prnt: Oscar Duardo; mtrx: Destroyed; Signed, Inscription in pencil located at the bottom reads: "Arturo Urista, Duel Citizenship, and 4/53". lower left hand; <u>Note:</u> Two figures fighting on a green and red checkered floor enclosed in a shrine. Colors used: 1. Red to Pink, 2. Light Grey, 3. Yellow, 4. Green, 5. Blue, 6. Dark Red, 7. Light Yellow, 8. Turquoise to Gray, 9. Black. "The fight represents the differences in ideologies concerning the decision-making about citizenship. The decision is either to maintain Mexican citizenship and deny any involvement in policy making in the United States or to give up Mexican citizenship and, much more, to become U.S. citizens. The images that I include are: A flag; a country's symbolic identity; el apache; a reminder of the country's cultural roots; the drum: the disciplining of a country's ideologies; el valiente: the defender of one's country." A. Urista. #Prints: 2.

Urista, Arturo; *El Llamado Dividido;* n.d. I-size: 22 1/2" x 35"; P-size: 26 1/4" x 40"; Ed#: 34/58; Signed, Inscription in pencil below image area reads: "34/58, El Llamado Dividido, [triangle symbol], Arturo Urista". embossed "SHG" insignia located in lower right corner outside image area; <u>Note:</u> Two main cartoon-like images almost identical and facing in opposite directions. The background is a big plane of yellow with several pieces of writing, small triangle- and cross-shapes, and small cartoon-like drawings. Colors used: 1. Yellow, 2. Split/Blue green to light blue green, 3. Split/Lt. Pink/Dark Pink, 4. Light Blue Gray, 5. Dark Red, 6. Black, 7. Dark Green, 8. Light Blue. "The 'El Llamado Dividido' or the 'Divide Call' is images and messages that constitute a call for unity under cultural/social and political beliefs but are divided because of soical (sic.) up bringings (sic.)." A.Urista.

Urista, Arturo; *Juego De Pelotá;* (July 19-24) 1987; Westwinds; I-size: 19" x 25"; P-size: 20" x 26"; Ed#: 42/57; prnt: Oscar Duardo; mtrx: Destroyed; Signed, Inscription in pencil on the left side, on the left corner below the image, and on the right side below the image; they read: "Juego De Pelotá, 42/57, Arturo Urista, 87". Right hand lower corner; <u>Note:</u> Colors used: 1. Blue gray (light), 2. Light Blue, 3. Yellow, 4. Red, 5. Black, 6. Blue. "'Juego de Pelotá' is a socal historical perspecive on the competitive games being played emotionally. The images shows [sic] the consequences of the games that never end. The image begins on the top left were [sic] Mexico's acient [sic] ball game is played and the *winner is honored to be sacrafized to the gods. The godess [sic] (right figure) rips apart a bird symbolizing man's ego when losing. The ball is being kicked into the chamber of a pistol whiched [sic] is being fired throught [sic] the body of a male holding a dag-

ger that is used for ritural [sic] sacrafices. (*The winner is never shown.).

Urista, Arturo; *Spiral and Bones;* (Sept 5-6) 1993; Special Project (Monotype); Coventry Rag, 290 grms; I-size: 15" x 18 5/8"; P-size: 20 1/8" x 26 1/8"; Ed#: 4/67,18/67; prnt: José Alpuche; mtrx: Destroyed; Signed, Inscription in pencil below image area reads: "Mono / type, 4/67, Spiral y Bonez [sic], Arturo Urista, 93". Lower left; Note: Two skeletons in black ink, wearing hats and suits are holding each other's arms and dancing on the top of spirals shapes. On each side, a stream of flowers grows a little higher than the figures, in a symbolic stem of leaves and fire. There are two versions of this print, one on a yellow- red background, and another in a blue-gradation background. #Prints: 2.

Urista, Arturo; *The Travel Back;* (Nov 20-24) 1989; Atelier 14; Westwinds (heavyweight); I-size: 20 1/2" x 30"; P-size: 26" x 35 3/4"; Ed#: 4/65, 42/65, 47/65; prnt: Oscar Duardo; mtrx: Destroyed; Signed, Inscription in pencil below the image reads: "The Travel Back, 42/65, Arturo Urista, 89" Signed, Inscription in pencil below image area reads: "4/65, title, signature and 89". Outside of lower right hand corner. Note: "A background of crosses (gold) and figures transforming from the cross[es]. Five gold goddess[es] pass through the scale of lady justice and proceed towards a "Mayan Residential" pyramid." (Taken from Certificate of Authenticity) Gold abstracted heads wearing bandanas facing a gold, yellow and orange temple. Gradation of gold/red crosses and abstracted torsos arranged in rows facing upward. Black fine print border 3" around the image. Colors used: 1. Pastel Green/Yellow (split fountain), 2. Red, 3. Gold, 4. Golden Yellow-Orange, 5. Pink, 6. Blue. "The migration of the cultural from the logic of Blind Justice back to the spirituality of the Mayans. The imagery depicts women as the sole identity of the movement towards the roots of cultural awareness; from Mexico to the U.S. and back." A. Urista. #Prints: 3.

Urista, Arturo; *Welcome To Aztlan;* (Feb 2-6) 1987; Atelier 9; Westwinds; I-size: 22 1/2" x 37"; P-size: 26 1/8" x 40 1/8"; Ed#: 20/46; prnt: Oscar Duardo; Signed, Inscription in pencil below image area reads: "Welcome to Aztlan, 20/46, Arturo Urista". None; Note: A configuration which is similar to a map of states in the southwest United States is the major image. Each state has small images such as guns, cacti, longhorns, and footprints within the borders. The map has some triangles across it and is surrounded by a dark border of symbols. Colors used: 1. Gray, 2. Light Blue, 3. Medium Green, 4. Medium Yellow, 5. Dark Scarlet Red, 6. (Transparent) Emerald Green, 7. (Transparent) Medium Yellow, 8. (Transparent) Rhodamine, 9. (Transparent) Turquoise Blue, 10. Gloss Black.

Valadez, John M. *Día de los Muertos, Announcement Poster for;* ca. 1977; I-size: 33" x 22 7/8"; P-size: 35" x 23 1/8"; Ed#: unknown ed. Signed, Inscription in blue ink in lower right corner inside image area reads: "J. M. Valadez, (c) copyright Rcaf, 1977". "(c) copyright RCAF, 1977" located in lower right corner and "Self Help Graphics & Art Inc. / 2111 Brooklyn Ave., Suite 3 / Los Angeles, Calif. 90033 / Phone; 264-1259" in back of print. Note: Announcement Poster for "Día de los Muertos." Image of Jesus Christ holding a heart in his hand with a figure of a dead man beneath it. There is lettering on the left-hand side of the print which reads: "In commemoration of / the dead and the / reaffirmation / of the joy / of life / Día de los Muertos / Day of the Dead / Evergreen Cemetery / November 6, 1977 / Procession 2:30 / entertainment / El Teatro Campesino / films-music-comida / sponsored by Self-Help / Graphics & Art Inc. / 2111 Brooklyn Ave. / Los Angeles, Califas / 90033. #Prints: 2.

Valadez, John M. *Novelas Kachina;* (Oct 13-15) 1992; Coventry Rag, 290 grms; I-size: 24 1/8" x 38"; P-size: 24 1/8" x 38"; Ed#: 37/52, 41/52; prnt: José Alpuche; mtrx: Destroyed; Signed, Inscription in pencil below image area reads: "37/52, Novelas Kachina, J.M. Valadez, 92'". Lower left; Note: Within the multi-colored, image-packed print there are three emotional, realistic, male faces surrounding a center that consists largely of wild, indigenous images. Throughout, there are small, subtle faces which seem real enough to be drawn from or as photographs. Two of the largest center images are of figures--one green, standing upright and the other red, bent forward holding a face or a mask. Colors used: 1. Yellow, 2. Pink Flesh, 3. Medium Flesh, 4. Blue, 5. Green (light), 6. Red. "Specifically explaining the prints (sic.) contents

risks convulsion. Simply I found a similarity in ancient cariacture and the more recent kind of popular graphics involving human drama." J.M.Valadez. #Prints: 2.

Valadez, John M. *Untitled;* (March 19-26) 1985; Atelier 5; Stonehenge 320 grams-white; I-size: 24 3/4" x 35 1/2"; P-size: 24 3/4" x 35 1/2"; Ed#: 4/88, 35/88; prnt: Stephen Grace; mtrx: Destroyed; Signed, Inscription in pencil located below the image area reads: "4/88, and signature". None; Note: Three blue male figures in the foreground. On a red field the remainder of the human figures are superimposed on each other. #Prints: 2.

Valdez, Patssi; *Calaveras De Azucar;* (Oct 16-20) 1992; Atelier 20; Coventry Rag, 290 grms; I-size: 34" x 25"; P-size: 34" x 25"; Ed#: 43/55, unknown ed. prnt: José Alpuche; mtrx: Destroyed; Signed, Inscription in pencil blending within the patterns at bottom reads: "Calaveras de Azucar, 43/55, Patssi Valdez". Lower right; Note: Two grinning skulls, one female (yellow head encircled by blue beads where neck would normally be, matching blue earrings, shoulder length hair) and one male (bow tie in place of neck, short red hair, green face) sit upon a circular table top with three smaller skulls in party hats, a bottle of liquor and two cocktail glasses. The images are surrounded by red and green crosses and colorful swirling designs. Colors used: 1. Trans Lt Yell (sic.), 2. Trans Blue, 3. Trans Red, 4. Trans Violet, 5. Trans Magenta. "This print is depicting the celebration of the dead." P. Valdez: #Prints: 2.

Valdez, Patssi; *Dia de los Muertos 2000;* September 5-13, 2000; Coventry Rag, 290 gms. I-size: 21" x 14"; P-size: 28 1/2" x 19 7/8"; Ed#: 4/80, 6/80; prnt: José Alpuche; mtrx: destroyed; signed. Note: Table alter for day of the dead. Colors used: Light Cerullean Blue, Dark Blue, Dark Brown, T Magenta, Marigold, T White, Light Purple, T Red, T Yellow, T Midtone Blue, Opaque White, T Drk Turquoise Blue, D Chocolate Brown, Clr Bse, Ivory White, Brown Blck.

Valdez, Patssi; *November 2;* 1998; Atelier 33; silkscreen; I-size: 18 1/4" x 12 1/8"; P-size: 26" x 20"; Ed#: 4/57, 6/57; Signed, Inscription in pencil below image reads: "4/57, November 2, Patssi Valdez 98.". embossed "SHG" insignia at lower left-hand corner; Note: The artist honors a woman recently deceased. Her framed picture is on a purple mat surrounded by the Zempasuchil/Marigold flowers. There are calaveras with lit candels, papel picado hanging on a string, and multi-colored confetti. #Prints: 2.

Valdez, Patssi; *Scattered;* (Nov 30—Dec 4) 1987; Atelier 10; Westwinds; I-size: 24" x 36"; P-size: 24" x 36"; Ed#: 4/54; prnt: Oscar Duardo; Signed, Inscription located at the bottom of the image area reads: "Signature, title, date". "SHG" chops located at the bottom of the image area; Note: A black and white collaged self portrait. Kodalith transfer. Full bleed. Colors used: 1. White, 2. Black/Blue, 3. White. "This print is autobiographical: The breaking away of the old and the emergence of the new self." P. Valdez.

Valdez, Vincent; *Suspect: Dark Hair, Dark Eyes, Dark Skin;* November 14 and 21-27, 2002; Special Project; Coventry Rag, 290 gms. I-size: 22" x 16"; P-size: 26" x 20"; Ed#: 4/77, 6/77; prnt: José Alpuche; mtrx: destroyed. signed. lower left; Note: "The context of this print deals with ideas and communities, social and political. The idea stemmed from several elements, particularly individual figures and incidents in society, For example, St. Sebastian was a religious martyrs, [sic] perseated [sic] and profiled for his religious beliefs, which is where the pose comes from. Bullet holes replaced the arrows which were shot into Sebastian. Second, his T-shirt identifies Bin Laden and is portraying a stereotypical and profiled Middle [Ea]stern male "This is the enemy"—Not only is this another type of racial profiling and brainwashing done in America, it is also a [sic] another hypocritical stone that America takes. Obviously we have foreign enemies, yet we presente [sic] our own and abuse our own. Finally this image was done in memory of, who was gunned down by several off-duty officers in Brooklyn, . He was stopped while walking on the sidewalk for no reason and as he reached into his pocket, he was shot 42 times and killed. He reached into his pocket for his I.D. "It is a dangerous time and a dangerous place to have dark clothes, dark hair, dark eyes, and dark skin." Vincent Valdez. [Note: the artist seems to be referring here to Amadou Diallo.] Colors used: 120C Yellow, 167C Orange, 032C Red, 000Z-C Black, ZN)R-C Brown, OSZN-C Dark Brown, 277C Light Black, 000Z-C Black, and Clear Gloss. #Prints: 2.

Vallejo, Linda; *Black Orchid;* (Jan 5-9) 1987; Atelier 9; Westwind; I-size: 36 1/8" x 24 1/8"; P-size: 40 1/8" x 26 1/8"; Ed#: 27/45; prnt: Oscar Duardo; Signed, Inscription in pencil below image area reads: "Black Orchid, 27/45, Vallejo, 87". None; <u>Note:</u> Oversized image of a multicolored flower in pink and purple tones on a navy blue background. Straight stems are spreading out from the center--like a light beam and spreading out in different directions. Colors used: 1. Pink-Whlte, 2. Yellow Primrose, 3. Yellow Chrome, 4. Blue 44, 5. Red 38, 6. Burgundy 36, 7. blue 45, 8. Blue 41, 9. Lilac, 10. Blue Black, 11. Blue Green 46.

Vallejo, Linda; *Untitled;* (Dec 4-13) 1984; Atelier 4; Stonehenge 245 gram; I-size: 24" x 36"; P-size: 41 1/4" x 28 1/2"; Ed#: 4/88, 34/88; prnt: Stephen Grace; mtrx: Destroyed; Signed, Inscription in pencil below image area reads: "4/88, signature and '84". None; <u>Note:</u> Human head. Tints and shades of magenta, with circular design. Center ground: yellow, orange, magenta, pink amd green in front of a dark blue sky. Mat varnish. Colors used: 1. White, 2. Dark Blue, 3. Magenta, 4. Pink, 5. Yellow, 6. Purple, 7. Pink, 8. Blue, 9. Yellow, 10. Blue, 11. White, 12. White, 13. Blue, 14. Varnish. #Prints: 2.

Vargas, Tecpatl; *The Mercury Weeps;* February 27- March 1, 2001; Maestras 2; Coventry Rag, 290 gms. I-size: 18" x 26"; P-size: 16" x 30"; Ed#: 4/62, 6/62; prnt: José Alpuche; signed. lower left; <u>Note:</u> Half-tone images from 1930's-1950's Popular Science, Popular Mechanics issues. Man wearing goggles, woman playing organ; woman playing organ, woman withte head of a chicken; flourescent light bulbs; feet in high heels, xerox enlargements, cut and paste, five color separations with ruby lith and stat film. Colors used: Light Blue, Dark Blue, Green, Yellow Green, Dark Grey Green.

Vega, Salvador J. *Volador;* (April 12-21) 1993; Special Project (Chicago); Coventry Rag, 290 grms; I-size: 26 1/2" x 38 1/2"; P-size: 26 7/8" x 38 7/8"; Ed#: 4/76, 14/76; prnt: José Alpuche; mtrx: Destroyed; Signed, Inscription in white color located at the bottom of the print reads: "4/76, 'Volador', Salvador J. Vela [illegible], 93". Lower Left; <u>Note:</u> Multicolored composition of geometrical shapes around a blue round form with human face. From the tip of the nose, a curvilinear shape opens up resembling sexual organs and extending around in the shape of wings. Colors used: 1. Trans Ultramarine, 2. Trans Medium Yellow, 3. Trans Orange Red, 4. Trans Green, 5. Trans Magenta, 6. Trans Cerulean Blue, 7. Trans Rich Brown, 8. Trans Orange Yellow, 9. Trans Turquoise, 10. Trans Gold, 11. Opaque Black, 12. Trans Pearl White. "Originally taken from one of my painting titled 'Volador,' meaning flyer, symbolizes a brid headress (sic.) face." S.J.Vega. #Prints: 2.

Velazquez Navarro, Genaro; *Algo Quedó;* 1997; Atelier 29-31 #4 & #6; I-size: 22 1/4" x 16"; P-size: 26" x 20"; Ed#: 4/59, 41/59; Signed. lower left corner; <u>Note:</u> Faceless woman with a black and purple cloak. #Prints: 2.

Villa, Esteban; *Homefront Homeboy;* June 10-14, 2003; Atelier XLI; Coventry Rag, 290 gms. I-size: 22" x 16"; P-size: 26" x 20"; Ed#: 4/72, 6/72; prnt: José Alpuche; mtrx: destroyed. signed. lower left; <u>Note:</u> "Close-up head and shoulder side view of a young Chicano man. His white T-shirt is used as a blind fold. Against a midnight-blue back ground are what appears to be bullet casings and blood drops metamorp[h]ized into hot jalapenos. "Homefront Homeboy" Street wars are happening. Boys are playing with guns. Like the Civil War its brother against brother. The blind fold on this young Chicano is symbolic of blind fury blind date blind execution blind presecution [sic] blind justice." Colors used: Clear Base, Ultra Blue, Sienna Flesh, Off White, Yellow Ochre, Red, Black, and Clear Gloss. #Prints: 2.

Villa, Esteban?; *Ruben's Graffitti;* n.d. I-size: 15" x 21"; P-size: 19" x 25"; Ed#: 20/50; Signed, Inscription in pencil below image area reads: "20/50, Rubens Graffitti, Villa". <u>Note:</u> Multiplied image of different sizes of a man (Ruben?). On the top of the print, flourescent orange type reads: 'Ruben's Graffitti; on the bottom, blue type reads: "Califa's Aztlan.".

Westcott, Gloria; ˜Adiós Hollywood!; (June 26-29) 1992; Atelier 19 L.A. Riots; Westwinds; I-size: 25 5/8" x 17 5/8"; P-size: 28" x 20"; Ed#: 4/54, 23/54; prnt: Richard Balboa; Signed, Inscription in pencil below image area reads: "4/54, ˜Adiós Hollywood!, Gloria Westcott, '92". Left lower corner; <u>Note:</u> The foreground is a palm tree whose leaves have been partially cut out to show different designs and patterns: asian characters, moiré patterns, flowers, maps.. The background is a view of the business district in downtwon Los Angeles with City Hall and hotel buildings. The main colors are fluorescent green, pink, purple, and orange. "This print represents the city of L.A. which I see everyday, during the riots the city smoked and burned, I have been doing a series of ˜Adios Hollywood! for over a year and always knew the city was going to burn but never understood why or how. It was only appropriate to make a print that captured the city burning: the palm tree [is] such a symbol of L.A. and my faithful companions from my window on Echo Park." G. Westcott: #Prints: 2.

Yáñez, Larry; *Cama Na My Howze;* December 14 and 17, 1999; Coventry Rag 290 gms. I-size: 26 1/2" x 31 7/8"; P-size: 30" x 34"; Ed#: 4/72, ?/72; prnt: José Alpuche; mtrx: Destroyed. signed. Inscription in pencil in image are reads, "4/72 -Para Karen- Cama Na My Howze TL Yáñez '99". There is also a signature and copyright symbol incorporated into the print. lower right in image area. <u>Note:</u> Bedroom Scene[.] Part of the Dream Chicano House—each room based on childhood memories—elements from different homes of my mother and many many tias + cousins, ninas + amigas de mi madre. Colors used: Pink, Blue, Purple, Red, Green, Yellow, Brown, Gray, Black, and Trans/Gloss.

Yañez, Lawrence M. *Cocina Jaiteca;* (Aug 1-5) 1988; Westwind (heavyweight); I-size: 36" x 24"; P-size: 39" x 26"; Ed#: 17/60; prnt: Oscar Duardo; mtrx: Destroyed; Signed, Inscription in ink and in pencil within the image area reads: "(pencil) 17/60, Yañez [illegible] and (ink) c/s Cocina Jaiteca, (c) Yañez, '91". Lower left hand corner of image; <u>Note:</u> "Kitchen interior with taco in foreground, refrigerator, stove, white, window view of the southwest." (Taken from Certificate of Authenticity) Colors used: 1. Peach Orange, 2. Scarlet Red, 3. Green, 4. Pink, 5. Light Gray, 6. Transparent Turquoise, 7. Transparent Purple, 8. Transparent Light Brown, 9. Orange, 10. Silver, 11. Charcoal Black.

Yañez, Lawrence; *Once Juan Won One;* (May 12-14) 1993; Special Project; Coventry Rag, 290 grms; I-size: 26 1/8" x 38"; P-size: 30" x 44"; Ed#: 4/56, 20/56; prnt: José Alpuche; mtrx: Destroyed; Signed, Inscription in pencil below image area reads: "Once Juan Won One, 4/56, ? [illegible] Yañez, '93". Lower gith; <u>Note:</u> Interior of a bathroom. The opened window reveals the landscape of Arizona. The curtains are green and have a pattern of skulls. To the left is the bath tub and the 'tacos' shower curtain. To the right is a blue dresser and a painting of San Juan Bautista. The mirror above the sink reflects a cross with the figure of Jesus which is hanging on the opposite wall. On the red tiled floor are a rubber duck, a ship, and sandals. The scene is framed all around by repeated images of an aeroplane, a face, a broken heart, and small triangles in a blue and green background. Colors used: 1. O. Mint Green, 2. O. Baby Blue, 3. T. Fire Red, 4. O. Lt. Pink, 5. O. Lt. Mouve (sic.), 6. O. Black. "Once my uncle bought a raffle ticket and won a complete bathroom set!" L. Yañez: #Prints: 2.

Yañez, Lawrence; *Sofa So Good;* (Jan 24-28) 1991; Atelier 16; Westwinds (heavyweight); I-size: 36" x 26"; P-size: 38 1/2" x 28"; Ed#: 14/56; prnt: Oscar Duardo; mtrx: Destroyed; Signed, Inscription in pencil and in ink within the image reads: "(pencil) 14/56, Yañez [illegible], and (ink) Sofa So Good, (c) Yañez, '91". Bottom right-hand corner; <u>Note:</u> "[A] living room scene" with a sofa, a back wall with a desert image, and carpet on the floor. Colors used: 1. Red, 2. Gray, 3. Tan, 4. Pink, 5. Lt. Green, 6. Green, 7. Lt. Turquoise, 8. Lt. Lavender, 9. Orange-Yellow, 10. Yellow, 11. Silver, 12. Black. "Part of a series of scenes from a Chicano house—foreground television—Moya serape throw rug—pair of P.F. flyers—jalapeño couch (hot seat) cucui cushion—la Virgen sin Cara, satire on de Grazia, mural or real landscape bordered by indigenous motif, jesus around the corner." L. Yañez.

Yanish, Mary; *Pericardium;* 1998; Atelier 33; silkscreen; I-size: 16" x 22"; P-size: 20" x 26 1/8"; Ed#: 4/55, 6/55; Signed, Inscription in pencil below image reads: "4/55, Pericardium, Mary Yanish 98". embossed "SHG" insignia at lower left-hand corner of poster; <u>Note:</u> Image of a winged sphinx in black with silver outline centers the poster. The figure has the face of a woman with horns, a yin and yang sign, and a moon with stars on her forehead. There is a golden halo-like shield behind the woman's head. Background is of green hills with a purple/pink sky. #Prints: 2.

Ybarra, Frank; *Our Lady of Guadalupe, Arizona;* February 3-4, 2000; Coventry Rag, 290 gms. I-size: 16" x 22"; P-size: 20" x 26"; Ed#: 4/80, 6/80; prnt: Joe Alpuche; mtrx: destroyed; signed. lower left; <u>Note:</u> Our Lady of Guadalupe, Street Scene, landscape im

background, rays extending our on upper third of print. My piece represents the town of guadalupe, Arizona. A small town located south-east of Phoenix. Guadalupe has ermained a small traditional community untouched by big development, surrounded by Mega malls and typical modern suburban living. Colors used: Dk. Violet Black, Yellow, Blue, Red, Purple, Green, and Beige/Transparent. #Prints: 2.

Yorba, Kathleen D.R. *The View;* 1995; Atelier 26; poster; I-size: 38 1/2" x 26"; P-size: 44" x 30"; Ed#: 30/63, 32/63; prnt: José Alpuche; mtrx: Destroyed; Signed. lower left; <u>Note:</u> View of an artist's studio in predominantly browns and greens. In the studio is the back of a female model and an easel. #Prints: 2.

Zains, Marisa; *Phantom Feur II;* 1983; Atelier 1; Artprint; I-size: 19" x 25"; P-size: 23" x 35"; Ed#: 27/60; prnt: Stephen Grace; mtrx: Destroyed; Signed, Inscription in pencil reads: "27/60, title, signature and 83". No chop; Fund: partially funded by the CAC and the NEA. <u>Note:</u> High contrast woman holding a yellow dot pattern. The sphere has a blue/purple gradation for the background.

Zenteno, Sergio; *Untitled;* 1992; Images Of The Future; Coventry Rag, 290 grms; I-size: 19" x 17 1/4"; P-size: 26" x 20"; Ed#: 4/62, 16/62; prnt: José Alpuche; mtrx: Destroye (sic.); Signed, Inscription in pencil below image area reads: "Sergio Zenteno, 92, 4/62". Lower right; <u>Note:</u> Seven independent black and white abstract shapes in a white background. It is not clear what they are although a cross, a female figure, an eye, an other anthropomorphic forms can be identified. These forms are filled in with several patterns that seem to be merely decorative. #Prints: 2.

Zoell, Bob; *Sunflowers For Gauguin;* (Oct 14-17) 1985; Atelier 6; Accent 290 gram-white; I-size: 29" x 18"; P-size: 33" x 22 1/4"; Ed#: 4/30; prnt: Stephen Grace; mtrx: Destroyed; Signed, Inscription in pencil located at the bottom of the image area reads: "4/30, title and signature". None; <u>Note:</u> Abstract saturated color fields. Red, yellow, green, blue and black outlines. White background.

Selected Bibliography

1. Archival Sources

California Ethnic and Multicultural Archives, Special Collections Department, University Libraries, University of California at Santa Barbara, http://cemaweb.library.ucsb.edu/cema_index.html:

Chicano Art Digital Image Collection
http://cemaweb.library.ucsb.edu/digital_Archives.html

Guide to the Self Help Graphics Archives 1960- (CEMA 3)
http://cemaweb.library.ucsb.edu/shg_toc.html

Self Help Graphics & Art Archives Catalog of Silkscreen Prints
http://cemaweb.library.ucsb.edu/

Self Help Graphics & Art Archives
Catalog of Slides http://cemaweb.library.ucsb.edu/shg_slides_toc.html

Smithsonian Institution Archives of American Art:

> Oral History Program (includes interviews by Jeffrey Rangel with Barbara Carrasco, Gronk, Judithe Hernández, Willie Herrón, Gilbert "Magu" Luján, Frank Romero, and Patssi Valdez, and an interview by Margarita Nieto with Carlos Almaraz)

> Papers of Tomás Ybarra-Frausto

Shifra M. Goldman (private collection), Los Angeles, California

UCLA Chicano Studies Research Center Library and Archive:

> Approximately 300 prints.
> http://www.chicano.ucla.edu/library/arch/archives.html

2. Books and Articles

Benitez, Tomás. "Self-Help Graphics: Tomás Benitez Talks to Harry Gamboa Jr." In *The Sons and Daughters of Los: Culture and Community in L.A.*, edited by David E. James, 195–210. Philadelphia: Temple University Press, 2003.

De la Cruz, Elena. "El Arte de Self-Help Graphics gana espacio." *La Opinión* (Los Angeles), April 5, 1995, 1D.

———. "Sendas muestras llenan de sabor latino al Hammer de UCLA." *La Opinión* (Los Angeles), October 14, 1995, 1D.

Dubin, Zan. "From 'Across the Street' to Laguna Beach Art: The Museum's Silkscreen Acquisitions Not Only Mean Exposure for Latino Artists, but Also Represent Progress." *Los Angeles Times* (Orange County edition), March 25, 1995, 2.

Goldman, Shifra. "A Public Voice: Fifteen Years of Chicano Posters." In *Dimensions of the Americas: Art and Social Change in Latin America and the United States* (Chicago: University of Chicago Press, 1994).

Hendrix, Kathleen. "Visual Aid: East L.A. Center Helps Brings Artists and Neighbors Together." *Los Angeles Times* (home edition), July 27, 1992, 1.

Hernández, Daniel. "A Changing Imprint: Self Help Graphics Is Forging Links beyond Its Eastside Roots and Planning a More Innovative Future." *Los Angeles Times*, August 1, 2004, E41.

Kun, Josh. "The New Chicano Movement." *Los Angeles Times*, January 9, 2005, I12.

———. "Vex Populi: At an Unprepossessing Eastside Punk Rock Landmark, Utopia Was in the Air. Until the Day It Wasn't." *Los Angeles Magazine*, March 2003.

Leonard, Jack. "Nun's Contributions to Chicano Heritage Recalled at Festival." *Los Angeles Times*, November 2, 1997, B2.

Limón, Leo. "A Tribute to the Ones Who Light Our Creative Spark, Fan Our Flames and Encourage Us to Pass It On." *Arroyo Arts Collective Newsletter*, September 1997, http://www.arroyoartscollective.org/news/sep97/tribute.html.

Lopez, Lalo. "Power Prints." *Hispanic* 8, no. 9 (October 1995): 68.

Ollman, Leah. "'Self-Help Graphics' Vibrates with Energy and Intimacy." *Los Angeles Times* (San Diego edition), August 10, 1990, F21.

Prado Saldivar, Reina Alejandra. "Self-Help Graphics: A Case Study of a Working Space for Arts and Community." *Aztlán* 25, no. 1 (Spring 2000): 167–81.

Rodriguez, Juan. "Self-Help Graphics, una institución cultural que merece el apoyo de todos los Angelinos." *La Opinión* (Los Angeles), June 30, 1996, 1D.

Schneider, Greg. "A Conversation with Sister Karen Boccalero, Founder of Self-Help Graphics." *Artweek*, August 6, 1992, 16–17.

Tobar, Hector. "Sister Karen Boccalero, Latino Art Advocate, Dies." *Los Angeles Times*, June 26, 1997, B, 1.

Venegas, Sybil. "The Day of the Dead in Aztlán: Chicano Variations on the Theme of Life, Death, and Self Preservation." PhD diss., University of California, Los Angeles, 1993.

Wilson, William. " 'Chicano Art': Energetic, Sincere Survey." *Los Angeles Times*, March 21, 1995, F9.

3. Catalogs

Farmer, John Allen, ed. *Pressing the Point: Parallel Expressions in the Graphic Arts of the Chicano and Puerto Rican Movements*. New York: El Museo del Barrio, 1999.

Griswold del Castillo, Richard, Teresa McKenna, and Yvonne Yarbro-Bejarano, eds. *Chicano Art: Resistance and Affirmation, 1965–1985*. Los Angeles: University of California, Wight Art Gallery, 1991.

Nieto, Margarita. *Across the Street: Self Help Graphics and Chicano Art in Los Angeles*. Edited by Colburn Bolton. Laguna Beach, CA: Laguna Beach Art Museum, 1995.

Noriega, Chon A., ed. *Just Another Poster? Chicano Graphic Arts in California*. Santa Barbara: University of California, University Art Museum, 2001.

Romo, Tere. *Chicanos en Mictlán: Día de los Muertos in California*. San Francisco: The Mexican Museum, 2000.

About the Author and Editor

KRISTEN GUZMÁN, PhD, is a historian specializing in Chicano history, art history and social change, and the history of Los Angeles. She was a fellow at the Smithsonian Institute for the Interpretation and Representation of Latino Cultures and teaches courses in the history of art and social movements in the United States. In addition to her academic work, she has been a union organizer and co-founded Arts in Action, an arts collective in Los Angeles.

COLIN GUNCKEL is a doctoral student in the Critical Studies Program of the Department of Film, Television and Digital Media at UCLA. His research focuses on low-budget and exploitation genres produced in Mexico, on contemporary Mexican cinema, and on Spanish-language film exhibition in the U.S. Southwest. Through UCLA's Chicano Studies Research Center, he helped organize and document the on-site archival holdings of Self Help Graphics & Art.

Atelier XVI and XVII orientation meeting, February 1991. From the CEMA Self Help Graphics Archives. Photograph by Rick Meyer. Large artwork at back of room by Luis Ituarte.From left to right in the back:

1. Miguel Angel Reyes
2. Not identified
3. Leo Limón
4. Ricardo Duffy
5. Raul de la Sota
6. José Lozano
7. Pat Gomez
8. Daniel J. Salazar
9. Oscar Duardo

10. Alex Donis
11. Dolores Guerrero Cruz
12. Yolanda Gonzalez
13. Sister Karen Boccalero

From left to right in the front:
14. Michael Amescua
15. Margaret Garcia
16. Yreina Cervantez

THE UCLA CHICANO STUDIES RESEARCH CENTER LIBRARY AND ARCHIVE

The CSRC Library and Archive is involved in documentation, preservation, and access projects funded by the center's Los Tigres del Norte Fund, the Ford Foundation, the Getty Foundation, the Haynes Foundation, the Museum of Fine Arts, Houston, and the Rockefeller Foundation, among others. We invite researchers and scholars to make use of our extensive resources, including a non-circulating library with over 12,500 volumes, 3,000 reels of microfilm, and important periodical and audiovisual holdings. The archive houses over sixty special collections that cover many aspects of the Chicana/o experience. These collections include:

Arhoolie Foundation's Strachwitz Frontera collection. The largest repository of Mexican and Mexican-American popular and vernacular recordings in existence. The first phase of preservation consists of 30,000 78-rpm phonograph recordings, which are available online at http://digital.library.ucla.edu/frontera/

CARA (Chicano Art Resistance and Affirmation) collection. Documentation relating to and images from the groundbreaking exhibit organized by and opened at the UCLA Wight gallery in 1990. The exhibition toured nationally. (75 linear feet)

Chicano Film and Video collection. Over 200 Chicana/o films on history and culture. Includes restored films and trailers by pioneer filmmaker Efraín Gutiérrez. Part of an ongoing collaboration with the UCLA Film and Television Archive. Some are now available on DVD from the CSRC.

CSRC Library Poster Collection. Over 700 prints and posters on the Chicana/o experience from the 1970s onward, including Luis Valenzuela's collection.

The Mexican Museum collection. Papers representing the thirty years of curatorial and administrative history of the Mexican Museum in San Francisco. Acquired and processed this summer. (150 linear feet)

Self Help Graphics & Art collection. Over 300 prints representing printmaking at the arts center from 1972 to 2005.

Descriptions for all our holdings are available at:

www.chicano.ucla.edu/library/arch/archives.html

For more information, please contact the librarian at yretter@chicano.ucla.edu.

THE UCLA CHICANO STUDIES RESEARCH CENTER PRESS

THE PRESS

has been publishing
high-quality, original research relevant to or
informed by the Chicana/o experience since
1970. Our series are of particular interest to
scholars, teachers, and libraries.

AZTLÁN: A JOURNAL OF CHICANO STUDIES. The leading journal
in its field since 1970. Published semi-annually in 250 to 300 pages.
ISSN: 0005-2604.

A VER: REVISIONING ART HISTORY. A ground-breaking series featuring scholarly books with
extensive color reproductions on individual Latino artists. The first book in the series is on the
artist Gronk, due fall 2006. ISSN: TBA.

THE CHICANO ARCHIVES. A collection guide series featuring scholarship on and documentation of U.S. archival holdings on
Chicana/os, including books on the Mexican Museum and on the Tejano filmmaker Efraín Gutiérrez. ISSN: TBA.

CHICANO CINEMA AND MEDIA ART. A DVD series preserving historic Chicano documentaries, video art, and feature films.
Three DVDs are now available. Upcoming titles include the first Chicano-directed feature film.

LATINO POLICY & ISSUES BRIEF. An occasional series for journalists and policymakers summarizing policy-related academic
studies in just four pages. Widely cited in such magazines as *Time* and such television outlets as CNN. The last issue addressed
the vital role of community colleges in Chicana/os gaining doctorates. ISSN: 1543-2238

AZTLÁN ANTHOLOGIES. An occasional series of books that place together the most popular articles in *Aztlán: A Journal of
Chicano Studies* on a particular topic. Widely used in the undergraduate and graduate school classroom. The last book in the
series included essays by noted Chicana/o scholars on the familial and personal nature of their research.

For more information, please contact the press at **press@chicano.ucla.edu**.

Descriptions for all our holdings and how to order them are available at:

WWW.CHICANO.UCLA.EDU/PRESS